American Drawings and Watercolors in
The Metropolitan Museum of Art

JOHN SINGER SARGENT

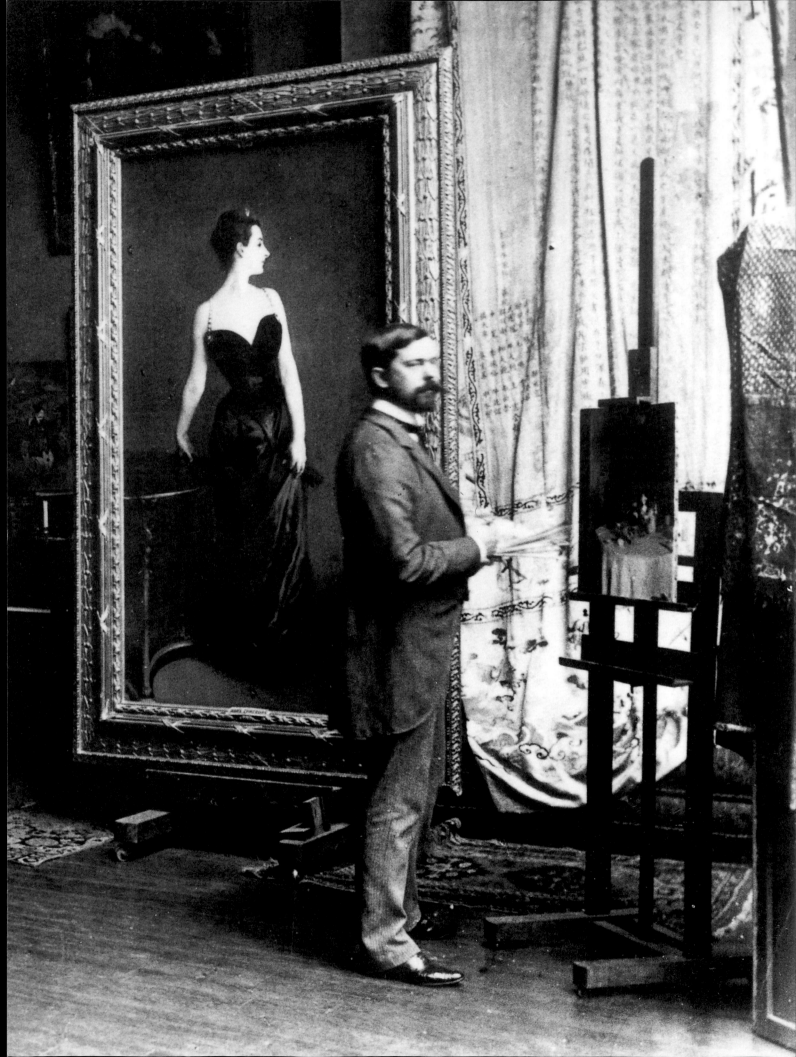

American Drawings and Watercolors in The Metropolitan Museum of Art
JOHN SINGER SARGENT

Stephanie L. Herdrich and H. Barbara Weinberg
with an essay by Marjorie Shelley

THE METROPOLITAN MUSEUM OF ART, NEW YORK

DISTRIBUTED BY YALE UNIVERSITY PRESS, NEW HAVEN

This publication is made possible by the
Marguerite and Frank A. Cosgrove Jr. Fund.

Published by The Metropolitan Museum of Art, New York

John P. O'Neill, Editor in Chief
Tonia L. Payne and Barbara Cavaliere, Editors
Bruce Campell, Designer
Peter Antony and Elisa Frohlich, Production

LIBRARY OF CONGRESS CATALOGING-IN-PUBLICATION DATA

Herdrich, Stephanie L.
 American drawings and watercolors in the Metropolitan Museum of Art : John Singer Sargent / Stephanie L. Herdrich and H. Barbara Weinberg ; with an essay by Marjorie Shelley.
 p. cm.
 Includes bibliographical references and index.
 ISBN 0-87099-952-4 (HC)—ISBN 0-300-8519-2 (Yale University Press)
 1. Sargent, John Singer, 1856–1925—Exhibitions. 2. Art—New York (State)—New York—Exhibitions. 3. Metropolitan Museum of Art (New York, N.Y.)—Exhibitions. I. Sargent, John Singer, 1856–1925. II. Weinberg, H. Barbara (Helene Barbara). III. Shelley, Marjorie. IV. Metropolitan Museum of Art (New York, N.Y.). V. Title.

 N6537.S32 A4 2000 759.13—dc21 00-026258

Jacket illustration: John Singer Sargent, *Mountain Stream* (detail), ca. 1912–14. Watercolor and graphite on off-white wove paper, 13¾ × 21 in. (34.9 × 53.3 cm). See catalogue 313.

Frontispiece: John Singer Sargent in his Paris studio, ca. 1885, with *Madame X* on an easel. Photographs of Artists Collection 1, Archives of American Art, Smithsonian Institution, Washington, D.C.

Table of Contents

Director's Foreword

The Metropolitan's collection of drawings and watercolors by John Singer Sargent (1856–1925)—some 337 sheets and four sketchbooks that contain more than two hundred images—is one of the world's largest and most diverse. These works reflect the long, multifaceted, and prolific career of an ardent draftsman and watercolorist who made studies on paper during his extensive travels, for his murals, and, less frequently, for his many portraits.

The varied circumstances that prompted Sargent to record his impressions with graphite, charcoal, or watercolor and the means by which his works in these media entered the Museum account for our collection's range and quality. The artist sold ten watercolors that he considered among his best to the Metropolitan in 1915. His family so esteemed his talent that they preserved even his earliest sketchbooks and a large number of his experimental and inconsequential sheets, along with more resolved images that he had chosen not to sell or give away. Although his sisters, Emily Sargent and Violet Sargent Ormond, donated to other institutions numerous drawings and sketchbooks and the mural studies that remained in his studios after his death (and gave nine drawings to the Metropolitan in 1930–31), they kept a large representation of his drawings and watercolors. Much of this latter group Mrs. Ormond gave to the Metropolitan in 1950, along with two dozen studies in oil and a few miscellaneous works. Since then, several additional drawings, including six sheets relating to Sargent's murals and two of his many formal portraits in charcoal, have been received from unrelated donors.

The Metropolitan's collection thus invites study of Sargent's prodigious talent, procedures, and production in many media. It also offers visual delights to be expected from the artist who possessed what painter-critic Kenyon Cox characterized in 1916 as "the most gifted and the most highly trained hand and eye now extant in the world."

This catalogue of Sargent's drawings and watercolors in the Metropolitan was organized and written by Stephanie L. Herdrich, research associate in the Department of American Paintings and Sculpture, and H. Barbara Weinberg, Alice Pratt Brown Curator of American Paintings and Sculpture. Marjorie Shelley, Sherman Fairchild Conservator in Charge, Sherman Fairchild Center for Paper and Photograph Conservation, contributed an essay on Sargent's technique. The publication of the catalogue in 2000 commemorates the seventy-fifth anniversary of the artist's death and the fiftieth anniversary of the great Ormond gift. The Metropolitan is indebted to the generous support of the Marguerite and Frank A. Cosgrove Jr. Fund for making this project possible. We acknowledge also the assistance of the William Cullen Bryant Fellows of the Museum's American Wing.

Philippe de Montebello
Director

Preface

Within the collections of the Metropolitan's Department of American Paintings and Sculpture is a large holding of drawings and watercolors created by artists born by 1876. This collection was transferred physically from the Museum's drawings department in 1990, when suitable storage space became available in the recently opened Henry R. Luce Center for the Study of American Art. The accessibility of drawings and watercolors in the American Wing and their proximity to related paintings, sculpture, and works in the decorative arts invite consideration of artists' concurrent accomplishments in diverse media. Without slighting connoisseurship, we study American artists as multifaceted creators, echoing the concern for context that has guided our installation of the American Wing's galleries and period rooms and our scholarship in general.

Since 1990, the curators of American paintings and sculpture have organized for display in the Luce Study Center exhibitions of varied works from the collection by Thomas Eakins, Arthur B. Davies, John La Farge, and Tonalist artists. In this gallery we have also presented drawings by John Singleton Copley, sketchbooks by John Singer Sargent, American pastels, drawings by the Hudson River School, images of women, and drawings and watercolors acquired since 1980. The tour of an ambitious exhibition of American watercolors culminated in an installation in the Erving and Joyce Wolf Gallery in fall 1991. The curators have also turned their attention to preparing a multivolume catalogue of the Metropolitan's American drawings and watercolors, of which this is the first to appear.

Works by John Singer Sargent (1856–1925) constitute about one third of the drawings and watercolors in the Department of American Paintings and Sculpture. The first watercolors by Sargent to enter the collection were purchased from the artist in 1915. Gifts from Sargent's sisters in 1930–31 added a few of his mural studies to our holdings. The most extraordinary windfall by far was the gift of hundreds of drawings and watercolors—along with more than twenty oils—by his sister, Mrs. Francis Ormond, received in 1950.

The immense size of the Ormond gift and the fact that it had been recorded only cursorily upon its arrival presented a challenge to the authors of this catalogue. Basic data needed to be clarified, accession numbers reorganized, and measurements and inscriptions recorded and checked. The recent resuscitation of Sargent's reputation after decades of neglect that followed his death abetted the authors' efforts. Scholarship, especially on Sargent's complex mural projects, has expanded; a catalogue raisonné is in progress; and the current popularity and increased market value of his works have brought more of them into circulation at sales and to public attention in major exhibitions. We hope that this catalogue will assist others who are involved in Sargent studies, and will provoke the appreciation of a wider audience that is increasingly aware of the prodigious accomplishment of one of the greatest American painters.

John K. Howat
Lawrence A. Fleischman Chairman
Departments of American Art

Acknowledgments

In preparing this catalogue, we received generous assistance from many individuals and institutions. At the Metropolitan, Philippe de Montebello, director, and Doralynn Pines, associate director for administration, recognized the importance of the project and endorsed it. Mahrukh Tarapor, associate director for exhibitions, coordinated preparations for the exhibition that will celebrate its publication, "John Singer Sargent Beyond the Portrait Studio: Paintings, Drawings, and Watercolors from the Collection." Emily Kernan Rafferty, vice president for external affairs, arranged essential funding.

John K. Howat, Lawrence A. Fleischman Chairman of the Departments of American Art, encouraged the larger undertaking: to catalogue all the drawings and watercolors within the compass of the American Wing. In the Department of American Paintings and Sculpture, Associate Curator Kevin J. Avery, project manager of the volumes that are next scheduled to appear, offered advice; Associate Curator Carrie Rebora Barratt helped us with information management and, with Assistant Curator Thayer Tolles, provided collegial support. Research Assistant Claire Conway and former Research Associate Susan G. Larkin contributed expertise. Peter M. Kenny, associate curator, American Decorative Arts, and administrator of the American Wing, oversaw the budget, with the late Emely Bramson. Administrative Assistants Dana Pilson and Catherine Scandalis gave unstinting help with all aspects of the project; their predecessors Julie Eldridge Edwards, Yasmin Ellis Rosner, and Jeannie Fraise also aided our efforts.

We are indebted to the late Stephen Rubin, whose love for Sargent's works—especially the early sketchbooks—is recalled in this volume. His notes and research files in the Department of American Paintings and Sculpture have been invaluable, and his enthusiasm for the artist and for the Metropolitan have been a sustaining legacy.

Doreen Bolger, former curator, American Paintings and Sculpture, created a solid foundation of scholarship on Sargent's oils in the collection. As a Chester Dale Fellow in the Department of American Paintings and Sculpture in 1994–95, M. Elizabeth Boone gathered information, prepared exhibition histories on individual sheets, and studied Sargent's Spanish works. Special thanks are owed to N. Mishoe Brennecke, former research associate, whose expertise provided a model for organizing the project. During the past five years, we have been assisted by volunteers and interns including Julie Doring, Jennifer Klein, Cheryl Osborne, Kate Rubin, Gene Silbert, and Linda Wassong. Mary Catlett and Margaret Mather checked Sargent's exhibition history.

Departmental technicians Gary Burnett, Rob Davis, Sean Farrell, and Don Templeton kept track of more than three hundred sheets and four sketchbooks, made endless trips to the Sherman Fairchild Center for Paper and Photograph Conservation and the Photograph Studio, and were essential to preparing and installing the exhibition.

In paper conservation, Marjorie Shelley, Sherman Fairchild Conservator in Charge, examined every sheet and wrote condition reports that Gene Silbert patiently added to our files. Shelley's essay on Sargent's technique, illustrated with infrared photographs taken by Alison Gilchrist, research assistant in paintings conservation, is a valuable addition to this catalogue. Assistant Conservator Akiko Yamazaki-Kleps and Christopher Sokolowsky (intern, summer 1999) treated several drawings and watercolors.

Working in an encyclopedic institution, we often drew upon the expertise of our colleagues in other curatorial departments. The following co-workers

helped us identify Sargent's subjects: Katharine Baetjer (curator, European Paintings), Nicole Carnevale (intern, 1997, Medieval Art), Charles T. Little (curator, Medieval Art), Carolyn Logan (former assistant curator, Drawings and Prints), Joan Mertens (curator, Greek and Roman Art), Stuart W. Pyhrr (Arthur Ochs Sulzberger Curator in Charge, Arms and Armor), William Rieder (curator, European Sculpture and Decorative Arts), Catharine H. Roehrig (associate curator, Egyptian Art), Jeff L. Rosenheim (assistant curator, Photographs). Scholars elsewhere who offered similar insights include Geoffrey Fisher, in the Conway Library, Courtauld Institute of Art, London; Gerbert Frodl, director, and Elisabeth Hülmbauer, exhibition assistant, Österreichische Galerie Belvedere, Vienna; Patrick Lenaghan, curator, Iconography and Medals, Hispanic Society of America, New York; Adam White, scholar; and Paul Williamson, at the Victoria and Albert Museum, London.

Such a large project also involved many non-curatorial departments within the Museum. We owe thanks to Kenneth J. Soehner, Arthur K. Watson Chief Librarian, and the following members of the staff of the Thomas J. Watson Library: Katria Czerwoniak (retired) and Heather Topcik, library associate, who assisted with interlibrary loans; the late Patrick F. Coman; Ronald Fein, supervising departmental technician; Mark Chalfant, senior departmental technician; and Robert Cederberg, Benita Lehman, Christopher Lowery, and Alberto Torres (retired), departmental technicians. In Systems, Jennie W. Choi, curatorial projects analyst, helped us to use the American Wing's collections-management system to organize data.

Jeanie M. James, archivist, and Elisabeth R. Baldwin and Barbara W. File, associate archivists, made available information on Sargent and the relationships that he, his sisters, and other others had with the Museum. We are particularly indebted to James for her endless patience in checking innumerable bits of information and in answering questions. The staff of the former Department of Accessions and Catalogue guided us on rationalizing accession numbers and other matters of curatorial "housekeeping."

Marion Burleigh-Motley, who oversees the Metropolitan's program in curatorial studies in partnership with the Institute of Fine Arts, New York University, and who sponsored Herdrich's initial internship in the Department of American Paintings and Sculpture, deserves special thanks.

We are grateful to the staffs of the Photograph and Slide Library and the Photograph Studio for their professionalism in photographing more than six hundred images. We acknowledge in particular the efforts of Deanna Cross and Diana H. Kaplan, Photograph and Slide Library senior coordinators, and Juan Trujillo, Peter Zaray, and Susanne Cardone, photographers; Eileen Travell, assistant photographer; Chad Beer, printer; Josephine Freeman, administrative assistant; and Nancy Rutledge, special projects assistant.

In the editorial department, John P. O'Neill, Editor in Chief and General Manager of Publications, supervised the catalogue. We are grateful to him and his colleagues for their hard work in transforming our stacks of papers and diskettes into this volume. Gwen Roginsky, associate general manager of publications; Peter Antony, chief production manager; and Elisa Frohlich, production associate, coordinated production. Connie Harper, finance adviser/administrator, handled invoices. Freelancers Jean Wagner and Jayne Kuchna managed the bibliography with care; Judith Hanson helped produce both chronologies and the concordance. We were also ably assisted by proofreaders Jeanne Marie Wasilik, Judy Sacks, and Penny Jones. Joan Holt, editor in chief of the *Bulletin*, and Jennifer Bernstein, editor, who oversaw the Museum's summer 2000 *Bulletin—John Singer Sargent and The Metropolitan Museum of Art,* which we also wrote—indirectly enhanced this volume as well. Former editor Barbara Cavaliere began work on this catalogue. Tonia L. Payne, editor, picked up where she left off with immense competence, patience, grace, and good cheer. She managed myriad details and worked with our masterful designer, Bruce Campbell, to integrate our texts and more than seven hundred images into an elegant and coherent design. Campbell's designs were implemented by JoEllen Ackerman, of Bessas and Ackerman, and at the Metropolitan by Minjee Cho, electronic publishing assistant. We are grateful to them for their meticulous efforts.

We wish to thank those who assisted with the accompanying exhibition. In Operations, Richard

R. Morsches, senior vice president, and Linda M. Sylling, associate manager, oversaw the project. In the Design Department, Dennis Kois, design assistant to the chief designer, and Constance Norkin, graphic designer, planned an installation worthy of Sargent, and Zack Zanolli, lighting designer, planned the lighting. Egle Žygas, senior press officer, coordinated our communications with the media.

Our preparation of this catalogue has been aided by colleagues outside the Museum who shared information that, in many instances, they themselves had only recently discovered and verified. Richard Ormond, Elaine Kilmurray, Warren Adelson, and Elizabeth Oustinoff, co-authors of the John Singer Sargent catalogue raisonné, provided extraordinary help. They examined works with us, offered their wide-ranging expertise on Sargent's works in all media, furnished us with obscure references and images, and answered our many queries. Ormond provided records pertaining to the dispersal of Sargent's estate and allowed us to publish family photographs. Kilmurray was unfailingly generous in responding to our questions and in meeting with us. The staff at Adelson Galleries, New York, including Cynthia Bird, Susan Mason, and Caroline Owens, also fielded inquiries and helped us obtain illustrations. John Fox and Pamela Morton informed us about their relatives Thomas A. Fox and Francis Henry Taylor, respectively.

Because of the breadth and depth of the Metropolitan's Sargent holdings, our project evolved as if it were a postdoctoral seminar conducted at the Museum over several years. Scholars who visited in connection with their own research on the artist found themselves enlisted in our efforts. Jane Dini imparted her knowledge of Sargent's murals at Harvard University. Trevor Fairbrother shared his wide-ranging understanding of Sargent's works. Sally Promey added her insights about the artist's murals for the Boston Public Library even before she published her discoveries. Marc Simpson looked at many drawings with us and inspired us with his scholarship and collegial wisdom. Mary Crawford Volk taught us a great deal about Sargent's mural studies and answered numerous queries ranging from archival matters to photography. Edward Nygren's 1983 catalogue *John Singer Sargent Drawings*

from the Corcoran Gallery of Art was essential to our efforts.

We are indebted to our colleagues at the Fogg Art Museum, Harvard University, Cambridge, and the Museum of Fine Arts, Boston, whose large collections of Sargent's drawings also reflect the generosity of Emily Sargent and Violet Sargent Ormond and manifest pleasures and problems in common with the collection at the Metropolitan. At Harvard, we thank Melinda Linderer (Lynn and Philip Straus Intern in the Drawing Department, 1995-96), Miriam Stewart (assistant curator), Kerry Schauber (research assistant), and Mary Ann Trulli (curatorial assistant and supervisor of the study room, Agnes Mongan Center). At the Museum of Fine Arts, Boston, we are grateful to Shelley Langdale (formerly of the Department of Prints, Drawings and Photographs) and Erica E. Hirshler (John Moors Cabot Curator of American Paintings).

Throughout the period of our research we depended upon numerous institutions and individuals for information. Among those who merit special acknowledgement are Stephen Nonack, head reference librarian, Boston Athenaeum; Sarah Cash, Bechhoefer Curator of American Art, Eric Denker, curator of prints and drawings, and Marisa Keller, archivist, Corcoran Gallery of Art, Washington, D.C.; Michael Moody, in the Department of Art, and Angela Weight, Keeper of the Department of Art, Imperial War Museum, London; Michele A. McDonald, chief museum curator, and her predecessor, Doris Littlefield, Vizcaya Museums and Gardens, Miami, Florida; Andrew Walker, assistant curator, American Arts, Art Institute of Chicago; Stephanie Levorack, department assistant, American Paintings and Sculpture, Brooklyn Museum of Art; Thomas Loughman (curatorial intern, 1997), Philadelphia Museum of Art; Amy Howell, assistant registrar, Weatherspoon Art Gallery, University of North Carolina, Greensboro; David Brigham, curator, American Art, Worcester Art Museum, Massachusetts; Daniell Cornell, assistant curator, Photographs, Yale University Art Gallery, New Haven, Connecticut.

At commercial galleries and auction houses, the following individuals helped us to check exhibition histories and provenance and to obtain photographs: Arlene Katz Nichols, Hirschl and Adler

Galleries Inc., New York; Meredith Miller, James Graham and Sons, New York; Laura Shirvinski, Sotheby's, New York; Natalie James, Prudence Cummings Associates, London; Joan Washburn, Joan Washburn Gallery, New York. We are also grateful to private collectors, including several who wish to remain anonymous, who furnished us with images of their works by Sargent and allowed us to reproduce them in this volume.

We appreciate the assistance of the staffs of the following institutions who provided information and photographs: Boston Public Library, Massachusetts; Mead Art Museum, Amherst College, Massachusetts; Society of the Four Arts, Palm Beach, Florida; Sterling and Francine Clark Art Institute, Williamstown, Massachusetts; Des Moines Art Center, Iowa; Isabella Stewart Gardner Museum, Boston; Gilcrease Museum, Tulsa, Oklahoma; Nelson-Atkins Museum of Art, Kansas City, Missouri; Spencer Museum of Art, University of Kansas, Lawrence; National Gallery of Scotland, Edinburgh; National Museums and Galleries of Wales, Cardiff; Israel Museum, Jerusalem.

Professor Kathleen Weil-Garris Brandt, adviser to Herdrich's doctoral dissertation on Sargent and Italy at the Institute of Fine Arts, has been a constant source of encouragement and personal and professional inspiration.

The generous support of the Marguerite and Frank A. Cosgrove Jr. Fund made possible this catalogue, the summer 2000 Museum *Bulletin*, and the accompanying exhibition, three projects that together commemorate the seventy-fifth anniversary of Sargent's death and the fiftieth anniversary of the Ormond gift of his works to the Metropolitan. The catalogue was underwritten in part by the William Cullen Bryant Fellows of the American Wing. A stipend received from the Museum's Theodore Rousseau Memorial Fund permitted Herdrich to travel to London to conduct research.

Finally, we thank Matthew Tirschwell and Michael B. Weinberg for their constant encouragement and support, as well as their enduring patience as we have spent not just days but evenings and weekends with Sargent.

Stephanie L. Herdrich, *Research Associate*
H. Barbara Weinberg, *Alice Pratt Brown Curator*
American Paintings and Sculpture
March 2000

American Drawings and Watercolors in
The Metropolitan Museum of Art

John Singer Sargent

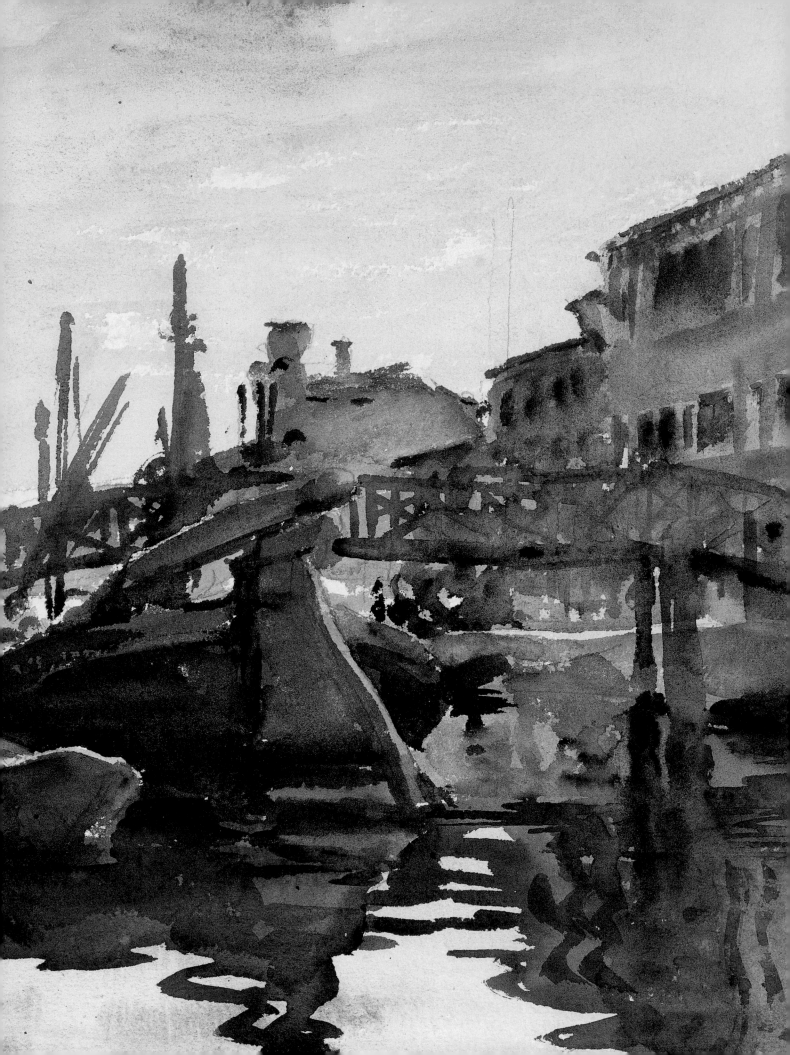

Introduction

The Formation of the Metropolitan's Collection of Sargent's Works

Like most owners of works by John Singer Sargent (1856–1925) during the late nineteenth century, the Metropolitan acquired its first painting by him through a portrait commission. In 1896, the trustees invited him to paint businessman and philanthropist Henry G. Marquand (1819–1902; figure 2), who had been serving as the Museum's second president since 1889.[1] By the time the trustees sought Sargent out, he had established an international reputation as a portraitist and was well known to Marquand. Sargent's first sitter in the United States had been Marquand's wife, Elizabeth Allen Marquand; he had traveled to Newport, Rhode Island, to paint her likeness in 1887 (Art Museum,

Princeton University, New Jersey).[2] In 1905, eight years after Sargent delivered the portrait of Marquand, the Metropolitan received its second painting by him, a lively image of William Merritt Chase (1849–1916; figure 3), which Chase's students had commissioned in 1902, intending to give it to the Museum.

The works by Sargent that the Metropolitan accessioned between 1905 and 1931 reflect the shift of his focus from portraits to more varied subjects, rendered in oil and watercolor, and to mural commissions. The acquisitions of that period were also the result of a cordial relationship between Sargent and Edward Robinson (1858–1931), who served the Metropolitan as assistant director from

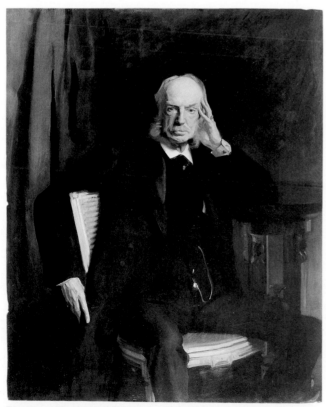

Figure 2. *Henry G. Marquand,* 1897. Oil on canvas, 52 × 41¾ in. (132.1 × 106 cm). The Metropolitan Museum of Art, Gift of the Trustees, 1897 (97.43)

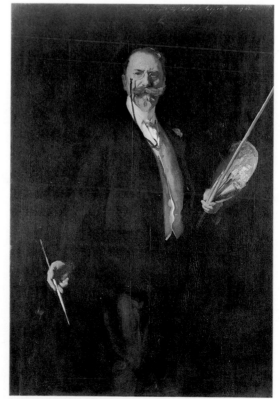

Figure 3. *William M. Chase, N.A.,* 1902. Oil on canvas, 62½ × 41⅜ in. (158.8 × 105.1 cm). The Metropolitan Museum of Art, Gift of the Pupils of Mr. Chase, 1905 (05.33)

Figure 1 (opposite). *Giudecca* (detail), see catalogue 321.

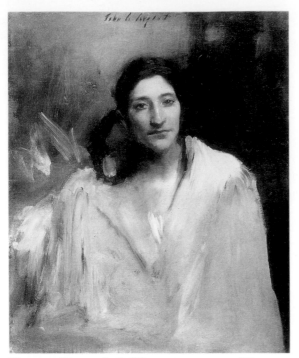

Figure 4. *Gitana,* 1876? Oil on canvas, 29 × 23⅜ in. (73.7 × 60 cm). The Metropolitan Museum of Art, Gift of George A. Hearn, 1910 (10.64.10)

Robinson had probably met Sargent in the early 1890s, when he was curator of classical antiquities at the Museum of Fine Arts, Boston, and the artist was painting murals for the Boston Public Library. After Sargent's decorations for the north end of the Special Collections Hall were unveiled in April 1895, Robinson led the campaign to raise fifteen thousand dollars so that the artist could continue the project. Robinson, who was also a member of the committee that organized the exhibition of Sargent's works at Copley Hall, Boston, in 1899,[3] was appointed director of the Boston museum in 1902.

In 1910, New York merchant and important trustee and benefactor George A. Hearn (1835–1913) presented the Metropolitan with *Gitana* (figure 4), a candid oil study of an exotic woman. In 1911, the Museum purchased from Sargent two oil paintings: *Padre Sebastiano* (figure 5), painted in a village in the Italian Alps, and *The Hermit (Il Solitario)* (see figure 101), executed in Val d'Aosta.[4] But, like most other museums, the Metropolitan had not yet acquired any of Sargent's watercolors.

1905 to 1910 and then as director until 1931. After Sargent's death in 1925 this friendship was sustained by his sisters, Emily Sargent (1857–1936) and Violet Sargent Ormond (1870–1955), who assumed responsibility for their brother's estate.

Of course, it was only after 1900 that Sargent's own commitment to watercolor increased substantially, as did his efforts to show and sell watercolors in England and the United States. At this time, apparently, he wished to build respect for the

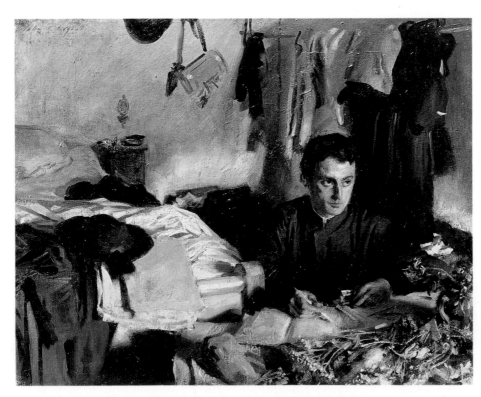

Figure 5. *Padre Sebastiano,* ca. 1904–6. Oil on canvas, 22¼ × 28 in. (56.5 × 71.1 cm). The Metropolitan Museum of Art, Rogers Fund, 1910 (11.30)

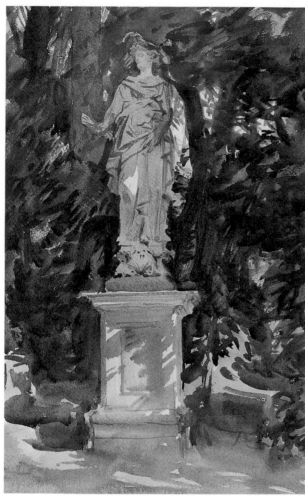

Figure 6. *Boboli,* 1907. Watercolor on paper, 14 × 10 in. (35.6 × 25.4 cm). Brooklyn Museum of Art, New York, Purchased by Special Subscription (09.817)

watercolors at M. Knoedler and Company, New York.[8] The Brooklyn Institute of Arts and Sciences (now the Brooklyn Museum of Art) purchased eighty-three of these sheets (figures 6 and 7), pursuant to Sargent's stipulation that the watercolors be sold en bloc [9] and "only to some museum in an Eastern State or to some large Eastern collector, with the requirement that the collection should be kept together for public exhibition."[10] Brooklyn's unprecedented acquisition[11] seems to have confirmed the resolve of the Museum of Fine Arts, Boston— which had wished to purchase that group—to buy the forty-five sheets that Sargent intended for his next major show, even before it opened at Knoedler in March 1912 (figures 8 and 9).[12] These well-received exhibitions and well-publicized sales to leading American museums encouraged the Metropolitan also to pursue Sargent's watercolors.

Robinson opened the Metropolitan's campaign on December 17, 1912, with a gracious plea to the artist:

Dear John,

The Trustees of our Museum have asked me to communicate to you their desire to purchase some of your watercolors, which I gladly do as I am anxious that we should have them. They do not ask for many—perhaps eight or ten at most, as our space for watercolors is limited at present,

medium and, as an astute scholar has argued, to "create a market demand for his watercolors that allowed him to reduce his portrait activity without having to relinquish his position of priority in the artistic spotlight."[5] Accordingly, he sent watercolors to London's Carfax Gallery for his first solo exhibition in London in 1903, and again in 1905 and 1908.[6] In 1904 he showed a watercolor at the New English Art Club, London, and began to contribute regularly to the annuals at the Royal Society of Painters in Water-Colours, London, where he was elected an associate shortly thereafter and a full member in 1908.[7] Increasingly, Sargent's lively watercolors reflecting his travels in Spain, Italy, Switzerland, and the Near East garnered appreciation.

Sargent restricted the sale of these works until February 1909, when he exhibited eighty-six

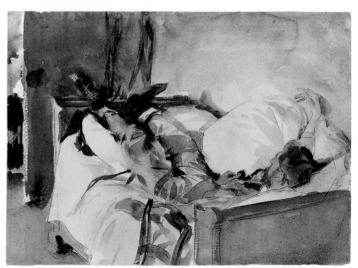

Figure 7. *In Switzerland,* 1908. Watercolor over graphite on off-white wove paper, 9⁷⁄₁₆ × 12⅝ in. (24.0 × 32.1 cm). Brooklyn Museum of Art, New York, Purchased by Special Subscription (09.827)

3

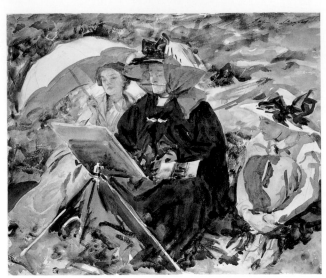

Figure 8. *Simplon Pass: The Lesson,* 1911. Watercolor over graphite with wax resist, on paper, 15¹³⁄₁₆ × 20¾ in. (40.1 × 52.7 cm). Museum of Fine Arts, Boston, The Hayden Collection, Charles Henry Hayden Fund (12.218). Photograph © 1999 Museum of Fine Arts, Boston. Reproduced with permission. All rights reserved.

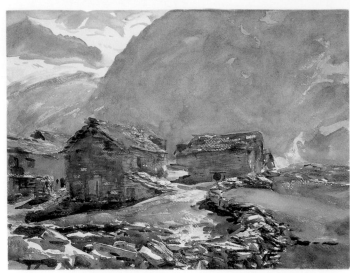

Figure 9. *Simplon Pass: Chalets,* 1911. Watercolor on paper, 15¾ × 20¾ in. (40 × 52.7 cm). Museum of Fine Arts, Boston, The Hayden Collection, Charles Henry Hayden Fund (12.217). Photograph © 1999 Museum of Fine Arts, Boston. Reproduced with permission. All rights reserved.

but the number can be determined better when we know what if anything you have to offer, and the prices.

Have you, by chance, any now on hand by which you would like to be represented in our collection? And if not will you keep us in mind when you do some more? We should naturally be guided largely by your own selection and if you say you have some which you would recommend, you will hear from me very promptly.[13]

As Sargent had orchestrated the placement of his watercolors in Brooklyn and Boston[14]—and as he would when he began, in 1913, to arrange to sell some to the Worcester Art Museum, Massachusetts[15]—he entered into a considered negotiation with the Metropolitan. Responding from England to Robinson's request on December 31, 1912, he agreed to sell only one watercolor but promised to set aside others in the coming year. Sargent wrote:

Dear Ned,

I am very flattered that the Metropolitan Museum should want a few of my water colours and wish I had the choice to offer, but I have done very few this year, and sold two or three of them. I kept back the two best for myself, but I would sell at least one of them to the Museum for £75—it is of a fountain in Granada [Spanish Fountain (cat. 315)]. . . .

I should be glad to reserve the best of the water colours that I shall do next year for the Museum to make up eight

or ten as you say. I hope £75 does not seem an unreasonable price—it is a rise on the two previous sales, but these were for an enormous number of water colours.[16]

On January 20, 1913, acting on the recommendation of curator of paintings Bryson Burroughs, Robinson agreed to purchase *Spanish Fountain* for £75 and told Sargent that the trustees appreciated his offer to set aside eight or ten of his best watercolors.[17] However, Sargent's stated ambivalence about the quality of the sheets that he had on hand and his worries about transatlantic shipping during World War I delayed the sale.

Almost two years later, on December 24, 1914, Sargent wrote to Robinson that he was still trying to decide which watercolors to send, volunteered to drop the price of each sheet to £50, and offered to include "the best oil picture I did in the Tirol [*sic*] last summer" for an additional £400. The artist enclosed a photograph of *Tyrolese Interior* (figure 10) for approval and wrote: "I feel more justified this time in acting on your repeated suggestion that I should report something that strikes me as worthy of the Museum."[18] In 1915, Sargent finally sent to the Metropolitan the oil painting and ten handsome, large-scale watercolors that he had made between 1912 and 1915 in Spain, Italy, and the Tyrol.[19]

In a letter of December 28, 1915, the Metropolitan's secretary, Henry W. Kent, had expressed to Sargent

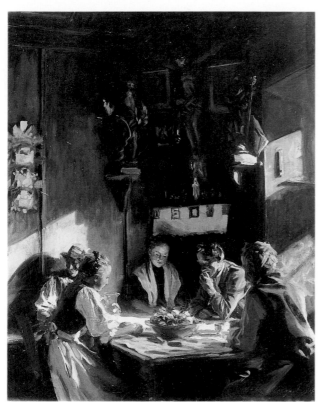

Figure 10. *Tyrolese Interior,* 1915. Oil on canvas, 28⅛ × 22¹/₁₆ in. (71.4 × 56 cm). The Metropolitan Museum of Art, George A. Hearn Fund, 1915 (15.142.1)

the trustees' thanks for his "generosity in giving them this opportunity" to acquire the watercolors.[20] That appreciation, Robinson's friendship and interest in Sargent's work, and the Metropolitan's growing stature undoubtedly prompted Sargent to propose early in 1916 a key acquisition, the extraordinary *Madame X (Madame Pierre Gautreau)* (see figure 61). Sargent had shown the portrait at the Carfax Gallery in 1905 and at three other European exhibitions, in 1908, 1909, and 1911, before sending it to the 1915 Panama-Pacific International Exposition, San Francisco (where it appeared as *Madame Gautrin*). On January 8, 1916, he wrote Robinson, offering the picture to the Museum: "My portrait of Mme. Gautreau is now, with some other things I sent from here, at the San Francisco Exhibition, and now that it is in America I rather feel inclined to let it stay there if a Museum should want it. I suppose it is the best thing I have done. I would let the Metropolitan Museum have it for £1,000 [$4,762; $76,158 in 1999]."[21]

Robinson conveyed Sargent's offer to the Committee on Purchases in a letter of January 24 and added that he had "tried in vain for years to get this picture from him, first for the Boston Museum and later for the Metropolitan, but for personal reasons

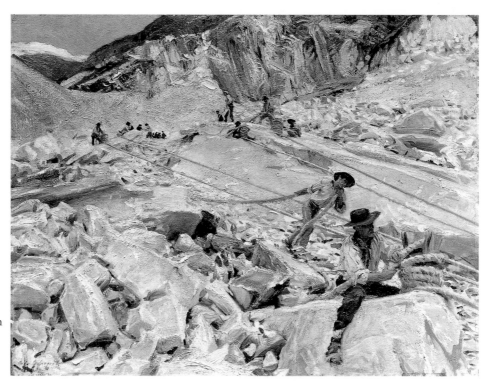

Figure 11. *Bringing down Marble from the Quarries to Carrara,* 1911. Oil on canvas, 28⅛ × 36⅛ in. (71.4 × 91.8 cm). The Metropolitan Museum of Art, Harris Brisbane Dick Fund, 1917 (17.97.1)

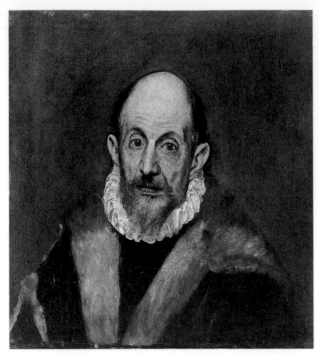

Figure 12. El Greco (Domenikos Theotokopoulos), Greek, 1541–1614. *Portrait of a Man,* ca. 1590–1600. Oil on canvas, 20¾ × 18⅜ in. (52.7 × 46.7 cm). The Metropolitan Museum of Art, Purchase, Joseph Pulitzer Bequest, 1924 (24.197.1)

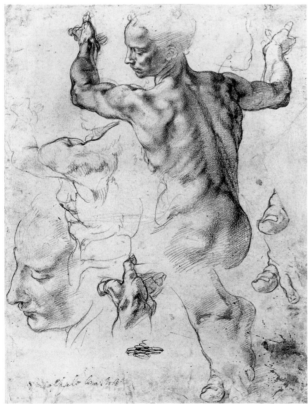

Figure 13. Michelangelo Buonarroti, Italian, 1475–1564. *Studies for the Libyan Sibyl.* Red chalk on paper, 11⅜ × 8⁷⁄₁₆ in. (28.9 × 21.4 cm). The Metropolitan Museum of Art, Purchase, Joseph Pulitzer Bequest, 1924 (24.197.2)

he has always refused to part with it, and his change of decision therefore comes as a complete surprise." Robinson further noted: "Mr. Burroughs agrees with me in strongly recommending the purchase, and in regarding this as an extremely favorable opportunity, both in the importance of the work and the moderate price at which it is offered."[22] The committee accepted Robinson's recommendation unanimously, and the trustees endorsed it.

Although the death of Virginie Gautreau in 1915 may have allayed Sargent's concern about publicity associated with the sale of her portrait, he asked the Metropolitan to be discreet. Replying to news of the intended purchase on January 31, he told Robinson: "I should prefer, on account of the row I had with the lady years ago, that the picture should not be called by her name."[23] The painting was installed as *Madame X* in the Metropolitan's gallery of recent accessions in May 1916. The acclaim it garnered more than thirty years after its scandalous debut is typified by the headline in the *New York Herald* on May 12, 1916: "Sargent Masterpiece Rejected by Subject Now Acquired by Museum."[24] *Madame X* and *Bringing down Marble from the Quarries to Carrara* (figure 11), which the Metropolitan acquired from the estate of Harris Brisbane Dick in 1917, were the last two works by Sargent added to the collection prior to the artist's death on April 15, 1925.

In the year before his death, however, Sargent demonstrated his devotion to the Metropolitan one final time. When the widow of Aureliano de Beruete y Moret, a former director of the Museo del Prado, Madrid, suggested to Sargent that a museum in the United States might be interested in acquiring some works from her husband's estate, Sargent contacted Robinson. In early 1924 the artist helped arrange for the Metropolitan to purchase *Portrait of a Man* (figure 12), by El Greco, and the *Libyan Sibyl* (figure 13), a superb red-chalk drawing for the Sistine Chapel ceiling by Michelangelo.[25]

In the foreword to the catalogue of the Metropolitan's 1926 memorial exhibition of Sargent's work, Robinson recorded the trustees' appreciation of the artist, as well as his own. Although Sargent's "visits to New York were rare and brief," Robinson wrote, "he remained a steadfast friend of our Museum, greatly interested in its growth and a firm

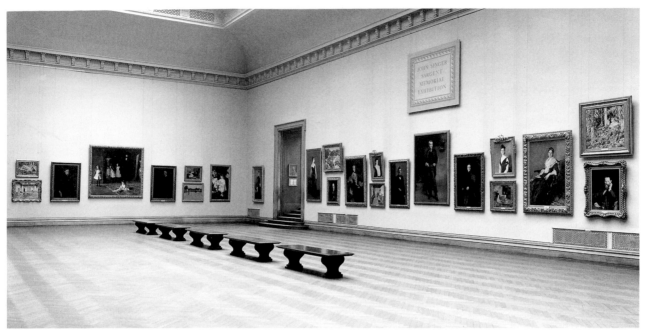

Figure 14. Photograph of "The Memorial Exhibition of the Work of John Singer Sargent," The Metropolitan Museum of Art, January 4–February 14, 1926, gallery of oil paintings

believer in its future." Robinson cited Sargent's willingness to sell *Madame X* at a favorable price and his making particular watercolors available: "When he learned that the Museum wished to form a small collection of his water-colors, he asked that he might make the selection himself and be allowed several years for doing so, in order that he might be sure of what he considered the best of his output during that time."[26]

Robinson had wished to include in the memorial exhibition a group of charcoal sketches that Sargent had made in Palestine for his Boston Public Library murals. He wrote about the matter on November 4, 1925, to Thomas A. Fox (1864–1946), a Boston architect who had assisted Sargent with his murals and who was involved in organizing drawings remaining in the artist's Boston studio after his

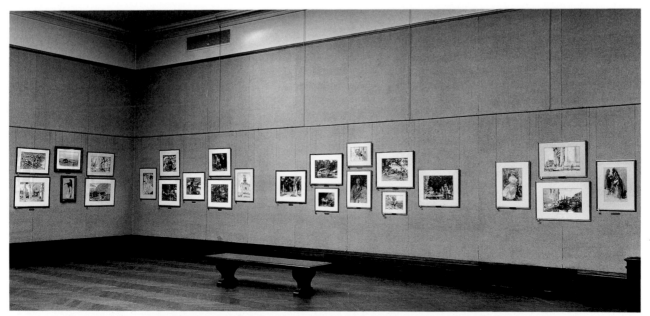

Figure 15. Photograph of "The Memorial Exhibition of the Work of John Singer Sargent," The Metropolitan Museum of Art, January 4–February 14, 1926, gallery of watercolors

death. "In view of the material we already have, the matter is not of such importance as to call for any special effort, although I am sure the sketches would be an attraction and would form a unique feature," Robinson told Fox. He added, "If, as I understood you to imply yesterday, there might be a prospect of securing some of his sketches permanently for the Museum by gift or otherwise, I should be glad to know of it. . . . Such material is always of great value to students, and is kept where it can be made accessible to them."[27]

Although the Palestine sketches would not appear in the memorial exhibition and the hoped-for gifts of drawings would not occur until 1930, Sargent's works on paper were well represented in the display. In addition to the fifty-nine oil paintings that were shown (figure 14), sixty watercolors and two drawings were installed in a separate gallery (figure 15).[28] The Brooklyn Museum of Art, the Museum of Fine Arts, Boston, and the Worcester Art Museum lent most of the watercolors, to which were added five of the Metropolitan's sheets and loans from several private collections. These works were praised by Henry B. Wehle, the Museum's associate curator of paintings, for "gusto, virtuosity, and accurate observation . . . raised to a pitch probably never achieved by another painter in this medium."[29]

In 1927, the Metropolitan purchased from the sitters' nephew *The Wyndham Sisters: Lady Elcho, Mrs. Adeane, and Mrs. Tennant* (see figure 76), adding to the collection of Sargent's oils one of his best-known, most ambitious, and most engaging English group portraits. At about the same time, the artist's sisters were considering how to dispose of works that had not been included in the July 1925 sale of his estate at Christie's, London, and that his family did not wish to keep.[30] At first, they gave a few works to institutions that had direct connections with Sargent or that he had decorated.[31] These ranged from Saint Paul's Cathedral, London, where a bronze cast of Sargent's Boston Public Library crucifix was installed as a memorial to him, to the Sargent family home in Gloucester, Massachusetts, and to several English provincial museums. Faced with dispersing a mass of large charcoal drawings for his murals at the Boston Public Library, the Museum of Fine Arts, Boston, and the Harry Elkins Widener Memorial Library, Harvard University, Cambridge, the sisters sought assistance from Fox. Like many other institutions, the Metropolitan was to benefit from this campaign of generosity.

Sargent's sisters preferred to give the drawings to art schools for the use of students. Their aims are

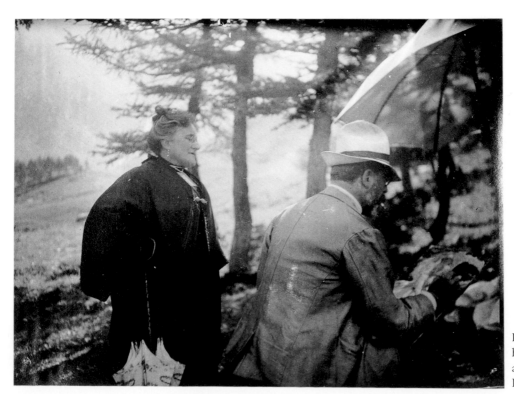

Figure 16. Sargent, with his sister Emily, painting at the Simplon Pass, 1911. Private collection

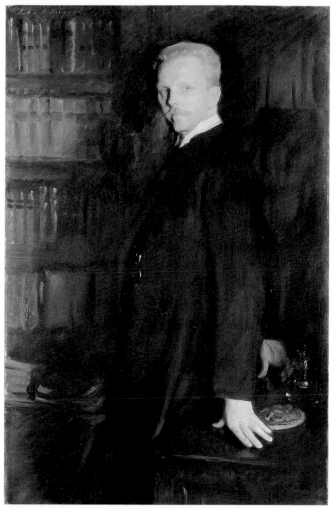

Figure 17. *Edward Robinson,* 1903. Oil on canvas, 56½ ×36¼ in. (143.5 × 92.1 cm). The Metropolitan Museum of Art, Gift of Mrs. Edward Robinson, 1931 (31.60)

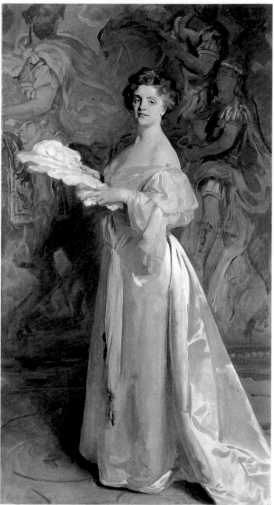

Figure 18. *Ada Rehan,* 1894–95. Oil on canvas, 93 × 50⅛ in. (236.2 × 127.3 cm). The Metropolitan Museum of Art, Bequest of Catharine Lasell Whitin, in memory of Ada Rehan, 1940 (40.146)

documented in extensive correspondence dated between 1926 and 1930 and preserved in the Boston Athenaeum.[32] Of particular interest are letters that passed among Emily Sargent, Fox, and Walter Clark, who had organized a retrospective of Sargent's works as the inaugural exhibition for New York's Grand Central Art Galleries in 1924.[33] These letters reflect the sisters' concern that the drawings be distributed fairly and their unsuccessful effort to thwart Clark's wish to sell some of them at Grand Central in 1928.[34] The major beneficiaries of the sisters' arduous deliberations were the Museum of Fine Arts, Boston (1928); the Corcoran Gallery of Art, Washington, D.C. (1928); and the Fogg Art Museum, Harvard University, Cambridge (1929–37).[35] In 1929–30, Yale University, the Pennsylvania (later Philadelphia) Museum of Art,

the Worcester Art Museum, and Amherst and Dartmouth Colleges received at least ten drawings each. Several other colleges and art schools—including Wesleyan University (Connecticut), Williams College, Bowdoin College, Smith College, the Massachusetts School of Art, and the Springfield Art Museum—acquired smaller groups of drawings. (For the most part, these works are kept in curatorial departments of the museums or in the museums associated with the colleges or universities, and they are as accessible to the general public as they are to art students.)

The gift to the Metropolitan of six charcoal mural studies was also modest, reflecting the sisters' awareness, noted in a letter of November 25, 1927, from Emily Sargent (figure 16) to Fox, that "New York . . . has so many of John's good paintings."[36]

The drawings were chosen by Fox in collaboration with Wehle and accessioned in 1930.[37] The following year, Violet Sargent Ormond (figure 19) and Emily Sargent gave to the Metropolitan through Fox a drawing in graphite (cat. 188) associated with Sargent's monumental portrait of the duchess of Marlborough and her family (see figure 78) and two studies in graphite (cats. 166 and 167) for *Madame X.*

Shortly after Robinson's death in 1931, his widow gave to the Museum the portrait that Sargent had painted of him in 1903 (figure 17), when he was director of the Museum of Fine Arts, Boston. The addition of this portrait to the collection was a fitting tribute to the sitter, who had acquired so many of Sargent's oils, watercolors, and drawings for the Metropolitan. In 1932, Sargent's grand watercolor *Camp at Lake O'Hara* (cat. 331) was given to the Museum by Mrs. David Hecht in memory of her son. Between 1930 and 1940, the Metropolitan also received three of Sargent's important full-length portraits in oil—*Lady with the Rose (Charlotte Louise Burckhardt)* (see figure 51),

Mr. and Mrs. I. N. Phelps Stokes (see figure 77), and *Ada Rehan* (figure 18)—but acquired no additional drawings or watercolors by him.

That the Metropolitan accessioned no works at all by Sargent during the 1940s manifests the distractions of World War II and the fact that interest in him—and in other late-nineteenth-century American cosmopolitan painters—was at its nadir. The two decades that followed Sargent's death had been marked by increasing indifference to his accomplishments. As an artist, he was too traditional to please partisans of modernism; too international, because of his long residence in London, to gratify cultural nationalists, who were seeking American traits in American art; too American, despite his long residence in London, to interest British art historians; too facile to satisfy those who preferred probing portraits; and too much a servant of his era's aristocrats and plutocrats to impress democrats. When, during the 1940s, patriotism was paramount and international impulses of all sorts were viewed with suspicion, Sargent disappeared from the consciousness of the Metropolitan's curators and

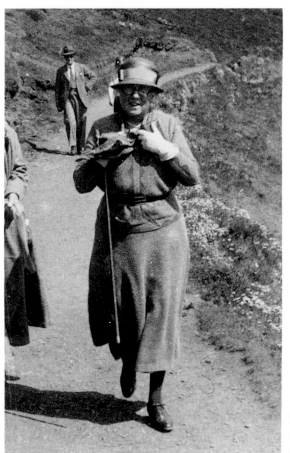

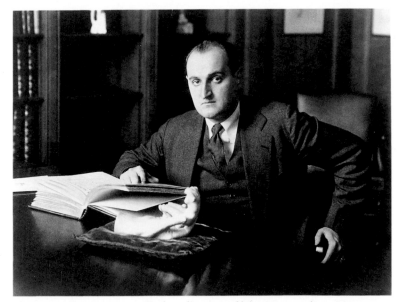

Figure 20. Francis Henry Taylor, director of The Metropolitan Museum of Art, 1940–55. Photograph © The Metropolitan Museum of Art

Figure 19. Violet Sargent Ormond, ca. 1930. Private collection

visitors. Illustrator James Montgomery Flagg (1877–1960) remembered him and complained in a letter dated November 27, 1947, to the *New York Herald Tribune*:

John Singer Sargent's reputation is too great to be arguable. The Metropolitan Museum of Art has a number of his works—all of them in the cellar, I am told. At least they are not on the walls, as they used to be, with one exception—the portrait of Mr. and Mrs. Stokes, one of his lesser canvases. The great portrait of the three Wyndham sisters has been hidden away for twelve years! The famous portrait of Mme. X is not hung. The finest portrait the museum has . . . is banished. That is the marvelous portrait of Marquand, who gave a great collection to the museum.[38]

Just two years later, the Metropolitan's indifference would cease, and its collection of Sargent's works would suddenly become one of the world's largest. A gift from Violet Sargent Ormond, initiated in fall 1949 and completed the following summer, would add to the Museum's holdings numerous oils, watercolors, and drawings that range from minor sketches he made during his childhood travels, as well as the cherished *Splendid Mountain Watercolours* sketchbook (cat. 17) of 1870,[39] to fine Impressionist canvases of the late 1880s, to brilliant watercolors he executed on the battlefields during World War I.

In November 1949, Mrs. Ormond contacted her cousin, Francis Henry Taylor (1903–1957; figure 20), the Metropolitan's fifth director, about her wish to make the gift.[40] Richard Ormond, the donor's grandson, speculated recently: "I suspect the late gift to the Met was due to Francis Taylor's influence. The existence of the drawings and sketchbooks must have come up in the course of conversation (maybe he asked about them), and because he was enthusiastic, she decided to donate them. As she got older, she may have wondered what to do with the mass of the material left over from studios, and Taylor provided the right answer at the right time."[41]

Specifically, Mrs. Ormond wished to resume the pattern of giving works by Sargent to institutions that could make them available to art students. Anticipating the sale of her house in London, she wrote to Taylor on November 21, 1949: "I have a quantity of

Figure 21. Folio 11 recto of John Singer Sargent scrapbook, ca. 1873–82. 12 13/16 × 18 11/16 in. (32.5 × 47.5 cm). The Metropolitan Museum of Art, Gift of Mrs. Francis Ormond, 1950 (50.130.154, folio 11 recto)

Figure 22. Folio 16 verso of John Singer Sargent scrapbook, ca. 1873–82. 12 13/16 × 18 11/16 in. (32.5 × 47.5 cm). The Metropolitan Museum of Art, Gift of Mrs. Francis Ormond, 1950 (50.130.154, folio 16 verso)

sketches, studies, some water colours, & some drawings by my brother. I should like to give them all to you, to dispose of as you see fit, to give to art schools, museums, or students, where you think they might be of service. You would have an absolutely free hand, even destroying those you consider of no interest." Mrs. Ormond added: "I also have quantities of photographs of my brother's works," and offered these, too. She concluded: "I should be very grateful if you would cable me the one word 'yes.'"[42]

Taylor replied on November 28: "We should, of course, be only too delighted to have the Sargent drawings, water colors, etc. offered as an outright gift to the Metropolitan Museum with a formal

Figure 23. *Study of a Young Man (Seated),* ca. 1895. Lithograph, 11⁹⁄₁₆ × 9⁹⁄₁₆ in. (29.4 × 24.3 cm). The Metropolitan Museum of Art, Gift of Mrs. Francis Ormond, 1950 (50.558.4)

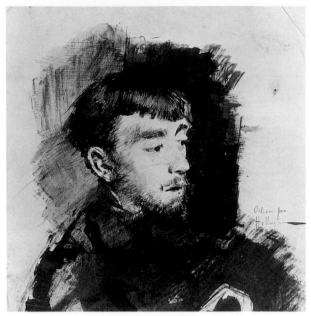

Figure 24. Paul-César-François Helleu, French, 1859–1927. *Portrait of a Man.* Ink and wash on paper, 8⅛ × 7¹³⁄₁₆ in. (20.6 × 19.8 cm). The Metropolitan Museum of Art, Gift of Mrs. Francis Ormond, 1950 (50.130.152)

recommendation to the trustees that distribution be made to other public, tax-free institutions in the United States in their discretion." He added in a postscript: "We should of course want the photographs for our library!" This was the second time that Taylor would play a role in making provisions for Sargent's works. As he explained to

Mrs. Ormond: "I am rather familiar with the problem of distributing these drawings because the late Tom Fox and I some years ago distributed all the sketches and drawings which were in Mr. Sargent's studio in Boston."[43]

Mrs. Ormond's gift to the Metropolitan comprised twenty-four oil paintings by Sargent; about

Figure 25. Mary Newbold Sargent, American, 1826–1906. *Corfu* (from sketchbook), 1904. Graphite and watercolor on paper, 5¼ × 8¼ in. (13.3 × 21 cm). The Metropolitan Museum of Art, Gift of Mrs. Francis Ormond, 1950 (50.130.150i)

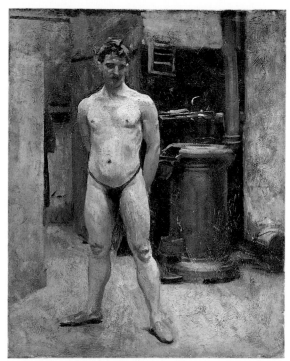

Figure 26. *A Male Model Standing before a Stove,* ca. 1875–1880. Oil on canvas, 28 × 22 in. (71.1 × 55.9 cm). The Metropolitan Museum of Art, Gift of The Marquis de Amodio, O.B.E., 1972 (1972.32)

110 of his watercolors, in general, less resolved and more experimental than those that he had arranged to sell; about 140 sheets of drawings and sketches and a scrapbook (50.130.154) apparently compiled by the artist containing 54 drawings and watercolors (figures 21 and 22); four sketchbooks; and impressions of five of his rare lithographs (figure 23),[44] as well as the photographs. Along with a few drawings and prints by Sargent's friends Edwin Austin Abbey (1852–1911), Paul-César-François Helleu (1859–1927; figure 24), and Albert Belleroche (1864–1944); two sketchbooks by Sargent's mother (figure 25); two prints by Francisco Goya (1746–1828); and three Japanese prints, the collection arrived at the Museum in two suitcases and several rolls and parcels on April 24, 1950,[45] and was accepted by the Museum's trustees on June 12.[46]

After the great Ormond gift, the Metropolitan's collection of Sargent's drawings was enhanced by gifts of likenesses of Helen A. Clark (cat. 192) and Anna Mills (cat. 189), which exemplify the bust-length images in charcoal that Sargent executed after 1900 in lieu of painting portraits in oil. In 1966, sculptor Paul Manship (1885–1966) bequeathed to the

Museum a drawing of himself (cat. 191) that Sargent had made in January 1921. In 1970, the Museum purchased a third study in graphite (cat. 168) for *Madame X.* In 1973, gifts from two donors added to the collection six large-scale studies for Sargent's murals in the Boston Public Library (cat. 203) and the Museum of Fine Arts, Boston (cats. 204–6 and 208–9). These drawings, which were among those that Sargent's sisters had given to the Corcoran Gallery of Art in 1928 and 1929, had been deaccessioned in 1960.[47]

Since 1973 the Metropolitan has acquired only two paintings by Sargent: an oil study from his student years of a male model standing before a stove (figure 26), and, recently, *Mrs. Hugh Hammersley* (see figure 74), a dazzling portrait that had verified Sargent's skills among potential (but reluctant) English patrons when it was shown at the New Gallery in London in 1893. As the portrait pertains to many works by Sargent already in the collection, it is a particularly fitting culmination to the story of the Metropolitan's acquisitions of Sargent's works to date. The positive reviews that *Mrs. Hugh Hammersley* received in London in 1893 and in Paris the following year finally quashed misgivings that *Madame X* had aroused nine years earlier. The sitter's lively pose echoes the informality of Sargent's Impressionist canvases, many of which are displayed in the same gallery in the American Wing. The portrait is among the first of a series of ravishing images by Sargent of glamorous English women that culminated in *The Wyndham Sisters.* Finally, the very fact that it was a gift reiterates the extraordinary generosity that created the Museum's collection of Sargent's works, especially of his drawings and watercolors.

1. For a discussion of the portrait, see Burke 1980, pp. 251–52; other oils in the collection are considered on pp. 219–74. See also Weinberg and Herdrich 2000a.
2. During the same visit (or ca. 1891–94), Sargent may have painted a portrait of Marquand's daughter Mabel, who would marry in 1891. After her death her portrait, *Mrs. Henry Galbraith Ward* (30.26), was given to the Metropolitan by her husband in 1930.
3. See *Catalogue of Paintings and Sketches by John S. Sargent* (exh. cat., Boston: Copley Hall, February 20–March 13, 1899, under the auspices of the Boston Art Students' Association). See Getscher and Marks 1986, pp. 443–70, for

references to catalogues of exhibitions (through 1985) in which Sargent's works were shown.

4. In 1905, Sargent sold *An Artist in His Studio* (1903–4) to the Museum of Fine Arts, Boston, for $1,000. It was the first subject picture by Sargent to enter an American public collection (Adelson et al. 1997, p. 230).

5. Gallati 1998, p. 120.

6. London 1903 included thirty works by Sargent. London 1905 included forty-four watercolors and three oils—among them, *Madame X (Madame Pierre Gautreau),* which Sargent would sell to the Metropolitan in 1916. *Water Colors by Sargent* (exh. cat., London, June 1908) included forty-eight watercolors and two oils. The shows of 1903 and 1905 were loan exhibitions; the 1908 display was not. Gallati notes that none of the works in the three exhibitions was for sale (Gallati 1998, p. 127).

7. Gallati 1998, p. 139, n. 22.

8. *Catalogue of Water Color Drawings by John Singer Sargent and Edward Darley Boit* (exh. cat., New York, February 15–27, 1909). The exhibition also included sixty-three works by Boit.

9. Harold Bentley, "In the Galleries," *The International Studio* 37 (April 1909): p. lv, cited in New York–Chicago 1986–87, p. 246, n. 35.

10. "Sargent Paintings Sold," *American Art News* (February 27, 1909), p. 1, quoted in Gallati 1998, p. 120.

11. An excellent account of Brooklyn's acquisition is in Gallati 1998, pp. 117–41. See also New York–Chicago 1986–87, pp. 224–30.

12. *Catalogue of Water Colors by John S. Sargent and Edward D. Boit* (exh. cat., New York, March 16–30, 1912). See also "Water-Colors of Boit and Sargent," 1912, pp. 18–21; *Catalogue of Paintings and Drawings in Water Color* (Boston, 1949), pp. 157–69; Boston 1993, pp. xlix–li.

13. Edward Robinson to JSS (copy), New York, December 17, 1912, Metropolitan Museum of Art Archives.

14. Sargent apparently wanted to remove several works from the group for Boston, but the curators persuaded him otherwise. One of them, Jean Guiffrey, explained in 1912:

 Three years ago it was hoped that the Museum would get possession of a remarkable collection of eighty-three water-colors by Mr. Sargent, but before the difficulties could be surmounted these paintings went to the Brooklyn Museum, where they are one of its chief treasures. As soon as it became known that a new series of water-colors was to be exhibited in New York in March, 1912, the Museum in Boston determined to examine them before they left the studio of the artist, and to purchase them immediately if that were possible. Mr. Sargent's kindness and generosity were only rivaled by the modesty with which he questioned the merit of certain of the paintings, which he hesitated to leave with the rest; it required not a little persuasion before he would consent to keep the collection intact. ("Water-Colors of Boit and Sargent" 1912, p. 19)

15. In 1917, the Worcester Art Museum purchased eleven watercolors that Sargent had recently painted in Florida. See Strickler 1987, pp. 14–19. Strickler notes that Worcester's pursuit of Sargent's watercolors began about 1913 (p. 14).

16. JSS to Edward Robinson, [London?], December 31, 1912, Metropolitan Museum of Art Archives. Brooklyn paid

$20,000 for eighty-three watercolors, according to Gallati 1998, p. 140, n. 43. In 1912, £75 equaled approximately $364. Adjusted for inflation, the price of the watercolor in 1999 would have been approximately $6,319.

17. Edward Robinson to JSS (copy), New York, January 20, 1913, Metropolitan Museum of Art Archives. See also Burroughs, purchase form, January 13, 1913, Metropolitan Museum of Art Archives.

18. JSS to Edward Robinson, London, December 24, 1914, Metropolitan Museum of Art Archives. "The highest price paid for a water-colour [by Sargent] before his death was in 1920, when £750 was paid for the *Church of the Gesuati on the Zattere, Venice*" (Charteris 1927, p. 223).

19. Sargent's correspondence with the Museum indicates that *Spanish Fountain* (cat. 315) was painted during the summer of 1912. This implies, therefore, that the remaining nine watercolors included in the 1915 purchase were created between 1912 and 1915, when they were sent to the Museum. It should be noted that although Sargent wrote in his December 31, 1912, letter to Robinson that *Spanish Fountain* was the only watercolor he could offer the Museum at that time, since he had done "very few this year, and sold two or three of them" and "kept back the two best for myself," he later added two great watercolors, also painted during the 1912 sojourn to Spain, to the group purchased by the Metropolitan: *Escutcheon of Charles V of Spain* (cat. 314) and *In the Generalife* (cat. 316). It is unclear whether these might be the "two best" he had retained for himself. The remaining watercolors included in the 1915 purchase are *Mountain Stream* (cat. 313), *Giudecca* (cat. 321), *Venetian Canal* (cat. 322), *Sirmione* (cat. 323), *Boats* (cat. 324), *Idle Sails* (cat. 325), and *Tyrolese Crucifix* (cat. 329). See individual catalogue entries for more specific discussions of the dating of these works.

20. Henry W. Kent to JSS (copy), New York, December 28, 1915, Metropolitan Museum of Art Archives.

21. JSS to Edward Robinson, London, January 8, 1916, Metropolitan Museum of Art Archives.

22. Edward Robinson to Committee on Purchases, New York, January 24, 1916, Metropolitan Museum of Art Archives. On January 20, 1913, when Robinson had thanked Sargent for his "very generous offer to set aside for us eight or ten of what you consider the best water-colors," he added: "Please understand, however, that the acquisition of these water-colors does not in any way affect our desire to have the large painting, of which I have written to you before, whenever the inspiration may seize you" (Edward Robinson to JSS, New York, January 20, 1913, Metropolitan Museum of Art Archives). While the identity of the painting referred to is unknown, subsequent events suggest that it might have been *Madame X.*

23. JSS to Edward Robinson (copy), London, January 31, 1916, Metropolitan Museum of Art Archives.

24. "Sargent Masterpiece Rejected," 1916.

25. Correspondence from Madame Beruete, Sargent, and Edward Robinson, January–June 1924, is in the Metropolitan Museum of Art Archives.

26. Edward Robinson, "Note," in New York 1926, p. xi.

27. Edward Robinson to Thomas A. Fox (copy), New York, November 4, 1925, Metropolitan Museum of Art Archives.

28. New York 1926.

29. H[enry] B. Wehle, "The Sargent Exhibition," *Bulletin of the Metropolitan Museum of Art* 21, no. 1 (January 1926), p. 4.

30. See *Catalogue of Pictures and Water Colour Drawings by J. S. Sargent, R.A., and Works by Other Artists: The Property of the Late John Singer Sargent, R.A., D.C.L., LL.D.* (sale cat., London: Christie, Manson and Woods, July 24 and 27, 1925). The sale included 320 works, 237 of which were by Sargent: 159 oils, watercolors, and studies, and seventy-eight drawings.

31. A useful, if flawed, overview of the sisters' dispersal of works appears in Mount 1966, n.p.

32. See Thomas A. Fox–John Singer Sargent Collection, Boston Athenaeum.

33. New York 1924.

34. See New York 1928. The exhibition included more than five hundred drawings, of which Sargent's sisters were the principal lenders. An inventory in the Thomas A. Fox–John Singer Sargent Collection, Boston Athenaeum ("Drawings from London loaned Mr. Clark") indicates that the works lent to Clark by the sisters were marked J.S. followed by a number. The Metropolitan's collection contains several sheets thus marked, which may have been shown in the 1928 exhibition. Between 1926 and 1930, Sargent's drawings were also exhibited at the City Art Gallery, York, England; the National Gallery, Millbank (later the Tate Art Gallery, London); Barbizon House, London; and the Museum of Fine Arts, Boston.

35. The Museum of Fine Arts, Boston, received more than five hundred drawings from the sisters in 1928. In the same year, the Corcoran received about two hundred works, under the provision that they were on loan until the National Gallery of Art, Washington, D.C., had space in which to store them; they were accessioned by the Corcoran Gallery of Art in 1949. (The Corcoran deaccessioned ninety of these works in 1960.) The Fogg Art Museum received some 350 drawings and watercolors and numerous sketchbooks from the sisters in five installments between 1929 and 1937.

36. Emily Sargent to Thomas A. Fox, London, November 25, 1927, Thomas A. Fox–John Singer Sargent Collection, Boston Athenaeum.

37. The selection process is recounted in a letter from Wehle to Robinson, New York, December 20, 1929, Metropolitan Museum of Art Archives. The six drawings were *Two Men, Possible Study for "Hell"* (cat. 197), *Kneeling Figure, Possible Study for "The Crucifixion"* (cat. 199), *Man Holding a Staff, Possible Study for Devil in "Judgment"* (cat. 200), *Man Standing, Hands on Head* (cat. 201), *Man Standing, Head Thrown Back* (cat. 202), and *Seated Figures, from Below* (cat. 207).

38. James Montgomery Flagg, "Sargents in the Cellar," letter to the editor, *New York Herald Tribune,* December 1, 1947, p. 22.

39. That Sargent's heirs gave a large number of his early sketchbooks to the Fogg Art Museum while keeping this early example (cat. 17) until 1950 may suggest their special esteem for this precocious effort.

40. Violet Ormond to Francis [Henry] Taylor, London, November 21, 1949, Metropolitan Museum of Art Archives, refers to a letter "of about a fortnight ago" to which she had not received a reply. Taylor, director of the Metropolitan from 1940 until 1954, was the son of Emily Buckley Newbold Taylor, a distant cousin of the artist's mother, Mary Newbold Sargent.

41. Richard Ormond to Stephanie L. Herdrich, Greenwich, England, July 30, 1997, departmental files, American Paintings and Sculpture.

42. Violet Ormond to Francis [Henry] Taylor, London, November 21, 1949, Metropolitan Museum of Art Archives.

43. Francis [Henry] Taylor to Violet Ormond (copy), New York, November 28, 1949, Metropolitan Museum of Art Archives. Taylor added that at the time of his association with Fox he was director of the Worcester Art Museum. Roland L. Redmond gives the date of Taylor's appointment as director at Worcester as 1931 ("Francis Henry Taylor," *The Metropolitan Museum of Art Bulletin* n.s. 15, no. 5 [January 1958], p. 145).

44. The lithographs, held in the Drawings and Prints department of the Metropolitan, are acc. nos. 50.558.1–.3, 50.558.4, 50.558.6–.7, 50.558.8–.9, and 50.558.10. See Belleroche 1926, pp. 31–45. Belleroche wrote that "only six lithographs by Sargent are known to exist" (p. 44). However, three of the Metropolitan's impressions were not known to him. The exact number of Sargent's lithographs is unknown, but Belleroche's assessment that they are scarce is probably accurate.

45. Memorandum, Gene Politis to Robert Beverly Hale, June 12, 1950, enclosing an inventory of the gift; both documents, Metropolitan Museum of Art Archives. Also included in the donation are twelve sheets now deemed to be of questionable attribution (see appendix).

46. Dudley T. Easby Jr., secretary, to Mrs. Francis Ormond, New York, June 12, 1950, copy in the possession of Richard Ormond, Greenwich, England.

47. See note 35.

Materials and Techniques

MARJORIE SHELLEY

The 337 sheets and four sketchbooks by John Singer Sargent in the collection of The Metropolitan Museum of Art reflect all phases of his oeuvre and the array of media in which he practiced. In addition to ten watercolors the artist sold to the Museum in 1915, the collection includes abundant juvenilia and student and professional drawings, items he chose not to present to friends, exhibit, or place in museums. These were saved by his family and given to the Metropolitan in 1950. Many are among his most highly developed compositions, while others are preparatory or unfinished sheets, or simply exercises in mastering his primary subjects: color and light. As a group, Sargent's drawings and watercolors provide insight into his technical means and working process, from his efforts as a young artist through his maturity.

Raised in an era that held drawing to be an essential adjunct to liberal education, Sargent also had the support of parents who nurtured his talents. His youthful works, from his childhood through his training with Carl Welsch in the winter of 1868–69 to his brief schooling at the Accademia delle Belle Arti in Florence in the early 1870s, bear witness to traditional beginnings and forecast his lifelong interest in representing the world around him. These sheets demonstrate his experimentation with various materials and an incessant honing of his skills as a draftsman. They include figures, landscapes, portraits, and copies of paintings and statuary recorded during the family's travels through Europe. Many reflect contemporary pedagogical practices as described in numerous readily accessible artists' manuals.[1] Sargent's future as an artist was determined during these years.

Sargent's alpine scenes and related drawings reveal a freedom of handling and a grasp of the potential of his materials that would characterize his work throughout his life. Watercolors such as *Mat-terhorn from Zmutt Glacier, Zermatt* (cat. 17kk) and *Handek Falls* (cat. 17x) were constructed in pencil overlaid with broad transparent and opaque washes. Although he used sketchbooks that were unsuited for dampening and for fluid strokes because of the absorbency and relative thinness of the smooth cartridge paper, the young artist mastered his materials. He learned to modify streaking and pooling of the colors and to produce varied effects using reductive means, such as blotting and incising. His bold manner differed greatly from that of the polished Pre-Raphaelite watercolors that were then fashionable.

Particularly precocious among the alpine group are sheets rendered in black crayon, a medium Sargent used only in these early years. The cohesive wax binder of this material made it well suited for lithography and commercial purposes but afforded little latitude for atmospheric gradations; thus it found limited use as a drawing medium. *Kandersteg from the Klus of the Gasternthal* (cat. 17d), however, demonstrates the young artist's superb ability to render a convincing receding vista with black crayon by controlling the pressure of his hand and thus the amount of pigment deposited on the sheet.

As a draftsman, Sargent showed a distinct preference for graphite throughout his career. This choice reflected current artistic practices, as the medium had become popular in the nineteenth century with the burgeoning of the pencil industry. Graphite pencils, available for purchase in a range of gray tones and various degrees of hardness, largely replaced pens and iron-gall ink and sticks of black chalk as drawing tools. Sargent's early pencil works were executed with soft, dark lead. Their metallic sheen and blunt lines result from this easily worn material being pressed heavily into the paper.[2] Among his diverse approaches to using graphite are the sweeping lines applied with the broad edge of the pencil in *Monte Rosa from Gorner Grat* (cat. 17p) and

Figure 27 (opposite). *In the Generalife* (detail), see catalogue 316; see also figures 34, 36, and 39.

the tonal gradations of *Moderne Amoretten* (cat. 10 recto), which he developed by drawing with the point, cross-hatching, and graining (applying the pencil in passages of broad, closely spaced lines).

Technical versatility was possible because of the morphological structure of graphite, which consists of platelike particles that slip over one another and are readily dislodged. This property allows for easy blending or stumping to create chiaroscuro. Even as a youth, Sargent rarely relied on this method, which was antithetical to the spontaneity he achieved with directly applied lines.[3] The loosely held particles also allowed the artist to make corrections and highlights by lifting the graphite to reveal the underlying paper, using bread crumbs, erasing blades, and India rubber.[4] Sargent employed such tools for *Lion Monument, Lucerne* (cat. 160), but by the end of his academic years he had abandoned this precise manner of drawing and the related devices it required.

The same property that makes graphite erasable causes it to offset and smudge, as has occurred on the versos of many of Sargent's early sheets. This is probably why he almost always used only one side of each page in his sketchbooks, even in later years, when he generally worked with lighter and hence more compact pencils that left more stable marks. Indeed, the prospect of smudging accounts for *House, Hammer* (cat. 44 recto) and other early drawings being fixed, which is evidenced by the brown oxidation of the protective coatings that has occurred over time.[5]

Sargent's youthful development must have been prodigious, as his portfolio of "canvases and papers . . . in various mediums"[6] brought him immediate acceptance in Carolus-Duran's atelier in May 1874. Although Carolus-Duran is recorded by his students as emphasizing painting, the curriculum of the École des Beaux-Arts, where Sargent also studied for three semesters, placed priority on drawing, the centuries-old basis of the French system of art education. In 1863, however, the emphasis on draftsmanship underwent an important change. Responding to the discontent of independent artists, the school questioned Davidian precision and sculptural form and began encouraging some measure of spontaneity. Maintaining that the artist's uniqueness was most apparent during the preparatory stages of

work, some academicians shifted emphasis to rapid, expressive handling, textured broken strokes, and sketchlike effects.[7] These ideas were in circulation for the decade preceding Sargent's admittance to the École. They had a far-ranging impact on artistic practices and would be evident in Sargent's works throughout his career.

Drawings from the years surrounding Sargent's attendance at the École reflect his transition to a mature style. These works in heavily applied graphite and charcoal reveal increasing economy in technique and the use of tonal means to construct form. Carolus-Duran's painting instruction can be detected in drawings such as *Firelight* (cat. 70), in which the face, depicted in artificial light, is broken into a mosaic of sharply contrasting dark, light, and half-tones, each unit being built up in hatched lines. This method is analogous to the preparatory stages of painting as taught by Carolus-Duran, in which the main planes of the face were laid in side by side without fusion, a concept Sargent was to recall in 1901 as "the faculty of dissecting all planes in a face and determining at once the greatest light, and the greatest dark . . . reason[ing] out everything, each plane and every individual point."[8] Other studies from this period, such as *The Plague at Ashdod* (cat. 61) or *Cattle in Stern of a Boat* (cat. 102), typify his increasing mastery at drawing in fluent, expressive strokes, varying the intensity of the graphite for the middle and dark tones and leaving the paper in reserve for highlights.

Sargent's exercises in correlating monochromatic values with color are seen in many sheets from about 1874–76. Presumably such studies were aimed at laying the groundwork for the *ébauche*—a draft of a figure or head rendered in oil in tonal gradations, and the core of academic technique. In *Boat Deck* (cat. 101) and *Men Hauling Boat onto Beach* (cat. 90), forms are modeled in graphite in a range of gradations accompanied by a description of the values: "dark, light, lighter, darker, warmer to darker, dark into shadow," and color names for the motifs. In other drawings the concept is more fully realized. The pencil drawing is either worked up in watercolor or, as in *Woman with Basket* (cat. 44 verso), there are color notations and dabs of paint applied next to the drawn design. A variant on the

study of tonal values is seen in the grisaille water-color over graphite of *Nubians in front of the Temple of Dendur* (cat. 144), copied from a photograph.[9]

Although graphite was an indispensable drawing medium, charcoal, a friable substance, became the material of preference at the École after the reforms of 1863.[10] Unlike pencil, ideal for precision and tight contours, charcoal was favored for introducing students to modeling in broad tonal gradations. Charcoal was originally available only in its natural twig form, which offered little variation in tone or texture. By the nineteenth century, however, the production of compressed charcoal gave artists an expanded range of densities and tones with which to work, including grayish, brownish, and rich saturated blacks. Far fewer of Sargent's charcoals survive than his works in graphite. An early example, *Life Study Class* (cat. 55), depicts the typical atelier in which Sargent would have worked. In it the window is set high in order to control the illumination for bright light, dark shadows, and half-lights, thereby enabling the students to portray the model in chiaroscuro. To achieve this effect, Sargent applied layers of rich, deeply toned charcoal; used an array of reductive methods, such as scraping and wiping, to expose gradations of the white paper; and added strokes of dense charcoal to define the forms.

In contrast to *Life Study Class,* which was done in the confines of the studio with its unchanging north light, plein-air drawing was encouraged by the École as part of the summer curriculum. Not intended to serve as a preliminary stage in the drawing process, nor to capture the atmospheric effects pursued by independent artists, these academic exercises were meant to encourage individuality as well as the rapid execution demanded by the changing conditions of nature.[11] For these quick drawings, or *croquis,* the sketchbook, with its abundant supply of paper, was recommended. The torn edge or traces of sewing holes in a large number of Sargent's drawings indicate that he relied on sketchbooks throughout his life and travels, often working in several simultaneously. Typically these were bound in paper or cloth, had a loop for holding a pencil, and contained machine-made wove paper (composed of linen fiber or wood pulp) with a smooth surface that did not disrupt the pencil stroke.

Sargent's sketchbooks range from a small *croquis en poche,* used for the densely applied rendering of *La Pierre du Champ Dolent* (cat. 80), a landscape done during his student years, to the midsize paper of the Javanese Dancers series, in which the light graphite skims the paper surface, to the larger format of *Greek Theatre, Epidaurus* (cat. 245 recto), executed in a medium-hard pencil with a relatively broad line. Sketches such as these do not show signs of having been reworked; rather, revisions were made by redrawing the motif elsewhere on the sheet or on a new page. Unlike the relatively static souvenir subjects of Sargent's youthful sketchbooks, his mature drawings—even when used as preparatory compositions—were exercises in capturing movement and gesture and for cultivating his powers of observation. Most of his later drawings are on off-white paper; however, among them are colored sketchbook sheets in green, gray, and buff (often now faded because of fugitive dyes). Such sheets probably were used for convenience alone; Sargent would not have purposely chosen colored paper, as it was best suited for compositions to which highlights were added by brush or with chalk. In some early works, such as *Jungfrau* (cat. 17b verso), Sargent applied white gouache for heightening on the dark sheets, a technique described in contemporary manuals. His later drawings on toned supports, however, were not developed to this degree of finish but instead relied on the paper reserve for the brightest accents.

The principles Sargent adopted during his student years in Paris extended their influence well into his maturity. The sense of immediacy he learned both in drawing classes and in Carolus-Duran's atelier is exemplified in *After "El Jaleo"* (cat. 162), executed on a fragment of commercial clay-coated paper intended for lithography. This material's brittle surface was readily damaged by corrections (as seen in the scraping at the nape of the neck) or overworking, and it thus demanded conviction from the outset. Varying the depth and texture of the graphite by graining, hatching, and deeply impressing the accents, and playing pencil lines against the brilliant opaque white surface, Sargent produced a dramatic study of a figure in high-contrast illumination. Perhaps because graphite at its darkest can yield only a

deep gray tone, Sargent enriched the drawing with black watercolor, applying it precisely to the hair and face and vigorously with the broad edge of the brush in a sweep from her sleeve to the flourish of her shawl.

The prepared paper for *After "El Jaleo"* is an exception in Sargent's graphic oeuvre, for his range of drawing materials was not extensive, nor did he fully exploit the technical possibilities of those he used. With few exceptions his mature drawings were worked in the equivalent of a modern-day semihard no. 2 pencil, without added heightening or reductive techniques. His versatility was in handling. In many sheets his emphasis is on line and foreshortening. Typifying this is *Gondolier* (cat. 156 recto). Rendered with no variation in the tonal value of the graphite, the form is reduced to the essentials of a broken, sinuous contour that conveys the thrust of the boatman's movement, summary modeling, and a few closely spaced strokes for the cap and sash.

Of somewhat greater complexity are drawings such as the seated, languid *Madame X (Madame Pierre Gautreau)* (cat. 168) and *Jane de Glehn, Study for "In the Generalife"* (cat. 317). In each, Sargent achieved a fleeting characterization with a rapidly drawn line that he reworked several times until the movement was established and then accented with simple shading ranging from lightly applied to deeply impressed strokes. Often differences in effect were the result of minor changes in means: the dark tones and the sharpened point used in *Madame X;* the harder pencil and thus lighter grays against the white paper of *Jane de Glehn,* which convey a sense of sunlight and shadow. In other compositions, such as *Loggia dei Lanzi, Florence* (cat. 284), the recesses of the colonnade and surrounding foliage were represented by thick pencil lines, modulated in spacing and intensity and assembled in a mosaic of tonal gradations.

The Metropolitan's holdings of Sargent's charcoal drawings include studies done for the Boston mural projects beginning in the 1890s and two of the many hundreds of portraits he executed after 1900. The popularity of charcoal had become fairly widespread beginning with the Romantic *fusainistes,* such as Odilon Redon (1840–1916) or Jacques Barthélemy (called Adolphe) Appian (1818–1898), whose highly finished compositions drawn in exacting detail and infused with atmospheric effects often included pastel, chalk, watercolor, or lithographic crayon. For Sargent, however, charcoal was primarily a quick sketching tool.[12] Because its weakly held particles readily crumble when stroked across a support and thus allow for broad handling, it was exceptionally well suited for large-scale studies for wall paintings that were to be viewed at a distance, such as the murals, and for the commissioned portraits he wished to execute rapidly. His nude and draped figures were generally rendered in semihard vine charcoal of moderate chromatic intensity.[13] Rather than being tonal compositions built up of textured layers of powder, drawings such as *Two Men* (cat. 197) and *Man Standing, Head Thrown Back* (cat. 202) emphasize contour. The physicality and volume of the models are summarily developed in directly applied strokes, stumping that merely grazes the projections of the support, and paper reserve used for highlights.

In the portraits, unlike the figure studies, Sargent employed charcoal in a more complex manner, although he allotted only two to three hours for their completion. *Anna R. Mills* (cat. 189) exemplifies how he took greater advantage of the properties of charcoal, manipulating it with simple tools or his fingers and realizing an expanded range of gradations. Typically these works were constructed with a ground layer of pulverized charcoal lightly rubbed on the support with a rag for a unifying effect. Over this, dark parallel strokes were applied with the broad side of the charcoal stick for the planes of the face and the background, and finally, using practices from his École years, the light and middle tones of details, such as hair and fur, were regained with various reductive techniques. Lacking the spontaneity and directness of a quick sketch or the tonal range of a fully developed composition, many of these portraits tend to be indifferent descriptions rather than penetrating characterizations of the models.

Whereas the charcoal sketches Sargent executed during his travels, such as *Draped Seated Woman* (cat. 239), were often on white wove sketchbook paper, the mural figures and portraits (which were posed in the studio) were on supports traditionally designated for charcoal or pastel, textured to provide

a tooth to hold the powder and lightly colored for a middle tone. Sargent's papers were generally hand-made, deckle-edge laid sheets with a moderate grain, in off-white, light blue, or gray, bearing Ingres, Michallet, or Berville watermarks. Many of the figure studies were pinned several times to a drawing board; multiple tack holes suggest repeated sessions of work. *Paul Manship* (cat. 191), a monumental form devoid of background context, stands apart in its rugged pinkish brown wove paper and its handling. Its simple linearity was dictated by the hardness of the compressed charcoal, which would not have yielded to blending. As in his other drawings, Sargent dispensed with added highlights, simplified the bulk of the sitter by foreshortening, indicated shadows and folds by rapid hatching, and applied the charcoal with impressed, compact strokes for the few well-placed dark accents of bow tie, collar, and hair.

Valued for the same virtuosity and summary qualities as his oils—a luminous palette, tactile brushwork, boldness of form, dramatic spatial organization, and immediacy of effect—Sargent's watercolors conjoin traditional nineteenth-century practices, his mastery as a painter on canvas, and his experience of Impressionism. Watercolor held a lifelong attraction for him, but his singular style cannot be tied to specific influences. Despite a lapse in his watercolor practice during his student years, he likely saw the compositions of acquaintances who worked in watercolor, as well as several watercolor exhibitions that took place during this time.[14] The medium's sustained importance in Sargent's oeuvre after about 1900 was spurred by his expressed dissatisfaction with portraiture and, undoubtedly, as his travels increased, by an attraction to the technical possibilities portable materials offered. Watercolor allowed him to abandon the somber and artificially lit studio for the brighter palette and effects of light that could be achieved in the open air.

Brightness and luminosity are inherent in watercolor, and these qualities must have appealed to Sargent's interest in conveying the changing aspects of direct and reflected light, effects that he repeatedly addressed in his works. Watercolor is composed of a colloidal suspension of pigment in water with a gum arabic binder. The medium's vibrancy

results from the transmission of light through transparent layers of color and the reflections off the underlying white paper. Although he limited the technical range of his other graphic works, Sargent explored all the technical devices of watercolor, exploiting the individual characteristics of his pigments, manipulating the flow of paint to produce fluid and transparent washes or thick and opaque layers, employing reductive means to modify hue, and imparting physical substance with gums and waxes to alter texture and enhance the reflection of light.

Sargent provided little written information about his watercolor practices; thus, our understanding of them comes mainly from the works themselves, as well as from his few comments and those of his companions. Also informative are effects from his studio and photographs of him painting out-of-doors with equipment developed in the nineteenth century for the many artists who chose to paint before nature: collapsible easel and stool, umbrella, and small folding japanned box of moist colors in pans.[15] Found at his death were an assortment of ten brushes—their range of shapes and sizes evident in his brushwork—and fifteen metal tubes of paint.[16] Whereas his earliest works, such as *Young Woman in Black Skirt* (cat. 158), *Venice* (cat. 157), and *Market Place* (cat. 251), reveal the influence of Carolus-Duran in their muted hues, these tubes of color verify the change that occurred in his palette during his trip to Palestine in 1905–6 and his increasing interest in landscape. Among the paints he used were those introduced or synthesized in the nineteenth or early twentieth century—bright cadmiums and chrome yellows, cobalt, scarlet vermilion, alizarin crimson and viridian—and traditional pigments including burnt sienna, Vandyke brown, and lamp black. Used for compound hues or in pure form, these hues are recognizable particularly in Sargent's works from the Middle East visits.

Two colors that must be presumed missing from this collection are mauve and Chinese white. The former, for which Sargent showed a marked proclivity—and which since its introduction in 1856 had become widely popular—was available in various purples and violets.[17] Chinese white, or gouache—also a water-based pigment—was the essential com-

ponent of his opaque washes,[18] which were often mixed with diluted gamboge, rose madder, or cobalt, resulting in pale and luminous tints. As opposed to the jewel-like, transparent quality of watercolor that depends upon a paper substrate to refract light, the glimmering brightness of the more solid gouache results from the reflection of light off its matte surface. Sargent exploited this subtle difference most effectively to convey the glare of sunlight playing off stone in architectural scenes, such as *Temple of Bacchus, Baalbek* (cat. 279) and *Escutcheon of Charles V of Spain* (cat. 314); or sunlight on fields of wheat, exemplified by *Camouflaged Field in France* (cat. 228); or to intensify high-keyed flesh tones surrounded by saturated washes, as in *Tommies Bathing* (cat. 225).

Despite Sargent's professed preference for pan colors, the bright impastos of *Venice, Arab Woman* (cat. 275), and *From Jerusalem* (cat. 277) were made with viscous tube paints applied at full strength. For his very deep hues he relied on pure tones or fusions of browns, blues, and black with admixtures of other colors. Often gum arabic was mixed with the umbers and Vandyke brown, as in *Italian Model* (cat. 233), enriching them with a gloss and conferring a shadowy transparency akin to that seen in his oils. Many of his later watercolors incorporate a bright spectrum of transparent and semiopaque color in varied brushwork and paint marks,[19] typified in his brook views (such as *Mountain Stream* [cat. 313]) and in many of the Florida scenes (such as *Man and Pool, Florida* [cat. 340]). Sargent's academic background is frequently recalled in the dominance of one tonality—invariably subdued or neutral or pitched at a particular key—within a composition: the somber scale of *Ruined Cellar, Arras* (cat. 216) or *Cathedral Interior* (cat. 271), both in umbers and siennas; the higher range of *Escutcheon of Charles V of Spain,* with its diffuse yellows and ochres amidst blues and browns; or the lavenders and greens of *Tommies Bathing,* colors to which he would continually return.

Sargent tended to work in water-based paints as he did in oil, covering his sheet with color and then reducing or removing it to produce the lights, half-lights, and deep tonalities—*les valeurs*—from which he developed his forms. In watercolor this required a white paper of substantial thickness and robust texture; it had to be able to withstand the rigors of dampening in order to yield gradations of color as well as scraping and rubbing for highlights, and to have surface characteristics that would impart textural interest and reflection when covered with paint. The sketchbook papers of his early watercolors, such as the alpine scenes and *Patio de los Leones, Alhambra* (cat. 136), restricted the flow of broad washes by their absorbency and were unsuitable for reductive techniques because of their thinness. A change to a more receptive, heavier, handmade linen paper with a gelatin surface sizing, which could withstand saturation and physical manipulation without allowing the washes to sink in, contributed to the more spontaneous effect that characterizes his later work. Several of his papers bear the Whatman watermark, but he also used comparable sheets from other mills made expressly for this medium, such as the hard-sized R.W.S. embossed paper of *Italian Model;*[20] however, most of his papers do not bear identification marks.

Sargent intuitively varied his brushwork depending upon the paper he used, randomly choosing the smoother wire or coarser felt side. A few of the Metropolitan's drawings are on relatively smooth ("hot pressed") watercolor paper (among them, *Three Oxen* [cat. 307] and *Garden near Lucca* [cat. 303]), a surface well suited both to detail and to flowing washes. Generally he preferred medium "not" (a softer, pebbled surface) or coarsely grained "rough" textures, including those with a rather rugged twill surface. The latter, used in *Tommies Bathing,* is not dissimilar in effect to the heavily textured canvas *coutil* that was popular among Impressionist painters because its prominent weave would remain visible through the priming layer, capturing and reflecting light.[21] In *Tommies Bathing* a vitality is imparted by the support's roughness, evidenced by the play of shadow and light across the projections and hollows of its painted surface, an effect that augments the high-keyed colors. The interplay of paper and painting technique is especially evident in a comparison of *Italian Model* and *Man with Red Drapery* (cat. 232). The rough paper of the former composition allowed for the more richly developed textural effects of fingerprints and dragged brushwork (a flat brush charged with "dry" color), whereas the

smoother support of the latter drawing was more receptive to fluid washes and allowed broad reflections of the paper reserve, as seen in the figure's upper torso.

Sketching blocks were an alternative to sheets purchased individually. These compressed pads of prestretched paper on millboard, bound at their edges with a gum adhesive, were comparable in texture and quality to single leaves of paper. Blocks were handy for outdoor work because of their rigidity, but the top sheet needed to dry before it was separated from the sheet below with a knife, thus requiring an artist to have many blocks on hand. Sketching blocks were available in a range of sizes[22] and were among the many supplies made expressly for working out-of-doors. A photograph of Sargent dressed for plein-air work (see figure 99) suggests by the simplicity of his easel that he is using a sketching block.[23] That this was the paper format he frequently employed is indicated by several references to it in his correspondence and by the adhesive residue at the edges of many drawings of diverse dimensions in the Metropolitan's collection. Another type of support employed outside the studio was commercially prepared artist's board, such as Sargent used for *Ruined Cellar, Arras*. This example, stamped with the label of Roberson, a London colorman with whom Sargent had a sporadic correspondence over a forty-year period,[24] is made of good-quality paper mounted to thick and resilient pulpboard, a composite well suited to the demands of work on the war front.

The preliminary stages of watercolor painting required that the paper be thoroughly dampened with flat brushes or sponges to avoid cockling and the inevitable puddling of colors. Prestretched paper on drawing blocks did not require this preparation, which would account for Sargent's reliance on such blocks for outdoor painting. Blocks were easy to use, as inferred by Adrian Stokes's comment about seeing Sargent begin a drawing: "He simply opened a block and began to paint straight away."[25] If instead a loose sheet was used, the wetted paper was affixed to a wooden drawing board, either by being glued at its edges or being tacked down, as in *Man with Red Drapery*. Upon completion of the watercolors such sheets generally would have been trimmed;

hence little evidence survives as to how often Sargent employed these methods. However, the convenience of the drawing board as a working surface is depicted in *In the Generalife* (cat. 316), in which the background figure holds such equipment on her lap. For studio work the expanded damp sheet could be held in place by a pin stretcher that would puncture the perimeter of the paper, as is evidenced by the evenly spaced tack holes in the border of *Italian Model*. Wetting, stretching, and trimming account in part for the fractional measurements of these works; in addition, Sargent may have selectively cut their edges in order to reposition the image.[26]

Sargent's practice of beginning his watercolors with graphite sketches was chronicled by those who observed him, including Stokes, who noted that "fine and correct drawing was the foundation on which all his work was built," and Charteris, who recalled that Sargent's "general habit was to make the lightest indications in pencil to fix the relative position of objects."[27] A number of the Metropolitan's watercolors were examined using infrared reflectography in order to study this preliminary stage of his work without the interference of wash layers and hence to reveal one of the steps involved in the compositions' construction. Comparable to the swift and energetic draftsmanship that characterizes Sargent's independent graphite drawings, his underdrawings were also concisely rendered without any revision. They were executed with a relatively soft, dark pencil, which—being only tenuously held on these hard-sized, textured papers—would have been partially washed away by the rigors of the painting process.

A significant diversity is evident in the extent of this preparatory layer, ranging from minimal markings and isolated details that are not readily apparent to the unaided eye to a fairly complete mapping out of the composition or of a major element that remains visible through the transparent layers. In the group of sheets examined, no correlation was found between the amount of underdrawing and the degree of finish of the watercolor: for example, those without an underdrawing included *Arab Woman* and the panoramic landscape vista *Sirmione* (cat. 323)—bravura performances executed with dashes of impasto, broad paint layers, and little detail—yet in the carefully rendered *Camouflaged Field in France*

Figure 28. *Alligators* (cat. 334): An infrared reflectogram assembly showing the graphite preliminary drawing.

Figure 30. *In the Generalife* (cat. 316): An infrared reflectogram assembly showing the graphite preliminary drawing.

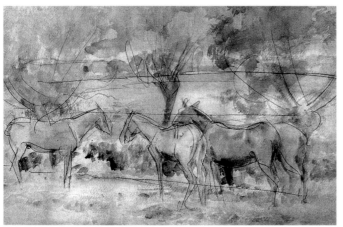

Figure 29. *Mules* (cat. 223): An infrared reflectogram assembly showing the graphite preliminary drawing.

Figure 31. *Escutcheon of Charles V of Spain* (cat. 314): An infrared reflectogram assembly showing the graphite preliminary drawing.

only meager strokes of graphite are present. In another group of watercolors, the preparatory work consists only of details seeming to function simply for laying out ideas or organizing space, and they are not readily discerned through the washes. In *Alligators* (cat. 334; figure 28), Sargent carefully outlined the group of reptiles in pencil in the upper register, whereas the highly crafted one in the center was developed only in paint; in *Camp at Lake O'Hara* (cat. 331), the pencil renderings are limited to the foreground bench laden with pots and pans and the simple profile of the hill, perhaps placed as markers to establish the boundaries of this compressed scene. In sheets such as these, great differ-

ences in the preliminary and final work clearly suggest that Sargent's ideas evolved as he painted. Study of these drawings with reflectography also revealed graphite designs that were brought to a far higher level of completion but were obscured by the deep tones of the washes. This is the case in *Mules* (cat. 223; figure 29), in which the animals, trees, and the division of the landscape into horizontal bands are completely laid out. In *In the Generalife,* the underdrawing of Emily Sargent at her easel and many other details has been obscured by dark colors, whereas the painted face of the older woman achieves its definition from the graphite strokes (figure 30).

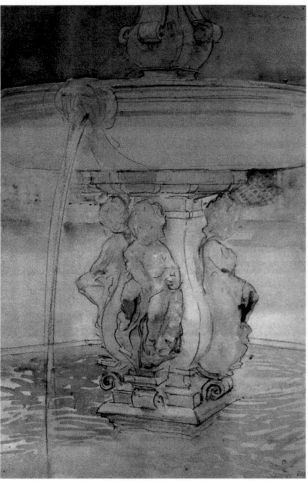

Figure 32. *Spanish Fountain* (cat. 315): An infrared reflecto-gram assembly showing the graphite preliminary drawing.

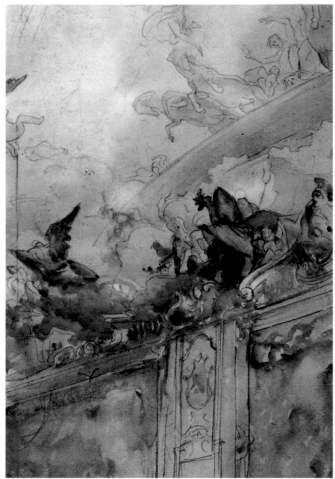

Figure 33. *Tiepolo Ceiling, Milan* (cat. 265): An infrared reflecto-gram assembly showing the graphite preliminary drawing.

The most significant presence of the preparatory layer was found in sheets in which it served in the development of the composition as well as in its final appearance. The visibility of these sketches is evocative of practices demonstrated by Carolus-Duran,[28] in which the preliminary design was to remain partially visible through the layers of oil paint in the completed work—an effect intended to convey the drawing process and hence reveal the artist's individuality. Sargent seems to have applied this concept to his watercolors. *Escutcheon of Charles V of Spain*, for example, although appearing to be bathed only in pools of colored light, is supported by a highly developed underdrawing and precise compass lines, both reinforced with clearly articulated brushwork (figure 31). In *Spanish Fountain* (cat. 315), the centrally located structure is described in graphite in great detail and used as the

armature for the broadly applied, amorphous washes (figure 32). Similarly, in *Tiepolo Ceiling, Milan* (cat. 265), the penciled rendering of the architecture gives structure to the bright washes and dabs of overlaid paint (figure 33), and in *Cathedral Interior* (cat. 271), the well-articulated drawing—possibly augmented after the washes were laid in[29]—defines the darkened chamber. In compositions such as these, the intermittent but intended presence of the graphite design through the layers of watercolor contributes to the sense of swift execution and immediacy of effect.[30]

Although observers of Sargent at work found his process extraordinary in its rapidity and seeming simplicity,[31] close examination of his watercolors suggests much greater care. Following the preparatory processes, his watercolors evolved from undefined masses of diluted and layered color to forms that

Figure 34. Detail, *In the Generalife* (cat. 316): The foliage in the background shows highlights produced using wax resist, which, when removed, revealed underlying color and allowed application of additional tints.

that flowed into one another as they were absorbed by the dampened sites on the paper, a "wet-on-wet" technique forming the basis of each of his compositions.[32] While wet, the washes were selectively lifted with a sponge or blotter or, if dry, reworked with water, methods leaving veil-like traces of pigment and infusing these watercolors with their atmospheric luminosity. Upon drying, this semi-transparent effect would be given definition with gestural strokes of more concentrated paint. Their edges—controlled and contained because they did not seep into the underlying or neighboring color—established the bold contours of the major elements, as is seen in the figures in *Tommies Bathing,* the massive shapes in *Oxen* (cat. 308), or the plinth and urn in *Garden near Lucca.* Analogous to his oil process, these broad effects were described in a popular manual as "dealing with things in mass . . . and leaving out much of the detail."[33]

Sargent executed numerous sheets composed of barely more than these expansive color-washed layers, among them *Women Approaching* (cat. 250), *Tiepolo Ceiling, Milan,* and landscapes such as *From Ávila* (cat. 268) and *Siena* (cat. 306). Within his watercolor oeuvre, however, degrees of finish can be discerned in his skillful rendering of detail. His more technically exacting works, which appear to be products of his creative process rather than of his intention to sell or keep a particular watercolor, are characterized by greater complexity in the use of reductive devices and in the play of paint textures

gradually assumed shape with an array of additive and reductive techniques. Study of the variations in the flow of paint and the appearance of the edges of the strokes reveals the complexity with which these watercolors developed. With a large, soft brush loaded with color, Sargent laid in preliminary washes

Figure 35. Detail, *Camouflaged Field in France* (cat. 228): The detail illustrates Sargent's use of wax scumbling over washes.

and opacity. Employing techniques based on traditional watercolor methods, they were radically transformed by his bravura. For Sargent, such devices as impasto, incising with the brush handle or knife, or flickers of white paper served as variations on the painted stroke. Applied with great care, these modulations in the paint were above all a means of imparting light and reflection.

Among the most complex of these sheets is *In the Generalife*. Its whorls of glinting light against the shadowed pavement and dark foliage were produced with a resist technique employing a white wax-emulsion crayon (figure 34). Stroked across the painted surface, this viscous medium would mask the support and repel the absorption of subsequent washes. When the wax was removed by solvent or scraping, any underlying color became evident and new tints could be applied, as is seen here. Although stopping-out agents were known to watercolorists in the nineteenth century, Sargent's diverse application of such substances stands as the boldest and most intentionally visible example of their use. Often employing this technique during the working process to introduce additional layers of color, Sargent also used white wax crayon as a drawing tool in the final stage of a composition. In *Camouflaged Field in France* (figure 35) or *Wheels in Vault* (cat. 215), the crayon was scumbled on the dark colors, its opacity and body having the broken effect of chalk or "dry" gouache.[34]

Other tactile effects and highlights were produced by the manipulation of paint and paper. For example,

in *In the Generalife* small areas of paper are kept in reserve to represent shafts of light, such as on the neck of the distant seated figure or on the converging apex of the easel legs (figure 36). The sharp contours and smooth surfaces of these voids reveal that the artist left areas of paper dry to prevent merging of the surrounding colors. Whereas these highlights may have been conceptualized during the preparatory drawing phase, the dramatic bright slash of the white support representing the central leg of the easel was clearly produced in the final stages of this work. Using a sharp tool, Sargent incised the line, pushing up ridges of paint and paper in the barely damp surface. Variations of such effects are seen, for example, in the sunlight piercing the fronds in *Palmettos* (cat. 333), made by abrading the surface with a flat scraper (like the one found among his effects) after the colors had dried and exposing the fibrous paper to reflect light (figure 37).

Sargent also made transformations in the opacity and texture of his paints. Watercolor megilp, a gelatinous substance composed of gum tragacanth, was used to thicken his dark colors without altering their transparency or imparting a luster. Additives including megilp, gum arabic, and glycerine were promoted for watercolorists toward the end of the nineteenth century as means to imitate the effects of oil paint.[35] Visual evidence of megilp in *In the Generalife* is noted in the broad tracks of brushwork in the brown-accented cobalt clothing and in the curtain of green shrubbery. Sargent also modified his dark

Figure 36. Detail, *In the Generalife* (cat. 316): The highlights were produced by incising into barely damp paper (as in the central easel leg) and by using paper reserve (as in the top of the easel legs). The paper reserve was created by keeping the area dry during the working process to prevent infusion of surrounding color.

Figure 37. Detail, *Palmettos* (cat. 333): Broad washes, as seen in the diffuse greens, characterize the underlying layer of Sargent's compositions, over which he applied a variety of other techniques, including dry-brush work and wax scumbling (seen on the right). Reserves of paper were used for highlights. Diffuse-edged white and light-colored details (as in the palm fronds at the upper left and the very small crisscross detail at the right) were made by wetting the paint and lifting it with a blotter, sponge, or other implement. Wax resist, scraping, and rewashing of scraped areas are techniques that exposed fibers in order to reflect light. The texture of the dark green paint has been modified with gum megilp.

colors by mixing them with gum arabic, rather than employing the more conventional brush coating, to enhance their depth and richness. The distinct glossiness of gum arabic is seen, for example, in the strokes of burnt umber, Vandyke brown, and the deep compound greens in *Palmettos* that have dried with a shiny rim, and in *Three Oxen*, in which Sargent plowed the heavily gummed paint—spotted with characteristic burst bubbles and drying cracks—with a blunt knife to suggest the coarse bed of straw (figure 38). In counterpoint to these diaphanous saturated tones are the paints that reflect light diffusely: opaque and high-keyed body color washes *(Temple of Bacchus, Baalbek)*, impastoed Chinese whites *(Sirmione)*, and broken dragged strokes *(Rushing Brook* [cat. 291])—paints

that, when applied thickly, are more evocative of oil than watercolor.

Sargent's virtuoso contrasting of textures with gradations of opacity and transparency on a broad scale is also apparent in his meticulous crafting of details. Integral to the overall effect of immediacy are those details bathed in sunlight, such as Jane de Glehn in her wide-brimmed hat *(In the Generalife),* confected of complementary dabs of yellow, mauve, and other colors in surfaces of gouache, manipulated paper, and pools of thin tints (figure 39). In yet a smaller space is the anchored rope in *Camp at Lake O'Hara*—no more than a precise scrape into the paper, washed over with pale color (figure 40)—or the complex cross-hatched skin of the basking reptile in *Alligators* (figure 41). Imparting to the work

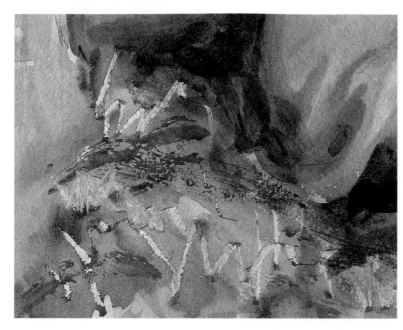

Figure 38. Detail, *Three Oxen* (cat. 307): The glossy quality of the paint was produced with an admixture of gum arabic. Its thickened texture was emphasized by scraping into the wet surface with a flat-ended implement.

the precision of a cut jewel, Sargent gently abraded the paper, having either masked the paint with wax or softened it with a wet brush, and lifted it with the corner of a rag or a blotter (as is betrayed by the fibers stuck to the gummed color), allowing each renewed surface to reflect or transmit light. With modifications such techniques were used to make revisions. For a late addition in *Camp at Lake O'Hara,* Sargent removed the underlying colors with moisture and, while the paper was damp,

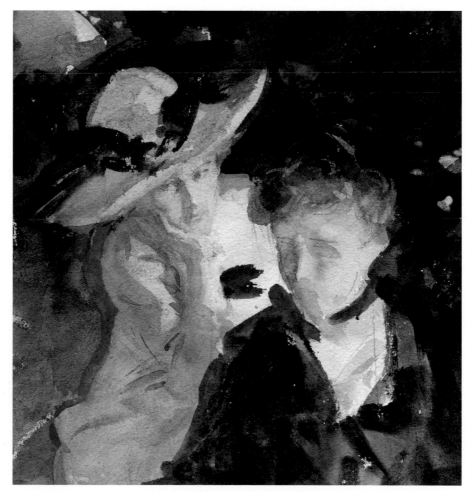

Figure 39. Detail, *In the Generalife* (cat. 316): The figure of Jane de Glehn shows the contrasting textures of scraped paper painted over with color, transparent washes and gouache, and graphite underdrawing; the figure of Emily Sargent shows gum megilp combined with the blue of her dress in order to vary the texture of the stroke and modify its transparency.

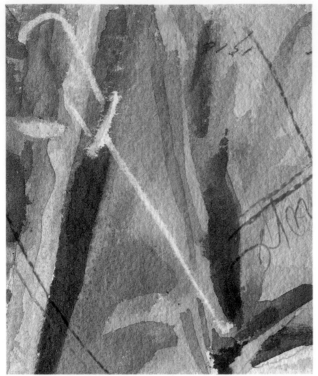

Figure 40. Detail, *Camp at Lake O'Hara* (cat. 331): The anchored rope was produced over layers of diffuse washes and more concentrated strokes by scraping into the paper, perhaps when the pigment was almost dry, with a blunt-ended tool.

painted the camper in washes that suffused the surrounding space. Similarly, the lower figure was added in *Tommies Bathing* (cat. 225) by vigorously rubbing out the initial paint layer and obscuring traces of it with a thick coating of opaque color.

It is not known how frequently Sargent reworked his watercolors, for the end result was meant to give the illusion of swift improvisation. However, the alternating processes of wetting and drying, subtracting and rewashing, masking and revealing would have given him the opportunity to capitalize on accidents, make revisions, or change course. In this context another group of watercolors can be identified, which may be regarded either as works in progress or as sheets that he did not complete. Exemplifying his process of compositional development is *Terrace and Gardens, Villa Torlonia, Frascati* (cat. 294), which he interrupted at a preliminary stage of execution, perhaps with the intention of returning when he could capture light at a certain time of day.[36] In the foreground the elaborate underdrawing was washed over with thin transparent tints, whereas the background foil was painted in a color thickened with gum megilp. Although Sargent brought this sheet to a fairly advanced level of development, covering it entirely with watercolor, the marked contrast between the two areas (the absence of layered effects in the foreground and the resultant visibility of the underdrawing) indicates that it is unfinished. *Alligators* is similarly intriguing because of the different stages of completion, evidenced by the contrast between the precise underdrawing of certain forms and its absence elsewhere; by the carefully rendered central reptile,

Figure 41. Detail, *Alligators* (cat. 334): Various reductive techniques are demonstrated, including lifting color (from the crisscross pattern) by masking with wax, wetting, scraping, and washing over with additional color (as in the blue alligator at right, which shows washes applied above the wax).

surrounded by others that were summarily indicated; and by the uncharacteristically broad areas of paper reserve. The uneven construction of this composition was perhaps again a consequence of changing light and movement, but it also suggests that this sheet was an independent study abandoned before completion, rather than being preparatory for the more highly finished *Muddy Alligators* in the Worcester Art Museum, Massachusetts.[37] A comparison of *Landscape with Palmettos* (cat. 332) and *Palmettos* reveals how the former exemplifies a more preliminary stage of development, lacking the subtractive devices, half-tones, and brilliant shots of semiopaque cadmiums and vermilion of the more elaborately constructed sheet. Sargent tackled this subject of dense tropical foliage on several occasions, and it remains to be pondered whether the simpler drawing was merely exploratory, not brought to completion because of dissatisfaction, or because, as he was wont to do, he moved on to another location and his subject—whose faithful visual representation Sargent claimed was his inspiration—was no longer before him.

The author of this essay would like to acknowledge her gratitude to the following people: at The Metropolitan Museum of Art, H. Barbara Weinberg, Alice Pratt Brown Curator, Stephanie L. Herdrich, research associate, Kevin J. Avery, associate curator, and Sean Farrell, senior departmental technician, American Paintings and Sculpture; Mary Jo Carson, assistant for administration, Paper Conservation; Malcolm Daniel, associate curator, Photographs; George Wheeler, research chemist, and Mark T. Wypyski, associate research chemist, Objects Conservation; and from other institutions, Annette Blaugrund, Luise Trabucchi, Alison Gilchrest, and Fredericke Steckling.

1. Sargent's childhood friend Vernon Lee's recollection of the books she and Sargent read as children and their debates regarding their worthiness (Ormond 1970b, p. 157), his family's concern with education, the widespread belief in the utility of art instruction, and the popularity of drawing as a pastime suggest Sargent's familiarity with some of the widely circulated artists' manuals of the time. Among those are J. D. Harding, *Elementary Art: Or, the Use of the Chalk and Lead Pencil* (London, 1846); John Ruskin, *Elements of Drawing* (London, 1857); George Barnard, *Theory and Practice of Landscape Painting in Water-Colours* (London, 1861); and Aaron Penley, *Elements of Perspective* (London, 1866). For Sargent's practices and sources see Shelley 1993.

2. Henry Petroski, *The Pencil: A History of Design and Circumstance* (New York, 1989), p. 184. The use of pencils was encouraged in manuals for amateurs because of their convenience for sketching from nature. See also John G. Chapman, *The American Drawing Book: A Manual for the Amateur and Basis of Study for the Professional* (New York, 1847), p. 32. Adjustments in the constituent clay and graphite accounts for the pencil's range of tones and degrees of hardness, which are designated by numbers or letters on the wooden casing.

3. Stumping graphite was described in various artists' manuals as a tool for modeling; however, the artist was advised to do so in moderation (see, e.g., Harding, *Elementary Art*, p. 95). Sargent occasionally experimented with this technique in his youthful work, as in catalogue numbers 47 and 103.

4. India rubber had been known in Europe since the 1770s (Petroski, *The Pencil*, p. 177), but because of its abrasive action it was not in widespread use for erasing pencil marks. For this reason, Ruskin discouraged its use, instead favoring bread crumbs (*Elements of Drawing*, pp. 13–14, 23–24).

5. Karl Robert, in *Charcoal Drawing without a Master* (Cincinnati, 1880, p. 55), lists fixatives manufactured and sold by art suppliers including Rouget, Durozier, Berville, and Meusnier. Robert also refers to the availability of a blowing apparatus and the rubber atomizer for dispersing fixatives (ibid., pp. 58, 60). The unequal-sized brown spots on catalogue number 25 suggest that it was fixed by a more traditional method, a spray of liquid delivered with the bristles of a flicked brush. Harding cites isinglass or gum water for fixing (*Elementary Art*, p. 96); Barnard cites gum arabic and hot water (*Theory and Practice*, p. 67).

6. Will H. Low, "The Primrose Way," typescript "revised and edited from the original MS by Mary Fairchild Low, with the collaboration of Berthe Helene MacMonnies," 1935, Albany [New York] Institute of History and Art, pp. 55–56.

7. Albert Boime, "The Teaching Reforms of 1863 and the Origins of Modernism in France," *Art Quarterly* 1 (1977), pp. 4, 14.

8. Sargent explained this concept to William C. Loring, the latter reporting it in a letter to his mother (February 15, 1901, quoted in Loring 1984, p. 19). Sargent's instruction was based on Carolus-Duran's method of painting the *ébauche*.

9. The interactive role of photography and painting at the École des Beaux-Arts was formalized in January 1864, when its vast photograph collection was opened to students, artists, and teachers for use in academic instruction. See Catherine Mathon, *Les Chefs-d'oeuvre de la photographie dans les collections de l'École des Beaux-Arts* (exh. cat., École Nationale Superieure des Beaux-Arts, Paris, 1992), p. xi. Photographs provided models for studying tonal gradations, as is implied by Barnard in *Theory and Practice*, pp. 145–47, in which he criticized the photographic palette for being restricted to only black, white, and shades of gray.

10. Albert Boime, *The Academy and French Painting in the Nineteenth Century* (New Haven, 1971), p. 32.

11. Boime, "The Teaching Reforms of 1863," p. 8. These ideas were developed as teaching tools by Eugine Emmanuel

Viollet-le-Duc: see "De l'enseignement de l'art: Il y a quelque chose a faire," *Gazette de Beaux-Arts* 12 (1862), p. 526.

12. An exceptional instance of white chalk heightening being used in a charcoal drawing is a study for the Boston mural project, folio 23 in the Fogg Art Museum's album of nudes (Fairbrother 1981a, p. 72).

13. Some of Sargent's charcoal portraits have a brownish cast, attributable to the source and particle size of the particular material he employed.

14. These exhibitions and Sargent's acquaintance with water-colorists while at the École are discussed in Hills 1987, p. 244, nn. 6–8. Among the exhibitions was one at the École des Beaux-Arts in 1877, the 1878 English watercolor show at the Exposition Universelle, and the show accompanying the 1879 formation of the Société des Aquarellistes Français (Charteris 1927, p. 13). In the late 1880s, years before he practiced watercolor in earnest, Sargent made plein-air oils in the Cotswolds with Edwin Austin Abbey (1852–1911), Alfred Parsons (1847–1920), and Francis Davis Millet (1846–1912), all of whom painted in watercolor and perhaps provided a source of inspiration for Sargent. Despite the prevalence of the Pre-Raphaelite manner during the middle years of the nineteenth century, the bold and expressive pictorial tech-niques of Joseph M. W. Turner (1775–1851), Antoine-Louis Barye (1796–1875), and Eugène Delacroix (1798–1863) would have struck a responsive chord in Sargent; however, there is no evidence of his awareness of their work.

15. Sargent commented that he found "box colour very useful and I use a great many different brushes, keeping my fist full when I work" (Birnbaum 1941, p. 10). His sister Emily is depicted in *In the Generalife* (cat. 316) using a popular "flexible-division" paint box, with its open wings serving as her palette and a water cup on her lap. Such boxes were used for "moist" colors, which were introduced in 1841 and contained glycerin, which increased fluidity and thereby contributed to the ease and rapidity of work.

16. Watercolors in metal tubes were introduced in 1846 by Winsor and Newton. The colors in Sargent's effects consisted of gamboge (made by Weber), chrome yellow (Newman), burnt sienna (Newman), scarlet vermilion (Winsor and Newton), deep vermilion (Hatfield), Vandyke brown (Newman), ultramarine (Schmincke), cadmium yellow pale (Newman), cadmium yellow no. 2 (Newman), rose madder (Winsor and Newton), alizarin crimson (Newman), viridian (Winsor and Newton), brown pink (Newman), cobalt blue (Newman), and lamp black (Winsor and Newton). See Marjorie B. Cohen, *Wash and Gouache: A Study of the Development of the Materials of Watercolor* (Cambridge, 1977), p. 66.

17. Mauve, a synthetic organic pigment, was developed from aniline dyes. Sargent may have made his lavenders from mixtures or used commercially prepared compounds, at least six of which were available in the late nineteenth century. See Townsend et al., "Later Nineteenth Century Pigments: Evidence for Additions and Substitutions," *The Conservator* 19 (1995), pp. 65–78. Sargent's frequent use of mauve was recalled by Edwin Blashfield, who noted that in "1887 he

seemed to have a predilection for the aniline suggestion in colors" (Blashfield 1925, p. 648).

18. The widespread commercial availability in 1834 of "Chinese white," a non-blackening zinc oxide, also known as body color or gouache, transformed the art of watercolor, becoming a mainstay in works by the English and American Pre-Raphaelites and diverse French practitioners including Alexandre Descamps (1803–1860), Auguste Raffet (1804–1860), Gustave Moreau (1826–1898), and Hercules Brabazon Brabazon (1821–1906). Its ratio of pigment to water, higher than that found in watercolor, resulted in a more manageable flow, enabling it to be applied with great control either as an opaque white or mixed with colors to produce pale hues that often served as the highest lights in a composition. Though body-color washes were used by Turner, Sargent's distinctive application of gouache was possibly inspired by the *peinture claire* of the Impressionists, one of their most important oil practices, which suffused the canvas with a pale, luminous tonality (for this technique see David Bomford et al., *Art in the Making: Impressionism,* London, 1990, p. 89).

19. The broken stroke, or *tache,* underlay Impressionist practice (Bomford et al., *Art in the Making: Impressionism,* pp. 92–93). Despite Sargent's later technique, in 1890 he denigrated the use of small patches of color to a student, Frederick Pratt, advising him to "always use a full brush and a larger one than necessary. Paint with long sweeps, avoiding spots and dots ('little dabs')" (Strickler 1982–83, p. 26).

20. The remains of the blind stamp at the upper right read " "[GUA?]RANTEED / PURE PAPER / R.W.S / [?] PALL MALL // 20." This 100% linen paper was developed in 1895 by John North, certified pure by the Royal Water-Colour Society, and embossed with their stamp.

21. Bomford et al., *Art in the Making: Impressionism,* p. 47.

22. The Rowney catalogue (in Henry Seward, *Manual of Colours,* 3rd ed. [London, 1889], p.11) lists eleven sizes from 5 × 3½ inches to 20 × 14 inches.

23. Sargent's outdoor painting practices and gear are recorded as follows: "His Italian valet, Nicola, carried his equipment. Once he had chosen a suitable spot he sat down on a stool to paint, surrounded by a series of protective umbrellas [to control and deflect light], which made him look 'like a newly hatched chicken surrounded by broken egg-shells'" (Birnbaum 1941, p. 11).

24. Ridge and Townsend 1998, p. 26. The full inked stamp reads: C. ROBERSON & CO. ARTISTS' COLOURMEN, 99 LONG ACRE, 154 PICCADILLY, LONDON.

25. Stokes 1926, p. 60.

26. For example, *In the Generalife* and *Garden near Lucca* are trimmed at all edges; *Tommies Bathing* (cat. 225) is cut on the right edge; *Man with Red Drapery* and *Palmettos* (cat. 333) are cut on the lower edges. Sargent also repositioned his compo-sitions in oil by selectively trimming the tacked edges of the canvases (Ridge and Townsend 1998, p. 26).

27. Stokes 1926, p. 60; Charteris 1927, p. 224.

28. Carolus-Duran's demonstration entailed freely drawing the

subject in charcoal or pencil on canvas, fixing it, and then applying the oil in a mosaic of discrete planes—thinly for the transparent shadows, opaquely for the highlights, and modulated for the few middle tones (Williamstown 1997, pp. 19–20, n. 25).

29. In traditional nineteenth-century watercolor practice the graphite outline was erased with India rubber or bread crumbs once the preliminary washes were laid in (for example, see the description by Thomas Rowbotham in *The Art of Landscape Painting in Water Colours* [London, 29th ed., n.d.], pp. 38–39). Although with the reforms of 1863 the École encouraged the student to leave the underdrawing visible in oil painting, the technique had been practiced frequently by watercolorists including Turner, Delacroix, Edward Lear (1812–1888), and Henri Harpignies (1819–1916) and would have been a natural consequence of the transparency of watercolor.

30. Sargent also occasionally used pen and iron-gall ink to give form to his washes, as in *Palazzo Navona* (1907, private collection). This would have been done upon completion of the watercolor, as the ink would have bled if the washes had been applied over it.

31. Charteris 1927, p. 224.

32. For the broad initial "wet-on-wet" layers, a wide camelhair brush, such as the one-inch round "mop" found in his studio among his painting tools, would customarily have been used.

33. Barnard, *Theory and Practice,* p. 120. Sargent conveyed a similar concept in 1890 to a protégé, Frederick Pratt, describing his method of oil painting: "Paint over the whole canvas with colors approximating the masses so as to obscure relations of tones while working—when finishing 'paint into paint' when possible" (Strickler 1982–83, p. 26, n. 30).

34. FTIR analysis and X-ray fluorescence carried out by George Wheeler, research scientist, and Richard Stone, objects conservator, The Metropolitan Museum of Art, reveal that the compound Sargent used is an emulsion of carnauba or beeswax and a resin that does not contain any pigment. Among the recipes for masking agents for watercolor painting is one cited by Barnard, in which wax was combined with egg white, lead white, and turpentine (*Theory and Practice,* p. 73).

35. Gum megilp is described in artists' manuals including those of Aaron Penley, *The English School of Water-Colour* (London, 1872), p. 13, and Barnard, *Theory and Practice,* p. 73. The name was based on a compound used for oil paint; however, the two were composed of different materials.

36. Sargent's sensitivity to capturing particular effects of light is discussed in the introduction to the studies for *Carnation, Lily, Lily, Rose* preceding catalogue number 175.

37. For a detailed sequence of the techniques used in the Worcester Art Museum's *Muddy Alligators,* see Walsh 1987, pp. 59–60.

Reader's Guide to the Catalogue

The catalogue is divided into four sections, each of which is introduced by a discussion of the period or aspect of Sargent's career under consideration. These essays provide a context for understanding the Metropolitan's works within the artist's greater oeuvre. The catalogue entries in each section are presented chronologically, except in certain instances where we have found it more useful to focus on thematic groupings. For example, works pertaining to Sargent's later professional commitments are treated together in section three, "Professional Activity, 1890–1925," although they were created concurrently with the travel studies that are the subject of section four, "Records of Travel and Other Studies, 1890–1925." In section three, as well, works pertaining to each of Sargent's three mural projects, which overlap in date, are treated in groups according to the project rather than strictly chronologically.

Every catalogue entry is illustrated and includes basic identification data and, where relevant, a commentary followed by provenance (ex collection), exhibition history, and references. Identification data are given for each side of every sheet on which an image appears. On occasion, several works of similar origin, such as a group of loose pages from a sketchbook (for example, cats. 26–33) or similar subject, such as studies for *Carnation, Lily, Lily, Rose* (cats. 175–78), are discussed in groups in brief essays that precede the individual catalogue entries.

Special treatment has been accorded Sargent's four sketchbooks. For each, the standard data on dimensions, support, cover or jacket inscriptions, manufacturer's marks, ex collections, credit line, and accession number are provided in the first overall identification, along with a discussion of its history and peculiarities. Every image on every page is illustrated. While each sketchbook appears in chronological order within the catalogue, the individual pages are set out in accession number order, that is, the order in which the pages arrived at the

Metropolitan in 1950. (Of the four sketchbooks, catalogue 16 and catalogue 186 arrived at the Museum with intact bindings.) Exceptions to this rule are noted in the text.

The chronology of Sargent's life at the end of this volume is intended to offer the reader more detailed biographical information than appears in the essays or catalogue entries. When we have been able to suggest only an approximate date for a sheet, the chronology provides more extensive information on the period. It also illuminates the inherent difficulties of organizing any catalogue of Sargent's works by date. Throughout his peripatetic career, Sargent visited and revisited certain places, such as Venice, and types of places, such as classical gardens in Italy and Spain. This pattern of travel often thwarts a definitive dating of a work based on the locale.

A separate chronology records the artist's lifetime exhibition history; the concordance matches catalogue numbers with the Museum's accession numbers; and the bibliography gives short forms for all titles. The appendix contains works that were attributed to Sargent when they were accessioned as part of the gift of Mrs. Francis Ormond in 1950 but for which that attribution now appears problematic.

As a whole, we have tried to make the catalogue useful to scholars without excluding readers whose interest in Sargent is more general and without sacrificing visual harmony. The following is an explanation of the categories of information given in the catalogue entries and the editorial procedures used, which we adapted from the format, methods, and procedures of *American Paintings in The Metropolitan Museum of Art* (three volumes).

Catalogue Numbers

Catalogue numbers reflect the chronological and thematic arrangement of the catalogue. Each sheet has received its own number. When images appear

Opposite: *Man and Pool, Florida* (detail), see catalogue 340.

on both sides of a sheet, they have been identified as recto and verso. The four sketchbooks by Sargent each receive one number to identify the entity (cats. 9, 16, 17, and 186). Individual sheets within are identified by letters from a to z; when necessary, z is followed by aa to zz. This method of designation mimics the works' accession numbers.

The collection contains one scrapbook (50.130.154), apparently compiled by the artist, that contains fifty-four drawings and watercolors pasted onto the pages. These fifty-four sheets, created between 1873 and 1882, appear in their appropriate chronological places in this volume. Each sheet has been given its own catalogue number and is noted as belonging to the scrapbook in the title line (see below). The concordance at the end of this volume identifies these drawings.

Titles

When known, the original title Sargent gave the picture or the title under which the work was first exhibited or published has been used, sometimes with minor grammatical corrections. The vast majority of the works represented in this volume were donated by Mrs. Francis Ormond in 1950. The descriptive titles that the Metropolitan gave to these works when they were accessioned derived in many instances from inscriptions made by Sargent's sisters on the backs of the sheets. These titles have been retained when they accurately describe or identify the image; others have been corrected as a result of our research. For example, when we identified the site depicted in catalogue 293, we changed the title from *Ionic Capitals, Italy* to *Loggia, Villa Giulia*. As so few of these works have been published heretofore, we have provided the correct title only.

Dates

Sargent dated his watercolors and drawings only rarely. In many instances, we have been able to date certain sheets by identifying the site depicted and determining when Sargent was there. When relevant, details regarding dating are discussed in the individual entries.

Medium and Support

The catalogue encompasses works done in ink, ink wash, graphite, charcoal, chalk, crayon, watercolor, and gouache. In general, the predominant medium is recorded first. Color and composition of the paper and the composition of the mount, if any, to which the paper is affixed are given.

Measurements

The dimensions of the support are given in inches followed by centimeters in parentheses. Height precedes width. The dimensions of sheets in the sketchbooks are given only in the introduction to the sketchbook, not for each sheet.

Inscriptions and Watermarks

The artist's signature and any inscriptions, as well as their location on the support, are given. Watermarks and supplier's marks are also included. Marks known to have been made by the Museum, including accession numbers and the Metropolitan's stamp, are not recorded, nor are small numbered adhesive stickers placed on the versos of works included in the 1950 Ormond gift and visible in some photographs. Certain labels or stickers are noted when they provide information, such as ex collections or exhibition history, that is not available elsewhere. Information in brackets is not part of the inscription and was supplied by the authors.

Accession Numbers

In compiling this catalogue, some accession numbers have been changed to correct minor errors in sequence that occurred during the accessioning of Mrs. Ormond's gift in 1950. The accession numbers for those works reflect the way in which they arrived at the Museum in several suitcases and five portfolios. Although there was no evidence that the grouping of the works in the portfolios was significant, each portfolio received a distinct accession number (50.130.82, 50.130.140, 50.130.141, 50.130.142, and 50.130.143). However, within the portfolios, the cataloguers departed from the Metropolitan's usual method of identifying individual

sheets. Where images appeared on the front and back of a sheet in a portfolio, the cataloguers incorrectly assigned letters in sequence from a to z to each image, instead of adhering to the standard Metropolitan practice of identifying each sheet with a single letter and each side as recto and verso. (For example, under this erroneous system, 50.130.82b recto was called simply 50.130.82b and 50.130.82b verso was called 50.130.82c.) In preparing this catalogue, the portfolios were relettered following standard Museum procedure. Such changes are listed in the concordance.

Entry Text

A discussion of a sheet is included where it is justified by the significance of the work, the relevance to the artist's work in other media, or by new discoveries; the lengths of the texts vary widely. In some instances, the entries consist merely of information on the site depicted. While basic cataloguing data are given separately for the recto and verso of a sheet, they are usually discussed in one entry text.

Wherever possible, locations of related works mentioned in the text are supplied in parentheses following the title of the related work. In cases where private owners have wished to remain anonymous, the designation "private collection" has been used. Whenever possible, published sources are given for reproductions of related works.

Ex collection

Information on previous ownership of drawings is extremely variable. While every reasonable attempt has been made to trace the ownership history of a work from the time it was made, the information available is often so scarce that gaps exist. The names of previous owners of a work from the earliest known to the last are given with the years when they are known to have held the work. (Dates are usually derived from exhibition information, and owners' death dates are sometimes supplied for the terminal date.) The family relationship of one owner to another is given when known. Ex collections—given only for works that were not part of the gift of Mrs. Francis Ormond of 1950—appear

after the entry texts. All works with the credit line "Gift of Mrs. Francis Ormond, 1950" have the following ex collection information: the artist, until d. 1925; his sisters, Mrs. Francis Ormond (Violet Sargent) and Miss Emily Sargent, until 1936 (Emily Sargent's death); Mrs. Francis Ormond until 1950.

Efforts have been made to verify the information we have on previous ownership, but these have not always been successful. In some cases, therefore, a listing may be qualified by "probably," "possibly," or with a question mark. Very often information comes to the Museum secondhand, and sometimes there is only family tradition to rely on. We have given the names of all collections known to us except in the case of anonymous donors to the Museum, where the person's intent or legal stipulations prevent such disclosure.

Exhibitions

We have attempted to include all known exhibitions of a work. The full title of the exhibition, the city, and the dates of the show are given when there is no exhibition catalogue or if the exhibition catalogue does not appear in the bibliography. When a catalogue is included in the bibliography, a short form is given. Semicolons are used between exhibitions.

References

Reference sources refer directly to the work under discussion. The citations are selective: contemporary sources on the works are included, as are newspaper and periodical reviews of their exhibitions; more recent books, articles, manuscripts appear when they offer new information, interpretations, or in general add to the knowledge of the works. Therefore, when a work is simply illustrated or mentioned in passing in a publication, no reference is given. When a work is discussed in an exhibition catalogue but was not included in the exhibition, the citation appears in the reference section.

References are given in a short form, which consists of the author's last name and the source's year of publication, followed by the relevant pages. The full citations may be found in the bibliography. Semicolons are used between references.

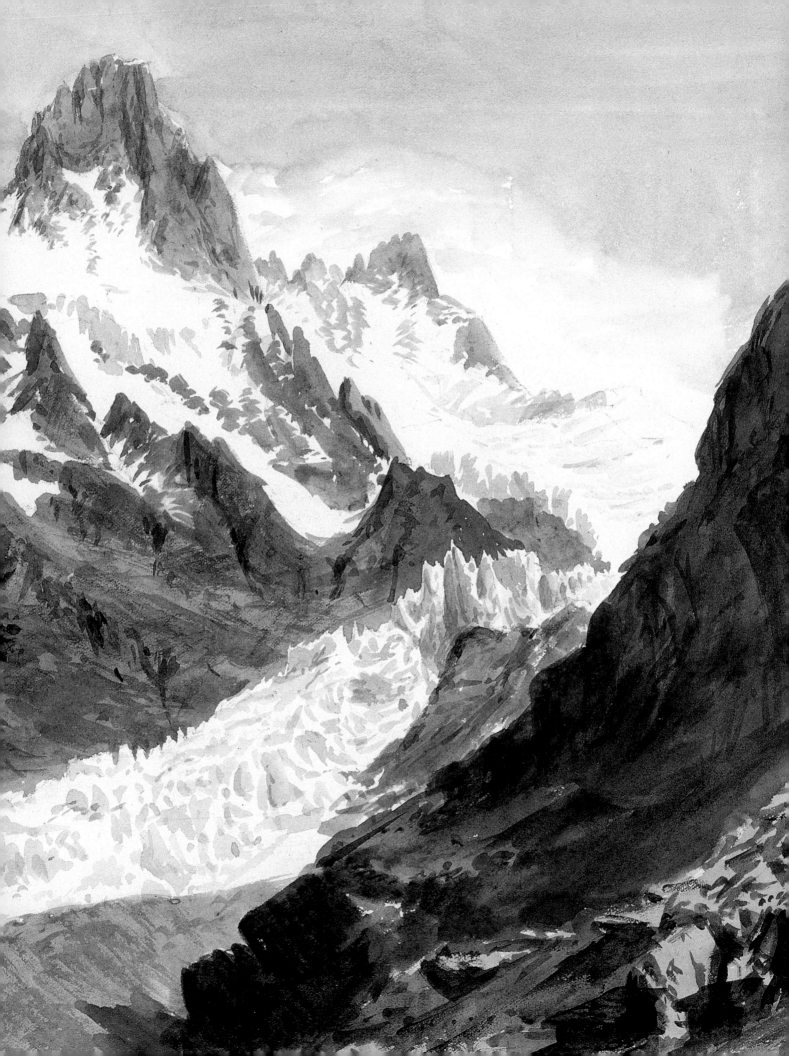

Childhood and Youthful Works, 1856–74

r. Fitzwilliam Sargent (1820–1889; figure 43) and his wife of four years, Mary Newbold Sargent (1826–1906; figure 44), accompanied by her mother, left Philadelphia for Europe in late summer 1854.[1] When the trio docked at Liverpool on September 13, their goal was to find a climate that would be beneficial to Mrs. Sargent's health. While the exact nature of her ailments is unclear, the death of the family's first-born child, a two-year-old daughter, in the summer of 1853 probably influenced their decision to get away from home. The Sargents' stay in Europe was meant to be temporary, but they became expatriates. Seeking healthful surroundings and moderate climates, they spent winters in Florence, Rome, or Nice, and summers in the Alps or other northerly regions. By 1870, Mrs. Sargent had given birth to five more children, of whom three had survived: John Singer Sargent, born in

Florence on January 12, 1856; Emily, born in Rome in 1857; and Violet, born in Florence in 1870.[2]

In 1857, shortly after Emily was born, Dr. Sargent seems to have realized that the family's stay in Europe would be protracted. Able to support their peripatetic existence in rented quarters with his wife's small annuity, he resigned his position as attending surgeon at Wills Hospital in Philadelphia. That decision notwithstanding, his letters to relatives and friends in the United States and in Europe often include rationales for extending their European sojourn—illness, pregnancy, the birth of a child—as if some justification were still required.

Dr. Sargent's letters to his aging parents in Philadelphia, in particular, suggest the conflict that he perceived between their claims on him and those of his wife and children. In 1868, for example, he wrote to his father:

Figure 43. Fitzwilliam Sargent, ca. 1870, detail of catalogue 12 recto

Figure 44. *Mary Newbold Sargent*, 1870, detail of catalogue 16v recto

Figure 42 (opposite). *Schreckhorn, Eismeer* (detail), see catalogue 17f recto.

I wish that I could be near you to try to do something towards ministering to you both. But my lot seems cast somewhere where Emily may have a better chance of acquiring a better constitution than she appears to have inherited, than at home,—somewhere where the winters are milder and more equable and more sunny. And Mary also, needs a similar climate. . . . Thus, I can truly say that I am only kept from constant discontent at being away from you, by the knowledge that duty keeps me, and all of us, here.[3]

An incurable romantic with a strong desire to remain in Europe, Mary Sargent resisted her husband's inclination to return to his responsibilities in Philadelphia. None of the Sargent children ever met their paternal grandmother, who died in 1871, or grandfather, who died in 1874. John Singer Sargent would not visit the United States until 1876, when he was twenty years old.

The family's itinerancy defined Sargent's childhood. In a letter of October 10, 1870, Fitzwilliam Sargent told his mother, "I am tired of this nomadic sort of life:—the Spring comes, and we strike our tents and migrate for the Summer: the Autumn returns, and we must again pack up our duds and be off to some milder region in which Emily and Mary can thrive."[4]

The "nomadic sort of life" determined the Sargent children's studies. Mrs. Sargent dutifully introduced them to the sights, historical monuments, and museums as they traveled each year from city to spa to city. Sargent's "*Baedeker* education"[5] exposed him to an immense array of fascinating places and people. His early letters to his childhood friend Ben del Castillo[6] are filled with references to the places he visited and testimony to his mother's diligent guidance, as the following examples only begin to suggest. On April 16, 1865, Sargent wrote: "We got to Pau on Wednesday. We stayed at Toulouse a day, and Mamma took Emily and me to the Museum. . . . The next day we got to Bordeaux in the afternoon, where Mamma took Emily and me to the Cathedral."[7] From Biarritz, on June 22, 1865, he wrote: "We are going to Pau on Saturday week and will stay only a few days, to get ready to go to the Eaux Bonnes. Mamma has promised to take us to see the Chateau there where Henry Quatre was born."[8]

From early childhood, Sargent drew ceaselessly, and his precocious talent is documented by his family's observations. In a letter of September 21, 1861, to his mother, Emily Haskell Sargent, Dr. Sargent mentioned his son's affinity for sketching, already apparent at age five: "Johnny is well and as fond as ever of drawing."[9] Six years later, the youngster's mother confided to the same correspondent John's developing proficiency: "Johnnie is growing to be such a nice boy, and is getting old enough to enjoy and appreciate the beauties of nature and art, which are so lavishly displayed in these old lands. He sketches quite nicely & has a remarkably quick and correct eye. If we could afford to give him really good lessons, he would soon be quite a little artist. Thus far he has never had any instruction, but artists say that his touch is remarkable."[10]

Mary Sargent, an amateur artist herself (figure 45), encouraged her son to draw and required that each day he finish at least one of the sketches that he started. Her insistence on a "nomadic sort of life" and her zeal for its advantages fueled his imagination and furnished him with subjects. Sargent drew, and eventually painted in watercolor, the people, places, and things that captured his interest: portraits of family members and friends, landscape vignettes, and copies after works by the old masters. That Sargent's family preserved a significant quantity of his early work and ultimately donated it to various museums suggests their great esteem for his ability.[11]

Since the family's seasonal peregrinations precluded the children's receiving continuous formal education, Sargent attended school very little during his childhood and adolescence. He was enrolled in a small day school in Nice for a short time during the autumn of 1868 and was a student in a day school run by a French political refugee in Florence during the winters of 1869–70 and 1870–71. Fitzwilliam Sargent assumed responsibility for instructing his children in traditional subjects; his letters chronicle tutorials in geography, arithmetic, reading, spelling, mathematics, and other disciplines. Although John Sargent learned French, German, and Italian, was an accomplished musician, and read a variety of sophisticated texts,[12] Fitzwilliam feared that his son's education was inadequate. In a letter sent from St. Moritz in September 1869, he lamented to his sister,

Figure 45. Mary Newbold Sargent, American, 1826–1906. *Salonika* (from sketchbook), 1904. Watercolor and graphite on off-white wove paper, 5⅞ × 17¼ in. (14.9 × 43.8 cm). The Metropolitan Museum of Art, Gift of Mrs. Francis Ormond, 1950 (50.130.151g verso–h recto)

Anna Maria Low (1815–1894), "I wish I was near a good school for boys, for my boy is now thirteen years old and is tolerably advanced in ignorance."[13] In the autumn of 1871, the family moved to Dresden, a city noted for its schools, where young Sargent prepared for entrance exams held in the spring at the Gymnasium zum Heilige Kreuz. But even this commitment was short-lived; Emily became ill and the family returned to the milder climate of Florence for the following winter.

Violet Paget (1856–1935), Sargent's childhood friend, who would become a celebrated author under the name of Vernon Lee, reported that Dr. and Mrs. Sargent initially envisioned a naval career for their son, but they could not ignore his artistic inclinations. In an essay written after the artist's death, Lee recalled their meeting in Nice during the winter of 1866–67, noting: "I do not know whether at that time John Sargent yet possessed a paint-box of his own. He certainly used mine. And I feel sure that my perennial supplies of water-colours and porcelain palettes and albums of vario-tinted paper were what drew him to me; and that our fraternal friendship grew out of those afternoons of *painting together*." Of their contact during the following year, Lee continued: "At Nice, in 1867–68, John Sargent, in furtive use of his mother's paints, or long afternoons with my preposterous and horribly messy boxes, was already a painter. In spirit and in fact."[14]

Sargent may have received his first artistic training from an instructor other than his mother during the winter of 1868–69 in Rome. There his

family's household above the Piazza di Spagna became a gathering place for the American expatriate community, including sculptor Harriet Hosmer (1830–1908) and writer and sculptor William Wetmore Story (1819–1895). The Sargents also seem to have met a German landscape painter, Carl Welsch, from whom young Sargent is said to have taken some lessons and whose watercolors he is said to have copied. Sargent later recalled that he "made free of the studio [and] . . . was kept busy fetching and carrying beer and wine from the nearest wine shops."[15] With Mrs. Sargent as guide and Violet Paget as companion, Sargent continued visiting and sketching the sights of Rome.

The earliest of the Metropolitan's four sketchbooks (cat. 9) and a number of loose sheets document the family's itinerary for the following summer, that of 1869. After traveling through southern Italy, they headed north and arrived in Innsbruck, Germany, by June 1 (cat. 7) and in Munich on June 2 (cat. 8), before touring the Alps. Sargent's careful landscape studies, often inscribed with date and location, reflect the seriousness with which the talented young amateur undertook to chronicle the journey. As the summer progressed, Sargent increasingly experimented with watercolor, creating topographical studies like those with which many tourists—usually less gifted—recorded their experiences.

The Metropolitan's other two early sketchbooks (cats. 16 and 17) date from the summer of 1870. In contrast to the 1869 sketchbook, they reveal a measure

of progress, although it is not known whether Sargent had any serious art instruction during the intervening winter in Florence. The precise, sometimes delicate pencil sketches of 1869 yield to bolder and more confident drawings, executed occasionally in wax crayon. One of the sketchbooks from this summer (cat. 17) is known as *Splendid Mountain Watercolours* because of an inscription, probably by Sargent's sister Emily, affixed to the front cover. The sketchbook, which seems to be a compilation of the summer's efforts in the medium, contains more than forty images that were either executed on the pages of the book or pasted into it. Although the watercolors of 1870 are more technically competent and ambitious than those of the summer of 1869, they betray little of the mastery that Sargent would eventually achieve in this medium.

Sargent's parents had recognized his increasing skill and dedication to art by October 1870, when they endorsed his choice of a career. Fitzwilliam wrote to his mother: "My boy John seems to have a strong desire to be an Artist by profession, a painter, he shows so much evidence of talent in that direction, and takes so much pleasure in cultivating it, that we have concluded to gratify him and to keep that plan in view in his studies."[16] The father's tone was more decisive than were his actions: he and his wife set no clear or immediate course by which to "gratify" their son. Sargent spent part of the summer of 1871 on a walking tour in the Tyrol with a man whom his father referred to as "a German landscape painter of reputation," possibly Welsch.[17] In Dresden in 1871–72, Sargent continued his practice of copying works of the old masters in the Albertinum.

Sargent enrolled for his first-documented formal art training during the winter of 1873–74 at the Accademia delle Belle Arti in Florence.[18] At about that time he met several young painters who were attracted to the Sargent household on via Magenta. When Dr. Sargent asked these artists where young John should continue his studies, the British recommended London, but the Americans strongly favored Paris, which had become the world's most powerful magnet for art students.

In December 1873, the Accademia closed for two months while its administrators and professors worked to reform its curriculum. Sargent studied art on his own in and around Florence, resuming classes when the Accademia reopened in March 1874. Shortly thereafter, Sargent's father resolved the question of where to further nourish his son's prodigious talent. On April 23, he wrote to his friend, lawyer George Bemis: "Every One says that Paris will be the best place to find such advantages as we w[oul]d like to give him."[19]

Although Sargent complained to his distant cousin Mary Austin on April 25 that the Accademia was "the most unsatisfactory institution imaginable," he hinted that neither he nor his family was determined to go to Paris. He wrote: "We are packing up in order to leave in the first week of May. . . . Our destination has been changed by reports of Cholera in Venice and of unique artistic training in Paris, so that we are bound for the latter place. . . . The Academy in Paris is probably better than the one here and we hear that the French artists undoubtedly the best now-a-days, are willing to take pupils in their studios."[20] He was also unsure that he would be ready to continue his instruction there, saying: "I do not think . . . that I am sufficiently advanced to enter a studio now, and I will probably have to study another year at the Academy. We go to Paris for a short time to make enquiries about this, which will decide whether we go to Paris or not for next winter."[21] The warm welcome that he received in Paris in May 1874 and his early success there would allay uncertainty.

1. Unless otherwise noted, this biographical account of Sargent's childhood and adolescence relies on Olson 1986. Supplementary material is derived from Charteris 1927. Two other important sources are New York–Glens Falls 1991–93 and Shelley 1993.

2. Mary Newbold Sargent gave birth to six children in all. Three died before the age of five years; these were Mary Newbold (1851–1853), Mary Winthrop (1861–1865), and Fitzwilliam Winthrop (1867–1869).

3. Fitzwilliam Sargent to Winthrop Sargent, Nice, February 16, 1868, Fitzwilliam Sargent Papers, Archives of American Art, Smithsonian Institution, Washington, D.C. (hereafter Fitzwilliam Sargent Papers).

4. Fitzwilliam Sargent to Emily Haskell Sargent, Florence, October 10, 1870, Fitzwilliam Sargent Papers.

5. Olson 1986, p. 45.

6. According to Charteris, the Sargent family met the del Castillo family in Nice in 1862 (Charteris 1927, pp. 5–6). The del Castillos were of Spanish descent and had settled in Cuba before becoming naturalized Americans and later expatriates, like the Sargents. Their son, Ben, was about the same age as John. The two boys became friends when their families occupied houses in Nice that shared a garden. Some of Sargent's earliest surviving letters were written to Ben, of which several (1865–80) are reprinted in Charteris 1927.

7. JSS to Ben del Castillo, Pau, April 16, 1865, quoted in Charteris 1927, p. 6.

8. JSS to Ben del Castillo, Biarritz, June 22, 1865, quoted in Charteris 1927, p. 8.

9. Fitzwilliam Sargent to Emily Haskell Sargent, [Switzerland?], September 21, 1861, quoted in New York–Glens Falls 1991–93, p. 12.

10. Mary Newbold Sargent to Emily Haskell Sargent, Nice, October 20, 1867, quoted in New York–Glens Falls 1991–93, p. 12.

11. Included among the numerous childhood works in the Metropolitan are three sketchbooks dating from 1869 and 1870 (cats. 9, 16, and 17). In 1937, the Fogg Art Museum also received from Violet Ormond a large gift that included numerous early works, among them several sketchbooks.

12. In 1868–70, Sargent read John Milton, *Paradise Lost* (1667); Wilhelm Becker, *Gallus, or Scenes of the Time of Augustus with Notes and Excursuses Illustrative of the Manner and Customs of the Romans* (1838); Sir William Smith, *Smaller Dictionary of Greek and Roman Antiquities* (1853); Jean–Jacques Ampère, *L'Histoire romaine à Rome* (1862–64); and Nathaniel Hawthorne, *Marble Faun* (1860) (Olson 1986 and New York–Glens Falls 1991–93, passim).

13. Fitzwilliam Sargent to Anna Maria Low, St. Moritz, postscript dated September 20 added to a letter begun in Naples, May 10, 1869, quoted in Olson 1986, p. 22. Olson erroneously reports that the letter was begun in July.

14. Vernon Lee, "J.S.S. In Memoriam," in Charteris 1927, pp. 239–40.

15. Ormond and Kilmurray 1998 suggest that Carl Welsch is the painter Theodore Charles Welsch (1828–1904) (p. xviii). Olson 1986, pp. 21–22 n., discusses Sargent's relationship with Welsch.

16. Fitzwilliam Sargent to Emily Haskell Sargent, Florence, October 10, 1870, quoted in New York–Glens Falls 1991–93, p. 9.

17. Olson 1986, pp. 21–22 n.

18. The date of Sargent's enrollment comes from Ormond and Kilmurray 1998, p. xii. Other scholars have suggested an earlier date. Charteris claims that Sargent entered the Accademia in the winter of 1870–71 (Charteris 1927, p. 15). Olson does not indicate when Sargent began his studies at the Accademia but notes that when the Sargent family returned to Florence in November 1873, Sargent "would have to make do [at the Accademia] for yet another year" (Olson 1986, p. 28).

19. Fitzwilliam Sargent to George Bemis, Florence, April 23, [1874], quoted in Olson 1986, p. 32.

20. JSS to Mrs. [Mary T.] Austin, Florence, April 25, 1874, quoted in Charteris 1927, p. 19.

21. Ibid.

1. Portrait of a Man

After Rembrandt Harmensz van Rijn, Dutch,
1606–1669
ca. 1865–68
Watercolor and graphite on off-white wove paper
14¼ × 11⅞ in. (37.5 × 30.2 cm)
Gift of Mrs. Francis Ormond, 1950
50.130.83b

This watercolor is a copy of a portrait by
Rembrandt formerly called *Willem
Burchgraeff* but now considered of unknown
identity by the Rembrandt Research Proj-
ect. The painting is in the Gemäldegalerie
in Dresden, where the Sargent family spent
the winter of 1871–72. While Sargent cer-
tainly copied works by the old masters in
the Dresden museums during his sojourn,
this drawing must have been done earlier.
By 1871–72, Sargent was preparing himself
in earnest for his career as an artist and was
much more skilled than this rather crude
drawing suggests. In fact, in handling and
technique, this drawing is less accomplished
than firmly dated works from as early as
1869 and 1870 (cats. 9, 16, and 17). It is not
known if Sargent visited Dresden before
1871. If he did not, he might have copied
the painting from a reproduction.

1

2. View of a Southern City

ca. 1868–70
Watercolor and graphite on off-white wove paper
5 × 6¹⁵⁄₁₆ in. (12.8 × 17.6 cm)
Inscribed on verso at lower center: EWS
Gift of Mrs. Francis Ormond, 1950
50.130.82h

The technique of this watercolor suggests
an early date. The unidentified site may be
in Spain, which Sargent visited in 1868, or
in southern Italy, which he visited in 1869.

2

3 recto

3 verso

4

3 recto. *Torre de los Picos, Alhambra*

1868
Watercolor and graphite on white wove paper
11⅝ × 9¼ in. (29.5 × 23.5 cm)
Inscribed at lower left: Generalife & Alhambra / 1867
Gift of Mrs. Francis Ormond, 1950
50.130.82i recto

3 verso. *Leaves*
1868
Watercolor on white wove paper
9¼ × 11⅝ in. (23.5 × 29.5 cm)
Gift of Mrs. Francis Ormond, 1950
50.130.82i verso

The Sargent family visited Spain in April 1868, not 1867, as the inscription at the lower left of the recto (not in Sargent's hand) suggests. While in Granada, they visited the Alhambra, the hilltop palace of the Moorish kings built from the thirteenth through the fifteenth centuries. On the recto, Sargent painted a picturesque view of the Torre de los Picos, a gate on the northern wall of the palace complex; on the verso, he practiced his brush technique for foliage studies.

REFERENCE (cat. 3 verso): Shelley 1993, p. 189.

4. *Riders on the Heath*

ca. 1868–72
Watercolor and gouache on off-white wove paper
8¼ × 14 in. (21 × 35.5 cm)
Inscribed on verso at center: "Riders on the Heath"
Gift of Mrs. Francis Ormond, 1950
50.130.83a

This watercolor may be a copy after an unidentified painting.

5. Apse Mosaic, San Clemente, Rome

1868–69
Watercolor, gouache, and graphite on off-white
wove paper
19⅞ × 13¼ in. (50.5 × 35 cm)
Inscribed on verso at upper left: 72 / 127 Ravenna
/ by J. S. Sargent / V.O. / (Trust); at center: J /
20; at lower left: C
Gift of Mrs. Francis Ormond, 1950
50.130.83g

Sargent probably copied this mosaic while he and his family were living in Rome during the winter of 1868–69. The remarkable basilica of San Clemente would have been a requisite stop on the Roman itinerary for inveterate sightseers such as the Sargents. The structure consists of two churches: a twelfth-century upper church built on top of the ruins of a fourth-century church. The Sargents were living in Rome when the lower church was discovered in 1857, but they had not visited the Eternal City since the lower church was excavated in 1861. Sargent commemorated his visit to San Clemente by recording the most striking and noteworthy aspect of the upper church, the twelfth-century apse mosaic depicting the cross of Christ as a tree of life above and the mosaic of Christ, the Virgin, and the twelve apostles below.

EXHIBITIONS: New York–Buffalo–Albany 1971–72, cat. 2; "Watercolors and Drawings of Centurion John S. Sargent," The Century Association, New York, September 21–October 23, 1982 (no catalogue).

5

6. Saint Matthew, Mosaic, Cathedral, Salerno

ca. 1869
Watercolor, gold paint, gouache, and graphite on
off-white wove paper
6⅛ × 9½ in. (15.6 × 24.1 cm)
Inscribed on verso at upper left: by John S. Sargent /
as a boy; at lower center: Byz Mosaic / St. Matthew;
at lower left: C
Gift of Mrs. Francis Ormond, 1950
50.130.83d

The Sargent family visited Naples and its environs in southern Italy in May 1869, but it is not known if they visited Salerno (about fifty kilometers southeast of Naples) to see this eleventh-century mosaic in situ. Sargent may have made this image after a reproduction. The meticulous and accurate rendering of minute drapery details seems to derive from the lengthy, close scrutiny that a reproduction could allow. In the cathedral, the ordinary viewer sees the mosaic above the main doorway, from below and at a distance, rather than straight on, as it is depicted here.

Sargent examined Early Christian mosaics in Italy during the late 1890s, in preparation for his Boston Public Library murals. This sheet is distinguished from Sargent's mosaic studies of that later period (cat. 262) by its awkward precision and obsessive attention to detail. A date close to that of *Apse Mosaic, San Clemente, Rome* (cat. 5) seems likely.

7. Theodoric the Goth, Tomb of Maximilian I, Innsbruck

After Peter Vischer, German, ca. 1460–1529
June 1, 1869
Graphite on off-white wove paper
11¾ × 7⅝ in. (29.8 × 19.4 cm)
Inscribed at lower left (on pedestal):
THEODORIC / THE GOTH; at lower right:
Theodoric the Goth / Innsbruck. / 1ˢᵗ of June. /
1869.; on verso at lower left: CP
Gift of Mrs. Francis Ormond, 1950
50.130.143y

6

After their tour of southern Italy in early summer 1869 (cat. 6), the Sargent family traveled north to the Alps. According to the inscription, in Sargent's hand, they arrived in Innsbruck by June 1. While there, Sargent copied the bronze statue (1514) of Theodoric the Goth from the funerary monument of Emperor Maximilian I in the Hofkirche (Franciscan Church). In 1871, Sargent returned to the church and sketched *Theodoric* and other figures from the monumental sculptural program (see Fogg sketchbook 1937.7.3, fol. 12–14). Other studies Sargent made in early June 1869 (cats. 8, 9i, and 9j) share the drawing style seen here, which is characterized by precise attention to detail rendered with a delicate touch.

This sheet was originally bound into the Switzerland 1869 sketchbook (cat. 9).

7

8. *Sleeping Faun, Glyptothek, Munich*

June 2, 1869
Graphite on off-white wove paper
7⅝ × 11⁷⁄₁₆ in. (19.4 × 29.1 cm)
Inscribed at lower right: Sleeping faun. / Munich. /
June 2ⁿᵈ.1869.; on verso at lower right: CD
Gift of Mrs. Francis Ormond, 1950
50.130.143x

From Innsbruck (cat. 7), the Sargent family passed through Munich before stopping at various spas in the Alps during the summer of 1869. In Munich, Sargent visited the Glyptothek, a museum built to house the royal sculpture collection of King Ludwig I of Bavaria (1786–1868). There Sargent made several studies after antique sculptures (cats. 9i and 9j), including this example, of the *Barberini Faun* (ca. 230–200 B.C.E.), so-called after the noble Roman family that owned it in the seventeenth century. The sculpture had been much admired by the writers of antiquity, but its whereabouts were unknown until it was rediscovered in excavations in Rome during the 1620s. Thereafter, the *Faun* became one of the most celebrated and often-copied examples of ancient art.

Sargent had shown serious interest in antiquities while living in Rome during the previous winter (1868–69). Mrs. Sargent had assiduously guided her son and daughter and their friend Violet Paget (later Vernon Lee) through the sights of the city. Lee recalled, "There were scamperings, barely restrained by responsible elders, through icy miles of Vatican galleries, to make hurried forbidden sketches of statues selected for easy portrayal" ("In Memoriam," reprinted in Charteris 1927, pp. 242–43). Two sketchbooks in the Fogg Art Museum (1937.7.1 and 1937.7.2) are testimony to these visits to the Vatican, which houses one of the world's finest collections of Greek and Roman sculpture. In the sketchbooks Sargent copied the paradigms of the collection: the *Hercules,* the *Apollo Belvedere,* the *Belvedere Torso,* and the *Laocoön,* among others. It is not surprising that he would seek out another of the most famous antiquities, the *Barberini Faun,* while he was in Munich.

Since the Renaissance, copying masterpieces of ancient sculpture had been understood to be a crucial component of artistic training. Renaissance artists believed that the sculptors of antiquity had mastered the portrayal of human anatomy and that study of Greek and Roman works was a proper starting place for a student. The laconic pose of the *Barberini Faun* in particular offered unique anatomical problems and made it an appropriate copyist's exercise.

Sargent approached the sculpture from the side, recording its contours in a careful and deliberate style. He would recapitulate the pose of the *Faun* in male figure studies executed when he was preparing for his Boston mural projects between 1890 and 1925 (see Fogg album 1937.9).

This sheet was originally bound in the Switzerland 1869 sketchbook (cat. 9).

REFERENCE: New York–Glens Falls 1991–93, pp. 13–14.

8

9. Switzerland 1869 Sketchbook

May–October 1869

Black impressed cardboard cover, embossed in gold at center: ALBUM; inscribed on label at center right: 1869

Sheet size: 7¾ × 11¾ in. (19.7 × 29.8 cm)

Gift of Mrs. Francis Ormond, 1950

50.130.147

Catalogue 9 and two sketchbooks in the collection of the Fogg Art Museum chronicle the Sargent family's itinerary during 1868 and 1869. Fogg 1937.7.1 (called "1868–69") includes drawings of sights in Rome, where the family spent the winter of 1868–69, and the Italian countryside. Fogg 1937.7.2 (called "1869") contains sheets depicting ancient statuary in Roman museums and sights from the family's trip to southern Italy in mid-May 1869. Catalogue 9, which is inscribed "May 26th 1869 / Naples" on the first page (cat. 9a), records places the family visited through October 1869.

Sargent often worked in more than one sketchbook at a time. The two Fogg sketchbooks in particular overlap in date, and both include drawings of Rome and southern Italy. Fogg 1937.7.2 and catalogue 9 include drawings made at Bozen (e.g., cat. 9h), dated May 29, 1869. Like catalogue 9, Fogg 1937.7.1 also includes Swiss alpine landscape studies.

The binding of the Metropolitan's sketchbook is no longer intact, and many of the leaves are separated. Although several sheets remain bound to each other, it is not clear whether Sargent used the pages in an order that corresponded to the itinerary. Of the two other early sketchbooks in the Metropolitan, only catalogue 17 has an intact binding. In that sketchbook, Sargent did not use the pages in strict order.

On May 23, 1869, Sargent wrote to his friend Ben del Castillo, "We leave Sorrento on Monday, day after to-morrow, and we will be seven days in getting to Munich. The first night we will spend in Roma, the second at Ancona, third at Padua, the fourth Botzen [Bozen], Innsbruck, Munich, and from Munich we will go to Carlsbad in Bohemia for waters for Papa" (Charteris 1927, p. 12).

On May 26, according to the inscription on the first page of the sketchbook, the

family was in Naples, and their journey north must have begun about this date. Their pace was leisurely, and their travel was broken up with overnight stops that had been planned. They reached Bozen, near the border of Italy and Switzerland, on May 29 (cat. 9h); other drawings in the Metropolitan indicate that they proceeded to Innsbruck by June 1 (cat. 7) and to Munich by June 2 (cat. 8). Along the way, their destination changed from Carlsbad to Kissingen, a spa in Bavaria. Fitzwilliam wrote, "Soon after we got there the baby [Fitzwilliam Winthrop Sargent] was taken sick, and after a fortnight's illness died" (Fitzwilliam Sargent to Anna Maria Low [his sister], Naples, May 10, 1869, with postscript from St. Moritz dated September 20, 1869, Fitzwilliam Sargent Papers). They remained there "about ten days after his death" (Fitzwilliam Sargent to George Bemis, St. Moritz, July 26, [1869], George Bemis Papers, Massachusetts Historical Society, Boston [hereafter George Bemis Papers]). Although their stay in Kissingen lasted for about four weeks, there are no drawings or watercolors in the sketchbook that are inscribed as portraying that spa town or its environs. By mid-July the family arrived in St. Moritz, Switzerland, where they would spend the rest of the summer.

Sargent's sketchbook is not a daily chronicle of the summer. Dated inscriptions are sporadic and cluster around a few periods in August and September. Sargent was sketching around Pontresina, not far from St. Moritz, from at least August 24 through August 27 (cats. 9u, 9w, 9x, and 9mm) and in St. Moritz again on September 21–22 (cats. 9r and 9v). By September 25 the family was at the Stelvio Pass and Bormio (cats. 9aa and 9cc). Dr. Sargent's correspondence fills in the gaps of the itinerary. He explained in a letter to Bemis that from St. Moritz "we . . . took wing for the Summit of the Stelvio, via La Prese, Tirano & Bormio & then having seen that Elephant & admired him very much & having been favored with uncommonly fine weather, we retraced our steps as far as Tirano & thence down the Valtelline [*sic*] to Colico, Where we took steamer & came to Bellagio, which we find an exceedingly agreeable place at this season" (Fitzwilliam Sargent to George Bemis, Bellagio, October 5, [1869], George Bemis Papers).

Dr. Sargent wrote to his mother about two weeks later that he "left Mary and the children on the lake of Como while I came down here [to Nice] to get the house 'to rights' for the winter" (Fitzwilliam Sargent to Emily Haskell Sargent, Nice, October 18, [1869], Fitzwilliam Sargent Papers). Several drawings in the sketchbook depicting the shores of Lake Como in northern Italy thus can be dated to October.

The sketchbook contains forty-six watercolors and drawings in various stages of completion. Sargent's main interest was landscape, and his studies include simple silhouettes of mountains or peaks drawn in graphite (cats. 9b and 9d), highly finished renderings of panoramic views (cat. 9h), close-up studies of rocks and foliage (cats. 9g and 9m), and ambitious watercolors of impressive vistas (cats. 9aa verso–bb, 9cc, and 9dd). Sargent's concern with depicting people, which would characterize his graphic oeuvre in its entirety and would be notable in his sketchbooks from the summer of 1870 (cats. 16gg, 17c verso, and 17z verso), is not reflected here. There is perhaps only one sheet with studies after live models (cat. 9hh). Other miscellaneous studies of ancient statuary done in Munich (cats. 9i and 9j) document his general interests, as they are also manifested in Fogg sketchbooks 1937.7.1 and 1937.7.2.

Sargent may have had his first art instruction from a nonfamily member, Carl Welsch, a German landscape painter, during the winter of 1868–69. While his tutelage under Welsch may have been limited to copying his watercolors, this experience laid the groundwork for Sargent's painting in summer 1869. His travels through the Alps provided a prime opportunity to practice and apply the lessons learned in Welsch's studio.

The pages of Sargent's sketchbook reveal his developing technical confidence as the summer progressed. In his earliest drawings (for example, cat. 9h), Sargent's technique in graphite was gentle and cautious. He built up darker areas by applying repeated scumbled layers of graphite. In the later drawings, his hatching became bolder, darker, and broader (cat. 9aa recto). In watercolor, he experimented with more intense colors instead of delicate layers of pale washes (cat. 9cc). Later in the summer, Sargent began to use gouache (cats. 9aa verso–bb, 9dd, 9hh, and 9pp).

9a. *Fish and Fishing Motifs, Faces and Figures*

May 26, 1869
Graphite and ink on off-white wove paper
Inscribed at upper center: John S. Sargent /
May 26th. 1869 / Naples.
50.130.147a

9a

Thirteen-year-old Sargent used the first page of the book for quick sketches, including several faces and heads with the exaggerated features of caricatures. The mountain peak at the center of the page reveals the theme of the sketches within the book. The inscription "May 26th. 1869" is the earliest date in the sketchbook and suggests when Sargent began using it.

To the left of the sheet are various fishing motifs, including a fisherman and fishing lures and, at the upper left corner, a fish. Fishing was a pastime that the young Sargent shared with his father. Fitzwilliam Sargent wrote from St. Moritz to his own father, "I have taken, in my old age, to fishing for trout—which are very abundant in these lakes and mountain streams. But as yet I have not had a bite, much less caught anything. However it is more to have an additional inducement to walk about and to live in the open air, than for anything else, that I have taken up with this apostolic occupation. I should like to catch one trout, I confess. Johnny has more success than I have had" (Fitzwilliam Sargent to Winthrop Sargent, St. Moritz, August 2, 1869, Fitzwilliam Sargent Papers). See catalogue 9tt for other sketches of fishing motifs.

9b

Catalogue 9c is distinguished in subject and technique from the other works in the sketchbook. While Sargent made studies of details of nature such as rocks and foliage, there are no other still lifes as consciously composed as this one and few watercolors as meticulously rendered. While elsewhere in the sketchbook Sargent generally relied on broadly defined washes of color, here he carefully modulated shades of white and beige with precise brushstrokes to produce the petals of the flowers. He gave equal care to the painted inscription, rendering it in two shades of red to give the lettering a three-dimensional quality. The date, June 29, would have been one day after the death of Sargent's two-year-old brother, Fitzwilliam Winthrop, an event that may have put the young artist in mind of memorial lilies.

9b. *Mountain Peak*

1869
Graphite on off-white wove paper
50.130.147b

9c. *Lilies*

June 29, 1869
Watercolor and graphite on off-white wove paper
Inscribed at lower right: Lillies. [sic] / June 29th 1869
50.130.147c

9c

9d

9d. *Mountains*

1869
Graphite on off-white wove paper
50.130.147d

Catalogue 9d and catalogue 9b suggest that Sargent began his alpine compositions by sketching the contours of the mountains. In this case, he experimented with the forms before penciling in more definite silhouettes.

9e recto. *Cupid and Psyche, Faces and Heads*

1869
Graphite on off-white wove paper
50.130.147e recto

The two sketches of Cupid and Psyche at the center of the page are after a replica of a sculpture by Antonio Canova (Italian, 1757–1822). Canova executed several versions of *Cupid and Psyche*, including those preserved in the Musée du Louvre, Paris (marble); State Hermitage Museum, St. Petersburg (marble); and The Metropolitan Museum of Art, New York (plaster). Canova gave one of his students, Adamo Tadolini (Italian, 1788–1868), permission to make a replica of the work, which Tadolini did between 1819 and 1824 for an Italian count, Giambattista Sommariva. This authorized replica (after the original now in the Hermitage) eventually made its way to Sommariva's residence, the Villa Carlotta at Lake Como, where Sargent must have seen and copied it.

The Villa Carlotta is near Cadenabbia, on the western shore of Lake Como across from Bellagio, where the Sargent family stayed in October 1869. Contemporary guidebooks mention the villa as an "interesting excursion" (*A Handbook for Travellers*

in *Southern Germany,* 9th ed., London, 1864, p. 294). Sargent may not have known that the sculpture was Tadolini's copy. Several guidebooks (Baedeker, Murray, Hare) ascribe the work directly to Canova. The Murray volume, for example, described the *Cupid and Psyche* as "one of his most beautiful works" (*Southern Germany,* 9th ed., 1864, p. 294). Sargent had drawn Canova's *Perseus* and *Boxer* in the Vatican the previous spring (see Fogg sketchbook 1937.7.1).

9e verso. *Bellagio, Lake Como*

1869
Watercolor and graphite on off-white wove paper
Inscribed at lower right: Bellagio.
50.130.147e verso

Dr. Sargent left his family at Lake Como in northern Italy in October 1869, while he packed up the family's apartment in Nice in preparation for their move to Florence for the winter of 1869–70. While the shores of Lake Como are well known for their picturesque appeal, the town of Bellagio, which is situated on a promontory between the southern branches of the lake, was frequently singled out by guidebooks. Hare wrote that "Bellagio is altogether one of the most charming places in Italy, for those

9e recto

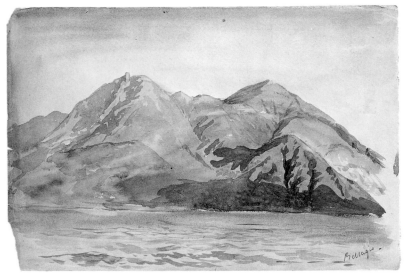

9e verso

9f recto

9f verso

9g

9g. *Serbelloni, Bellagio*

1869
Graphite on off-white wove paper
Inscribed at lower right: Serbelloni. / Bellagio.
50.130.147g

While Sargent was more assiduous in transcribing the details of nature in the early 1870s, he made a few careful studies of rocks and foliage in this sketchbook: catalogue numbers 9l, 9m, 9o, and the present sheet.

The park of the Villa Serbelloni, noted for its excellent views of the lake, is one of the primary attractions in Bellagio.

9h. *Botzen*

May 29, 1869
Graphite on off-white wove paper
Inscribed at lower right: Botzen. May 29th. 1869.
50.130.147h

The town of Bozen (in Italian, Bolzano) is along the Brenner Pass between Verona and Innsbruck. In the 1860s, when it was still known as Botzen, it was described as "one of the most flourishing commercial towns in the Tyrol, highly favoured by its position at the junction of the roads from Switzerland, Germany, and Italy, which renders it a staple place for the trade of the 3 countries" (*Southern Germany*, 9th ed.,

who are content to be quiet for a time" (Augustus Hare, *Cities of Northern and Central Italy,* vol. 1, 1876, p. 195). The Murray book opines: "Bellagio . . . is universally allowed to be the finest point of view [over the lake]" (*Handbook for Travellers in Southern Germany,* 12th ed., London, 1873, p. 303). In catalogue 9e verso, Sargent limited his use of graphite to the contours of the landscape and then applied a palette of pale colors—gray-blues, lavender, yellow, green, rose—in layers to produce the effect of the mountains. There are at least three other depictions of Bellagio in this sketchbook: a watercolor, catalogue 9f recto; and two drawings, catalogue numbers 9g and 9t.

9f recto. *Mountain View*

1869
Watercolor and graphite on off-white wove paper
50.130.147f recto

Although the site is not identified with an inscription, the mountains are similar in appearance and execution to those in catalogue 9e verso, except for Sargent's use of a slightly paler palette. Although there is no water in the foreground, this work may also depict the shore of Lake Como at Bellagio.

9f verso. *Knights in Armor, Warrior, Neptune Fountain*

1869
Graphite on off-white wove paper
50.130.147f verso

9h

9j

London, 1864, p. 311). This sheet, one of the earliest drawings in the sketchbook, is notable for the very delicate and modulated application of graphite.

REFERENCE: Weinberg and Herdrich 2000a, p. 7.

9i. *Pediment Sculptures from Temple at Aegina, Glyptothek, Munich*

June 2, 1869
Graphite on off-white wove paper
Inscribed at upper center: From temple at Aegina; at center left: from Temple of Minerva / at Aegina. / Munich; Hercules. June 2nd; From Aegina. Laomedon; at lower left: Telamon; Hector
50.130.147i

Catalogue 9i and *Ancient Greek Sculptures, Glyptothek, Munich* (cat. 9j) are related to *Sleeping Faun* (cat. 8), which is also from this sketchbook. All the sculptures depicted

are in the Glyptothek, Munich, which Sargent visited on June 2, 1869. On this sheet Sargent copied some of the most notable examples of sculpture in the collection.

The sculptures from the pediment of the Temple at Aegina are extolled in the Murray *Handbook for Travellers in Southern Germany* as "among the most valuable remains of ancient art that have reached us" (12th ed., London, 1873, p. 57). Murray also notes that the sculptures were installed in the museum to mimic the arrangement in which they had been discovered. Sargent, however, did not copy the whole ensemble. From the west pediment, a group of ten sculptures, he selected two standing warriors with shields and spears (lower left). Hercules, depicted as a kneeling archer, and the dying warrior Laomedon, belonged to what was then thought to be the east pediment of the building.

9j. *Ancient Greek Sculptures, Glyptothek, Munich*

June 1869
Graphite on off-white wove paper
Inscribed at lower left: Boy wrestling with a goose. / Munich.; at right: Pallas. / Munich.
50.130.147j

Boy Wrestling with a Goose, the dynamic marble that Sargent drew at the left of catalogue 9j, is thought to be a copy after a bronze original (200 B.C.E.) by the legendary Greek sculptor Boethius.

9k. *Piz Muretto, St. Moritz*

1869
Graphite on off-white wove paper
Inscribed at lower left: Piz Muretto.; at lower right: St Moritz
50.130.147k

9i

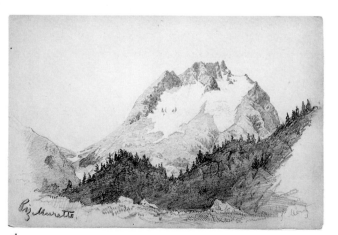

9k

9l

9o

9l. *Mountain Study*

1869
Graphite and watercolor on off-white wove paper
50.130.147l

9m. *Rocks and Cliffs*

1869
Graphite and watercolor on off-white wove paper
50.130.147m

9n. *Val Bregaglia from Maloja*

1869
Watercolor and graphite on off-white wove paper
Inscribed at lower left: Val Bregaglia / from Maloja.
50.130.147n

Val (valley) Bregaglia begins at Maloja, southwest of St. Moritz, and extends about twenty miles. Sargent attempted to render atmospheric perspective by lightening his palette for the receding mountains, using a

9m

9p

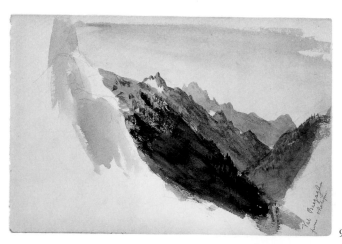

9n

9q

dark green pigment to suggest the trees of the foreground mountain, blue-gray for the middle ground, and a paler shade for the most distant mountain. See catalogue 9k for another image drawn in the vicinity of Maloja.

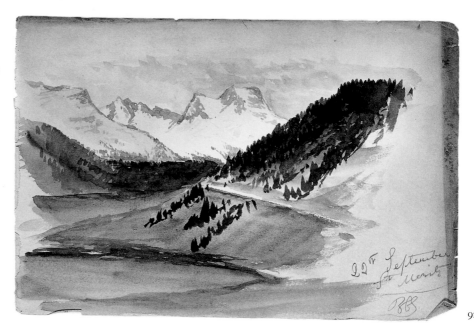

9r

90. *Rocky Cliff*

1869

Graphite on off-white wove paper

50.130.1470

9p. *Temples at Sunset, Heads*

1869

Watercolor and graphite on off-white wove paper

50.130.147p

9q. *Piz Julier from St. Moritz*

1869

Graphite on off-white wove paper.
Inscribed at lower right: Piz Julier, from / St Moritz [illegible] / [illegible]

50.130.147q

9r. *St. Moritz*

September 22, 1869

Watercolor and graphite on off-white wove paper
Inscribed at lower right: 22nd September / St Moritz / 1869

50.130.147r

In catalogue 9r, one of the most ambitious watercolors in the sketchbook, Sargent combined several techniques. In the foreground he painted stylized trees in dark green pigment over washes of pale greens and chartreuse. For the snow-capped mountain peak in the background, he left in reserve the white sketchbook page and applied accents with a dry brush.

9s. *Mountains and Sky*

1869

Watercolor and graphite on off-white wove paper

50.130.147s

9t. *Mountain, Bellagio*

1869

Graphite on off-white wove paper
Inscribed at lower right: Bellagio —

50.130.147t

Other studies done at Bellagio are catalogue numbers 9e verso, 9f recto, and 9g.

9s

9t

9u

9v

9w

9x

9u. *Bridge at Pontresina*

August 27, 1869
Graphite on off-white wove paper
Inscribed at lower right: Bridge at Pontresina /
August 27ᵗʰ / 1869
50.130.147u

The town of Pontresina is just to the west
of St. Moritz. Sargent sketched in this
vicinity in late August 1869. See also cata-
logue numbers 9w and 9x.

9v. *Piz Albris and Glacier du Paradis, St. Moritz*

September 21, 1869
Watercolor and graphite on off-white wove paper
Inscribed at lower right: Piz Albris & / Glacier du
Paradis / Sᵗ Moritz / Sept 21 1869
50.130.147v

Piz Albris is a few kilometers southeast of
Pontresina.

9w. *Piz Murailg from Alp Muottas, Pontresina*

August 26, 1869
Graphite on off-white wove paper
Inscribed at lower right: Piz Murailg——/ From Alp
Muottas. / Pontresina / Aug. 26——
50.130.147w

9y

9x. Mill at Pontresina

August 27, 1869
Watercolor and graphite on off-white wove paper
Inscribed at lower right: Mill at / Pontresina /
August 27th 1869
50.130.147x

Catalogue 9x is one of the few architectural studies in the sketchbook. Sargent took great care in delineating the details of the building, including the shutters, roof, and eaves, while he treated the landscape in a cursory manner.

Other studies done at Pontresina are catalogue numbers 9u and 9w.

9y. Mont Blanc from Brevent

1869?
Watercolor on off-white wove paper
Inscribed at lower right: Mont Blanc / from
Brevent—; on verso at lower right: Summit of /
Bernina Pass / June 23d / 1869 [pertains to cat. 9z]
50.130.147y

The inscription on catalogue 9y recto is problematic. The putative subject, Mont Blanc, is located in the southwestern Alps, near Chamonix, France, quite distant from the Engandine region of Switzerland depicted in the rest of the sketchbook. Sargent is not known to have made an excursion to Chamonix during the summer of 1869. Yet this sheet is attached by part of the binding to several sheets inscribed with dates in September 1869 (cats. 9aa, 9cc, and others) and thus seems to have belonged originally to this sketchbook.

9z. Summit of Bernina Pass

June 23, 1869?
Watercolor and graphite on off-white wove paper
50.130.147z

This site is identified by an inscription on the verso of the previous attached sheet (cat. 9y). It reads, "Summit of / Bernina Pass / June 23d / 1869." The inscription is problematic. Family history indicates that young Fitzwilliam Winthrop Sargent died in

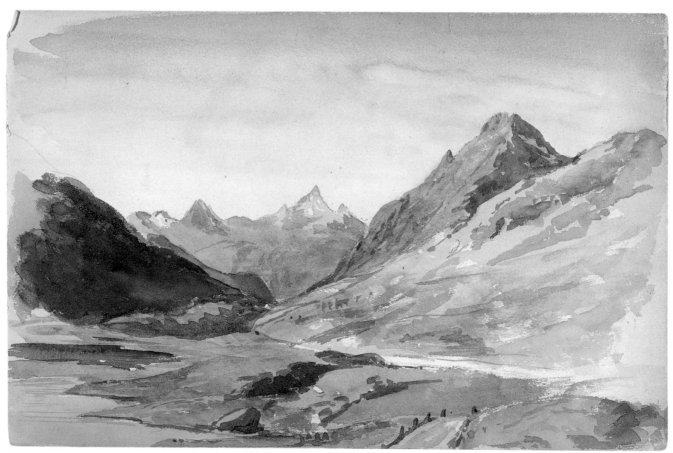

9z

57

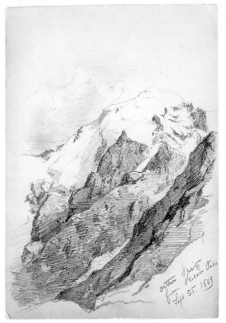

9aa recto

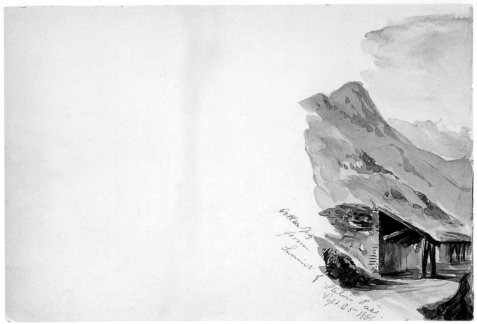

9aa verso

Kissingen, Germany, on June 28, 1869. According to a letter from Dr. Sargent, the family was in Kissingen at least two weeks before he died (Fitzwilliam Sargent to Anna Maria Low, Naples, May 10, 1869, with postscript from St. Moritz dated September 20, 1869, Fitzwilliam Sargent Papers). There is no indication that John was away from his family when his brother died, but the Bernina Pass is a considerable distance from Kissingen. The family crossed over the Bernina Pass in late September en route to Lake Como.

9aa recto. *Ortler Spitz from Stelvio Pass*

September 25, 1869
Graphite on off-white wove paper
Inscribed at lower right: Ortler Spitz / from Stelvio Pass / Sept 25. 1869
50.130.147aa recto

The Sargents seem to have made an excursion from St. Moritz especially to see the Stelvio Pass, located at the border of Italy, Switzerland, and Austria, which was "the highest in Europe practicable for carriages" (*Southern Germany,* 9th ed., London, 1864, p. 292). As Fitzwilliam wrote to George Bemis: "We . . . took wing for the Summit of the Stelvio . . . then having seen that Elephant & admired him very much &

having been favored with uncommonly fine weather, we retraced our steps as far as Tirano & thence down the Valtellina to Colico" (Fitzwilliam Sargent to George Bemis, Bellagio, October 5, [1869], George Bemis Papers). The Murray travel guide describes the impressive sight: "Whether we consider the boldness of the design, the difficulties of its execution from the great height and exposure to storms and avalanches, or the grandeur of the scenery through which it passes, the route of the Stelvio is the most remarkable in Europe" (*Southern Germany,* 9th ed., London, 1864, p. 292). In catalogue 9aa recto, Sargent focused on the peak of the Ortler, the most prominent feature of the view from the pass. This graphite drawing is probably a study for the panoramic watercolor on the following pages (cats. 9aa verso and 9bb).

9aa verso. *Ortler Spitz from Summit of Stelvio Pass*

September 25, 1869
Watercolor, gouache, and graphite on off-white wove paper
Inscribed at lower right: Ortler Spitz / from / Summit of Stelvio Pass. / Sept. 25. 1869
50.130.147aa verso

9bb. *Ortler Spitz from Summit of Stelvio Pass*

September 25, 1869
Watercolor, gouache, and graphite on off-white wove paper
50.130.147bb

The preceding graphite study of the Ortler Spitz (cat. 9aa recto) was probably a preliminary study for this panoramic view, which includes the right third of catalogue 9aa verso and continues across the binding onto catalogue 9bb.

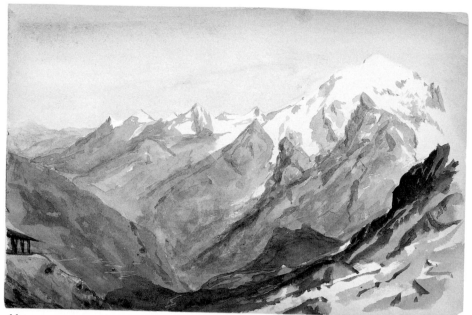

9bb

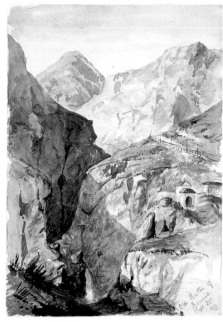

9cc

9cc. *Old Baths at Bormio*

September 25, 1869
Watercolor and graphite on off-white wove paper
Inscribed at lower right: Old Baths of / Bormio. /
Sept. 25. / 1869
50.130.147cc

The town of Bormio marks the beginning of the winding Stelvio Road, which leads to the Stelvio Pass (cats. 9aa recto and verso, 9bb). Another view of Bormio is catalogue 9dd.

9dd. *Mountain View at Bormio*

1869
Watercolor, gouache, and graphite on off-white wove
paper
Inscribed at lower right: Bormio
50.130.147dd

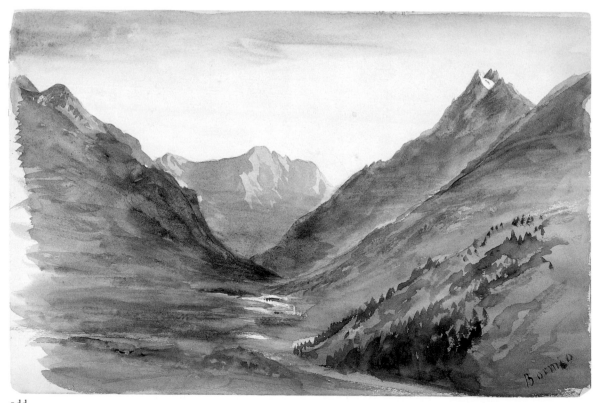

9dd

9ee

9ee. Boat

1869
Graphite on off-white wove paper
50.130.147ee

9ff recto. Boats on Mountain Lake

1869
Watercolor and graphite on off-white wove paper
50.130.147ff recto

9ff verso. Mountain Peaks

1869
Graphite on off-white wove paper
50.130.147ff verso

The page following this image (50.130.147gg) is blank.

9hh

9kk

9hh. Two Men at a Table, Man Eating

1869
Watercolor, gouache, and graphite on off-white wove paper
50.130.147hh

Except for catalogue 9hh, the few drawings of heads in this sketchbook have the qualities of caricatures or quick sketches (cats. 9a and 9p). Here, two men, apparently drawn from life, are depicted in profile facing each other. Their faces are carefully drawn, and their torsos and hair are rendered in watercolor. A tabletop covered with glasses and other dining accoutrements is outlined only in graphite. While the portraits are quite careful, their spatial relationship to the crowded tabletop is disjointed.

The next two sheets (50.130.147ii and 50.130.147jj) are blank.

9ff recto 9ff verso

9ll

9kk. *Town at Edge of Mountain Lake*

1869
Watercolor and graphite on off-white wove paper
50.130.147kk

This drawing is related to catalogue 9qq.

9ll. *Boat*

1869
Watercolor and graphite on off-white wove paper
50.130.147ll

9mm. *Roseg Glacier, Pontresina*

August 24, 1869
Watercolor and graphite on off-white wove paper
Inscribed at lower right: Roseg Gla – / cier. Pon. / tresina / Aug. 24th / 1869
50.130.147mm

The Roseg Glacier is south of Pontresina, near Morteratsch and Piz Bernina (cat. 9nn).

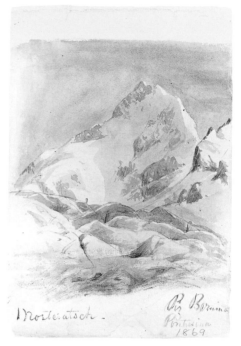

9nn

9nn. *Morteratsch, Piz Bernina, Pontresina*

1869
Watercolor and graphite on off-white wove paper
Inscribed at lower left: Morteratsch.; at lower right: Piz Bernina / Pontresina / 1869
50.130.147nn

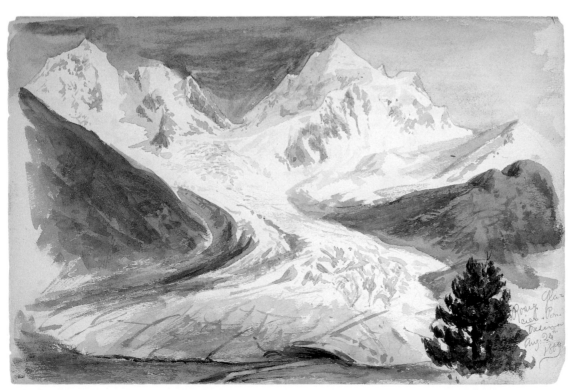

9mm

900

9pp

900. *Boats on Lake of Lecco*

1869
Watercolor and graphite on off-white wove paper
Inscribed at lower right: Lecco
50.130.14700

The southeastern branch of Lake Como is called the Lake of Lecco, after the town of the same name located at its southern end. Sargent could have been referring to either the body of water or the town when he inscribed the drawing. This watercolor is related to catalogue 9ll.

9pp. *Lake of Lecco*

1869
Watercolor, gouache, and graphite on off-white wove paper
Inscribed at lower left: Lake of / Lecco.
50.130.147pp

9qq. *Town at Edge of Mountain Lake*

1869
Graphite and watercolor on off-white wove paper
50.130.147qq

This drawing is related to catalogue 9kk.

9rr. *Sailboats, Geometrical Design*

1869
Graphite on off-white wove paper
Inscribed at lower left: Moulin
50.130.147rr

9ss. *Mountain Climbers*

1869
Graphite on off-white wove paper
50.130.147ss

This highly finished drawing is one of the few figural depictions in the sketchbook. The composition and the poses of the figures seem contrived and are not characteristic of Sargent's life studies. The overall style, which relies on hatching and cross-hatching, and the very detailed rendering of costume suggest that the work may be a copy, perhaps after a drawing or print by another artist.

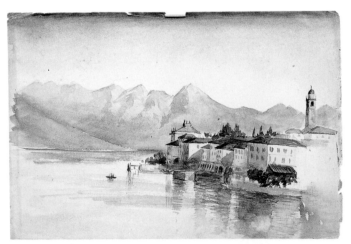

9qq 9rr

9ss

9tt

9tt. *Fish, Caricatures (inside back cover)*

1869
Graphite on off-white wove paper
50.130.147tt

10 recto. *Moderne Amoretten (detail)*

After Hans Makart, Austrian, 1840–1884
ca. 1869–70
Graphite on off-white wove paper
12⅛ × 4⅜ in. (30.8 × 11.1 cm)
Inscribed at upper right: by Mackart [sic]
Gift of Mrs. Francis Ormond, 1950
50.130.143n recto

10 verso. *Faces, Trees, Horses*

ca. 1869–70
Graphite on off-white wove paper
4⅜ × 12⅛ in. (11.1 × 30.8 cm)
Inscribed at upper left: CP
Gift of Mrs. Francis Ormond, 1950
50.130.143n verso

In 1868, Hans Makart created two versions of his wall decoration *Moderne Amoretten* (Modern Cupids), an ambitious ensemble of paintings depicting mythological figures and decorative elements. The second version (Österreichische Galerie, Vienna, since 1896) is a smaller copy that Makart painted over a photograph of the original (Zentsparkasse, Vienna). Sargent copied only the central vertical panel of the ensemble, which depicts a group of cupids passing through a forest. It is unclear how Sargent might have known Makart's painting. Both versions

10 recto 10 verso

were exhibited in Munich in 1868, and one version was shown there again in 1869. Sargent may have seen and copied the painting when he was in Munich during the summer of 1869. However, *Moderne Amoretten* and its creator were the subject of intense discussions in Munich and Vienna, and Sargent may have known the image from a reproduction.

The sketches on catalogue 10 verso may be related to drawings in the Switzerland 1870 sketchbook (cat. 16). See especially catalogue numbers 16w and 16nn for similar studies of heads.

11

11. *Heads*

ca. 1870
Pen and ink and graphite on light buff wove paper
7 3/16 × 11 13/16 in. (18.2 × 30 cm)
Gift of Mrs. Francis Ormond, 1950
50.130.110

12 recto. *Heads, Hands, Mother and Child, and Other Figures*

ca. 1870
Pen and ink on blue wove paper
12 5/8 × 18 7/8 in. (32 × 47.9 cm)
Gift of Mrs. Francis Ormond, 1950
50.130.141z recto

Rubin has suggested that the head of a man wearing glasses, to the right of center, is a portrait study of Fitzwilliam Sargent (New York–Glens Falls 1991–93, p. 11). See figure 43.

REFERENCES: New York–Glens Falls 1991–93, p. 11; Shelley 1993, p. 192.

12 verso. *Head of a Child, Mountain Scene, Objects for a Still Life, Trees, Figure in a Boat*

ca. 1870
Graphite and chalk on blue wove paper
12 5/8 × 18 7/8 in. (32 × 47.9 cm)
Gift of Mrs. Francis Ormond, 1950
50.130.141z verso

The study of the child's head in the upper left corner is related to catalogue 13.

13. *Heads*

ca. 1870
Watercolor and graphite on off-white wove watercolor paper
14 1/8 × 10 3/16 in. (35.9 × 25.9 cm)
Inscribed on verso at center left: EP
Gift of Mrs. Francis Ormond, 1950
50.130.141x

The identity of these heads is unknown. The upper left corner of catalogue 12 verso includes a graphite study that may depict the same baby as the watercolor representation at the center of this sheet. The two sketches of the girl at right, in particular, are similar in style to drawings in the Switzerland 1870 sketchbook (cats. 16t recto and 16ii recto).

12 recto 12 verso

13

14. *Sailboats on a Lake*

1870
Watercolor and graphite on off-white wove paper
4⅛ × 6⅜ in. (10.5 × 16.2 cm)
Inscribed on verso at lower left: EWS
Gift of Mrs. Francis Ormond, 1950
50.130.82g

This sheet comes from an unknown sketchbook. For comparable subjects, see catalogue numbers 9ee, 9oo, 9pp, 16mm, and 17rr verso.

15. *Venice; Villa Nicolini, Florence; Architectural Details*

1870
Watercolor and graphite on off-white wove paper
5⅞ × 9¼ in. (15 × 23.5 cm)
Inscribed at lower left: VENICE. MAY; at lower right: Villa Nicolini. / Florence. // 1870; on verso at lower left: EWS
Gift of Mrs. Francis Ormond, 1950
50.130.82j

The inscription at the lower right, 1870, although not in Sargent's hand, is probably correct. In May of that year, the Sargent family traveled from Florence, where they had spent the winter, to Venice.

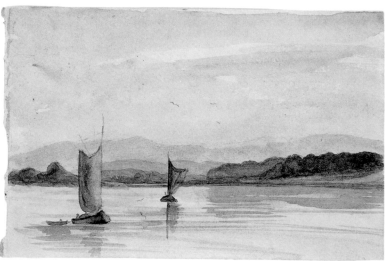

14

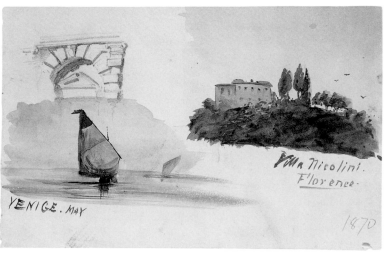

15

16. Switzerland 1870 Sketchbook

Summer 1870
Black impressed cardboard cover; inscribed on label at center left: 1870
Sheet size: 8 × 11⅛ in. (20.3 × 28.3 cm)
Gift of Mrs. Francis Ormond, 1950
50.130.148

17. *Splendid Mountain Watercolours* Sketchbook

Summer 1870
Black impressed cardboard cover; inscribed on label affixed at center: 1870; at center right: Splendid Mountain / Watercolours
Sheet size: 10⅞ × 16 in. (27.6 × 40.6 cm)
Gift of Mrs. Francis Ormond, 1950
50.130.146

The Sargent family resided in Florence during the winter of 1869–70 and for the summer of 1870 once again traveled north to Switzerland. Their itinerary is well documented by two sketchbooks in the Metropolitan (cats. 16 and 17) and by Dr. Sargent's correspondence, which, while imprecise about dates, describes their travel route in detail.

The family arrived in Venice on May 10, 1870, and remained there for about two weeks. Despite the uncomfortably warm weather, they were still there on May 23, according to the inscription on the first page of one of the sketchbooks (cat. 16a). Fitzwilliam later wrote to George Bemis: "We left Venice . . . the weather having quite exhausted us—it was awfully hot, and refreshed ourselves on the Lago Maggiore for a week" (Fitzwilliam Sargent to George Bemis, Thun, Switzerland, June 21, [1870], George Bemis Papers). They left Lake Maggiore in early June and journeyed north across the St. Gotthard Pass into Switzerland, where they spent the rest of the summer traveling through the Bernese Oberland. They arrived in Lucerne by June 6. By June 10 they were at Thun. In a letter of October 15, Dr. Sargent recalled their trip for Bemis:

From Thun John & I, after incubating three weeks, hatched a three weeks walk amongst the Mountains & Glaciers,—going over the Gemmi to Zermatt & the Rifflelberg to the Aggishorn, the Rhone Glacier, the Grimsel, Meiringen &c, &c, &c to Interlaken, where we found the rest of the family. After spending a fortnight, or more, at Interlaken we all went to Murren [sic] (above Lauterbrunnen) where we passed the month of August in the clouds & fogs & rain . . . thence we went to Grindelwald, from which we made some excursions; then over the Brunig to Lucerne, where we spent a fortnight with the Bronsons. (Fitzwilliam Sargent to George Bemis, Florence, October 15, [1870], George Bemis Papers)

In the smaller of the two sketchbooks (cat. 16), Sargent recorded the family's journey from about the time they left Venice in late May 1870 until mid-June, when they were in Thun. He used the larger of the two books (cat. 17) from the end of June into October. He seems to have switched to this book when he and his father set out for their walking tour and to have drawn a few subjects after their return to Florence for the winter of 1870–71. Sargent resumed use of the smaller sketchbook in August 1870 in Mürren, a resort town known for its spectacular alpine views, and worked in the two books concurrently.

Sargent seems to have employed each of the sketchbooks in a distinctive way. The smaller book, whose binding remains intact, contains relatively fewer watercolors, seven out of forty-four images. Several pages contain multiple studies. For example, catalogue numbers 16b, 16c, and 16d all include more than one study or landscape vignette. It is a true "sketch" book, in which the young artist experimented with technique and recorded the world around him. Catalogue 16ff contains the beginnings of an abandoned portrait study of Gottlieb Feutz, a boy Sargent apparently met in Mürren. On the following page (cat. 16gg) is a more highly finished graphite study of the same subject.

While catalogue 17 also contains various cursory sketches, it seems to function more as a showcase for the young artist's efforts in watercolor. This book has become known as the Splendid Mountain Watercolours sketchbook because of an inscription affixed to its cover that was almost certainly added by Sargent's sister Emily, probably after the artist's death. The high proportion of watercolors it contains (forty of sixty-one sheets) justifies the title. The binding of the sketchbook was damaged when it arrived at the Metropolitan. Many sheets were detached, and several had been removed (see "Note to the Reader," below). One sheet belonging to the sketchbook was found in a portfolio that Sargent's sister also gave to the Museum in 1950 (cat. 18). Three sheets in the collection of the Fogg Art Museum (1937.1, 1937.2, 1937.8.15), one in the Museum of Fine Arts, Boston (37.51), and three in private collections have been identified by Rubin as having originally belonged to the sketchbook (New York–Glens Falls 1991–93, p. 8). Two of the Fogg watercolors were included in the Sargent memorial exhibition at the Royal Academy, London, in 1926 (among "six early drawings done at the age of 14–16"). Sargent's heirs seem to have removed the errant pages from catalogue 17 after the artist's death.

Splendid Mountain Watercolours includes forty-seven studies drawn directly on the pages and fourteen additional drawings that were pasted into the sketchbook. Inscriptions in the margins next to the pasted-down drawings may not have been written by Sargent, and it is unclear if he was involved in assembling the sketchbook. Eleven of the fourteen pasted-down images have the same approximate measurements (8⅜ × 11¹¹⁄₁₆ in.; 21.3 × 29.7 cm), suggesting that Sargent was working consistently on a particular kind of paper, possibly a water-color block, throughout the summer. Other loose sheets in the Metropolitan's collection seem to have come from the same block (cats. 19, 20, and 21).

The trip that Sargent recorded in Splendid Mountain Watercolours was no doubt planned so that father and son could see the most magnificent alpine scenery. According to Rubin, the Sargents carried with them a guide from the series of Handbooks for Travellers published by the British firm John Murray (New York–Glens Falls 1991–93, p. 15). A slightly later edition of the guide that pertains to the Swiss Alps recommends the regions that Sargent and his father visited: "For a near view of Alpine scenery, amidst the recesses of the mountains, the localities which afford a concentration of grand and sublime objects are the passes and valleys of the Bernese Oberland, those around Monte Rosa, especially the valleys of Zermatt" (A Handbook for Travellers in Switzerland and the Alps of Savoy and Piedmont, 14th ed., London, 1872, p. xl).

Little is known of Sargent's artistic training during the winter of 1869–70, but these two sketchbooks from summer 1870 reveal a measure of progress in technique and composition from the previous summer. While Sargent's landscapes from the summer of 1869 demonstrate his knowledge of landscape conventions, the works in the Splendid Mountain Watercolours sketchbook show increased awareness of artistic contrivances or embellishments of landscape painting. For example, in the foregrounds of catalogue numbers 17aa verso and 17f verso, Sargent painted in a small figure with a rake. In addition, catalogue numbers 17f verso and 1700 recto include flying birds represented stenographically with quick brushstrokes. Throughout the summer, Sargent portrayed architecture in his compositions. In August, especially in Mürren, Sargent produced a series of watercolors of chalets with alpine backdrops (cats. 17aa recto and verso, 1700 recto, and 19 recto).

In both sketchbooks and the loose sheets from summer 1870, Sargent displayed a new and serious interest in portraiture, making several highly finished watercolor studies of people whom he encountered (for example, cats. 17bb verso, 1700 verso, and 17pp verso).

16a

16b

Splendid Mountain Watercolours occupies a special place in Sargent's early oeuvre. Of his known sketchbooks up to and including 1870, it has the largest sheets, whose scale must have challenged the ambitious young artist. As a showcase of his summer's efforts, the sketchbook may have played a key role in the Sargents' decisions about their son's career. While his parents had often referred to his artistic inclinations in letters to friends and relatives, a letter written by Fitzwilliam Sargent to his mother on October 10, 1870, shortly after he had returned from the summer's travels, is definitive on the subject: "My boy John seems to have a strong desire to be an Artist by profession, a painter, and he shows so much evidence of talent in that direction, and takes so much pleasure in cultivating it, that we have concluded to gratify him and to keep that plan in view in his studies" (Fitzwilliam Sargent to Emily Haskell Sargent, Florence, October 10, 1870, Fitzwilliam Sargent Papers).

NOTE TO THE READER: When the Metropolitan received catalogue 17, many pages were detached from the binding and out of order. The pages were reordered by Rubin and Shelley before the exhibition "John Singer Sargent's Alpine Sketchbooks: A Young Artist's Perspective" (New York–Glens Falls 1991–93). The current order of the accession numbers corresponds to the pagination done by Rubin and Shelley. The pages are discussed in this order with one exception: in cataloguing the sketchbook for this publication, it was decided that catalogue 17cc should actually precede catalogue 17ii.

16a. *First Page of Switzerland 1870 Sketchbook*

1870
Graphite on off-white wove paper
Inscribed at upper right: J. S. Sargent. / Venice. May 23ᵈ.1870—
50.130.148a

16b. *Trees and Foliage, Head of a Bull, Man*

1870
Graphite on off-white wove paper
50.130.148b

The trees studied here are similar to those painted in watercolor in catalogue 16c.

16c. *Two Landscapes*

1870
Watercolor and graphite on off-white wove paper
50.130.148c

Sargent seems to have transferred his method for drawing foliage to the watercolor medium. The short quick brushstrokes used to represent the leaves on this sheet are analogous to the short graphite hatched lines of the tree studies in catalogue 16b.

16c

16d

16d. *Landscape at Faido, Tree*

June 3, 1870
Graphite on off-white wove paper
Inscribed at center left: FAIDO.JUNE 3ᵈ 1870
50.130.148d

This study of a rocky hillside covered with fir trees was drawn at the Italian town of Faido, which the Sargents passed through en route to the St. Gotthard Pass (cats. 16e, 16i, and 16k). Sargent's technique relied

16e

16g

16f

heavily on quick, short hatched lines, especially in the foliage.

For a watercolor made at Faido, see catalogue 20 verso.

16e. *Railway Bridge at Dazio Grande, St. Gotthard*

June 3, 1870
Wax crayon on off-white wove paper
Inscribed at lower right: DAZIO GRANDE. St. GOTTHARD— / JUNE 3. 1870—
50.130.148e

Dazio Grande, which the Baedeker guide describes as an "insignificant village," is not far from Faido (*Switzerland, and Adjacent Portions of Italy, Savoy, and the Tyrol: Handbook for Travellers*, Coblenz, 1869, p. 81).

16f. *Schöllinen Gorge, Hospenthal*

June 3, 1870
Watercolor and graphite on off-white wove paper
Inscribed at lower right: Schellinen [sic] Gorge. / Hospenthal— / June 3ᵈ. 1870—
50.130.148f

See catalogue numbers 16d and 16e for other works made on June 3, as Sargent traveled north through the St. Gotthard Pass.

16g. *Alpine Village*

1870
Watercolor and graphite on off-white wove paper
50.130.148g

Sargent began to sketch the buildings and towers of an unidentified mountain village. Catalogue 16p (also of an unknown town) is another study of the regional architecture.

16h. *St. Gotthard and Mythen, Brunnen*

1870
Watercolor and graphite on off-white wove paper
Inscribed at lower center: St Gotthard; at lower right: Miethen [sic] Brunnen
50.130.148h

The Sargents passed through St. Gotthard on June 4 before reaching Brunnen, on Lake Lucerne, the same day. *St. Gotthard* (cat. 16k) and *Bay of Uri, Brunnen* (cat. 16l) are both dated June 4. *Uri Rothstock from*

16h

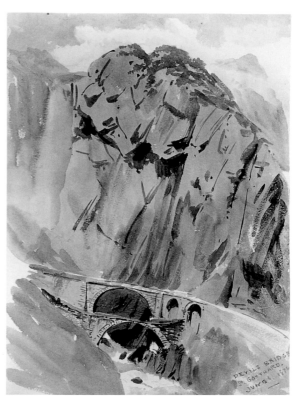

16i

Brunnen (cat. 16n) is dated June 5.

See catalogue 16l for a description of the picturesque town of Brunnen.

16i. *Devil's Bridge, St. Gotthard*

June 4, 1870
Watercolor and graphite on off-white
wove paper
Inscribed at lower right: DEVILS BRIDGE /
S^t. GOTTHARD. / JUNE 4. 1870
50.130.148i

North of the St. Gotthard Pass and Hospenthal, the Devil's Bridge crosses the falls of the Reuss River. When Sargent visited the site in 1870, the river was spanned by the two bridges depicted here: the "new" bridge, built in 1830 above an older bridge (date unknown), which Baedeker describes as "disused and entirely overgrown with moss" (*Switzerland, and Adjacent Portions,* Coblenz, 1869, p. 78). While Sargent contrasted the newer bridge with the sagging older bridge below, his composition is dominated by the craggy precipices.

Henry Wadsworth Longfellow (1807–1882) immortalized the old bridge in *The Golden Legend* (1851):

Never any bridge but this
Could stand across the wild abyss;
All the rest, of wood or stone,
By the Devil's hand were overthrown,
He toppled crags from the precipice,
And whatsoe'er was built by day
In the night was swept away;
None could stand but this alone.
(Quoted in Joel Cook, *Switzerland*

Picturesque and Descriptive, Philadelphia, 1904, p. 127).

Longfellow did not live to see the old bridge destroyed by a flood in 1888. Today, the gorge is spanned by a bridge built in 1955–56.

16j recto. *Urner Loch, Hospenthal*

June 4, 1870
Wax crayon on off-white wove paper
Inscribed at lower right: URNER LOCH. /
HOSPENTHAL. / JUNE. 4. 1870—
50.130.148j recto

In catalogue 16j recto, Sargent depicted the entrance to the Urner Loch, an eighty-yard-long tunnel cut through a mountain in 1701. For another sketch made at Hospenthal, see catalogue 16f.

16j verso. *Waterfall, Figures*

1870
Graphite on off-white wove paper
50.130.148j verso

A group of sheets in this sketchbook is characterized by a bolder, freer, and more assured graphic style that is inconsistent with Sargent's work of about 1870. He may have returned to this sketchbook at a later date.

In addition to catalogue 16j verso, included in this group are catalogue

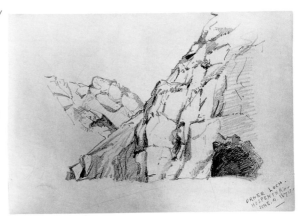

16j recto

16j verso

16k

numbers 16s verso, 16t verso, 16v verso, 16ii verso, and 16jj verso. Several of these pages depict exotic figures and horses. The sketch of the leg of a horse at the lower right of this sheet relates to catalogue numbers 16ii verso and 16jj verso.

16k. St. Gotthard

June 4, 1870
Wax crayon on off-white wove paper
Inscribed at lower right: St. Gotthard— June 4. / 1870
50.130.148k

The St. Gotthard Pass connects the Valais and the Grisons Alps. Baedeker opines, "In magnificence of scenery the St. Gotthard is far superior to any of the other passes" (*Switzerland, and Adjacent Portions,* Coblenz, 1869, p. 67).

Other images drawn at St. Gotthard are catalogue numbers 16e, 16h, and 16i.

16l. *Bay of Uri, Brunnen*

June 4, 1870
Watercolor, gouache, and graphite on off-white wove paper
Inscribed at lower right: BAY OF URI / BRUNNEN / JUNE 4. 70
50.130.148l

According to Baedeker, the town of Brunnen, located at the bend of the Vierwaldstätter See and the Bay of Uri (the southern arm of the lake), was "perhaps the most beautifully situated place on the Lake of

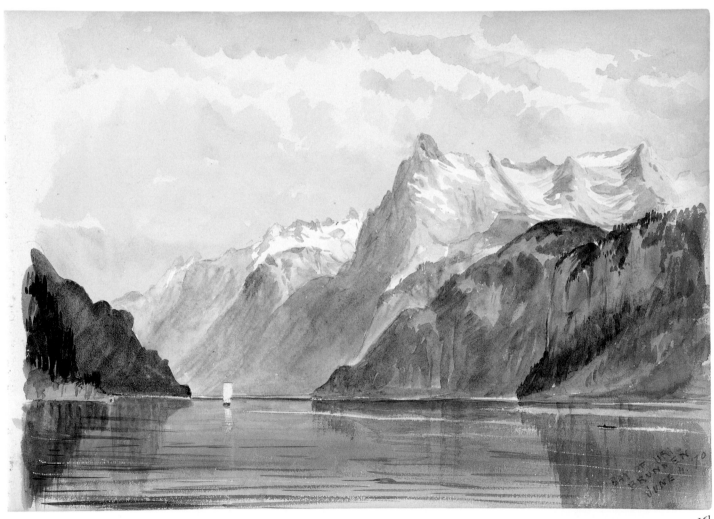

16l

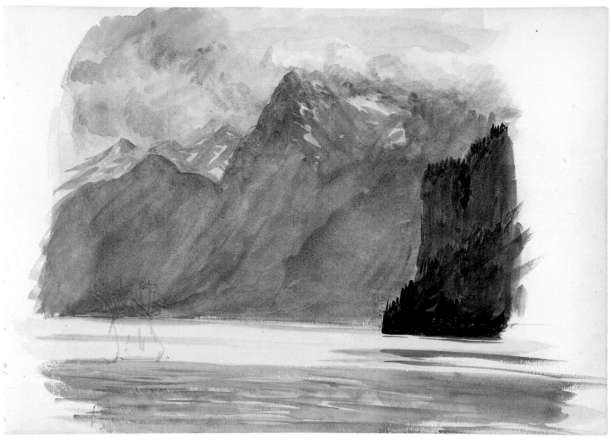

16m

Lucerne, of late years much frequented, and suitable for a stay of some duration" (*Switzerland, and Adjacent Portions,* Coblenz, 1869, p. 70). Baedeker continues with a description of the scenery near Brunnen similar to the view recorded by Sargent: "The precipices become almost perpendicular. Lofty snow-clad mountains, often partially veiled with clouds, are visible through the gorges which open at intervals" (ibid., p. 71).

Catalogue numbers 16m and 16n represent the same site.

16m. *Mountain Lake*

1870
Watercolor and graphite on off-white wove paper
50.130.148m

Catalogue 16m appears to represent a view of the same site depicted in catalogue 16l. Here Sargent studied the highest central peak seen in catalogue 16l from a slightly different angle and a closer vantage point.

16n. *Uri Rothstock from Brunnen*

June 5, 1870
Graphite on off-white wove paper
Inscribed at lower right: URI ROTHSTOCK /
from Brunnen / June 5th. 1870
50.130.148n

This precise study depicts the Bay of Uri from the same vantage point shown in catalogue 16l.

Reference: New York–Glens Falls 1991–93, p. 17.

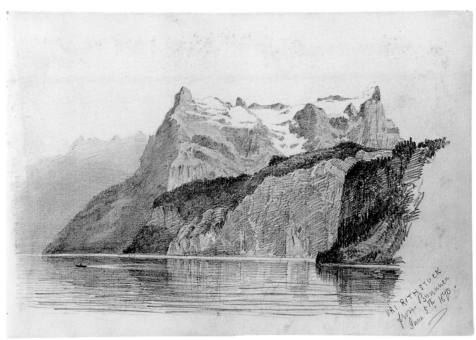

16n

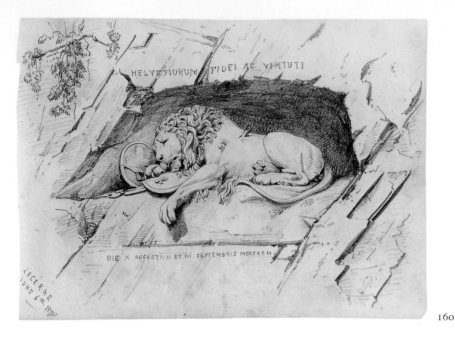

160 16p

160. *Lion Monument, Lucerne*

After Bertel Thorwaldsen, Danish, 1768/1770–1844
June 6, 1870
Graphite on off-white wove paper
Inscribed across upper center: HELVETIORUM
FIDEI AC VIRTUTI; across lower center: DIE X
AUGUSTI: II ET III SEPTEMBRIS MDC-
CXCII.; at lower left: LUCERNE / JUNE 6th. 1870
50.130.148o

Perhaps no monument is more closely asso-
ciated with the city of Lucerne than the
wounded lion carved into the sandstone walls
by the Danish sculptor Bertel Thorwaldsen
in 1821 to commemorate the death of Swiss
Guards in Paris in 1792 during the French
Revolution (*Switzerland, and Adjacent Por-
tions,* Coblenz, 1869, p. 51). Shortly after
his arrival in the city in early June, Sargent
recorded the massive monument—the lion
alone is about twenty-eight feet long—with
great fidelity to details, from the carefully
carved mane to the Latin inscriptions.

The high regard in which the monu-
ment was held in Sargent's day is evident in
Baedeker's assessment: "The work is
extremely impressive, and affords a proof
that in true Art the simplest idea carried out
by a masterhand never fails in its effect"
(ibid.). Sargent's admiration is apparent in
the care with which he recorded the mon-
ument's appearance.

Exhibition: New York–Glens Falls 1991–93, p. 18.

Reference: Weinberg and Herdrich 2000a, p. 7.

16p. *Rooftops and Spire*

1870
Graphite on off-white wove paper
50.130.148p

See catalogue 16g for another architectural
study.

16q. *Three Views of the Bernese Oberland from Thun*

June 10 and 15, 1870
Graphite on off-white wove paper
Inscribed at middle left: STOCKHORN. THUN.
/ JUNE 10th 1870; at middle right: JUNGRAU
[sic] from / THUN. / June 15. 1870.
50.130.148q

Other images of the Jungfrau are catalogue
numbers 16aa, 17b verso, 17c recto, and
17bb recto.

Exhibition: New York–Glens Falls 1991–93, p. 19.

16r. *Mountain View*

1870
Graphite on off-white wove paper
50.130.148r

A similarly composed study (of a different
site) is catalogue 17ss recto.

16s recto. *Schreckhorn and Eiger from Thun*

1870
Graphite on off-white wove paper
Inscribed at upper left: Schreckhorn.; at upper right:
Eiger.; at lower center: from Thun—
50.130.148s recto

The Sargent family spent about three weeks
at Thun in June before Sargent and his
father set out for their walking tour.
Another view from Thun is catalogue 16q.

16s verso. *Figure on Horseback*

1870
Graphite on off-white wove paper
50.130.148s verso

See catalogue 16j verso for a discussion of
this sheet and its relation to catalogue num-
bers 16t verso, 16v verso, 16ii verso, and
16jj verso.

16t recto. *Woman Sketching, Various Portraits*

1870
Graphite on off-white wove paper
Inscribed at lower left: Au ber gines —; at upper
right: Miss Stuarta Erskine.; at center right (faintly):
Mme la Baroness
50.130.148t recto

16q

16r

16s recto

16s verso

No details are known about Miss Stuarta Erskine, the woman depicted at upper right. See catalogue numbers 16u and 16v recto for similar studies.

REFERENCE: New York–Glens Falls 1991–93, p. 31.

16t verso. *Man Carrying a Sword*

1870
Graphite on off-white wove paper
50.130.148t verso

See catalogue 16j verso for a discussion of this sheet and its relation to catalogue numbers 16s verso, 16v verso, 16ii verso, and 16jj verso.

16t recto

16t verso

16u

16u. *Miss Mary Douglas Scott Sewing*

1870
Graphite on off-white wove paper
Inscribed across bottom: Miss Mary Douglas Scott
50.130.148u

16v recto. *Mary Newbold Sargent*

1870
Graphite on off-white wove paper
Inscribed at lower right: Regardez moi ca / 1870
50.130.148v recto

Rubin identified this figure as Sargent's mother, Mary Newbold Sargent (New York–Glens Falls 1991–93, p. 30). Throughout his life, Sargent recorded his family and companions in sketches and paintings. In this early study, he rendered Mrs. Sargent's profile with few lines, in contrast with her ruffled skirt, wide sleeves, and ornate hat (see figure 44).

EXHIBITION: New York–Glens Falls 1991–93, p. 30.

16v verso. *Head of a Man, Hands*

1870
Graphite on off-white wove paper
50.130.148v verso

See catalogue 16j verso for a discussion of this sheet and its relation to catalogue numbers 16s verso, 16t verso, 16ii verso, and 16jj verso.

16w. *Heads*

1870
Graphite on off-white wove paper
50.130.148w

16x. *Foxes*

1870
Graphite on off-white wove paper
50.130.148x

16y. *Eiger from Lauterbrunnen, Mürren*

August 1870
Graphite on off-white wove paper
Inscribed at lower right: Lauterbrunnen—Eiger /
Mürren / Aug. 1870
50.130.148y

In this sketch and in catalogue 16z, Sargent described form with hatching.

The Eiger is one of the three peaks of the Jungfrau. See catalogue 16aa for a view of all three peaks. Other studies of the Eiger are catalogue numbers 1700 recto, 21, and 23.

16z. *Mountains*

1870
Graphite on off-white wove paper
50.130.148z

See catalogue 16y for a similarly drawn landscape.

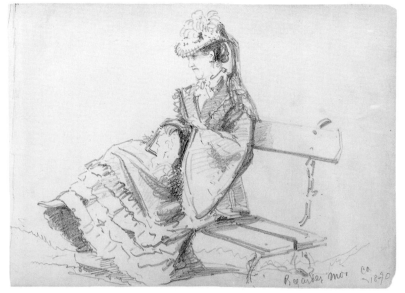

16v recto 16v verso

16w

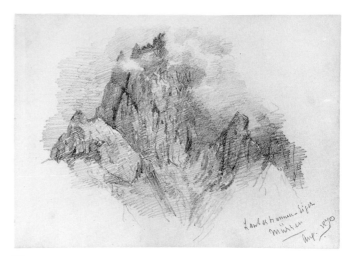

16y

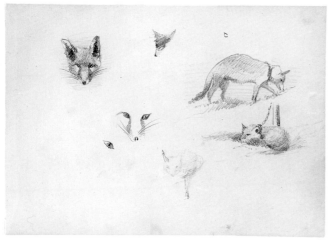

16x

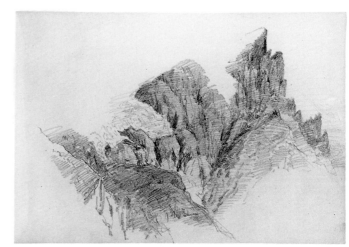

16z

16aa. *Eiger, Mönch, and Jungfrau from Mürren*

1870
Graphite on off-white wove paper
Inscribed at lower right: Eiger, Mönch & /
JUNGFRAU / MÜRREN
50.130.148aa

Sargent made this study of the three peaks
of the Jungfrau—the Eiger, the Mönch,
and the Jungfrau—from Mürren during his
stay there in August.

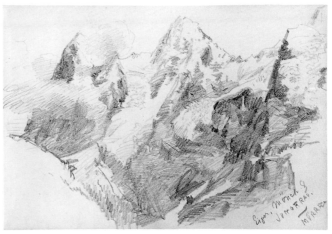

16aa

16bb. *Two Landscape Studies, Face*

1870
Graphite on off-white wove paper
50.130.148bb

16cc. *Breithorn and Schmadribach Falls*

1870
Graphite on off-white wove paper
Inscribed at lower right: Breithorn. & Schmadribach
50.130.148cc

16dd. *Breithorn and Schmadribach Falls*

1870
Graphite on off-white wove paper
Inscribed at lower right: Breithorn / Schmadribach
50.130.148dd

Baedeker opines: "A day can hardly be more agreeably employed than in making an excursion to . . . the Fall of the Schmadribach. . . . The loneliness of the surrounding scene, the imposing character of the cascade, and the magnificent panorama of mountains and glaciers combine to produce a profound impression" (*Switzerland, and Adjacent Portions*, Coblenz, 1869, pp. 111–12).

In catalogue numbers 16cc and 16dd,

Sargent studied from slightly different vantage points the upper waterfall as it plunges over the top with the Breithorn peak in the distance. Like catalogue 16ee, a near view of the cascade, these sketches may have been made on August 18.

16ee. *Schmadribach Falls*

August 18, 1870
Graphite on off-white wove paper
Inscribed at lower right: Schmadribach / 18. Aug—
/ 1870
50.130.148ee

In this near view of Schmadribach Falls, Sargent concentrated on the flowing water and surrounding rocks.

Two distant views of Schmadribach Falls (cats. 16cc and 16dd) focus on the grander panorama.

16ff. *Gottlieb Feutz*

1870
Graphite on off-white wove paper
50.130.148ff

Sargent appears to have abandoned this portrait study before finishing it. Whether he was frustrated with his drawing or with the sitter is uncertain, but for an unknown

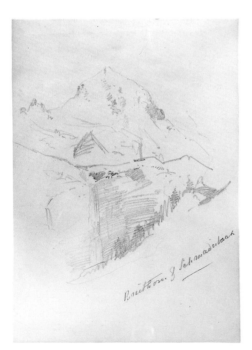

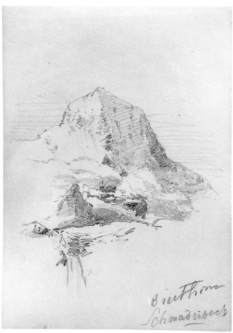

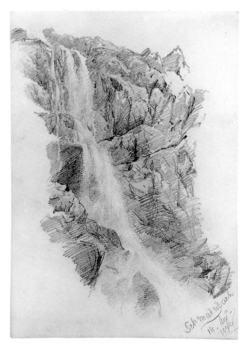

16ff

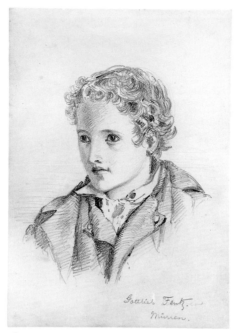

16gg

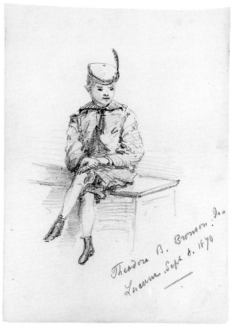

16hh

16ii recto

16ii verso

reason, he lightly sketched in animal-like ears and horns. This drawing is related to catalogue numbers 16gg and 19 verso.

16gg. *Gottlieb Feutz, Mürren*

1870

Graphite on off-white wove paper

Inscribed at lower right: Gottlieb Feutz. / Mürren.

50.130.148gg

Catalogue 16gg may be a preliminary study for a watercolor portrait of the same sitter shown wearing a hat (cat. 19 verso). Catalogue 16ff is an abandoned graphite study of this sitter.

REFERENCE: New York–Glens Falls 1991–93, p. 34.

16hh. *Theodore B. Bronson Jr., Lucerne*

September 8, 1870

Graphite on off-white wove paper

11 × 7¾ in. (27.8 × 19.7 cm)

Inscribed at lower right: Theodore B. Bronson Jr / Lucerne. Sept 8. 1870

50.130.148hh

In September, the Sargents spent a fortnight in Lucerne with family friends, the Bronsons. Theodore Bronson may also appear at the bottom of catalogue 16ii recto and in several small sketches on catalogue 16nn.

Although this page was cut from the binding of the sketchbook, its slightly curved edge matches a fragment that remains intact in the book.

16ii recto. *Lucerne Cathedral, Farmer in Field, Foliage, Two Children*

1870

Graphite on off-white wove paper

Inscribed at upper right: Cathedral. / Lucerne.

50.130.148ii recto

16ii verso. *Man, Horse*

1870

Graphite on off-white wove paper

50.130.148ii verso

See catalogue 16j verso for a discussion of this sheet and its relation to catalogue numbers 16s verso, 16t verso, 16v verso, and 16jj verso.

16jj recto

16jj verso

16jj recto. *Leg*

1870
Graphite on off-white wove paper
50.130.148jj recto

16jj verso. *Man on Horseback, Woman Carrying a Jug, Figure with Halo, Figures*

1870
Graphite on off-white wove paper
50.130.148jj verso

See catalogue 16j verso for a discussion of this sheet and its relation to catalogue numbers 16s verso, 16t verso, 16v verso, and 16ii verso.

16kk. *Figures*

1869
Graphite on off-white wove paper
7½ × 10⅝ in. (19.2 × 27.1 cm) (irregular)
Inscribed on verso at upper left: Sketchbook / 1868.
50.130.148kk

This loose, inserted page is not originally from this sketchbook. It may have come from the same sketchbook as catalogue 16mm and may have been drawn about the same time in 1869.

16ll. *Man in a Boat, Foliage*

1869?
Graphite on off-white wove paper
7½ × 10¾ in. (19.2 × 27.4 cm) (irregular)
50.130.148ll

This loose, inserted page is not originally from this sketchbook. It may have come from the same sketchbook as catalogue 16mm and may have been drawn about the same time in 1869.

16mm. *Boat on Lake of Lecco*

1869?
Graphite on off-white wove paper
7⅝ × 11 in. (19.4 × 28 cm) (irregular)
Inscribed at lower right: Lecco
50.130.148mm

It is not known when and by whom this loose sheet was inserted in this sketchbook. If the inscription, "Lecco," is correct, then the sketch was probably made during October 1869, when Sargent visited this branch of Lake Como in northern Italy. See general introduction for catalogue 9 and catalogue numbers 9oo and 9pp.

16nn. *Heads (inside back cover of Switzerland 1870 Sketchbook)*

1870
Graphite on off-white wove paper
Label at upper right: NEGOZIO / Vendita Carta, ogetti di Can- / celleria e Belle Arti, ecc. / DI GIOVANNI BRIZEGHEL / Tip. Lit. Cale. Lib. Editore / Merceria dell'Orologio № 300 / VENEZIA; inscribed at upper right: 2.25
50.130.148nn

16kk

16ll

17a

16mm

16nn

17a. First Page of "Splendid Mountain Watercolours" Sketchbook

1870
Graphite on off-white wove paper
Inscribed at upper left: Rome / 17 Trinità de'Monti
/ Cavalliere Ugo / Switzerland / 1870 Tyrol /
Innsbruck; at upper right: J. S. Sargent / from /
E. S. / Interlaken / Switzerland; at lower left:
V[illegible] merchand. / Nice / Masion Virello. /
Rue Grimaldi. / pres St. E[illegible]. / Mürren.
[illegible] Lauterbrunnen / Nice / 115 Via de'
Serrgli [sic] Florence / Italy
50.130.146a

Surrounding a slight contour drawing of an
alpine landscape, inscriptions in unidenti-
fied hands record the Sargent family's vari-
ous addresses for several winters: in the
1860s (Maison Virello, Nice), winter
1868–69 (Trinità dei Monti, Rome), and
winter 1869–70 (Via dei Serragli, Florence),
as well as places they visited during the
summer of 1870.

17b recto. Wellhorn and Wetterhorn from Brunig (overleaf)

1870
Watercolor and graphite on off-white wove paper
Inscribed at lower right: WELLHORN. & /
WETTERHORN
50.130.146b recto

Rubin identified this watercolor of the
peaks of Wellhorn and Wetterhorn as a
view looking south from Brunig, a town

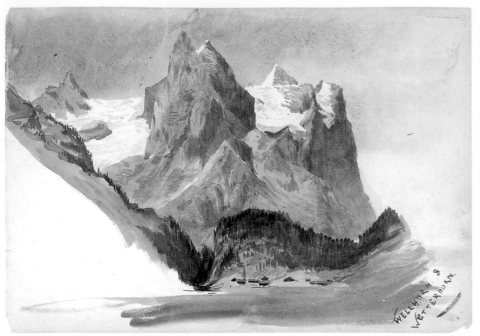

17b recto

17b verso

on the Sargents' route between Mürren, where the family spent the month of August, and Lucerne, where they spent a fortnight in September (departmental files, American Paintings and Sculpture).

Two other watercolors of the Wetterhorn (cats. 17f verso and 17jj verso) are views from Grindelwald, a town outside of Mürren and west of the peak.

EXHIBITION: New York–Glens Falls 1991–93, p. 40.

REFERENCE: Shelley 1993, pp. 198, 200, 203 (referred to incorrectly as 50.130.146i).

17c recto 17c verso

17b verso. *Jungfrau*

1870

Watercolor, gouache, and graphite on pale blue wove paper

9⅞ × 6⅞ in. (25 × 17.5 cm) (originally pasted into "Splendid Mountain Watercolours" sketchbook)

Inscribed at lower center: JUNGFRAU.

50.130.146b verso

By composing a panoramic view of the Jungfrau framed between two slopes, Sargent attempted to suggest the grandeur of the majestic peak, which Baedeker calls "the queen of the Bernese Alps" (*Switzerland, and Adjacent Portions,* Coblenz, 1869, p. 111), as it rises in the distance. Other views of the Jungfrau are catalogue numbers 16aa, 17c recto, and 17bb recto.

REFERENCE: Shelley 1993, p. 200.

17c recto. *Jungfrau from Mürren*

1870

Watercolor and graphite on off-white wove paper

Inscribed at lower right: Jungfrau from / Murren [sic]

50.130.146c recto

In catalogue 17c recto Sargent studied the Jungfrau from a high and relatively close viewpoint while concentrating on capturing the atmospheric effect of clouds that partially obscure the peak.

Other views of the Jungfrau are catalogue numbers 16aa, 17b verso, and 17bb recto.

EXHIBITION: New York–Glens Falls 1991–93.

REFERENCE: Shelley 1993, p. 192.

17c verso. *Frau von Allmen and an Unidentified Man in an Interior*

1870

Watercolor and graphite on off-white wove paper

8⅜ × 11¾ in. (21.4 × 29.8 cm) (originally pasted into "Splendid Mountain Watercolours" sketchbook)

Inscribed at lower left on sketchbook page: Mürren / 1869 [sic]

50.130.146c verso

Sargent made several careful portrait studies at Mürren (cats. 17z verso and 17bb verso). Frau von Allmen appears with an accompanying inscription in catalogue 1700 verso. Here she is shown with an aged man in a highly detailed and meticulously rendered interior.

EXHIBITION: New York–Glens Falls 1991–93, p. 35.

REFERENCE: Shelley 1993, pp. 190, 200, 210.

17d. *Kandersteg from the Klus of the Gasternthal*

1870

Wax crayon on off-white wove paper

Inscribed at lower right: Kandersteg

50.130.146d

According to Rubin, "Kandersteg, a picturesque village located high in the mountains of the Bernese Oberland, was an overnight station on the first leg of the 'pedestrian excursion' undertaken by John Sargent and his father" (New York–Glens Falls 1991–93, p. 20).

Sargent concentrated on the steep rugged cliffs in the foreground, which he drew quickly and boldly with wax crayon. By contrast, the mountain landscape beyond is faintly laid out with thin, delicate lines. According to the inscription on catalogue 17k, which presents two views at Kandersteg, Sargent and his father were there on June 30. One sketch on catalogue 17k, also drawn in wax crayon in a vertical composition, presents a similar view down the gorge.

EXHIBITION: New York–Glens Falls 1991–93, p. 21.

REFERENCE: Shelley 1993, pp. 188, 189, 190.

17e. *View of Four Mountains from Gorner Grat, Rock*

1870

Watercolor and graphite on off-white wove paper

Inscribed across center: DENT BLANCHE / 13,461; GABELHORN / 12,609; TRIFTHORN. / 11,504; ROTHHORN. / 13,065

50.130.146e

17d

In catalogue 17e, Sargent contrasted a lone rock above with the panoramic vista below, in which he labeled each peak and recorded its altitude.

Rubin identified the landscape as a view from the Gorner Grat, a celebrated vantage point for alpine scenery in the environs of Zermatt (departmental files, American Paintings and Sculpture). Baedeker opines, "The Panorama from the Gorner Grat, though destitute of the common attributes of the picturesque, still cannot fail to strike the imagination of the spectator by its unparalleled grandeur" (*Switzerland, and Adjacent Portions,* Coblenz, 1869, p. 269).

EXHIBITION: New York–Glens Falls 1991–93.

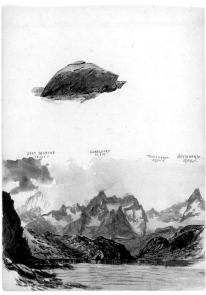

17e

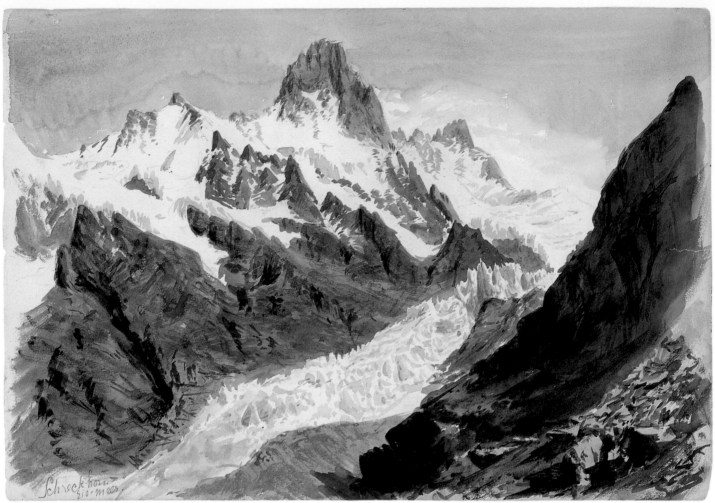

17f recto

17f recto. *Schreckhorn, Eismeer*

1870
Watercolor and graphite on off-white wove paper
Inscribed at lower left: Schreckhorn. / Eis-meer.
50.130.146f recto

The Schreckhorn is one of the three major peaks near Grindelwald, a town Sargent visited at the end of August after passing the month in nearby Mürren. Baedeker notes: "The chief attractions of Grindelwald are its two Glaciers . . . , which descend far into the valley, and are extremely easy to access" (*Switzerland, and Adjacent Portions,* Coblenz, 1869, p. 117). The two glaciers, known as the upper and lower, are surrounded by the three major mountains of Grindelwald: the Schreckhorn, the Eiger, and the Wetterhorn. Here Sargent depicted a picturesque vista with the Schreckhorn at

center and the Eismeer (literally, "ice sea").
Another depiction of glaciers at Grindelwald is catalogue 17qq recto.

EXHIBITION: New York–Glens Falls 1991–93.

REFERENCES: Shelley 1993, pp. 197, 199; Weinberg and Herdrich 2000a, p. 7.

17f verso. *Wetterhorn, Grindelwald*

1870
Watercolor and graphite on off-white wove paper
8⅜ × 11¹¹⁄₁₆ in. (21.1 × 29.6 cm) (originally pasted into "Splendid Mountain Watercolours" Sketchbook)
Inscribed at lower right on sketchbook page: Wetterhorn—/ Grindelwald—
50.130.146f verso

According to Baedeker, "The village of Grindelwald (2,950 inhabitants), with its scattered houses of wood, occupying a considerable space in the valley, is recommended as excellent headquarters for mountaineers" (*Switzerland, and Adjacent Portions,* Coblenz, 1869, p. 117). Sargent and his father apparently made several excursions in this vicinity.

The height of the massive peak, which dominates the composition, is accentuated by its proximity to the top edge of the sheet. Sargent included several picturesque conceits: the chalets in the foreground, animals, a woman working, and stylized birds in the sky at left. In another view of the Wetterhorn from Grindelwald (cat. 17jj verso), Sargent studied the peak from a similar prospect but left the foreground barren of these details.

REFERENCES: New York–Glens Falls 1991–93, p. 38; Shelley 1993, pp. 197, 199.

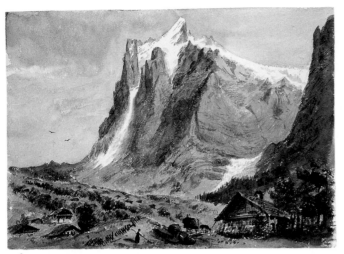

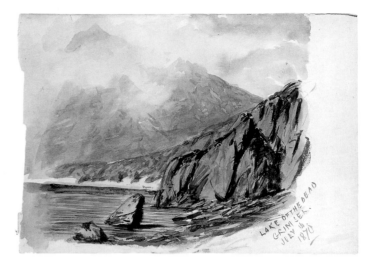

17f verso 17g

17g. *Lake of the Dead, Grimsel*

July 14, 1870
Watercolor on off-white wove paper
Inscribed at lower right: LAKE OF THE DEAD
/ GRIMSEL. / JULY 14. / 1870
50.130.146g

The name of this lake (in German, Totensee), which is not far from the Grimsel Pass, commemorates brutal battles between Austrian and French forces that occurred there in 1799 (Baedeker, *Switzerland,* New York, 1996, p. 95).

Another watercolor that Sargent may have made at the same site is catalogue 17w recto.

REFERENCE: Shelley 1993, p. 194.

17h. *Rhône Glacier*

July 15, 1870
Watercolor and graphite on off-white wove paper
Inscribed at lower right: Rhone Glacier. / July 15th 1870
50.130.146h

In 1869, Baedeker described the Rhône Glacier, which was then eighteen miles long and one of the most impressive in the Alps, as rising "in a terrace-like form, resembling a gigantic waterfall suddenly arrested in its career by the icy hand of some Alpine enchanter" (*Switzerland, and Adjacent Portions,* Coblenz, 1869, p. 137).

EXHIBITION: New York–Glens Falls 1991–93, pp. 28–29.

REFERENCE: Shelley 1993, pp. 194, 197, 203.

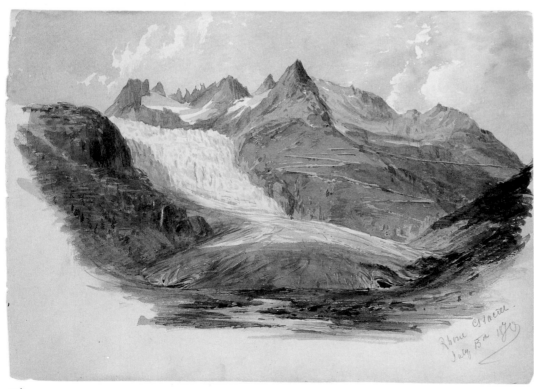

17h

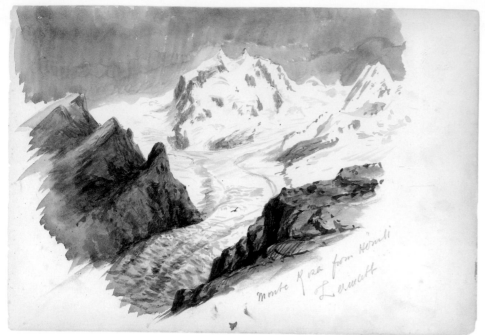

17i

July 2, 1870
Watercolor, wax crayon, and graphite on off-white
wove paper
Inscribed at center right: July 2ᵈ. 1870 / Loèche-les-
Bains.
50.130.146j

The village of Loèche-les-Bains (Leuker-bad) is not far from Kandersteg and the Gemmi Pass (see also cats. 17d, 17k, 17l, and 17mm).

EXHIBITION: New York–Glens Falls 1991–93.

17k. *Views from Kandersteg: Entrance to Gasternthal, Kanderthal from Hotel Gemmi*

June 30, 1870
Wax crayon, graphite, and watercolor on off-white
wove paper
Inscribed at lower left: from. KANDERSTEG /
JUNE 30. 1870— ; inscribed at lower right: HOTEL
GEMMI / KANDERSTEG. / JUNE 30. / 1870
50.130.146k

See catalogue 17d for a related view at Kandersteg.

EXHIBITION: New York–Glens Falls 1991–93, p. 20.

17i. *Monte Rosa from Hornli, Zermatt*

1870
Watercolor on off-white wove paper
Inscribed at lower right: Monte Rosa from Hornli /
Zermatt
50.130.146i

In early July, Sargent sketched in the vicinity of Zermatt, the southernmost point of the alpine excursion.

Among other works that he made in this region during the period are catalogue numbers 17n, 17o, 17q, 17kk, and 17nn.

EXHIBITION: New York–Glens Falls 1991–93, p. 25.

REFERENCE: Shelley 1993, pp. 192, 193–94, 200.

17j

17k

17l

17m

17l. *Gemmi Pass*

July 1, 1870
Wax crayon on off-white wove paper
Inscribed at lower right: Gemmi. / July 1. 1870
50.130.146l

Other views at Gemmi are catalogue numbers 17k and 17mm.

EXHIBITION: New York–Glens Falls 1991–93.

17m. *Weisshorn*

1870
Wax crayon on off-white wove paper
Inscribed at center right: WEISSHORN.
50.130.146m

This cursory sketch of the Weisshorn, near Zermatt, is similar in composition to catalogue 17nn and may be a preliminary study. In catalogue 17m, Sargent suggested distance by alternating light and dark areas.

17n. *Matterhorn*

1870
Graphite on off-white wove paper
50.130.146n

17o. *Matterhorn, Zermatt*

1870
Graphite on off-white wove paper
Inscribed at lower right: Matterhorn. / Zermatt.
50.130.146o

In catalogue numbers 17n and 17o, Sargent studied the Matterhorn from the same side. In catalogue 17n, he carefully sketched the contour of the peak, only beginning to suggest form with delicate shading at the top and indicating some foreground landscape details. In catalogue 17o, however, Sargent concentrated on the peak, defining the form with elaborate shading.

Catalogue 17kk is a watercolor of the Matterhorn.

EXHIBITION (cat. 17o): New York–Glens Falls 1991–93.

REFERENCE (cats. 17n and 17o): Shelley 1993, pp. 187, 189, 192.

17n

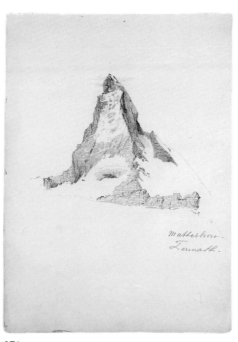

170

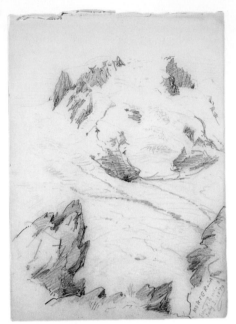

17p

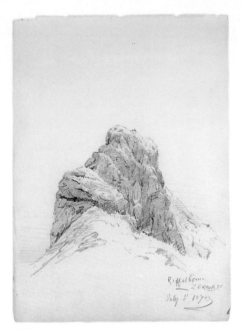

17q

17r

17p. *Monte Rosa from Gorner Grat*

July 3, 1870
Graphite on off-white wove paper
Inscribed at lower right: MONTE ROSA / from
G. Grat. / July 3. 1870
50.130.146p

The Gorner Grat is known for its splendid views. According to Baedeker, "The summit commands a prospect of the most magnificent description; the spectator is entirely surrounded by snow-peaks and glaciers," including Monte Rosa, which is characterized as "snow-white from base to summit" (*Switzerland, and Adjacent Portions,* Coblenz, 1869, p. 270).

The precipitous vantage point of this study is unusual. Sargent focused on the contrast between the snowy expanses and the jagged rocks rather than the panorama.

Other sketches that Sargent made around Zermatt in early July are catalogue numbers 17i, 17m, 17n, 17o, 17q, 17kk, and 17nn.

EXHIBITION: New York–Glens Falls 1991–93.

REFERENCE: Shelley 1993, pp. 189, 192.

17q. *Riffelhorn from Zmutt Glacier, Zermatt*

July 3, 1870
Graphite on off-white wove paper
Inscribed at lower right: Riffelhorn. / ZERMATT
/ July 3ᵈ. 1870
50.130.146q

EXHIBITION: New York–Glens Falls 1991–93.

REFERENCE: Shelley 1993, pp. 188, 189.

17r. *Waterfall*

1870
Wax crayon on off-white wove paper
50.130.146r

17s recto. *Waterfall*

1870
Wax crayon on off-white wove paper
50.130.146s recto

Catalogue numbers 17r and 17s recto present views of the same waterfall from different distances and with varying degrees of detail. The first sketch records the fall from farther away and less precisely than the second. Unfortunately, Sargent did not identify this site with one of his customary inscriptions, and, as the Murray travel guide notes, "In Switzerland, waterfalls are as numerous as blackberries" (*Switzerland and the Alps,* 14th ed., London, 1872, p. xlii).

REFERENCE (cat. 17r): Shelley 1993, pp. 191, 192.

EXHIBITION (cat. 17s recto): New York–Glens Falls 1991–93.

REFERENCE (cat. 17s recto): Shelley 1993, pp. 189, 190 , 192.

17s recto

17s verso. *Aletsch Glacier from Eggishorn*

1870
Watercolor and graphite on off-white wove paper
Inscribed across top edge: ROTHHORN / 11532;
ALETSCHHORN / 12950; OLMENHORN /
10483; DREIECKHORN / 11766; at lower left:
FROM ÄGGISHORN [sic]; at lower center:
MIDDLE ALETSCH GLACIER
50.130.146s verso

17t. *Aletsch Glacier from Eggishorn*

July 10, 1870
Watercolor and graphite on off-white wove paper
Inscribed across center top: JUNGFRAU / 12827;
MONCH / 12609; TRUGBERG / 12107;
EIGER. /12240; WALLISER / 12460;
VIESCHER HÖRNER. / WANNEHORN. /
11442.; at bottom center: GREAT ALETSCH
GLACIER; at bottom right: Aletsch Gl. from /
Eggischhorn. [sic] / July 10. 1870
50.130.146t

Sargent devoted two sketchbook pages
(cats. 17s verso and 17t) to this splendid
view of the Aletsch Glacier, which Murray
calls one of the "most remarkable" of the
accessible glaciers in Switzerland (the others
being at Chamonix and Zermatt; *Switzer-
land and the Alps,* 14th ed., London, 1872,
p. xli). Sargent's detailed topographical
record of the grand sight is elaborated by
his meticulous identification of the various
peaks and their altitudes across the
panorama. Rubin suggests that this double-
page panorama demonstrates Sargent's
knowledge of similar images in contempo-
rary travel books (New York–Glens Falls
1991–93, p. 27).

Dr. Sargent recalled the excursion in a
letter to George Bemis: "At Bel-Alp oppo-
site Brieg . . . The Inn is quite comfortable
there, and if you feel inclined to visit the
largest glacier in Europe, you can easily do
so from the Bel-Alp—The Aletsch gla-
cier—an easy walk. The Aggishorn [sic]
hotel is also a tolerably comfortable inn,
with a fine view from the summit"
(Fitzwilliam Sargent to George Bemis,
Pontresina, Switzerland, August 8, [1873?],
quoted in New York–Glens Falls 1991–93,
p. 26).

A page from this sketchbook that con-
tains a graphite drawing of the Aletsch
Glacier is now in the Fogg Art Museum
(1937.8.15). See catalogue 17u for another
view from Eggishorn painted on the same
day.

EXHIBITION (cats. 17s verso and 17t): New
York–Glens Falls 1991–93, pp. 26–27.

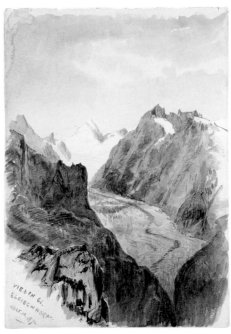

17u

17u. *Fiesch Glacier from Eggishorn*

July 10, 1870
Watercolor and graphite on off-white wove paper
Inscribed at lower left: VIESCH GL. /
EGGISCHHORN. [sic] / July 10. 1870
50.130.146u

See catalogue numbers 17s verso and 17t.

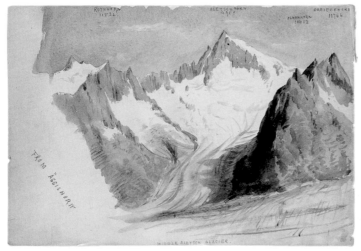

17s verso

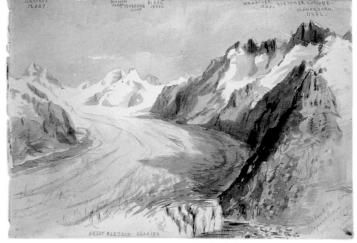

17t

17v

17v. *Alpine View, Mürren*

1870
Watercolor and graphite on off-white wove paper
50.130.146v

EXHIBITION: New York–Glens Falls 1991–93.

REFERENCE: Shelley 1993, p. 198.

17w recto. *Grimsel Pass*

July 14, 1870
Watercolor on off-white wove paper
Inscribed at lower right: GRIMSEL. / July 14.
1870
50.130.146w recto

Another watercolor painted in the vicinity of Grimsel, as Sargent and his father headed north from Zermatt, is catalogue 17g.

EXHIBITION: New York–Glens Falls 1991–93.

17w verso. *Handek Falls*

1870
Watercolor and graphite on off-white wove paper
50.130.146w verso

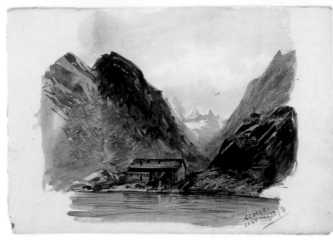

17w recto

17x. *Handek Falls*

1870
Watercolor and graphite on off-white wove paper
Inscribed at lower right: Handek
50.130.146x

The Murray guide ranks the falls at Handek second among Swiss waterfalls. It opines that it "combines a graceful shoot with great elevation; an abounding torrent, and a grand situation. It may be said to attain almost to perfection . . . but unfortunately it cannot be well seen" (*Switzerland and the Alps,* 14th ed., London, 1872, pp. xlii–xliii).

Sargent must have passed by Handek, which is in the vicinity of Grimsel, in mid-July (see cats. 17g and 17w).

EXHIBITION: New York–Glens Falls 1991–93.

REFERENCE: Shelley 1993, pp. 191, 192, 198.

17y. *Mountain*

1870
Graphite on off-white wove paper
50.130.146y

REFERENCE: Shelley 1993, p. 189.

17w verso

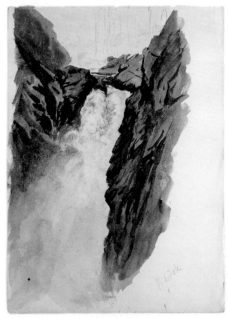

17x

17y

17z recto. *Gspaltenhorn, Mürren*

August 5, 1870
Watercolor and graphite on off-white wove paper
Inscribed across top: Lauterbrunnen Eiger;
Gspaltenhorn; Hundshorn; at middle right:
GSPALTENHORN. / MÜRREN. / Aug.5.
1870; at lower right: MÜRREN
50.130.146z recto

EXHIBITION: New York–Glens Falls 1991–93.

REFERENCE: Shelley 1993, pp. 194, 196, 197.

17z verso. *Fraulein Sterchi, Mürren*

1870
Watercolor and graphite on off-white wove paper
11 ¹¹⁄₁₆ × 8⅜ in. (29.7 × 21.3 cm) (originally pasted into
"Splendid Mountain Watercolours" sketchbook)
Inscribed at lower right: Fraulein Sterchi
50.130.146z verso

Notes in Rubin's research files indicate that
Fraulein Sterchi was the daughter of hotel-
iers in Mürren (departmental files, Ameri-
can Paintings and Sculpture).

EXHIBITION: New York–Glens Falls 1991–93.

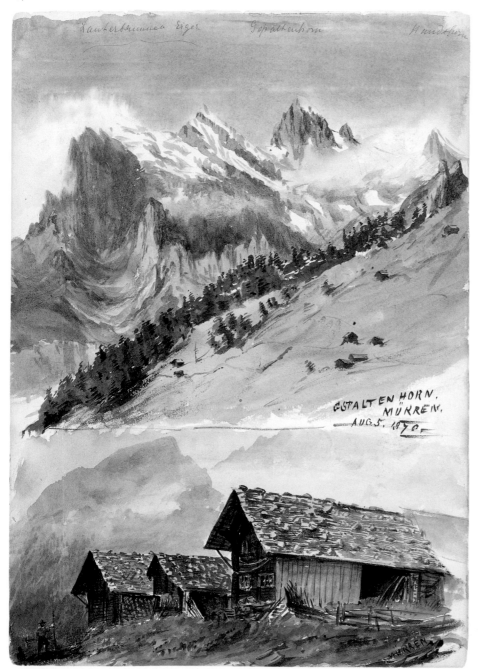

17z recto

17z verso

17aa recto. *Chalets, Breithorn, Mürren*

August 5, 1870
Watercolor and graphite on off-white wove paper
Inscribed at center right: BREITHORN.
MÜRREN / Aug. 5, 1870.; across center:
Grosshorn.; Breithorn.; Tschingelhorn
50.130.146aa recto

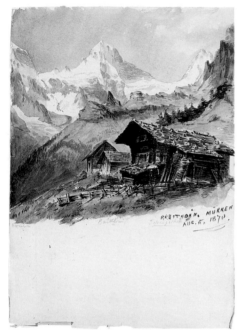

During his extended stay in Mürren, Sargent made several studies such as this one of characteristic architecture against a scenic alpine backdrop. Related works are catalogue numbers 17z recto, 17aa verso, 17oo recto, and 19 recto.

EXHIBITION: New York–Glens Falls 1991–93.

REFERENCE: Shelley 1993, p. 197.

17aa verso. *Chalets, Mürren*

1870
Watercolor on off-white wove paper
8⅜ × 11¾ in. (21.3 × 29.8 cm) (originally pasted into "Splendid Mountain Watercolours" sketchbook)
Inscribed at lower right: MÜRREN
50.130.146aa verso

17aa recto

17bb recto. *Jungfrau from above Mürren*

1870
Graphite on off-white wove paper
Inscribed at lower right: JUNGFRAU. / from above Murren
50.130.146bb recto

For other views of the Jungfrau, see catalogue numbers 16aa, 17b verso, and 17c recto.

REFERENCE: Shelley 1993, pp. 189, 192.

17bb verso. *Two Children in Interior, Mürren*

1870
Watercolor and graphite on off-white wove paper
11¹¹⁄₁₆ × 8⅜ in. (29.7 × 21.3 cm) (originally pasted into "Splendid Mountain Watercolours" sketchbook)
Inscribed at lower right on sketchbook page: Mürren
50.130.146bb verso

As in catalogue 17c verso, Sargent depicted the figures in a detailed interior. (See "Note to the Reader," page 67, regarding the sequence of 17cc).

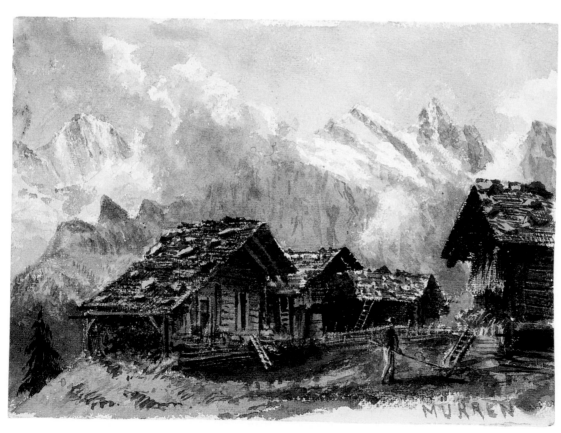

17aa verso

17bb recto

17bb verso

17dd. *Iselle from Mount Pilatus*

1870
Watercolor and graphite on off-white wove paper
Inscribed at lower right: from PILATUS
50.130.146dd

By September 1870, the Sargents had traveled back north from Mürren to Lucerne. Sargent and his father made an excursion to climb Mount Pilatus, which, according to Baedeker, had been "formerly one of the best-known of the Swiss mountains, [and] had for many years been superseded by the

Rigi, but since the last ten years it has again become one of the most frequented of the Swiss heights" (*Switzerland, and Adjacent Portions,* Coblenz, 1869 p. 52). Fitzwilliam Sargent recorded the memorable excursion in a letter:

John & I made a splendid and never-to-be-forgotten ascent of Pilatus (overnight there) and seeing the sunrise at 6 o'cl in the morning.—
 "Nor dim, nor red,—
 Like God's own head
 The Glorious sun uprist,"
out of a sea of clouds which tossed in mountainous masses against the grey rocks, of which a few shot out their snow-capped summits from out the white ocean. (Fitzwilliam Sargent to George Bemis, Florence, October 15, [1870], George Bemis Papers)

Of Sargent's images at Mount Pilatus (cats. 17ee, 17ff, and 17uu), only this watercolor and catalogue 22 aim to record the atmospheric effects described in Dr. Sargent's letter.

EXHIBITION: New York–Glens Falls 1991–93, pp. 42–43.

REFERENCE: Shelley 1993, p. 199.

17ee

17gg

17ff

17hh

17ee. *Mount Pilatus*

1870
Wax crayon on off-white wove paper
Inscribed at lower right: M^t. Pilatus.
50.130.146ee

See catalogue 17dd for a discussion of Pilatus.

REFERENCE: Shelley 1993, pp. 194, 195.

17ff. *Hotel Bellevue and Esel Peak, Mount Pilatus*

1870
Wax crayon on off-white wove paper
Inscribed at lower right: Pilatus
50.130.146ff

The site of this sketch, Esel Peak, was iden-tified by Rubin (departmental files, Ameri-can Paintings and Sculpture).

EXHIBITION: New York–Glens Falls 1991–93, p. 43.

17gg. *Dawn*

After Michelangelo Buonarroti, Italian, 1475–1564
1870
Graphite on off-white wove paper
50.130.146gg

See catalogue 18 (a page that was removed from this sketchbook) for a discussion of Sargent's interest in Michelangelo. In this quick sketch, made after the sculpture from the tomb of Lorenzo de Medici in the Medici Chapel, Church of San Lorenzo, Florence, the multiple contour lines around the head, left arm, and legs suggest the difficulty that the figure's pose presented for Sargent.

REFERENCE: Shelley 1993, p. 190.

17hh. *Child Holding Skull*

After Giovanni Francesco Barbieri, called
Il Guercino, Italian, 1591–1666
1870
Charcoal on off-white wove paper
Inscribed at lower center: Guercino
50.130.146hh

Catalogue 17hh is a copy after a drawing in the Uffizi Gallery, Florence, by the Baroque painter Guercino (1591–1666). Sargent may have copied it after his return to Florence in autumn 1870. However, the drawing was reproduced in an engraving as early as 1804, and Sargent could have known a reproduction.

The Guercino was first engraved by Stefano Mulinari (1741–after 1804), and was reproduced in *Istoria Pratica dell'incomincia-mento della Pittura o sia Raccolta di cinquanta stampe estratte da equale numero di disegni origi-nali esistenti nella R. Galleria di Firenze per la prima volta incise* (Florence, 1804).

EXHIBITION: New York–Glens Falls 1991–93.

REFERENCE: Shelley 1993, p. 190.

17cc recto. *Chalet, Mürren*

1870
Watercolor and graphite on off-white wove paper
Inscribed at center right: MÜRREN [in rectangular box]
50.130.146cc recto

17cc verso. *View from Schilthorn*

1870
Graphite on off-white wove paper
50.130.146cc verso

17ii recto. *View from Schilthorn*

1870
Graphite on off-white wove paper
Inscribed across lower center: TSCHINGEL-HORN / LAUTERBRUNNEN EIGER; GSPALTENHORN; BLUMLISALP; at lower right: From SCHILTHORN.
50.130.146ii recto

17ii verso. *Mountain View, Mürren*

1870
Watercolor and graphite on off-white wove paper
11¹¹⁄₁₆ × 8⅜ in. (29.7 × 21.3 cm) (originally pasted into "Splendid Mountain Watercolours" sketchbook)
Inscribed on verso: [illegible inscription in German]; at lower right on sketchbook page: Mürren
50.130.146ii verso

Although the sheets were accessioned in a different order (see "Note to the Reader," page 67), catalogue 17cc verso is the continuation of catalogue 17ii recto.

Baedeker describes the ascent of the Schilthorn as taking four and one-half hours, "partly over snow and slate-detritus, but free from danger." Once one arrives at the summit, the guide continues, "an extensive prospect is also obtained of the whole chain as far as the Blumisalp (or Frau), the Altels, many of the mountains of the Valais, the Rigi, the N. of Switzerland etc." (*Switzerland, and Adjacent Portions,* Coblenz, 1869, pp. 111–12). Sargent used delicate shading to suggest several of these peaks rising above the clouds.

REFERENCE (cat. 17ii recto): Shelley 1993, pp. 194, 200.

17cc recto

17ii verso

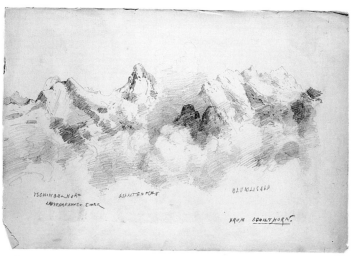

17cc verso 17ii recto

17jj recto. *Staubbach Falls*

1870
Watercolor and graphite on off-white wove paper
11 ¹¹⁄₁₆ × 8 ⁷⁄₁₆ in. (29.6 × 21.4 cm) (originally pasted into
"Splendid Mountain Watercolours" sketchbook)
Inscribed at lower right on sketchbook page: Staub-
bach
50.130.146jj recto

Staubbach Falls is near Lauterbrunnen, out-
side of Mürren. Baedeker calls Staubbach
"the most important" of the numerous
brooks in the region (*Switzerland, and Adja-
cent Portions*, Coblenz, 1869, p. 110).

17jj verso. *Wetterhorn, Grindelwald*

1870
Watercolor and graphite on off-white wove paper
11 ¹¹⁄₁₆ × 8 ⁷⁄₁₆ in. (29.7 × 21.4 cm) (originally pasted into
"Splendid Mountain Watercolours" sketchbook)
Inscribed at lower right: Wetterhorn. / Grindelwald
50.130.146jj verso

See catalogue 17b recto for another view of
the Wetterhorn.

17kk. *Matterhorn from Zmutt Glacier, Zermatt*

1870
Watercolor and graphite on off-white wove paper
Inscribed at lower right: Matterhorn / from Zmutt /
Glacier— / Zermatt.
50.130.146kk recto

Baedeker calls the Matterhorn "incon-
testably the chief boast of Zermatt"
(*Switzerland, and Adjacent Portions*, Coblenz,
1869, p. 270). Here Sargent focused on the
majestic peak, the very tip of which is
obscured by clouds.

The Matterhorn (altitude 14,692 feet) is
far more accessible today than it was when
Sargent visited the region. In 1996, the
annual average number of climbers who
succeeded in reaching the summit was esti-
mated to be three thousand (Baedeker,
Switzerland, New York, 1996, p. 469). In
1870, the peak must have retained a certain
mystique. The first ascent of the Matter-

horn was in July 1865—only five years
before the young Sargent painted there—
and it resulted in several deaths.

Another view from the Zmutt Glacier is
depicted in catalogue 17q. Other views of
the Matterhorn are catalogue numbers 17n
and 17o. A watercolor of the Matterhorn
that originally belonged to this sketchbook
is in the Fogg Art Museum (1937.2).

EXHIBITION: New York–Glens Falls 1991–93, p. 24.

REFERENCE: Shelley 1993, pp. 192, 196, 199, 203.

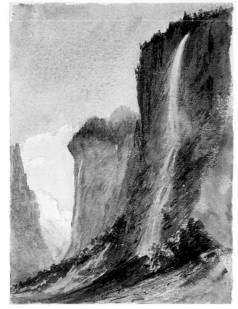

17jj recto

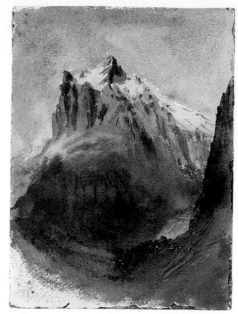

17jj verso

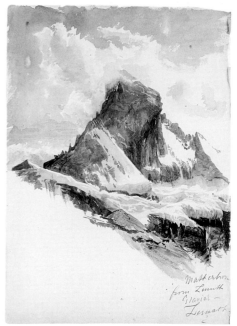

17kk

17ll verso

17ll verso. *Mountain Landscape*

1870

Graphite on off-white wove paper

*Inscribed at left with columns of numbers totaled with
the headings: John.; M. Moore.; J. S. S.; h.B.*

50.130.146ll verso

The recto of catalogue 17ll is blank.

17mm. *Gemmi Pass*

July 1, 1870

Wax crayon on off-white wove paper

Inscribed at lower right: GEMMI. / July 1. 1870

50.130.146mm

The Gemmi Pass (near Kandersteg and
Loèche-les-Bains) is one of the most
extraordinary Swiss alpine passes. From its
summit to the valley below, it plunges pre-
cipitously over 1,900 feet. Here the bold,
graphic style Sargent employed to record a
view of the steep, rocky slopes accentuates
the rugged and dramatic character of the
landscape.

 Mark Twain described his descent of the
pass in *A Tramp Abroad:*

*We began our descent, now, by the most remark-
able road I have ever seen. It wound in corkscrew
curves down the face of the colossal precipice,—a
narrow way, with always the solid rock wall at
one elbow, and perpendicular nothingness at the
other. . . . The path here was simply a groove cut
into the face of the precipice . . . [one] could look
out from this gallery and see a sheer summitless
and bottomless wall of rock before him. (A Tramp
Abroad, 1880; reprint, New York, 1997,
pp. 248–49)*

 Other views at Gemmi are catalogue
numbers 17k and 17l.

EXHIBITION: New York–Glens Falls 1991–93, p. 23.

17mm

17nn. *Bies Glacier and the
Weisshorn, Zermatt*

1870

Watercolor on off-white wove paper

Inscribed at center right: Bies Glacier & Weisshorn

50.130.146nn recto

See catalogue 17m for a sketch related to
this view of the Weisshorn.

EXHIBITION: New York–Glens Falls 1991–93.

REFERENCE: Shelley 1993, pp. 192, 193, 200.

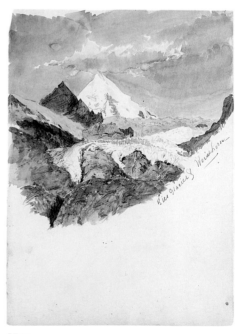

17nn

1700 recto

1700 verso

1700 recto. *Eiger from Mürren*

August 3, 1870
Watercolor and graphite on off-white wove paper
Inscribed at lower right: August 3ᵈ 1870. Mürren—
50.130.14600 recto

Sargent also depicted chalets against mountain scenery in Mürren in catalogue numbers 17aa recto, 17aa verso, and 19 recto. In catalogue 1700 recto, however, the chalets dominate the foreground and are cropped dynamically along the left edge. Sargent reserved the upper third of the sheet for sky. The resulting composition appears bolder and less crowded than his other images of chalets at Mürren.

The Eiger is one of the three peaks of the Jungfrau. See catalogue 16aa for a depiction of all three peaks—the Eiger, the Mönch, and the Jungfrau.

EXHIBITION: New York–Glens Falls 1991–93.

REFERENCE: Shelley 1993, pp. 192, 194, 196, 197, 198.

1700 verso. *Frau von Allmen, Mürren*

1870
Watercolor and graphite on off-white wove paper
11⅛ × 9¼ in. (29.6 × 23.5 cm) (originally pasted into "Splendid Mountain Watercolours" sketchbook)
Inscribed at lower right: Von Allmen— / Mürren; on verso at upper right: Madame Von Allmen / Mürren.
50.130.14600 verso

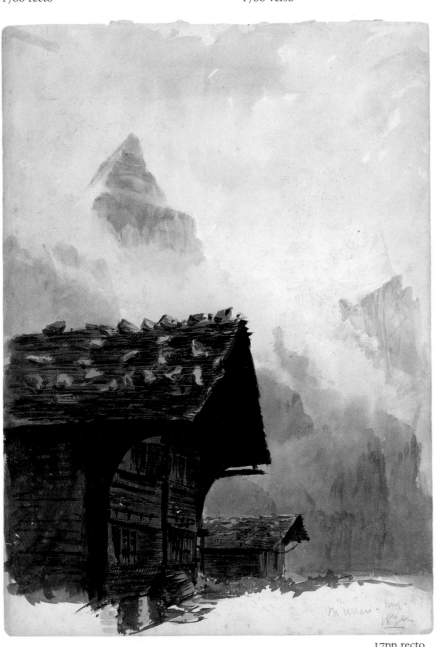

17pp recto

17pp verso

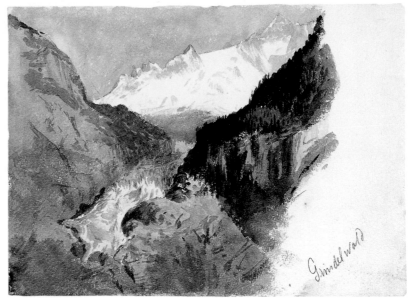

17qq verso

17qq recto

Frau von Allmen also appears in catalogue 17c verso. Here she is shown by herself against a dark backdrop, holding a book.

EXHIBITION: New York–Glens Falls 1991–93, p. 33.

17pp recto. *Chalets, Mürren*

August 4, 1870
Watercolor on off-white wove paper
Inscribed at lower right: Murren. Aug. 4 / 1870
50.130.146pp recto

This watercolor is similar in composition to catalogue 1700 recto. Here, however, the chalet in the foreground appears larger, and the mountain peak is obscured by clouds.

EXHIBITION: New York–Glens Falls 1991–93.

17pp verso. *Two Children in Landscape, Mürren*

1870
Watercolor and graphite on off-white wove paper
11 11/16 × 9 1/4 in. (29.7 × 23.5 cm) (originally pasted into "Splendid Mountain Watercolours" sketchbook)
Inscribed at lower right: MÜRREN
50.130.146pp verso

17qq recto. *Eismeer, Grindelwald*

1870
Watercolor and graphite on off-white wove paper
Inscribed at lower right: Eismeer / Grindel. / wald
50.130.146qq recto

Rubin's research notes indicate that this watercolor depicts the lower glacier at Grindelwald (departmental files, American Paintings and Sculpture). See also catalogue 17f recto.

EXHIBITION: New York–Glens Falls 1991–93.

17qq verso. *Grindelwald*

1870
Watercolor and graphite on off-white wove paper
11 3/4 × 8 3/8 in. (29.8 × 21.2 cm) (originally pasted into "Splendid Mountain Watercolours" sketchbook)
Inscribed at lower right: Grindelwald
50.130.146qq verso

Other images of Grindelwald are catalogue numbers 17f verso, 17jj verso, and 17qq recto.

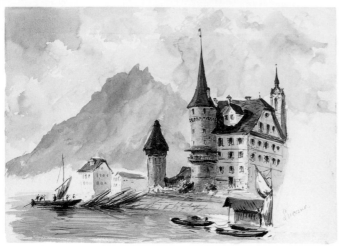

17rr recto

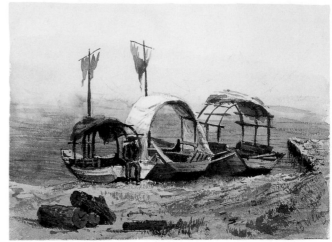

17rr verso

17rr recto. *Zur Gilgen House, Lucerne*

1870
Watercolor and graphite on off-white wove paper
Inscribed at lower right: Lucerne
50.130.146rr recto

Rubin's research notes identify this site on the banks of the Reuss River in Lucerne. Included in the view at right is the tower of Saint Peter's Church (built 1178), the oldest church in the city (departmental files, American Paintings and Sculpture).

EXHIBITION: New York–Glens Falls 1991–93, p. 42.

17rr verso. *Boats on Shore, Lake of Brienz*

1870
Watercolor and graphite on off-white wove paper
8⁷⁄₁₆ × 11¹¹⁄₁₆ in. (21.4 × 29.6 cm) (originally pasted into "Splendid Mountain Watercolours" sketchbook)
Inscribed at lower right: Brienz
50.130.146rr verso

The Lake of Brienz extends northeast from Interlaken. The Sargents spent about two weeks in Interlaken in late July, before heading to Mürren. They may also have passed along the lake on their way from Mürren to Lucerne toward the summer's end.

17ss recto. *View of Schreckhorn and Finsteraarhorn on the Way up to Faulhorn*

1870
Wax crayon and graphite on off-white wove paper
Inscribed at lower right: Way up to Faulhorn
50.130.146ss recto

See catalogue numbers 17ss verso and 17tt recto.

REFERENCE: New York–Glens Falls 1991–93, pp. 36–37.

17ss verso. *From Faulhorn*

September 3, 1870
Watercolor and graphite on off-white wove paper
50.130.146ss verso

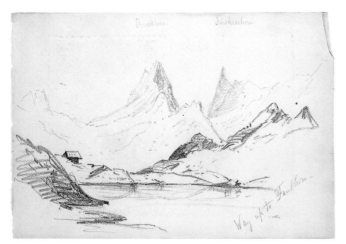

17ss recto

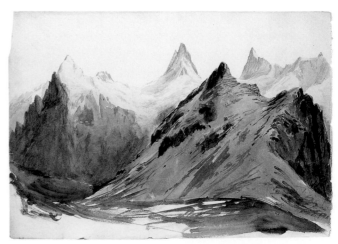

17ss verso

17tt recto. *From Faulhorn*

September 3, 1870
Watercolor and graphite on off-white wove paper
Inscribed at lower right: FROM FAULHORN /
SEPT. 3. 1870
50.130.146tt recto

Baedeker reports: "The Faulhorn . . . rising between the Lake of Brienz and the valley of Grindelwald . . . is a very favourite point of view, as it commands a fine survey of the giants of the Bernese Oberland" (*Switzerland, and Adjacent Portions,* Coblenz, 1869, p. 119). Sargent devoted two pages to the panoramic vista (cats. 17ss verso and 17tt recto). Unlike the double-page panorama of the Aletsch Glacier (cats. 17s verso and 17t), he eschewed the careful labeling of each peak. In general, he used broader washes (especially at right) to represent the shadowed peaks in this view from the Faulhorn.

Dr. Sargent recommended the magnificent scenery in a letter to George Bemis: "I should add to the above catalogue [of agreeable excursions] the Ascent of the Faulhorn from Grindelwald—which gives a most deliciously grand view of the Oberland peaks. . . . If you have not ascended the Faulhorn, you would be well repaid, if the weather should favor you. . . . How impressive is the effect of night gradually stealing over such a landscape as that one sees from the Faulhorn!—more impressive than the morning view, I think. I should immensely enjoy repeating my visit to that region" (Fitzwilliam Sargent to George Bemis, Pontresina, Switzerland, August 8, [1873?], quoted in New York–Glens Falls 1991–93, p. 37).

EXHIBITION (17ss verso and 17tt recto): New York–Glens Falls 1991–93, pp. 36–37.

REFERENCE (17ss verso and 17tt recto): Shelley 1993, pp. 198, 200.

17tt verso. *From Faulhorn*

1870
Watercolor on off-white wove paper
8⅜ × 11¹¹⁄₁₆ in. (21.2 × 29.7 cm) (originally pasted into "Splendid Mountain Watercolours" sketchbook)
Inscribed at lower right on sketchbook page: from Faulhorn
50.130.146tt verso

Sargent avoided his usual detailed style of representation in favor of broader washes to represent atmospheric perspective in this view.

EXHIBITION: New York–Glens Falls 1991–93.

REFERENCE: Shelley 1993, p. 203.

17uu. *Mount Pilatus, Stansstadt*

1870
Graphite on off-white wove paper
Inscribed at lower right: Pilatus from / Stansstadt.
50.130.146uu

Stansstad is a port on the Vierwaldstätter Lake, south of Lucerne near the base of Mount Pilatus. See catalogue numbers 17dd, 17ee, and 17ff for views from Pilatus.

17uu

17vv

17vv. *Mountain Sketches (inside back cover)*

1870
Graphite on off-white wove paper
50.130.146vv

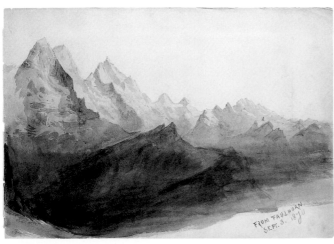

17tt recto

17tt verso

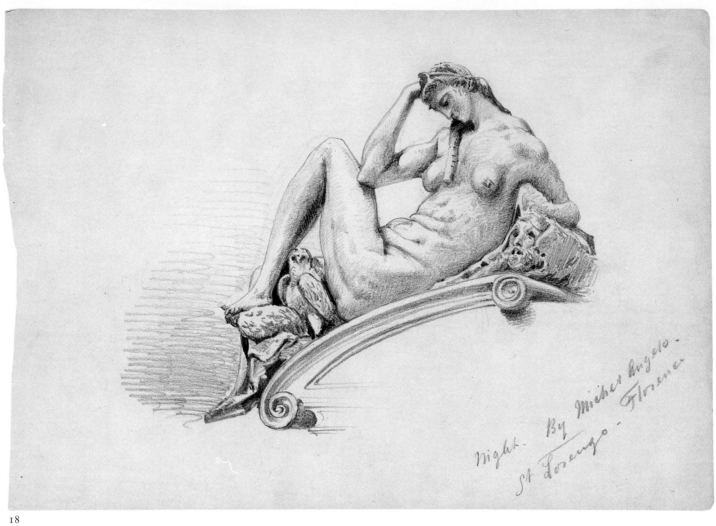

18

18. *Night*

After Michelangelo Buonarroti, Italian, 1475–1564
1870
Graphite on off-white wove paper
10¼ × 15¼ in. (27.3 × 38.7 cm)
Inscribed at lower right: Night. By Michel Angelo. /
St. Lorenzo. Florence
Gift of Mrs. Francis Ormond, 1950
50.130.143z

This sheet was originally bound into the *Splendid Mountain Watercolours* sketchbook (cat. 17). Since Sargent began using that sketchbook in May 1870 in Venice (after he had left Florence for the summer), he probably made this drawing from the sculpture (1519–34) by Michelangelo on the tomb of Giuliano de Medici in the Medici Chapel, Church of San Lorenzo, following his return to Florence in October. Sargent's drawing of Michelangelo's *Dawn,* from the tomb of Lorenzo de Medici in the same

chapel, remains in the sketchbook (cat. 17gg).

Sargent's copies of *Night* and *Dawn* were made at the time his parents sanctioned his intention to become an artist (Fitzwilliam Sargent to Emily Haskell Sargent, October 1870, see "Childhood and Youthful Works, 1856–74"). As an aspiring young painter, Sargent appreciated the role of the old masters in artistic education and the high esteem in which Michelangelo was held.

The sixteenth-century writer and artist Giorgio Vasari (1511–1574) was largely responsible for establishing Michelangelo's critical reputation. He asserted that Michelangelo surpassed the ancients partly by combining the study of nature with the study of the best examples of ancient and what he called "modern" art. Vasari's estimation of Michelangelo had a significant impact on art history: while Michelangelo's status rose and fell according to contemporary tastes, Vasari's notions about the artist's supremacy always fueled the debate.

Vasari's esteem for simultaneous study of nature, antiquity, and modern masters and his belief that Michelangelo was the exemplar of such study made the great Florentine an inevitable model for prospective artists. Young Sargent, born in Florence and residing there in the early 1870s, could not have escaped Michelangelo's influence.

Sargent had some trouble rendering the difficult pose of *Night.* He elongated her twisted torso and struggled to portray her left foot, both arms, and her head. Traces of adjusted contour lines can be seen in these areas of the drawing, but they are most evident along the left leg and right arm. Sargent studied her lower body straight on but shifted his vantage point for her upper body to show her head in profile (rather than in three-quarter view) and her left arm (which would be barely visible).

A drawing of the same subject is catalogue 52. Other drawings after the tomb are in an album in the Fogg Art Museum

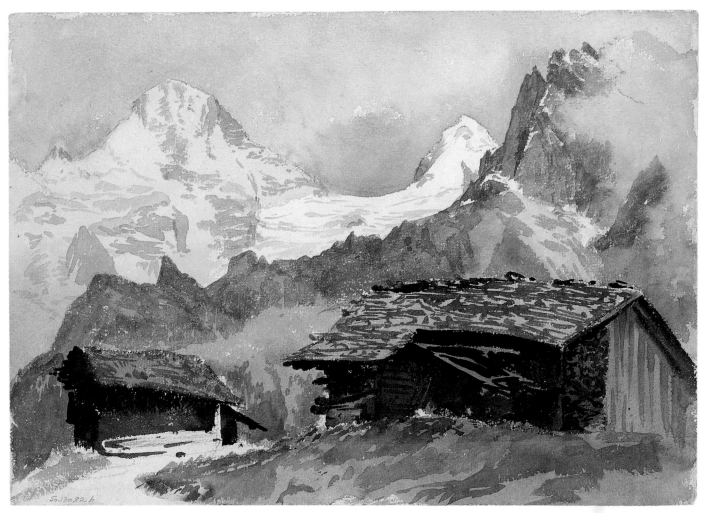

19 recto

(1943.1815.20). Sargent also pasted photographs of casts of *Night* and *Dawn* into his scrapbook (50.130.154).

See catalogue 8 for a discussion of Sargent's interest in ancient sculpture and its role in artistic training.

EXHIBITION: New York–Glens Falls 1991–93, p. 44.

REFERENCE: Shelley 1993, p. 190.

19 recto. *Chalets, Breithorn, Mürren*

1870
Watercolor and graphite on white wove paper
8⅜ × 11⅝ in. (21.2 × 29.5 cm)
Gift of Mrs. Francis Ormond, 1950
50.130.82b recto

19 verso. *Gottlieb Feutz, Mürren*

1870
Watercolor and graphite on off-white wove paper
11⅝ × 8⅜ in. (29.5 × 21.2 cm)
Inscribed at upper right: 1870
Gift of Mrs. Francis Ormond, 1950
50.130.82b verso

While he was in Mürren, Sargent made a series of studies of the characteristic architecture against scenic alpine backgrounds (cats. 17aa recto and verso, 1700 recto). He would return to this subject during visits to similar regions about 1909–11 (see figure 9).

The sitter portrayed on catalogue 19 verso is identified on the basis of catalogue 16gg, which is inscribed "Gottlieb Feutz / Mürren." An additional related drawing is catalogue 16ff.

This sheet and catalogue numbers 20 and 21 appear to have come from the same

19 verso

20 recto

20 verso

20 verso. *Mountains and Stream, Faido*

1870
Watercolor and graphite on off-white wove paper
11⅝ × 8¼ in. (29.6 × 21 cm)
Inscribed at lower right: Faido
Gift of Mrs. Francis Ormond, 1950
50.130.82c verso

Faido is on the road to the St. Gotthard Pass. The Sargents went through the village when they crossed the pass in early June 1870 on their way from Florence to Lucerne. They could have traveled through Faido again in October. In this watercolor, one of the freest and most spontaneous of the trip, Sargent wet the paper and used loose brush strokes for the trees and landscape.

block as many of the drawings that are pasted into the *Splendid Mountain Watercolours* sketchbook (cat. 17).

EXHIBITIONS (cat. 19 recto): "Grand Reserves," The New York Cultural Center, New York, October 24–December 8, 1974, cat. 89, as *Snow Capped Mountains and Chalets;* New York–Glens Falls 1991–93.

20 recto. *Eiger*

1870
Watercolor on off-white wove paper
11⅝ × 8¼ in. (29.6 × 21 cm)
Inscribed at lower right: EIGER
Gift of Mrs. Francis Ormond, 1950
50.130.82c recto

The Eiger is between Mürren and Grindelwald. While visiting this region in August 1870, Sargent studied the mountain from multiple viewpoints, under different atmospheric conditions, and in a variety of media, creating a group of drawings with varying degrees of finish (cats. 16s recto, 16y, 16aa, 17z recto, 17oo recto, 21, and 23).

This sheet and catalogue numbers 19 and 21 appear to have come from the same block as many of the drawings that are pasted into the *Splendid Mountain Watercolours* sketchbook (cat. 17).

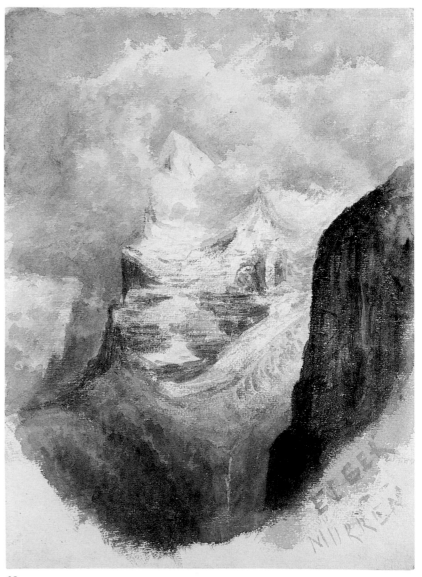

21

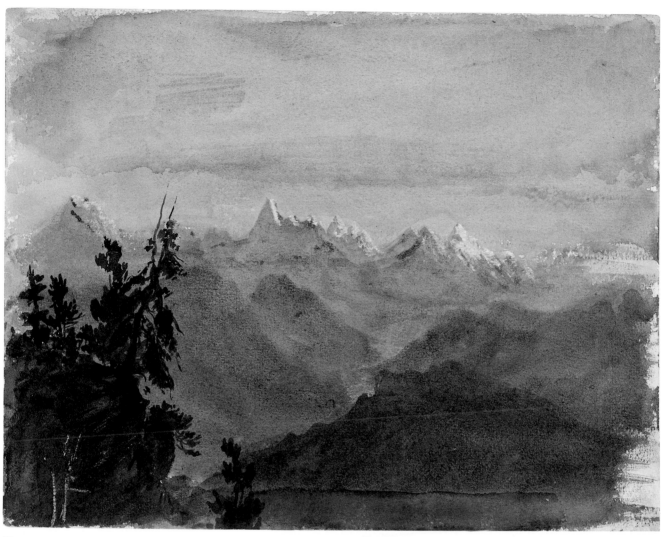

22

21. *Mürren*

1870

Watercolor on off-white wove paper

11¾ × 8⅜ in. (29.8 × 21.3 cm)

Inscribed at lower right: EIGER / MURREN; on verso at lower left: EWS; at lower center: 1870 — or 71

Gift of Mrs. Francis Ormond, 1950

50.130.82d

Sargent studied the Eiger from the same vantage point that he used for catalogue 20 recto, but he did so under different atmospheric conditions. In catalogue 21 the peak is partially covered by clouds, and Sargent carefully recorded the rock formations and shadows on the face of the mountain.

This sheet and catalogue numbers 19 and 20 appear to have come from the same block as many of the drawings that are pasted into the *Splendid Mountain Watercolours* sketchbook (cat. 17).

22. *View from Mount Pilatus*

1870

Watercolor on white wove paper

8⅜ × 11⅝ in. (21.2 × 29.6 cm)

Inscribed on verso at upper right: Pilatus 1870

Gift of Mrs. Francis Ormond, 1950

50.130.82e

Mount Pilatus is just south of Lucerne, which the Sargent family visited in early June 1870 for several days and again in early September for two weeks. In September, Sargent and his father climbed Mount Pilatus. Young Sargent made several drawings and watercolors to record the event, and Fitzwilliam Sargent described the memorable excursion in a letter to George Bemis (cat. 17dd).

Other depictions of or from Mount Pilatus include catalogue numbers 17dd, 17ee, 17ff, and 17uu.

EXHIBITION: New York–Glens Falls 1991–93.

REFERENCE: Shelley 1993, p. 203.

23

23. *Eiger from Mürren*

August 30, 1870
Graphite on off-white wove paper
12¹⁵⁄₁₆ × 9½ in. (32.8 × 24.1 cm)
Inscribed at lower left: J.S. 379; at lower right:
EIGER. / MÜRREN. AU[G?] / 30,187[0?];
on verso at upper right: 354; at left center: EP
Gift of Mrs. Francis Ormond, 1950
50.130.141v

Although the dated inscription at the right
edge is partially lost, catalogue 23 must date
from 1870, when Sargent executed his stud-
ies of the Eiger (cats. 16s recto, 16y, 16aa,
17z recto, 17oo recto, 20 recto, and 21).
This graphite drawing, the most precise of
the group, seems to reflect a similar vantage
point as catalogue numbers 20 recto and 21.
In catalogue 17oo recto, the same view
serves as a backdrop for chalets.

EXHIBITIONS: Probably included in New York
1928 (inventory listing J.S. 379); New York–Glens
Falls 1991–93, p. 32.

REFERENCE: Shelley 1993, p. 192 (identified by for-
mer accession number, 50.130.141z).

24. *Thistle*

ca. 1870–72
Watercolor and graphite on off-white wove paper
6⅝ × 4⁹⁄₁₆ in. (16.8 × 11.6 cm)
Inscribed on verso at center right: EP
Gift of Mrs. Francis Ormond, 1950
50.130.141w

Sargent recorded the plant's form, except
for the blossom, with a precise graphite
underdrawing and then filled it in using a
fairly fluid watercolor technique. The blos-
som's fine details are meticulously painted
in watercolor with short, accurate brush-
strokes. This fastidious execution and
fidelity to nature suggest an early date.
However, Sargent's use of the more
advanced technique of leaving the brightest
highlights in reserve may indicate a date
slightly later than the similar, carefully
painted *Lilies* (cat. 9c) from 1869.

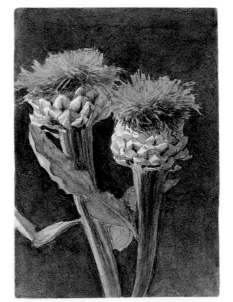

24

25

25. *Palamedes Palamedesz*

After Anthony Van Dyck, Flemish, 1599–1641
ca. 1871–72
Graphite and gouache on tan wove paper
11⅝ × 8⅞ in. (29.5 × 22.5 cm)
Inscribed at lower right corner: Van Dyck; on verso
at center bottom edge: CP
Gift of Mrs. Francis Ormond, 1950
50.130.143q

Van Dyck's portrait is in the Alte
Pinakothek in Munich, a city Sargent is
sure to have visited in 1867, 1869, 1871,
and 1872. But the high degree of finish and
detailing in the drawing suggests that
Sargent may have made it from a print, of
which there are numerous examples.
Sargent's technique of modulating black
and white is more competent here than in
his copies of the late 1860s; thus a date
about 1871–72 seems likely.

Catalogue Numbers 26–33

The following nine drawings, all with approximately the same measurements, seem to come from the same sketchbook, most likely Fogg 1937.7.5, which chronicles Sargent's family's activities in June 1871. They had spent winter 1870–71 and spring 1871 in Florence, departing that city on June 8 and heading north to Innsbruck, Austria, to pass the summer in the Alps. The Metropolitan's sheets record several sites in Florence and northern Italy.

26 recto. *Seated Girl (Katy Eyre?)*

1871
Graphite on off-white wove paper
6¾ × 4 1/16 in. (17.2 × 10.4 cm)
Gift of Mrs. Francis Ormond, 1950
50.130.141a recto

Katy Eyre was the daughter of an expatriate family also living in Florence during this period. She is identified in catalogue 26 recto on the basis of a related drawing depicting her and her sister Virginia (private collection; see Ormond 1970a, fig. 5). That much larger sheet (9¼ × 14¼ in.) is inscribed "June 4, 1871," four days before the Sargents left Florence for the summer.

26 verso. *Tomb?*

1871
Graphite on off-white wove paper
6¾ × 4 1/16 (17.2 × 10.4 cm)
Gift of Mrs. Francis Ormond, 1950
50.130.141a verso

Catalogue 26 verso is only partially realized with very pale graphite lines. At the upper center an arch or vault is indicated, beneath which is an ornamented horizontal element surmounted by a suggestion of a reclining figure. The drawing may represent a funerary monument or tomb similar to that in catalogue 32, perhaps something that Sargent saw in Florence or during his travels.

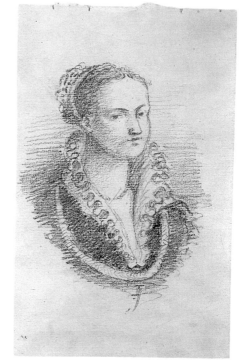

27

27. *Portrait of a Woman*

1871
Graphite on off-white wove paper
6¾ × 4 1/16 in. (17.2 × 10.4 cm)
Gift of Mrs. Francis Ormond, 1950
50.130.141b

Catalogue 27 may be a copy after a painting that Sargent encountered in or around Florence or during his travels in the summer of 1871. Katharine Baetjer, curator of European Paintings, The Metropolitan Museum of Art, has suggested that the source is Venetian (oral communication, January 29, 1998).

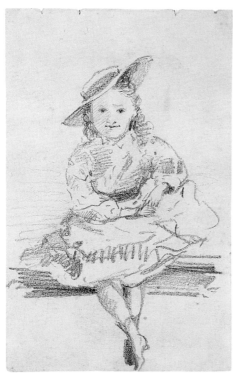

26 recto

26 verso

28

28. *Helmet, Bargello, Florence*

June 1871
Graphite on off-white wove paper
6¾ × 4¹⁄₁₆ in. (17.2 × 10.4 cm)
Inscribed across bottom: Helmet / Bargello Florence.
June 1871; on verso at upper left: Cathedral /
Florence / June 7 / 71
Gift of Mrs. Francis Ormond, 1950
50.130.141c

Sargent recorded a famous composite
Renaissance helmet formerly in the Medici
armory and transferred to the Museo
Nazionale del Bargello, Florence, at its
founding in 1856. Assembled in the sixteenth
century using a fifteenth-century gilt-copper
eagle crest, the helmet is ceremonial rather
than utilitarian. Sargent also drew other
chivalrous subjects (cats. 7, 32, and 68).

The inscription on the verso must have
pertained to the drawing on the following

sketchbook page, which is probably cata-
logue 29, *Lectern, Cathedral, Florence*.

Stuart W. Pyhrr, Arthur Ochs Sulzberger
Curator in Charge, Arms and Armor, The
Metropolitan Museum of Art, identified
the subject of this drawing (memorandum,
July 11, 1997, departmental files, American
Paintings and Sculpture).

29. *Lectern, Cathedral, Florence*

June 1871
Graphite on off-white wove paper; illegible water-
mark at lower right,
6¾ × 4¹⁄₁₆ in. (17.2 × 10.4 cm)
Gift of Mrs. Francis Ormond, 1950
50.130.141d

The day before he left Florence, Sargent
drew a lectern in the duomo, with a view of
the transept in the background.

A dated inscription pertaining to this
drawing is on the verso of catalogue 28:
"Cathedral / Florence / June 7 / 71."

30. *Door of Campanile, Florence*

June 1871
Graphite on off-white wove paper
6¾ × 4¹⁄₁₆ in. (17.2 × 10.4 cm)
Inscribed at lower right: Door of Campanile /
Florence / June 71
Gift of Mrs. Francis Ormond, 1950
50.130.141g

The campanile, or bell tower, is adjacent to
the duomo in the heart of Florence. View-
ing the door from the cathedral, Sargent
accurately recorded its ornament and sculp-
tures, ignoring the ornate architecture of
the campanile itself.

31. *Tomb of Antenore, Padua*

June 9, 1871
Graphite on off-white wove paper
6¾ × 4¹⁄₁₆ in. (17.2 × 10.4 cm)
Inscribed at upper right: Tomb at / Padua /
June 9–71
Gift of Mrs. Francis Ormond, 1950
50.130.141e

An inscription on folio 29 verso in Fogg
sketchbook 1937.7.5 records that the family
took the train from Florence to Bologna on
June 8. As this drawing and catalogue 32
indicate, they reached Padua by the follow-
ing day. By June 12 they were at the Bren-
ner Pass (cat. 33), on the border between
Italy and Austria.

The Tomb of Antenore was built in the
late thirteenth century. According to the
Roman poet Virgil, Antenore, the mythical
king of Troy, founded Padua (*Aeneid* 1.242).
Sargent's casual inscription on the sheet,
"Tomb at / Padua," suggests that he was
captivated less by the mythical and histori-
cal implications of the monument than by
its form and its function as a gathering place
for local characters, some of whom he
depicted, with baskets and other parapher-
nalia, at its base.

29

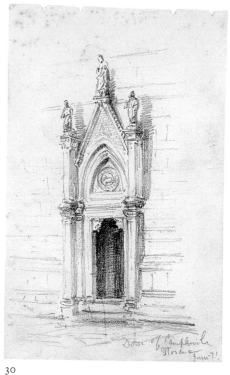

30

31

32. *Tomb of a Knight, Basilica of San Antonio, Padua*

June 9, 1871
Graphite on off-white wove paper
4¹/₁₆ × 6¹¹/₁₆ in. (10.4 × 17 cm)
Inscribed at lower right: Tomb of a Knight / Padua.
/ June 9–71
Gift of Mrs. Francis Ormond, 1950
50.130.141f

South of the Tomb of Antenore in Padua (cat. 31) stands the important basilica of San Antonio, begun in 1232 and completed in the fourteenth century. Built to accommodate the tomb of Saint Anthony of Padua, the basilica houses many masterpieces of Gothic and early Renaissance art, including a sculptural ensemble on the high altar by Donatello (1386?–1466), whose work interested Sargent later in his career (Fogg 1937.7.3, 1937.8.55, and 1937.8.8). In catalogue 32 Sargent recorded the tomb of a knight, Federico da Lavellongo, near the south door of the church. The tomb, dated 1373, shows a sculpted effigy atop a richly carved base that includes small figures in niches. It is surmounted by a fresco depicting

the Virgin and Child surrounded by saints. Sargent concentrated on the three-dimensional elements of the monument, the effigy and base; the fresco above is only roughly sketched in and is cropped by the top edge of the page.

Nicole Carnevale, intern, Medieval Art, The Metropolitan Museum of Art, identified the tomb (memorandum, 1997, departmental files, American Paintings and Sculpture).

32

33

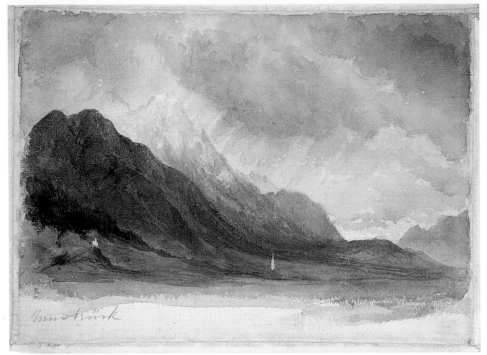

34

33. *On the Brenner*

June 12, 1871
Graphite on off-white wove paper
6⁷⁄₁₆ × 4 in. (16.3 × 10.3 cm)
Inscribed at lower right: On the / Brenner / June 12.71
Gift of Mrs. Francis Ormond, 1950
50.130.141k

The top edge of catalogue 33 has been
trimmed to remove the traces of the
sketchbook binding; this accounts for the
discrepancy of sheet size from the previous
examples, which also belonged to Fogg
sketchbook 1937.7.5. Another drawing of
the Brenner can be found on folio 14 of
that book. According to Murray's *Handbook
for Travellers in Southern Germany*, the Bren-
ner Pass was "the lowest carriage-road over
the main chain of the Alps" (9th ed., Lon-
don, 1864, p. 307). The guidebook also
notes the medieval castles that lined the
route, one of which Sargent recorded here.

34. *Innsbruck*

1871
Watercolor and gouache on off-white wove paper
11¹⁄₁₆ × 15½ in. (28 × 39.3 cm) (slightly irregular)
*Inscribed at lower left: Innsbrück [sic]; on verso at
upper left: Innsbruck 1871; at lower left: EWS*
Gift of Mrs. Francis Ormond, 1950
50.130.82f

Sargent visited Innsbruck in 1869, 1871,
and 1872. While not in Sargent's hand,
the inscription on the verso of this sheet,
"Innsbruck 1871," may be correct. The
style and technique of this watercolor sup-
port such a date.

In subject and composition, this water-
color resembles catalogue 40, which also
probably depicts Innsbruck and may have
originally belonged to a sketchbook Sargent
used during the summer of 1871 (Fogg
1937.7.8).

35. *Mountains*

ca. 1871
Graphite on brown wove paper
11⁷⁄₁₆ × 16¹⁄₁₆ in. (29 × 40.8 cm)
Inscribed on verso at center right: 1871
Gift of Mrs. Francis Ormond, 1950
50.130.85

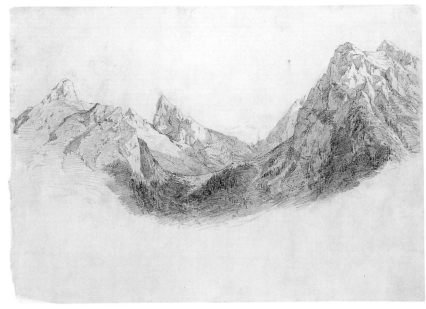

35

36. Cows and Goats, Boy Milking

1871
Graphite on buff wove paper
11 7/16 × 15 11/16 in. (29 × 39.9 cm)
Inscribed at lower right corner: Hintersee;
on verso: NS
Gift of Mrs. Francis Ormond, 1950
50.130.142m

37. Tyrolean Man

1871
Graphite on off-white wove paper
11 3/8 × 15 7/8 in. (29 × 40.4 cm)
Inscribed on verso at lower right: EP
Gift of Mrs. Francis Ormond, 1950
50.130.141cc

36

Catalogue numbers 36 and 37 seem to come from the same sketchbook, possibly Fogg 1937.7.4 (*Zitterthal* [sic] *Bavarian Highlands /1871*). In addition to matching that sketchbook in size, they have corresponding stains near the center. The model depicted in catalogue 37 appears in a third drawing, in the Museum of Fine Arts, Boston, in two different vignettes: in Tyrolean costume seated at a table in a three-quarter frontal view and sitting on a rock (29.487). The Boston drawing also corresponds in sheet size and contains a similar stain near the center.

The inscription "Hintersee" on catalogue 36 links that drawing to a group of loose sheets executed at the same site, namely three drawings that seem to have belonged to the Fogg sketchbook: *Rocks and Brush, Hintersee* (inscribed "Hintersee / Aug. 1871"; Corcoran Gallery of Art); *Landscape Studies* (inscribed "Hintersee"; Philadelphia Museum of Art); and *Sketch of a Tree* (inscribed "Hintersee / Aug. 27 1871"; Museum of Fine Arts, Boston). An additional drawing, catalogue 38, is inscribed "Hintersee," but it does not belong to the Fogg sketchbook.

Nygren notes that Hintersee is a fairly common place name in Germany and Austria. He suggests that the Hintersee depicted by Sargent is not far from Ramsau, Germany, because of a related drawing in the Corcoran Gallery of Art (49.101) that is inscribed simply "Ramsau Sept. 4 / 1871" (Nygren 1983, pp. 38–39). However, Sargent and his family spent the summer of 1871 in the environs of Innsbruck and the Zillerthal Alps in the Tyrol, not in Germany. There is a village named Ramsau about forty kilometers east of Innsbruck, near Zillerthal in the Tyrol. There is also a Hintersee about forty kilometers east of Ramsau in the Tyrol. Sargent could have made these sketches at any of these sites.

37

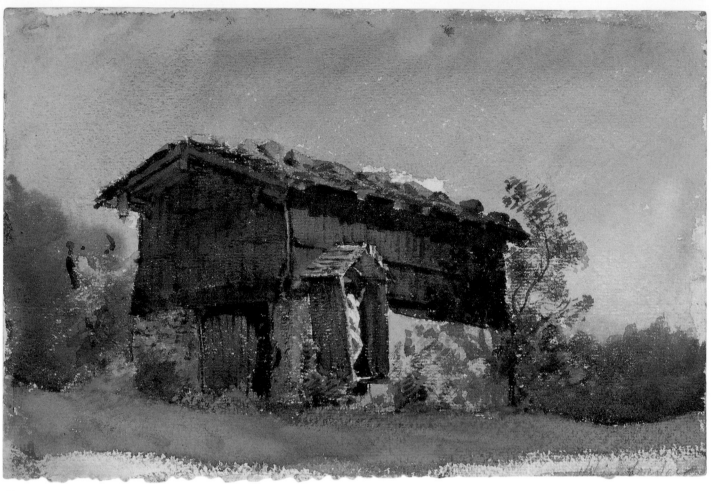

38

38. *Tyrolean Shrine*

1871
Watercolor and graphite on white wove paper
6¾ × 10¹⁄₁₆ in. (17 × 25.6 cm)
Inscribed at lower right: Hintersee; on verso at upper
right: Hintersee 1871; at lower center: Tyrolean
Shrine / Tyrol (?); at lower right: EWS
Gift of Mrs. Francis Ormond, 1950
50.130.82a

This watercolor is inscribed "Hintersee," a
place where Sargent sketched in August 1871
(cats. 36 and 37). Sargent's success in depict-
ing sunlight, shadows, and texture across the
shrine make this one of his most attractive
and accomplished early watercolors.

39 recto. *Chalets*

July 1871
Graphite on off-white wove paper
4 × 13⅜ in. (10.2 × 34 cm)
Inscribed at lower right: 1871
Gift of Mrs. Francis Ormond, 1950
50.130.141j recto

39 verso. *Zillerthal*

July 1871
Graphite on off-white wove paper
4 × 13⅜ in. (10.2 × 34 cm)
Inscribed at lower right: Zillerthal / July 1871
Gift of Mrs. Francis Ormond, 1950
50.130.141j verso

Catalogue 39 recto originally comprised
two consecutive pages from a sketchbook.
On the verso, Sargent composed a
panoramic view of mountains at Zillerthal,
extending the drawing across what was the
binding (indicated by the holes at the cen-
ter) while the pages were still in the sketch-
book. This sheet comes from a book in the
Fogg Art Museum (1937.7.8) and was
removed before the pages in that book
were numbered. It fits between folios 13
and 14 under the current pagination. Folio
14 of the sketchbook contains the musical
score whose counterproof is found on the
left side of catalogue 39 recto. The pictur-
esque architecture depicted at right is char-
acteristic of Sargent's interests and style
during this period.

For the chronology of the summer of
1871, see catalogue numbers 26 to 33, a
group of sheets from Fogg sketchbook
1937.7.5, which Sargent used before Fogg
sketchbook 1937.7.8.

40. *Mountains, Clouds, and Lake*

1871

Watercolor and graphite on light gray wove paper

4 × 6⅝ in. (10.2 × 16.8 cm)

Inscribed at center: light; on verso at center: fr. book / 1871–72

Gift of Mrs. Francis Ormond, 1950

50.130.141l

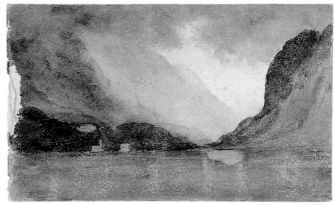

40

Like catalogue 39, this page may come from Fogg sketchbook 1937.7.8. Folio 25 verso in that book seems to contain the counterproof of catalogue 40. See catalogue numbers 45 and 46 for a discussion of circumstantial evidence regarding the inscription, which may also suggest that this page is from Fogg sketchbook 1937.7.8.

A drawing in another Fogg sketchbook (figure 46) has a composition similar to this watercolor and is inscribed "Innsbruck / June 13, 1871." In catalogue 40, Sargent replaced the details of the carefully rendered topographical drawing with broad general washes to suggest atmosphere and distance. See catalogue 34 for a comparable work.

Figure 46. *Mountain Landscape, Innsbruck, Austria,* June 13, 1871. Watercolor and white gouache over graphite on gray wove paper, 4¹⁄₁₆ × 6¾ in. (10.3 × 17.2 cm). Fogg Art Museum, Harvard University Art Museums, Cambridge, Gift of Mrs. Francis Ormond (1937.7.5.16, recto). © President and Fellows of Harvard College, Harvard University; photograph courtesy of Photographic Services

39 recto

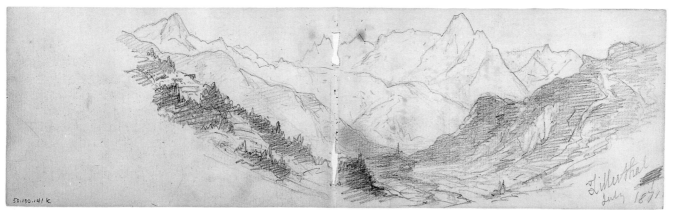

39 verso

41

1871–74
Pen and ink and graphite on off-white wove paper
7¾ × 5¼ in. (19.7 × 13.3 cm)
Inscribed at lower left: ala!
Gift of Mrs. Francis Ormond, 1950
50.130.141t recto

1871–74
Graphite on off-white wove paper
7¾ × 5¼ in. (19.7 × 13.3 cm)
Inscribed at lower left: EP
Gift of Mrs. Francis Ormond, 1950
50.130.141t verso

42 recto

42 verso

41. *Mystical Marriage of Saint Catherine Attended by Doge Francesco Donato*

After Jacopo Robusti, called Tintoretto, Italian, ca. 1518–1594
Early 1870s
Pen and ink and graphite on tracing paper
10⅝ × 17⅛ in. (27 × 43.5 cm)
Inscribed at lower left corner: C Naya / 759; at center right edge: VT / PRUD
Gift of Mrs. Francis Ormond, 1950
50.130.143h

In considering Sargent's many copies after works of art, it is often difficult to determine whether he studied the original work or created his image from a photograph or other reproduction. Although Sargent probably saw Tintoretto's *Mystical Marriage of Saint Catherine* in its original location in the Sala del Collegio of the Palazzo Ducale in Venice, he made this drawing after a photograph, which he may even have traced. The inscription at the lower left, "C Naya / 759," refers to Carlo Naya (1816–1882), a Venetian photographer whose principal subjects were Venice and its artworks. Naya operated primarily from a shop in Piazza San Marco, but his photographs were sold throughout Europe. The number 759 in

the inscription indicates the negative order number, which is confirmed by a catalogue from Naya's shop (*Catalogue général des photographies publiées par C. Naya,* n.p., n.d.). According to this catalogue of about 1885 (Thomas J. Watson Library, The Metropolitan Museum of Art), this image was available in two sizes: *grand format* (27 × 35 cm) or *format plaque* (18 × 24 cm). In Sargent's drawing, the borders of the image are demarcated to measure 26.2 × 35.5 cm, which approximates the *grand format.*

Sargent collected photographs from an early age. In a letter to Ben del Castillo, the thirteen-year-old artist wrote: "Ma gave me a large album of white Roman binding to stick photographs in, and I have stuck in about 60 of Rome and a great many of Naples." His collecting efforts included photographs of works of art. As he continued to del Castillo, "I will get some photographs of the Museum at Munich, where there are some very beautiful statues" (JSS to Ben del Castillo, Sorrento, May 23, 1869, quoted in Charteris 1927, pp. 11–12). A scrapbook in the Metropolitan (50.130.154) shows that he continued this habit through the 1870s and probably thereafter. Another drawing in the Metropolitan's collection after a photograph is catalogue 144.

For Sargent's interest in Tintoretto, see catalogue numbers 50, 51, 56, and 57.

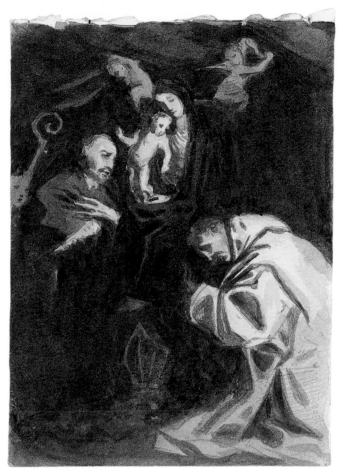

43

43. *Holy Family and a Monk (from scrapbook)*

Early 1870s
Watercolor and graphite on off-white wove paper
6¼ × 4½ in. (15.9 × 11.4 cm)
Gift of Mrs. Francis Ormond, 1950
50.130.154ll

Catalogue 43 seems to be a copy after an unknown painting or altarpiece. A date in the early 1870s seems likely because of the watercolor's technique and its inclusion in the scrapbook that contains material from this period.

44 recto. *House, Hammer*

May 1872
Graphite on off-white wove paper
4⁷⁄₁₆ × 6 in. (11.2 × 15.2 cm)
Inscribed at lower right: Hammer / May 1872
Gift of Mrs. Francis Ormond, 1950
50.130.141p recto

44 verso. *Woman with a Basket*

1872
Watercolor and graphite on off-white wove paper
4⁷⁄₁₆ × 6 in. (11.2 × 15.2 cm)
Inscribed at right: black / yellow / dark red
Gift of Mrs. Francis Ormond, 1950
50.130.141p verso

This sheet comes from a sketchbook in the Fogg Art Museum ("1872"; 1937.7.7). Like catalogue 44 recto, folios 21 and 22 of the Fogg sketchbook are inscribed "Hammer / May 1872." Several other pages of the Fogg sketchbook contain studies of peasant women similar to catalogue 44 verso.

Hammer is a small town near the German-Austrian border, between Munich and Salzburg. The Sargent family spent the winter of 1871–72 in Dresden, where the harsh weather took its toll on Emily's health. As Fitzwilliam Sargent explained in a letter to his sister, the family traveled to Carlsbad, a renowned spa, "in search of health from Dresden, or rather from Berlin whither we went from Dresden" (Fitzwilliam Sargent to Anna Maria Low, Carlsbad, Bohemia, May 30, 1872, Fitzwilliam Sargent Papers). Since the family spent most of May and

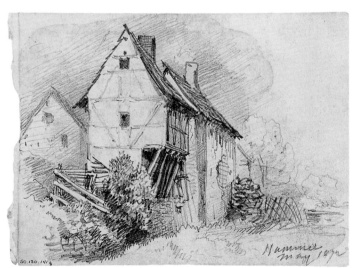

44 recto

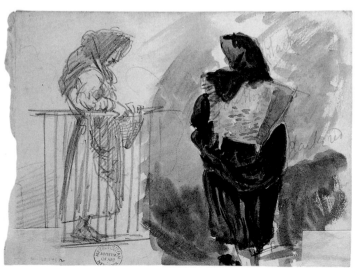

44 verso

early June in Carlsbad, they must have passed through Hammer at the beginning of May.

REFERENCE: Nygren 1983, p. 44.

45. *Men; Landscape with Pines, Certosa*

November 1872
Graphite on dark gray-green wove paper
4¹⁄₁₆ × 6¾ in. (10.3 × 17.1 cm)
Inscribed at lower left: Certosa / Nov. 1872; on verso at center: from book 1871–72
Gift of Mrs. Francis Ormond, 1950
50.130.141h

46. *Pines*

1872
Graphite on gray-green wove paper
4¹⁄₁₆ × 6¹¹⁄₁₆ in. (10.3 × 17 cm)
Inscribed on verso at center: from book 1871–72
Gift of Mrs. Francis Ormond, 1950
50.130.141i

The dimensions of catalogue numbers 45 and 46 suggest that they were originally part of a sketchbook now in the Fogg Art Museum (1937.7.8). Additional evidence also connects them with that sketchbook. Many of Sargent's sketchbooks are labeled with stickers affixed to the front cover that usually identify the book with a date (but sometimes a title; see cat. 17, *Splendid Mountain Watercolours* sketchbook). The

handwriting is not Sargent's. These labels appear to have been made after Sargent's death, during the process of sorting and identifying the sketchbooks. This task was performed largely by the artist's sisters before they began dividing the estate (with the assistance of Thomas A. Fox, Sargent's associate in Boston) among various art museums and schools. While the Fogg Art Museum received most of the sketchbooks in 1937, the sisters apparently kept several pages that had been removed from them. Fogg sketchbook 1937.7.8, one such book with missing pages, is labeled "1871–72." Catalogue numbers 45 and 46 are inscribed on their versos "from book 1871–72." Presumably when these pages were removed, these inscriptions were added to identify their origin.

The Italian word "Certosa," inscribed on catalogue 45, means a Carthusian monastery. The most famous of these is in the Italian town of Pavia (near Milan), which the Sargent family visited in autumn 1873. As these drawings do not depict the flat landscape at Pavia, the inscription must refer to another of the Carthusian monasteries in Italy, possibly the Certosa di Galluzzo, just outside of Florence, which, according to Baedeker, sat on a hill "clothed with cypresses and olive-trees" (*Italy: Handbook for Travellers,* Leipzig and London, 1889, p. 455). Charteris noted that Sargent often made excursions with his mother from Florence in the early 1870s "to sketch in the neighbourhood, in the Boboli Gardens, or in the Poderi of Fiesole, or among the valleys and slopes that curl

and tumble from the mountains to the plain, or among the olives and cypresses at their feet" (Charteris 1927, p. 15; see also Nygren 1983, p. 41). If catalogue 45 does represent an Italian landscape, it could not have been executed between spring 1871 and autumn 1872, because Sargent was not in Italy at that time. Thus the date "Nov. 1872," which may not have been written by Sargent, could be correct.

In style and subject, catalogue 45 is related to a drawing in the Corcoran Gallery of Art, *Landscape with Villa* (49.138b), which depicts a silhouetted hilltop landscape. The verso of the Corcoran drawing, *Peasants with Wheelbarrow and Other Sketches,* contains figure studies comparable to those at the upper left of the Metropolitan sheet.

47. *Sleeping Child*

ca. 1872–73
Graphite on off-white wove paper
11¹¹⁄₁₆ × 8¹⁵⁄₁₆ in. (29.6 × 22.6 cm)
Inscribed on verso at lower left: EP
Gift of Mrs. Francis Ormond, 1950
50.130.141y

The identity of the child in this delicate graphite sketch is unknown. The drawing could represent the artist's sister Violet (b. 1870). A date of about 1872–73 is consistent with the apparent age of the child depicted, if the subject is indeed Violet, and with Sargent's graphic style at that time.

45 46

47

48

48. Pietà, Detail

After Guido Reni, Italian, 1575–1642
ca. 1873
Graphite on off-white wove paper
9⅜ × 5¹⁵⁄₁₆ in. (23.8 × 15.1 cm)
Inscribed at lower right corner: By Guido Reni /
Bologna; on verso at center right: CP
Gift of Mrs. Francis Ormond, 1950
50.130.143p

Style suggests that catalogue 48, which
shows a detail of a painting in Bologna,
dates from the early 1870s. Sargent spent
some time in Bologna in 1873, but he also
may have passed through that city on several
occasions on his way to or from the Alps.

See catalogue 17hh for another copy
after a Baroque master, from 1870.

49. *Glacier on the Ortler*

September 4, 1873?
Graphite and gouache on gray wove paper
10⁵⁄₁₆ × 14⁹⁄₁₆ in. (26.2 × 37 cm)
Inscribed at lower right: Glacier on the Ortler /
[illegible] Sept.4.187[3?]
Gift of Mrs. Francis Ormond, 1950
50.130.107

The last digit of the year in the inscription
is difficult to read. The drawing's style and
the location it records suggest that the last
digit is 3. In the autumn of 1873, Sargent
was with his family in Pontresina, which is
not far from the mountains of the Ortler

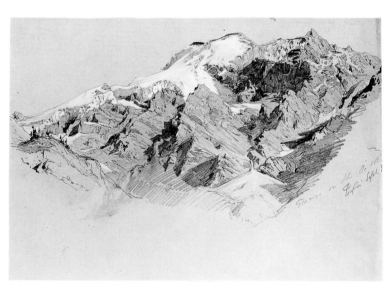

49

50 recto

50 verso

1873. Later that summer he recalled his trip and expressed his interest in Tintoretto in a letter to Vernon Lee: "But I long for the time when I can show you, in Rome, some drawings of particularly beautiful bits of Tintoretto that I did this spring, and try to convert you to at least some of my intense admiration for that great master" (JSS to Vernon Lee, Pontresina, August 12, 1873, quoted in Ormond 1970b, p. 159). While there is no concrete evidence to link catalogue 50 recto to Sargent's letter, this may be the kind of "beautiful bit" to which he was referring.

See also catalogue numbers 41, 51, 56, and 57.

group. Sargent had sketched in this area in 1869 (cats. 9aa recto and verso and 9bb).

EXHIBITION: Fine Arts Museums of San Francisco, M. H. de Young Memorial Museum, June–September 1977 (no catalogue).

50 recto. *The Miracle of Saint Mark, Detail (from scrapbook)*

After Jacopo Robusti, called Tintoretto, Italian, ca. 1518–1594
ca. 1873
Graphite on off-white wove paper
6¹⁵⁄₁₆ × 4 in. (17.6 × 10.2 cm)
Inscribed at lower right: Tintoretto / Belle Arti Venice
Gift of Mrs. Francis Ormond, 1950
50.130.154e recto

50 verso. *Figures (from scrapbook)*

ca. 1873
Graphite on off-white wove paper
4 × 6¹⁵⁄₁₆ in. (10.2 × 17.6 cm)
Gift of Mrs. Francis Ormond, 1950
50.130.154e verso

On catalogue 50 recto Sargent selected a detail of a woman and child from Tintoretto's painting *The Miracle of Saint Mark* (*Saint Mark Freeing a Christian Slave*; 1548, Accademia, Venice). He carefully studied a figure, seen at the left edge of the crowded composition, who is not central to the dynamic narrative of the painting. He indicated only partially the surrounding figures in pale graphite scumbling and omitted entirely a figure whom Tintoretto depicted on his knees on the ground at the woman's feet.

Sargent visited Venice in May–June

51. *The Marriage at Cana (from scrapbook)*

After Jacopo Robusti, called Tintoretto, Italian, ca. 1518–1594
ca. 1872–74
Graphite and watercolor on off-white wove paper
9½ × 14⅛ in. (24.1 × 37.8 cm)
Gift of Mrs. Francis Ormond, 1950
50.130.154b

Sargent's interest in Tintoretto was confirmed by his visits to Venice in 1870 and 1873. He wrote his cousin Mrs. Austin, in 1874: "I have learned in Venice to admire Tintoretto immensely and to consider him perhaps second only to Michael Angelo and Titian, whose beauties it was his aim to unite" (JSS to Mrs. Austin, Florence, March 22, 1874, quoted in Charteris 1927, pp. 18–19). In the same letter, he asked her

about obtaining photographs of an unnamed painting by Tintoretto.

Catalogue 51, which probably dates from Sargent's period of intense admiration for Tintoretto, records one of the Venetian painter's much-lauded masterpieces. John Ruskin had opined of *The Marriage at Cana* (1561): "Taken as a whole, the picture is perhaps the most perfect example which human art has produced of the utmost possible force and sharpness of shadow united with richness of local colour" (*The Stones of Venice,* vol. 3, London, 1853, p. 356).

While Sargent probably saw this painting in situ in the Church of Santa Maria della Salute during one of his visits to Venice, he could easily have seen a reproduction of it, given the popularity of the picture.

See catalogue 273 for a discussion of Sargent's fascination with the architecture of the Salute during the first decade of the twentieth century. For his interest in Tintoretto, see catalogue numbers 41, 50, 56, and 57.

52

52. *Night (from scrapbook)*

After Michelangelo Buonarroti, Italian, 1475–1564
ca. 1872–74
Graphite on off-white wove paper
7¼ × 3⅞ in. (18.4 × 9.8 cm)
Gift of Mrs. Francis Ormond, 1950
50.130.154a

Catalogue 52 represents Michelangelo's sculpture *Night* (1519–34), in the Medici Chapel, San Lorenzo, Florence, which is installed in the chapel above eye level and against the wall. Because Sargent's drawing depicts the sculpture from above and behind, it is unlikely that he made it from the original in situ. He probably worked from a plaster cast.

In drawing from a cast after Michelangelo and from an unusual viewpoint, Sargent may have been inspired by Tintoretto, a painter whom he very much admired in the early 1870s (cats. 41, 50, 51, 56, and 57). In the first full-scale biography of Tintoretto, Carlo Ridolfi (1594–1658) described the artist's practice of collecting plaster casts of sculpture, noting: "He had brought from Florence the small models that Daniele da Volterra had copied from the Medici tomb figures in San Lorenzo, that is to say, Dawn, Dusk, Day and Night. These he studied intensively, making an infinite number of drawings of them by the light of an oil lamp, so that he could compose in a powerful and solidly modeled manner by means of those strong shadows cast by the lamp" (Carlo Ridolfi, *The Life of Tintoretto and of His Children Domenico and Marietta,* 1648; trans. Catherine Enggass and Robert Enggass, University Park, Pennsylvania, 1984, p. 16). Tintoretto's drawings after the casts can be found in the Uffizi Gallery, Florence; Christ Church, Oxford; and the Seilern Collection, London.

While Sargent could have absorbed details of Tintoretto's life from later scholarly works, he had read Ridolfi's text and went on to recommend it to his cousin in a letter of 1874 (JSS to Mrs. Austin, Florence, March 22, 1874, quoted in Charteris 1927, p. 18).

See catalogue 18 for another drawing after *Night* and for a discussion of Sargent's interest in Michelangelo.

51

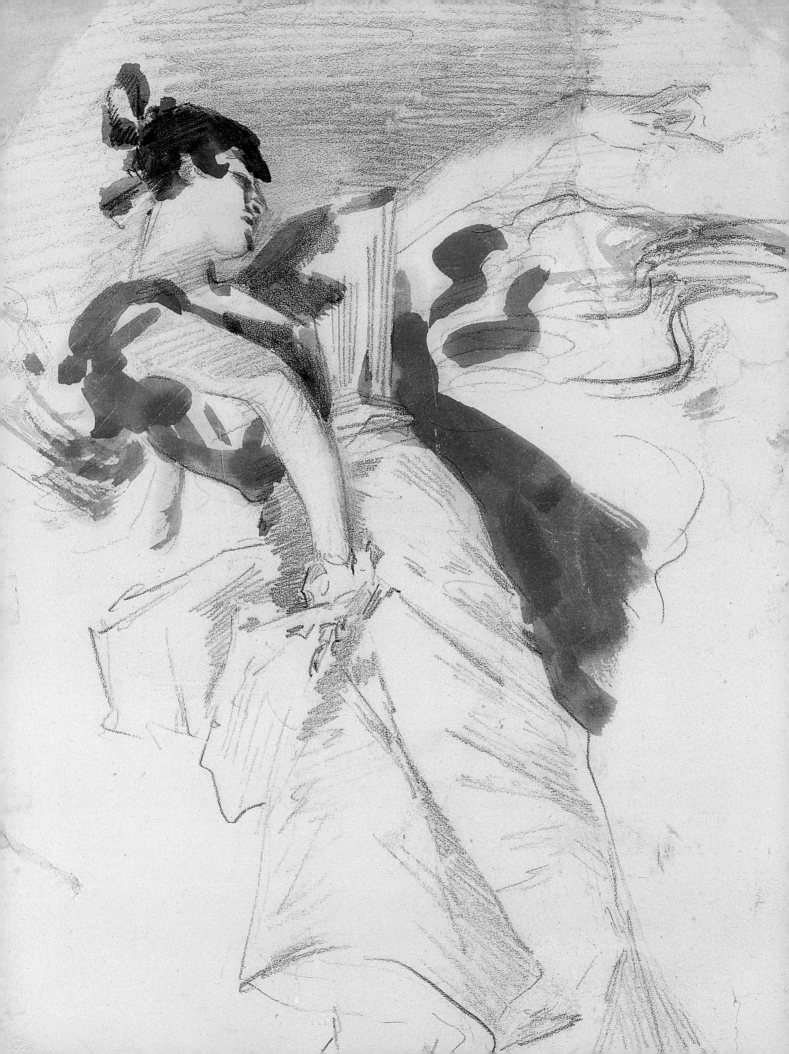

Student Years and Early Career, 1874–89

After a haphazard departure from Florence, the Sargents reached Paris on May 16, 1874. A week later, on May 23, the young artist noted in a letter to his painter friend and advisor Charles Heath Wilson (1810–1882) that he and his family had been so "busy looking for an apartment and visiting the galleries and Exhibitions . . . that we have not yet made any very thorough enquiries about ateliers." Just a few days later, Sargent joined the teaching studio of Carolus-Duran (1838–1917; see figure 50) on the boulevard Montparnasse. Not only had the studio been recommended by Walter Launt Palmer (1854–1932), an American friend from Florence who was already enrolled there, but Sargent had admired Carolus's pictures in the 1874 Salon, especially by comparison with those of the prominent academic Jean-Léon Gérôme (1824–1904).[1]

Sargent's habit of drawing ceaselessly and even his disappointing period of work at the Accademia in Florence had prepared him well. The vivid impression that he and his youthful efforts made in Carolus's studio on May 26 was later chronicled by American painter Will H. Low (1853–1932):

He made his appearance in the Atelier Carolus-Duran almost bashfully, bringing a great roll of canvases and papers, which unrolled displayed to the eyes of Carolus and his pupils gathered about him sketches and studies in various mediums, seeming the work of many years; (and John Singer Sargent was only seventeen) . . . an amazement to the class, and to the youth [Low] in particular a sensation that he has never forgotten.

The master studied these many examples of adolescent work with keenest scrutiny, then said quietly: "You desire to enter the atelier as a pupil of mine? I shall be very glad to have you do so." And within a few days he had joined the class.

Having a foundation in drawing which none among his new comrades could equal, this genius—surely the correct word—quickly acquired the methods then prevalent in the studio, and then proceeded to act as a stimulating force

which far exceeded the benefits of instruction given by Carolus himself.[2]

On May 30, Fitzwilliam Sargent wrote to his own father, "We have placed John in the Studio of a rising painter."[3]

Sargent recorded his observations in a letter to Wilson on June 12, 1874: "It is now almost three weeks since I entered the atelier of M. Carolus-Duran, a young and rising artist whose reputation is continuously increasing. He is chiefly a portrait painter and has a very broad, powerful and realistic style. I am quite delighted with the atelier, where with the exception of two nasty little fat Frenchmen, the pupils are all gentlemanly, nice fellows." After describing the hazings that were usual in the Beaux-Arts classes of Gérôme and Alexandre Cabanel (1823–1889) and complaining about those teachers' apparent lack of interest in individual pupils, he added with pleasure: "Duran comes regularly twice a week to our atelier and carefully and thoroughly criticises the pupils' work staying a short time with each one."[4] Sargent remained in the studio until it closed for the summer on July 3 and, after joining his family for a holiday on the Normandy coast, returned to Paris to resume his instruction in late August or early September 1874. Sargent would work with Carolus-Duran regularly until 1878–79.

In choosing to enroll under Carolus, Sargent rejected the most obvious alternatives, the three painting ateliers in the École des Beaux-Arts, the bastion of stylistic orthodoxy, and the independent studio of Léon Bonnat (1833–1922), a portraitist who conjoined academic fundamentals with a more painterly manner derived from seventeenth-century Spanish art.[5] In 1874, Carolus-Duran's class was newer and less tested than Bonnat's and much more radical in rejecting Beaux-Arts strictures. It was also

Figure 47 (opposite). *After "El Jaleo"* (detail), see catalogue 162.

distinguished by the youth of its *patron,* its small size, the predominance of Anglo-Americans in its ranks, its accessibility to women—who received criticism (on separate premises) from both Carolus-Duran and Jean-Jacques Henner (1829–1905)—and, most important, its emphasis on painting rather than drawing.[6]

By about 1870, Carolus-Duran had renounced Realism in favor of an ingratiating—and lucrative—portrait business, but he avoided academic orthodoxy. He believed in conducting a personal dialogue with the past, choosing mentors according to one's individual inclinations and artistic needs if their lessons seemed apt. He espoused not the classical heritage of antiquity, Raphael, Poussin, and David, but the painterly tradition of Titian, English Baroque portraitists, and, above all, the seventeenth-century Spanish masters. "Velasquez, Velasquez, Velasquez [*sic*], étudiez sans relache Velasquez," he always reminded his students.[7] His teaching methods were also at odds with the Beaux-Arts emphasis on drawing. As Low noted: "We were all, no matter what our previous lack of familiarity with colour had been, given a model, a palette and brushes, and told to render what we saw."[8]

Before he arrived in Paris, Sargent had asserted his belief in the interdependence of drawing and painting in a letter to his cousin Mary Austin. Writing on March 22, 1874, he told her of his admiration for Tintoretto, whom he considered "perhaps second only to Michael Angelo and Titian, whose beauties it was his aim to unite."[9] Contemporary biographies lauded Tintoretto for his ability to fuse the drawing *(disegno)* of Michelangelo with the painting *(colorito)* of Titian,[10] and it was a style based on that duality to which Sargent seemed to aspire. An accomplished and practiced draftsman already, to judge by his surviving works and colleagues' appraisals,[11] Sargent may have seen in Carolus's espousal of the painterly tradition a necessary antidote to his own earlier immersion in *disegno* and a guide to the artistic balance that Tintoretto had achieved.[12]

Sargent's affiliation with Carolus notwithstanding, he continued to hone his already admirable drawing skills when he returned to Paris in autumn 1874. Like many other students who trained with independent teachers outside the École des Beaux-Arts, Sargent may have been determined to secure the École's imprimatur by some means. He sat for the *concours des places,* the semiannual examination for matriculation in the École proper, which began September 26, 1874, and was one of only two Americans to matriculate on October 27. Sargent placed thirty-seventh out of the seventy students admitted (from a field of 162 competitors); the only other American to pass the *concours* was J. Alden Weir (1852–1919), a student of Gérôme's, who placed thirty-first.[13]

Thus, when Sargent began his first full year of Parisian instruction, he could work mornings in Carolus-Duran's atelier and, as a matriculant in the École, could spend each afternoon from four until six drawing there under the direction of Adolphe Yvon (1817–1893).[14] By December 1874, however, James Carroll Beckwith (1852–1917), an American student who had joined Carolus's atelier in 1873, reported in his diary their teacher's new emphasis on drawing: "Duran I am most happy to observe is becoming much more sure in our drawing, somebody has awakened him to the realization of his neglect with us on this point and his latest criticisms have been very strict on this point."[15] Despite Carolus's apparent change of direction, Sargent essayed the *concours des places* for matriculation in the École again in spring 1875, placing thirty-ninth out of 197 competitors when the semester began on March 16, 1875. His name is absent from the semiannual rosters of the École's matriculants until spring 1877, when, on March 20, he was ranked second among the 179 competitors, the highest place achieved by any American in the period. Shortly thereafter, on May 24, 1877, Sargent was awarded a third-class medal in ornamental drawing in one of the École's numerous *concours* for matriculants.

Sargent's commitment to a career as a portraitist is not documented before he began his studies under Carolus-Duran. Although his preserved juvenilia reveal his attraction to capturing human physiognomy and gesture, they disclose an even more substantial interest in landscape. However, without ample financial resources to look forward to, Sargent may have grasped the necessity for and wisdom of working on commission rather than on speculation and may

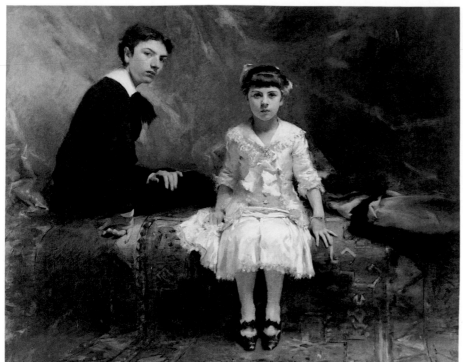

Figure 48. *Portraits de M. E. P. . . . et de Mlle L. P. (Édouard and Marie-Louise Pailleron),* 1881. Oil on canvas, 60 × 69 in. (152.4 × 172.5 cm). Des Moines Art Center, Iowa, Permanent Collections, Purchased with funds from the Edith M. Usry Bequest, in memory of her parents, Mr. and Mrs. George Franklin Usry, the Dr. and Mrs. Peder T. Madsen Fund, and the Anna K. Meredith Endowment Fund (1976.61)

Figure 49 (below). *Madame Ramón Subercaseaux,* ca. 1880–81. Oil on canvas, 65 × 43¼ in. (165.1 × 109.9 cm). Photograph courtesy Adelson Galleries Inc., New York

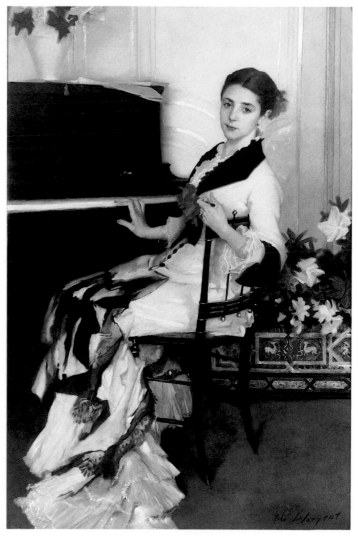

have recognized in portraiture a subject that suited both his artistic temperament and his personal needs.

Sargent made his public debut at the 1877 Salon with a portrait, *Fanny Watts* (Philadelphia Museum of Art), which Dr. Sargent described as his son's "first serious work, his, as yet, 'opus magnum.'"[16] The portrait was a striking success for Sargent: the young artist had a canvas accepted at the Salon on his first attempt; the painting was well displayed; and critics for the *Gazette des beaux-arts* and the *Revue des deux mondes* mentioned it favorably in their reviews.[17] Commissions from French patrons followed, including portraits of the noted playwright Édouard Pailleron (1879, Musée Nationale, Versailles, France); his wife (1879, Corcoran Gallery of Art, Washington, D.C.); her mother, Madame Buloz (1879, private collection, Paris); and their children, Édouard and Marie-Louise (figure 48). Members of the international community in Paris whom Sargent painted at about the same time included Madame Ramón Subercaseaux, wife of the Chilean consul in Paris (figure 49), and Mrs. Henry White (1883, Corcoran Gallery of Art), wife of an American diplomat who was appointed secretary to the American Legation in London shortly after the portrait's completion. Her portrait was installed in the dining room of the Whites' London home,

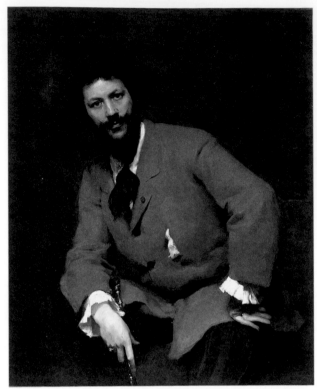

Figure 50. *Carolus-Duran* (Charles-Emile-Auguste Durand), 1879. Oil on canvas, 46 × 37¹³⁄₁₆ in. (116.8 × 96 cm). Sterling and Francine Clark Art Institute, Williamstown, Massachusetts (1955.14). Photograph © 1996 Sterling and Francine Clark Art Institute

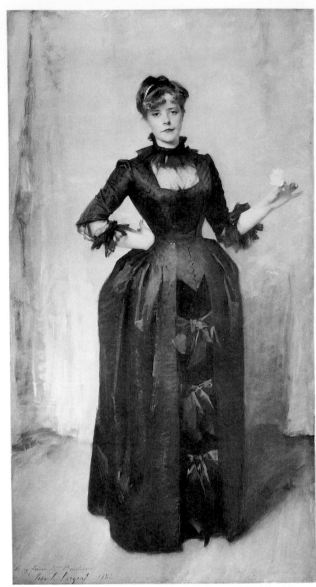

Figure 51. *Lady with the Rose (Charlotte Louise Burckhardt)*, 1882. Oil on canvas, 84 × 44¾ in. (213.4 × 113.7 cm). The Metropolitan Museum of Art, Bequest of Valerie B. Hadden, 1932 (32.154)

where it was seen by their prominent and fashionable visitors and, according to Ormond and Kilmurray, "it contributed significantly to the establishment of Sargent's reputation both in England and America."[18]

Despite his gifts as a draftsman and his success in the École des Beaux-Arts, almost every easel painting by Sargent—from his atelier studies to his portraits, early and late, to his outdoor pictures—discloses a strong affiliation with the painterly, anti-academic manner of Carolus-Duran[19] and with the works of Carolus's ultimate mentor, Velázquez. Even before his 1879 trip to Spain to study the Spanish master, Sargent had absorbed his teacher's admiration for Velázquez, whose fluent paint handling and interest in monochromatic palette and ambiguous space shaped Carolus-Duran's lessons. A stylish "Spanishness" appears in Sargent's portrait of Carolus-Duran (figure 50), a great success of the 1879 Salon.[20] While visiting the Prado in autumn 1879, Sargent made about two dozen oil copies of Velázquez's works, including *Las Meninas* (1646).[21]

Back in Paris, Sargent demonstrated his debt to

Velázquez in *The Daughters of Edward D. Boit* (1882, Museum of Fine Arts, Boston), a commentary on *Las Meninas,* and *Dr. Pozzi at Home* (1881, Armand Hammer Collection, University of California, Los Angeles, at the Armand Hammer Museum of Art and Cultural Center), a portrait of the renowned Parisian surgeon. *Dr. Pozzi,* the artist's first lifesize, full-length portrait of a man, emulates the dazzling red-on-red color scheme that Velázquez used for *Pope Innocent X* (1650, Galleria Doria-Pamphili, Rome). Like Velázquez, Sargent often painted monochromatic portraits, using black-against-black in *Lady with the Rose (Charlotte Louise Burckhardt)*

(figure 51) and *Madame X (Madame Pierre Gautreau)* (see figure 61); lush, rosy magenta in *Mrs. Hugh Hammersley* (see figure 74); and a white-gray-black triad in *Mr. and Mrs. I. N. Phelps Stokes* (see figure 77).

Sargent adhered to Carolus's method and to the lessons of Velázquez, painting what he saw as directly as possible, especially when creating portraits. This method may explain the scarcity of Sargent's preliminary drawings for portraits and the cursory quality of such sketches in the Metropolitan's collection. While he seems to have explored the linear issues associated with *Madame X* with some care and in several drawings (cats. 166–68), his study of a hand for *Carolus-Duran* (cat. 135) and a small profile sketch of Mrs. Daniel Sargent Curtis (cat. 164; see also figure 52) are the merest stenographic jottings. Other drawings, such as two academic studies that seem to relate to the pose of *Madame Subercaseaux* (cats. 147 and 148), are linked with painted portraits only tangentially.

After a peripatetic childhood and under the influence of a teacher who ignored the Beaux-Arts canon, Sargent built his early career on the mutually reinforcing habits of creative eclecticism and extensive travel. He continued to sketch from and copy varied works: Egyptian reliefs (e.g., cats. 125–29); Greek vases (e.g., cat. 130); paintings by Tintoretto (e.g., cat. 56) and Poussin (e.g., cat. 59); and sculptures by Michelangelo (e.g., cat. 52); as well as paintings and prints by newer masters such as Jean-François Millet (e.g., cat. 63). Sargent shared with Carolus-Duran an affection for the painterly realism of certain contemporaries and may have been introduced by his teacher to avant-garde notions and individuals. The theater scenes of Edgar Degas (1834–1917) may have influenced Sargent's *Rehearsal of the Pasdeloup Orchestra at the Cirque d'Hiver* (figure 53). The brilliant palette of Claude Monet (1840–1926)—whom Sargent met in Paris, possibly as early as 1876[22]—may have inspired *Neapolitan Children Bathing* (figure 54), as well as the more ambitious and similarly dazzling *The Oyster Gatherers of Cancale* (figure 55). For these works, Sargent recorded his initial impressions with quick

Figure 52. *Mrs. Daniel Sargent Curtis,* 1882. Oil on canvas, 28 × 21 in. (71.1 × 53.3 cm). Spencer Museum of Art, University of Kansas, Lawrence, Gift of Samuel H. Kress Study Collection

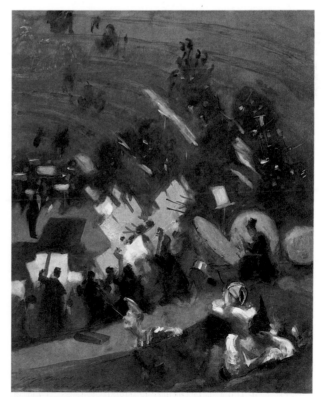

Figure 53. *Rehearsal of the Pasdeloup Orchestra at the Cirque d'Hiver,* 1876/78. Oil on canvas, 36⅝ × 28¾ in. (93.0 × 73 cm). The Art Institute of Chicago, Anonymous Loan (81.1972). Photograph © 2000 The Art Institute of Chicago. All rights reserved

Figure 54. *Neapolitan Children Bathing,* 1879. Oil on canvas, 10⁹⁄₁₆ × 16³⁄₁₆ in. (26.8 × 41.1 cm). Sterling and Francine Clark Art Institute, Williamstown, Massachusetts (1955.852). Photograph © 1996 Sterling and Francine Clark Art Institute

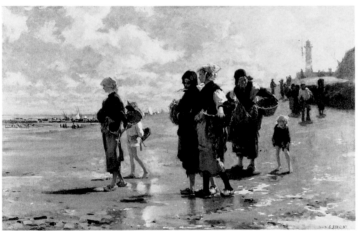

Figure 55. *The Oyster Gatherers of Cancale,* 1878. Oil on canvas, 31⅛ × 48½ in. (79.1 × 123.2 cm). Corcoran Gallery of Art, Washington, D.C., Museum Purchase, Gallery Fund (17.2)

sketches (cats. 108, 109, and 120 recto), which he combined with meticulous academic studies in graphite (cat. 118) and oil for the finished composition.

With respect to travel, Sargent may have joined a group of classmates on a trip to Barbizon in the early summer of 1875, not long after Millet's death in January, and spent time with his family at St. Enogat and St. Malo, on the Brittany coast, during 1875–76. In May 1876, accompanied by his mother and his sister Emily, Sargent sailed from Liverpool on his first trip to the United States, which would include visits to Newport (see cat. 93), Niagara Falls, and the Centennial exhibition in Philadelphia. Sargent's Atlantic crossings in May and October inspired him to fill sketchbooks with

and paint (figure 56) nautical subjects (e.g., cats. 96 and 97) similar to vignettes that he had gathered earlier along the coast of Normandy and Brittany (e.g., cats. 89 and 90).

Like many artists of his period, including Carolus-Duran, Sargent exhibited his genre paintings alongside his portraits as he built his early reputation.[23] His major canvases often reflected the picturesque locales that he visited. Studies he made on the Brittany coast during the summer of 1877 formed the foundation for *The Oyster Gatherers of Cancale.* His 1878 trip to Capri and southern Italy yielded *Among the Olive Trees, Capri* (1879, private collection).

By autumn 1879, Sargent was no longer bound to the atelier of Carolus-Duran, and he traveled extensively. His first destination was Madrid, where he nourished his curiosity about Spanish art at the Prado. He extended his experience of the picturesque by going on from Madrid to Ronda, Granada, and Seville. He then went on to Gibraltar and crossed over to Morocco (figure 57), where he spent January and February 1880 living in Tangier and sketching there and in the coastal town of Tetuan. Sargent journeyed to Holland in August 1880 to study works by Frans Hals and other northern masters, whose technique would inspire his developing painterly style. As a result of visits he made to Venice from September 1880 to January or February 1881 and in August 1882, Sargent executed a memorable series of oils and watercolors (cat. 157) in which he explored the characteristic color harmonies of the city in winter and the peculiar perspectives offered by its narrow streets and secluded courtyards.[24]

Sargent's Mediterranean travels yielded informal drawings and paintings of exotic figures and buildings, sketches for the subtle and mysterious *Fumée d'Ambre Gris* (figure 58), and a series of paintings of Spanish dancers that encodes his enthusiastic artistic Hispanism (figure 59). Of these, the great, theatrical, lifesize *El Jaleo* (figure 60) is by far the most ambitious. Exotic music and dance would appear in Sargent's oeuvre again during the next decade in his sketches (cat. 186) and paintings (see figure 72) of the Javanese dancers at the Exposition Universelle in Paris in 1889 and in his portrait of the Spanish dancer La Carmencita (1890,

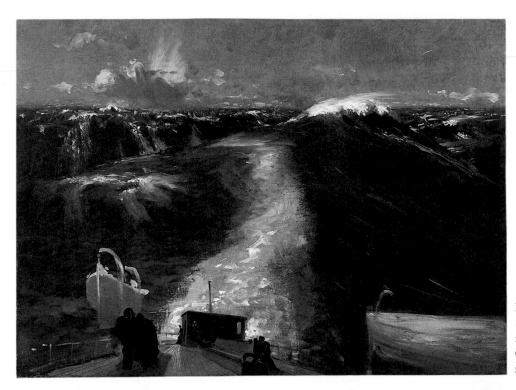

Figure 56. *Atlantic Storm,* 1876. Oil on canvas, 23½ × 31¾ in. (59.7 × 80.6 cm). Curtis Galleries, Minneapolis, Minnesota

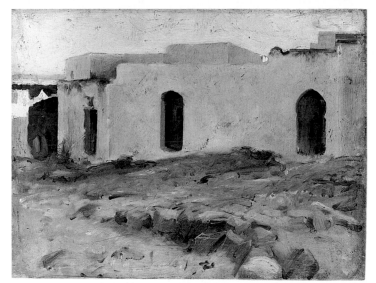

Figure 57. *Moorish Buildings on a Cloudy Day,* 1879–80. Oil on wood, 10¼ × 13¾ in. (26.0 × 34.9 cm). The Metropolitan Museum of Art, Gift of Mrs. Francis Ormond, 1950 (50.130.7)

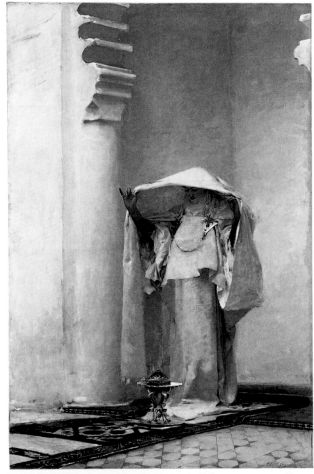

Figure 58. *Fumée d'Ambre Gris,* 1880. Oil on canvas, 54¾ × 35¹¹⁄₁₆ in. (139.1 × 90.7 cm). Sterling and Francine Clark Art Institute, Williamstown, Massachusetts (1955.15) Photograph © 1989 Sterling and Francine Clark Art Institute

Museé d'Orsay, Paris), whom Sargent saw perform in New York in 1890.

Having attracted much favorable commentary for his gifts as a genre painter with *El Jaleo* in the Salon of 1882, Sargent attempted to prove his growing abilities as a portraitist with *Madame X* (figure 61). Sargent had been attracted by the eccentric beauty of Virginie Avegno Gautreau (1859–1915), the young Louisiana-born wife of a prominent Paris

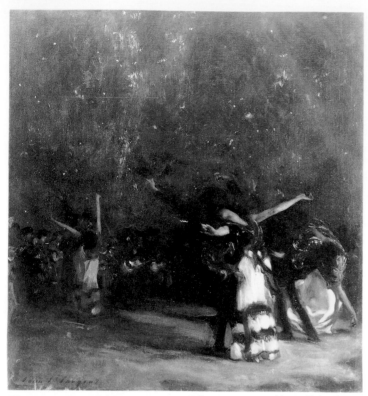

Figure 59. *Spanish Dance,* ca. 1880. Oil on canvas, 35¼ × 33¼ in. (89.5 × 84.5 cm). The Hispanic Society of America, New York

banker, whom he apparently met in 1882. He had written to his friend Ben del Castillo, "I have a great desire to paint her portrait and have reason to think she would allow it and is waiting for someone to propose this homage to her beauty."[25] As the sittings began, Sargent described her to Vernon Lee: "She has the most beautiful lines and if the lavender or chlorate-of-potash-lozenge colour be pretty in itself I shall be more than pleased."[26] Madame Gautreau's beauty challenged the young artist's dual mastery of *colorito,* apparent in his subtle rendering of her lavender-powdered skin and the broader treatment of the satin and velvet of her dress, and *disegno,* manifest in his articulation of her contours. Perhaps it was Sargent's interest in Madame Gautreau's "lines," particularly her profile, that provoked him to make more studies of her than he seems to have made of any other sitter.[27] At the Gautreau vacation home in Brittany during the summer of 1883, Sargent struggled to find the best pose for and characterization of his sitter; of the many extant studies, including the three in the Metropolitan (cats. 166–68), almost every one shows Madame Gautreau in profile.[28]

In the canvas, Sargent combined a mono-chromatic experiment and an ambiguous, flattened space in the manner of Velázquez; a profile pose

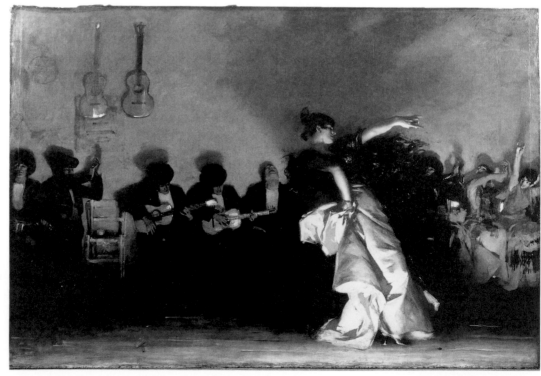

Figure 60. *El Jaleo,* 1882. Oil on canvas, 94½ × 137 in. (240 × 350.5 cm). Isabella Stewart Gardner Museum, Boston

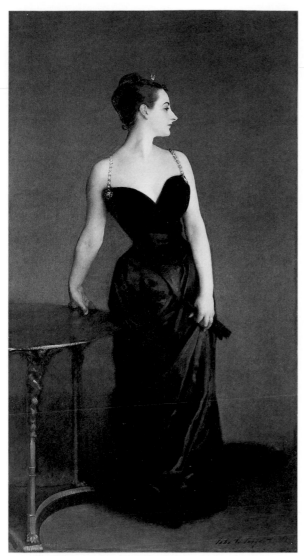

Figure 61. *Madame X (Madame Pierre Gautreau),* 1883–84. Oil on canvas, 82⅛ × 43¼ in. (208.6 × 109.9 cm). The Metropolitan Museum of Art, Arthur Hoppock Hearn Fund, 1916 (16.53)

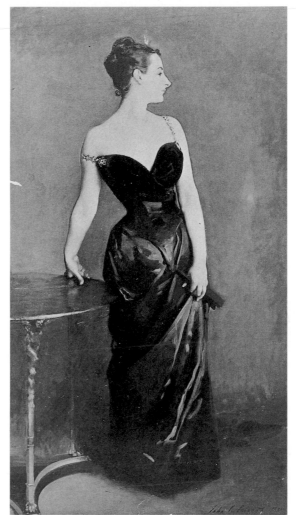

Figure 62. Photograph of *Madame X* before repainting of shoulder strap, The Metropolitan Museum of Art, Gift of Mrs. Francis Ormond, 1950

that recalls Titian's iconic portrait of Francis I (1539, Musée du Louvre, Paris); and an unmodulated treatment of the face inspired by Édouard Manet (1832–1883) and Japanese prints. The product, however, is synergistic, as these sources are integrated with such economy, force, and severity as to set the portrait apart as a masterpiece within Sargent's oeuvre. That extraordinary quality notwithstanding, the well-known outcome of the portrait's display in the Salon of 1884 was a succès de scandale. The haughty and striking profile, the morbid skin color, the shocking décolletage and exposure of bare arms,

and the fact that Sargent had shown the jeweled strap of her gown falling off her right shoulder (figure 62) placed *Madame X* outside the bounds of decorum.[29] Although the sitter had complied with the artist's choices at the time of the sittings, she was embarrassed by the public's reaction and thought that Sargent was mocking her. Perceiving caricature rather than characterization, she and her family demanded that Sargent remove the painting from the Salon. Sargent would not yield to that pressure, but he did repaint the shoulder strap after the exhibition (see frontispiece) and kept the canvas until 1916, when he sold it to the Metropolitan.

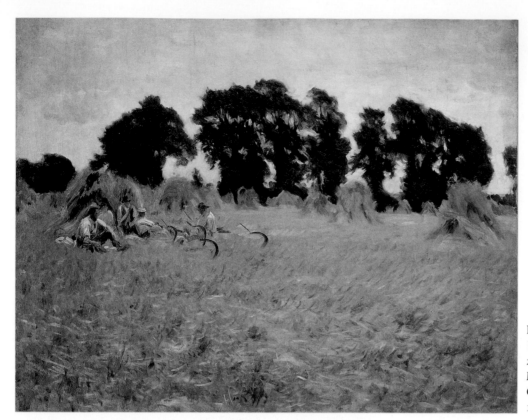

Figure 63. *Reapers Resting in a Wheat Field,* 1885. Oil on canvas, 28 × 36 in. (71.1 × 91.4 cm). The Metropolitan Museum of Art, Gift of Mrs. Francis Ormond, 1950 (50.130.14)

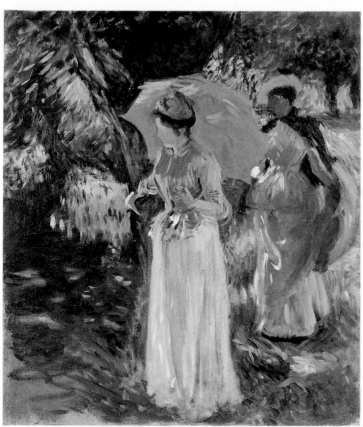

Figure 64. *Two Girls with Parasols at Fladbury,* 1889. Oil on canvas, 29½ × 25 in. (74.9 × 63.5 cm). The Metropolitan Museum of Art, Gift of Mrs. Francis Ormond, 1950 (50.130.13)

To the modern eye, *Madame X* is more than a portrait; it is a symbol, a highly stylized distillation of a professional beauty intensely and timelessly captured in her self-conscious devotion to appearance alone as character. The painting, however, was disastrous for Sargent, who evidently anticipated neither the public's disdain of Madame Gautreau's bizarre glamour nor the critics' complaints about his using radical techniques—even twenty years after Manet's pioneering efforts—for a portrait. Having acquired notoriety rather than fame in Paris, Sargent decided that London, where he had considered settling as early as 1882, would be a more hospitable city in which to pursue his career. In spring 1886 he closed his Paris studio and moved to England for the rest of his life. Suspicious of Sargent's conjoining of strategies from French modernism with the traditional requirements of portraiture, English patrons and critics would resist his innovations until the 1890s.

Following the debacle of *Madame X* in the 1884 Salon, Sargent spent several summers engaged in Impressionist projects, resuming experiments he had announced in impressive proto-Impressionist works such as *Oyster Gatherers of Cancale.* His Impressionist

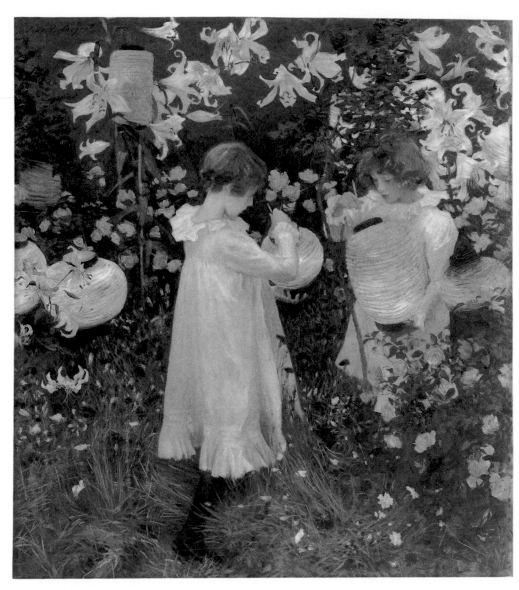

endeavors were nourished by his contact with Monet, whom he visited several times at Giverny beginning in the summer of 1885. Sargent also spent portions of the summers of 1887 through 1889, respectively, in Henley, Calcot Mill, and Fladbury, England, where he worked outdoors (figures 63 and 64). He combined Monet's chromatic palette and high key with a distinctive spiky stroke and modified the French Impressionist's instinct to dissolve forms in corrosive light with a portrait painter's interest in specificity.

Sargent painted his most ambitious outdoor work of the period, the ravishing *Carnation, Lily, Lily, Rose* (figure 65), over the course of two summers he spent in the Cotswolds village of Broadway, Worcestershire, in the company of American painters Francis Davis Millet (1846–1912) and Edwin Austin

Abbey and English artist Alfred Parsons (1847–1920). The lifesize canvas depicts illustrator Frederick Barnard's daughters in white frocks, lighting Japanese paper lanterns in a garden bursting with carnations, lilies, and roses in full bloom. The girls posed every afternoon at a specified moment just after sunset so that Sargent could capture the contrast between the fading daylight and the glowing lanterns. Although he intended to render an impression, he made numerous pencil studies for the painting: quick sketches to record suggestions for the composition and precise drawings to work out particular forms (cats. 175–78).

The freshness of *Carnation, Lily, Lily, Rose* is extraordinary, despite the long process of its creation, as is the charming visual dialogue between

the children and the lanterns. The composition seems to conjoin Impressionist candor with the interest in flat patterns derived from natural forms that characterized the concurrent Aesthetic Movement. Like an Aesthetic interior, the painting layers and juxtaposes shapes and rich designs in a pleasing way; individual objects invite attention while the whole appears like a unified decorative tapestry when seen from a distance.[30] English critics' favorable response to the painting upon its exhibition at the Royal Academy in 1887 offset their earlier complaints about some of Sargent's portraits and portended more consistent approbation of his works. The purchase of the painting for the British nation augured well for Sargent's future in London.

Later in 1887, Sargent traveled to Newport, Rhode Island, to paint a portrait of Elizabeth Allen Marquand, wife of the future president of the Metropolitan Museum, whose portrait Sargent would paint ten years later.[31] He found American patrons much more eager to engage his skills than their English counterparts. Sargent spent six months in the United States, dividing his time between Boston and New York, executing more than twenty portraits and establishing relationships that would lead to a major mural commission for the Boston Public Library designed by the architectural firm McKim, Mead and White. Sargent's first solo exhibition opened at the Saint Botolph Club in Boston in January 1888. In London in the early 1890s, his almost predestined role as the Van Dyck of his time—as Auguste Rodin would characterize him in 1902[32]—became increasingly evident and the support of London patrons and critics would help to make Sargent the leading international portraitist of his era.

1. Information from a typewritten transcription of JSS to Charles Heath Wilson, [Paris], May 23, 1874. The original, now destroyed, was in the possession of William H. Allen, bookseller, Philadelphia, who kindly made the transcription available. Edited excerpts from this and from a letter of June 12, 1874, cited below, are quoted in Leeds–London–Detroit 1979, p. 18, without citations. Wilson had taught ornament drawing and design in Edinburgh and was director of the art schools at Somerset House in London before becoming headmaster of the Glasgow School of Design in 1849. He had moved to Italy in 1869. The Sargents met Wilson while they were living in Florence and sought his advice about John's artistic education. See "Childhood and Youthful Works, 1856–74," in this volume.

 Carolus-Duran was born Charles-Emile-Auguste Durand and changed his name to avoid using the very common surname.

 For a fuller consideration of Sargent's studies in Paris, see H. Barbara Weinberg, "Sargent and Carolus-Duran," in Williamstown 1997, pp. 5–30.
2. Will H. Low, "The Primrose Way," typescript, "revised and edited from the original MS by Mary Fairchild Low, with the collaboration of Berthe Helene MacMonnies," 1935, Albany [New York] Institute of History and Art, p. 56. See also Low (1910) 1977, p. 89; James Carroll Beckwith in Coffin 1896, p. 172.
3. Fitzwilliam Sargent to Winthrop Sargent, Paris, May 30, [1874], quoted in Olson 1986, p. 33.
4. Typewritten transcription of JSS to Charles Heath Wilson, Paris, June 12, 1874 (courtesy of William H. Allen, Philadelphia).
5. Several writers have noted that in fall 1874 Sargent also studied in the evenings in Bonnat's atelier, working in the company of Walter Gay (1856–1937) and other Americans. See Charteris 1927, p. 36; New York 1980b, p. 22. In the latter volume, Gary A. Reynolds cites Walter Gay, Memoirs of Walter Gay (New York: privately printed, 1930), p. 11, and New York 1980a, n.p. We are grateful to William Rieder, curator, Department of European Sculpture and Decorative Arts, The Metropolitan Museum of Art, whose publication The Spirit of Empty Rooms: Walter and Matilda Gay is forthcoming.
6. The studio flourished until Carolus closed it in 1888. During its time, it attracted ninety Americans, of whom Sargent was the sixth to enroll, after Robert Hinckley (1853–1941), Palmer, James Carroll Beckwith, and Low—who all enrolled in 1873—and, probably, Hiram Reynolds Bloomer (1845–1911), who seems to have enrolled by 1874. The most accessible source of biographical information on Carolus-Duran is Gabriel P. Weisberg, "Charles-Emile-Auguste Durand, Carolus-Duran," in Cleveland and other cities 1980, p. 280. For the range of options open to American painting students in Paris, see Weinberg 1991; chapter 8 considers Carolus-Duran's studio.
7. Charteris 1927, p. 28. Carolus-Duran was quoted as remarking: "In the French school since Ingres, the tradition comes from Raphael. That was very well for Ingres, who freely chose the master from whom he really descended; but we who have other needs, who desire reality . . . we should search a guide among the masters who responds most fully to our temperament." H. [Robert Hinckley?], "A French Painter and His Pupils," Century 31 (January 1886), pp. 373–74.

8. Low (1910) 1977, pp. 185–88 passim.

9. JSS to Mary Austin, Florence, March 22, 1874, quoted in Charteris 1927, p. 18.

10. Sargent's letter to Mrs. Austin continues, "If my artistic cousin Mary would like to read about Tintoretto . . . she may find in the royal library an old Italian book entitled 'Le Maraviglie dell'Arte, ovvero Vite degli Illustri pittori Veneti e dello Stato' by Ridolfi'" (JSS to Mary Austin, Florence, March 22, 1874, quoted in Charteris 1927, p. 18). Ridolfi's work (1648) was the basis of many later biographies of Tintoretto. Ridolfi explained that Tintoretto thought

he could become a painter by studying the canvases of Titian and the reliefs of Michelangelo Buonarroti, who was recognized as the father of design. Thus with the guidance of these two divine lights who have made painting and sculpture so illustrious in modern times, he started out toward his longed-for goal, furnished only with good counsel, to point the way on his difficult journey. So as not to stray from his proposed aim he inscribed on the walls of one of his rooms the following work rule: Michelangelo's design (disegno) and Titian's color (colorito). (Carlo Ridolfi, *The Life of Tintoretto and of His Children Domenico and Marietta,* 1648, trans. Catherine Enggass and Robert Enggass, University Park, Pennsylvania: Penn State University Press, 1984, p. 16)

See also catalogue 56.

11. American J. Alden Weir met Sargent while both artists were sitting for the *concours des places* at the École des Beaux-Arts in autumn 1874, and in a letter to his mother recorded his initial impressions of Sargent and his abilities as a draftsman: "I met this last week a young Mr. Sargent about eighteen years old, and one of the most talented fellows I have ever come across; his drawings are like the old masters, and his color is equally fine" (J. Alden Weir to Susan Martha Bayard Weir, Paris, October 4, 1874, quoted in Young 1971, p. 50).

12. In his diary entry for November 14, 1873, Palmer noted Sargent's lack of experience in oil painting: "He is but 17 & had done a most remarkable amount of work very little oil" (quoted in Ormond and Kilmurray 1998, p. xii).

13. Details pertaining to Sargent at the École des Beaux-Arts are gleaned from *Procès-verbaux originaux des jugements des concours des sections de peinture et de sculpture, 1874–1883* (AJ52:78) and *Dossiers individuels des élèves: Série antérieure au 31 décembre 1893* (AJ52: 271), Archives of the École Nationale Supérieure des Beaux-Arts, National Archives, Paris.

14. See note 5.

15. James Carroll Beckwith diaries, December 6, 1874, quoted in Weinberg 1991, p. 201.

16. Fitzwilliam Sargent to his sister, Paris, March 1, 1877, quoted in Olson 1986, p. 56.

17. In a letter of June 5, 1877, to Vernon Lee, Emily Sargent wrote: "I think I told you that his portrait was accepted and very well hung at the Salon" (Emily Sargent to Vernon Lee, June 5, 1877, quoted in Ormond and Kilmurray 1998, p. 42). For contemporary reviews, see Williamstown 1997, p. 81.

18. Ormond and Kilmurray 1998, p. 106.

19. Mount suggests many analogies between the works of Sargent and his teacher (Mount 1963).

20. For a discussion of the portrait, see Margaret C. Conrads, *American Paintings and Sculpture at The Sterling and Francine Clark Art Institute,* New York, 1990, pp. 166–72. For contemporary reviews, see Williamstown 1997, pp. 84–85.

21. See Juan J. Luna, "John Singer Sargent y el Museo del Prado," *Historia 16* 13 (June 1988), pp. 100–107.

22. The exact date of the meeting between Sargent and Monet is not known. They may have met at the second Impressionist exhibition at the Durand-Ruel Gallery in 1876. See Ormond and Kilmurray 1998, pp. 155–56, for details regarding their friendship.

23. For a detailed discussion of Sargent's exhibiting activities between 1877 and 1887, see Williamstown 1997.

24. See ibid., pp. 98–99, 174, for a discussion of the Venetian paintings.

25. JSS to Ben del Castillo, [Paris], 1882, quoted in Charteris 1927, p. 59.

26. JSS to Vernon Lee, Nice, February 10, 1883, quoted in Ormond and Kilmurray 1998, p. 113.

27. Sittings began in the winter of 1882–83 and continued through summer 1883 at the Gautreau vacation home at Paramé in Brittany.

28. For other studies of Madame Gautreau see Ormond and Kilmurray 1998, pp. 113–18.

29. For a discussion of the original position of the shoulder strap see Fairbrother 1981b. For transcriptions of critics' remarks, see Williamstown 1997, pp. 140–41.

30. For the Aesthetic Movement, see Doreen Bolger Burke et al., *In Pursuit of Beauty: Americans and the Aesthetic Movement* (exh. cat., New York: The Metropolitan Museum of Art, 1986).

31. See the introduction to this volume.

32. Olson 1986, p. 157.

53 recto. *Seagull*

August 18, 1874
Pen and ink on paper
7¹⁵⁄₁₆ × 5⅝ in. (20.2 × 14.3 cm)
Inscribed at top center: Seagull.; Aug. 18ᵗʰ 1874 /
Beuzeval / Hirondelle / de Mer.; at bottom half of
sheet: White underneath. back white and / delicate
gray with black spots. / feet small black webbed /
Length from end of bill to end of / tail: 14 inches.
Width across from tip of outstretched wings: 35
inches. / bill black, yellow inside, head white
beneath / speckled on sides and grey above. neck
quite / white and downy.; at lower left: J.S. 302
Gift of Mrs. Francis Ormond, 1950
50.130.86 recto

53 verso. *Seagull, Kingfisher*

August 18, 1874
Pen and ink on paper
7¹⁵⁄₁₆ × 5⅝ in. (20.2 × 14.3 cm)
Inscribed: Other specimen of Hirondelle de Mer. /
neck and Tail quite white and / very silky and
glossy, changing / into very delicate pure light / grey
on the back. wings same / grey, and large feathers of
wing / darker. black tuft on the top / of the head.
Whole bird rather / larger than last. / King-fisher,
in sketch: / head very large / body small / tail
infinitesimal
Gift of Mrs. Francis Ormond, 1950
50.130.86 verso

After the studio of Carolus-Duran closed for its summer recess in July 1874, the Sargents headed to the coast of Normandy, once again in search of a temperate climate for the women of the family. Beginning in 1927 with Charteris's biography of Sargent, sources have called the town where the Sargents resided during that summer "Benzeval." While the name of the town as it is inscribed on catalogue 53 recto could easily be interpreted as Benzeval, evidence in other letters and on a map suggests that the name of the town is Beuzeval. In two other sources, both of which give additional hints about the location of the town, the name is more clearly legible as Beuzeval. A letter from Fitzwilliam Sargent to George Bemis reads: "Hotel Imbert. Beuzeval / Calvados. July 5. or 6." Attached to the same letter, a receipt for some clothing purchased for the Sargents in Paris by Bemis is made out to "Dr. F. W. Sargent / Hotel Imbert / Beuzeval / Calvados,

53 recto

53 verso

pres Dives . . ." (Fitzwilliam Sargent to George Bemis, Calvados, July 5 or 6, [1874], George Bemis Papers).

Sargent's inscriptions include color notations but also indicate a level of scrutiny characteristic of a biologist-ornithologist. It is unclear whether Sargent drew an actual bird or took his information from a book. He used a similar artist-naturalist approach in *Studies of a Dead Bird* (1878, oil on canvas, The Metropolitan Museum of Art).

EXHIBITIONS: Probably included in New York 1928 (inventory list J.S. 302); New York/San Francisco 1974/1977, cat. 86.

54. *Oscar and Bobino on the Fishing Smack (from scrapbook)*

August 25, 1874
Graphite on off-white wove paper
11⅞ × 16½ in. (30.2 × 41.9 cm)
Inscribed at lower center: Oscar and Bobino / on the
fishing smack. Aug. 25ᵗʰ / 1874.
Gift of Mrs. Francis Ormond, 1950
50.130.154pp

Sargent probably painted this watercolor depicting two young sailors on the deck of a fishing ship at or near Beuzeval (cat. 53), on the Normandy coast, where he spent the summer of 1874.

54

55. *Life Study Class*

ca. 1874–76
Charcoal on off-white laid paper
6¹¹⁄₁₆ × 9¹⁄₁₆ in. (17 × 23 cm)
Gift of Mrs. Francis Ormond, 1950
50.130.128

The subject of catalogue 55 suggests a date during Sargent's student years in Paris.

Charcoal drawings of similar technique with a strong interest in chiaroscuro dating from about this time are catalogue 148 and *Value Drawing of a Man's Head* in the Corcoran Gallery of Art (49.147a).

EXHIBITIONS: Fort Worth Art Association, February 5–28, 1952; "Sargent, Whistler and Cassatt," American Federation of Arts, traveling exhibition, September 1954–57 (no catalogue); Fine Arts Museums of San Francisco, M. H. de Young Memorial Museum, June–September 1977.

REFERENCES: Nygren 1983, p. 48; Kilmurray and Ormond 1998, p. 24.

56 recto

56 verso

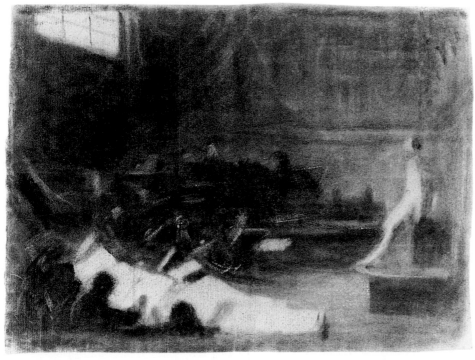

56 recto. *Paradise, Detail*

After Jacopo Robusti, called Tintoretto,
Italian, ca. 1518–1594
ca. 1874–78
Graphite on off-white wove paper
3½ × 5¹⁵⁄₁₆ in. (8.9 × 15 cm)
Gift of Mrs. Francis Ormond, 1950
50.130.143d recto

56 verso. *Paradise, Detail*

After Jacopo Robusti, called Tintoretto,
Italian, ca. 1518–1594
ca. 1874–78
Graphite on off-white wove paper
3½ × 5¹⁵⁄₁₆ in. (8.9 × 15 cm)
Gift of Mrs. Francis Ormond, 1950
50.130.143d verso

Sargent copied these vignettes from Tintoretto's painting *Paradise,* in the Musée du Louvre, Paris. Tintoretto's large canvas (56¼ × 142½ in.; 143 × 362 cm), is a sketch for his immense decorative program of the same subject for the Palazzo Ducale, Venice (painted 1588–92). Both works depict a mass of humanity surrounding

57

Christ and the Virgin in glory. The Louvre painting and the Palazzo Ducale decoration are sufficiently different to verify that Sargent made his studies from the former. Sargent selected only a few figures to copy from diverse areas of the canvas. His attention to relatively small details suggests that he worked directly from the painting, not from a reproduction.

Other drawings after paintings in the Louvre are catalogue numbers 59, 60, and 61. All four drawings probably date from Sargent's student years in Paris, about 1874–78.

For Sargent's interest in Tintoretto see catalogue numbers 41, 50, 51, and 57.

REFERENCE: Nygren 1983, p. 51.

57. *Adoration of the Shepherds*

After Jacopo Robusti, called Tintoretto, Italian,
ca. 1518–1594
ca. 1874–78
Graphite on off-white wove paper
5 15/16 × 3 13/16 in. (15 × 9.7 cm)
Inscribed at lower left: J.S. 348; on verso at center: CP
Gift of Mrs. Francis Ormond, 1950
50.130.143g

Catalogue 57 seems to have belonged to the same sketchbook and was probably made at the same time as catalogue numbers 58, 59, and 60. However, it does not depict a painting in the Louvre. Sargent's subject is Tintoretto's *Adoration of the Shepherds* (1579–81), from the artist's monumental decorative program for the Scuola di San Rocco in Venice. The drawing depicts Tintoretto's composition in reverse and thus seems to have been copied from a print of the painting.

EXHIBITION: Probably included in New York 1928 (inventory listing J.S. 348).

REFERENCE: Nygren 1983, p. 51.

58 recto

Figure 66. Catalogue 59 as pasted onto scrapbook page

58 verso

59

58 recto. *Man in Landscape with Temple on Hill in Background (from scrapbook)*

ca. 1874–80
Graphite on off-white wove paper
3 ¹³⁄₁₆ × 5 ¹⁵⁄₁₆ in. (9.7 × 15 cm)
Gift of Mrs. Francis Ormond, 1950
50.130.154gg recto

58 verso. *The Nurture of Bacchus, Detail (from scrapbook)*

After Nicolas Poussin, French, 1593/94–1665
ca. 1874–80
Graphite on off-white wove paper
3 ¹³⁄₁₆ × 5 ¹⁵⁄₁₆ in. (9.7 × 15 cm)
Inscribed at center: Nicolas Poussin
Gift of Mrs. Francis Ormond, 1950
50.130.154gg verso

In preparation for this publication, this sheet was lifted from the scrapbook to reveal the drawing on its verso, which is the continuation of catalogue 59.

59. *The Nurture of Bacchus (from scrapbook)*

After Nicolas Poussin, French, 1593/94–1665
ca. 1874–80
Graphite on off-white wove paper
3 ¹³⁄₁₆ × 5 ⅞ in. (9.7 × 14.9 cm)
Gift of Mrs. Francis Ormond, 1950
50.130.154f

Catalogue 59, originally from a sketchbook, is now pasted into a scrapbook that Sargent compiled in the 1870s or early 1880s. The sheet contains a study of Poussin's painting *The Nurture of Bacchus* (ca. 1626–27, Musée du Louvre, Paris). After affixing it in the scrapbook, Sargent continued drawing figures from the left edge of the composition directly onto the scrapbook page (figure 66). When Sargent made the sketch of the painting, perhaps in the galleries at the Louvre, he began the drawing on the right-hand sheet of the open sketchbook and continued drawing across the binding onto the left-hand sheet. The continuation of the drawing was discovered on the verso of catalogue 58 when it was removed from the scrapbook in preparation for this publication.

Other sheets probably from the same sketchbook are catalogue numbers 57, 58, and 60.

60. *The Triumph of Flora*

After Nicolas Poussin, French, 1593/94–1665
ca. 1874–78
Graphite on off-white wove paper
3 ¹³⁄₁₆ × 5 ¹⁵⁄₁₆ in. (9.7 × 15 cm)
Inscribed at lower left: Poussin / J.S. 347; on verso at upper center: CP; at upper right: 3[2?]6
Gift of Mrs. Francis Ormond, 1950
50.130.143l

Sargent studied the figures at the lower left corner of Poussin's painting *The Triumph of Flora* (ca. 1627, Musée du Louvre, Paris). As in two other studies after Poussin (cats. 59 and 61), Sargent eschewed detail and focused on the composition. He concentrated on the outlines and contours of the figures, emphasizing the distinctive linearity of Poussin's work.

Other sheets probably from the same sketchbook are catalogue numbers 57, 58, and 59.

EXHIBITION: New York 1928 (inventory listing J.S. 347).

61. *The Plague at Ashdod (from scrapbook)*

After Nicolas Poussin, French, 1593/94–1665
ca. 1874–80
Graphite on off-white wove paper
9 × 11 ⅝ in. (22.9 × 29.5 cm)
Gift of Mrs. Francis Ormond, 1950
50.130.154g

Like catalogue numbers 59 and 60, this drawing is a copy of a painting (1630–31) by Poussin in the Louvre. Sargent only summarized the background and most of the crowd, concentrating on the figures in the foreground, particularly the man at the left.

60

61

62

62. *Angel with Sundial, Chartres*

after 1874

Graphite on off-white wove paper

13 13/16 × 10 3/16 in. (35 × 25.8 cm)

Inscribed at lower left corner: Chartres; on verso at
lower right: CP

Gift of Mrs. Francis Ormond, 1950

50.130.143u

The inscription at the lower right of cata-
logue 62, although not in Sargent's hand,
correctly indicates that this sketch was
made after the sundial on the great Gothic
cathedral of Chartres, northwest of Paris.
The meticulous style suggests an early date,
probably sometime after Sargent's arrival in
Paris in 1874.

A related drawing of jamb figures, prob-
ably also made at Chartres, is in the Fogg
Art Museum (1931.89).

63. *La Faucheur (The Reaper)*

After Jean-François Millet, French, 1814–1875

ca. 1875

Graphite on off-white laid paper

6 13/16 × 4 1/16 in. (17.3 × 10.3 cm)

Gift of Mrs. Francis Ormond, 1950

50.130.143a

63

64. *La Tondeuse de Moutons (Woman Shearing Sheep)*

After Jean-François Millet, French, 1814–1875

ca. 1875

Graphite on off-white laid paper

6 7/16 × 4 1/4 in. (16.3 × 10.8 cm)

Gift of Mrs. Francis Ormond, 1950

50.130.143b

65. *Le Botteleur (Gathering Grain)*

After Jean-François Millet, French, 1814–1875

ca. 1875

Graphite on off-white laid paper

6 13/16 × 4 5/16 in. (17.3 × 11 cm)

Gift of Mrs. Francis Ormond, 1950

50.130.143c

Sargent's interest in Millet probably origi-
nated after his arrival in Paris. As an art
student there, Sargent was certainly aware
of Millet's work and his reputation as an
instructor at the École des Arts Décoratifs

(known as the "Petite École"). Several events
undoubtedly increased Sargent's awareness of
Millet in 1875: the French artist's death in
January, the sale of his studio contents in
May, and an exhibition and sale of his pastels
in June ("Dessins de Millet provenant de la
collection de M.G." [Gavet], Paris, rue St.
Georges). Ormond has proposed that Sargent
visited Barbizon in the summer of 1875
(Ormond 1970a, p. 17). Also, Sargent men-
tioned Millet in passing in a letter to Vernon
Lee in March 1882 (Charteris 1927, p. 56).

Sargent drew catalogue numbers 63–65
after three of Millet's etchings from *Les
Travaux des Champs*, a series of ten prints
depicting rustic labor, printed by Adrien
Lavieille and published in *L'Illustration* in
1853 and again in a separate publication in
1855. See catalogue 66 for another copy
after a print by Millet.

EXHIBITIONS (cats. 63, 64, and 65): New
York/San Francisco 1974/1977, cat. 88.

REFERENCES (cats. 63, 64, and 65): Nygren 1983,
p. 51; (cat. 65) Fairbrother 1994, p. 14.

64

65

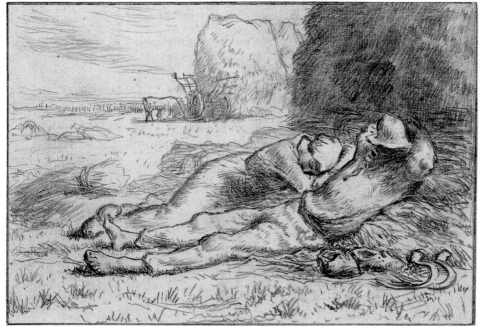

66

66. Noon (from scrapbook)

After Jean-François Millet, French, 1814–1875
ca. 1875
Graphite on off-white laid paper
Image: 5⅞ × 8⅝ in. (14.9 × 21.9 cm)
Inscribed at lower left: J. F. Millet.
Gift of Mrs. Francis Ormond, 1950
50.130.154d

In the late 1850s Millet produced a series of four designs depicting different times of a peasant's day. The series was engraved by Adrien Lavieille in 1860. Sargent seems to have used a combination of methods to copy the print *Noon*. Small pinholes are evident in many areas of this sheet. Each corner of the composition is marked by a pinhole that may have been used to hold the blank sheet to the original for copying. Relying on a certain transparency of the sheet, Sargent seems to have traced important areas of the composition with a series of pinholes. Presumably, he later connected the dots with

pencil, either freehand or by tracing. He varied the density of the pinholes, according to the significance of the element in the composition. For example, they are numerous and closely spaced along the contour of the peasant woman's body. Sargent also seems to have used the pinholes to distinguish elements in the composition or to denote where a line changed direction. Pinholes mark the top corners of the haystack in the center background as well as the point where that haystack meets the darker one in the foreground.

Catalogue 66 is pasted into a scrapbook compiled by Sargent. Based on the material in the book and the technique used for making the copy, a date after Sargent's arrival in Paris seems likely.

See also catalogue numbers 63, 64, and 65 for copies after Millet.

67 recto. *Entombment*

ca. 1874–77
Charcoal and chalk on pale blue wove paper
14⅜ × 18⅞ in. (36.5 × 47.9 cm)
Watermark: CANSON FRÈRES VIDALON LES ANN[illegible]
Gift of Mrs. Francis Ormond, 1950
50.130.141aa recto

67 verso. *Heads, Entombment, Other Studies*

ca. 1874–77
Graphite and pen and ink on pale blue wove paper
18⅞ × 14⅜ in. (47.9 × 36.5 cm)
Watermark: CANSON FRÈRES VIDALON LES ANN[illegible]
Gift of Mrs. Francis Ormond, 1950
50.130.141aa verso

Rubin dated this sheet about 1870, based on the carefully hatched ink drawing on the verso of the head of a woman, whom he identified as Mary Newbold Sargent, the artist's mother (New York–Glens Falls 1991–93, p. 10). However, the charcoal sketch depicting an entombment scene on the recto is too sophisticated to coincide in date with Sargent's alpine sketchbooks (cats. 16 and 17), and the sheet must date at least a few years later. Catalogue 67 recto could have been an academic exercise or a copy made in Paris. On the upper half of catalogue 67 verso, Sargent made a quick compositional study of the central figures.

REFERENCE (cat. 67 verso): New York–Glens Falls 1991–93, p. 10.

68 recto. *Orlando Innamorato*

ca. 1874–78
Pen and ink on off-white wove paper
17⁵⁄₁₆ × 12⁹⁄₁₆ in. (44 × 32 cm)
Inscribed at lower right: Boiardo Orlando Innamorato / see Leigh Hunt Ariosto
Watermark: G C Δ
Gift of Mrs. Francis Ormond, 1950
50.130.140x recto

68 verso. *Orlando Innamorato*

ca. 1874–78
Pen and ink on off-white wove paper
17⁵⁄₁₆ × 12⁹⁄₁₆ in. (44 × 32 cm)
Watermark: G C Δ
Gift of Mrs. Francis Ormond, 1950
50.130.140x verso

The scene depicted in catalogue 68 is identified on the basis of the inscription. "Boiardo" refers to the Italian poet Matteo Maria Boiardo (1441?–1494), who is best known for his unfinished historical epic *Orlando Innamorato* (1487). In 1506, Ludovico Ariosto (1474–1533) published a continuation of that work, entitled *Orlando Furioso*, a masterpiece of Italian Renaissance literature. Leigh Hunt (1784–1859) was a British essayist and publisher. The inscription "see Leigh Hunt Ariosto" probably refers to Hunt's *Stories from the Italian Poets with Critical Notice of the Life and Genius of the Authors*, first published in 1846, which discusses both of the Italian authors and recounts pivotal events from their poems.

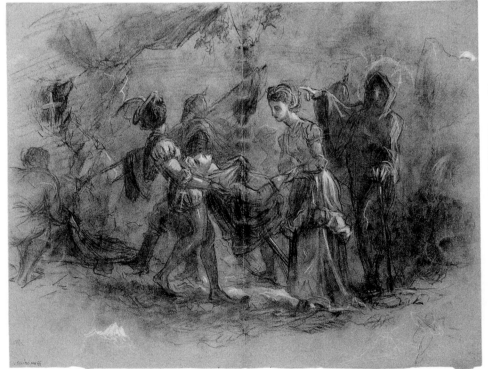

67 recto 67 verso

68 recto

68 verso

69. Head of a Man

ca. 1874–78
Graphite on gray-green laid paper
7¼ × 5⁵⁄₁₆ in. (18.4 × 13.5 cm)
Gift of Mrs. Francis Ormond, 1950
50.130.140n

The precise contours of the profile study and the shading of catalogue 69 suggest an early date, perhaps during Sargent's student years in Paris. A sketch of two heads in profile in the Corcoran Gallery of Art (49.254) is drawn similarly and may represent the same model.

Ormond and Kilmurray have also suggested a date in the late 1870s (oral communication, June 25, 1999).

Sargent portrayed a climactic moment from the story of the paladin Rinaldo from *Orlando Furioso* (rather than *Orlando Innamorato,* as suggested in the inscription). Rinaldo, in defense of the honor of a princess, slays her detractor, the Baron Lurcanio. Having driven his spear through the villain's breast, Rinaldo dismounts, rushes to the baron, and removes his helmet so that the king can hear his dying confession.

Sargent used an academic approach to record the scene. In repeated sketches on the four quarters of this folded sheet, he studied both the broader composition and the pose and gestures of the two central figures together and separately to various degrees of completion. Sargent's shorthand method for recording human form, especially in the compositional studies, is similar to the technique he used in his quick copies after the old masters, such as catalogue 57.

After the turn of the century, Sargent may have incorporated this subject into a painting. According to Ormond, the puppeteers depicted in the oil *Marionettes* (1903, private collection) are "almost certainly" performing a scene from Ariosto's *Orlando Furioso* (Adelson et al. 1997, p. 158).

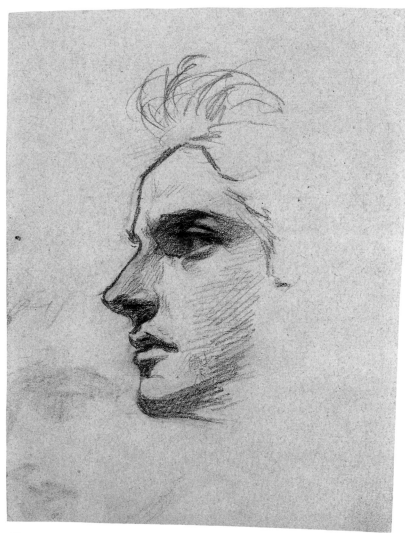

69

70. *Firelight*

ca. 1875
Graphite on off-white wove paper
6⁹⁄₁₆ × 3¹⁵⁄₁₆ in. (16.7 × 10 cm)
Inscribed at lower right: Firelight
Gift of Mrs. Francis Ormond, 1950
50.130.140m

Sargent's interest in the effects of light is
documented in a letter from his sister Emily
to Vernon Lee. Emily wrote in November
1876: "We used to paint in oils by lamp-
light often, & the results were quite pass-
able sometimes at night, but by daylight the
colours looked very differently" (Emily
Sargent to Vernon Lee, quoted in Ormond
and Kilmurray 1998, p. xviii). Although
Emily referred to painting, Sargent's inter-
est in modeling by means of strong shadow
and light is evidenced in his drawings as well.
He may have been inspired by his admiration
for Tintoretto, who drew small figurines
under strong light, a practice Sargent seems
to have emulated in the 1870s (cat. 52).
While Sargent painted several portraits by
lamplight in the 1880s (for example, *Alma
Strettell*, ca. 1889, private collection, and
Mrs. J. W. Comyns Carr, ca. 1889, J. B.
Speed Art Museum, Louisville, Kentucky),
the style of catalogue 70 suggests a date in
the mid-1870s.

EXHIBITION: New York 1928.

REFERENCE: Nygren 1983, p. 48.

70

71. *St. Malo (from scrapbook)*

May 1875
Graphite on off-white wove paper
3½ × 5¹¹⁄₁₆ in. (8.9 × 14.4 cm)
Inscribed at lower left: St. Malo. / Mai 1875.
Gift of Mrs. Francis Ormond, 1950
50.130.154w

In the summer of 1875, Sargent visited his
family at St. Enogat, where his parents
remained until spring 1876.

In a letter of January 9, 1876, Dr. Sargent
described the area to his sister:

71

72

We are spending the winter on the coast of Brittany, at a little village called St. Enogat—a village which you are not likely to find indicated on any map in your possession, so insignificant a place is it; but it is on the opposite side of the bay from Saint Malo—a city, or large town, of some importance as a sea port. (Fitzwilliam Sargent to sister [which one is undetermined], St. Enogat, January 9, 1876, Fitzwilliam Sargent Papers)

Another drawing that Sargent made at St. Malo, *Ramparts at St. Malo—Yacht Race,* is in the Corcoran Gallery of Art (49.148c).

REFERENCE: Nygren 1983, p. 46.

72. Goethe

After Pierre-Jean David, called David d'Angers, French, 1788–1856

ca. 1871–75

Graphite on grayish white wove paper, partially laid down on oatmeal paper

6⁵⁄₁₆ × 2³⁄₁₆ in. (16 × 5.5 cm) (irregular)

Inscribed across lower edge: Goethe by David D'Angers; at lower left: J.S. 342; on verso at lower right: CP

Gift of Mrs. Francis Ormond, 1950

50.130.143m

Sargent could have seen a replica of David d'Angers's monumental marble bust (1831) of the German poet and author Goethe while he was living in Dresden in 1871–72 (the original is in Weimar). However, in a letter to Ben del Castillo from St. Enogat in June 1875, Sargent mentioned a bust of Goethe without naming its creator. In a detailed description of his bedroom, he noted, "There is a great tapestried chimney piece, plenty of oil portraits, a few small choice casts such as a head of Goethe and a beautiful reduction of the Moses of Michel Angelo" (JSS to Ben del Castillo, St. Enogat, June 20, 1875, quoted in Charteris 1927, p. 38). Whether or not catalogue 72 depicts the bust of Goethe in Sargent's St. Enogat bedroom, its style suggests a date in the early to mid-1870s.

EXHIBITION: Probably included in New York 1928 (inventory listing J.S. 342).

Catalogue Numbers 73–84

The following twelve sheets, pasted into a scrapbook in the Metropolitan, have the same approximate dimensions and may have originated in the same sketchbook. One drawing, catalogue 80, is inscribed with a location not far from St. Malo and the date June 1875. A drawing in the Corcoran Gallery of Art, *Ramparts at St. Malo—Yacht Race* (49.148c), has the same approximate dimensions and may have belonged to the same sketchbook as these sheets. These drawings of ships and rocky coastlines probably depict the Brittany coast around St. Enogat and St. Malo, where the Sargent family spent the summer of 1875. However, since Sargent spent at least part of each summer from 1874 to 1877 at the shore (1874 in Normandy; 1876 in Newport, Rhode Island; and 1877 again in Brittany), and since specific locales are undetermined for some of the sheets, an approximate date of about 1875 has been assigned to most of this group.

73. *Schooner and Bark in Harbor (from scrapbook)*

ca. 1875

Graphite on off-white wove paper

4 × 6½ in. (10.2 × 16.5 cm)

Inscribed at lower right: Schooner & Bark.

Gift of Mrs. Francis Ormond, 1950

50.130.154p

73

74

75

76

77

74. *Sailors in Rigging of Ship (from scrapbook)*

ca. 1875
Graphite on off-white wove paper
4 × 6½ in. (10.2 × 16.5 cm)
Inscribed at left: grey / light yellow [and other illegible color notations]
Gift of Mrs. Francis Ormond, 1950
50.130.154u

75. *Two Sailors Furling Sail (from scrapbook)*

ca. 1875
Watercolor and graphite on off-white wove paper
3¹⁵⁄₁₆ × 6⁹⁄₁₆ in. (10 × 16.7 cm)
Gift of Mrs. Francis Ormond, 1950
50.130.154v

76. *Two Men in Ship's Rigging, Two Scenes with Sailboats (from scrapbook)*

ca. 1875
Graphite on off-white wove paper
3¹⁵⁄₁₆ × 6½ in. (10 × 16.5 cm)
Gift of Mrs. Francis Ormond, 1950
50.130.154jj

Catalogue numbers 73–76 probably represent the harbor at St. Malo or environs.

Catalogue 76, in particular, is related to a drawing in the Corcoran Gallery of Art, *Ramparts at St. Malo—Yacht Race*, which has the same approximate dimensions and may have come from the same sketchbook as these sheets. The drawings have a similar tonality as a result of Sargent's hatching in dark graphite. They may also be related in subject: the Corcoran drawing portrays spectators at a yacht race at St. Malo; catalogue 76 may depict part of that race.

REFERENCE (cat. 75): Nygren 1983, p. 47.

77. *Waves Breaking on Rocks (from scrapbook)*

ca. 1875
Watercolor and graphite on off-white wove paper
4 × 6½ in. (10.2 × 16.5 cm)
Inscribed on scrapbook page: murky sky warm . water general / tone in foreground like sky. in distance / dark blue purple. Accents clear blue / green. foreground foam lightest value, / blue lilac & icegreen. rocks dark brown / darkest value : in rough streaks [illegible] / to marblings of foam lighter than water.
Gift of Mrs. Francis Ormond, 1950
50.130.154q

78. *Rocky Coast (from scrapbook)*

ca. 1875
Watercolor and graphite on off-white wove paper
4 × 6½ in. (10.2 × 16.5 cm)
Gift of Mrs. Francis Ormond, 1950
50.130.154r

78

79. *Coastal Scene (from scrapbook)*

ca. 1875
Graphite on off-white wove paper
6⅝ × 4 in. (16.8 × 10.2 cm)
Gift of Mrs. Francis Ormond, 1950
50.130.154s

Catalogue numbers 77, 78, and 79 probably represent the coast of Brittany around St. Malo and St. Enogat.

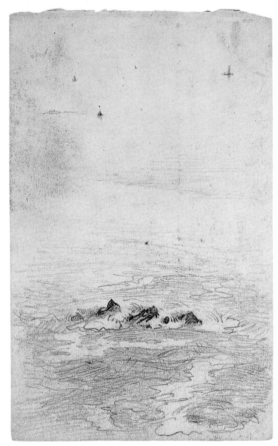

79

80. *La Pierre du Champ Dolent (from scrapbook)*

June 1875
Graphite on off-white wove paper
3¹⁵⁄₁₆ × 6½ in. (10 × 16.5 cm)
Inscribed at lower right: La Pierre du Champ Dolent
/ Dol June '75
Gift of Mrs. Francis Ormond, 1950
50.130.154kk

The small town of Dol is about fifteen miles southeast of St. Malo, near where Sargent spent the summer of 1875 with his family. Just outside the town is the Pierre du Champ Dolent, a prehistoric menhir. From a vantage point in a field, Sargent studied the imposing thirty-two-foot-high megalith against silhouetted trees. The cross atop the menhir was removed about 1900.

80

81. *Two Men and a Hayrack Drawn by a Horse (from scrapbook)*

1875
Graphite on off-white wove paper
3 ¹⁵⁄₁₆ × 6½ in. (10 × 16.5 cm)
Gift of Mrs. Francis Ormond, 1950
50.130.154ii

82 recto. *Boy and Girl Seated by Tree (from scrapbook)*

1875
Graphite on off-white wove paper
3 ¹⁵⁄₁₆ × 6½ in. (10 × 16.5 cm)
Gift of Mrs. Francis Ormond, 1950
50.130.154mm recto

82 verso. *Sailors and Reapers (from scrapbook)*

1875
Graphite on off-white wove paper
3 ¹⁵⁄₁₆ × 6½ in. (10 × 16.5 cm)
Gift of Mrs. Francis Ormond, 1950
50.130.154mm verso

83. *Windmill and Reapers (from scrapbook)*

1875
Graphite on off-white wove paper
4 × 6½ in. (10.2 × 16.5 cm)
Gift of Mrs. Francis Ormond, 1950
50.130.154oo

Catalogue numbers 81, 82 recto, and 83 are similar in subject and technique to *La Pierre du Champ Dolent* (cat. 80), which is inscribed "June 1875." Unlike most of the drawings in this group, which record nautical themes, these three focus on rural activities, possibly in the vicinity of Dol, site of *La Pierre du Champ Dolent,* near St. Enogat and St. Malo. For this publication, catalogue 82 was lifted from the scrapbook page to reveal on the verso the studies of a sailor and reapers that link the seemingly disparate themes of sea and countryside explored in catalogue numbers 73–83. Sargent's graphic style here is distinguished by his bold use of dark pencil.

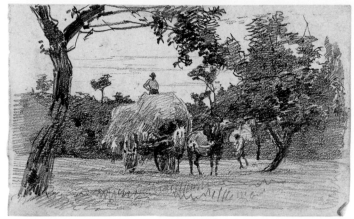

81

82 recto

82 verso

83

84. Two Small Boats Moored to Beach (from scrapbook)

ca. 1875
Graphite on off-white wove paper
3¹⁵⁄₁₆ × 6½ in. (10 × 16.5 cm)
Gift of Mrs. Francis Ormond, 1950
50.130.154hh

84

85. Sailboat Towing Dory (from scrapbook)

ca. 1875
Graphite on off-white wove paper
2¹¹⁄₁₆ × 3⁹⁄₁₆ in. (6.8 × 9 cm)
Gift of Mrs. Francis Ormond, 1950
50.130.154t

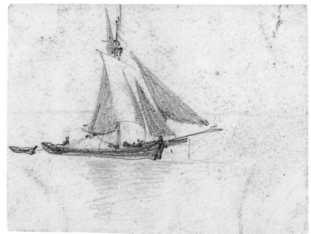

85

86. Fishermen with Nets

ca. 1875
Graphite on off-white wove paper
4³⁄₁₆ × 6⁷⁄₁₆ in. (10.6 × 16.3 cm)
Gift of Mrs. Francis Ormond, 1950
50.130.94

86

87. Water's Edge (from scrapbook)

ca. 1874–77
Graphite on off-white wove paper
5½ × 7½ in. (14 × 19.1 cm)
Gift of Mrs. Francis Ormond, 1950
50.130.154nn

Sargent could have made this study on the coast of Brittany or Normandy in the mid-1870s.

87

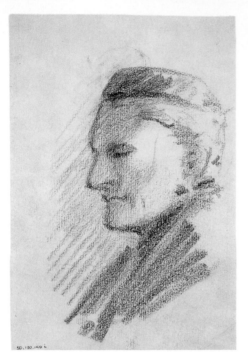

88 recto

88 verso

89 recto

89 verso

88 recto. *Head*

ca. 1876
Graphite on off-white wove paper
7¹¹⁄₁₆ × 5⅛ in. (19.6 × 13 cm)
Gift of Mrs. Francis Ormond, 1950
50.130.140g recto

88 verso. *Three Heads*

ca. 1876
Graphite on off-white wove paper
5⅛ × 7¹¹⁄₁₆ in. (13 × 19.6 cm)
Gift of Mrs. Francis Ormond, 1950
50.130.140g verso

The style of catalogue numbers 88 recto and verso indicates an early date. Ormond suggests that the figure depicted on the recto may be one of Sargent's American cousins, possibly drawn during the artist's first visit to the United States in 1876 (oral communication, June 16, 1997).

89 recto. *Men Hauling Lifeboat Ashore (from scrapbook)*

1876
Watercolor and graphite on off-white wove paper
3¾ × 11¾ in. (9.5 × 29.8 cm)
Gift of Mrs. Francis Ormond, 1950
50.130.154n recto

89 verso. *Sailor (from scrapbook)*
1876
Watercolor and graphite on off-white wove paper
11¾ × 3¾ in. (29.8 × 9.5 cm)
Gift of Mrs. Francis Ormond, 1950
50.130.154n verso

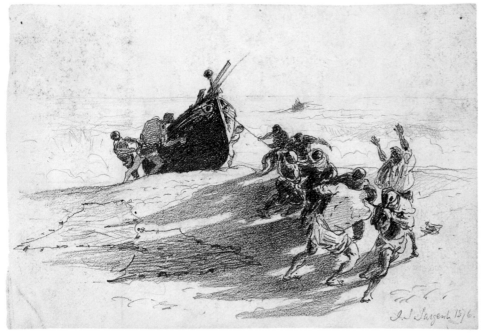

90

92

90. Men Hauling Boat onto Beach (from scrapbook)

1876
Graphite on off-white wove paper
6⅝ × 9¾ in. (16.8 × 24.8 cm)
Inscribed at lower right: J. S. Sargent 1876.
Gift of Mrs. Francis Ormond, 1950
50.130.154o

In catalogue numbers 89 recto and 90, Sargent rendered the same subject; catalogue 90, which is signed and dated, is probably the final study.

Catalogue 89 recto occupies two sketchbook pages. In the smaller drawing on the right-hand page, Sargent studied the scene from a distance, barely suggesting the boat at the left edge of the composition. The watercolor on the left-hand page contains fewer details and is broadly painted, but it includes the boat on the beach. Sargent seems to have combined the two sketches from catalogue 89 recto for the final composition, catalogue 90, borrowing the angle and position of the men from the small graphite sketch on the right-hand page and the position of the boat and shore from the study on the left-hand page. In preparation for this publication, catalogue 89 was removed from the scrapbook to reveal the drawing on the right side of the verso of the double sheet; the left side is blank.

91. Men Pulling Ropes (from scrapbook)

ca. 1876
Graphite on tan wove paper
4⁵⁄₁₆ × 6¼ in. (11 × 15.9 cm)
Gift of Mrs. Francis Ormond, 1950
50.130.154aa

The costume of the figure at the right edge of catalogue 91 may be that of a sailor. These studies may be related to catalogue numbers 89 and 90 or to other nautical subjects Sargent rendered in the mid-1870s.

92. Sails (from scrapbook)

ca. 1874–77
Graphite on tan wove paper
6¼ × 4¼ in. (15.9 × 10.8 cm)
Gift of Mrs. Francis Ormond, 1950
50.130.154z

Catalogue 92 may come from the same sketchbook as catalogue 91.

91

93

Figure 67. *Becalmed*, 1877. Graphite on paper, 8¼ × 11 in. (21 × 27.9 cm). Photograph courtesy of Sotheby's Inc., New York

93. *Siesta on a Boat*

1876
Graphite on off-white wove paper
4 × 6¹¹⁄₁₆ in. (10.2 × 17 cm)
Inscribed on verso at center: EP
Gift of Mrs. Francis Ormond, 1950
50.130.141m

Sargent copied this charming vignette of three intertwined figures dozing on the deck of a boat in a drawing entitled *Becalmed— Souvenir of Newport* (figure 67) that was originally included in an album presented to the famous Canadian soprano Dame Emma Albani (1847–1930) by American art students in Paris on the occasion of her visit there in 1877. The locale and date of catalogue 93 are based on the inscription on *Becalmed*, which reads: "Becalmed—Souvenir of / Newport. / John S. Sargent / March 1877." Sargent had visited Newport, Rhode Island, during his first visit to the United States in

1876. The date, March 1877, inscribed on *Becalmed* must refer to the date when Sargent made the copy and the presentation to Dame Albani.

In addition to making several minor changes, Sargent enlarged the composition of *Becalmed* to include a pipe-smoking sailor seated on the back ledge and the edge of a sail at the left side of the composition. The Albani album, which also included drawings by J. Alden Weir, Walter Launt Palmer, and James Carroll Beckwith, among others, was dismantled. *Becalmed* was sold at Sotheby's, New York, in March 1992 (sale number 6279, lot 52).

REFERENCES: Nygren 1983, p. 45; Weinberg and Herdrich 2000b, p. 230.

94. *Hugh McGehan and James Roarity*

ca. 1876?
Graphite on off-white wove paper
4 × 6¹¹⁄₁₆ in. (10.2 × 17 cm)
Inscribed: Hugh MᶜGehan James Roarity; on verso at center left: EP
Gift of Mrs. Francis Ormond, 1950
50.130.141n

95. *James Roarity and a Woman at Table, Four Profiles of James Roarity*

ca. 1876?
Graphite on off-white wove paper
4 × 6¹¹⁄₁₆ in. (10.2 × 17 cm)
Inscribed on verso at center: EP
Gift of Mrs. Francis Ormond, 1950
50.130.141o

These two sheets seem to have belonged to the same sketchbook as catalogue 93, which Sargent used at Newport during the summer of 1876. James Roarity and Hugh McGehan are identified from the inscription on catalogue 94. Nothing else is

94 95

96

97

known about them. Sargent may have encountered them at Newport or elsewhere in the United States during his visit.

Catalogue Numbers 96–100

The following five sheets belonged to a sketchbook that Sargent used during his Atlantic crossing in autumn 1876.

96. *Sailors on Sloping Deck (from scrapbook)*

1876
Graphite on off-white wove paper
4⁵⁄₁₆ × 7¼ in. (11 × 18.4 cm)
Gift of Mrs. Francis Ormond, 1950
50.130.154i

97. *Lifeboats on Davits (from scrapbook)*

1876
Graphite on off-white wove paper
4⁵⁄₁₆ × 7¼ in. (11 × 18.4 cm)
Inscribed on back of lifeboat: ALGERIA
GLASGOW; [color notations across the sheet].
Inscribed beneath the drawing (on the scrapbook
page): sea deep blue darker than shade in boats.
foam colder than boats; / close by, [marblings?] of
light green. immense spreading surf thick cold white /
deck lighter than sea, where wet, rich brown with
purple — shade of boats / lighter than sea; very var-
ied in tone. dark accents at top and / bottom. sail
very dark brownish purple shade
Gift of Mrs. Francis Ormond, 1950
50.130.154j

Algeria, inscribed on the stern of the lifeboat in catalogue 97, is the name of the ship on which the Sargents returned from the United States in 1876. During their crossing, they encountered a storm that Sargent documented in catalogue numbers 96 and 97 and in the oil *Atlantic Storm* (see figure 56), a view off a slanting boat deck into a turbulent ocean. In all three works, the dramatic slope of the pitching ship in relation to the high waves creates dynamic compositions.

Other drawings from the same sketchbook that were also made during the Atlantic crossing are catalogue numbers 98 and 99. Another drawing of a lifeboat with color notations is catalogue 101.

REFERENCE (cat. 97): Olson 1986, p. 52.

98. *Sailors Relaxing on Deck (from scrapbook)*

1876
Graphite on off-white wove paper
4⁵⁄₁₆ × 7¼ in. (11 × 18.4 cm)
Gift of Mrs. Francis Ormond, 1950
50.130.154x

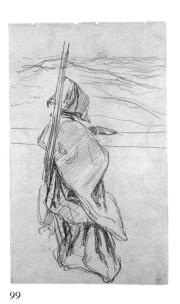

99

99. *Woman Looking Out to Sea*

1876
Graphite on off-white wove paper
7⁵⁄₁₆ × 4³⁄₁₆ in. (18.5 × 10.7 cm)
Gift of Mrs. Francis Ormond, 1950
50.130.140c

The swelling waves in the distance resemble those in catalogue numbers 96 and

98

100

101

97. A similarly dressed figure is depicted in the lower left corner of catalogue 98.

EXHIBITION: "Images of Women: Nineteenth-Century American Drawings and Watercolors," The Metropolitan Museum of Art, October 29, 1996–February 2, 1997.

100. *Five Figures (from scrapbook)*

1876
Graphite on off-white wove paper
4⁵⁄₁₆ × 7¼ in. (11 × 18.4 cm)
Gift of Mrs. Francis Ormond, 1950
50.130.154y

Although the figures, drawn with short, quick lines, resemble those in catalogue numbers 98 and 99, the subject does not clearly represent a scene aboard ship.

101. *Boat Deck*

1876
Graphite on pale green wove paper
3¹⁵⁄₁₆ × 6¹¹⁄₁₆ in. (10.1 × 17 cm)
Inscribed at right center: whole boat in shadow. Light / mass darker than / sky lighter than / water. darker / than deck / shadow on / deck / warmer / to darker / than sail.; [also other scattered color notations on lifeboat]
Gift of Mrs. Francis Ormond, 1950
50.130.90

This drawing of lifeboats marked with color notations is related to *Lifeboats on Davits* (cat. 97) and may have been drawn during one of Sargent's Atlantic crossings in 1876. The calm ocean distinguishes this drawing from catalogue 97. Sargent may have made the notations of color and relative tones for use in a later painting.

102. *Cattle in Stern of a Boat*

ca. 1876
Graphite on off-white wove paper
3¹⁵⁄₁₆ × 6¹¹⁄₁₆ in. (10 × 17.2 cm)
Inscribed on verso at top: water light clear green, immense eddies / sunshine glittering all over
Gift of Mrs. Francis Ormond, 1950
50.130.91

Catalogue 102 has the same approximate dimensions as catalogue 101 and may have come from the same sketchbook. In subject and style, it relates to the nautical drawings of the mid- to late 1870s.

103. *Men Sleeping on Deck of Ship (from scrapbook)*

1876?
Graphite on off-white wove paper
4 × 6¾ in. (10.2 × 17.1 cm)
Gift of Mrs. Francis Ormond, 1950
50.130.154k

104. *Sailors on Deck of Ship (from scrapbook)*

1876?
Graphite on off-white wove paper
4 × 6⅝ in. (10.2 × 16.8 cm)
Gift of Mrs. Francis Ormond, 1950
50.130.154m

Catalogue numbers 103 and 104 have the same approximate dimensions and may have come from the same sketchbook. In these vignettes of life aboard ship, possibly drawn during one of the artist's Atlantic

102

103

104

105

crossings of 1876, Sargent depicted a group
of sailors sleeping on deck, as he had in the
background of catalogue 98.

In catalogue 104, Sargent abandoned
the rapid and generalized style of many of
his shipboard sketches to render a detailed
study of the sailors. Catalogue 103 may
represent the ship deck that appears in cat-
alogue 105.

105. *Deck of Ship in Moonlight (from scrapbook)*

1876
Watercolor on off-white wove paper
9 × 11¼ in. (22.9 × 29.8 cm)
Gift of Mrs. Francis Ormond, 1950
50.130.154bb

Sargent probably painted this careful study
of the deck of a ship lit by a full moon dur-
ing one of his Atlantic crossings in 1876.
This drawing may depict the same deck
that appears in catalogue 103.

106. *Moonlight on Waves (from scrapbook)*

ca. 1876
Graphite on off-white wove paper
3¾ × 5⅞ in. (9.5 × 14.9 cm)
Gift of Mrs. Francis Ormond, 1950
50.130.154l

Sargent studied the effect of light on the
water in the wake of the ship. He probably
made this sketch during one of his Atlantic
crossings in 1876.

106

107

107. Sailboat Deck with Figures

ca. 1876?

Graphite on off-white wove paper
4³⁄₁₆ × 7³⁄₁₆ in. (10.7 × 18.2 cm)
Inscribed on verso: Chorus— / And its home deary
home / And its home or ought to be / Its home
deary home in the old country / Where the oak and
ash / And the bonny birchen tree / Are all growing
green in the old country— / Oh! I lived in an inn /
In Rosemary lane / And gained the good will / Of
the inmates within / Until there pass I by / A sailor
boy so bold / And that was the beginning / Of the
sad tale to be told. / And when it got dark / The
sailor boy grew tired / & asked for a candle / To
light him to bed— / I gave him the candle / As an
honest maid should / When he said and he swore /
I should get to bed too.
Gift of Mrs. Francis Ormond, 1950
50.130.140a

The style of catalogue 107 and the hand-
writing on the verso suggest a date in the
mid-1870s. The sheet originally belonged
to a sketchbook, and its size approximates
that of several images drawn during one
of Sargent's Atlantic crossings in 1876
(cats. 96–100).

The nautical subject relates to various
sketches Sargent made on the shores of
Brittany, Normandy, and possibly even
Newport during various summers in the
1870s. The schooner, heavily laden with
baggage and a few passengers, yields little
information to assist with dating or identifi-
cation of locale.

On the verso, Sargent transcribed the
chorus and first two verses of "Rosemary
Lane," a popular sea song that had been

Figure 68. Verso of catalogue 107, *Sailboat
Deck with Figures,* showing inscription.

printed as a broadside as early as about
1809–15 and that exists in several versions.
The song continues to tell the "sad tale" of
the maiden left pregnant by the sailor. "At
first sight this is the story of an innocent
girl betrayed. . . . Yet Rosemary Lane (now
called Royal Mint Street) was in a part of
London, near the Tower, where brothels
abounded" (Roy Palmer, ed., *The Oxford
Book of Sea Songs,* Oxford, 1986, p. 180).

108. Compositional Study for "Rehearsal of the Pasdeloup Orchestra at the Cirque d'Hiver" (from scrapbook)

ca. 1876–78
Graphite on off-white wove paper
3³⁄₈ × 5³⁄₈ in. (8.6 × 13.7 cm)
Gift of Mrs. Francis Ormond, 1950
50.130.154c

The Pasdeloup orchestra, so-called after its
conductor Jules-Étienne Pasdeloup
(1819–1887), rehearsed in public on Sun-
days at the open-air amphitheater in Paris,
the Cirque d'Hiver, from 1861 to 1884.
Sargent, an accomplished musician and
inveterate concertgoer, often attended these
rehearsals.

In 1896 William Coffin recalled that
Sargent "was struck by the odd pictur-
esqueness of the orchestra. . . . While he
listened he looked, and one day he took a
canvas and painted his impression" (Coffin
1896, p. 172). Contrary to Coffin's descrip-
tion, Sargent made several pencil studies
before he painted two versions of *Rehearsal
of the Pasdeloup Orchestra at the Cirque d'Hiver*
(1876, Museum of Fine Arts, Boston; pri-
vate collection, on loan to the Art Institute
of Chicago, see figure 53).

The spontaneous quality recognized by
Coffin in the oil he described is especially
vivid in catalogue 108. Sargent captured the
impression of the amphitheater by delineat-
ing the silhouettes of several musicians and
instruments but relying mostly on broad,
rapid hatching to suggest space. The draw-
ing differs from both paintings in its hori-
zontal format. It includes an ambiguous
element in the lower right corner that may
be analogous to a group of clowns observ-
ing the concert in the painting now in
Chicago. The lower right corner of the
composition is left empty in the Boston
painting.

See catalogue 109 for a discussion of
other sketches related to the paintings.

REFERENCES: Ormond 1970a, p. 236; Nygren
1983, p. 46; Barter et al. 1998, pp. 212–13; Ormond
and Kilmurray 1998, p. 84.

108

109. Musicians, Related to "Rehearsal of the Pasdeloup Orchestra at the Cirque d'Hiver" (from scrapbook)

ca. 1876–78
Graphite on off-white wove paper
3³⁄₁₆ × 5½ in. (8 × 14 cm)
Gift of Mrs. Francis Ormond, 1950
50.130.154c2

On the right of catalogue 109, Sargent depicted a figure with a bass viol. At the center and left he suggested the shapes of the tympanum and a top-hatted figure playing the bass viol or cello who is seen at the right edges of the paintings at the Museum of Fine Arts, Boston, and on loan to the Art Institute of Chicago (see cat. 108). A related drawing on the same size sheet is in the Museum of Fine Arts, Boston (28.50).

Two other studies related to the paintings are illustrated in New York 1928.

110

110. Foot

1875–80?
Graphite on off-white wove paper tacked to card
3¹¹⁄₁₆ × 2¹¹⁄₁₆ in. (9.6 × 6.8 cm)
Inscribed at left corner: J.S. 340; on verso at upper right: 32
Gift of Mrs. Francis Ormond, 1950
50.130.140p

The multiple contour lines and problematic foreshortening in catalogue 110 seem to indicate an early date. A possibly related drawing of a foot appears on a sheet of hand studies in the Corcoran Gallery of Art (49.130) for *Fumée d'Ambre Gris* (see figure 58).

EXHIBITION: Probably included in New York 1928 (inventory listing J.S. 340).

III

109

111. Nostrils and Lips

1875–80?
Graphite on off-white wove paper
2⅛ × 2⁹⁄₁₆ in. (5.4 × 6.6 cm)
Inscribed at lower left corner: J.S. 339
Gift of Mrs. Francis Ormond, 1950
50.130.140q

EXHIBITION: Probably included in New York 1928 (inventory listing J.S. 339).

112 recto. *Woman with Bow*

ca. 1877?
Graphite on off-white wove paper
5 15/16 × 3 7/16 in. (15 × 8.7 cm)
Gift of Mrs. Francis Ormond, 1950
50.130.141q recto

112 verso. *Heads*

ca. 1877?
Graphite and pen and ink on off-white wove paper
3 7/16 × 5 15/16 in. (8.7 × 15 cm)
Gift of Mrs. Francis Ormond, 1950
50.130.141q verso

For his oil portraits from the mid- to late 1870s, Sargent most often used a bust-length format. Several of his canvases of female sitters created about this time show the subject with upswept hair and an ornamented neckline, as in catalogue 112 recto, the sketch of an unidentified woman. Sargent painted both *Harriet Louise Warren* (1877, private collection) and *Emily Sargent* (ca. 1877, private collection) with fancy bows at their necks, similar to that in catalogue 112 recto.

113. *Two Heads*

ca. 1877?
Pen and ink on off-white wove paper
3 7/16 × 5 15/16 in. (8.8 × 15 cm)
Inscribed on verso at center: EP
Gift of Mrs. Francis Ormond, 1950
50.130.141s

This sheet may come from the same sketchbook as catalogue 112.

114 recto. *Men*

ca. 1877
Graphite on off-white wove paper
3 7/16 × 5 15/16 in. (8.8 × 15.1 cm)
Gift of Mrs. Francis Ormond, 1950
50.130.140e recto

114 verso. *Kneeling Woman*

ca. 1877
Graphite on off-white wove paper
5 15/16 × 3 7/16 in. (15.1 × 8.8 cm)
Gift of Mrs. Francis Ormond, 1950
50.130.140e verso

115 recto. *Men*

ca. 1877
Graphite on off-white wove paper
3 7/16 × 5 15/16 in. (8.8 × 15 cm)
Gift of Mrs. Francis Ormond, 1950
50.130.140f recto

115 verso. *Horse and Two Men*

ca. 1877
Graphite on off-white wove paper
3 7/16 × 5 15/16 in. (8.8 × 15 cm)
Gift of Mrs. Francis Ormond, 1950
50.130.140f verso

Catalogue numbers 114 and 115 may have come from the same sketchbook as catalogue numbers 112 and 113.

116. *Dome of San Lorenzo and Campanile, Turin*

ca. 1877–78
Pen and ink and graphite on off-white wove paper
9 × 11 3/4 in. (22.9 × 29.8 cm)
Inscribed at right: proportions ought to be taller; on verso at lower center: EP
Gift of Mrs. Francis Ormond, 1950
50.130.141u

In catalogue 116 Sargent recorded the dome of the seventeenth-century Church of San Lorenzo, Turin, and the nearby campanile of the Duomo (completed 1720). Ormond suggested a date before 1880, based on the style of both the drawing and Sargent's handwriting in the inscription at right (oral communication, June 1997).

Turin is situated in northwest Italy, near the French border. Sargent could have vis-

112 recto

112 verso

113

154

50.130.140 e

114 recto

50.130.140 f

114 verso

50.130.140 g

115 recto

50.130.140 h

.278

115 verso

ited that city in 1877, when he spent time
with his family in nearby Genoa, or he
could have passed through in 1878 en route
from Paris to Naples and Capri.

Other studies of the campanile are in the
Fogg Art Museum (1931.102, 1931.72,
1931.73).

117

117. *Woman with Basket*

ca. 1875–78
Graphite on dark buff wove paper
5⅝ × 3⁷⁄₁₆ in. (14.3 × 8.7 cm)
Inscribed at lower left: J.S. 342; at lower right:
J.S.S. 1875
Gift of Mrs. Francis Ormond, 1950
50.130.92

The inscribed date does not seem to be by
the artist but was on catalogue 117 when it
was inventoried for the Grand Central Art
Galleries exhibition in 1928 (New York
1928; inventory in the Thomas A. Fox–
John Singer Sargent Collection, Boston
Athenaeum). In style and subject, the quick
sketch resembles works of the mid-1870s.
The woman's costume and her basket may
relate to those of the women in *Fishing for
Oysters at Cancale* (1878, Museum of Fine
Arts, Boston) and *Oyster Gatherers of Cancale*
(see figure 55). See also catalogue 118.

EXHIBITIONS: Probably included in New York
1928 (inventory listing J.S. 343 or 388); "Sargent,
Whistler and Cassatt," American Federation of Arts,
traveling exhibition, September 1954–57 (no cata-
logue); untitled exhibition, The Metropolitan
Museum of Art, September 1980.

118

118. *Child, Study for "Oyster Gatherers of Cancale"*

1877–78
Graphite on off-white wove paper
8¼ × 5 in. (21 × 12.7 cm)
Inscribed at lower left: J.S. 353; on verso at upper
right: 338
Gift of Mrs. Francis Ormond, 1950
50.130.114

During the summer of 1877, Sargent spent
about ten weeks at the fishing village of
Cancale on the Brittany coast. Two related
oils resulted from the summer's efforts: *Fish-
ing for Oysters at Cancale* (1878; Museum of
Fine Arts, Boston), which Sargent showed at
the 1878 Society of American Artists exhibi-
tion in New York, and *Oyster Gatherers of
Cancale* (see figure 55), which he sent to
the 1878 Paris Salon. Sargent based these

119

120 recto

120 verso

paintings, which he finished in his Paris studio, on studies made on site.

Patricia Hills first identified catalogue 118 as a study for the paintings (Hills 1986, p. 254). While the figure is similar in type and costume to the two children in each painting, his contrapposto pose is more like that of the boy at center left, whose face is partially obscured by a woman's basket.

EXHIBITION: Probably included in New York 1928 (inventory listing J.S. 353).

REFERENCE: Hills 1986, pp. 254, 256.

119. *Wading Children*

ca. 1878
Graphite on off-white wove paper
2 × 3¹⁵⁄₁₆ in. (5.1 × 10 cm)
Gift of Mrs. Francis Ormond, 1950
50.130.140b

Margaret Conrads has linked catalogue 119 and *Bathing Children* (cat. 120 recto) to the painting *Neapolitan Children Bathing*

(see figure 54). While the similarity of subject is compelling, catalogue 119 could also date from the summer of 1877, which Sargent spent on the Brittany coast. His major work from that summer, *Oyster Gatherers of Cancale* (see figure 55), depicts wading figures in the background.

EXHIBITION: "A Selection of Six: American Painting from the Clark Collection," Sterling and Francine Clark Art Institute, Williamstown, Mass., November 17, 1990–January 13, 1991 (no catalogue; exhibition accompanied publication of Conrads 1990).

REFERENCE: Conrads 1990, p. 163.

120 recto. *Bathing Children*

1878
Graphite on off-white wove paper
3⁹⁄₁₆ × 5⅞ in. (9 × 14.9 cm)
Gift of Mrs. Francis Ormond, 1950
50.130.140d recto

120 verso. *Heads*

1878
Graphite on off-white wove paper
3⁹⁄₁₆ × 5⅞ in. (9 × 14.9 cm)
Gift of Mrs. Francis Ormond, 1950
50.130.140d verso

In August 1878, Sargent traveled to Naples and Capri. One of the results of this trip is *Neapolitan Children Bathing* (see figure 54), which depicts four boys on a beach. While Sargent probably finished the oil painting in 1879, after his return to Paris, he may have executed catalogue 120 recto on site. The three figures at the right appear to wear water wings, as does one of the figures in the painting. To the left of the sheet, a head covered with a dark hat resembles a head bobbing out of the water seen in the background of the painting. See also catalogue 119.

EXHIBITION: "A Selection of Six: American Painting from the Clark Collection," Sterling and Francine Clark Art Institute, Williamstown, Mass., November 17, 1990–January 13, 1991 (no catalogue; exhibition accompanied publication of Conrads 1990).

REFERENCE: Conrads 1990, p. 163.

121. *Man*

ca. 1878
Graphite on off-white wove paper
3⁹⁄₁₆ × 5⁹⁄₁₆ in. (9 × 14.1 cm)
Inscribed at lower left: J.S. 343; on verso at lower right: 333
Gift of Mrs. Francis Ormond, 1950
50.130.97

121

122 recto

122 verso

123

124

122 recto. *Two Men in Boats*

ca. 1878
Graphite on off-white wove paper
3⁹⁄₁₆ × 5¹³⁄₁₆ in. (9 × 14.8 cm)
Gift of Mrs. Francis Ormond, 1950
50.130.98 recto

122 verso. *Oar*

ca. 1878
Graphite on off-white wove paper
5⁹⁄₁₆ × 3⁹⁄₁₆ in. (14.8 × 9 cm)
Gift of Mrs. Francis Ormond, 1950
50.130.98 verso

123. *Two Men in Boat*

ca. 1878
Graphite and gray pencil on off-white wove paper
3⁹⁄₁₆ × 5¹³⁄₁₆ in. (9 × 14.8 cm)
Gift of Mrs. Francis Ormond, 1950
50.130.99

124. *Oarsman*

ca. 1878
Graphite on off-white wove paper
5¹⁵⁄₁₆ × 3⁹⁄₁₆ in. (15 × 9 cm)
Gift of Mrs. Francis Ormond, 1950
50.130.104

Catalogue numbers 121–24 have the same approximate dimensions as catalogue 120, which Sargent drew during his trip to Naples and Capri in 1878. If these sheets are from the same sketchbook, they may all depict sailors on the coast of Italy. While their subject could link them to one of the previous summers, which Sargent spent on the coast of northern France, the shorthand method for sketching figures that he used here seems more expressive and effective than that seen in his drawings from the mid-1870s (e.g., cats. 74, 75, and 76). Therefore, a date about 1878 seems justified.

Catalogue 122 verso seems to be an abandoned sketch of the same subject as catalogue 124.

EXHIBITION (cat. 121): Probably included in New York 1928 (inventory listing J.S. 343).

125. *Egyptian Sculpture and Motifs (from scrapbook)*

ca. 1878
Pen and ink on off-white wove paper
8¼ × 10½ in. (21 × 26.7 cm)
Inscribed at upper left: wooden images of mummies in the / form of Osiris from 1½ foot / to 3 feet in height, brought / to Egyptian feast as a / memento mori.; at upper right: rings; at center left: "Egypt" // symbol of truth // offerings; at center right: The goddess of Truth & Justice; at lower left: censer and / pastille of incense; at lower center: the / goddess / "Truth" / with her / eyes / closed
Gift of Mrs. Francis Ormond, 1950
50.130.154qq

126. *Egyptian Winepress and Architectural Motifs (from scrapbook)*

ca. 1878
Graphite and pen and ink on tracing paper
5 × 4½ in. (12.7 × 11.4 cm)
Inscribed at upper left: Porch of a house.
Gift of Mrs. Francis Ormond, 1950
50.130.154rr

125

126

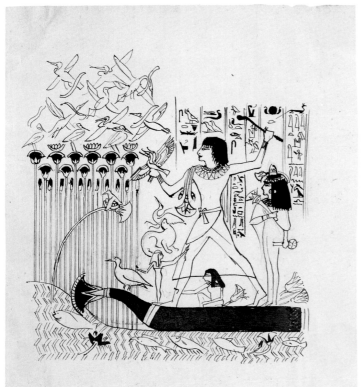

127

128

129

127. *Hunting Birds, after Egyptian Relief Sculpture (from scrapbook)*

ca. 1878

Graphite and pen and ink on off-white wove paper

5¼ × 4¾ in. (13.3 × 12.1 cm)

Gift of Mrs. Francis Ormond, 1950

50.130.154ss

128. *Egyptian Queens and Priest-esses (from scrapbook)*

ca. 1878

Pen and ink on off-white wove paper

5¼ × 8³⁄₁₆ in. (13.3 × 20.8 cm)

Gift of Mrs. Francis Ormond, 1950

50.130.154tt

129. *Egyptian Motifs and Musical Instruments (from scrapbook)*

ca. 1878

Pen and ink on off-white wove paper

8½ × 10½ in. (21.6 × 26.7 cm)

Inscribed at upper left: necklace of flowers.; at upper right: a single chair, a dippos / or double / chair. // bier on which the bodies / were placed after death.

Gift of Mrs. Francis Ormond, 1950

50.130.154uu

Sargent copied the drawings in catalogue numbers 125–29 from illustrations in J. Gardner Wilkinson, *The Manners and Customs of the Ancient Egyptians* (3 vols., London, 1837; third ed., 1878). He chose a

wide variety of images from different sections of the three volumes, usually tracing them directly, but in several instances copying them freehand. In two notable examples, Sargent conflated multiple images from the book to create his own compositions: on the upper right of catalogue 125, he changed the offerings in the hands of the male figure; in catalogue 127, he ambitiously combined elements from three different hunting scenes (Wilkinson's figures 363, 365, and 366) to fabricate his own image.

Catalogue 129 is drawn on the back of a printed announcement that reports the sale of Christmas toys at a shop in Nice on November 12, 1878. Sargent may have

159

130

131

made these drawings while visiting his family in Nice in October–November 1878.

Catharine Roehrig, associate curator, Egyptian Art, The Metropolitan Museum of Art, identified the source of the copies (undated memorandum, departmental files, American Paintings and Sculpture). For other drawings after Egyptian art, see catalogue numbers 240 and 241.

130. *Classical Ornament and Greek Lekythoi (from scrapbook)*

ca. 1878
Pen and ink on off-white wove paper
5⅝ × 7¼ in. (14.3 × 18.4 cm)
Gift of Mrs. Francis Ormond, 1950
50.130.154e2

131. *Classical Ornament and Warrior (from scrapbook)*

ca. 1878
Graphite on off-white wove paper
3⅝ × 6¼ in. (9.2 × 15.9 cm)
Inscribed at upper left: ought to be / taller & slenderer. / face, vase on [illeg.] / to feet white.
Gift of Mrs. Francis Ormond, 1950
50.130.154e3

132. *Tripod (from scrapbook)*

ca. 1878
Graphite on tracing paper
3¾ × 3⅛ in. (9.5 × 7.9 cm)
Gift of Mrs. Francis Ormond, 1950
50.130.154e4

133. *Classical Ornament (from scrapbook)*

ca. 1878
Graphite on tracing paper
1½ × 5⅜ in. (3.8 × 13.7 cm)
Gift of Mrs. Francis Ormond, 1950
50.130.154e5

134. *Chariot (from scrapbook)*

ca. 1878
Graphite on off-white wove paper
Sheet size: 3⅝ × 6⅛ in. (9.2 × 15.6 cm) (drawing extends onto scrapbook page)
Gift of Mrs. Francis Ormond, 1950
50.130.154e6

In catalogue numbers 130–34, Sargent copied various classical decorative elements from an unknown source, possibly a book or objects he saw in a museum. The careful ink drawing of catalogue 130 is similar in style to catalogue numbers 125–29; it may have been drawn about the same time. Catalogue numbers 131 and 134 both come from a sketchbook and may depict designs from vases. The drawing on catalogue 134 extends onto the scrapbook page.

132

133

134

135

135. *Hand for "Carolus-Duran"*

1878–79
Graphite on off-white wove paper
9 × 7 in. (22.8 × 17.8 cm) (unfolded)
Gift of Mrs. Francis Ormond, 1950
50.130.140r

Sargent began painting his master's portrait (see figure 50) in the summer of 1878, before his trip to Naples and Capri, and probably finished it in early 1879. In catalogue 135 he drew the subject's right hand twice. On the left he suggested the cane held by Carolus in the finished portrait and indicated the edge of his cuff; on the right he concentrated solely on the position of the hand and fingers. Neither study includes the gold and turquoise ring worn by Carolus in the oil portrait. Carolus was known around Paris for his stylish appearance and dandyish

self-presentation that often included jewelry.

The portrait earned Sargent an honorable mention when it was shown at the Paris Salon of 1879.

136. *Patio de los Leones, Alhambra*

1879
Watercolor, gouache, and graphite on off-white wove paper
9¾ × 13½ in. (24.8 × 34.3 cm)
Inscribed on verso at center left: SW; at lower center: Architectural Sketch
Gift of Mrs. Francis Ormond, 1950
50.130.36

Catalogue 136 almost certainly depicts the Patio de los Leones, a courtyard of the

Alhambra palace (begun 1377) in Granada, Spain. Off the rectangular, colonnaded courtyard there are four chambers, one at the center of each side. This image may depict the entrance to the Sala de las Dos Hermanas (possibly part of the harem) on the north side.

Sargent eschewed the distinctive architectural elements and ornaments of the well-known space. Instead, he concentrated on perspective and spatial relations as he looked downward to the edge of the pavement and the column bases. He only began to suggest decorative details in his treatment of the geometric pattern of the carved wooden door.

Sargent collected photographs of the Alhambra palace and gardens in a scrapbook now in the Metropolitan (50.130.154; see concordance for catalogue numbers of drawings from the scrapbook). A photograph affixed to folio 57 shows a broader and more general view of the side of the courtyard that may be depicted in this watercolor.

Sargent visited Granada at least four times: in 1867 (cat. 3), 1879, 1902, and 1912 (cats. 314–19). Style, technique, and composition suggest that the most likely date for catalogue 136 is 1879. The application of relatively broad passages of color to fill in spaces is suggestive of Sargent's watercolor technique about this time, as are an

136

interest in dramatically cropped spaces and perspective. Several small architectural studies in the Metropolitan that Sargent painted in oil in Spain and Morocco in winter 1879–80 (see figure 57) show similar spatial concerns and anticipate his Venetian genre scenes of 1880–82 (see cat. 157).

Two other paintings depicting the courtyard may date from the same trip. In the watercolor *Moorish Patio* (British Museum, London), Sargent concentrated on decorative elements. An oil, *Court of the Lions,* depicting the colonnade of the courtyard, is in a private collection.

EXHIBITION: New York–Buffalo–Albany 1971–72, cat. 19.

REFERENCE: Boone 1996, p. 190, n. 30.

137 recto. *Left Hand for "Fumée d'Ambre Gris"*

1879–80
Graphite on off-white wove paper
9¹³⁄₁₆ × 13³⁄₁₆ in. (24.9 × 33.4 cm)
Inscribed at lower left: J.S. 374
Gift of Mrs. Francis Ormond, 1950
50.130.140s recto

137 verso. *Spanish Dancers*

1879–80
Graphite on off-white wove paper
9¹³⁄₁₆ × 13³⁄₁₆ in. (24.9 × 33.4 cm)
Inscribed at lower left: 359
Gift of Mrs. Francis Ormond, 1950
50.130.140s verso

Catalogue 137 probably comes from a sketchbook that Sargent used during his travels to Spain and Morocco in 1879–80.

Sargent suggested the dramatic and expressive body positions inherent in the Spanish dance with loose, flowing lines on catalogue 137 verso. This sketch is a precursor to a painting, *Spanish Dance* (see figure 59), a nocturnal scene that depicts several dancing couples. Sargent later based an illustration for his friend Alma Strettell's book *Spanish and Italian Folk Songs* (1887) on this composition.

The sketches of hands on catalogue 137 recto are preliminary studies for Sargent's

137 recto

137 verso

162

exhibition piece *Fumée d'Ambre Gris* (see figure 58), a mysterious image of an African woman perfuming herself with incense of ambergris that Sargent executed largely on site in Morocco in early 1880. A second study of hands for *Fumée* is in the Corcoran Gallery of Art (49.130). During this period, Sargent typically made careful preparatory studies such as this for his subject pictures (see cat. 118).

The juxtaposition of the subjects of catalogue numbers 137 verso and 137 recto documents the coincidence of Sargent's preoccupation with Spanish dance and "Oriental" exoticism during his journey to Spain and Morocco. The trip marks the beginning of his serious interest in Spanish music and dance, which culminated three years later in his monumental canvas *El Jaleo* (see figure 60). *Fumée d'Ambre Gris,* inspired by the sights of Islamic Spain and North Africa, is an important result of his attraction to orientalist subjects; it was exhibited to much acclaim at the Salon of 1880.

EXHIBITIONS (cat. 137 recto): Probably included in New York 1928 (inventory listing J.S. 374); "Sargent, Whistler and Cassatt," American Federation of Arts, traveling exhibition, September 1954–57 (no catalogue).

REFERENCES (cat. 137 recto): Nygren 1983, p. 52; Conrads 1990, pp. 172–77; Volk 1992, pp. 27–28; Kilmurray and Ormond 1998, p. 88.

EXHIBITION (cat. 137 verso): Volk 1992, pp. 140–141, cat. 9.

138

138. *Spanish Dancer*

1879–80
Graphite on off-white wove paper
14⅝ × 10⅟₁₆ in. (37.1 × 25.5 cm) (irregular)
Gift of Mrs. Francis Ormond, 1950
50.130.137

Catalogue 138 probably dates from Sargent's trip to Spain in the autumn of 1879.

Three related drawings depict a costumed male figure in variations of the pose shown here: his left arm raised above his head, his right arm bent at the elbow with the hand at or near the waist. Two of the drawings are in the Fogg Art Museum (1937.8.115 and 1937.7.116), and the third is in a private collection (see Volk 1992, cat. 4, p. 131). All four sheets have approximately the same

dimensions and may have come from the same sketchbook.

An additional drawing (on a smaller sheet of paper), possibly of the same figure shown seated and clapping his hands, is also in the Fogg Art Museum (1937.8.22).

EXHIBITION: Washington, D.C. 1992, p. 131.

REFERENCE: Fairbrother 1994, p. 27.

139. *Spanish Musicians with Poem*

1879–80?

Graphite on off-white wove paper

10¹/₁₆ × 14¹¹/₁₆ in. (25.5 × 37.3 cm) (irregular)

Inscribed at left and upper right, superimposed on part of image: Parece un ramo de flores / la capa d'un estudiante / Toda llena de pedazos / de differentes colores; Yo le dire cuales son / Las prendas d'un estudiante / La sutana y el [illegible] / La cuchara y el perol; Un puñado de valientes / Un cañon y una mujer / Un puñado de valientes / Libraron a Zaragoza / De el ejercito Frances; at upper right: Zaragoza esta en el llano / Y la torre nueva el medio / Y la Virgen del Pilar/ En las orillas del Ebro [The cape of a student / looks like a bough of flowers / all full of little patches / of many colors; I will identify for you / these garments of a student / the cassock and [illegible] / the spoon and soup-kettle; A handful of brave men / A cannon and a woman / A handful of brave men / liberated Zaragoza / from the French army; Zaragoza is on the plain / with the new tower central / and the Virgin of the Pillar / on the banks of the Ebro (translation from Volk 1992, p. 134)]; at lower left: J.S. 22; on verso at lower right: 5845

Gift of Mrs. Francis Ormond, 1950

50.130.103

Sargent, always interested in music, sought out opportunities to hear local performances while he was traveling. While in Spain in 1879–80, he became particularly engrossed in songs of the region and began a series of sketches with musical associations that would culminate in his monumental painting *El Jaleo* (see figure 60).

While Mary Crawford Volk has acknowledged that catalogue 139 may date from one of Sargent's later trips to Spain, its origin in 1879 seems likely. Even before visiting Spain that year, Sargent had apparently been asked by Vernon Lee to collect Spanish songs. He wrote to her in July 1880:

You wished some Spanish songs. I could not find any good ones. The best are what one hears in Andalucia, the half African Malagueñas & Soleàs, dismal, restless chants that it is impossible to note. They are something between a Hungarian Czardas and the chant of the Italian peasant in the fields, and are generally composed of five strophes and end stormily on the dominant the theme quite lost in strange fioritures and guttural roulades. The gitano voices are marvelously supple. (JSS to Vernon Lee, July 9, 1880, quoted in Ormond 1970b, p. 163)

This sketch, which shows two guitarists surrounded by the lyrics of two separate songs, may record one of the performances Sargent attended while he was in Spain and may refer to such songs. Contrary to Volk's suggestion that the size of this sheet does not correspond to others from this period, it is possible that it comes from the same sketchbook as catalogue 138. The sheet widths are the same (25.5 cm); the differences in sheet lengths may be explained by their having been trimmed from the sketchbook. Catalogue 139 has not been trimmed and maintains the binding marks; its length varies from 37.1 to 37.3 cm. The sheet length of catalogue 138, which has been trimmed, varies from 36.8 to 37.1 cm.

Two related sheets bearing transcriptions of Spanish songs or poems are in the Fogg Art Museum (1937.8.23 and 1937.8.24 verso).

EXHIBITIONS: Probably included in New York 1928 (inventory listing J.S. 22); Washington, D.C.–Boston 1992, cat. 6, pp. 134–35.

REFERENCES: Volk 1992, cat. 6, p. 135; Boone 1996, p. 192, n. 42; *Sargent at Harvard*, Harvard University Art Museums website (http://www.artmuseums.harvard.edu/sargent/archive.html; hereafter *Sargent at Harvard* website), October 23, 1997, as a related work for Fogg 1937.8.23.

140. *Queen Maria of Hungary*

After Pompeo Leoni, Italian, ca. 1533–1608

ca. 1880?

Graphite on ledger paper

7¹⁵/₁₆ × 6⅜ in. (20.2 × 16.2 cm)

Inscribed on verso at lower left: EP

Gift of Mrs. Francis Ormond, 1950

50.130.141r

Sargent sketched catalogue 140 after a sculpture of Queen Maria of Hungary (1505–1558), the sister of Emperor Charles V of Spain. The lifesize, gilt-bronze figure is part of the cenotaph to the emperor created in the late sixteenth century by Pompeo Leoni for the Capilla Mayor of the church at the Escorial. The massive compound, about thirty miles northwest of Madrid, was built (1563–74) by Philip II, son of Charles V. It also includes a palace, a monastery, and a library.

It is unclear whether Sargent made this quick sketch in the church or from a reproduction. The broad rendering of the face may reflect his inability to approach the monument because of its elevated position in the chapel. An early date, possibly during Sargent's trip to Spain in 1879–80, is likely.

Patrick Lenaghan, of the Hispanic Society

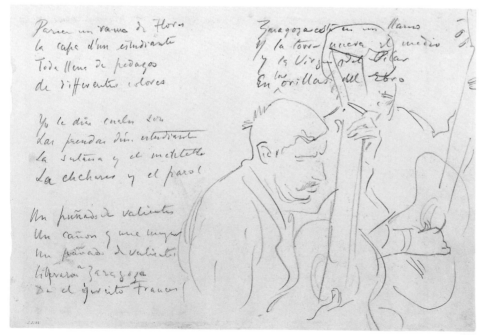

140

of America, New York, assisted with the identification of the figure (oral communication, 1999).

141. *Two Cats*

ca. 1880
Graphite on light grayish buff wove paper
10¹⁄₁₆ × 14⁹⁄₁₆ in. (25.5 × 37 cm)
Gift of Mrs. Francis Ormond, 1950
50.130.129

142. *Barber Shop*

ca. 1880
Graphite on off-white wove paper
6¹⁵⁄₁₆ × 9¼ in. (17.7 × 23.5 cm)
Inscribed at lower left: J.S. 363; on verso at upper left: 30; at upper right: 370
Gift of Mrs. Francis Ormond, 1950
50.130.134

The exact activity depicted in catalogue 142 is unclear. In a copy of an inventory that records works sent to New York for "Exhibition of Drawings by John Singer Sargent" at the Grand Central Art Galleries (New York 1928), this sheet was entitled *Nurse* ("Drawings from London loaned Mr. Clark," Thomas A. Fox–John Singer Sargent Collection, Boston Athenaeum). The title *Barber Shop* was assigned by the Metropolitan when the sheet was accessioned.

EXHIBITION: Probably included in New York 1928 (inventory listing J.S. 363).

143. *Dog*

ca. 1880
Pen and brown ink on off-white wove paper
8¹⁵⁄₁₆ × 7¹³⁄₁₆ in. (22.8 × 19.8 cm)
Inscribed on verso at lower right: NS
Gift of Mrs. Francis Ormond, 1950
50.130.142a

Sargent studied the same dog from three different angles on a sheet in the Fogg Art Museum (1937.8.31). While the identity of the dog is unknown, he appears similar in type to Pointy, the dog of Sargent's friend Charlotte Louise Burckardt, who is portrayed in *Lady with the Rose* (see figure 51). Sargent painted an oil portrait of Pointy in the early 1880s (private collection; Sotheby's, New York, sale 6144, April 12, 1991, lot 70).

143

141

142

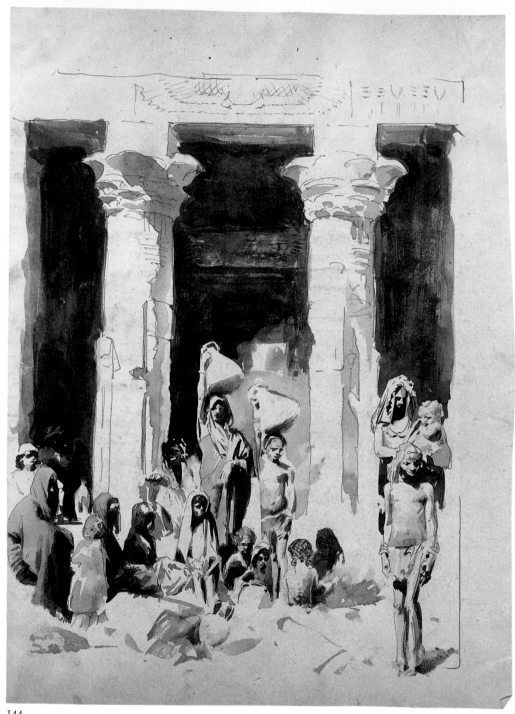

144

144. *Nubians in front of the Temple of Dendur (from scrapbook)*

After J. Pascal Sébah, Turkish, 1838–1890
ca. 1880
Brush and ink and graphite on off-white wove paper
12⅛ × 8¾ in. (30.8 × 22.2 cm)
Gift of Mrs. Francis Ormond, 1950
50.130.154cc

Catalogue 144 is after a photograph by
J. Pascal Sébah, whose firm in Constantinople
was founded in 1868. Sébah won a silver
medal at the 1878 Exposition Universelle in
Paris for his photographs of Egypt, especially
Nubian peoples. While it is not known if
this photograph appeared in the Exposition,
Sargent could have become familiar with
Sébah's work at about this time.

Sargent was probably attracted to the
photograph because of its exotic subject

matter, but his prime concern as a copyist
was to capture the effects of light and
shadow in modulated layers of ink wash.

The Temple of Dendur, located on the
west bank of the Nile about fifty miles
south of Aswan, was threatened by the
construction of the great dam at Aswan and
was given to The Metropolitan Museum of
Art in 1970. The reconstructed temple was
installed in a special gallery in 1978.

See also catalogue 145.

145

147

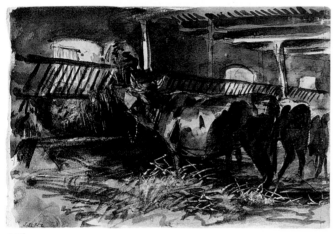

146

148

145. *Boy on Water Buffalo (from scrapbook)*

ca. 1880
Watercolor on off-white wove paper
7⅞ × 12³⁄₁₆ in. (20 × 31 cm)
Gift of Mrs. Francis Ormond, 1950
50.130.154dd

The exotic subject matter and the cursory watercolor technique of catalogue 145 suggest that, like catalogue 144, it may have been copied from a photograph.

Both catalogue numbers 144 and 145 are pasted into a scrapbook (50.130.154) of sketches, magazine clippings, and photographs that Sargent compiled in the 1870s and early 1880s. His interest in the exotic is reflected in the numerous photographs of picturesque locales and peoples that he collected during his trip to southern Spain and Morocco in 1879–80.

146. *Cattle in Stable*

1880s?
Watercolor and graphite on off-white wove paper
5⅛ × 7⁷⁄₁₆ in. (13 × 19.2 cm)
Inscribed on lower left: J.S. 352
Gift of Mrs. Francis Ormond, 1950
50.130.26

Ormond has suggested that catalogue 146 was painted in the 1880s (oral communication, June 16, 1997).

EXHIBITION: Probably included in New York 1928 (inventory listing J.S. 352).

147. *Youth (from scrapbook)*

ca. 1880
Graphite on off-white wove paper
9 × 11⅞ in. (22.9 × 30.2 cm)
Gift of Mrs. Francis Ormond, 1950
50.130.154ee

148. *Woman Seated before Piano (from scrapbook)*

ca. 1880
Charcoal and graphite on off-white wove paper
9 × 11⅝ in. (22.9 × 29.5 cm)
Gift of Mrs. Francis Ormond, 1950
50.130.154ff

In the academic tradition, Sargent used a nude study (cat. 147) to help him render a clothed figure in a complicated position (cat. 148). Several elements relate catalogue numbers 147 and 148 to Sargent's full-length portrait *Madame Ramón Subercaseaux* (see figure 49). As in these studies, Subercaseaux is shown seated at an upright piano with the fingers of her right hand resting on the keyboard. Her wrist is bent at ninety degrees, and her left arm is draped over the back of the chair. The principal difference between the poses in the studies and the portrait of Madame Subercaseaux is in the twist of the torso. In the studies, the figures have their backs to the piano. Subercaseaux

turns only ninety degrees away from the piano to face the viewer, which reduces the problem with which Sargent struggled in catalogue 148, of showing simultaneously the rotation of the torso and shoulder and a foreshortened right arm.

149 recto. *The Marriage of Saint Catherine*

After Hans Memling, Flemish, ca. 1430–1494
ca. 1880
Graphite on off-white wove paper
10¼ × 13¹³⁄₁₆ in. (26 × 35 cm)
Gift of Mrs. Francis Ormond, 1950
50.130.143s recto

149 verso. *Hand of Spanish Dancer*

ca. 1880
Graphite on off-white wove paper
10¼ × 13¹³⁄₁₆ in. (26 × 35 cm)
Inscribed: CP; sticker on recto at lower right: .221
Gift of Mrs. Francis Ormond, 1950
50.130.143s verso

In late summer 1880, while Sargent was still preoccupied with themes relating to Spanish dance, he traveled to Belgium and Holland with two artist friends, Brooks Chadwick (1850–1943) and Ralph W. Curtis (1854–1922), to study the northern masters. While Sargent was particularly interested in Frans Hals and copied several of his works, his sister Emily recounted his broader interests in a letter to Vernon Lee:

John left Paris about ten days ago for a tour in Holland and Belgium with two very nice friends . . . before going to Venice. I had a letter from him yesterday just as he was leaving Rotterdam for Haarlem. He has enjoyed the pictures immensely & thinks one can have no adequate idea of the works of Rubens, Rembrandt, Memling & Frans Hals without having seen them in those countries. (Emily Sargent to Vernon Lee, August 25, 1880, quoted in Ormond and Kilmurray 1998, p. xviii, n. 48)

In Bruges, Sargent seems to have visited the Hans Memling Museum, housed in a former convent. There he copied the main figures of the central panel, *The Marriage of Saint Catherine,* of Memling's monumental *Saint John Altarpiece* (1479). By slightly exaggerating characteristic traits of Memling's style—the delicately attenuated figures and stiff drapery folds—Sargent managed to suggest Memling's manner without concentrating on specific details of the painting.

The sketch of the hand on the right edge of catalogue 149 verso also links this sheet to about 1880, when Sargent executed *Studies of a Spanish Dancer* (figure 69). The hand shown in catalogue 149 verso resembles the hand at the upper right of *Studies,* which seems to have followed catalogue 149 verso in a sketchbook. An arm on *Studies* is cut off near the wrist at the left edge of the sheet; the hand on the Metropolitan sheet may be the continuation of this drawing.

149 recto

149 verso

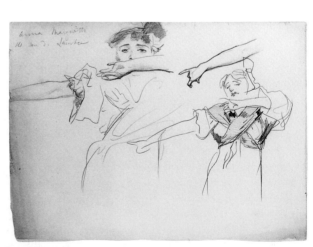

Figure 69. *Studies of a Spanish Dancer,* 1880–81. Graphite on off-white paper, 10 × 13 in. (25.4 × 33 cm). Photograph courtesy of The Fine Art Society plc, London

In addition to *Studies,* Volk has identified four other drawings as originating in "a sketchbook Sargent was using in 1880, which included drawings made during his trip to Belgium and Holland in late August and to Venice in September" (Volk 1982, p. 159). These drawings include additional studies of a Spanish dancer (Volk 1982, cat. 21) and drawings after works by Hals in Haarlem (Volk 1982, figures 9 and 10). The combination of subjects on catalogue 149—the hand of the Spanish dancer and the copy after Memling—further links the sheet to this group and sketchbook.

150. *Paul Helleu*

early 1880s
Graphite on off-white paper board
13³⁄₁₆ × 10⁵⁄₁₆ in. (33.6 × 26.2 cm)
Inscribed on verso at center top: Paul Heleu [sic] /
by himself or by J. S. Sargent ?; at lower right: 40;
[pasted on verso, photograph of a portrait by
Leonardo da Vinci at the Ambrosiana, Milan]
Gift of Mrs. Francis Ormond, 1950
50.130.121

While the exact date when Sargent first met French artist Paul-César Helleu (1859–1927) is not known, it is said to have been about 1876, not long after Sargent's arrival in Paris in 1874 (Ormond and Kilmurray 1998, p. xiii). The two were lifelong friends.

According to Ormond and Kilmurray, catalogue 150 was originally framed with two other images of Helleu: a watercolor of him reclining in a chair before a fireplace (ca. 1882–85, private collection) and a pastel of him lying in the grass (before 1886, British Museum, London; Ormond and Kilmurray 1998, p. 95). They suggest that this framed trio appears in Sargent's painting of the dining room of his studio at boulevard Berthier in Paris (*My Dining Room,* before 1886, Smith College Museum of Art, Northampton, Massachusetts). Sargent closed that studio when he moved to London in 1886.

See Ormond and Kilmurray for other images of Helleu made by Sargent about this time (Ormond and Kilmurray 1998, pp. 93–95). In the oil *Paul Helleu Sketching with His Wife* (1889, Brooklyn Museum of Art, New York), Sargent depicted Helleu in

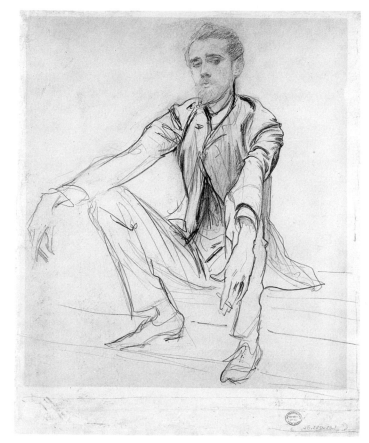

150

a similar pose, seated on a low object with his knees bent.

A photograph of a drawing by Leonardo da Vinci (*Ritratto d'ignoto,* Pinacoteca Ambrosiana, Milan) is affixed to the verso.

REFERENCE: Ormond and Kilmurray 1998, p. 93

151. *Two Women*

ca. 1880
Graphite on off-white wove paper
3⁷⁄₁₆ × 5¹⁵⁄₁₆ in. (8.8 × 15 cm)
Gift of Mrs. Francis Ormond, 1950
50.130.140h

In subject this sketch relates to catalogue 154a.

151

Catalogue Numbers 152–55

Catalogue numbers 152–55, which seem to
have come from the same sketchbook,
were probably drawn during one of
Sargent's visits to Venice in the early 1880s
(1880–81 or 1882).

152. *Man in Hat*

1880–82
Graphite on off-white wove paper
6¼ × 3¹⁵⁄₁₆ in. (15.9 × 9.9 cm)
Inscribed at lower left corner: J.S. 292; on verso at
upper right: 39
Gift of Mrs. Francis Ormond, 1950
50.130.88

The model in catalogue 152, with his dis-
tinctive features, dark eyes, heavy eyelids,
and Mediterranean appearance, represents
an exotic type that appealed to Sargent.

In contrast with the other sheets in this
group, Sargent limited his use of contour
lines; instead, he suggested form almost
entirely with pale graphite shading.

EXHIBITION: Probably included in New York 1928
(inventory list J.S. 292).

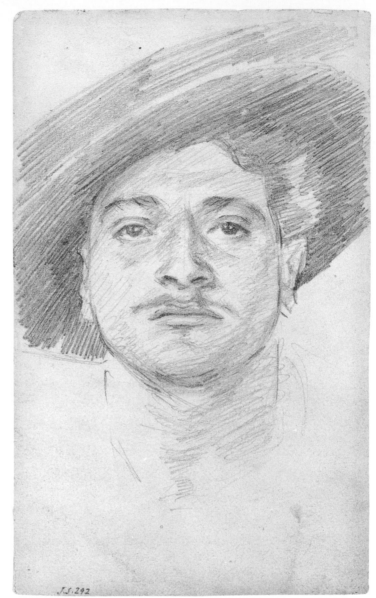

152

153. *Gondoliers*

1880–82
Graphite on off-white wove paper
3¹³⁄₁₆ × 6⁵⁄₁₆ in. (9.6 × 16 cm)
Inscribed at lower left: J.S. 349
Gift of Mrs. Francis Ormond, 1950
50.130.89

Sargent provides no context for the figures
in this quick sketch. However, the pose of
the figure at right, in particular, clearly
records the action of a gondolier propelling
his boat through a canal. The loosely
drawn, sweeping lines suggest the fluid
motion of the figure and recall other draw-
ings from this period.

EXHIBITIONS: Probably included in New York
1928 (inventory list J.S. 349); "Sargent, Whistler and
Cassatt," American Federation of Arts, traveling
exhibition, September 1954–57 (no catalogue).

153

170

154a

154b

Albright-Knox Art Gallery, Buffalo, New York), and *A Venetian Interior* (ca. 1882, Sterling and Francine Clark Art Institute, Williamstown, Massachusetts).

Catalogue 154b is a sketch of an unidentified metal object, perhaps also something Sargent saw in Venice.

EXHIBITION: "Sargent, Whistler and Cassatt," American Federation of Arts, traveling exhibition, September 1954–57 (no catalogue).

154a. *Two Seated Women*

1880–82
Graphite on off-white wove paper
3⅞₁₆ × 6⁵⁄₁₆ in. (9.1 × 16 cm)
Gift of Mrs. Francis Ormond, 1950
50.130.93a

154b. *Venetian Ornament*

1880–82
Graphite on off-white wove paper
6⁵⁄₁₆ × 3⁹⁄₁₆ in. (16 × 9.1 cm)
Inscribed across top: steel; gold; steel; at center: gold
50.130.93b

Catalogue 154 consists of two attached sketchbook pages.

Despite the lack of specific detail in catalogue 154a, the costumes, which include long skirts, mules, and shawl collars, recall those seen in Sargent's Venetian paintings of 1880–82. In pose and attitude, these figures recall the women depicted in interior scenes such as *Venetian Women in the Palazzo Rezzonico* (ca. 1880, Mr. and Mrs. Peter G. Terian), *Venetian Bead Stringers* (ca. 1880,

155 recto. *Figures in Gondola*

1880–82
Graphite on off-white wove paper
3¹³⁄₁₆ × 6¼ in. (9.6 × 15.9 cm)
Inscribed at lower left: J.S. 351
Gift of Mrs. Francis Ormond, 1950
50.130.95 recto

155 verso. *Caricature of Man*

1880–82
Graphite on off-white wove paper
6¼ × 3¹³⁄₁₆ in. (15.9 × 9.6 cm)
Inscribed at top: pretty cho-o-orming
Gift of Mrs. Francis Ormond, 1950
50.130.95 verso

EXHIBITIONS (cat. 155 recto): Probably included in New York 1928 (inventory listing J.S. 351); "Sargent, Whistler and Cassatt," American Federation of Arts, traveling exhibition, September 1954–57 (no catalogue).

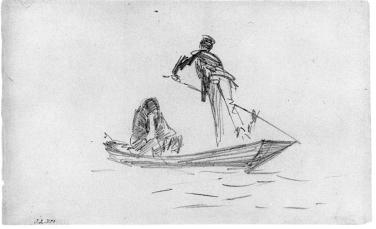
155 recto

155 verso

171

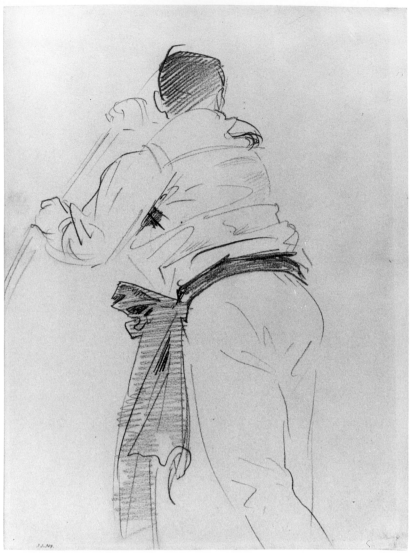

156 recto

156 verso

156 recto. *Gondolier*

ca. 1880–1900
Graphite on light buff wove paper
10 ¹¹⁄₁₆ × 7 ¹³⁄₁₆ in. (27.1 × 19.9 cm)
Inscribed at lower left: J.S.369.
Gift of Mrs. Francis Ormond, 1950
50.130.111 recto

156 verso. *Gondolier*

ca. 1880–1900
Graphite on light buff wove paper
7 ¹³⁄₁₆ × 10 ¹¹⁄₁₆ in. (19.9 × 27.1 cm)
Inscribed at right edge: 35
Gift of Mrs. Francis Ormond, 1950
50.130.111 verso

Sargent probably made these sketches of gondoliers during one of his visits to Venice in the early 1880s (1880–81 or 1882). Catalogue 156 recto, with its rapidly drawn contours and bold hatching, relates to other works from this period, including catalogue 138. Nygren cautiously dated a similar drawing of a gondolier (Corcoran 49.137) to 1880–1900 (Nygren 1983, p. 55). After visiting Venice in 1880–81 and 1882, Sargent did not return there until 1897.

EXHIBITIONS (cat. 156 recto): Probably included in New York 1928 (inventory listing J.S. 369); "Sargent, Whistler and Cassatt," American Federation of Arts, traveling exhibition, September 1954–57 (no catalogue).

REFERENCE (cat. 156 recto): Nygren 1983, p. 55.

157. *Venice*

1880–82
Watercolor and graphite on white wove paper
9 ⅞ × 14 in. (25.1 × 35.6 cm)
*Inscribed on verso at upper left: 109 Venice / By
J. S. Sargent / E.S. / ⅔ [encircled]; at center: ⁵⁄₂₀*
Gift of Mrs. Francis Ormond, 1950
50.130.29

Between 1880 and 1882, Sargent made two visits to Venice with the intention of creating an exhibition picture. He wrote to Vernon Lee's mother from Venice in September 1880 to decline an invitation to visit her family in Florence: "I am forced to consider that there may be only a few more weeks of pleasant season here and I must make the most of them. . . . I must do something for the Salon and have determined to stay as late as possible in Venice" (JSS to Mrs. Paget, September 27, 1880, quoted in Simpson 1997a, p. 95). From September 1880 until early 1881, Sargent worked in a studio in the Palazzo Rezzonico on the Grand Canal. He returned to Venice for a shorter stay in August 1882, when he was the guest of his cousins the

157

Daniel Sargent Curtises (see cat. 164) in the Palazzo Barbaro, also on the Grand Canal, across from the Accademia.

During this period, Sargent avoided the characteristically picturesque views of Venice painted by his contemporaries. Instead he focused on Venetians engaged in quotidian activities, not within the grand public spaces of the city but rather in the narrow, dark alleys and passageways and subdued interiors. Collector and connoisseur Martin Brimmer recalled seeing some of these paintings during a visit to the Curtises at the Palazzo Barbaro in October 1882. He wrote: "They are very clever but a good deal inspired by the desire of finding what no one else has sought here—unpicturesque subjects, absence of color, absence of sunlight" (Martin Brimmer to Sarah Wyman

Whitman, October 26, 1882, quoted in Simpson 1997a, p. 97).

Several paintings, including *Street in Venice* (1882, National Gallery of Art, Washington, D.C.) and *Venetian Street* (ca. 1882, Collection of Rita and Daniel Fraad), depict figures dressed in typical Venetian costumes standing in the sort of narrow passageway depicted in catalogue 157. Fairbrother argued that this watercolor may have been made as a preliminary study for one of Sargent's more ambitious genre scenes (Fairbrother 1994, p. 31).

The unifying characteristic of Sargent's interior and outdoor Venetian scenes from this period is the spatial construction. As in this watercolor, the artist usually offered a view into a somewhat shallow, boxlike space seen slightly obliquely. He cropped

the receding planes of street or floor to create dynamic spatial recessions. If present, sky and ceiling are minor elements.

Margaretta Lovell dated this work to the early twentieth century, when Sargent was a frequent visitor to Venice, and she compared it to his unpeopled architectural studies of that period (Lovell 1989, p. 91). However, in light of its subject and technique, a date in the early 1880s seems likely. Other watercolors from this period are catalogue numbers 158 and 159.

EXHIBITIONS: New York–Buffalo–Albany 1971–72, cat. 22; San Francisco–Cleveland 1984–85, cat. 78.

REFERENCES: Lovell 1989, p. 91 (illus. in reverse); Fairbrother 1990, p. 34; Fairbrother 1994, p. 31; Ormond and Kilmurray 1998, p. 79.

158. *Young Woman in Black Skirt*

early 1880s
Watercolor and graphite on white wove paper
13 15⁄16 × 9 13⁄16 in. (35.5 × 25 cm)
*Inscribed on verso at upper center: ⁰⁄28 [encircled]; at
lower left: SW*
Gift of Mrs. Francis Ormond, 1950
50.130.33

The solidity and attention to detail in this
watercolor of a young woman in typical
Venetian peasant costume suggest an early
date, perhaps while Sargent was still under
the influence of his Parisian master
Carolus-Duran. He may also have been
responding to paintings by the Spanish
artist Mariano Fortuny (1838–1874), which
were popular in Paris in the 1860s and
1870s.

Although catalogue 158 has been dated
as early as 1876 (New York–Chicago
1986–87, pp. 211–12), it was more likely
made during one of Sargent's two early vis-
its to Venice, either between September
1880 and early 1881 or in August 1882.
Annette Blaugrund noted that Sargent
painted very few watercolors while he
studied under Carolus-Duran, focusing
instead on oil sketches and finished oils
(New York–Chicago 1986–87, p. 210).
While it is difficult to find comparative
watercolors from the 1870s, catalogue 158
resembles Sargent's watercolor portraits of
the 1880s, especially, for example, *Violet
Sargent* (see figure 70), which shows the
subject standing against a broadly painted
flat backdrop.

EXHIBITIONS: New York–Buffalo–Albany 1971–72,
cat. 8; "The Americans: Masters of Watercolor,"
Andrew Crispo Gallery Inc., New York, May 16–
June 30, 1974, cat. 140; The Metropolitan Museum
of Art, September 1980 (no catalogue); "Watercolors
and Drawings by Centurion John S. Sargent," The
Century Association, New York, September 21–
October 23, 1982 (no catalogue); New York–Chicago
1986–87 (shown only in Chicago); "Images of Women:
Nineteenth-Century American Drawings and Water-
colors," The Metropolitan Museum of Art, October
1996–February 1997 (no catalogue).

REFERENCES: New York–Chicago 1986–87, pp. 64,
211–12; Weinberg and Herdrich 2000b, p. 229.

159

159. *Boy in Costume*

early 1880s
Watercolor and graphite on white wove paper
13 15⁄16 × 9 13⁄16 in. (35.5 × 25 cm)
Inscribed at lower left: 1869; on verso at center: 1869
Gift of Mrs. Francis Ormond, 1950
50.130.34

The date, "1869," inscribed on the lower
left corner of this sheet was not written
by Sargent and—when the watercolor is
compared to those in Sargent's sketchbooks
from 1869 and 1870, such as catalogue 17c
verso—is clearly incorrect.

Sargent's watercolors of the early to
mid-1880s characteristically combine solid
figural forms with backgrounds constructed
of blotted pools of color (see *Fanny Watts*

175

[private collection; Ormond and Kilmurray 1998, p. 80] and *Paul Helleu* [private collection; Ormond and Kilmurray 1998, p. 95]). This costume piece may also depict a Venetian subject and may date from the same approximate period as catalogue 158.

EXHIBITIONS: "200 Years of Watercolor Painting in America," The Metropolitan Museum of Art, December 8, 1966–January 29, 1967, cat. 103; New York–Buffalo–Albany 1971–72, cat. 10; The Metropolitan Museum of Art, September 1980 (no catalogue); New York–Chicago 1986–87, fig. 169; "Five American Masters of Watercolor," Terra Museum of American Art, Evanston, Illinois, May 5–July 12, 1981.

REFERENCE: New York–Chicago 1986–87, pp. 212–13.

160. *Seated Woman with Fan (from scrapbook)*

ca. 1880
Graphite on off-white wove paper
12⅛ × 8 in. (30.8 × 20.3 cm)
Gift of Mrs. Francis Ormond, 1950
50.130.154h

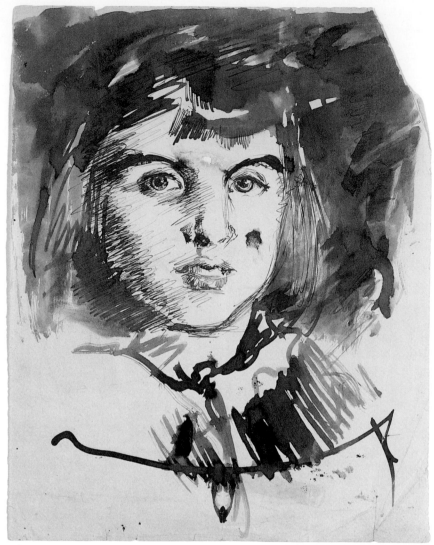

161

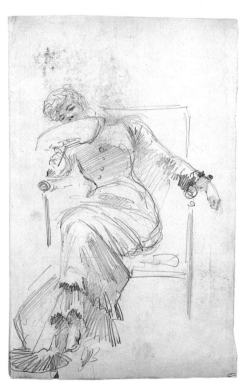

161. *Marie-Louise Pailleron*

ca. 1881
Ink applied with pen and brush on white wove paper
9⅛ × 7⁷⁄₁₆ in. (23.2 × 18 cm)
On verso: child's drawing of a house
Gift of Mrs. Francis Ormond, 1950
50.130.115

The French poet and playwright Édouard Pailleron (1834–1899) was one of Sargent's important early patrons. Sargent painted portraits of him (Musée d'Orsay, Paris) and his wife, Marie Pailleron (1840–1913, Corcoran Gallery of Art, Washington, D.C.), in 1879, before being commissioned to paint a double portrait of the children, Édouard and Marie-Louise (see figure 48).

In catalogue 161 Sargent drew Marie-Louise's face straight on, lit from the right

as in the oil portrait. She is shown here, and in another watercolor study (private collection; Ormond and Kilmurray 1998, p. 53), with her long hair down. In the oil portrait her hair is tied back. Sargent had painted an informal oil portrait of Marie-Louise in August 1879 (private collection; Ormond and Kilmurray 1998, pp. 36–37) while he was at the house of Marie-Louise's grandparents in Ronjoux, in Savoy, to paint her mother's portrait. Marie-Louise recalled her family's relationship with the artist and the sittings for *The Pailleron Children* in her autobiography, *Le Paradis perdu* (Paris, 1947).

Kilmurray identified the subject of this watercolor (oral communication, June 1997).

REFERENCE: Ormond and Kilmurray 1998, cat. 39, pp. 51, 53.

162. After "El Jaleo"

ca. 1882

Graphite and watercolor on prepared clay-coated paper

10⅛ × 5½ in. (27 × 14 cm) (irregular)

Inscribed on verso at top: F. W. Sargent / 4 rue Longchamp / Nice / Alpes Maritimes; [French postage stamp attached to verso at center]; stamp cancelled: Avril 82[?]; [sealing wax stamp]; at center: 1623

Gift of Mrs. Francis Ormond, 1950

50.130.139

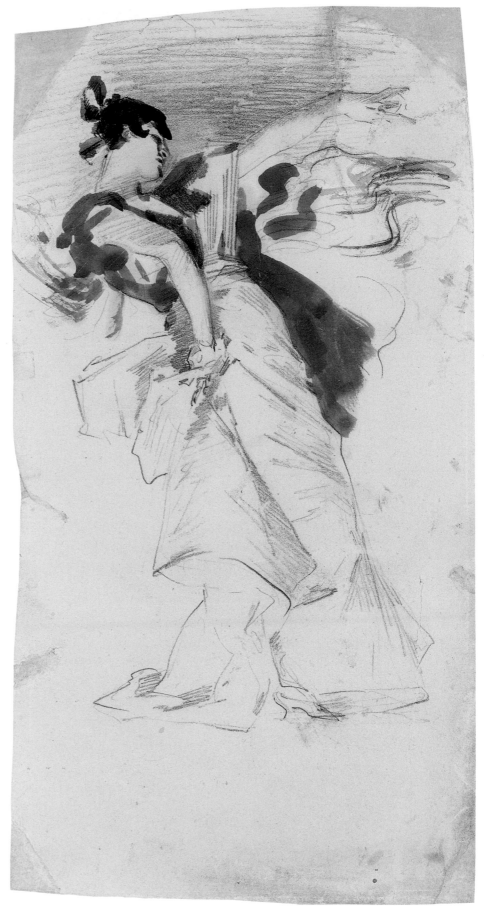

Two years after Sargent returned to Paris from his trip to Spain and Morocco, he exhibited his dramatic monumental painting of a Spanish dancer, *El Jaleo* (see figure 60), at the Salon of 1882. Since catalogue 162 records the principal figure as it appears in the final composition, it must be one of the final preliminary studies or a study after the finished painting (see Washington, D.C.–Boston 1992, p. 184).

The verso is inscribed with the address of Sargent's father in Nice. The wax seal and postage stamp (apparently dated 1882) indicate that Sargent mailed the sheet to his father, possibly to provide a preview of the painting. A precedent for this exists: in 1880 Sargent sent a replica watercolor of *Fumée d'Ambre Gris* (see figure 58) to his family before the opening of the Salon (see Simpson 1997a, p. 62 and n. 148).

For related images, see Washington, D.C.–Boston 1992.

EXHIBITIONS: New York–Buffalo–Albany 1971–72, no. 4; "American Art in the Making: Preparatory Studies for Masterpieces of American Painting, 1800–1900," Smithsonian Institution, Washington, D.C., Traveling Exhibition Service (traveled to numerous venues), November 1975–May 1977, p. 67; Washington, D.C.–Boston 1992, cat. 46; "Images of Women: Nineteenth-Century American Drawings and Watercolors," The Metropolitan Museum of Art, October 1996–February 1997 (no catalogue).

REFERENCES: Washington, D.C.–Boston 1992, cat. 46, pp. 184–85; Fairbrother 1994, p. 26.

162

163

164. *Mrs. Daniel Sargent Curtis*

ca. 1882
Graphite on off-white wove paper
6⁵⁄₁₆ × 3¾ in. (16.1 × 9.5 cm)
On verso: indecipherable marks
Gift of Mrs. Francis Ormond, 1950
50.130.122

Mrs. Daniel Sargent Curtis (née Ariana Randolph Wormeley, 1833–1922) was the wife of one of Dr. Fitzwilliam Sargent's cousins. The Curtises lived in an apartment in the Palazzo Barbaro, a Renaissance palace in Venice where Sargent was a frequent guest over the years. In catalogue 164 Sargent sharply delineated the sitter's profile and accentuated her nose and brow against a darkly hatched area. This study was probably drawn in connection with the portrait of Mrs. Curtis that Sargent painted during his visit to Venice in 1882 (see figure 52). An abandoned sketch on the verso may depict the same sitter facing the opposite direction. Sargent's emphasis on profile calls to mind his numerous pencil sketches of Madame Pierre Gautreau of 1883–84 (cats. 166–68).

EXHIBITION: "Sargent, Whistler and Cassatt," American Federation of Arts, traveling exhibition, September 1954–57 (no catalogue).

164

163. *Pope Paul III*

After unknown artist, Venetian school, 16ᵗʰ century
early 1880s?
Graphite on off-white wove paper
6⁵⁄₁₆ × 3¹³⁄₁₆ in. (16 × 9.6 cm)
Inscribed at lower right: Pitti; on verso at upper right: CP
Gift of Mrs. Francis Ormond, 1950
50.130.143f

Among Sargent's numerous sketches after works of art, copies of portraits are rare. In catalogue 163, after a portrait in the Pitti Palace in Florence, Sargent avoided detail to make a quick record of pose and composition. He probably executed this sketch on site in the galleries, perhaps during one of his visits to Florence in the early 1880s (1882 or 1883) and perhaps intending to use this dignified but classic pose for one of his own patrons. The three-quarter length seated position of Pope Paul III recalls that which Sargent used for his portrait of Elizabeth Allen Marquand (1887, Art Museum, Princeton University).

REFERENCE: Nygren 1983, p. 51.

165. *Violet Sargent*

ca. 1883
Graphite on off-white wove paper
18¹³⁄₁₆ × 13¹⁵⁄₁₆ in. (47.8 × 35.3 cm)
Inscribed on verso: Violet Sargent / by J. S. Sargent
Gift of Mrs. Francis Ormond, 1950
50.130.87

This delicate pencil sketch is associated with a watercolor of the same subject dated by Ormond and Kilmurray to about 1883 (figure 70). She wears her hair in the same style in the drawing and the watercolor and appears to be about the same age.

REFERENCE: Ormond and Kilmurray 1998 p. 134.

165

Catalogue Numbers 166–69: *Madame X (Madame Pierre Gautreau)*, 1883–84

It is unclear how Sargent met Virginie Avegno Gautreau (1859–1915), the American-born wife of a Parisian banker, but it was he who sought an introduction and proposed to paint her portrait (see figure 61) in 1882. Sittings began in the winter of 1882–83 and lasted through the summer of 1883, when Sargent worked on the portrait at the Gautreau summer home, Les Chênes, at Paramé in Brittany. Numerous studies that Sargent executed during countless sittings show the consideration he gave to the enigmatic subject. In a letter to Vernon Lee, he complained about "struggling with the unpaintable beauty and hopeless laziness of M[adame] G[autreau]" (JSS to Vernon Lee, no date, quoted in Charteris 1927, p. 59).

As the sittings began, Sargent described Madame Gautreau in another letter to Vernon Lee: "She has the most beautiful lines and if the lavender or chlorate-of-potash-lozenge colour be pretty in itself I shall be more than pleased" (JSS to Vernon Lee, February 10, 1883, quoted in Ormond and Kilmurray 1998, p. 113). Sargent's interest in her "lines," particularly her profile, may account for the fact that more studies for this portrait survive than for any other by Sargent. Although he experimented with the pose of Madame Gautreau's body, almost every known study shows her head in profile.

For other studies of Gautreau, see Ormond and Kilmurray 1998, pp. 114–18.

166. *Madame X (Madame Pierre Gautreau)*

1883–84
Graphite on off-white wove paper
12⁹/₁₆ × 8¼ in. (32 × 21 cm)
Inscribed at lower left (very faint): J.S. 61.
Gift of Mrs. Francis Ormond and Miss Emily Sargent, 1931
31.43.3

Sargent's interest in the "lines" of Madame Gautreau's face is evident in catalogue 166 and in a related drawing of the subject in profile facing left (private collection; Ormond and Kilmurray 1998, fig. 51). In catalogue 166, he lightly suggested her hair

Figure 70. *Violet Sargent*, ca. 1883. Watercolor and graphite on paper, 17¾ × 8½ in. (45.1 × 21.6 cm). Private collection

and ear and left off the drawing at the base of the neck. Her profile, however, is rendered with precise, dark lines. The contour of her neck suggests that her body was turned to the right for this study rather than seen frontally, as in the painting.

EX COLLS.: The artist, until d. 1925; his sisters, Violet Sargent Ormond and Emily Sargent, 1925–31.

EXHIBITIONS: Probably included in New York 1928 (inventory listing J.S. 61); "Sargent, Whistler and Cassatt," American Federation of Arts, traveling exhibition, September 1954–57 (no catalogue); "The American Muse: Parallel Trends in Literature and Art," Corcoran Gallery of Art, Washington, D.C., April 4–May 17, 1959, no. 53; New York–Buffalo–Albany 1971–72, cat. 5; The Metropolitan Museum of Art, September 1980 (no catalogue); "Giovanni Boldini and Society Portraiture 1880–1920," Grey Art Gallery, New York University, November 13–December 22, 1984, cat. 34.

REFERENCES: Fairbrother 1983, in introduction; Fairbrother 1994, p. 51; Ormond and Kilmurray 1998, pp. 114–15; Weinberg and Herdrich 2000b, pp. 229–30.

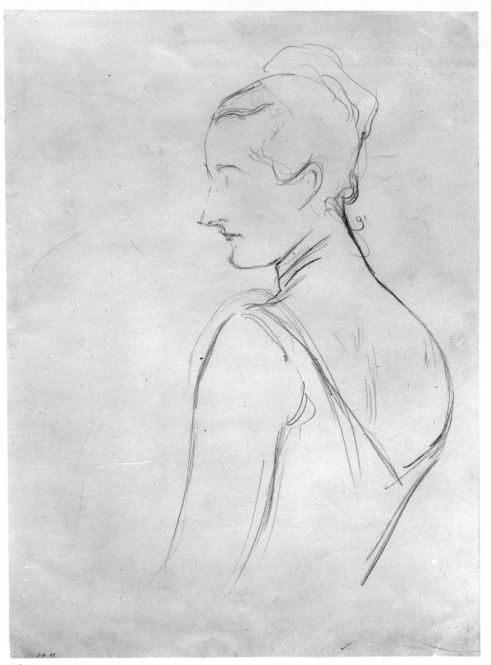

167

167. *Madame X (Madame Pierre Gautreau)*

1883–84
Graphite on off-white wove paper
12⁹/₁₆ × 8¼ in. (32 × 21 cm)
Inscribed on lower right: J.S. 69.
Gift of Mrs. Francis Ormond and Miss Emily Sargent, 1931
31.43.2

In catalogue 167, Sargent studied Madame Gautreau's upper back and the profile of her head, concentrating on the twist of her neck that makes the simultaneous views possible. In comparison to his emphasis on her profile in catalogue 166, Sargent here treated it in a cursory manner. He described the point of her nose and indicated her eyes beneath her brow only slightly. He was more interested in the relationship of her head to her body, which is also a crucial feature of the finished portrait.

EX. COLLS.: The artist, until d. 1925; his sisters, Violet Sargent Ormond and Emily Sargent, 1925–31.

EXHIBITIONS: Probably included in New York 1928 (inventory listing J.S. 69); "Sargent, Whistler and Cassatt," American Federation of Arts, traveling exhibition, September 1954–57 (no catalogue); "Giovanni Boldini and Society Portraiture, 1880–1920," Grey Art Gallery, New York University, November 13–December 22, 1984, cat. 36.

REFERENCES: New York–Chicago 1986–87, p. 259; Ormond and Kilmurray 1998, pp. 114–15; Weinberg and Herdrich 2000a, p. 56.

168. Madame X (Madame Pierre Gautreau)

1883–84
Graphite on off-white wove paper
9 11/16 × 13 3/16 in. (24.6 × 33.5 cm)
Inscribed at lower left: J.S. 82
Purchase, Charles and Anita Blatt Gift, John Wilmerding Gift, and Rogers Fund, 1970
1970.47

Sargent may have considered a seated pose for his portrait of Madame Gautreau. Catalogue 168 and another drawing in the Fogg Art Museum (1943.319; Ormond and Kilmurray 1998, fig. 56) show her seated languorously on an ornate sofa. Two other studies concentrate on her torso but also portray her seated (British Museum, London,

and private collection; Ormond and Kilmurray 1998, figs. 53 and 54). As he did in catalogue 167, Sargent presented the subject's back while maintaining a (near) profile. The right shoulder strap of the subject's dress is shown sliding down her arm, as it appeared in the oil portrait when Sargent showed it in the 1884 Salon (see figure 62). He later repainted the shoulder strap.

Another study in a private collection (Ormond and Kilmurray 1998, fig. 57) shows Gautreau from behind, kneeling on the same sofa.

EX. COLLS.: The artist's estate, 1925–38; sale, Grand Central Art Galleries, New York, 1938; Mrs. David Bloch, New York, by 1970.

EXHIBITIONS: Probably included in New York 1928 (inventory listing J.S. 82); Grand Central Art Galleries, New York, 1938; New York–Buffalo–Albany 1971–72, cat. 6; Leeds–London–Detroit 1979 (Detroit only); "American Drawings, Watercolors, and Prints: A Special Exhibition, Part II," The Metropolitan Museum of Art, September 23–December 7, 1980; "Giovanni Boldini and Society Portraiture, 1880–1920," Grey Art Gallery, New York University, November 13–December 22, 1984, cat. 35; New York–Chicago 1986–87.

REFERENCES: *Sargent at Harvard* website, July 14, 1997, Harvard acc. no. 1943.319; Ormond and Kilmurray 1998, p. 115; Weinberg and Herdrich 2000a, p. 56.

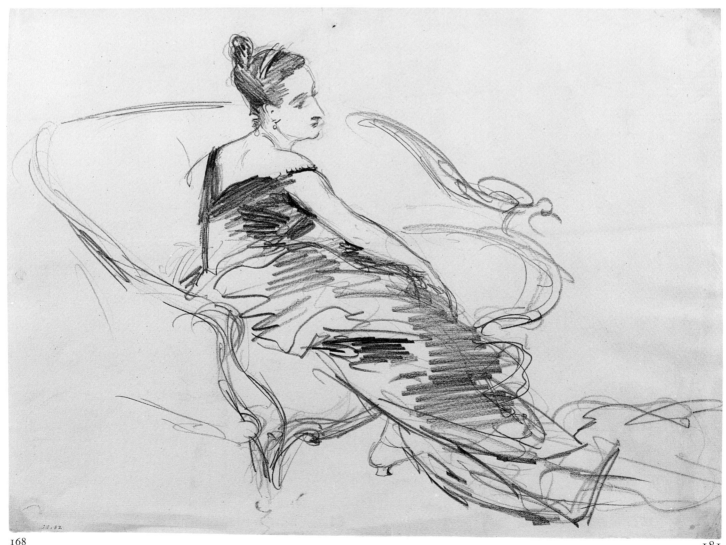

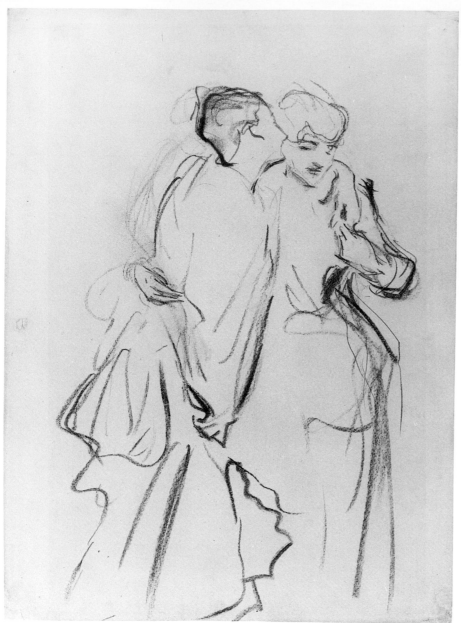

169

170. *Woman Holding Glass*

1880s
Graphite on light tan wove paper
12⅛ × 8¾ in. (30.8 × 22.2 cm)
Inscribed at lower left: J.S. 362
Gift of Mrs. Francis Ormond, 1950
50.130.140k

The identity of the model in catalogue 170 is unknown. The style of her dress, with its low neckline, elbow-length sleeves, and dropped waist with gathered fabric at the hips, generally resembles costumes depicted in several of Sargent's portraits of the 1880s such as *Mrs. Henry White* (1883, Corcoran Gallery of Art), *Mrs. Thomas Wodehouse Legh* (1884, private collection), and Mildred Vickers in *The Misses Vickers* (1884, Sheffield City Art Galleries, England).

The drawing, with its combination of fancy dress and seemingly informal pose, has the air of an impromptu sketch made during a break from portrait sittings. However, the extreme turn of the head in relation to the torso and shoulders recalls the pose of *Madame X (Madame Pierre Gautreau)* and could well have been contrived by Sargent for this sketch.

EXHIBITION: Probably included in New York 1928 (inventory listing J.S. 362).

169. *Whispers*

ca. 1883–84
Charcoal and graphite on off-white laid paper
13⁹⁄₁₆ × 9¹¹⁄₁₆ in. (34.4 × 24.7 cm)
Gift of Mrs. Francis Ormond, 1950
50.130.117

Ormond and Kilmurray suggest that the figure on the left is Madame Gautreau (Ormond and Kilmurray 1998, p. 117.) While details of her face are obscured, her upswept hair, dramatic profile, and bustled dress are reminiscent of Gautreau. The woman on the right is unidentified. The style of the drawing is consistent with the many studies of Gautreau, and a date of about 1883–84 does seem likely. If the drawing portrays Gautreau, it has little to do with the final oil portrait. It seems to record a spontaneous moment when the fleeting poses and gestures of the two women interested the artist more than detailed anatomical study.

EXHIBITIONS: "Sargent, Whistler and Cassatt," American Federation of Arts, traveling exhibition, September 1954–57 (no catalogue); "Images of Women: Nineteenth-Century American Drawings and Watercolors," The Metropolitan Museum of Art, October 1996–February 1997 (no catalogue).

REFERENCE: Ormond and Kilmurray 1998, pp. 115, 117.

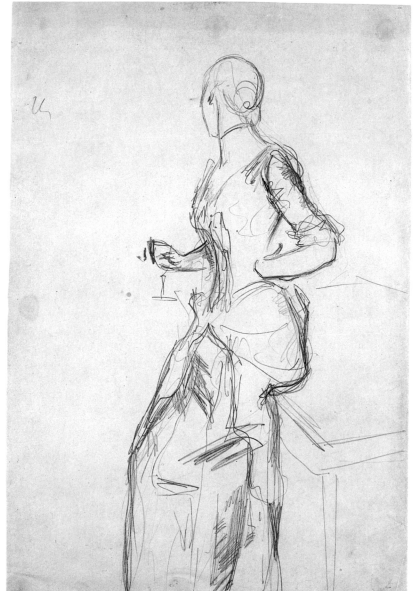

170

171. *Man Leading Horse*

1880s
Graphite on off-white wove paper
10 × 14⁵⁄₁₆ in. (25.4 × 36.3 cm)
Gift of Mrs. Francis Ormond, 1950
50.130.135

172. *Seated Woman with Hat*

late 1880s
Graphite on off-white wove paper
12¹³⁄₁₆ × 9⁷⁄₁₆ in. (32.6 × 24 cm)
Gift of Mrs. Francis Ormond, 1950
50.130.140l

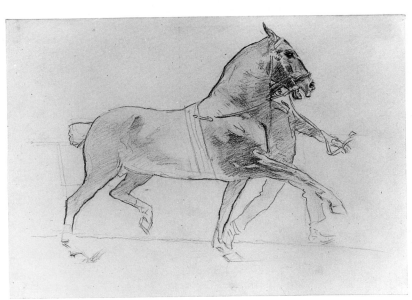

171

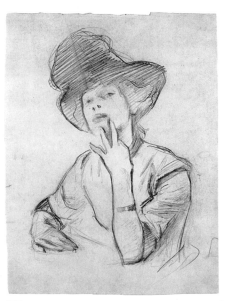

172

173. Conversation Piece

mid-1880s
Ink on off-white wove paper
12⁵⁄₁₆ × 8⁷⁄₁₆ in. (31.2 × 21.5 cm)
Gift of Mrs. Francis Ormond, 1950
50.130.120

In catalogue 173, Sargent combined broad passages of ink with hatching in a technique similar to that in works such as *Marie-Louise Pailleron* (cat. 161). However, the rendering of forms in this conversation piece is more adept and subtle than in the slightly earlier work.

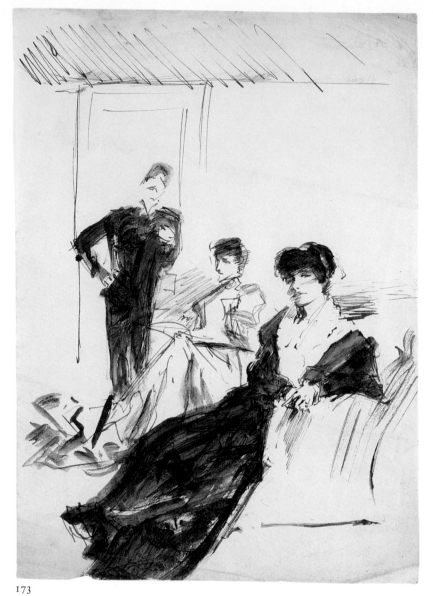

173

174. Parlor Concert

1880s
Graphite and black chalk on off-white wove paper
8⁷⁄₁₆ × 12⁵⁄₁₆ in. (21.5 × 31.2 cm)
Gift of Mrs. Francis Ormond, 1950
50.130.140i

An accomplished pianist and inveterate concertgoer, Sargent was devoted to music. Formal and informal recitals, whether at his studio or at the homes of friends, were a significant part of his social life. While scenes such as the one depicted in catalogue 174 could have occurred at any time throughout Sargent's career, Ormond suggests a date in the 1880s based on the style of the quick sketch (oral communication, June 1997).

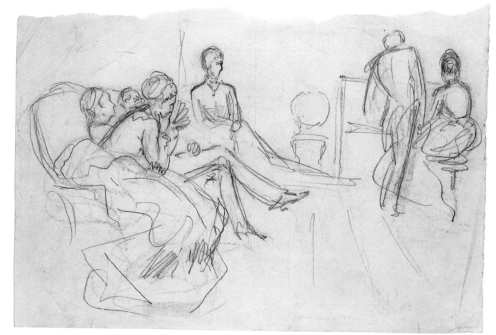

174

Catalogue Numbers 175–78: *Carnation, Lily, Lily, Rose,* 1885–86

The concept for Sargent's large exhibition painting *Carnation, Lily, Lily, Rose* (see figure 65) came to him in late summer 1885. In September, he wrote to artist friend Edward Russell: "I am trying to paint a charming thing I saw the other evening. Two little girls in a garden at dusk lighting paper lanterns among the flowers from rose-tree to rose-tree. I shall be a long time about it if I don't give up in despair" (JSS to Edward Russell, September 1885, quoted in New York 1986, p. 65). Sargent worked on the painting between August and early November 1885, and again in late August and/or early September and late October 1886; he exhibited it at the Royal Academy, London, in May 1887.

Several contemporary commentators recalled the creation of the canvas. For example, Edwin Blashfield, a visitor to Broadway during summer 1886, later remembered:

Each evening at twenty-five minutes to seven, Sargent dropped his tennis racquet and lugged his big painting from the studio into the garden. Until just seven, that is to say while the effect of the light lasted, he painted away like mad, then carried the thing back stood it against the studio wall and we spectators admired. Each morning, when after breakfast we went into the studio, we found the canvas scraped down to the quick. This happened for many days, then the picture, daughter of repeated observation and reflection, suddenly came to stay. (Edwin Howland Blashfield, "John Singer Sargent," in *Commemorative Tributes to Sargent,* 1927, quoted in Simpson 1993, p. 432)

Such descriptions emphasize Sargent's impressionistic method and minimize the fact that he made numerous careful and precise preliminary studies in graphite and oil in order to develop and refine the composition and plan the general effects. Drawings related to *Carnation, Lily, Lily, Rose* survive at the Fogg Art Museum, the Tate Gallery, London, and The Metropolitan Museum of Art. Ormond's essay on the work in New York 1986 (pp. 63–75) discusses the painting and some of the oil studies.

Five drawings in the Metropolitan have the same approximate dimensions and may have belonged to the same sketchbook, probably Fogg 1937.7.21, which contains several studies for *Carnation, Lily, Lily, Rose* and other works from the early to mid-1880s. Two of the sheets, catalogue numbers 177 and 180, were still attached to each other when they arrived at the Metropolitan.

175. *Lily, Study for "Carnation, Lily, Lily, Rose"*

1885–86
Graphite and pen and ink on off-white wove paper
13 9/16 × 9 11/16 in. (34.5 × 24.5 cm)
Gift of Mrs. Francis Ormond, 1950
50.130.125

Although Sargent did not mention lilies

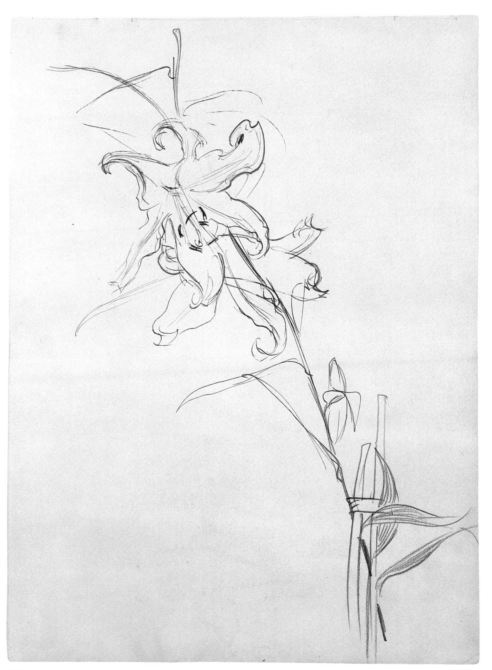

when he wrote in September 1885 about painting the effects of the lanterns "among the flowers from rose-tree to rose-tree," his friend Edward Russell wrote in the same month that Sargent's lanterns were hung among "the trees and the bed of lilies" (quoted in New York 1986, p. 65). At Lavington Rectory near Petworth in Sussex in summer 1884, Sargent painted two children standing amidst lilies in full bloom in his composition *Garden Study of the Vickers Children* (1884, Flint Institute of Arts, Michigan), and lilies became an important element in *Carnation, Lily, Lily, Rose.*

Early autumn is not the most propitious time to find lilies and roses in blossom in an English garden, and Sargent lamented the shortage to his sister in late September or October 1885: "I am launched into my garden picture and have two good little models and a garden that answers the purpose although there are hardly any flowers and I have to scour the cottage gardens and transplant and make shift" (JSS to Emily Sargent, Broadway, Worcestershire, [September or October, 1885?], quoted in New York 1986, p. 66). Lilies were so important to the composition that, in order to avoid a shortage in spring 1886, Sargent sent fifty lily bulbs to Broadway to be planted in the garden for his use in the painting when they bloomed a month later (Simpson 1993, p. 430).

Despite Sargent's rather broad and cursory treatment of the lilies in the painting, he made several precise graphite drawings of the blossoms (cat. 176 recto and Fogg 1937.7.21, fol. 10v.) and stalks. These do not appear to be exact studies for the final composition but records of general botanical characteristics.

REFERENCE: Weinberg and Herdrich 2000a, p.20.

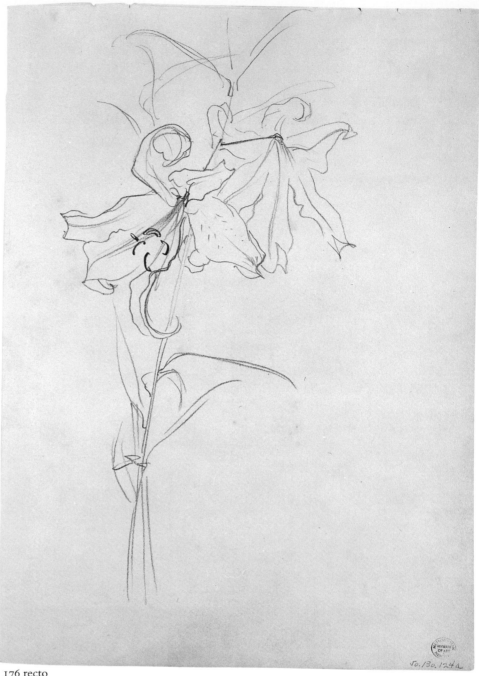

176 recto

176 recto. *Lily, Study for "Carnation, Lily, Lily, Rose"*

1885–86
Graphite on off-white wove paper
13⁹⁄₁₆ × 9¹¹⁄₁₆ in. (34.5 × 24.5 cm)
Gift of Mrs. Francis Ormond, 1950
50.130.124 recto

176 verso. *Japanese Lanterns and Lilies, Study for "Carnation, Lily, Lily, Rose"*

1885–86
Graphite on off-white wove paper
9¹¹⁄₁₆ × 13⁹⁄₁₆ in. (24.5 × 34.5 cm)
Gift of Mrs. Francis Ormond, 1950
50.130.124 verso

Although catalogue 176 verso records lanterns amidst flowers and foliage, it does not seem to be directly related to the final painting.

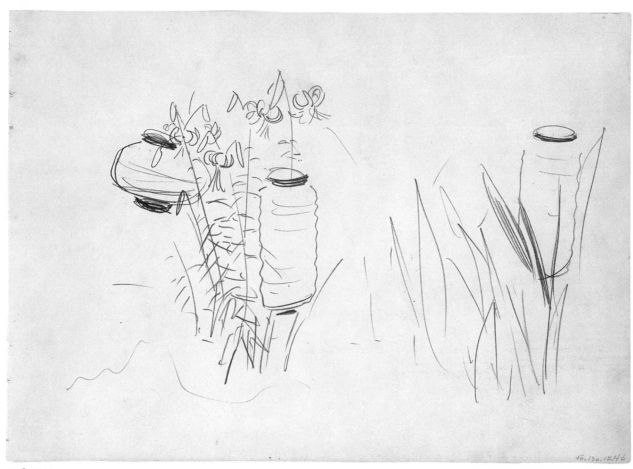

176 verso

No. 130.124-b

177

177. Rose Branch, Study for "Carnation, Lily, Lily, Rose"

1885–86
Graphite on gray-green wove paper
13 ¹¹⁄₁₆ × 9 ¹¹⁄₁₆ in. (34.7 × 24.6 cm)
Inscribed on verso at lower left: NS
Gift of Mrs. Francis Ormond, 1950
50.130.142g

Unlike the drawings of lilies on catalogue numbers 175 and 176, catalogue 177 is a precise compositional study for *Carnation, Lily, Lily, Rose*. Sargent examined the relationship between the branch and the head of a child, which is only barely suggested by pale graphite outlines of her face and hair on the right of the sheet. The position of the head and its relation to the branch are similar to, but not identical with, the image of Polly Barnard, the girl on the

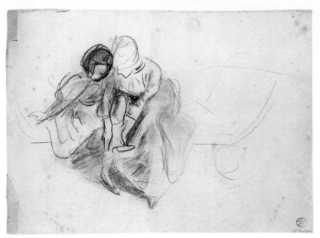

178 recto

right in the painting. This study documents how carefully Sargent considered individual compositional elements. While he only suggested the shape and space occupied by the rose blossoms, he delineated precisely the leaves immediately around the girl's face and related them to her head and hair.

178 recto. *Woman and Child*

1885–86
Charcoal on off-white wove paper
9 11⁄16 × 13 1⁄2 in. (24.5 × 34.3 cm)
Gift of Mrs. Francis Ormond, 1950
50.130.119 recto

178 verso. *Rose Branch, Study for "Carnation, Lily, Lily, Rose"*

1885–86
Graphite on off-white wove paper
13 1⁄2 × 9 11⁄16 in. (34.5 × 24.5 cm)
Gift of Mrs. Francis Ormond, 1950
50.130.119 verso

Catalogue 178 verso is related to catalogue 177, in which Sargent represented the same rose branch from a slightly different angle and distance.

Catalogue 178 recto shows a woman and child seated on what appears to be a garden lounge chair. The woman is helping the girl with her boot. This quick sketch may record preparations for the daily painting sessions.

178 verso

179. *Peacocks*

ca. 1886
Graphite on manila wove paper
9 11⁄16 × 13 5⁄8 in. (24.7 × 34.6 cm)
Inscribed on verso at lower left: NS
Gift of Mrs. Francis Ormond, 1950
50.130.142e

180 recto. *Peacocks*

1885–86
Graphite on gray-green wove paper
9 11⁄16 × 13 11⁄16 in. (24.6 × 34.7 cm)
Gift of Mrs. Francis Ormond, 1950
50.130.142f recto

180 verso. *Figures*

1885–86
Graphite on gray-green wove paper
9 11⁄16 × 13 11⁄16 in. (24.6 × 34.7 cm)
Gift of Mrs. Francis Ormond, 1950
50.130.142f verso

Catalogue 180 was originally attached to catalogue 177, and thus, like that sheet, it seems to have belonged to Fogg sketchbook 1937.7.21. Although Simpson notes that Sargent began using this sketchbook in Paris by early 1884 (Simpson 1993, p. 327), catalogue numbers 179 and 180 were probably drawn at Broadway, which Sargent first visited in 1885. Catalogue numbers 179 and 180 recto may depict the large peacocklike bird, kept at Broadway, that Sargent had received as a gift from his friend Edmund Gosse (1849–1928). Lucia Millet,

179

sister of painter Francis Davis Millet (1846–1912), described the bird in a letter to her family:

I must tell you of Mr. Sargent's bird which the Gosses gave him and which we have as a pet. It is all the colors of a peacock and is as large as one of mother's large hens, its feet are so huge that it always has to plan where to put each toe yet when it starts to run it runs faster than a child can and generally screeches dreadfully. It is very tame and seems fond of "grown-ups" as Kate [Lucia Millet's niece] says but let any child come in sight and it will stop even a good meal to run after it screeching and when once having caught the child, it will bite her legs and then turn toward her as any dog would. This I saw myself the other day, I heard a little girl screaming as if frightened to death and got out just in time to see the blue-bird coming home just as fast as he could come. He evidently had scared her all he wanted to. When he finds we are not scared then he turns his back, puts his wings to-gether spread out and stands first on one leg and then on the other. He is most amusing. (Lucia Millet to her family, April 11, 1886, quoted in Simpson 1993, p. 346)

If Sargent made these studies from this bird, he must have done so before April 27, 1886, when Lucia Millet recorded the bird's death in a letter to her family (Simpson 1993, p. 346).

Other drawings of peacocks dating after 1884 appear in catalogue numbers 181, 182, and 183.

EXHIBITION (cat. 180 recto): "Grand Reserves: An Exhibition of 235 Objects from the Reserves of Fifteen New York Museums," The New York Cultural Center, October 14–December 8, 1974, cat. 87.

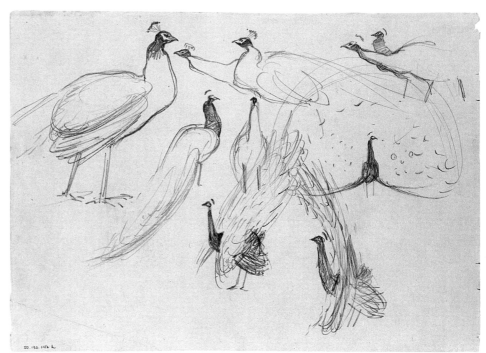

180 recto

180 verso

181 recto

181 verso

182 recto

182 verso

181 recto. *Peacocks*

1884–86
Graphite on off-white wove paper
3⅝ × 6⁵⁄₁₆ in. (9.2 × 16 cm)
Inscribed at center left: [illegible]
Gift of Mrs. Francis Ormond, 1950
50.130.142b recto

181 verso. *Peacocks*

1884–86
Graphite on off-white wove paper
3⅝ × 6⁵⁄₁₆ in. (9.2 × 16 cm)
Gift of Mrs. Francis Ormond, 1950
50.130.142b verso

182 recto. *Peacocks*

1884–86
Graphite on off-white wove paper
3⁹⁄₁₆ × 6⁵⁄₁₆ in. (9.1 × 16 cm)
Gift of Mrs. Francis Ormond, 1950
50.130.142c recto

182 verso. *Peacocks*

1884–86
Graphite on off-white wove paper
3⁹⁄₁₆ × 6⁵⁄₁₆ in. (9.1 × 16 cm)
Gift of Mrs. Francis Ormond, 1950
50.130.142c verso

183. *Peacocks*

1884–86
Graphite on off-white wove paper
3⁹⁄₁₆ × 6⁵⁄₁₆ in. (9.1 × 16 cm)
Inscribed on verso at center: NS
Gift of Mrs. Francis Ormond, 1950
50.130.142d

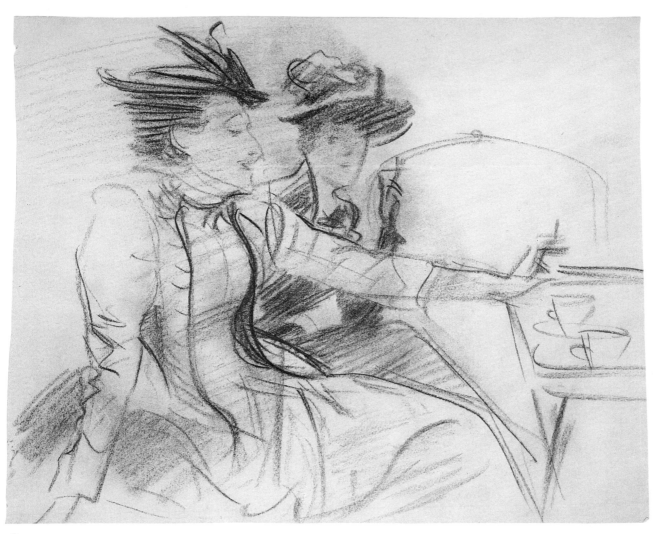

184

Catalogue numbers 181, 182, and 183 may have been removed from Fogg sketchbook 1937.7.15, in which a similar drawing of a peacock is found on folio 15 and from which the three preceding pages have been removed (traces of the page edges remain in the binding). The first page of the Fogg sketchbook is inscribed "Emily Sargent to / John S. Sargent — / Munich. July 1st / 84."

These drawings may depict the same bird seen in catalogue numbers 179 and 180 recto and were probably executed at Broadway after 1884 but before the bird was found dead in April 1886.

184. *Two Women in Café*

late 1880s
Charcoal on off-white wove paper
8¹¹⁄₁₆ × 11⅛ in. (22.1 × 28.3 cm)
Inscribed on verso at lower left: [zigzag lines]
Gift of Mrs. Francis Ormond, 1950
50.130.118

Kilmurray suggests that the figure at the left in catalogue 184 is Sargent's childhood friend Flora Priestley (1859–1944), whom he probably met in Nice (oral communication, October 1996) and whose portrait he painted a number of times in the 1880s (see Ormond and Kilmurray 1998, pp. 226–29).

In this informal sketch, Sargent recorded a vignette of modern life: women's new access to public places. The table and loosely drawn cups, represented by a few quick lines, suggest that the setting is a café. The relaxed and confident poses of the two elegantly attired women seated on a banquette may imply that they are "new women" who defy decorum by smoking in public.

A related subject, possibly drawn about the same time as catalogue 184, is *Tea Party at Fladbury* (1889, private collection; Ormond and Kilmurray 1998, fig. 47, p. 109).

EXHIBITION: "Images of Women: Nineteenth-Century American Drawings and Watercolors," The Metropolitan Museum of Art, October 1996–February 1997 (no catalogue).

Catalogue Numbers 185–86: Javanese Dancers, 1889

When Sargent visited the Exposition Universelle in Paris in 1889, he was captivated by one of the features of the Dutch exhibition, a group of dancers from the Indonesian island of Java, then a Dutch colony. On the Exposition's Esplanade des Invalides, the Dutch had reconstructed a typical Javanese village, or *kampong,* which was populated by forty Javanese men and twenty women. They included musicians, artisans, and the dancers—five young women and one man.

An article in the *Illustrated London News* singled out the dancers as "the most interesting exhibition" and described them. Four of the female dancers were of the highest rank of their profession, the order of the *Tandak,* the writer noted, adding:

They are of good birth, have been carefully educated in a sort of nunnery, and are trained, like the famous "Bayaderes" of ancient India, to assist in certain mystical rites of temple worship. . . . Their dresses, made of the richest embroidered silks and velvets, with massive golden ornaments, necklaces, bracelets, and jewelled hair-dresses, are carefully regulated, and seem to have been copied from the costumes of sacred figures in the antique bas-reliefs that still exist among the Khmer ruins of temples in Cambodia. ("The Java Village at the Paris Exhibition," *Illustrated London News,* July 6, 1889, pp. 17–18)

Several artists, including Sargent, Camille Pissarro (1830–1903), Henri de Toulouse-Lautrec (1864–1901), and Auguste Rodin (1840–1917), were fascinated by the dancers and sketched them and their mystical and novel performances. The dancers seemed particularly pertinent to Sargent's long-standing interests in music, dance, theater, and the exotic, which he had explored (in various combinations) in works such as *Fumée d'Ambre Gris* (see figure 58), *El Jaleo* (see figure 60), and even *Ellen Terry as Lady Macbeth* (1889, Tate Gallery, London).

The *Illustrated London News* described the characteristic synthesis of Javanese dance and music: "Their performance . . . is accompanied by the orchestral music of the 'Gamelang': and though it may seem dull and monotonous—consisting of slow, gliding movements, waving of the arms, and waftings of the scarf with a pantomime understood to be symbolical of some mythological legend of the gods and heroes—it has a rather impressive effect." But the author lamented: "Parisian levity does not understand its significance, which is, perhaps, more intelligible to learned students of the ancient religious poetry of the Asiatic nations" ("The Java Village," *Illustrated London News,* July 6, 1889, pp. 17–18). The esoteric nature of the performances must have increased their appeal to Sargent.

The artist filled a sketchbook (cat. 186) with studies of the dancers and made several drawings on loose sheets (cat. 185, Fogg 1937.8.69, and Museum of Fine Arts, Boston, 50.3834). He also painted watercolors (see figure 72) and several oils, including at least three full-length portraits (Ormond Collection) and a portrait of one of the dancers at her toilette (private collection). He was so fascinated by the dancers that he postponed a visit to Claude Monet at Giverny in order to extend his stay in Paris. He wrote to Monet, "Je voudrais bien pouvoir m'arrêter à Giverny mais les Javannaises me retiennent ici jusqu'au dernier moment qui est déjà passé du reste. Il-y-a plus d'une semaine que je devrais être en Angleterre" (JSS to Claude Monet, Paris, no date, quoted in Charteris 1927, p. 102).

Although Sargent did paint oil likenesses of the dancers, his sketchbook suggests that his primary interest was in the movements and body positions inherent in their dances. In numerous rapid sketches he attempted to capture specific moments of the dance (cats. 186v verso, 186w, and 186x). He was characteristically attentive to gestures, particularly the positions of arms and hands, which conveyed sacred and mystical meanings and, according to one source, were thought to be "les moyens évocateurs les plus importants de la danse" (cats. 186bb verso and 186ff). Because of the dancers' special training, they were able to perform certain hand and arm movements, which were said to be "inexécutables pour un Européen" (Th. B. van Lelyveld, *La Danse dans le Théâtre Javanais,* Paris, 1931, pp. 73–74).

Although the dancers were described as "women," they were rather young. The four dancers of the *Tandak* ranged in age from twelve to sixteen. A photograph of the dancers (reproduced in Thompson 1990, p. 127) shows that they have the bodies of children despite their elaborate costumes and makeup, a fact that is obscured by most of Sargent's sketches, which make their figures seem attenuated and graceful beyond their age.

Sargent was apparently able to view the dancers behind the scenes. Several sketches that seem to be related to the oil portrait of the dancer at her toilette (private collection) show the dancers applying makeup or adjusting their hair (186m recto, 186o verso, 186p, 186q, 186r, and 186s). The writer for the *Illustrated London News* emphasized the dancers' good upbringing and religious background and the fact that they were closely supervised. At home "they dwell, under strict supervision, in a palace appropriated to their residence by the Prince Manka Negaia," and "the four members of the 'Tandak' . . . have been sent to France in special charge of M. Cores De Vries" ("The Java Village," *Illustrated London News,* July 6, 1889, pp. 17–18). While it is not known how Sargent gained access to the dancers' private world, it is not surprising that, as a portraitist, he was captivated by seeing them apply the makeup that completed their transformation from young girls to performers.

REFERENCE: Thompson 1990, pp. 124–33.

185. *Javanese Dancer*

1889
Graphite on off-white wove paper
12¹¹⁄₁₆ × 9¹¹⁄₁₆ in. (32.3 × 24.5 cm)
Inscribed at lower left: J.S. 378; on verso at upper right: 355
Gift of Mrs. Francis Ormond, 1950
50.130.109

A related drawing that studies this pose is in the Fogg Art Museum (1937.8.69).

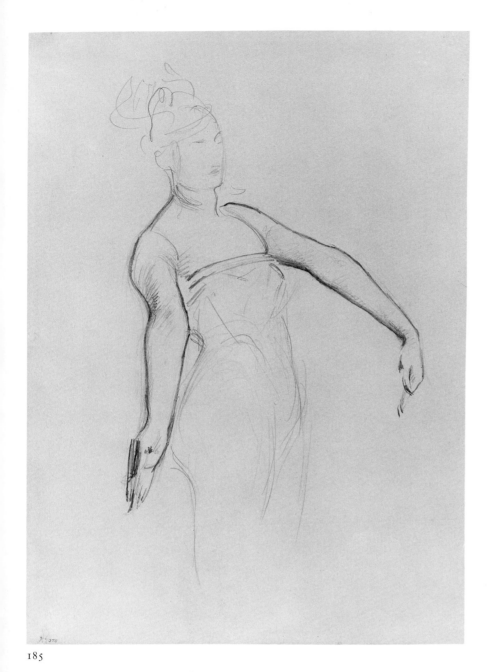

185

Figure 71. Inside front cover, Javanese Dancers sketchbook. 1889, graphite on off-white wove paper. The supplier's sticker is seen at upper right in this photograph; the bound edge of the notebook is at bottom.

186a. *Foot of a Javanese Dancer*

1889
Graphite on off-white wove paper
Signed at top center: Sargent
50.130.149a

186. Javanese Dancers Sketchbook

1889
Cover: cardboard covered with beige canvas
Sheet size: 5½ × 8½ in. (14 × 21.6 cm)
*Inscribed on cover at center: Javanese; on sticker at center: Javanese; on inside front cover: Harford /
Bowton House / Vauxhall // Niccola Inverno /
189 High Holborn / Saturday / Raffaelo Corsi / 6
Britannia St. Kings Cross / Road; supplier's sticker
at upper left: PAPETERIE / L. GASTOU / 240,
422, Rue S.^t Honoré; inscribed on sticker: Gal a [?]*
Gift of Mrs. Francis Ormond, 1950
50.130.149

186a

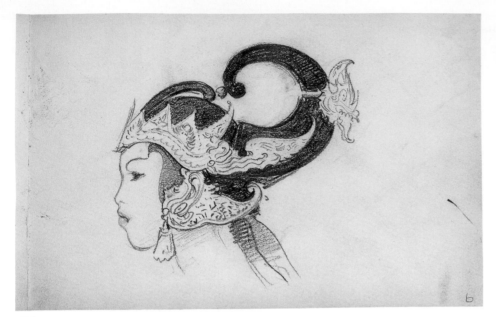

186b

186d

186b. *Head of a Javanese Dancer in Profile*

1889
Graphite on off-white wove paper
50.130.149b

The dancers' elaborate costumes, particularly their ornate headdresses, were an important part of the overall image that they presented. Catalogue 186b, a precise drawing, is exceptional among Sargent's numerous quick studies of the fleeting gestures of the dancers while performing.

186c. *Arm of a Javanese Dancer*

1889
Graphite on off-white wove paper
50.130.149c

186d. *Head of a Javanese Dancer*

1889
Graphite on off-white wove paper
50.130.149d

This sketch continues onto the verso of catalogue 186c.

186e. *Hand of a Javanese Dancer*

1889
Graphite on off-white wove paper
50.130.149e

186c

186e

186f

186f. *Arm of a Javanese Dancer*

1889
Graphite on off-white wove paper
50.130.149f

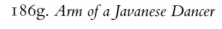

186g. *Arm of a Javanese Dancer*

1889
Graphite on off-white wove paper
50.130.149g

Catalogue 186g continues onto the verso of catalogue 186f.

186h. *Arm of a Javanese Dancer*

1889
Graphite on off-white wove paper
50.130.149h

186i recto. *Legs and Costume of a Javanese Dancer*

1889
Graphite on off-white wove paper
50.130.149i recto

186i verso. *Standing Javanese Dancer from Behind*

1889
Graphite on off-white wove paper
50.130.149i verso

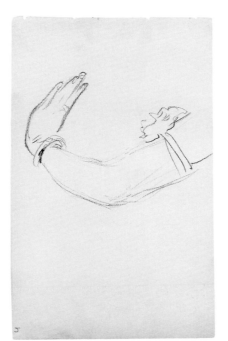

186h

186g

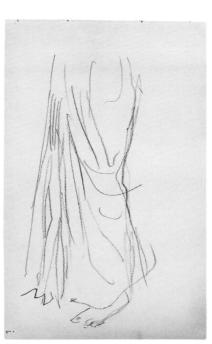

186i recto

186i verso

186j

186j. *Hand of a Javanese Dancer*

1889
Graphite on off-white wove paper
50.130.149j

186k recto. *Two Seated Javanese Dancers*

1889
Graphite on off-white wove paper
50.130.149k recto

186k verso. *Arm of a Javanese Dancer*

1889
Graphite on off-white wove paper
50.130.149k verso

186l. *Seated Javanese Dancer*

1889
Graphite on off-white wove paper
50.130.149l

186m recto. *Javanese Dancer in Profile Fixing Her Hair*

1889
Graphite on off-white wove paper
50.130.149m recto

186m verso. *Hands of a Javanese Dancer*

1889
Graphite on off-white wove paper
50.130.149m verso

186n recto. *Hands of a Javanese Dancer*

1889
Graphite on off-white wove paper
50.130.149n recto

186n verso. *Architectural Ornament*

1889
Graphite on off-white wove paper
50.130.149n verso

A similar architectural motif appears in the background of Sargent's watercolor of three dancers, *Javanese Dancing Girls* (see figure 72).

186o recto. *Hand and Body Positions of a Javanese Dancer*

1889
Graphite on off-white wove paper
50.130.149o recto

186o verso. *Seated Javanese Dancer Fixing Her Hair*

1889
Graphite on off-white wove paper
50.130.149o verso

186k recto

186k verso

186l

186m recto

186m verso

186n recto

186n verso

186o recto

186o verso

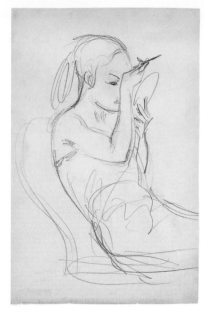

186p 186q recto 186q verso

186p. *Javanese Dancer Applying Makeup*

1889
Graphite on off-white wove paper
50.130.149p

186q recto. *Javanese Dancer Applying Makeup*

1889
Graphite on off-white wove paper
50.130.149q recto

186q verso. *Javanese Dancer Applying Makeup*

1889
Graphite on off-white wove paper
50.130.149q verso

186r. *Javanese Dancer Applying Makeup*

1889
Graphite on off-white wove paper
50.130.149r

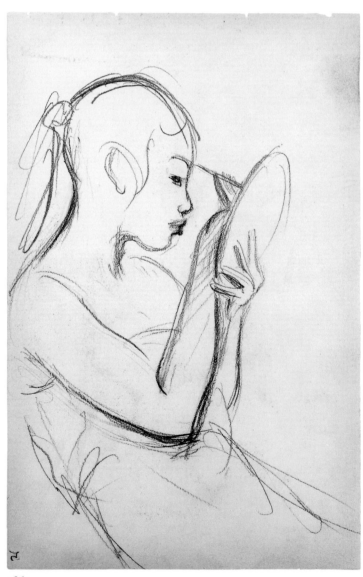

186r

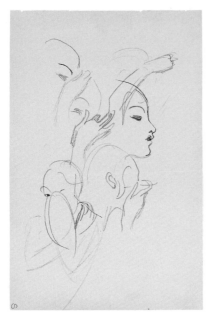

186s

186s. Heads and Faces of Javanese Dancers

1889
Graphite on off-white wove paper
50.130.149s

186t recto. Two Javanese Dancers Applying Makeup

1889
Graphite on off-white wove paper
50.130.149t recto

186t verso. Javanese Dancers Applying Makeup and Adjusting Hair

1889
Graphite on off-white wove paper
50.130.149t verso

186u recto. Heads and Feet of Two Javanese Dancers

1889
Graphite on off-white wove paper
50.130.149u recto

186u verso. Two Standing Men

1889
Graphite on off-white wove paper
50.130.149u verso

186u recto

186u verso

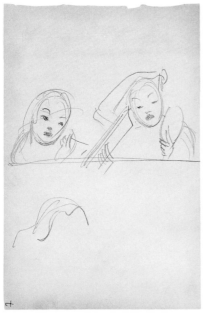

186t recto

186t verso

186v recto

186v verso

186v recto. *Head with Turban*

1889
Graphite on off-white wove paper
50.130.149v recto

186v verso. *Three Standing Javanese Dancers*

1889
Graphite on off-white wove paper
50.130.149v verso

The pose of the figure in the lower right corner of catalogue 186v verso is similar to that of the central figure in the watercolor *Javanese Dancing Girls* (see figure 72).

186w recto. *Standing Javanese Dancer*

1889
Graphite on off-white wove paper
50.130.149w recto

186w verso. *Javanese Dancer, Arm and Hand Positions*

1889
Graphite on off-white wove paper
50.130.149w verso

186x. *Javanese Dancer*

1889
Graphite on off-white wove paper
50.130.149x

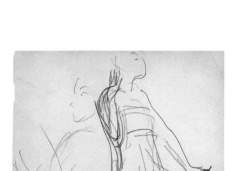

186w recto 186w verso 186x

186y recto. *Javanese Dancer Applying Makeup*

1889
Graphite on off-white wove paper
50.130.149y recto

186y verso. *Javanese Dancer*

1889
Graphite on off-white wove paper
50.130.149y verso

186z recto. *Two Javanese Dancers*

1889
Graphite on off-white wove paper
50.130.149z recto

186z verso. *Javanese Dancer with Fan, Foot, Man*

1889
Graphite on off-white wove paper
50.130.149z verso

186aa recto. *Javanese Dancer, Two Musicians*

1889
Graphite on off-white wove paper
50.130.149aa recto

186aa verso. *Seated Javanese Dancer, Foot and Leg Positions*

1889
Graphite on off-white wove paper
50.30.149aa verso

186y recto

186y verso

186z recto

186z verso

186aa recto

186aa verso

186bb recto. *Javanese Dancer Applying Makeup*

1889
Graphite on off-white wove paper
50.130.149bb recto

186bb verso. *Javanese Dancer, Hand and Arm Positions*

1889
Graphite on off-white wove paper
Inscribed at top left: right arm / facing figure / left arm
50.130.149bb verso

186cc recto. *Arms and Torso of a Javanese Dancer*

1889
Graphite on off-white wove paper
50.130.149cc recto

186cc verso. *Two Standing Javanese Dancers*

1889
Graphite on off-white wove paper
50.130.149cc verso

186dd. *Seated Javanese Dancers*

1889
Graphite on off-white wove paper
50.130.149dd

186bb recto

186bb verso

186cc recto

186cc verso

186dd

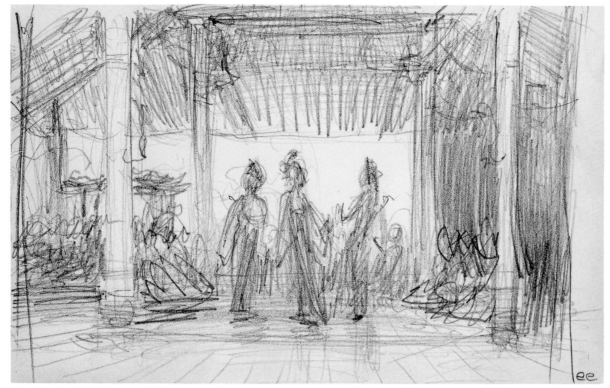

186ee

186ee. *Javanese Dancers on Stage*

1889
Graphite on off-white wove paper
50.130.149ee

Catalogue 186ee relates to the watercolor
Javanese Dancing Girls (figure 72).

Figure 72. *Javanese Dancing
Girls,* 1889. Watercolor on
paper, 12¼ × 10 in. (31.1 ×
25.4 cm). Private collection

186ff

186hh recto

186hh verso

186ff. *Arms of Javanese Dancers*

1889
Graphite on off-white wove paper
50.130.149ff

Catalogue 186ff continues onto the verso of
catalogue 186ee. The following page, folio
186gg, is blank.

186hh recto. *Figure in Architectural Setting*

1889
Graphite on off-white wove paper
50.130.149hh

186hh verso. *Architectural Setting*

1889
Graphite on off-white wove paper
50.130.149ii

Catalogue 186hh verso continues onto cat-
alogue 186ii. Folios 186jj–qq of the sketch-
book are blank.

186rr recto. *Three Standing Dancers*

1889
Graphite on off-white wove paper
50.130.149rr recto

Catalogue 186rr recto notes the general composition of the watercolor *Javanese Dancing Girls* (see figure 72). See also catalogue 186rr verso.

186rr verso. *Standing Javanese Dancer, Face, Composition Study*

1889
Graphite on off-white wove paper
Inscribed at upper right: mi re l[illegible] re la sol la sol / (do mi)
50.130.149rr verso

186rr recto

186rr verso

186ss

186ss. *Javanese Dancers Performing (inside back cover)*

1889
Graphite on off-white wove paper
50.130.149ss

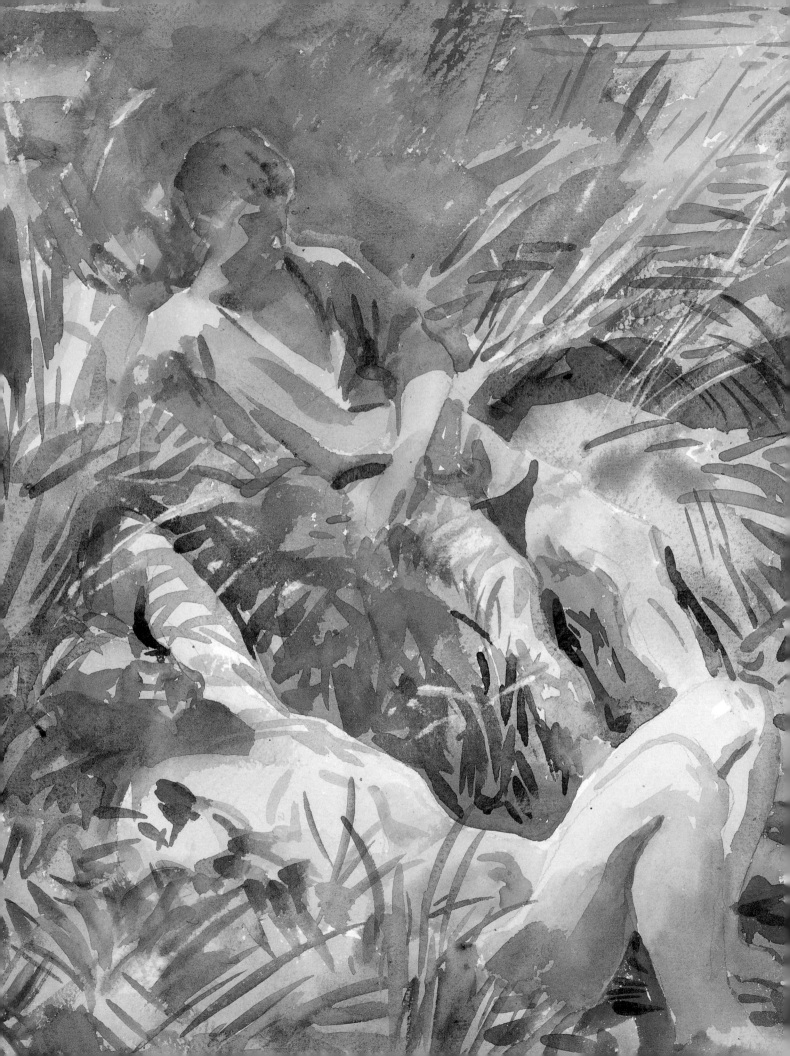

Professional Activity, 1890–1925

Sargent's third visit to the United States began in December 1889. The eleven-month sojourn, which would include stays in New York, Boston, and Worcester, Massachusetts, was one of the most prolific periods of his career. By the time he left the country in November 1890, he had painted nearly forty portraits, almost twice as many as he had executed during his visit to the United States in 1887.[1] He had also received a prestigious commission for a mural project in McKim, Mead and White's Boston Public Library, constructed between 1887 and 1894 in Copley Square. Back in England, however, Sargent did not immediately repeat his American success as a portraitist. Preoccupied with his murals, family obligations, and continued travels, he was absent from London until early 1892.[2] Thus he painted only a few portraits at the beginning of the 1890s, the decade that would ultimately be called his "great decade of portraiture."[3]

Sargent did continue to exhibit portraits at London's principal venues during this period, but British critics were skeptical about them, and potential patrons were reluctant to favor him with commissions. Typically, critics praised Sargent's two submissions to the 1890 Royal Academy exhibition, but their remarks alerted prospective clients to his stylistic eccentricities. For example, the critic for the *Art Journal* commended *Mrs. Benjamin Kissam* (1888, The Biltmore Company, Biltmore House, Asheville, North Carolina) for "her extraordinarily living character" but noted that she appeared to be gathering the hems of her skirt "as for a trudge across a crossing."[4] The writer for the *Magazine of Art* cited Sargent's other submission, *Clementina Anstruther-Thomson* (1889, Mr. and Mrs. Stanley Cohen), for her "shocking eccentricity."[5] When Sargent sent *La Carmencita* to the Royal Academy in 1891, the writer for the *Art Journal* deemed it

the "picture of the year."[6] However, the critic for *Athenaeum* noted that the painting was "a long way from being a specimen of choice art."[7] In spring 1892, perhaps thoroughly immersed in his murals, Sargent chose not to exhibit in London at all.

Sargent returned to London's exhibition fray in 1893, concurrently showing *Mrs. Hugh Hammersley* (figure 74) and *Mrs. George Lewis* (1892, private

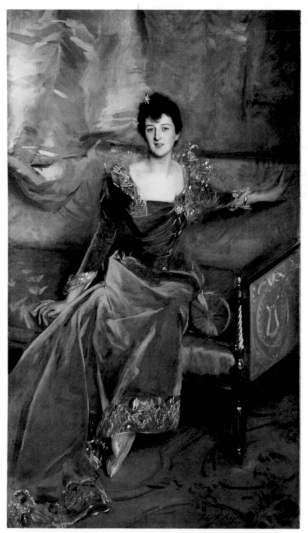

Figure 74. *Mrs. Hugh Hammersley,* 1892. Oil on canvas, 81 × 45½ in. (205.7 × 115.6 cm). The Metropolitan Museum of Art, Gift of Mr. and Mrs. Douglass Campbell, in memory of Mrs. Richard E. Danielson, 1998 (1998.365)

Figure 73 (opposite). *Tommies Bathing* (detail), see catalogue 225.

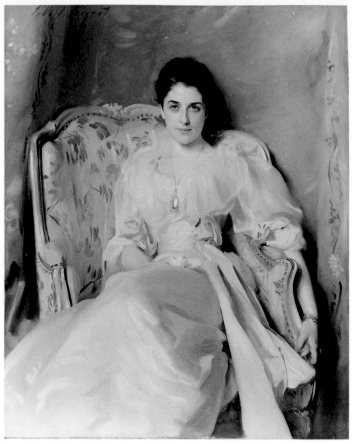

Figure 75. *Lady Agnew of Lochnaw,* 1892. Oil on canvas, 50 × 39¾ in. (127 × 101 cm). The National Gallery of Scotland, Edinburgh

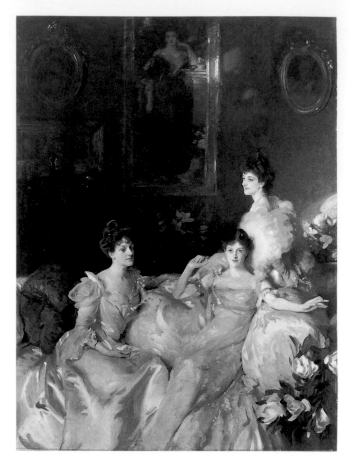

Figure 76. *The Wyndham Sisters: Lady Elcho, Mrs. Adeane, and Mrs. Tennant,* 1899. Oil on canvas, 115 × 84⅛ in. (292.1 × 213.7 cm). The Metropolitan Museum of Art, Wolfe Fund, Catharine Lorillard Wolfe Collection, 1927 (27.67)

collection) at the progressive New Gallery and *Lady Agnew of Lochnaw* (figure 75) at the venerable Royal Academy. Sargent's friend Clementina Anstruther-Thomson described Sargent's triumph in a letter to Vernon Lee: "As to Mr Sargent London is at his feet, Mrs Hammersley & Mrs Lewis are at the New Gallery, Lady Agnew at the Academy. There can be no two opinions this year. He has had a cracking success."[8] Critics' discussions centered on *Mrs. Hammersley* and *Lady Agnew*. They praised the former for the sitter's vivaciousness and for the painter's ability to capture a fleeting impression boldly and immediately. They described the portrait as chic, clever, unconventional, realistic, daring, bizarre, and bold, qualities that were admirable or lamentable, depending on the writer. By contrast, most commentators lauded the portrait of Lady Agnew, saying it was solid, convincing, and enduring as a characterization.[9] When Sargent was elected an associate of the Royal Academy in January 1894,

the *Sunday Times* suggested the relative roles of the two portraits in assuring his election:

His brilliant portrait of Mrs. Hammersley at the New Gallery last May showed the Carolus Duran influence pure and simple. The famous picture of Mrs. Agnew which appeared on the line at the Academy in 1893 may be said to have made the election of Tuesday practicable. It supplied that evidence of solidity and seriousness of purpose, that understanding of the graver simplicities of effect which the startling [Mrs. Hugh Hammersley] at the New did not quite afford.[10]

Throughout the nineteenth century, critical acclaim at the Royal Academy was crucial to a traditional artist's success in London. Sargent had apparently calculated that *Lady Agnew*, the conservatively posed, subtly colored portrait of an aristocrat, would represent him well at that staid institution, where the sitter's social peers and other potential aristocratic clients could take notice. He

sent the bolder portrait of Mrs. Hammersley, the wife of a British banker, to the New Gallery, which fostered modern tendencies in British art and was a more hospitable venue for a canvas that featured a nonchalant pose and a brilliant magenta dress.

Stanley Olson has noted that the success of *Lady Agnew* transformed the sitter into a celebrity and assured the public of Sargent's competence by remedying the concerns he had provoked with *Madame X:* "It was another way of saying future patrons had little to fear from Sargent, he would not drag them into controversy, and there was a distinct possibility their social prominence might be enhanced if they made themselves available for his canvas."[11] Impressed by the portrait, the praise it provoked, and Sargent's ensuing election to the Royal Academy, British patrons responded with numerous commissions. Sargent painted approximately 150 portraits between 1891 and 1903 and would show many of them at the Royal Academy. Specifically, according to Fairbrother: "In the five-year periods 1890–1894, 1895–99 and 1900–1904 the commissioned portraits exhibited [by Sargent] at the Royal Academy numbered five, twenty-four, and thirty-three respectively (almost all of them British subjects)."[12] Sargent's British patrons represented diverse groups, from actors and artists to businessmen and their families. The prominent London art dealer Asher Wertheimer, whom Sargent painted in 1898 (Tate Gallery, London), became the artist's greatest single patron, commissioning twelve likenesses of family members over a ten year period.[13]

Sargent flourished as a purveyor of portraits to the English aristocracy. He maintained in these works a self-conscious dialogue with tradition, producing pendants to family heirlooms by Anthony Van Dyck (1599–1641), Sir Joshua Reynolds (1723–1792), John Singleton Copley (1738–1815), and others. A fine example is *The Wyndham Sisters: Lady Elcho, Mrs. Adeane, and Mrs. Tennant* (figure 76), which presents three well-born young women arranged like so many huge white flowers on a sumptuous sofa. Sargent studied the Wyndham sisters in the family residence on Belgrave Square, rather than following his usual practice of conducting sittings in his Tite Street studio. George Frederick Watts's (1817–1904) portrait of the young women's mother

(1866–77, private collection) on the wall above them establishes both their genealogy and Sargent's, reminding the viewer of his ties to painters of the past.

An original and memorable demonstration of Sargent's skill as a portraitist in the 1890s, and of his international patronage, is *Mr. and Mrs. I. N. Phelps Stokes* (figure 77), an image of a handsome young American couple. Sargent had been asked to paint Mrs. Stokes alone; he selected a blue satin evening

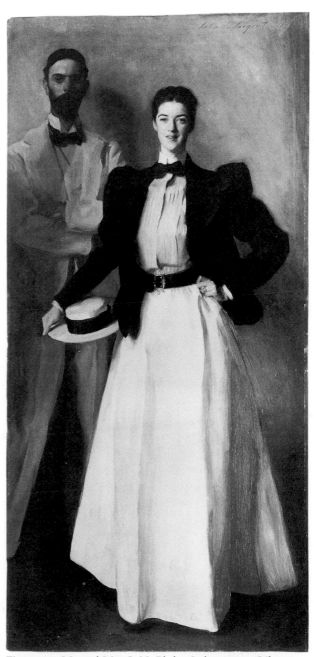

Figure 77. *Mr. and Mrs. I. N. Phelps Stokes,* 1897. Oil on canvas, 84¼ × 39¾ in. (214 × 101 cm). The Metropolitan Museum of Art, Bequest of Edith Minturn Phelps Stokes (Mrs. I.N.), 1938 (38.104)

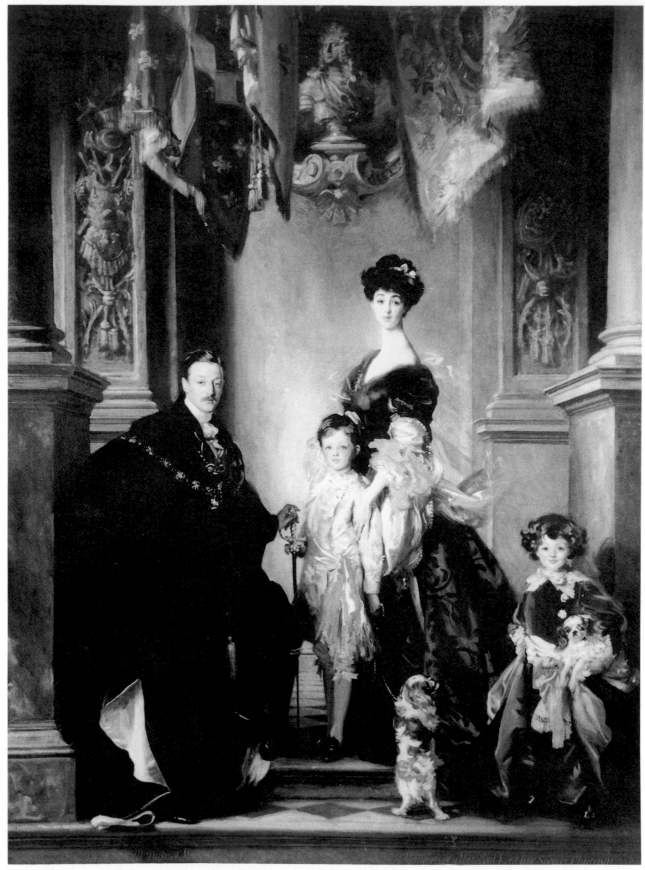

Figure 78. *The Ninth Duke and Duchess of Marlborough and Their Sons,* 1905. Oil on canvas, 145 × 95 in. (368.3 × 241.3 cm). Reproduced by kind permission of His Grace the Duke of Marlborough, Blenheim Palace, Woodstock, Oxfordshire, England

gown for her to wear and undertook a few sittings. He soon decided instead to portray her wearing the white piqué skirt, shirtwaist, and serge jacket in which she walked to his studio one day. She was to be depicted accompanied by a Great Dane borrowed from the kennel of one of Sargent's friends. When the couple abandoned their plan to have James Abbott McNeill Whistler paint Mr. Stokes's portrait—and when the dog was unavailable—Stokes had "a sudden inspiration," as he noted, "and offered to assume the role of the Great Dane in the picture. Sargent was delighted, and accepted the proposal at once. . . . He painted me in three standings—purely as an accessory."[14] The resulting double portrait invokes Velázquez in its monochromatic palette and flattened space and Van Dyck in its attenuated forms. But it suggests as much the modern spirit of the sitters: a young architect and scholar and his wife, a "new woman" of the time, encouraged but not dominated by her husband, dressed in street clothes, and seeming to have stopped by the studio and just caught her breath an instant before Sargent snapped her portrait onto the canvas.

Michael Quick has astutely summarized the general aspect of Sargent's late portraits:

His supremacy in England came only in 1893, when much of the edge had been taken off his assertive, challenging realism of ten years earlier. The crisp planes and sharp contrasts of that earlier period had given way to a softer, buttery brushwork of equal brilliance. The sometimes sharp accent colors of the 1880s were now muted, the strong lighting that approached harshness in some earlier portraits now tamed by a gently enveloping chiaroscuro. Most importantly, Sargent had cultivated the means of suggesting, through fabrics, furniture, costume, and setting, that the subject was at home in a world of prestige and opulent grandeur.[15]

Although Sargent's expressive agenda as a portraitist evolved considerably after his move from Paris to London, his working method seems to have changed little between his student and early professional years and the height of his career. As his teacher Carolus-Duran had insisted, Sargent painted (and, when necessary, repainted) what he saw directly onto the canvas, making few preliminary studies.[16] In the 1890s and later, Sargent drew as an aid in planning portrait compositions or poses, especially for multifigure groups such as *Mr. and Mrs. I. N. Phelps Stokes* and *The Wyndham Sisters*. A sketch in the Fogg Art Museum (1937.7.11, fol. 24 recto) records Mrs. Stokes at full length, her left hand on her hip, her right hand holding her hat, with only a cursory suggestion of her head.[17] He planned the principal compositional elements of *The Wyndham Sisters* on a page in a sketchbook now in the Fogg (1937.7.20, fol. 10 verso), delineating the silhouette of the three figures on the settee and suggesting the rectangular shape of Watts's portrait in the background. The Metropolitan's collection contains only one sketch related to Sargent's later society portraits: a study of the head of the duchess of Marlborough (cat. 188), associated with his monumental portrait of the Marlborough family (figure 78).

While Sargent's career as a portraitist thrived in the 1890s and after the turn of the century, he would balance its demands against those of mural commissions and other interests. From 1890 until 1919 he would labor on his project for the Boston Public Library, a building whose Beaux-Arts design invokes the side elevation of Leon Battista Alberti's San Francesco (Tempio Malatestiano) in Rimini (1447–56) and the facade of Henri Labrouste's Bibliothèque Sainte-Genèvieve in Paris (1844–50), among other classical sources.[18] In the spirit of the American Renaissance—the movement in architecture and art that flourished in the United States from 1885 until about 1915—the library's architecture would be complemented by an impressive decorative ensemble that included work by leading painters and sculptors who were chosen by the chief architect, Charles Follen McKim (1847–1909), with apparently little involvement from the library trustees. McKim gathered an impressive group of artists—mostly Americans who had studied in Europe. Sargent, who was a friend of McKim's and who moved in the same expatriate circles as Stanford White (1853–1906), was one of the first choices.[19] Sargent's friend Abbey received the commission to create murals for the book delivery room on the second floor. French muralist Pierre Puvis de Chavannes (1824–1898) would decorate the main staircase, and Augustus Saint-Gaudens (1848–1907) and Daniel Chester

211

French (1850–1931) would contribute sculptures to the scheme.

Sargent's experience as a muralist had been limited to his painting some of the ancillary figures in Carolus-Duran's ceiling decoration *The Triumph of Marie de Medici* (1877–78) in the Palais du Luxembourg, Paris, during his student years. Nevertheless, he was awarded a prominent commission, the decoration of the Special Collections Hall—a long, windowless, barrel-vaulted corridor at the top of the library's main staircase—and was allowed to choose both the content and the style for his decorations. While Sargent initially considered themes from Spanish literature as the subject for the project, he quickly settled on the formidable and monumental program *The Triumph of Religion*. This he described (in 1895) as "a mural decoration illustrating certain stages of Jewish and Christian religious history."[20]

Sargent was well prepared to undertake major decorative work by his cosmopolitan education, academic training in Florence and Paris, extensive travel, familiarity with traditional art, and wide circle of well-educated American and European friends. Still only in his mid-thirties in 1890, he may have wished to establish a reputation as an even more serious and multifaceted artist than his subject pictures and his increasingly successful portraits had announced him to be. The library murals preoccupied Sargent until the installation of the last elements in 1919. He would also decorate the rotunda and staircase (1916–25) of the Museum of Fine Arts, Boston, and create a pair of murals (1921–22) for the Harry Elkins Widener Memorial Library at Harvard University, Cambridge. Originally well received, all of Sargent's murals later fell into obscurity.

Recapitulating the pattern of American expatriate Copley, who pursued a dual career as a portraitist and a history painter, Sargent divided his energies between portraits and murals after 1890. Sargent's contemporaries struggled to reconcile his concurrent commitments to the two modes. As early as 1903, Royal Cortissoz declared that the Boston Public Library murals occupied "a place apart in [Sargent's] activity."[21] In his monograph of 1970, Ormond discussed the murals only in an appendix, explaining: "Sargent's mural decorations constitute a largely independent subject; hence the decision to discuss them in a separate appendix, rather than chronologically in the text. . . . The stylistic links between Sargent's portraiture or landscape painting and his murals are very tenuous. Combining the two would inevitably result in greater confusion."[22] Other writers have followed suit, often championing Sargent's portraits, landscapes, and genre scenes and dismissing or ignoring the murals, despite the artist's preoccupation with them during thirty-five of his forty-eight years of professional activity.

Although they kept him from other pursuits, Sargent's murals were by no means detached from them. The artist allowed the imperatives of grand-manner portraits and murals to inform each other. For example, he used the profile of *Coventry Patmore* (1894, National Portrait Gallery, London) in the *Frieze of the Prophets* for the Boston Public Library. His group portraits from about 1900 reiterate some of the technical choices he made in his murals: large scale (*The Wyndham Sisters* measures nearly ten by seven feet), broadly treated forms, clearly articulated contours, dramatic contrasts of light and dark, and friezelike arrangements of figures close to the picture plane. The travel that he undertook to study settings for his murals inflected his thinking about portraits. For example, in 1907 Sargent wrote to painter Ralph W. Curtis (1854–1922), "I did in Rome a study of a magnificent carved staircase and balustrade leading to a grand façade [that of San Domenico] that would reduce a millionaire to a worm—it would be delightful to paint a rather anxious overdressed middle-aged lady there, with all her pearls and her bat look, and of course never be chosen to do portraits any more."[23]

Trips that Sargent made in connection with the mural commissions inspired landscapes and genre scenes in oil and many of the numerous bravura watercolors that became hallmarks of his late oeuvre. In 1897 he spent six weeks in Italy, where he examined early Christian mosaics in Palermo and Renaissance frescoes in the Vatican, occasionally painting them in watercolor (cat. 262), and paused to record the landscape (cat. 263). His 1898 visit to Italy included a stay in Venice that led him to paint his great conversation piece, *An Interior in Venice* (1898, Royal Academy of Arts, London).

He traveled on to Ravenna, where he made additional studies after mosaics, this time in the basilica of Sant'Apollinare Nuovo. In 1905–6, he traveled again to biblical lands, visiting Syria and Palestine, painting more than a dozen oils and more than forty watercolors of local people (e.g., cat. 275) and picturesque sites (e.g., cat. 279). A 1908 trip to Majorca yielded a series of images of fruits and foliage, including several of pomegranates (e.g., cat. 298) that, although they can be associated with the library lunette *The Messianic Era* (installed 1916), are works of art in their own right. Sargent specifically created significant demand for these paintings, especially the watercolors, by exhibiting them to great acclaim but limiting their sale until the early 1900[24] (see "Records of Travel and Other Studies, 1890–1925").

The increase in Sargent's production of subject pictures in watercolor and oil after the turn of the century corresponds to his waning interest in portrait painting. About 1907 he began to rail against taking on commissions and "vowed a vow not to do any more portraits," as he wrote to Ralph Curtis's mother, adding, "it is to me positive bliss to think that I shall soon be a free man."[25] He often voiced his growing frustration with witty cynicism. "No more paughtraits. . . . I abhor and abjure them and hope never to do another especially of the Upper Classes," he wrote to Ralph Curtis.[26] "Ask me to paint your gates, your fences, your barns, which I should gladly do, but not the human face," he told his friend Lady Radnor.[27]

Avoiding commissions for portraits in oil, Sargent offered his patrons bust-length charcoal representations that he could draw in one session lasting only two or three hours, rather than the eight or ten sittings that an oil might require.[28] Sargent made about a dozen such charcoals in 1908 and about twenty the following year. In 1910, his production of portraits in charcoal more than doubled, to exceed forty, while the number in oil decreased substantially.

Sargent's charcoal likenesses are characterized by a bravura technique and an exploitation of the medium. Sargent generally preferred to place the sitter against a dark background, which he suggested with bold strokes in order to set off the face. The fluid, velvety tones of charcoal elsewhere in the drawings recall the lush pigments in Sargent's late oil portraits. The Metropolitan's collection includes two of Sargent's hundreds of formal charcoal images—*Anna R. Mills* (cat. 189) and *Helen A. Clark* (cat. 192)—as well as more candid sketches of artist friends Hercules Brabazon Brabazon (cat. 187) and Paul Manship (cat. 191).

By 1910, Sargent was painting only one or two oil portraits each year, a change in professional course that stunned and disappointed the art world. On one occasion, Sargent's willingness to take on a commission for a portrait in oil was so exceptional as to warrant newspaper coverage. On January 24, 1912, a headline in the *New York Times* noted: "SARGENT BREAKS VOW." The subhead added: "Had Stopped Painting Portraits, but Is to Paint One of Nijinsky."[29] Sargent made other exceptions to his vow, painting Henry James (1913, National Portrait Gallery, London) for the writer's seventieth birthday, President Woodrow Wilson (1917, National Gallery of Ireland, Dublin), John D. Rockefeller Sr. (1917, Rockefeller Foundation, New York), and other fortunate sitters. Freedom from major portrait commissions gave Sargent more time to work on his murals, travel, and paint for his own pleasure.

The first section of the eclectic mural program for the Boston Public Library—the "Pagan end," on the north wall—was installed in 1895; it included *Pagan Deities, Israelites Oppressed,* and *Frieze of the Prophets.* In 1903 a small portion of the "Christian end," on the south wall, was installed: the lunette *Dogma of Redemption* (the Trinity with the crucifix and *Frieze of Angels*). The ceiling vault of the south end (*Fifteen Mysteries of the Rosary* [figures 79 and 80], the lunettes of the west wall (*Judgment* [figure 81], *Heaven,* and *Hell* [figure 82]), and the lunettes of the east wall (*Fall of Gog and Magog, Israel and the Law* [figure 83], and *Messianic Era*), the largest installment, were put in place in 1916. Two murals, *Synagogue* and *Church* (figure 84), were installed on the east wall, above the stairs, in 1919. Sargent never completed the central panel of the east wall, *Sermon on the Mount*, which was to culminate his program.[30]

The complex, multilayered iconographic program that Sargent devised for his library murals required

Figure 79. *Sorrowful Mysteries of the Rosary,* installed 1916. Oil on canvas (mural), w. approx. 64½ in. (164 cm). Boston Public Library, Trustees of the Boston Public Library

Figure 80. *Joyful Mysteries of the Rosary,* installed 1916. Oil on canvas (mural), w. approx. 100 in. (254 cm). Boston Public Library, Trustees of the Boston Public Library

that he adopt a more calculated technical approach than he used for portraits. Whereas he painted portraits directly on his canvases with only minimal drawn notes, he used drawing as a generative process for the murals, relying on his studies to guide the paintings' designs and execution. He drew and sketched compositions and schematic arrangements, working out his ideas on numerous sheets. The Metropolitan contains a representative selection of various types of drawings associated with Sargent's murals; the Fogg Art Museum and the Museum of Fine Arts, Boston, have immense collections.

Nygren has reconstructed Sargent's creative process in mural work on the basis of contemporary descriptions and extant drawings. Beginning with an idea that sometimes emerged from a painting or a sculpture (either by an old master or from a contemporary source), Sargent used multiple drawings to refine first the general composition and then the details.[31] Sargent's numerous figure studies document his practice of recording his models in different positions before selecting the ultimate arrangements. In dramatic compositions such as *Hell* and *Fall of Gog and Magog,* he used contorted poses to suggest the expressive possibilities of the human form. Two studies in the Metropolitan (cats. 197 and 198 recto) seem to relate to the writhing bodies that appear in these murals, but they are not exact studies. Other charcoal drawings of male nudes in the collection (cats. 200–202) show figures in various dynamic attitudes but elude identification with specific murals. "Whereas months went into the preparation and the studies," as Nygren suggests,[32] the actual painting in each phase progressed rapidly, occupying only several weeks.

214

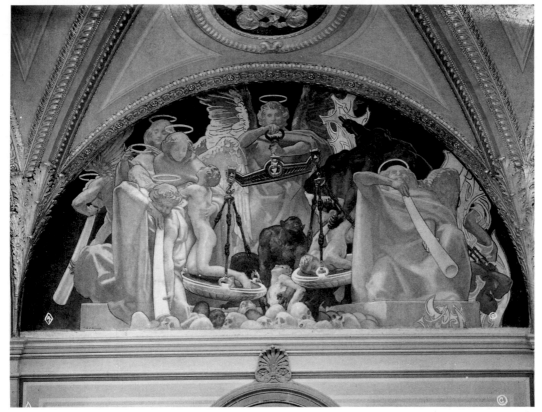

Figure 81. *Judgment,* installed 1916. Oil on canvas (mural), w. approx. 202 in. (513 cm). Boston Public Library, Trustees of the Boston Public Library

Sargent's drawings for murals reveal his delight in the human form and in the media in which he worked, as well as his academic heritage. His Beaux-Arts training had emphasized the human figure as fundamental to history painting, which occupied the pinnacle of the academic subject hierarchy. His obsession with the human figure in his murals and in preparatory works associated with them affirms his respect for this tradition. His numerous studies of the male nude in particular have provoked curiosity about his sexuality, though most scholars are hesitant to make assumptions.[33]

Figure 82. *Hell,* installed 1916. Oil on canvas (mural), w. approx. 202 in. (513 cm). Boston Public Library, Trustees of the Boston Public Library

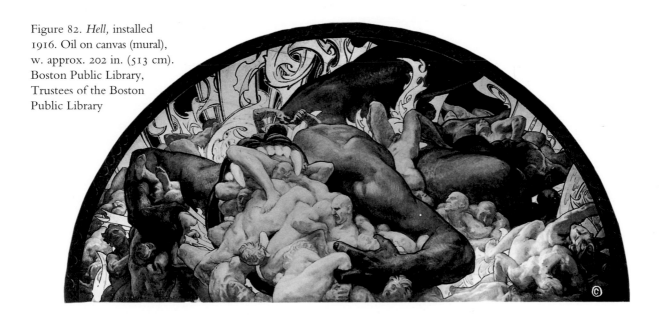

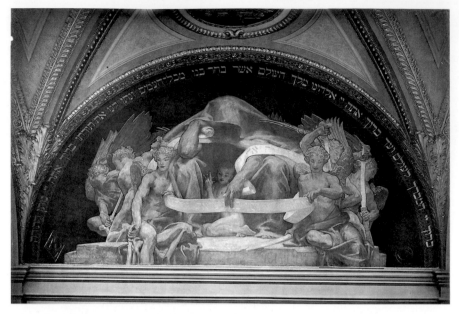

Figure 83. *Israel and the Law,* installed 1916. Oil on canvas (mural), w. approx. 202 in. (513 cm). Boston Public Library, Trustees of the Boston Public Library

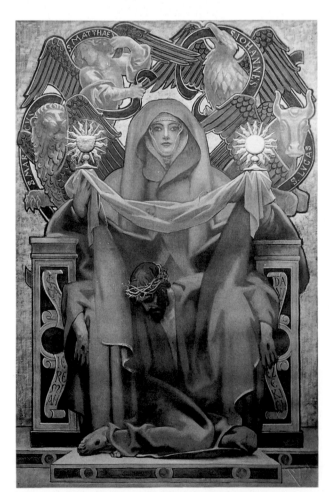

Figure 84. *Church,* Boston Public Library, installed 1919. Oil on canvas (mural), w. approx. 64½ in.(164 cm). Boston Public Library, Trustees of the Boston Public Library

The dating of many of Sargent's mural studies is problematic. He apparently began considering figures and poses for inclusion in his library murals as soon as he received the commission. Abbey wrote to McKim in late May 1890: "I went into [Sargent's] studio a day or two before I sailed and saw stacks of sketches of nude people—saints, I dare say, most of them, although from my cursory observations of them they seemed a bit earthy."[34] Sargent continued to draw nudes throughout the project, producing many sheets of the sort Abbey described. The preparatory works and their relation to the murals have not been thoroughly analyzed. When a drawing can be associated with a particular mural composition, often only broad dates can be assigned. The earliest possible date is the beginning of a project phase; the latest possible is the installation date of the canvas (i.e., the "Pagan end," 1890–95; lunette of the "Christian end," 1895–1903, etc.).

In 1916, before Sargent had completed the library project, he accepted his second mural commission, decorations for the new rotunda of the Museum of Fine Arts, Boston. In approaching the task, Sargent again considered the space and site carefully. Instead of the sweeping historical narrative that he had invented for the library, he chose classical and mythological subjects that related to each other

216

only generally and did not require a sequential arrangement. Nygren has argued that Sargent's selection of subject and style was provoked by the very nature of the space, a well-lighted elliptical classical dome, and by the function of the building. He notes: "A graceful elegance informs both the preliminary studies as well as the finished decorations at the museum, which [Bernard] Berenson has dismissed as 'very ladylike.'"[35]

For the museum rotunda, Sargent designed four

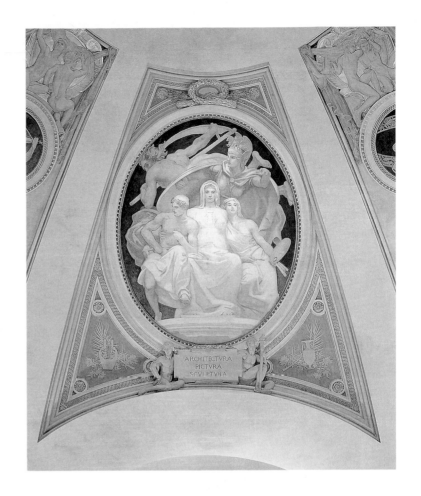

Figure 85 (right). *Architecture, Painting and Sculpture Protected from the Ravages of Time by Athena,* 1921. Oil on canvas (installed in rotunda), 10 ft. 6⅛ in. × 8 ft. 6⅞ in. (3.2 × 2.6 m). Museum of Fine Arts, Boston, Francis Bartlett Donation of 1912 and Picture Fund (21.10513) © 1999 Museum of Fine Arts, Boston. All rights reserved.

Figure 86 (below). *Apollo in His Chariot with the Hours,* 1922–25. Oil on canvas (installed on ceiling vault), 10 ft. 9 in. × 25 ft. 2 in. (3.3 × 7.7 m). Museum of Fine Arts, Boston, Francis Bartlett Donation of 1912 (25.640) © 1999 Museum of Fine Arts, Boston. All rights reserved.

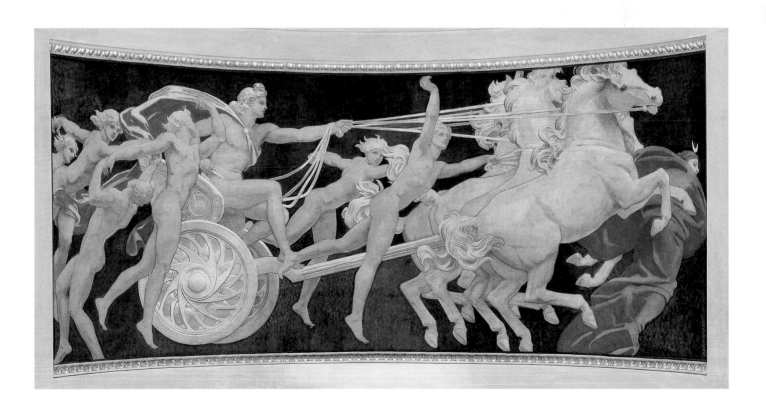

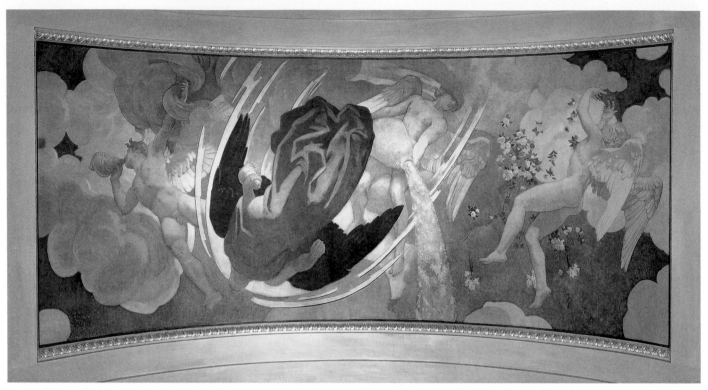

Figure 87. *The Winds,* 1922–25. Oil on canvas (installed on ceiling vault), 10 ft. 9 in. × 25 ft. 2 in. (3.3 × 7.7 m). Museum of Fine Arts, Boston, Francis Bartlett Donation of 1912 (25.641) © 1999 Museum of Fine Arts, Boston. All rights reserved.

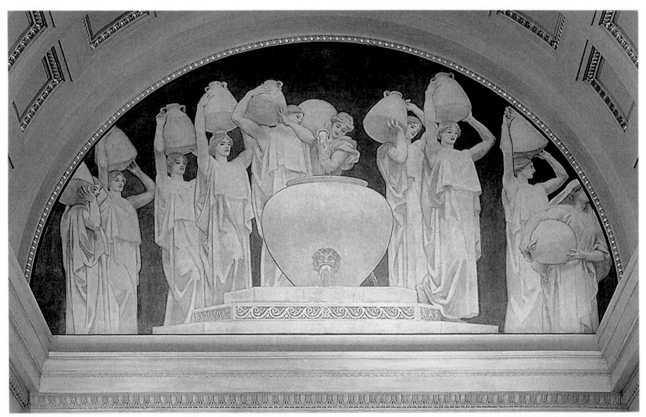

Figure 88. *The Danaïdes,* 1922–25. Oil on canvas (mural),11 ft. × 20 ft. 9 in. (3.3 × 6.3 m). Museum of Fine Arts, Boston, Francis Bartlett Donation of 1912 (25.636) © 1999 Museum of Fine Arts, Boston. All rights reserved.

Figure 89. *Death and Victory,* 1922. Oil on canvas, 173 × 73½ in. (439.4 × 186.6 cm). Harvard University Portrait Collection, Cambridge, Anonymous gift to Harvard University (L108) © President and Fellows of Harvard College, Harvard University. Photograph courtesy of Photographic Services

Figure 90. *Coming of the Americans,* 1922. Oil on canvas, 176 × 73½ in. (447 × 186.7 cm). Harvard University Portrait Collection, Cambridge, Anonymous gift to Harvard University (L109) © President and Fellows of Harvard College, Harvard University. Photograph courtesy of Photographic Services

principal paintings: *Apollo and the Nine Muses*; *Architecture, Painting and Sculpture Protected from the Ravages of Time by Athena* (figure 85); *Classic and Romantic Art*; and *Sphinx and the Chimaera*. He also designed and executed a series of molded reliefs of classical subjects to enframe various compositions. While he had experimented with sculpture in the Boston Public Library, producing a crucifix for the "Christian end" and numerous low reliefs, he integrated cast-plaster reliefs as a prominent design element in the museum. In addition, he made several little-known, small-scale bronzes, some of which were based on his mural designs.[36]

A month after the museum rotunda was unveiled in October 1921, Sargent was invited to continue his

decorations on the ceiling above the main staircase. He added twelve canvases with subjects from classical mythology. Across the barrel vault, two large rectangular compositions, *Apollo in His Chariot with the Hours* (figure 86) and *The Winds* (figure 87), flank a skylight. Sargent created six plaster reliefs to surmount the architrave and six canvases depicting Greek gods and heroes to decorate the side walls: *Hercules, Orestes, Perseus, Chiron, Phaeton,* and *Atlas*. At the short end of the hall (near the bottom of the stairs), a lunette, *The Danaïdes* (figure 88), crowns three smaller panels: *Philosophy, The Unveiling of Truth,* and *Science*. Sargent completed the paintings shortly before his death in 1925; the final installation was made posthumously.

Figure 91. *Gassed: The Dressing Station at Le Bac-de-Sud, on the Doullens-Arras Road, August 1918,* 1919. Oil on canvas, 91 × 240¾ in. (231 × 611.1 cm). Imperial War Museum, London

Figure 92. *A Crashed Aeroplane,* 1918. Watercolor on paper, 13½ × 21 in. (34.2 × 53.3 cm). Imperial War Museum, London

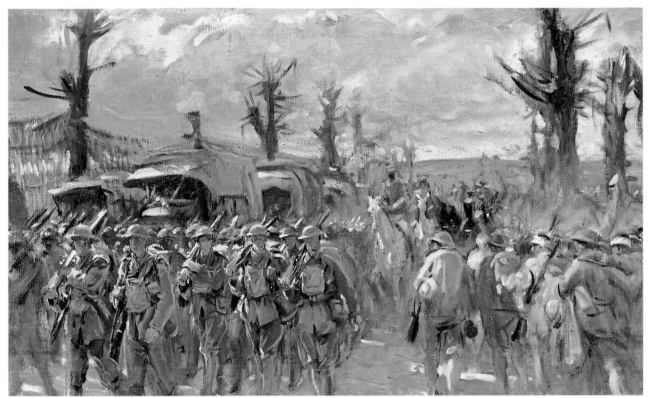

Figure 93. *The Arrival of the American Troops at the Front,* 1918. Oil on canvas, 18 × 28 in. (45.7 × 71.1 cm). © Gilcrease Museum, Tulsa, Oklahoma

The third and most modest of Sargent's mural projects was for the main staircase of Harvard's Widener Library, a pair of paintings commemorating alumni who had died in World War I. The murals flank a doorway on a landing; to the left is an allegorical depiction, *Death and Victory* (figure 89); to the right, *Coming of the Americans* (figure 90). Two watercolors in the Metropolitan's collection (cats. 213 and 214) reflect the near-final designs for the project, which commenced in 1921 and was completed in 1922.

In 1918 Sargent accepted a commission that took him to the western front in the valley of the Somme during World War I. The British Ministry of Information's War Memorial Committee invited him to create a picture for installation in a planned Hall of Remembrance (ultimately not built) that would commemorate the joint efforts of English and American troops. Under the care first of Major Philip Sassoon, his long-time friend, and then Major A. N. Lee, Sargent traveled with British artist friend Henry Tonks (1862–1937) to the battlefields of

Arras, Ypres, and Peronne. Throughout his three-month tour, Sargent sought a fitting and significant theme for his canvas. He wrote to friend and future biographer Charteris in September 1918:

The programme of "British and American troops working together," has sat heavily upon me for though historically and sentimentally the thing happens, the naked eye cannot catch it in the act, nor have I, so far, forged the Vulcan's net in which the act can be imprisoned and gaily looked upon. How can there be anything flagrant enough for a picture when Mars and Venus are miles apart whether in camps or front trenches. . . . I have only seen three fine subjects . . . one a harrowing sight, a field full of gassed and blindfolded men—another a train of trucks packed with "chair à cannon"—and another frequent sight a big road encumbered with troops and traffic, I daresay the latter combining English and Americans, is the best thing to do, if it can be prevented from looking like going to the Derby.[37]

Although Sargent explored the road scene in several canvases (see cat. 218), he fulfilled his

commission with the painting *Gassed* (figure 91), which depicts British soldiers who were blinded by mustard gas being led to treatment.

While traveling around the front, Sargent continued his customary habit of painting in watercolors (figure 92). Upon his return to London in 1918, he carefully dispersed these works, donating fifteen sheets to the Imperial War Museum, London[38] and giving a few to friends; others found their way into various public collections in small numbers.[39] The Metropolitan, whose collection of Sargent's World War I works is second only to the Imperial War Museum's, received eleven such watercolors and five drawings from Mrs. Francis Ormond in 1950 (cats. 215–28). While Sargent personally selected the works for the collection of the Imperial War Museum, the Metropolitan's sheets had remained in his studio long after his death. Although some of the Metropolitan's watercolors appear unfinished (e.g., cats. 217 and 222), Sargent may not have deemed others that were fully worked up suitable for a public collection. In particular, he may have considered inappropriate such informal depictions as *Tommies Bathing* (cats. 224 and 225).

In general, Sargent's World War I watercolors in the Metropolitan's collection are distant in spirit from the much more somber *Gassed*. Although they depict the French countryside in ruins, the machinery of war, and quotidian camp life, they pertain more to Sargent's larger watercolor oeuvre than to the issue of war. Puffy clouds (cat. 222), foliage (cats. 226 and 227), and figures lounging in deep grass (cat. 224) or swimming (cat. 225) recall Sargent's holiday watercolors.

In 1919, Sargent would accept another war-related commission for a large portrait, *Some General Officers of the Great War* (National Portrait Gallery, London). From 1920 to 1922, he undertook sittings with the twenty-two individuals to be depicted. Before he started the project, he lamented its demands: "The Generals loom before me like a nightmare. I curse God and man for having weakly said I would do them, for I have no ideas about it and I foresee a horrible failure."[40] Sargent used a 208-inch-long canvas and portrayed all twenty-two figures stoically standing. Freed from that obligation, whose burdens are encoded in the painting's documentary value and dull artistic aspect, Sargent spent the last years of his life working on his murals for the Widener Library and the Museum of Fine Arts. Upon completing the last canvases for the museum project, he remarked to a friend, "Now the American things are done, and so, I suppose I may die when I like."[41] Three days before he was to sail for Boston to oversee the mural installation in April 1925, he suffered a heart attack in his sleep and died.

1. Gary Reynolds discusses Sargent's visit to the United States in New York–Chicago 1986–87, pp. 159–62. For Sargent's stay in Worcester, see Strickler 1982–83.

2. Although the official contract for the library was not signed until January 1892, it had been confirmed in October 1890. Sargent stopped briefly in England before making a study trip to Egypt, Greece, and Turkey in connection with the murals. He returned to England for a short time in June 1891 before heading to Paris for his sister Violet's wedding and then to the Alps for the rest of the summer. He passed through London in September 1891 before going to work on the murals at his studio at Fairford, Gloucestershire. Fairford is about forty miles south of Broadway, where Sargent, Abbey, Millet, and others had lived and worked during the 1880s. Abbey, who had also accepted a mural commission for the library, and his wife established their household in 1891 in Fairford, where Abbey had a cavernous studio constructed to accommodate work on his murals. Sargent followed him there (Olson 1986, pp. 174–75).

3. Ormond and Kilmurray 1998, p. 19.

4. *Art Journal*, 1890, p. 217. The critic for *Art Amateur* called the painting a "celebration of washing day" (August 1890, p. 42). Both reviews are quoted in Ormond and Kilmurray 1998, p. 213.

5. *Magazine of Art*, 1890, p. 258, quoted in Ormond and Kilmurray 1998, p. 222.

6. Claude Phillips, "The Royal Academy and New Gallery," *Art Journal*, July 1891, p. 198, quoted in Fairbrother (1981) 1986, p. 164.

7. *Athenaeum*, no. 3314 (1891), quoted in Ormond 1970a, p. 246–47.

8. Clementina Anstruther-Thomson to Vernon Lee, spring 1893, quoted in London–Washington, D.C.–Boston 1998–99, p. 34.

9. Criticism gathered from a scrapbook of contemporary reviews compiled by Mrs. Hammersley, 1893–1904, departmental files, American Paintings and Sculpture, gift of Mr. and Mrs. Douglass Campbell.

10. "Art and Artists," *Sunday Times* (London), January 14, 1894. Clipping from Mrs. Hammersley's scrapbook, departmental files, American Paintings and Sculpture. Page number is not included.

11. Olson 1986, pp. 185–86.
12. Fairbrother (1981) 1986, p. 184.
13. For a discussion of Sargent's portraits of the Wertheimers, see New York–New Orleans–Richmond–Seattle 1999–2000.
14. I. N. Phelps Stokes, "Random Recollections of a Happy Life," rev. ed. of unpublished manuscript, New York, 1941, pp. 117–18, departmental files, American Paintings and Sculpture.
15. Michael Quick, "Achieving a Nation's Imperial Destiny: 1870–1920," in Michael Quick, *American Portraiture in the Grand Manner: 1720–1920* (exh. cat., Los Angeles: Los Angeles County Museum of Art, 1981), p. 70.
16. Sargent's procedure for painting portraits, gleaned from contemporary descriptions, shows the importance he placed on lighting and viewpoint. The sitter and the canvas were set side by side so that they were in the same light. He would slowly back away from the painting and sitter to study them at a distance before charging towards the canvas with his loaded paint brush. Olson observed, "By retreating he was able to make the model and the canvas equal before his eye" (Olson 1986, p. 130). Olson cites an appreciation of the spectacle of Sargent at work by Sir John Sitwell, who described the artist "rushing bull-like . . . and shouting" toward the canvas (ibid., p. 131).
17. Fogg sketchbook 1937.7.11 includes numerous drawings related to portraits executed between 1892 and 1898. Sargent may have also recorded the poses of sitters for future reference.
18. An excellent summary of the design of the Boston Public Library appears in Jordy 1972, chapter 7.
19. For Sargent's relationship with McKim and White see Fairbrother (1981) 1986, pp. 213–16, and Olson 1986, pp. 164–66.
20. JSS to Herbert Putnam, [May 1895], quoted in Promey 1997, p. 218.
21. Cortissoz 1913, p. 228.
22. Ormond 1970a, p. 89.
23. Ibid., p. 58. According to Ormond, "Sargent used this study (Ashmolean Museum, Oxford) for the portrait of *Charles Eliot* (Harvard University, Cambridge, Mass.)." Ormond cites an additional example: "The architecture in the background of the portrait of the *Countess of Strafford* [Lady Elizabeth Byng, Barnet] is the portico of the Villa Falconieri, near Rome" (ibid.).
24. For a discussion of Sargent's marketing of his watercolors and his exhibition strategy after the turn of the century, see Gallati 1998.
25. JSS to Mrs. Curtis, quoted in Olson 1986, p. 227.
26. JSS to Ralph W. Curtis, quoted in Olson 1986, pp. 227–28, and Charteris 1927, p. 155.
27. JSS to Lady Radnor, quoted in Olson 1986, p. 228.
28. "He told men to plan for a minimum of eight sittings, and women ten," according to Fairbrother 1994, p. 75.
29. *New York Times,* January 27, 1912, p. 3. The brief article continued: "It is stated that Mr. Sargent has broken his vow not to paint any more portraits, as he is to paint Nijinksky [*sic*], the Russian dancer. Possibly his decision only applied to accepting commissions to paint portraits of people of fashion."
30. Promey 1997, pp. 224–32.
31. Nygren 1983, p. 26.
32. Ibid.
33. For the typical response to this issue, see London–Washington, D.C.–Boston 1998–99, p. 14. Compare Fairbrother 1994, pp. 8, 83.
34. Edwin Austin Abbey to Charles Follen McKim, late May 1890, quoted in Olson 1986, p. 167.
35. Nygren 1983, p. 22. Berenson (1865–1959) was a connoisseur of Italian Renaissance art.
36. See Washington, D.C., and other cities 1964–65, which illustrates two bronzes related to Sargent's mural projects: *Israel and the Law,* based on the library project, and *Death and Victory,* related to the Widener Library murals (both bronzes are in the Hirshhorn Museum and Sculpture Garden, Smithsonian Institution, Washington, D.C.). Unrelated to the mural projects is Sargent's cast of a bronze turkey (see figure 96). The Metropolitan owns one drawing (cat. 235) that seems to relate to this cast.
37. JSS to Evan Charteris, G.H.Q., September 11, 1918, quoted in Charteris 1927, p. 214.
38. The Imperial War Museum's collection of Sargent's works was augmented by a 1987 donation from the Ormond family of twelve preparatory charcoal studies for *Gassed.*
39. For example, the Museum of Fine Arts, Boston, purchased two World War I watercolors in 1921: *Bailleul: Tents* (21.139) and *Poperinghe: Soldiers* (21.140).
40. JSS to Evan Charteris, May 12, 1920, quoted in Charteris 1927, p. 217.
41. Stokes 1926, p. 52.

Portrait Studies

187. *Hercules Brabazon Brabazon*

1890s
Charcoal on off-white wove paper
10 15/16 × 7 9/16 in. (27.8 × 19.2 cm)
Inscribed at lower left: J.S. 364.; on verso at top:
H. B. Brabazon / by J. S. Sargent; at upper right: 369
Gift of Mrs. Francis Ormond, 1950
50.130.123

According to Charteris, Sargent first met
English watercolorist Hercules Brabazon
Brabazon (1821–1906) in 1886 or 1887
(Charteris 1927, p. 224). Brabazon's method
of painting in broad areas of wash in the tra-
dition of Joseph M. W. Turner (1775–1851)
may have stimulated Sargent's increasing
preoccupation with watercolor in the 1890s
and afterwards. Encouraged by a group of
young admirers, including Sargent, the
largely self-taught Brabazon had his first
solo exhibition in 1892 at Goupil Gallery in
London. Sargent wrote a short introduction
for the catalogue, lauding Brabazon's works
for their "gift of colour," sensitivity to
nature, and harmony (reprinted in C. Lewis
Hind, *Hercules Brabazon Brabazon, 1821–1906:
His Art and Life,* London, 1912, pp. 85–86).

In addition to catalogue 187, three other
portraits of Brabazon by Sargent are known,
including two oils (both 1890s; National
Portrait Gallery, London, and figure 94)
and a charcoal (location unknown, repro-
duced as frontispiece in Hind, *Hercules
Brabazon Brabazon, 1821–1906*). In the Lon-
don oil, which is inscribed "To Mr.
Brabazon John S. Sargent," the subject is
portrayed nearly half length, facing to the
left. Catalogue 187 seems to relate to the oil
at Cardiff (figure 94), although Brabazon's
head is seen more frontally in the sketch,
and his eyes gaze more directly toward the
viewer. Sargent employed varied short
strokes in catalogue 187 to suggest form
and shadow while seeking to establish the
precise contours of Brabazon's head.

187

EXHIBITIONS: Probably included in New York
1928 (inventory listing J.S. 364); "Hercules Brabazon
Brabazon," Godwin-Ternbach Museum, Queens
College, Flushing, New York, April 15–June 17,
1985, cat. 50.

Figure 94. *Hercules Brabazon
Brabazon,* 1890s. Oil on canvas,
22¼ × 16 in. (56.5 × 40.6 cm).
National Museum and Gal-
leries of Wales, Cardiff

224

188. *Duchess of Marlborough (Consuelo Vanderbilt)*

ca. 1905
Graphite on white wove paper
11³⁄₁₆ × 7¹³⁄₁₆ in. (28.5 × 19.9 cm)
Inscribed on lower left: J.S. 138
Gift of Mrs. Francis Ormond and Miss Emily Sargent, 1931
31.43.1

During the summer of 1905, Charles, ninth duke of Marlborough, his wife Consuelo (née Vanderbilt), and their two sons, John and Ivor, sat for Sargent in his London studio. Sargent made several studies (for example, Fogg 1937.7.17) in preparation for the monumental oil portrait *The Marlborough Family* (see figure 78). According to Ormond, Sargent also made three drawings of the duchess after he completed the oil (Ormond 1970a, p. 253). The chronological relation of catalogue 188 to the oil portrait is not known.

In the formal portrait, Sargent represented the head of the duchess from straight on and emphasized her bare neck with an off-the-shoulder gown. In her autobiography, the duchess recalled Sargent's "predilection for a long neck, which he compared to the trunk of a tree. For that aesthetic reason he refused to adorn mine with pearls [in the oil portrait], a fact that aggrieved one of my sisters-in-law, who remarked that I should not appear in public without them" (Consuelo Vanderbilt Balsan, *The Glitter and the Gold,* Maidstone, Kent, England, 1953, p. 146). In catalogue 188, however, Sargent turns the sitter's head slightly and interrupts the contour of her neck with two parallel lines, perhaps indicating her customary pearls or some other ornament.

188

EX COLLS.: The artist, until d. 1925; his sisters, Violet Sargent Ormond and Emily Sargent, 1925–31.

EXHIBITIONS: Probably included in New York 1928 (inventory listing J.S. 138); "Portraits of Yesterday and Today," Portraits Inc., New York, April 24–May 21, 1968, cat. 75; "Giovanni Boldini and Society Portraiture, 1880–1920," Grey Art Gallery, New York University, November 13–December 22, 1984, cat. 39, p. 45.

REFERENCES: McKibbin 1956, p. 108; Mount 1966, n.p.

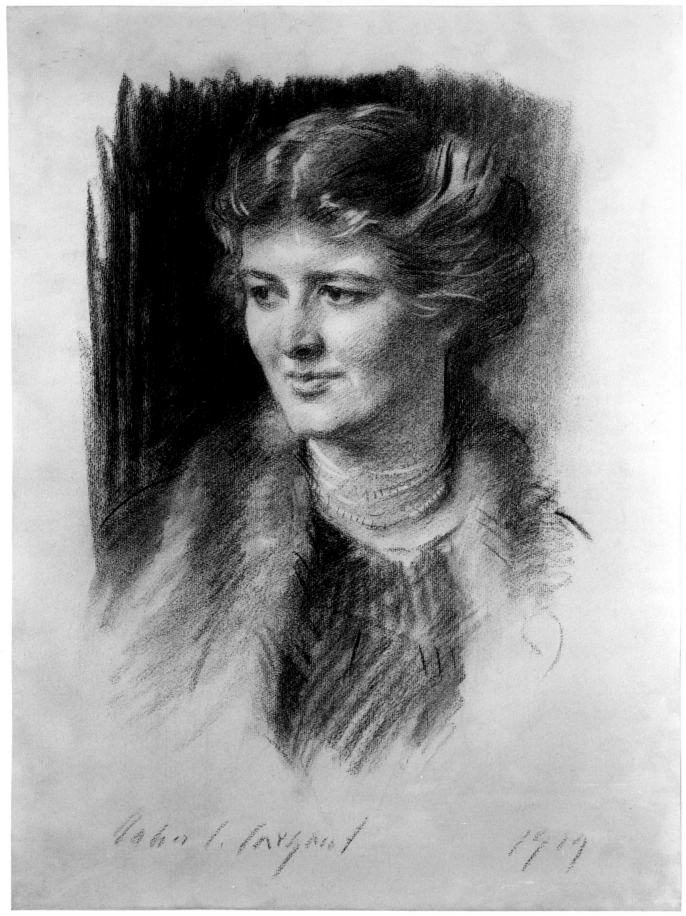

John S. Sargent 1919

189

189. Anna R. Mills

1917
Charcoal on off-white laid paper mounted on
pulpboard
23⅛ × 18¹/₁₆ in. (60.6 × 45.8 cm)
Signed and dated at bottom: John S. Sargent 1917
Gift of Mary van Kleeck, 1954
54.96.2

Anna Rogers Mills, née Case (1885–after 1936), of Bristol, Rhode Island, was the granddaughter of Admiral Augustus Ludlow Case (1813–1893), an American naval officer and longtime friend of the Sargent family. The Sargents seem to have first met the Cases while living in Nice in the 1860s. During the artist's first trip to the United States in 1876, he visited the Case family in Newport and painted a portrait of the admiral's son-in-law Charles Deering, who would become an important patron of Sargent's. In the following year, Sargent painted a posthumous portrait of the admiral's daughter Annie Deering (1848–1876), who had died during childbirth. The admiral was the first owner of Sargent's early salon painting *Oyster Gatherers of Cancale* (figure 55). It is no doubt through this long-standing connection to the Case family that Sargent drew the thirty-two-year-old Anna Rogers Case while he was in the United States in 1917.

As usual in his charcoal portraits, Sargent sets off the head against a boldly rendered dark background, reserving the brightest highlights for hair and describing details of the face and costume primarily with pale tones and subtle shading. Case's multistrand necklace and fur-collared garment, suggested with soft scumbling over the textured paper, suggest affluence.

In 1920 Anna Rogers Case married John Beale Mills (1851–1927), a retired lawyer who had lived in Bristol, Rhode Island, since the death of his first wife in 1906. Sargent drew a charcoal portrait of Anna's sister, Helena St. Prie Case (later Mrs. George Francis Connal-Rowan) in 1921 (private collection).

EX COLL.: Anna Rogers Mills, until before d.; Charles M. Van Kleeck, until d. 1951; his sister, Mary van Kleeck, 1951–54.

REFERENCE: Weinberg and Herdrich 2000a, p. 60.

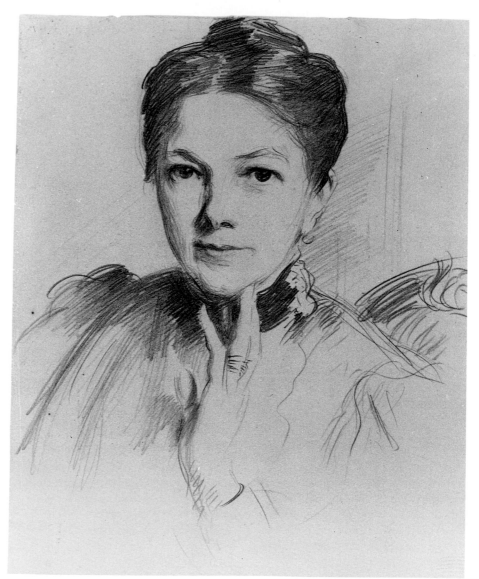

190

190. Mrs. Louis Ormond

ca. 1920
Graphite on off-white wove paper
12⅛ × 8⅝ in. (30.8 × 21.9 cm)
Gift of Mrs. Francis Ormond, 1950
1950.130.153

Ormond has identified the subject of catalogue 190 as Mrs. Louis Ormond, the mother-in-law of Sargent's sister Violet, and suggested its date (oral communication, June 16, 1997). This drawing was originally pasted into a scrapbook of photographic reproductions of works by Sargent that was part of the Ormond gift in 1950. A related sketch of the same sitter, inscribed to Francis Ormond (the sitter's son and Violet's husband), is in the collection of the Ormond family.

EXHIBITIONS: "The American Line," Addison Gallery of American Art, Phillips Academy, Andover, Massachusetts, January 6–February 15, 1959, then circulated as American Federation of Arts traveling exhibition, March 1959–March 1960, cat. 33.

191. Paul Manship

January 30, 1921
Charcoal on pinkish brown wove paper
22 1/16 × 17 7/16 in. (56.1 × 44.4 cm)
Signed and inscribed at lower left: [for?] Manship /
J. S. Sargent; at lower right: Jan 30. 1921; on verso:
[sketches of ornament]; at lower center: portrait sketch
of PM
Bequest of Paul H. Manship, 1966
66.70

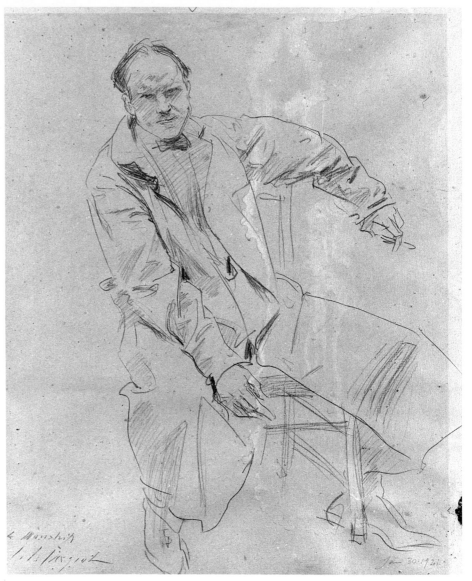

191

According to Mount, Sargent met the American sculptor Paul Manship (1885–1966) in 1916 through a friend in Boston, Mrs. J. Montgomery (Sarah Choate) Sears (Mount 1955a, p. 341). The two artists apparently became very close friends. Sargent helped Manship obtain several commissions, including busts of two of his own portrait subjects, John D. Rockefeller and the marchioness of Cholmondeley. Manship's sittings for the bust of the marchioness were held in Sargent's Tite Street studio, which the sculptor often used while he was in London in the early 1920s. Manship named his son, born in 1927, after Sargent.

According to the *New York Times*, Sargent arrived in New York aboard the *Cedric* on January 29, 1921, the day before he drew this portrait sketch of his friend ("John S. Sargent, R.A., Here," *New York Times*, Jan. 30, 1921, p. 2). Mount, however, dated both Sargent's arrival and the execution of the portrait to January 30. He recalled:

[Sargent] arrived on January 30, 1921, looking with jaundiced eye at the press and refusing any statement. He registered at the Ritz-Carlton Hotel, where Helleu was installed, and then, as it was early on a Sunday morning, he took a cab down to 42 Washington Mews, just off the Square, where Manship lived. For an hour or more they talked in the studio, and out of whim he decided to make a sketch of the sculptor. Manship whipped out a sheet of paper without letting the minute pass, and Sargent began to scribble in a figure as the sculptor smoked, straddling his chair. (Mount 1955a, p. 378)

Relying on the observations of Manship's daughter, Mount also described the quick and spontaneous execution of the drawing: "The hand moved rapidly over the paper, watched closely by little Pauline Manship,

who ran off to tell her mother, 'Mama, Mr. Sargent is drawing Papa just like writing!' In a few minutes he was displeased with what he had done and with a 'no good' he threw it down. Manship thought otherwise, and asked him to sign it" (ibid.).

While the drawing is similar in spirit to Sargent's later charcoal portraits, the informal pose and apparently rapid execution suggest the casual friendship between the two artists. Sargent characterizes Manship's face adroitly, with few details, capturing surfaces and shadow with swift parallel lines. His lack of effort is apparent in the stenographic representation of the chair and of Manship's legs.

EX COLL.: Paul Manship, until d. 1966.

EXHIBITIONS: Washington, D.C., and other cities 1964–65; "The Art of Paul Manship," traveling exhibition, National Museum of American Art, Smithsonian Institution, Washington, D.C., 1989–91, pp. 49–50, fig. 36. Catalogue 191 was shown only at The Metropolitan Museum of Art (June–September 1991) and the Herbert F. Johnson Museum, Cornell University, Ithaca, New York (September–December 1991); "As They Were: 1900–1929," The Metropolitan Museum of Art, April–September 1996 (no catalogue).

REFERENCES: Birnbaum 1941, p. 74; McKibbin 1952 1956, p. 108; Mount 1955a, p. 341; Fairbrother 1983, fig. 38; Weinberg and Herdrich 2000a, p. 60.

192. *Helen A. Clark*

1924
Charcoal on off-white laid paper, mounted on board
24 × 17¹⁵⁄₁₆ in. (61 × 45.5 cm)
Signed and dated at top: John S. Sargent 1924
Bequest of Helen A. Clark, 1953
53.186

Little is known about Helen Ainsworth
Clark (1880–1953). The daughter of a mer-
chant, she was born in Illinois and raised in
Chicago. She never married and seems to
have lived with her widowed father in
Chicago until his death in 1915. Thereafter
she resided in Washington, D.C.; London;
and Paris and spent a few summers in fash-
ionable New England towns such as New-
port, Rhode Island; Bar Harbor, Maine; and
Litchfield, Connecticut. About 1934, she
settled in New York, where she remained
until her death. It is unclear whether she
posed for Sargent in London or while he
was in the United States in early 1924. In
1940, when she offered to bequeath this
charcoal to the Metropolitan, she recalled
with humility: "The chief reason for this,
of course, is not that I like it myself, but
that [Sargent], himself, said it was one of
the best he had ever done" (Helen Clark to
H. W. Kent, New York, March 10, 1940,
Metropolitan Museum of Art Archives).

Ex coll.: Helen A. Clark, until d. 1953.

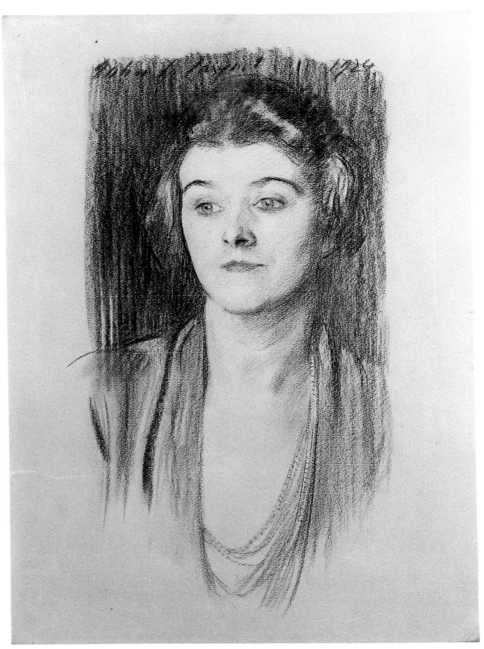

192

Catalogue Numbers 193–203: Studies for the Boston Public Library Murals

193. *Study for South End of the Special Collections Hall*

ca. 1895–1900
Graphite on off-white wove paper
9 15/16 × 14 5/16 in. (25.3 × 36.3 cm)
Inscribed on verso: CP
Gift of Mrs. Francis Ormond, 1950
50.130.143t

Catalogue 193, which contains all the major elements of Sargent's ultimate composition, represents a fairly advanced preliminary design for the decoration. In the lunette, the Trinity surmounts a frieze of figures that, although illegible in this image, represents angels holding instruments of the Passion. The centerpiece is a crucifix of gilded and painted wood in high relief. Here, Sargent studied the relationship of the sculpture to the murals. Although the drawing is somewhat cursory in areas, there are differences between the design of the crucifix as it is shown here and the installed version. In the sculpture, Adam and Eve flank the crucified Christ beneath the arms of the cross; they hold chalices to catch the blood from the wounds in his hands. That they do not appear in this sketch suggests it was made prior to the final design phase. Sargent completed the crucifix by 1900 and installed it in 1903.

REFERENCE: Promey 1999, pp. 89–90.

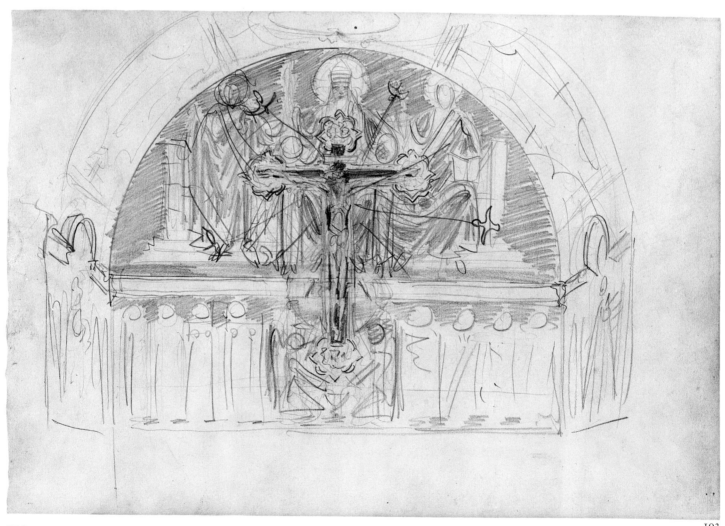

194 recto. *Arm*

ca. 1890–95
Charcoal on off-white wove paper
10 15/16 × 10 in. (27.7 × 25.4 cm)
Inscribed at lower left: J.S. 370
Gift of Mrs. Francis Ormond, 1950
50.130.140ee recto

194 verso. *Trinity Lunette, Study for South End of the Special Collections Hall*

ca. 1890–95
Graphite on off-white wove paper
10 15/16 × 10 in. (27.7 × 25.4 cm)
Inscribed at upper left: 363
Gift of Mrs. Francis Ormond, 1950
50.130.140ee verso

The date of catalogue 194 recto is based on the cursory sketch on the verso, which seems to represent an even earlier phase of design than catalogue 193. Here Sargent conceived a crucifix form, but the background is vague and bears little resemblance to the final composition.

Two sheets in the Fogg Art Museum (1931.104 and 1937.8.168) contain sketches of the same composition as catalogue 194 recto. These three careful studies of a muscular arm grasping an unidentified object suggest that Sargent had a specific project in mind. Although the drawing's bold graphic style and attention to shadows resemble many of the library mural studies, it has not been linked to a particular figure. The dramatic pose could relate to a number of the later library murals, such as *Judgment* (see figure 81), *Passing of Souls into Heaven*, *Israel and the Law* (see figure 83), or *Fall of Gog and Magog*.

EXHIBITION (cat. 194 recto): Probably included in New York 1928 (inventory listing J.S. 370).

194 recto

194 verso

195. Mary, Study for "The Annunciation"

ca. 1909–10
Pen and ink on tracing paper with printed grid
10 1/16 × 7 7/8 in. (25.6 × 20 cm) (irregular)
Gift of Mrs. Francis Ormond, 1950
50.130.140ff

196. Angel, Study for "The Annunciation"

ca. 1909–10
Pen and ink on tracing paper with printed grid
11 7/16 × 9 3/4 in. (29 × 24.8 cm) (irregular)
Gift of Mrs. Francis Ormond, 1950
50.130.140gg

Sargent illustrated the fifteen Mysteries of the Rosary on the vault above the Dogma of the Trinity at the south end of the Special Collections Hall (see cat. 193). As the centerpiece of his composition of the Joyful Mysteries of the Rosary (see figure 80), Sargent designed *The Annunciation* in a vertical rectangular composition and surrounded it with depictions of the four remaining Joyful Mysteries in smaller medallions. Counterclockwise from the left, they are *The Visitation, The Nativity, The Finding of Our Lord in the Temple,* and *The Presentation.* This section was completed and installed in 1916.

For *The Annunciation*, Sargent carefully studied the poses of the angel Gabriel and the Virgin Mary. In addition to catalogue numbers 195 and 196, there are a number of related drawings in the Fogg Art Museum. A related study of Mary is Fogg 1937.8.171. Gabriel is shown in Fogg 1937.8.172, 1937.8.173, and 1937.8.174. Sargent studied the entire composition in Fogg 1937.8.178 verso and 1937.8.170 verso.

Although catalogue numbers 195 and 196 are drawn on graph paper, and Sargent is known to have squared mural studies for transfer to canvas (see, for example, Corcoran 49.79, 49.126, and 49.122), the spontaneous quality of these sheets and an absence of detail are inconsistent with drawings made for transfer. The positions of the figures in both studies are slightly different from those in the mural: catalogue 195 shows Mary more frontally, and there are

195

197

variations in the position of her cloak; catalogue 196 shows the angel in a near three-quarter view instead of in profile.

REFERENCE (cat. 195): "1937.8.171: Cloaked Female Figure, Kneeling, Study for the 'Annunciation,'" *Sargent at Harvard* website, October 29, 1997, (referred to by its former accession number, 50.130.140ll).

197. *Two Men, Possible Study for "Hell"*

ca. 1910
Charcoal on white laid paper
18¹⁵/₁₆ × 27¹¹/₁₆ in. (48 × 70.3 cm)
Inscribed at lower left: 4.4; on verso at upper right: S.4.4; at lower left: S.4.4
Watermark: MICHALLET / FRANCE
Gift of Miss Emily Sargent, 1930
30.28.4

Volk has suggested that the study at the bottom of catalogue 197 is for a figure at the lower left center of the *Hell* lunette (figure 82) on the west wall of the Special Collections Hall (oral communication, March 20, 1997). Sargent worked on *Hell* about 1910; the mural was installed in 1916.

EX COLL.: the artist, until d. 1925; his sister, Emily Sargent, 1925–30.

EXHIBITIONS: Possibly shown at the Museum of Fine Arts, Boston, in an exhibition of studies and preliminary works by Sargent for decorations in the Boston Public Library and the Museum of Fine Arts. The exhibition opened on May 24, 1927, and the selection of works was rotated in February 1928. ("INVENTORY OF DRAWINGS ETC. WHICH WERE BROUGHT OVER FROM LONDON RECENTLY BY MR. THOMAS A. FOX, AND WHICH ARE NOW AT THE BOSTON ART MUSEUM"), hereafter Museum of Fine Arts, Boston, 1927–28 ("Inventory of Drawings etc.," Thomas A. Fox–John Singer Sargent Collection, May 11, 1926, Boston Athenaeum, inv. no. S.4.4); The Metropolitan Museum of Art, June 1930.

REFERENCE: Mount 1966, n.p.

198 recto. *Reclining Man*

ca. 1910

Graphite on off-white wove paper

10 × 14¼ in. (25.4 × 36.2 cm)

Inscribed at upper left: 349; at lower left: J.S. 384.

Gift of Mrs. Francis Ormond, 1950

50.130.127 recto

198 verso. *Figure Study*

ca. 1910

Graphite on off-white wove paper

14¼ × 10 in. (36.2 × 25.4 cm)

Gift of Mrs. Francis Ormond, 1950

50.130.127 verso

Catalogue 198 recto and verso resemble Sargent's many drawings for the Boston Public Library, although they have not been associated with specific compositions. This sheet may have been created about the same time as catalogue 197.

EXHIBITIONS (cat. 198 recto): Probably included in New York 1928 (inventory listing J.S. 384); (cats. 198 recto and verso): "Sargent, Whistler and Cassatt," American Federation of Arts, traveling exhibition, September 1954–57 (no catalogue).

198 verso

198 recto

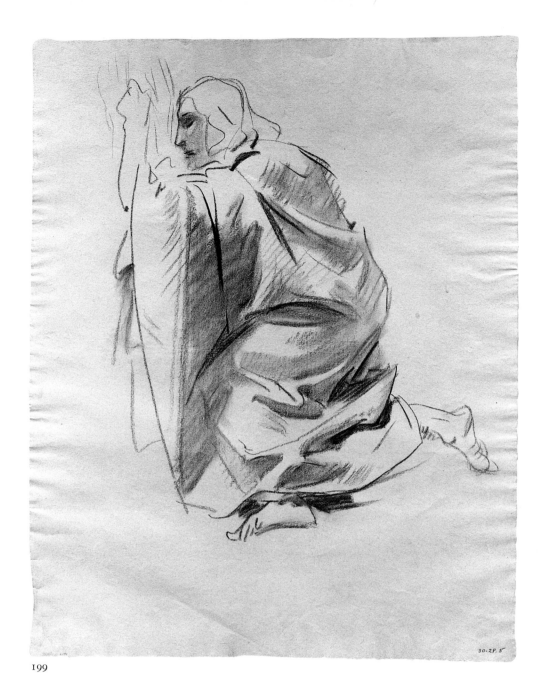

199

199. Kneeling Figure, Possible Study for "The Crucifixion"

ca. 1903–16
Charcoal on light blue laid paper
23 ¹³⁄₁₆ × 18 ³⁄₁₆ in. (60.4 × 46.3 cm)
Inscribed at lower left: AS; 6.178; on verso at upper left: S.6.178
Watermark: MICHALLET
Gift of Miss Emily Sargent, 1930
30.28.5

The Crucifixion (see figure 79), the principal narrative scene of the five Sorrowful Mysteries of the Rosary, is depicted on the vault at the south end of the Special Collections Hall. Sargent included several draped kneeling and swooning figures at the foot of the cross.

Ormond and Meg Robertson suggested a connection of catalogue 199 to *The Crucifixion* (note in departmental files, October 16, 1981, American Paintings and Sculpture).

EX COLL.: The artist, until d. 1925; his sister, Emily Sargent, 1925–30.

EXHIBITIONS: Possibly shown in Museum of Fine Arts, Boston, 1927–28 ("Inventory of Drawings etc.," Thomas A. Fox–John Singer Sargent Collection, May 11, 1926, Boston Athenaeum, inv. no. S.6.178); The Metropolitan Museum of Art, June 1930.

REFERENCE: Mount 1966, n.p.

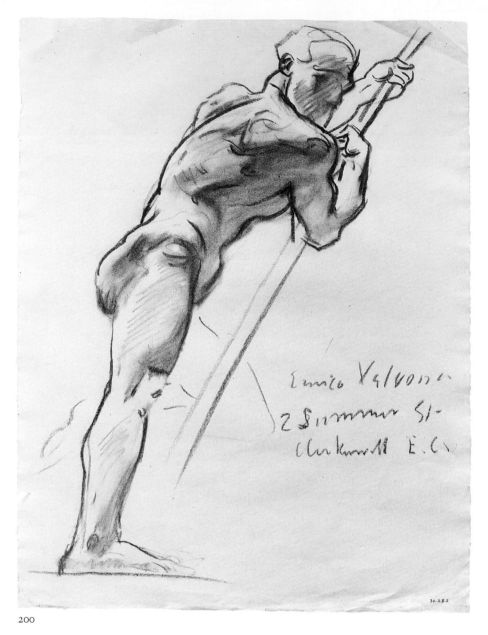

200

200. Man Holding a Staff, Possible Study for Devil in "Judgment"

ca. 1910
Charcoal on paper
24½ × 18¼ in. (62.2 × 47.6 cm)
Inscribed at lower right: Enrico Valrossa / 2 Summer St / Clerkenwell E.C.; at lower left: 6.56
Gift of Miss Emily Sargent, 1930
30.28.2

In the *Judgment* lunette (see figure 81), Sargent depicted the head and torso of a devil, turned to the left, leaning on a pole or staff. Although in catalogue 200 Sargent studied his model at full length and facing to the right, the figure's tilted position, bent arms grasping the rod, and turned head are similar to the devil in the painting.

Another drawing of a half-length male figure with a pole is Corcoran 49.100. Although Nygren dated that sheet 1890–1900, he also suggested that it could be a preliminary study for a devil in *Judgment* (Nygren 1983, p. 74).

Catalogue 200 has been missing since the 1970s and is known only from a photograph. Its paper type and inscriptions were not recorded prior to its disappearance; the inscriptions noted here are transcribed from the photograph. A partially legible watermark, which does not match the watermark on the Corcoran sheet, is faintly visible in the photograph (parallel to the right and left edges of the sheet). It seems to read: M. B. M. (FRANCE).

Ex coll.: The artist, until d. 1925; his sister, Emily Sargent, 1925–30.

Exhibitions: Possibly shown in Museum of Fine Arts, Boston, 1927–28 ("Inventory of Drawings etc.," Thomas A. Fox–John Singer Sargent Collection, May 11, 1926, Boston Athenaeum, inv. no. S.6.56); probably included in New York 1928 (inventory listing J.S. 69); The Metropolitan Museum of Art, June 1930.

Reference: Mount 1966, n.p.

201. Man Standing, Hands on Head

ca. 1890–1910
Charcoal on light blue laid paper
24⁷⁄₁₆ × 18¹⁵⁄₁₆ in. (62 × 48 cm)
Inscribed at lower left: Mario Mancini / 77 [illegible] St. / Hammersmith // 6.34; on verso at upper left: S.6.34
Watermark: INGRES / FRANCE
Gift of Miss Emily Sargent, 1930
30.28.1

As in catalogue 200, the inscription records a name and address (in London), presumably those of the model. According to Olson, Sargent often brought Italian models from London to his studio in Fairford to pose for murals (Olson 1986, p. 183).

The relatively quiet static contrapposto pose of the figure does not relate to a specific mural composition. Sargent's long-standing interest in *académie* exercises and his devotion to modeling though manipulation of shadow are evident.

Ex coll.: The artist, until d. 1925; his sister, Emily Sargent, 1925–30.

Exhibitions: Possibly shown in Museum of Fine Arts, Boston, 1927–28 ("Inventory of Drawings etc.," Thomas A. Fox–John Singer Sargent Collection, May 11, 1926, Boston Athenaeum, inv. no. S.6.34); The Metropolitan Museum of Art, June 1930.

References: Mount 1966, n.p.; Weinberg and Herdrich 2000a, p. 30; Weinberg and Herdrich 2000b, p. 232.

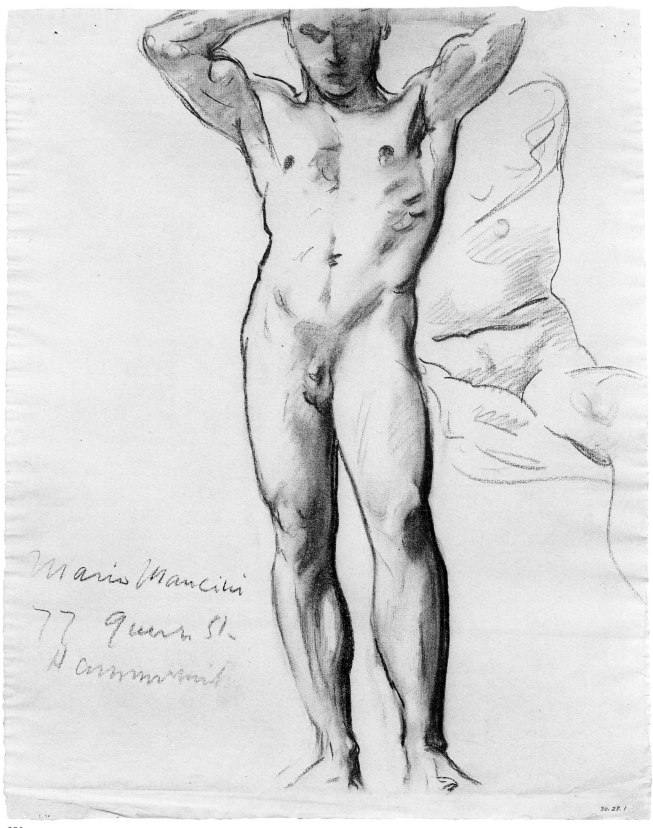

Mario Mancini
77 Queen St.
Hammersmith

30. 28. 1

201

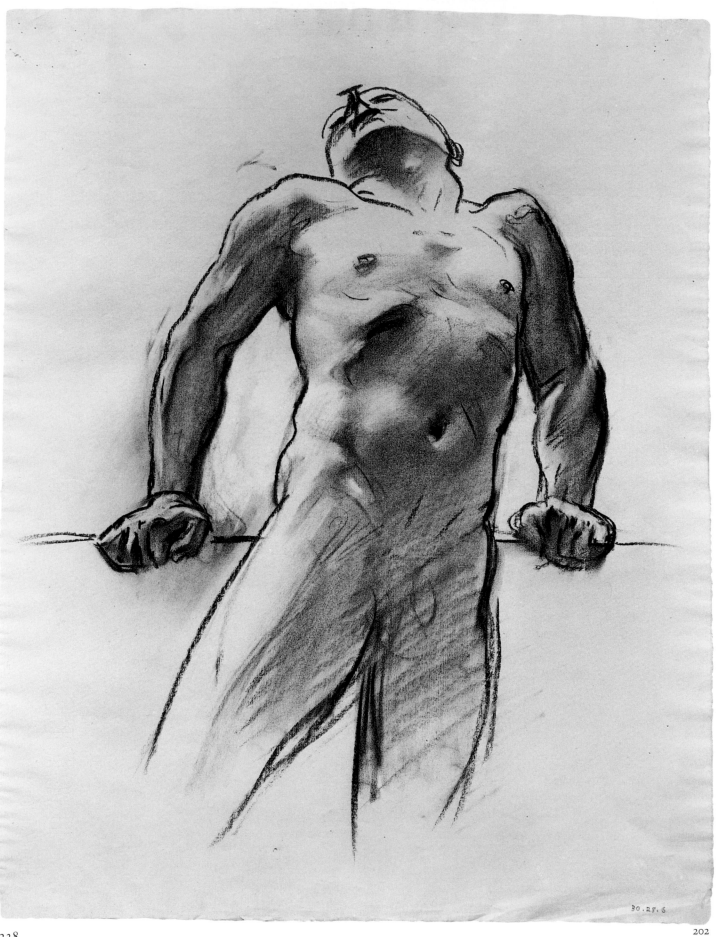

202. Man Standing, Head Thrown Back

ca. 1890–1916
Charcoal on white wove paper
24½ × 18¾ in. (62.4 × 47.6 cm)
Inscribed at lower left: 6.51; on verso at upper left:
S.6.51; at lower right: 6.51
Watermark: INGRES / FRANCE
Gift of Miss Emily Sargent, 1930
30.28.6

In catalogue 202, Sargent suggests the effort of the figure as he supports his weight on his hands on a ledge behind him. The expressive pose recalls in spirit the figures in Sargent's later library murals such as *Judgment* (figure 81), *Hell* (figure 82), and *Fall of Gog and Magog* (installed 1916).

Ex COLL.: The artist, until d. 1925; his sister, Emily Sargent, 1925–30.

EXHIBITIONS: Possibly shown in Museum of Fine Arts, Boston, 1927–28 ("Inventory of Drawings etc.," Thomas A. Fox–John Singer Sargent Collection, May 11, 1926, Boston Athenaeum, inv. no. S.6.51); The Metropolitan Museum of Art, June 1930.

REFERENCE: Mount 1966, n.p.

203. Drapery Studies for "Church"

ca. 1916–19
Charcoal on off-white laid paper
24¼ × 18¹¹⁄₁₆ in. (61.5 × 47.4 cm)
Inscribed at lower right: 8.2.2; on verso at upper left:
S.6.21
Watermark: MICHALLET / FRANCE
Anonymous gift, 1973
1973.267.4

In 1919 Sargent installed *Church* (figure 84) and *Synagogue* on the east wall above the staircase of the Special Collections Hall. He intended the two panels to flank the climactic (but never executed) composition of his program, *Sermon on the Mount*.

Sargent depicted the allegorical figure of the Church enthroned, holding objects of the Eucharist: the chalice in her right hand and the paten in her left hand. In catalogue 203, Sargent studied the drapery with which she supports the holy objects. A similar study for the drapery is in the Museum of Fine Arts, Boston (28.616).

EX COLL.: The artist, until d. 1925; his sisters, Violet Sargent Ormond and Emily Sargent, 1925–28; Corcoran Gallery of Art, Washington, D.C., 1928–60; purchase, Victor Spark and James Graham Gallery, 1960; the donor, before 1971–73.

EXHIBITION: Possibly shown in Museum of Fine Arts, Boston, 1927–28 ("Inventory of Drawings etc.," Thomas A. Fox–John Singer Sargent Collection, May 11, 1926, Boston Athenaeum, inv. no. S.6.21).

REFERENCE: London–Washington, D.C.–Boston 1998–99, p. 207.

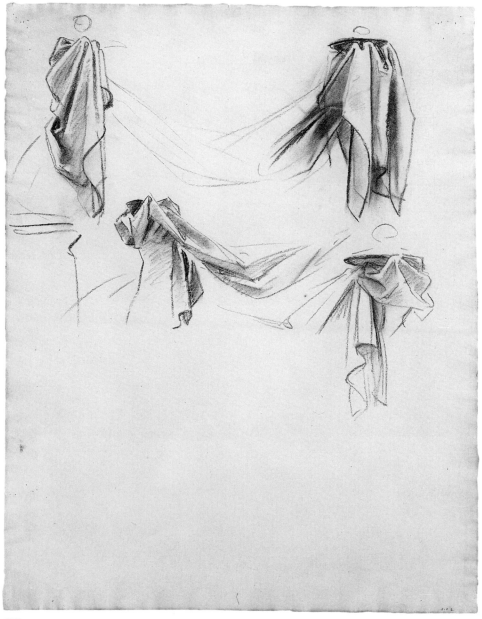

203

Catalogue Numbers 204–12: Studies for the Museum of Fine Arts, Boston, Murals

204. *Apollo, Study for "Apollo and Daphne"*

ca. 1918–20
Charcoal on off-white wove paper
16¾ × 21¹⁄₁₆ in. (42.5 × 53.4 cm)
Inscribed at upper left: Apollo / & Daphne; at lower
right: 12.14.4. // 117 [encircled]
Watermark: O.W.P. & A.O.L.
Anonymous gift, 1973
1973.267.1

Sargent planned to include the subject of Apollo and Daphne in his decorative scheme for the rotunda of the Museum of Fine Arts, Boston. He made several figure studies and even executed an oil sketch (figure 95), usually one of the final steps in his design process. Ultimately, he omitted the subject from the program.

The sun god Apollo, the symbol of ideal male physical beauty, is an important protagonist in several of the museum murals

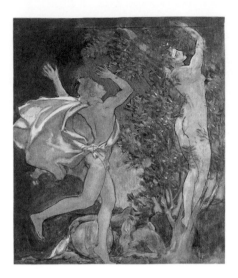

Figure 95. *Apollo and Daphne,* 1916–19. Oil on canvas, 32½ × 28⅞ in. (82.6 × 73.3 cm). The Corcoran Gallery of Art, Washington, D.C., Gift of Violet Sargent Ormond (49.133)

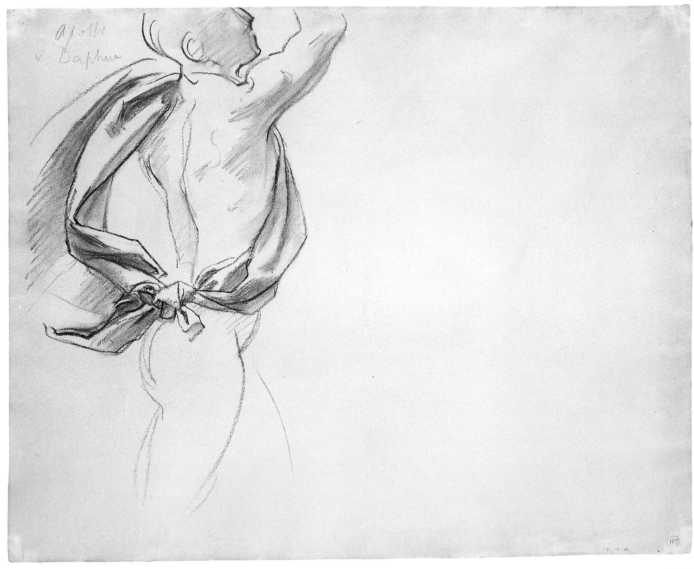

(cat. 208). Sargent's depiction of Apollo and Daphne illustrates the climactic moment of the god's pursuit of the nymph after he had been struck by Cupid's golden arrow and she by Cupid's leaden arrow. As the unwilling object of Apollo's affections, Daphne prayed to her father, the river god Peneus, to save her. Peneus transformed her into a laurel tree.

Sargent apparently studied Apollo's pose and anatomy separately from his drapery. In Corcoran 49.126, which is squared for transfer, presumably for the oil sketch in the Corcoran Gallery of Art, Sargent studied the nude body of Apollo. In catalogue 204, he concentrated on the billowing drapery, particularly the fabric surrounding the god's torso. The figure's pose is suggested with faint charcoal lines, and his head and legs are partially omitted.

EX COLL.: The artist, until d. 1925; his sisters, Violet Sargent Ormond and Emily Sargent, 1925–28; Corcoran Gallery of Art, Washington, D.C., 1928–60; purchase, Victor Spark and James Graham Gallery, 1960; private collection, New York (the donor), before 1971–73.

REFERENCE: Nygren 1983, p. 86.

205. *Drapery Studies*

ca. 1916–21
Charcoal on off-white laid paper
18¹⁵⁄₁₆ × 24¹¹⁄₁₆ in. (48 × 62.8 cm)
Inscribed at lower right: 82 [encircled]
Watermark: Lalanne; L. BERVILLE (FRANCE)
Anonymous gift, 1973
1973.268.1

Relief sculpture was an important component in Sargent's decoration of the neoclassical rotunda of the Museum of Fine Arts. Sargent made numerous studies for his depictions of ideal male figures surrounded by swags of fabric. The angular stiffness of the drapery in catalogue 205 is similar in style to those reliefs, although this drawing has not been associated with a particular composition.

EX COLL.: The artist, until d. 1925; his sisters, Violet Sargent Ormond and Emily Sargent, 1925–28; Corcoran Gallery of Art, Washington, D.C., 1928–60; purchase, Victor Spark and James Graham Gallery, 1960; private collection, New York (the donor), before 1971–73.

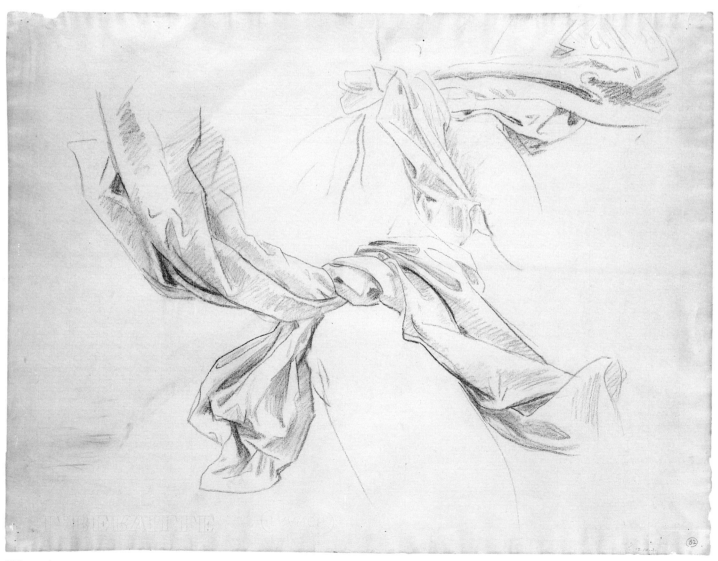

206. *Painting, Study for "Architecture, Painting and Sculpture Protected from the Ravages of Time by Athena"*

1916–21

Charcoal on off-white laid paper

18¹⁵⁄₁₆ × 24¾ in. (48 × 62.9 cm)

Inscribed at lower right: 56 [encircled]; on verso at upper left: 11.6.2; at lower left: 11.6.2

Watermark: Lalanne; L. BERVILLE (FRANCE)

Anonymous gift, 1973

1973.267.2

In catalogue 206, Sargent studied the drapery for his allegorical representation of Painting in the museum rotunda (see figure 85). The anatomy that is revealed, particularly in the study on the left, suggests that he may have used a male model for the female figure. Sargent may also have used male models for female figures in catalogue 209.

EX COLL.: The artist, until d. 1925; his sisters, Violet Sargent Ormond and Emily Sargent, 1925–28; Corcoran Gallery of Art, Washington, D.C., 1928–60; purchase, Victor Spark and James Graham Gallery, 1960; private collection, New York (the donor), before 1971–73.

EXHIBITION: "Weatherspoon Annual Exhibition: Art on Paper," Weatherspoon Art Gallery, University of North Carolina, 1971, cat. 103.

207. *Seated Figures, from Below*

ca. 1916–21

Charcoal on white laid paper

24¾ × 18¹³⁄₁₆ in. (62.9 × 47.7 cm)

Inscribed at lower left: 6.35.; on verso at upper left: S.6.55; at lower left: 6.55

Watermark: INGRES

Gift of Miss Emily Sargent, 1930

30.28.3

In style and subject the figures in catalogue 207 resemble studies for the rotunda of the Museum of Fine Arts, in which two roundels are occupied by images of Ganymede and Prometheus and two depict personifications of Music and Astronomy. The personifications, like these drawings, focus on single figures seen from below in a

207

manner that recalls dome and ceiling paint-
ings by old masters such as Giambattista
Tiepolo (1696–1770). For another response
to Tiepolo, see catalogue 265.

EX COLL.: The artist, until d. 1925; his sister, Emily
Sargent, 1925–30.

EXHIBITIONS: Possibly shown in Museum of Fine
Arts, Boston, 1927–28 ("Inventory of Drawings
etc.," Thomas A. Fox–John Singer Sargent Collec-
tion, May 11, 1926, Boston Athenaeum, inv. no.
S.6.55); probably included in New York 1928

(inventory listing J.S. 61); The Metropolitan
Museum of Art, June 1930.

REFERENCE: Mount 1966, n.p.

208. Hands, Study for "Apollo in His Chariot with the Hours"

1921–25
Charcoal on off-white wove paper
21 1/16 × 16 9/16 in. (53.6 × 42 cm)
Inscribed at lower right: 12.5.5; on verso at upper
right: S.5.107
Watermark: O.W.P. & A.O.L.
Anonymous gift, 1973
1973.268.2

Apollo was associated with the sun god Helios. On the ceiling over the Museum of Fine Arts stairway, Sargent depicted Apollo racing across the heavens in his horse-drawn golden chariot in pursuit of the moon goddess Diana (see figure 86). Catalogue 208 demonstrates Sargent's characteristic scrutiny of details in his mural compositions as well as his attention to gesture. Although Sargent sketched both outstretched arms of his model in catalogue 208, he incorporated only the two studies of the left arm into Apollo's pose.

When catalogue 208 was accessioned by the Metropolitan in 1973, it was erroneously identified as a preliminary study for the murals Sargent made for the Harry Elkins Widener Memorial Library, Harvard University, Cambridge.

Ex COLL.: The artist, until d. 1925; his sisters, Violet Sargent Ormond and Emily Sargent, 1925–28; Corcoran Gallery of Art, Washington, D.C., 1928–60; purchase, Victor Spark and James Graham Gallery, 1960; private collection, New York (the donor), before 1971–73.

EXHIBITIONS: Possibly shown in Museum of Fine Arts, Boston, 1927–28 ("Inventory of Drawings etc.," Thomas A. Fox–John Singer Sargent Collection, May 11, 1926, Boston Athenaeum, inv. no. S.5.107).

209. Study for "The Danaïdes"

1921–25
Charcoal and white chalk on off-white laid paper
24 9/16 × 18 15/16 in. (62.3 × 48 cm)
Inscribed at lower right: 12.1.18; on verso at upper
right: S.5.140; at lower left: 12.1.18
Watermark: INGRES
Anonymous gift, 1973
1973.267.3

Sargent depicted *The Danaïdes* (see figure 88) in a lunette above the stairway in the Museum of Fine Arts. In mythology, the fifty daughters of Danaus were betrothed to the fifty sons of Aegyptus. Danaus armed his daughters with daggers and instructed them to murder their husbands on their wedding night. All but one obeyed. The only surviving husband avenged his brothers' deaths by murdering the fifty sisters. In Hades, the daughters were condemned to pour water into a bottomless receptacle for all eternity.

In an early guidebook to the decorations, the foregoing mythological interpretation appears along with an allegorical interpretation: "The figures represent the various sources of wisdom from which the 'fountain of knowledge' is supplied" (*Decorations over the Main Stairway and Library: John Singer Sargent*, Boston, 1925, p. 6).

As usual, Sargent studied details of the composition such as the arms, shoulders, heads, and feet of the figures and a section of drapery as women carry the urns on their heads. David McKibbin says that Sargent hired three models from the Ziegfeld Follies to pose for the Danaïdes (McKibbin 1956, p. 53). However, the anatomy on this sheet and in a related study (Fogg 1929.275) suggests that Sargent employed a male model. Sargent may have used the Ziegfeld models for the final composition, particularly for the heads of the figures, although even there the anatomy appears somewhat masculine. Fairbrother has observed that Sargent also used a male model for the female personification of *Synagogue* at the Boston Public Library (installed 1919; Fairbrother 1990, p. 49, n. 21).

An additional related study is in the Corcoran Gallery of Art (49.122).

EX COLL.: The artist, until d. 1925; his sisters, Violet Sargent Ormond and Emily Sargent, 1925–28; Corcoran Gallery of Art, Washington, D.C., 1928–60; purchase, Victor Spark and James Graham Gallery, 1960; private collection, New York (the donor), before 1971–73.

209

210

210. *Wing, Study for Notus in "The Winds"*

ca. 1922–24
Black chalk on blue laid paper
24⅛ × 18⅞ in. (61.3 × 47.9 cm)
Inscribed at lower left: 12.6.17; on verso at upper
left: S.5.67; at lower left: 12.12.17
Watermark: INGRES / FRANCE
Anonymous gift, 1980
1980.284

Thomas A. Fox, Sargent's assistant, who catalogued his mural studies after the artist's death, associated this drawing with *The Winds*, a mural over the staircase in the Museum of Fine Arts (see figure 87). In

type and pose, it resembles the right wing of Notus, the south wind, who is depicted at the center right of the composition holding an inverted urn. Fogg 1929.269, a study of wings drawn in a style similar to that in catalogue 210, contains on its verso a compositional sketch for *The Winds*. Winged figures appear in Sargent's other museum murals, including *Perseus Slaying Medusa*, *Ganymede*, and *Prometheus*.

EX COLL.: Private collection, New York, by 1974.

EXHIBITIONS: Possibly shown in Museum of Fine Arts, Boston, 1927–28 ("Inventory of Drawings etc.," Thomas A. Fox–John Singer Sargent Collection, May 11, 1926, Boston Athenaeum, inv. no. S.5.67).

211. *Swans*

after 1890
Graphite on off-white wove paper
6⅛ × 9½ in. (15.6 × 24.1 cm)
Inscribed on verso at lower right: NS
Gift of Mrs. Francis Ormond, 1950
50.130.142j

212. *Swans*

after 1890
Graphite on off-white wove paper
6⅛ × 9½ in. (15.6 × 24.1 cm)
Inscribed on verso at center right: NS
Gift of Mrs. Francis Ormond, 1950
50.130.142k

Sargent's graphic oeuvre is replete with animals. In addition to catalogue numbers 211 and 212, several studies of swans are found in the Fogg Art Museum (1937.8.82, 1937.8.83, 1937.8.84, and 1937.8.88) and the Corcoran Gallery of Art (49.253a and 49.253b). There is no concrete evidence to date this group of drawings. Based on their style, Nygren convincingly argues that the Corcoran sheets belong to a mature period and assigns a broad date of 1880–1900. Melinda Linderer associates the Fogg sketches with the Museum of Fine Arts rotunda mural, *Classical and Romantic Art,* in which a swan appears as a symbol of beauty (entries for 1937.8.82, 1937.8.83, 1937.8.84, and 1937.8.88, *Sargent at Harvard* website). Although catalogue numbers 211 and 212, like the mural, show the swan pluming itself with its beak, the link to the murals remains tenuous, and the date is uncertain.

REFERENCES (cats. 211 and 212): Nygren 1983, p. 55; "1937.7.82, Two Sketches of a Swan; 1937.7.83, Four Sketches of Swans; 1937.7.84, Four Sketches of Swans Pluming Themselves; 1937.7.88, Two Sketches of a Swan," *Sargent at Harvard* website, October 28, 1997 (referred to by old accession number, 50.130.142h).

211

212

247

Catalogue Numbers 213–14: Studies for The Harry Elkins Widener Memorial Library Murals, Harvard University

213. *Study for "Death and Victory"*

1921–22

Watercolor, graphite, and gouache on off-white wove paper

20¹⁵⁄₁₆ × 8¹⁵⁄₁₆ in. (53.2 × 22.7 cm) (irregular)

Inscribed on verso at top: #6; at bottom: 5464 [encircled]

Gift of Mrs. Francis Ormond, 1950

50.130.84

214. *Study for "Coming of the Americans"*

1921–22

Watercolor, gouache, and graphite on off-white laid paper

22¼ × 9⅛ in. (56.5 × 23.2 cm)

Inscribed on verso at top: #5 / #6

Gift of Mrs. Francis Ormond, 1950

50.130.79

In November 1921, Sargent accepted his third mural commission. He was to paint a pair of arched panels for the stairway of Harvard University's Widener Memorial Library to commemorate alumni who fought and died in World War I. Unlike his two previous mural projects, which permitted him to adjust the physical space to accommodate them, the Widener Library paintings were designed for an existing space. The panels, an allegory of a struggle between Death and Victory and the *Coming of the Americans* (also called *Soldiers of the Nation Marching to War;* see figures 89 and 90), were unveiled on November 1, 1922. They have been dismissed by scholars as showing "the forced enthusiasm . . . of wartime propaganda" (Ratcliff 1982, pp. 203–4), as being "fairly insipid and banal compositions" (Ormond 1970a, p. 94), and as "conventionally jingoistic paintings" (Fairbrother 1994, p. 121).

Catalogue numbers 213 and 214 depict the finished compositions of the murals and correspond in size to an architectural rendering of the landing of the staircase that is in the Fogg Art Museum (1968.79). They

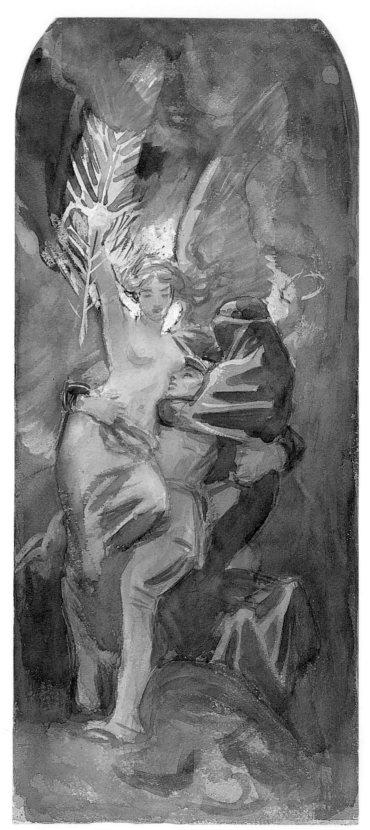

213

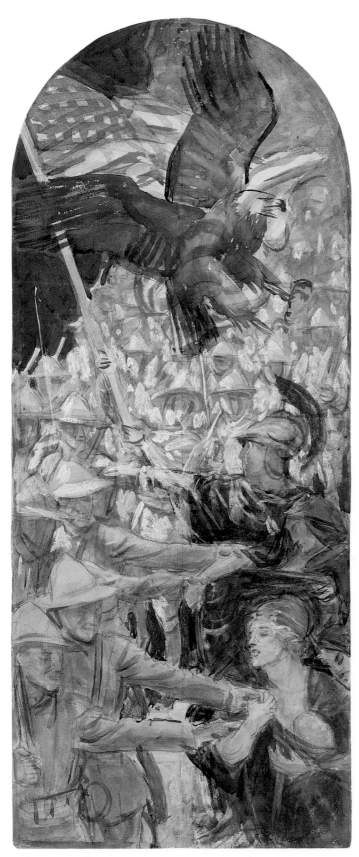

provide interesting evidence of Sargent's creative process. Pinholes in all three sheets suggest that the watercolors were at one time attached to the architectural study, perhaps as a presentation piece. While the watercolors are sketchy, they must have provided a general impression of the murals in situ when they were affixed to the architectural model. The top of the arch is truncated in catalogue 213. That portion of the design is painted directly on Fogg 1968.79. Catalogue 214 is squared for transfer.

Numerous other studies for the murals are in the collection of the Fogg Art Museum.

EXHIBITION (cat. 213): "Flights of Fantasy," Queens Museum, Flushing, New York, August 14–November 7, 1982, cat. 43.

REFERENCES (cat. 213): "1968.79, Study for 'Death and Victory' and 'Coming of the Americans,' with Architectural Framework, Widener Memorial Library, Harvard College Mural Project," *Sargent at Harvard* website, October 27, 1997; Dini 1998, pp. 141–42.

EXHIBITION (cat. 214): "Watercolors and Drawings by Centurion John S. Sargent," The Century Association, New York, September 21–October 23, 1982 (no catalogue).

REFERENCES (cat. 214): "1968.79, Study for 'Death and Victory' and 'Coming of the Americans,' with Architectural Framework, Widener Memorial Library, Harvard College Mural Project," *Sargent at Harvard* website, October 27, 1997; Dini 1998, pp. 141–42.

214

215. *Wheels in Vault*

1918
Watercolor, graphite, and wax crayon on white wove paper
15⅛ × 20¹³⁄₁₆ in. (39.1 × 52.9 cm)
Inscribed on verso at upper left: E.S.; at upper center: ⅔ [encircled]; at center ³¹⁄[₂₁?]; at lower left: WW
Gift of Mrs. Francis Ormond, 1950
50.130.56

216. *Ruined Cellar, Arras*

1918
Watercolor and graphite on wove paper, mounted on cardboard
14⅜ × 21³⁄₁₆ in. (36.5 × 53.9 cm)
Inscribed on verso at upper right: 28; 990 // Arass [sic] [encircled]; at center: ¹⁸⁄₁; along left edge: by J. S. Sargent 1914; at lower left: V.O / (Trust); stamped at center: C. ROBERSON & CO. ARTISTS' COLOURMEN, 99 LONG ACRE, 154 PICCADILLY, LONDON
Gift of Mrs. Francis Ormond, 1950
50.130.78

Sargent left England for the battlefields of France on July 2, 1918. By July 16 he was north of Paris, not far from the Belgian border at Arras, with his artist friend Henry Tonks. Sargent would remain in that town until sometime in August. Arras was greatly damaged during the war by four years of close-range bombardment. The Blue Guides volume for the region asserts that "Arras holds a place second only to that of Rheims among the 'martyred' towns of France" (*The Blue Guides: North-Eastern France*, London, 1922, p. 42). Sargent's letter to Fox dated August 9 probably describes Arras: "We are now in a ruined

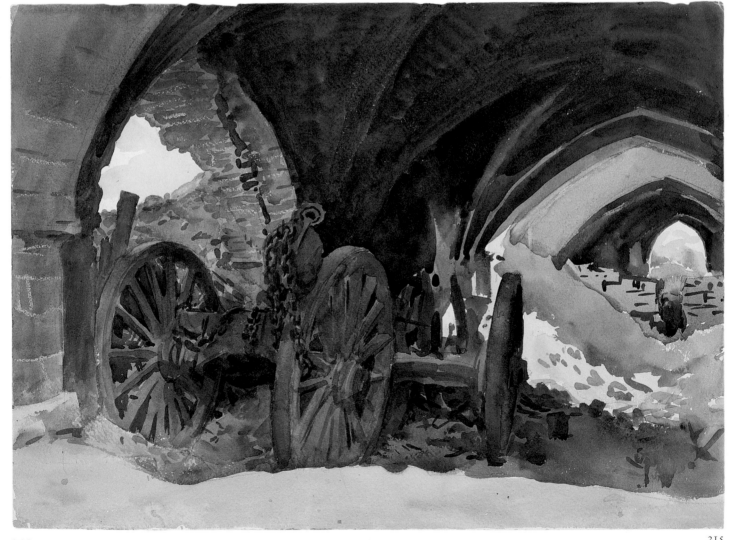

215

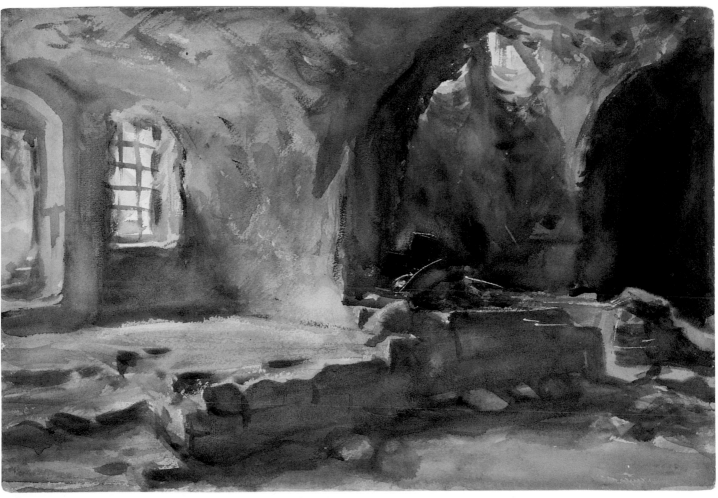

216

town, comfortably lodged in a big empty
house without a whole pane of glass in any
window, shaken to its foundations night
and day by guns going off within a few
yards. The air full of whistlings and whin-
ings and hummings but on the whole pleas-
anter than the mud of the trenches we have
come from" (JSS to Thomas A. Fox, Gen-
eral Headquarters, British Armies in France,
August 9, 1918, Thomas A. Fox–John
Singer Sargent Collection, Boston
Athenaeum).

In addition to catalogue numbers 215
and 216, Sargent painted the ruins of the
town in an oil, *Ruined Cathedral, Arras*

(1918, private collection), and a watercolor,
A Street in Arras (1918, Imperial War
Museum, London). In all of these works,
Sargent explored the juxtaposition of exter-
iors with interior spaces that had been
revealed by war damage. In catalogue 215,
the wheels are sheltered by the arches
above but exposed to the elements through
the holes in the collapsed walls. In cata-
logue 216, light cascades through a hole in
the wall at the upper right to illuminate
rubble. Sargent studied the dramatic con-
trasts between light and dark with a somber
palette that imbues the ruins with a roman-
tic atmosphere. In the absence of humans

and other animate forms, the immediacy of
war seems forgotten and the works have a
timeless quality.

Ruined Cellar may depict a particular
phenomenon of quotidian life in Arras dur-
ing the war, when "extensive cellars and
quarry workings (called 'the Caves') were
transformed into an underground city"
(*The Blue Guides: North-Eastern France*,
London, 1922, p. 42).

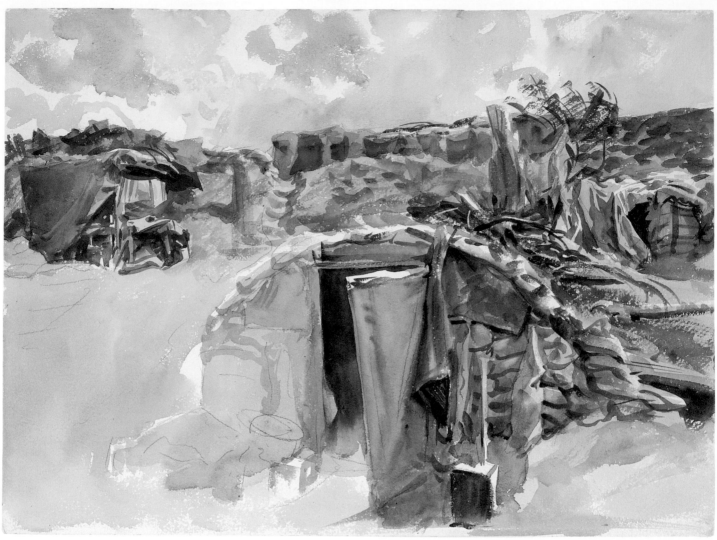

217

217. Dugout

1918
Watercolor and graphite on white wove paper
15 5/16 × 20 7/8 in. (39 × 53 cm)
Inscribed on verso at upper left: E.S.; at center: F/[217];
at center right: 3/28 [encircled]; at lower left: WW
Gift of Mrs. Francis Ormond, 1950
50.130.53

Sargent depicted dugouts, bivouacs, and other battlefield lodgings in at least three other watercolors: *Old Bivouacs*; *A Tarpaulin over a Dug-out, Ransart*; and *The Sunken Road, Ransart* (all 1918, Imperial War Museum, London). As in the case of two of these watercolors, catalogue 217 could have been made at Ransart, a town near Berles-au-bois and Arras, where Sargent was in July and August.

Sargent left this sheet unfinished, like catalogue 222. Although covered with a pale, flat wash, the lower left corner of the composition is devoid of detail. Sargent penciled in some unidentifiable objects to the left of the dugout entrance but left them unpainted. He offered a possible explanation for his leaving such works unfinished in a letter to Alfred Yockney of the Ministry of Information: "Tonks and I are working hard in an interesting region . . . but the weather is horribly changeable and makes it difficult to finish

anything through. I am keeping a number of things going for all sorts of matters" (JSS to Alfred Yockney, H.Q. Guard Division, British Armies in France, July 26, 1918, Imperial War Museum, London, First World War Artists Archive [hereafter, Imperial War Museum, Artists Archive], file 284, nos. 146–47).

EXHIBITION: New York–Buffalo–Albany 1971–72, cat. 43.

REFERENCES: Hoopes 1970, p. 82.

218. Truck Convoy

1918
Watercolor and graphite on white wove paper
13⅛ × 21 1/16 in. (34 × 53.4 cm)
Inscribed on verso at lower left: V.O; at center: 392
[encircled]; ²/[21?]
Gift of Mrs. Francis Ormond, 1950
50.130.54

Sargent wrote to Yockney on October 4: "For a long time I did not see any means of treating the subject given me of 'British and American troops working together.' . . . A crowded road on which both are moving is the only chance I have found & by the way it is a very fine sight and might make a good picture—But much of my work was done before I determined this and I must stay out a few weeks longer and make some more studies with this in view" (JSS to Alfred Yockney, October 4, [1918], Imperial War Museum, Artists Archive, file 284, no. 138).

Although Sargent ultimately settled on gassed soldiers as the subject of his commission (see figure 91), he pursued the crowded-road image in at least three oils: *The Arrival of the American Troops at the Front* (Gilcrease Museum, Tulsa; see figure 93), *American Troops Going up the Line* (1918, private collection), and *The Road* (1918, Museum of Fine Arts, Boston). All three canvases respond to the same basic concept in similar compositions. Yockney wrote to artist Muirhead Bone (who had also spent time at the front lines) on November 5, 1918, that Sargent had decided against the road scene for his monumental canvas: "He fears this is rather an illustrated paper kind of subject and would not do it on a large scale. He thought, however, that a 5 ft. picture might be made of it" (Alfred Yockney to Muirhead Bone, November 5, 1918, Imperial War Museum, Artists Archive, file 284, nos. 130–31).

The details of catalogue 218 most closely resemble the Gilcrease painting, and this watercolor must be one of the studies (mentioned by Sargent) made about early October for this subject. In catalogue 218, Sargent planned the general setting for the composition, omitting the troops. In the Gilcrease painting and catalogue 218, the road recedes from the foreground toward a vanishing point at the right. In the oil, however, the vanishing point is just right of center, creating a more dynamic and open angle for the receding road. In both works, the convoy lines the further edge of the road, and several shattered trees line the near edge. Sargent left a large area of paper in reserve in the sky on the left of the watercolor, which has the effect of dividing the composition.

For other studies pertaining to the Gilcrease painting (and related compositions), see catalogue numbers 219 and 220.

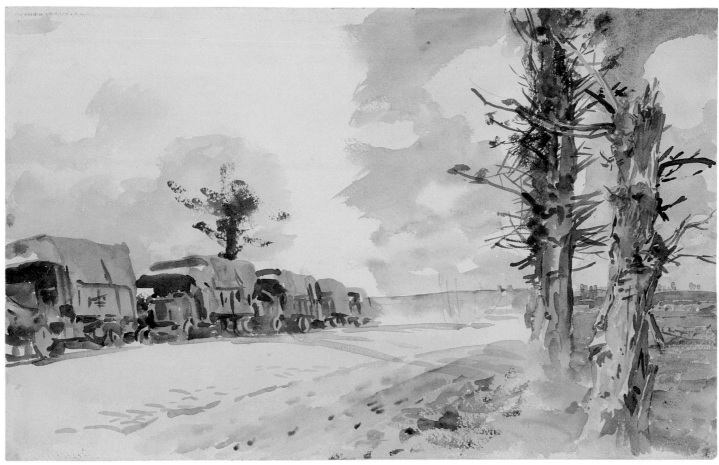

219 recto

219 verso

219 recto. *Poperinghe Road near Ypres*

September 1918
Graphite on off-white wove paper
10 × 14⅜ in. (25.4 × 36.5 cm)
Inscribed at lower right: Poperinghe Road near Ypres / Sept. 1918; at lower right: J.S. 386
Gift of Mrs. Francis Ormond, 1950
50.130.138 recto

219 verso. *Shattered Trees*

ca. September 1918
Graphite on off-white wove paper
10 × 14⅜ in. (25.4 × 36.5 cm)
Inscribed at lower left: 347
Gift of Mrs. Francis Ormond, 1950
50.130.138 verso

220 recto. *Wasted Trees*

ca. September 1918
Graphite on off-white wove paper
10 × 14⅜ in. (25.4 × 36.5 cm)
Inscribed at lower left: J.S. 385.; at lower right: 348
Gift of Mrs. Francis Ormond, 1950
50.130.136 recto

220 verso. *Walking Soldiers*

ca. September 1918
Graphite on off-white wove paper
10 × 14⅜ in. (25.4 × 36.5 cm)
Gift of Mrs. Francis Ormond, 1950
50.130.136 verso

In subject and dimension, catalogue numbers 219 and 220 may be grouped with three sheets at the Corcoran Gallery of Art (49.128, 49.139, and 49.142). All five sheets may have come from the same sketchbook.

The sketches relate to compositions for Sargent's crowded road subject (cat. 218) and include, on the verso of Corcoran 49.128, a compositional study for *The Road* (Museum of Fine Arts, Boston).

The Blue Guides: North-Eastern France reflects on the significance of Poperinghe Road, the site depicted in catalogue 219 recto, during the war: "Between Poperinghe and Ypres a line of shell-scarred trees, parallel with the railway . . . marks the famous main road along which 5 million British and

220 recto

220 verso

Overseas troops marched to fight. Of these a million returned wounded, while 300,000 lost their lives within the salient" (London 1922, p. 28). As a key transportation artery, the locale would have been an appropriate site for Sargent's painting. Although devoid of military equipment and personnel, catalogue 219 recto relates to the setting of the Gilcrease painting (see figure 93). Sargent

also painted the watercolor *Two Soldiers* (1918, Museum of Fine Arts, Boston) at the Belgian town of Poperinghe.

EXHIBITION (cats. 219 recto and 220 recto): Probably included in New York 1928 (inventory listing J.S. 386 and J.S. 385).

REFERENCE (cat. 219 recto): Nygren 1983, p. 100.

221. Road at Peronne

1918
Graphite on off-white wove paper
7¹⁄₁₆ × 10¼ in. (17.9 × 26 cm)
Inscribed at center right: Peronne / 1918
Gift of Mrs. Francis Ormond, 1950
50.130.100

In this expansive view, Sargent suggests distance with an empty foreground, high horizon, and receding road filled with military vehicles at the center of the sheet. Figures, tents, and horses—details of the distant camp—are suggested by small silhouettes.

Peronne was captured by the Germans in March 1918. Sargent was there in late September to October 1918, shortly after it had been won back in battles on August 29 and September 2 (*The Blue Guides: Belgium and the Western Front*, London, 1920, p. 161).

Two studies of motorcycles in the Corcoran Gallery of Art (49.103a and 49.103b) are also inscribed "Peronne."

221

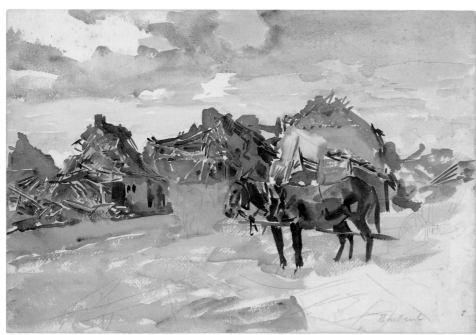

222

222. *Mules and Ruins*

September 1918
Watercolor and graphite on white wove paper
14⁵⁄₁₆ × 20⅞ in. (36.4 × 53 cm)
Inscribed at lower right: Bailleul
Gift of Mrs. Francis Ormond, 1950
50.130.55

Catalogue 222 was made at Bailleul, a town near Ypres close to the Belgian border, where, according to an inscription on Corcoran 49.142, Sargent was in September 1918. The Corcoran sheet shows a group of soldiers in a horse-drawn carriage and a devastated landscape.

That catalogue 222 is unfinished is evident in the large areas of exposed underdrawing in the foreground. Many of the graphite elements—rubble in the foreground, a second horse in the middle distance, and the carriage behind the horse at right—are covered with a layer of wash but

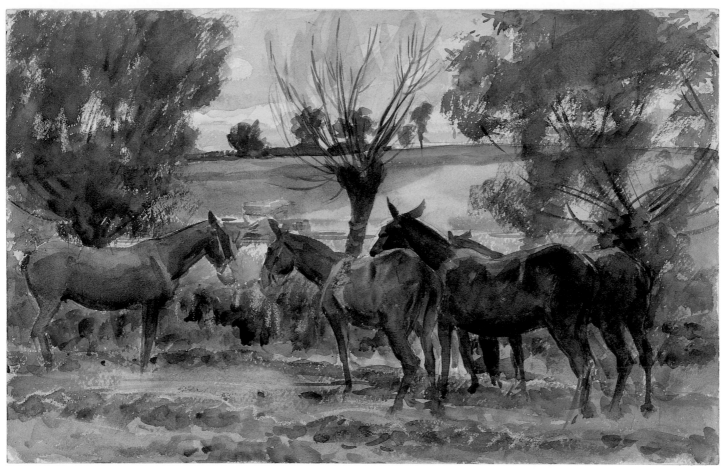

223

223. Mules

1918

*Watercolor, graphite, and wax crayon on off-white
wove paper*

13³⁄₁₆ × 20¹⁵⁄₁₆ in. (33.4 × 53.1 cm)

*Inscribed on verso at upper left: 149 / By J. S.
Sargent / E.S. / V.O / (Trust); at center: [?]⁄₂₁; at
lower left: WW; at lower right: 990 [encircled]*

Gift of Mrs. Francis Ormond, 1950

50.130.49

Animals are ubiquitous in Sargent's oeuvre.
Adelson et al. discuss "beasts of burden"—
including oxen, mules, and horses—in
Sargent's paintings of the first decade of the
twentieth century (Adelson et al. 1997,
pp. 160–65). Sargent often painted these ani-
mals in stables (for example, *Stable at Cuenca*,
1903, The Warner Collection of Gulf States
Paper Corporation, Tuscaloosa, Alabama,

and *Arab Stable,* 1903, Brooklyn Museum
of Art, New York).

It is not surprising that Sargent turned to
a familiar subject while at the front, sketch-
ing and painting horses and mules that were
usually employed to haul equipment. Here
Sargent showed mules outdoors, separated
from a distant field by a cluster of trees. As
in *Tommies Bathing* (cats. 224 and 225), the
military association is minimal.

A related subject is *Horse Lines* (1918,
Imperial War Museum, London), which
portrays a large number of horses at the edge
of a wood from a slightly higher viewpoint.
Other paintings of horses done at the front
are *Shoeing Cavalry Horses at the Front* (1918,
private collection) and *Scott's Greys* (1918,
Imperial War Museum, London).

EXHIBITIONS: "Watercolors and Drawings by
Centurion John S. Sargent," The Century Associa-
tion, New York, September 21–October 23, 1982
(no catalogue); New York and other cities 1991,
cat. 110.

are not painted in any detail. This visible
underdrawing suggests that Sargent began
his watercolors by delineating the main
forms of the composition in a cursory man-
ner and applying broad layers of wash
before working up the details.

The *Blue Guide* describes the destruction
of Bailleul: "Bailleul . . . was a picturesque
lace-making town (13,251 inhab.) with two
16th cent. churches and Hôtel de Ville with
a tall campanile. During the greater part of
the War its narrow streets and market-square
were thronged with British troops enjoying
a respite from the trenches. Its ruin dates
from the capture and recapture in 1918"
(*The Blue Guides: North-Eastern France,* Lon-
don, 1922, p. 28).

Another related watercolor, *Bailleul: Tents*
(1918; 21.139), is in the Museum of Fine
Arts, Boston.

224. *Tommies Bathing*

1918
Watercolor and graphite on white wove paper
15 5/16 × 20 13/16 in. (39 × 52.8 cm)
Inscribed on verso at upper left: Tommies bathing /
1917; E.S. / 2/3 [encircled]; at center: 1/21; at lower
left: WW
Gift of Mrs. Francis Ormond, 1950
50.130.48

225. *Tommies Bathing*

1918
Watercolor, gouache, and graphite on white wove
paper
13 5/16 × 20 15/16 in. (33.9 × 53.1 cm)
Inscribed on verso at upper left: 151 / By J. S.
Sargent; at center: [10]1/3; at lower left: V.O. (Trust) /
WW; at lower right: 990 [encircled]
Gift of Mrs. Francis Ormond, 1950
50.130.58

The moniker "Tommy" comes from "Thomas Atkins," the fictitious name used by the British Army on official forms for private soldiers—similar to the American "John Doe." These two sheets depicting Tommies at leisure are among the most informal of Sargent's wartime watercolors. In catalogue 225 Sargent suggests the ordinary off-duty pastimes of the soldiers in a variety of poses and activity levels, from right to lower left: bathing, resting but partially sitting up, and sleeping or napping. These poses may also imply a continuous narrative: from the bathing soldier at right, to the soldier drying himself in the sun at left, to the partially dressed soldier above.

In catalogue 224, Sargent depicts two nude figures sleeping or at rest in the same mound of grass at water's edge. The prox- imity of the figures and their apparent state of complete relaxation makes catalogue 224 more informal and even more private than catalogue 225. This casual impression is enhanced by the very broad treatment of the foreground and the unpainted area at the lower right corner of the sheet, which isolate the figures and their pillow of grass from the surrounding landscape. In both sheets, Sargent employs the same high, almost voyeuristic viewpoint.

The works are characterized by a lack of specificity, particularly in the faces and anatomy of the figures. Sargent used satu- rated light both to define the anatomy in a general but subtle way by modulating the flesh tones and to obscure in shadow details of faces and genitals. The flesh tones become almost reflective surfaces in the

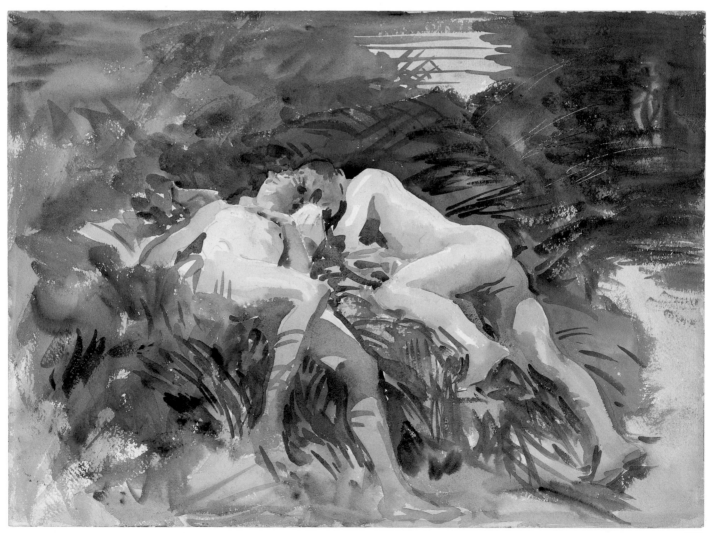

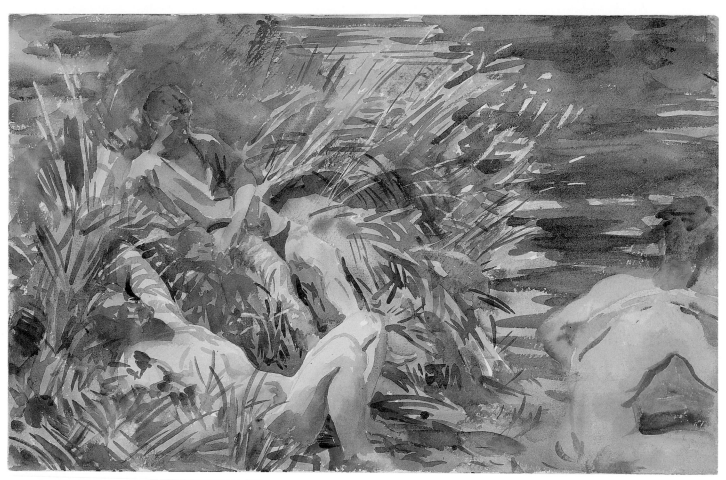

225

bright daylight. Sargent masterfully depicts the play of sunlight in the long, green blades of grass as they cast shadows across the bodies. Aside from the title, there are no details in either work to confirm that the figures are soldiers. Knowing the title, one might deduce from the color of the garment on the figure at the upper left of catalogue 225 that he wears military fatigues.

These informal works relate to a series of paintings in watercolor and oil that Sargent produced after about 1905 of his friends and travel companions—always clothed—lolling about outdoors. Dubbed the "siesta pictures" by Ormond, they show figures resting, if not sleeping, usually from a vantage point above (Adelson et al. 1997, p. 80ff). Sargent studied both men and women intertwined in their lassitude. In composition and pose of the figures, catalogue 224 in particular can be compared to *Siesta* (1907, private collection; Adelson et al. 1997, fig. 71), a watercolor of two women napping under an umbrella.

Related watercolors executed at the front, but depicting the soldiers in uniform with their weapons, are *Highlanders Resting at the Front* (1918, Syndics of the Fitzwilliam Museum, Cambridge) and *Poperinghe: Two Soldiers* (1918, Museum of Fine Arts, Boston). The informality of the nude figures in a landscape also recalls Sargent's Florida watercolors of 1917, such as catalogue numbers 337–40. The anatomy and pose of the bathing figure at the right edge of catalogue 225, with his twisted torso and head turned away from the viewer, recall that of the nude male in *Mountain Stream* (cat. 313).

EXHIBITIONS (cat. 224): "Two Hundred Years of Watercolor Painting in America," The Metropolitan Museum of Art, December 8, 1966–January 29, 1967, cat. 114; New York–Buffalo–Albany 1971–72, cat. 42; New York 1980a, cat. 64; The Metropolitan Museum of Art, September 1980 (no catalogue); "Watercolors and Drawings by Centurion John S. Sargent," The Century Association, New York, September 21–October 23, 1982 (no catalogue); New York and other cities 1991, cat. 107.

REFERENCES (cat. 224): Fairbrother 1990, p. 42; Weinberg and Herdrich 2000b, p. 232.

EXHIBITIONS (cat. 225): Probably London 1926a, cat. 491; "Watercolors and Drawings by Centurion John S. Sargent," The Century Association, New York, September 21–October 23, 1982 (no catalogue); New York and other cities 1991, cat. 109.

REFERENCES (cat. 225): London 1926b; Fairbrother 1981a, pp. 75 and 79, n. 12.

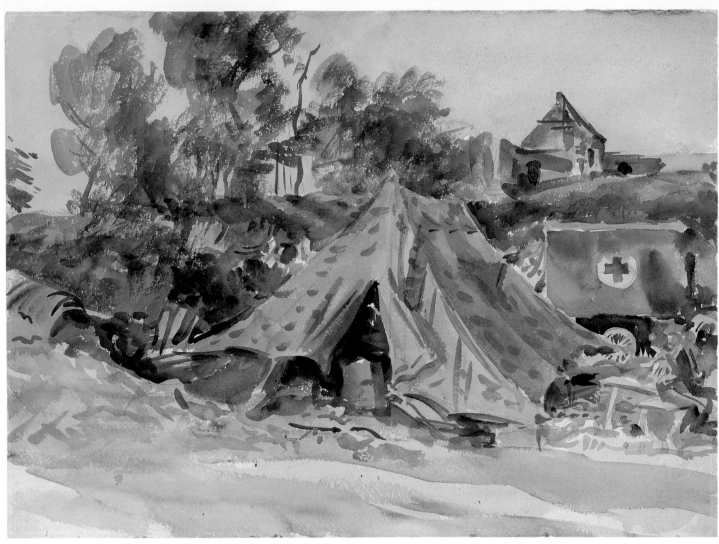

226

226. Camp with Ambulance

1918
Watercolor and graphite on white wove paper
15⁵⁄₁₆ × 20¾ in. (39 × 52.7 cm)
Inscribed on verso at upper left: 102; at upper right:
V. O (Trust); along right edge: By J. S. Sargent
1914; at center: N / [illegible crossed-out mark] /
21; at lower left: WW
Gift of Mrs. Francis Ormond, 1950
50.130.50

EXHIBITION: "Watercolors and Drawings by Centurion John S. Sargent," The Century Association, New York, September 21–October 23, 1982 (no catalogue).

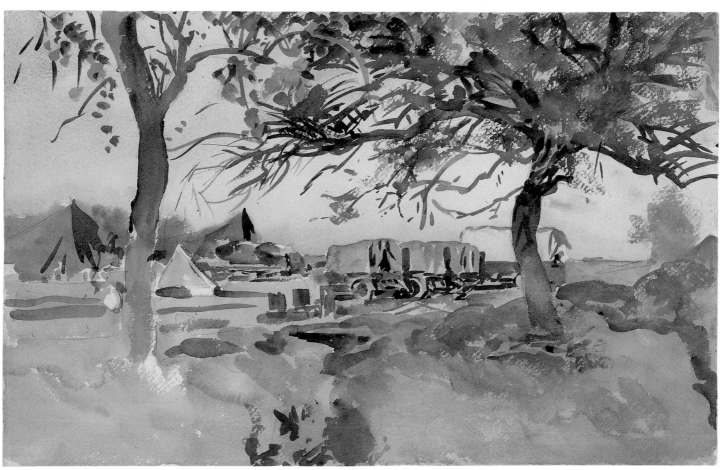

227

227. *Military Camp*

1918
Watercolor and graphite on white wove paper
13⅜ × 20⅞ in. (34 × 53.1 cm)
Inscribed on verso at upper left: 43; 82 By J. S.
Sargent 1914; at center: [G?]/21; at lower left: V. O /
(Trust); at lower left: WW
Gift of Mrs. Francis Ormond, 1950
50.130.51

EXHIBITION: "Watercolors and Drawings by Cen-
turion John S. Sargent," The Century Association,
New York, September 21–October 23, 1982 (no cat-
alogue).

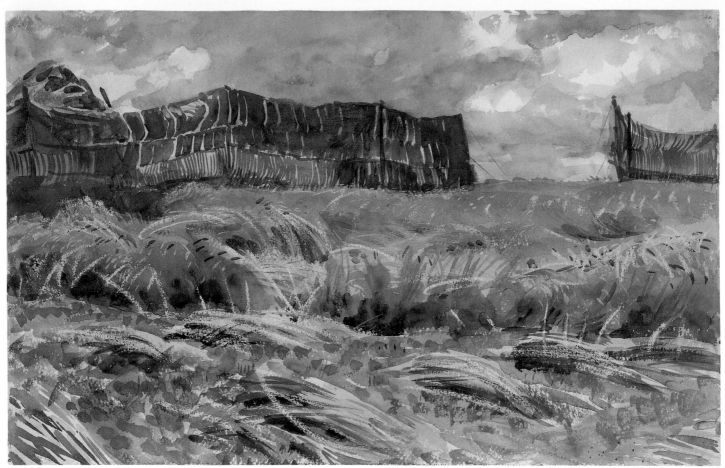

228

228. Camouflaged Field in France

1918

*Watercolor, gouache, graphite, and wax crayon on
white wove paper*

13 5/16 × 20 15/16 in. (33.9 × 53.1 cm)

*Inscribed on verso at upper left: Camouflaged field /
in France 1917; at upper center: ⅔ [encircled]; at
center 11/[212]; at lower left: WW*

Gift of Mrs. Francis Ormond, 1950

50.130.52

Sargent divided the composition of cata-
logue 228 into four elements: sky, fence, and
uncut and cut hay. Although the camouflage
fence in the background suggests the threat
of war, the image is tranquil. The presence
of man is suggested by the bundles of hay on
the ground and in the distance, where the
tall grass is yet to be reaped.

This sheet is related in subject to *A
Crashed Aeroplane* (see figure 92), which
depicts two workers cutting and binding
hay in the foreground with a wrecked air-
plane in the green field beyond. Kilmurray

229

262

suggests that the workers, who go about their business oblivious or indifferent to the activity in the background, represent "the continuity of life" (London–Washington, D.C.–Boston 1998–99, p. 269).

EXHIBITIONS: "Sargent Watercolors," National Collection of Fine Arts, Smithsonian Institution, Washington, D.C., July 1977 (no catalogue); "Watercolors and Drawings by Centurion John S. Sargent," The Century Association, New York, September 21–October 23, 1982 (no catalogue); New York and other cities 1991, cat. 108.

229. *Military Insignias*

ca. 1918
Pen and ink on tan wove paper
6⁹⁄₁₆ × 8⁵⁄₁₆ in. (16.6 × 21.1 cm)
Inscribed at upper center: artillery Sp[?] cap // no broad stripes; at upper right: bronze grenade // four buttons; at center: gold gold 3 broad stripes khaki braid / crown also} lighter khaki // Artillery Major
Gift of Mrs. Francis Ormond, 1950
50.130.140cc

The sketches and notes about the uniform of a major of the British Royal Artillery on catalogue 229 are most likely related to Sargent's work as an artist-correspondent during World War I. Based on the uniform, the drawing must date from 1913 or after, when the artillery adopted the four-button, open-collared jacket that is depicted here.

This sketch does not appear to be related to Sargent's *Some General Officers of the Great War* (1920–22, National Portrait Gallery, London), which portrays generals. It could relate to his studies for his "road scene," which Yockney described as depicting "Americans going up to the line, with British artillery and so forth and with wounded British returning on the other side of the road" (Alfred Yockney to Muirhead Bone, November 5, 1918, Imperial War Museum, Artist Archive, John Sargent 1918–1924, file 284 A/7, nos. 130–31). For a discussion of Sargent's painting of this subject, see catalogue 218.

230. *Charity, After a Sculpture at Abbeville*

1918?
Graphite on off-white wove paper
7¹⁄₁₆ × 5⅛ in. (17.9 × 13 cm)
Inscribed at lower right: Abbeville; on verso at lower right: CP
Gift of Mrs. Francis Ormond, 1950
50.130.143j

231. *Portal, Abbeville*

1918?
Graphite on off-white wove paper
7¹⁄₁₆ × 5⅛ in. (17.9 × 13 cm)
Inscribed at lower left: Abbeville; on verso at lower right: CP
Gift of Mrs. Francis Ormond, 1950
50.130.143k

In catalogue numbers 230 and 231, Sargent copied early-sixteenth-century sculpture on the facade of the Church of Saint Vulfran (begun 1488) in Abbeville, France. Catalogue 230 represents the figure of Charity, carved on a socle, to the left side of the right portal. Catalogue 231 represents the relief depicting Saint Eustache in the niche above the left door. The absence of detail may suggest that Sargent visited Abbeville and made quick sketches on site, but it is not possible to rule out his use of photographs.

Although the date of these drawings remains uncertain, Sargent may have visited Abbeville during his assignment as a war artist in 1918. The town is situated about twenty-five miles west of Doullens, in the Somme region, where Sargent witnessed the scene that would become his monumental war painting, *Gassed* (figure 91). During the war Abbeville was "an important British base for auxiliary services" (*The Blue Guides: North-Eastern France*, London, 1922, p. 22).

230

231

Miscellaneous Studies

232. *Man with Red Drapery*

after 1900
Watercolor and graphite on white wove paper
14⅜ × 21³⁄₁₆ in. (36.5 × 53.8 cm)
Gift of Mrs. Francis Ormond, 1950
50.130.73

After 1890 Sargent created many studies of nude male models in connection with various mural projects. While planning his compositions, the artist drew as a generative process, studying and recording the figure in a variety of attitudes and poses in order to work out ideas and refine compositions. Sargent's preoccupation with the human figure and his appreciation of its centrality to monumental history painting may also be seen as byproducts of his academic training. However, the vast quantity of these studies, mostly drawings but also watercolors such as catalogue numbers 232 and 233, reveal Sargent's delight in the human form for its own sake.

In catalogue 232, the model is presented leaning back with arm outstretched and head thrown back, an active pose that is comparable to those seen in murals for the Boston Public Library such as *Hell* (see figure 82) and *Fall of Gog and Magog*. Sargent created a dynamic foreshortening by depicting the figure from an oblique vantage point, receding at an angle into the picture space. He enlivened the composition by dramatically cropping the figure's left arm and placing the face near the top edge of sheet.

Sargent painted catalogue 232 with a brilliant immediacy and sensuous vivacity that distinguish it from both the murals and their preparatory studies. He began by laying out the composition in graphite in an economical manner, briefly recording a general outline of the figure and delineating important compositional elements such as the point where the red drapery crosses the leg and the position of the nipples (indicating the twist of the torso relative to the picture plane). The genius of Sargent's watercolor technique is in his ability to suggest form and detail with a minimal number of strokes. He created volume by using multiple layers of washes in varied tones while boldly and effectively exploiting the natural color of the paper, which is left in reserve for the brightest highlights.

Sargent focused attention on the figure by only vaguely describing the setting with broadly painted brown pigment on the left and splashes of transparent wash in diverse

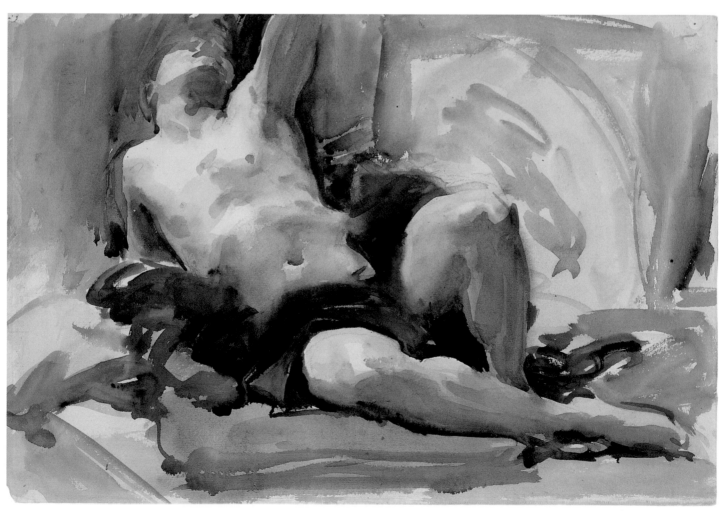

colors on the right. A brilliant example of Sargent's mastery and efficiency is his rendering of the figure's navel. A small oval of paper is left in reserve; above it, a pool of darker pigment gathers, as if by accident, to describe the shadow of the navel. The generally limited palette is accented by the rich red of the drapery, which meanders around the model's hips and legs near the center of the composition. The fabric provides a striking and dramatic note in its variety of tone and opacity against the muted tans and beiges of the model's flesh.

EXHIBITIONS: New York–Buffalo–Albany 1971–72, cat. 12; "Turn-of-the-Century America," Whitney Museum of American Art, New York, June 30–October 2, 1977; The Metropolitan Museum of Art, May 1980 (no catalogue); "Watercolors and Drawings by Centurion John S. Sargent," The Century Association, New York, September 21–October 23, 1982 (no catalogue); New York–Chicago 1986–87; New York and other cities 1991, cat. 94.

REFERENCE: Weinberg and Herdrich 2000b, p. 232.

233. *Italian Model*

after 1900
Watercolor and graphite on white wove paper
14⅞ × 22¹⁄₁₆ in. (37.8 × 56.1 cm)
Inscribed at upper left: 140; embossed at upper right corner: [GUA?]RANTEED / PURE PAPER / R.W.S / [?] PALL MALL // 20: inscribed on verso at center right: ¹⁸⁄₁; 921 [encircled]
Gift of Mrs. Francis Ormond, 1950
50.130.72

Catalogue 233, a broadly painted, immediate record of a male nude, can be associated with the studies Sargent made in connection with his various mural projects after 1890. Like catalogue 232, this sheet depicts a reclining male figure swathed in red drapery. While both works are distinguished by a confident, bravura technique, *Italian Model* is characterized by an even bolder composition, brush stroke, and palette.

Although the figure resembles Nicola d'Inverno, whom Sargent hired as a model in the early 1890s, his identity is uncertain because of Sargent's broad treatment of details and his preference for certain general characteristics in his models. While working on his mural projects, he often hired Italian men from London's industrial districts to pose for him, and many of these studies feature similar dark-haired figures. Nicola appears in several charcoal studies in an album in the Fogg Art Museum (1937.9; see, for example, 1937.9.28). After about a year in Sargent's employ, Nicola assumed greater responsibility around the studio, eventually becoming Sargent's valet, a position that he held until 1918, when he was dismissed after a brawl in a bar.

Sargent explores the expressive possibilities of the human form in this calculated pose. The model's chest parallels the picture plane, but the twist of his hips pushes his right leg toward the picture plane. His bent left arm rests on his hip while the right is folded behind his head, which is turned down and immersed in shadow. The broadly and abstractly rendered background and the

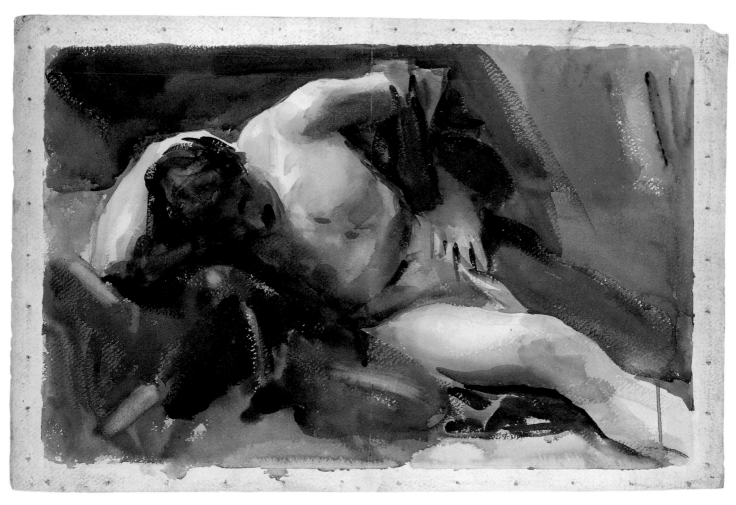

absence of spatial depth and distance enhance the dominance of the figure, who confronts the viewer directly, provoking a sense of intimacy and immediacy.

Sargent displayed his command of watercolor by selecting a heavy-weight, textured paper and masterfully combining wet and dry techniques in multiple layers. By varying the amount of water in his pigments, he not only altered the intensity of his colors but also exploited the surface of the paper to maximum effect. Wet washes are absorbed into the paper, creating broad passages of color. They are blotted or dabbed—for example, in the lower left corner—to remove pigment and reveal previously applied layers. A drier brush skims across the surface of the paper, leaving the textured valleys free of color. Sargent exquisitely applied wet over dry (the upper left arm), dry over dry (the lower left corner), and wet over wet (the bleeding lines in the upper right corner) to create diverse effects.

As in catalogue 232, Sargent suggested form and detail with minimal effort. This sheet, however, is characterized by a more spontaneous, abstract or abbreviated, expressive brushwork. Sargent indicated the left hand with a pale wash of color and delineated the fingers by indicating the shadows between with dashes of dark pigment. The figure rests his arm and head on an unidentifiable support, which is represented with an explosion of strokes in deep colors at the lower left corner of the composition.

A series of small holes around the border of the sheet suggests that it was mounted at one time, probably for painting. Dripping paint, particularly in the lower right corner of the composition, indicates that the work was painted upright, probably on an easel, and suggests the speedy, apparently effortless execution.

EXHIBITIONS: New York–Buffalo–Albany 1971–72, cat. 11; "Turn-of-the-Century America," Seattle, January 25–March 12, 1978 (shown only at Seattle venue of exhibition originating at Whitney Museum of American Art, New York); "American Watercolors, Drawings, and Prints: A Special Exhibition, Part II," The Metropolitan Museum of Art, September 16–December 16, 1980 (no catalogue); "Watercolors and Drawings by Centurion John S. Sargent," The Century Association, New York, September 21–October 23, 1982 (no catalogue); New York–Chicago 1986–87 (shown only in Chicago).

REFERENCE: Fairbrother 1981a, pp. 75–77.

234. Allegorical Subject with Winged Figures

after 1910
Watercolor and graphite on off-white wove paper
12⁵⁄₁₆ × 7⁷⁄₈ in. (31.2 × 20 cm)
Gift of Mrs. Francis Ormond, 1950
50.130.140dd

Broad passages of dark wash cover cursory underdrawings and preclude precise identification of the subject of catalogue 234. The composition includes various winged figures, trumpeting figures to the right, ascending and/or descending figures to the left, and a group at the bottom center. The lower right is covered in large passages of dark watercolor wash; graphite underdrawing, while evident beneath the wash in this area, is difficult to read. The combination of winged and trumpeting figures recalls Last Judgment imagery that Sargent used in two late mural compositions: *Judgment* at the Boston Public Library (see figure 81) and *Death and Victory* at the Widener Memorial Library at Harvard University (see figure 89).

Jane Dini suggests that this composition might be linked to a preliminary study (Fogg 1929.307) for *Death and Victory* (oral communication, February 1997). The group at the left may be related to the main figures of the mural, in which a soldier is depicted intertwined with the personifications of Death and Victory. See catalogue numbers 213 and 214 for studies for *Death and Victory* and its companion mural at the Widener Library.

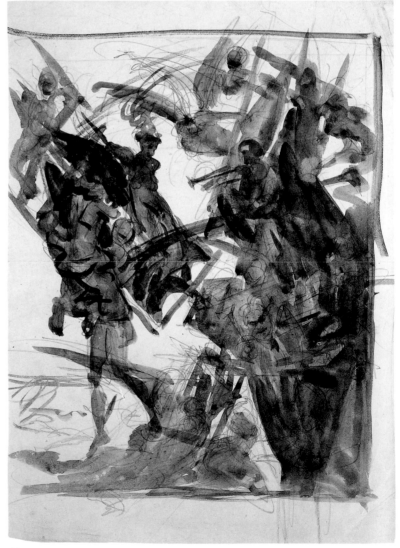

234

235. *Turkeys*

1913 or later
Graphite on off-white wove paper
9¹⁵⁄₁₆ × 14⁹⁄₁₆ in. (25.2 × 36.9 cm)
Inscribed at lower left: J.S. 380; on verso at upper
right: 353; at upper left: NS
Gift of Mrs. Francis Ormond, 1950
50.130.142l

As animals are a recurring theme in Sargent's graphic oeuvre, such studies are often difficult to date (see, for example, cats. 211 and 212). Catalogue 235, however, may be related to a bronze sculpture (figure 96) that its owner dates to 1913. Two studies of turkeys in the Fogg Art Museum (1937.8.4 and 1937.8.39) are on the same size paper, probably from a sketchbook. On the Fogg sheets, Sargent studied the entire body of the bird in profile facing left and right, as well as head-on. In catalogue 235, he explored details of the bird's head (facing left and right) and plumage. As a group, these drawings suggest the careful consideration of all sides of an object necessary to create a sculpture.

Sargent's friend Eliza Wedgwood recalled his encounter with a turkey at San Vigilio at Lake Garda, Italy, in 1913: "Jane de Glehn . . . and I were so amused one day

on hearing strange noises, to see John, camera in hand squatting and gobbling, till he was red in the face, trying to attract the turkey-cock, who he afterwards reproduced in plaster [and bronze]" (Eliza Wedgwood, quoted in Olson 1986, p. 240).

Sargent's activity as a sculptor has not been thoroughly studied. His most ambitious work was his large crucifix for the Boston Public Library. He also designed reliefs for the library and for the Museum of Fine Arts, Boston.

EXHIBITION: Probably included in New York 1928 (inventory listing J.S. 380).

Figure 96. *Turkey,* 1913. Bronze, h. 17¾ in. (45.1 cm). Corcoran Gallery of Art, Washington, D.C.; Museum Purchase (25.2)

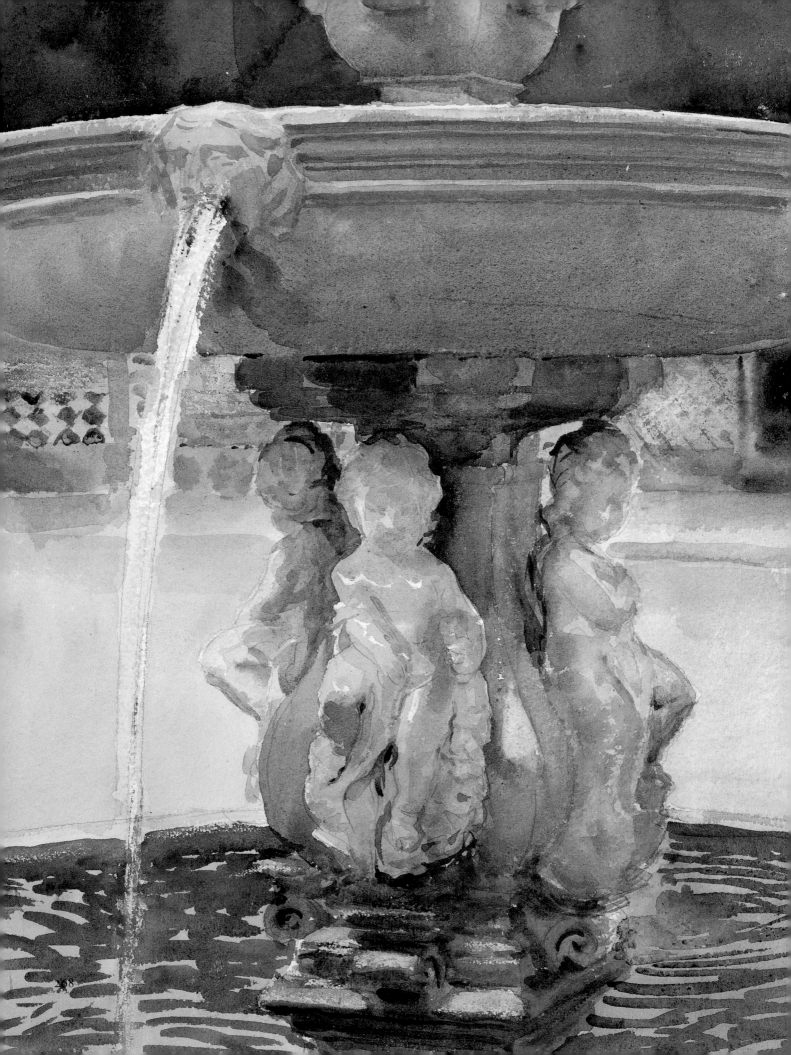

Records of Travel and Other Studies, 1890–1925

During the 1890s Sargent established his reputation as a portraitist and gained the patronage of distinguished and well-connected sitters from several sectors of international society. He was at the same time deeply involved with painting murals and was able to install major portions of his ambitious decorative scheme in the Boston Public Library in 1895 and 1903. Simultaneously, Sargent began a process of self-reinvention that would culminate during the first decade of the twentieth century. It was then that casual travel vignettes and more ambitious works inspired by them, executed in oil and especially in watercolor, would occupy more of his time and become a new source of critical and financial support. The virtuoso watercolor "snapshots"[1] that Sargent created after 1900 are among his masterpieces and account for his reputation as one of the greatest American watercolorists.

Sargent's ability to travel reflected the pattern of his professional development and obligations. Throughout an unusually peripatetic childhood and during his student years, he had traveled widely to study traditional art and to paint at picturesque locales. After the debacle of the 1884 Salon and his ensuing move to London, he found diversion in Impressionist experiments in the English countryside. During the late 1880s and early 1890s, as his clientele for portraits and his commitment to decoration increased, he was obliged to stay close to his studios, painting portraits in London and working on the library project at Broadway. When he found time to travel, it was to depict patrons in the United States in 1887 and 1889, for example, or to make studies for his murals in Italy in 1897. He journeyed to Spain in 1892 (to visit his mother and sister) and in 1895 (to meet his mother, who was recovering from an illness), and in 1897 he visited Scotland.

While Sargent painted in watercolor during these excursions (see cats. 251 and 258), he did not produce the quantities of works that his later travels would inspire.

Having decided to elucidate at the Boston Public Library a subject no less ambitious than *The Triumph of Religion,* an erudite program that described the history of religious thought from paganism through Judaism to Christianity, Sargent visited Egypt, Greece, and Turkey immediately after he received the commission late in 1890, noting the sights he encountered in sketches and paintings (figure 98). His experience of the ancient lands validated for him the choice of a religious subject and inspired him, as he explained in a letter to Isabella Stewart Gardner in August 1891: "The consequence of going up the

Figure 98. *Egyptians Raising Water from the Nile,* 1890–91. Oil on canvas, 25 × 21 in. (63.5 × 53.3 cm). The Metropolitan Museum of Art, Gift of Mrs. Francis Ormond, 1950 (50.130.16)

Figure 97 (opposite). *Spanish Fountain* (detail), see catalogue 315.

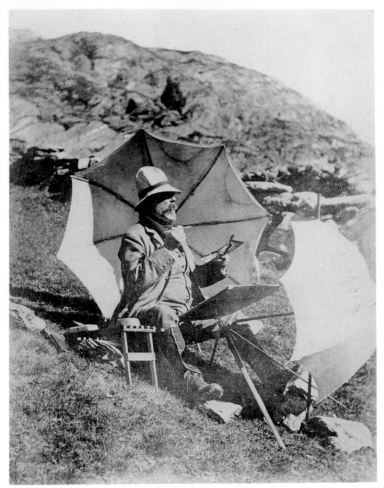

Figure 99. Sargent sketching outdoors, Simplon Pass, ca. 1909–11. Private collection

Nile is, as might have been foreseen, that I must do an Old Testament thing for the Boston Library, besides the other one, & I saw things in Egypt that I hope will come in play."[2]

Adelson has speculated that it was actually Sargent's wish to travel that prompted his choice of a complex theme for the library murals. The recondite program, Adelson noted, "had less to do with his own dilute personal religion than with the fact that it would allow him to depict exotic and arcane elements of Eastern culture, indulging his own fascination for the costumes and rituals of intriguing characters and places."[3] Throughout the lengthy project, Sargent would incorporate into his itinerary sites where he could view a variety of actual and artistic sources, from Egyptian and Syrian to European Renaissance and Baroque. He would also travel specifically to conduct research, as he did in 1905–6, when he made mural studies in Syria, Palestine, and Lebanon.

From about 1900 until the beginning of World War I, Sargent enjoyed annual holidays that sometimes lasted three or four months. In the company of family members and friends, he usually went to rural locales in temperate climates where he could indulge

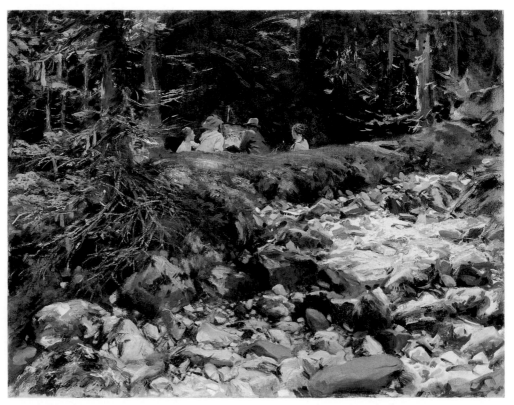

Figure 100. *The Master and His Pupils,* 1914. Oil on canvas, 22 × 28 in. (55.9 × 71.1 cm). Museum of Fine Arts, Boston, The Hayden Collection (22.592) © 1999 Museum of Fine Arts, Boston. All rights reserved.

his passion for plein air work (figure 99). Having passed July and August in such places, he often journeyed on to Venice or to destinations further south. Sargent particularly favored regions that he had visited during his childhood: the Alps, the Italian lake district, and Spain. He went to Italy or Spain every year between 1900 and 1913, and was caught in the Austrian Tyrol when World War I started in 1914.

As he had always done, Sargent recorded the sights and people he encountered, drawing in sketchbooks, completing informal oils, and making studies for more ambitious canvases. Portable watercolors were especially well suited to Sargent's summer wanderings, and as he traveled more often after 1900, his output of radiant works in the medium increased dramatically. Adrian Stokes (1854–1935), Sargent's artist friend and traveling companion, observed: "Though he most likely considered himself to be on a holiday his industry was constant."[4]

Beginning in 1903, Sargent showed large groups of his "holiday" watercolors to great acclaim at various exhibitions, first in London and then in New York. Barbara Gallati reasonably claims that Sargent "should be credited with having charted a course to encourage general respect for the medium and to enhance interest in his own watercolor output specifically with a view toward engineering his emancipation from commissioned portraiture."[5] Sargent orchestrated his career so astutely that by 1907, when he pledged not to accept any more portrait commissions, he had established a solid reputation as a watercolorist.

Sargent not only visited similar places year after year but repeated certain subjects to create what Ormond has called a "coherent artistic vision."[6] During his frequent trips to Venice, he produced numerous images of canals and monuments. His many sojourns in the mountains, from the Alps and the Tyrol to the Rockies, yielded dramatic landscapes. In Italy and Spain, he painted buildings, gardens, and monuments. Sargent often included companions in these works (figure 100), portraying them reading, sketching, or resting outdoors, or dressing them up for exotic costume pieces.

Fundamental to Sargent's "coherent artistic vision" was his interest in optical effects, especially how various surfaces reflected and absorbed light.

As Ormond has explained, Sargent's subjects were "primarily vehicles for statements about colour and light, even paint itself."[7] Sargent's handling of light has long provoked enthusiastic appraisals. Stokes noted: "My own feeling about Sargent's watercolours is that—invariably brilliant in execution—they usually record, with the utmost directness, something that had excited his admiration, or appealed to his artistic intelligence. That may have been the clearly defined and exquisite edge of some rare object; or the way in which a dark thing, when opposed to vivid light, is invaded by it and loses local colour."[8] Charteris remarked in 1927: "To live with Sargent's water-colours is to live with sunshine captured and held."[9]

While Sargent's enchantment with color and light transcends media as well as subject, it was especially abetted by the transparency and spontaneity of watercolor. When painting in watercolor, he chose subjects that invited virtuoso rendering, and he defied any inherent constraints of the medium by altering the consistency and opacity of his pigments to suit his bravura style. In 1921, art critic Henry Tyrell summarized Sargent's accomplishment:

From one radiant sketch to another, we can see his growing infatuation with the free untrammeled medium, until what was taken up as a holiday plaything finally absorbs all the resources of a spontaneous and in some ways incomparable talent. The method is neither French nor English, but all original Sargent. . . . Work like this, always an intrinsic delight, reveals the strength and adaptability of water-colour, as giving full scope to the individual artist in his best line of endeavour.[10]

Although the genius of Sargent's technique appears to lie in its seeming spontaneity and effortlessness, contemporary descriptions of him at work suggest that the apparent facility of the finished composition was in part a deception. The American modernist painter Manierre Dawson (1887–1969), who observed Sargent at work in Italy in 1910, noted in his diary: "At the start of a painting he is very careful and then as it develops he lays on the paint with more freedom. When about done he looks at it with piercing eyes and making a stroke here and there, gives the whole a look of spontaneous dash. Although nine-tenths of

Figure 101. *The Hermit (Il Solitario),* 1908. Oil on canvas, 37¾ × 38 in. (95.9 × 96.5 cm). The Metropolitan Museum of Art, Rogers Fund, 1911 (11.31)

the work is very careful indeed, there is a look of bold virtuosity when the work is done."[11] (Although Dawson's remarks do not differentiate between Sargent's approaches to oil and watercolor, they seem especially pertinent to the latter medium.) Tyrell echoed: "New possibilities are added to water-colour, in this quick conjuring forth of faces, figures, objects, architecture with the patina of time on bronze and marble, and landscapes of country-side and city, all in open air and sunlight, done in seemingly careless dashes of delicate liquid colour

Figure 102. *Alpine Pool,* 1907. Oil on canvas, 27½ × 38 in. (69.9 × 96.5 cm). The Metropolitan Museum of Art, Gift of Mrs. Francis Ormond, 1950 (50.130.15)

stain, yet with the same firm precision of brushwork that characterized his 'swagger' presentments in oil."[12] Marjorie Shelley discusses the careful preparation that underlies Sargent's apparently effortless results in "Materials and Technique," in this volume.[13]

Ultimately, Sargent's watercolors reveal his *sprezzatura,* or studied nonchalance. His ability to suggest forms with minimal brush strokes adds to the appearance of ease. In 1926, Stokes, who had been with Sargent in the Tyrol in 1914, recalled the artist's method:

He came to work beside me, and that was the first occasion when, for any length of time, I saw him paint. It was an experience never to be forgotten!

His hand seemed to move with the same agility as when playing over the keys of a piano. That is a minor matter; what was really marvellous was the rightness of every touch. I knew those rocks—I had been struggling with them for days. . . . All was rendered, or suggested, with the utmost fidelity. Parts were loaded, parts were painted clear and smooth, every touch was individual and conveyed a quick unerring message from the brain. It was—if you will—a kind of shorthand, but it was magical![14]

In an account published in 1930, painter and writer Martin Hardie (1875–1952) wrote that Sargent knew "exactly how his free and simple blots and dashes of colour—seemingly indefinite, none of them really irrelevant—would coalesce into form and meaning when viewed from further off." Hardie also invoked the notion of magic: "It is astounding to note the almost magical skill by which the swift touches of his brush build up and express the infinite varieties of the surfaces and substances which he was painting."[15]

Sargent's gift for fashioning objects as if by magic was enhanced by his unconventional compositions. He often cropped his images dramatically, providing only partial glimpses of monuments or fragments of architecture. In pastoral settings, he rejected broad vistas, ignored the sky, exploited close vantage points, and directed his gaze downward to grass, rocks, and brooks. His broad application of pigment, indifference to details, and attention to pattern rather than forms make many images nearly abstract (figure 103).

Between 1904 and 1908 Sargent paid annual visits to Val d'Aosta, in the foothills of the Alps in north-

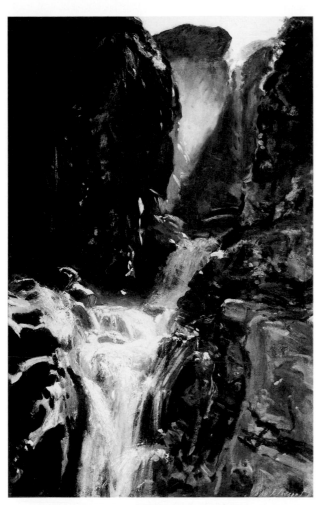

west Italy. Sargent's coterie settled at a *pensione* in the remote town of Purtud. In the nearby hamlet of Peuterey, he painted a group of exotic costume pieces in oil and watercolor for which his companions served as models and the town's picturesque brook was often the setting. The grandest of the exotic figure paintings is *Cashmere* (figure 104), which depicts seven figures (all modeled by the artist's niece, Reine Ormond), each draped in the same cashmere shawl and progressing mysteriously across a tapestry-like landscape background.

As he would often do when he encountered picturesque alpine brooks, Sargent adopted a near view to study the brook at Peuterey and the rocks and foliage along its banks. Watercolors depicting this subject are usually associated with Peuterey but may pertain as well to similar locales that he visited in the ensuing years. They reveal Sargent's transformation of flowing pigments into flowing brooks and

Figure 103 (left). *A Waterfall*, ca. 1910. Oil on canvas, 44½ × 28½ in. (113 × 72.4 cm). Private collection

Figure 104 (below). *Cashmere*, 1908. Oil on canvas, 28 × 43 in. (71.1 × 109.2 cm). Private collection. Photograph © 1996 Sotheby's Inc., New York.

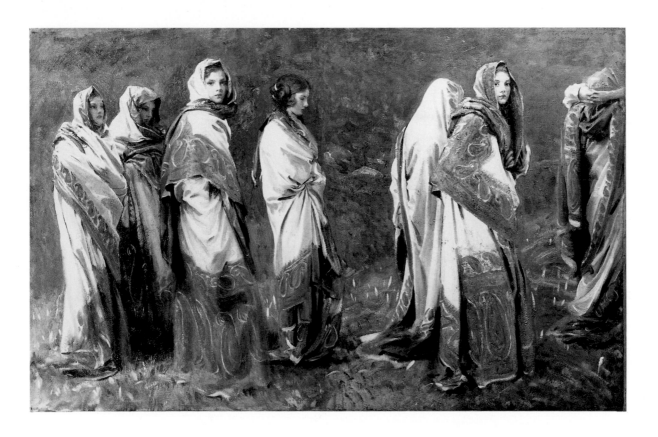

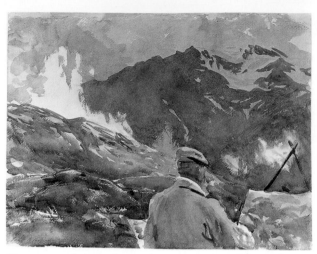

Figure 105. *Artist in the Simplon,* ca. 1910–11. Watercolor and graphite on white wove paper, 15¹³⁄₁₆ × 20¹³⁄₁₆ in. (40.2 × 52.9 cm). Fogg Art Museum, Harvard University Art Museum, Cambridge, Gift of Grenville L. Winthrop (1942.54) © President and Fellows of Harvard College, Harvard University. Photograph courtesy of Photographic Services

his fascination with light on water: running rapidly, as in *Rushing Brook* (cat. 291); or relatively still and transparent, as in *Brook and Meadow* (cat. 290); or reflecting the objects along the banks, as in *Stream and Rocks* (cat. 289). Even an oil such as *Alpine Pool* (figure 102) effectively conveys the experience of submerged forms seen through sparkling water.

Reiterating the interdependent relationship between Sargent's portraits and his mural paintings, his candid Val d'Aosta landscapes were linked with intellectual works such as *The Hermit (Il solitario)* (figure 101). This oil painting shares the unconventional presentation and facile execution of his Val d'Aosta watercolors; like them, it concentrates on varied paint surfaces and allows light and shadow to appear as if they were independent of form. Yet *The Hermit* includes two gazelles (contrived from a stuffed specimen)[16] and a figure whose harmonious relationship with his surroundings invokes religious characters such as Saint Anthony and philosophical ideas such as pantheism.[17]

Sargent also painted the mountains at Val d'Aosta and the nearby Simplon Pass (figure 105), the French Alps (1912), northern Italy (1913), and the Tyrol (1914). He preferred oblique, close-up views that concentrate on rugged foregrounds and that are dynamically cropped to eliminate the sky. His focus

on the surface of the earth allowed him to explore patterns of color and light among the rocks. The Metropolitan's collection includes a graphite study (cat. 287) for *Val d'Aosta* (figure 106), one of his grandest alpine oils. Many other alpine watercolors resist identification of site and can be dated only generally between 1904 and 1914. Sheets such as *Glacier* (cat. 292) and *Mountain Torrent* (cat. 302), for example, are very broadly painted, highly experimental, and indifferent to specific landscape details.

Although Sargent wrote to Henry Tonks in 1920, "As you know enormous views and huge skies do not tempt me,"[18] he was occasionally tempted to depict broad panoramas under transitory atmospheric conditions. *From Jerusalem* (cat. 277) and *Sunset* (cat. 278), painted during his 1905–6 trip to the Middle East, record changing effects of light and atmosphere over open vistas. In the latter sheet, broad, fluid strokes and a wet-on-wet technique suggest the shimmer of waning daylight. In *Sirmione* (cat. 323), he represented the clouds over the peak at the edge of Lake Garda in Italy.

Like many of his contemporaries, Sargent was captivated by Venice.[19] He had visited the city as a child and returned there during the early 1880s. Between 1898 and 1913 he made nine sojourns there, creating more than 150 watercolors and oils.[20] While in Venice, he visited his relatives the Curtises at their Renaissance palazzo, sometimes lodging with them. Although he painted a few studies such as *Madonna, Mosaic, Saints Maria and Donato, Murano* (cat. 261) that may have pertained to his murals, the principal attraction for Sargent during his later visits to Venice was sun shimmering off the canals onto buildings, creating patterns across the ornament.

While Sargent captured broad vistas, as in *Giudecca* (cat. 321) and *Venetian Canal* (cat. 322), he most often described the city as it is seen from a gondola, exploiting low vantage points, cropping forms abruptly, and offering indirect, partial impressions of major landmarks and less familiar sites. He was enchanted by intimate, sometimes obscure, details, which appear in watercolors such as *Venetian Passageway* (cat. 274) and *Green Door, Santa Maria della Salute* (cat. 273).

Sunlight and shadow are the near-universal protagonists in watercolors that Sargent made in

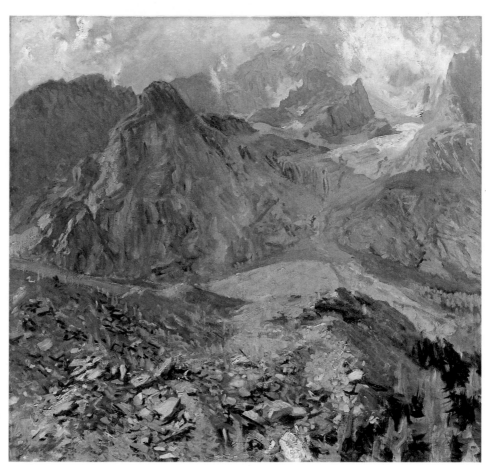

Figure 106. *Val d'Aosta,* 1907. Oil on canvas, 35½ × 37 in. (90.2 × 94 cm). © Tate Gallery, London

Italy and Spain between 1905 and 1912. In *Loggia, Villa Giulia, Rome* (cat. 293), he delighted in the contrast between the brilliant columns and the cool interior. In a pair of watercolors, he studied the effects of sunlight on a group of buildings in Borgo San Lorenzo (cats. 304 and 305), northeast of Florence. In *Escutcheon of Charles V of Spain* (cat. 314), he translated the relief representing the coat of arms of the emperor into a dazzling pattern.

The grand parks and gardens of Italy and Spain particularly engaged Sargent's attention. In the autumn of 1906, he expressed his enthusiasm for the villas and gardens in the Roman campagna in a letter to painter Ralph Curtis: "They are magnificent and I should like to spend a summer at Frascati and paint from morning till night at the Torlonia or the Falconiere, ilexes and cypresses, fountains and statues—ainsi soit il—amen."[21] He would return to sketch and paint in the region in 1907 (cats. 294 and 295). Beyond the environs of

Rome, he painted watercolors such as *Boboli Gardens, Florence* (cat. 286), *Garden near Lucca* (cat. 303), and *Spanish Midday, Aranjuez* (cat. 320), which celebrate sunlight on marble or stone and on lush foliage.

During his 1912 visit to Granada, Spain, Sargent painted in the gardens of the Alhambra. *In the Generalife* (cat. 316), a masterful watercolor from this trip, depicts Sargent's sister Emily painting as artist Jane de Glehn, at left, and a companion look on. Sargent frequently recorded his associates, who were often artists by profession or avocation, poised at their easels.

When World War I limited Sargent's European holidays, he found alpine subjects in 1916 in the Canadian Rockies (cats. 330 and 331). In 1917 he visited longtime friends, the Deerings, in Miami, Florida. Vizcaya, James Deering's Renaissance-style villa (now a museum), and its Italianate gardens struck a resonant chord; long accustomed to the old

European originals, Sargent was enchanted by their new American counterparts. He described Vizcaya in a letter to Fox: "The great big villa that James Deering has built down here *(Chalfin architect)* is a mine of sketching. It is like a giant Venetian Villa on the Brenta with columns & loggias & porticoes and ships down to the water, and dark gardens with statues just like Frascati. I can't tear myself away."[22] Of his watercolors, the Metropolitan owns but one example depicting the formal grounds of Vizcaya, catalogue 336, which shows a carved balustrade and urn-shaped finial against the landscape and ocean.

Sargent sold seven of his Florida watercolors, executed at Vizcaya and other places around Miami, to the Worcester Art Museum in 1917. Many related works remained in his collection until his death, after which Mrs. Francis Ormond gave several to the Metropolitan. Sargent explored the patterns and colors of the local landscape in *Landscape with Palmettos* (cat. 332), *Palmettos* (cat. 333), and *The Pool* (Worcester Art Museum). Worcester's *The Bathers* (figure 107) appears to culminate a series of less resolved studies of a nude male made in the pre-

served natural landscape on the outskirts of the Vizcaya property (cats. 337–40). The Metropolitan's unfinished study *Alligators* (cat. 334) relates to Worcester's *Muddy Alligators*.

Sargent's travel watercolors have provoked a range of appreciation and interpretation since he began to exhibit them in 1903. In an unsigned review of the 1903 exhibition at Carfax Gallery in London, modernist critic Roger Fry, often an antagonist of Sargent's, was particularly dismissive. Citing what he perceived to be Sargent's lack of innovation, he opined sarcastically: "Frankly, we like Mr. Sargent better on parade at the Academy than in undress at the Carfax Gallery. . . . For here we see, alas! that Mr. Sargent when he goes to Venice for his holidays reacts to the new surroundings for all the world like an ordinary tourist."[23] After the memorial exhibitions in 1925 and 1926, Fry was even more emphatic, describing Sargent's *"impressions de voyage"* as "desperately commonplace originalities of aristocratic vulgarity."[24]

By contrast, the appreciation that Tyrell, Stokes, Charteris, and others conferred on Sargent's travel watercolors has been noted. Conservative painter and

Figure 107. *The Bathers,* 1917. Watercolor, gouache, and graphite on off-white wove paper, 15¾ × 20¾ in. (39.8 ×52.7 cm). Worcester Art Museum, Massachusetts, Sustaining Membership Fund (1917.91)

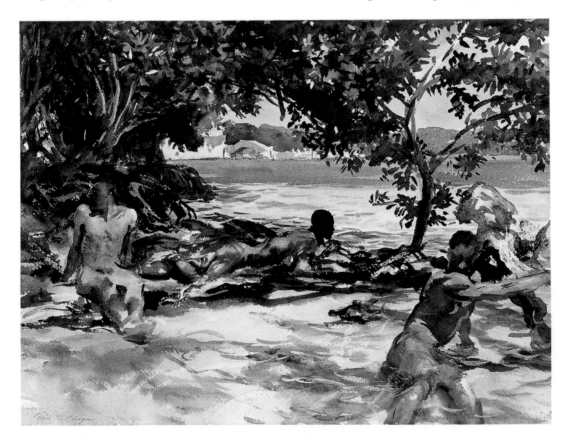

critic Kenyon Cox (1856–1919) was similarly ecstatic about ten handsome, large-scale travel watercolors that Sargent sold to the Metropolitan in 1915. When these sheets were put on display in January 1916, together with watercolors by Winslow Homer (1836–1910) from the collection, Cox enthused in the Museum's *Bulletin* about their directness:

In these sketches from the portfolio of a wandering painter we have the typical modern naturalist noting whatever chances to appeal to him; and the things appeal to him, one feels, not for what they are or what they mean, but almost solely for how they look. . . .

He is an eye and a hand. He seems to say: "I assure you this is the way things really look if you know how to see. These strange blots and touches of mine truly represent the colors and shapes that strike upon the retina. It is your mind that makes boats or stones or clouds or trees out of them." And because his are perhaps the most gifted and the most highly trained hand and eye now extant in the world you are quite content to forget with
him, for the moment, that art has ever had anything else to say than, "This is the way things look."[25]

Late twentieth-century observers agree more often with Cox and other enthusiasts than with Fry.

Not only has critical response to Sargent's travel watercolors varied, but the very issue of his intentions in making them has been subject to reconsideration. Just as some early critics and biographers disparaged these works, others, such as Albert E. Gallatin, writing in 1922, understated their importance by describing them as "holiday recreations, glimpses and souvenirs of his travels."[26] Recent studies of Sargent's exhibition strategies after 1900 have helped to aggrandize these works within his oeuvre.[27] Even Ormond, who wrote in 1970 that "the enormous number of oil sketches and watercolors which he painted were undertaken purely for his own pleasure,"[28] recently reassessed the relative weight of Sargent's concerns and concluded: "He did not paint because he went abroad; he went abroad to paint."[29]

1. "What to ask for a mere snapshot, especially if it does not happen to be a miraculously happy one," JSS in Martin Hardie, *Water-colour Painting in Britain* 3, p. 159, quoted in Walsh 1987, p. 63, n. 32.
2. JSS to Isabella Stewart Gardner, Bursa, Turkey, [August] 1891, Isabella Stewart Gardner Papers, Archives of American Art. "The other one" may refer to the subject of the pagan gods, also part of the library scheme.
3. Adelson et al. 1997, p. 24.
4. Stokes 1926, p. 53.
5. Gallati 1998, p. 120. See also the introduction to this catalogue.
6. Adelson et al. 1997, p. 7.
7. Ormond 1970a, p. 69.
8. Stokes 1926, p. 60
9. Charteris 1927, p. 225.
10. Tyrell 1921, p. xxx.
11. Manierre Dawson journal, September 26, 1910, Archives of American Art, quoted in Burke 1980, p. 264.
12. Tyrell 1921, p. xxx–xxxi.
13. In addition to Shelley's discussion, in an excellent essay on the watercolor techniques of Sargent and Winslow Homer, conservator Walsh supports Sargent's friends' observations with technical data, concluding that "Sargent's approach to watercolor might have appeared almost intuitive and his execution amazingly swift. However, close scrutiny of individual works reveals dexterous manipulation of the medium" (Walsh 1987, p. 56).
14. Stokes 1926, p. 54.
15. Hardie 1930, pp. 4–5.
16. Adelson notes that "the animals were modeled from a stuffed gazelle that Sargent had packed into his Alpine luggage as a prop" (Adelson et al. 1997, p. 40).
17. Approving of *The Hermit* as the translated title for the picture, Sargent wrote to Robinson, director of the Metropolitan: "I wish there were another simple word that did not bring with it any Christian association, and that rather suggested quietness or pantheism" (JSS to Edward Robinson, [London], March 16, 1911, Metropolitan Museum of Art Archives).
18. JSS to Henry Tonks, 1920, quoted in Ormond 1970a, p. 69.
19. For a discussion of American artists and Venice in the nineteenth century, see San Francisco–Cleveland 1984–85 and Lovell 1989.
20. Donna Seldin Janis determined that Sargent painted some 150 Venetian works during the first decade of the century (Adelson et al. 1997, p. 214).
21. JSS to Ralph W. Curtis, [Rome], quoted in Charteris 1927, p. 171.
22. JSS to Thomas A. Fox, Brickell Point, Miami, Florida, April 10, [1918], in Thomas A. Fox–John Singer Sargent Collection, Boston Athenaeum.
23. "Mr. Sargent at the Carfax Gallery," *Athenaeum*, no. 3943 (May 23, 1903), p. 665, quoted in Adelson et al. 1997, p. 224.
24. Fry 1926, p. 128.
25. Cox 1916, pp. 36–37.
26. Gallatin 1922, p. 6.
27. New York–Chicago 1986–87, pp. 209–49; Gallati 1998, p. 117–41.
28. Ormond 1970a, p. 68.
29. Adelson et al. 1997, p. 6.

236

236. Musicians and Listeners

after 1890
Graphite on off-white wove paper
10⅛ × 13⁹⁄₁₆ in. (25.7 × 34.5 cm)
Gift of Mrs. Francis Ormond, 1950
50.130.102

237 recto. Vulture

after 1890
Graphite on off-white wove paper
5 × 7 in. (12.7 × 18 cm)
Gift of Mrs. Francis Ormond, 1950
50.130.142i recto

237 verso. Vultures

after 1890
Graphite on off-white wove paper
5 × 7 in. (12.7 × 18 cm); attached piece: 5⅜ × 2½ in.
(13.7 × 6.4 cm)
Gift of Mrs. Francis Ormond, 1950
50.130.142i verso

The sketches on catalogue 237 have a
quick and confident style similar to that of
Sargent's studies of swans (cats. 211 and
212) and may date from about the same
time. Sketches of vultures are in the Museum
of Fine Arts, Boston (28.918), and vultures
also appear in Fogg sketchbook 1937.7.29
(ca. 1912).

238

238. Woman Walking

1890s?
Charcoal on off-white wove paper
10¹⁄₁₆ × 6⅝ in. (25.5 × 16.8 cm)
Inscribed at lower left: J.S. 360; on verso at upper
right: 373
Gift of Mrs. Francis Ormond, 1950
50.130.108

Sargent may have sketched catalogue 238
in one of the exotic locales he visited in the
1890s. A related drawing is in the Fogg Art
Museum (1937.8.189).

EXHIBITIONS: Probably included in New York
1928 (inventory listing J.S. 360); "Sargent, Whistler
and Cassatt," American Federation of Arts, traveling
exhibition, September 1954–57 (no catalogue).

237 recto 237 verso

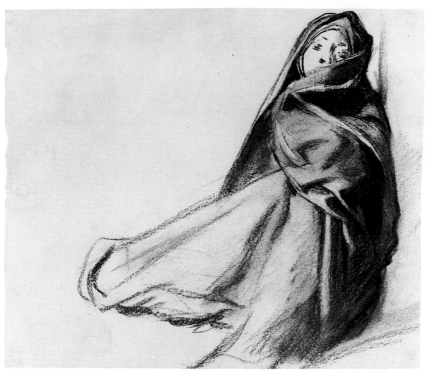

239

239. Draped Seated Woman

1890–95
Charcoal on white wove paper
10 1/16 × 11 3/4 in. (25.5 × 29.8 cm)
Watermark: J. Whatman 1889
Gift of Mrs. Francis Ormond, 1950
50.130.105

After receiving the commission late in 1890 to paint murals for the Boston Public Library, Sargent traveled to Egypt, Greece, and Turkey with his mother and two sisters. While he could have sketched the mysterious figure in catalogue 239 during that trip, Volk has suggested that Sargent may have drawn it as late as 1895, when he visited Morocco (London–Washington, D.C.–Boston 1998–99, p. 187). Catalogue 239 belongs to a group of drawings of similarly draped standing figures rendered in dark charcoal, which includes works in the Corcoran Gallery of Art (49.252); the Museum of Fine Arts, Boston (28.936); the Fogg Art Museum (1931.96); and the Mead Art Museum, Amherst College, Massachusetts (D1930.8). In all of these drawings, Sargent concentrates on the stiff drapery as it falls in angular folds. Of this group of drawings Volk has observed, "This is the costume worn by all the women in the vault imagery above the south wall at the Library" (London–Washington, D.C.–Boston 1998–99, p. 187).

These sheets attest to Sargent's continuing fascination with the exotic, especially elaborately attired women, as is seen in such works as *Fumée d'Ambre Gris* (see figure 58), *El Jaleo* (see figure 60), and his Javanese dancers (cats. 185 and 186a–ss).

EXHIBITIONS: "Sargent, Whistler and Cassatt," American Federation of Arts, traveling exhibition, September 1954–57 (no catalogue); "Images of Women: Nineteenth-Century American Drawings and Watercolors," The Metropolitan Museum of Art, October 1996–February 1997 (no catalogue).

REFERENCES: Nygren 1983, p. 59; London–Washington, D.C.–Boston 1998–99, p. 187.

240

241

240. Egyptian Relief Head

1890–91
Graphite on off-white laid paper
8 11/16 × 6 3/4 in. (22.1 × 17.1 cm)
Inscribed on verso at lower center: CP
Gift of Mrs. Francis Ormond, 1950
50.130.143dd

241. Egyptian Relief

1890–91
Graphite on off-white wove paper
10 1/8 × 14 in. (25.7 × 35.6 cm)
Inscribed on verso at left: CP
Gift of Mrs. Francis Ormond, 1950
50.130.143ee

The subjects of catalogue numbers 240 and 241 have not been determined with certainty. Catharine H. Roehrig (associate

curator, Department of Egyptian Art, The Metropolitan Museum of Art) has suggested that they are copies after early Ramesside reliefs, probably from one of the sites at Luxor (memorandum to Stephanie Herdrich, November 17, 1997, departmental files, American Paintings and Sculpture). Sargent visited Luxor while traveling up the Nile on a steamer in January–February 1891.

Roehrig observes that catalogue 241 most closely resembles scenes at the mortuary temple of Ramesses II (the Ramesseum), but there the king appears with a sun disk flanked by cobras above his head, not the falcon seen in this drawing. She suggests that Sargent may have conjoined different elements to create his own composition. During his student years, Sargent had copied Egyptian motifs from a book, combining forms to invent his own arrangements (cats. 125–29).

The cursory style of catalogue numbers 240 and 241 relates them to several images in a sketchbook in the Yale University Art Gallery, New Haven (1937.4083), which Sargent seems to have used during his travels in Egypt, Greece, and Turkey.

EXHIBITION (cat. 240): "Artistic Responses to Egypt," Newcomb College Art Gallery, Tulane University, New Orleans, October 6–November 2, 1977, p. 8.

242. *Kore 674, Acropolis Museum, Athens*

1891

Graphite on off-white wove paper

9 13/16 × 6 15/16 in. (25 × 17.7 cm)

Inscribed on verso at upper left: by John S. Sargent; at center: "Archaic / Koure [sic] / Athens, / Acropolis Museum"; at lower left: CP

Gift of Mrs. Francis Ormond, 1950

50.130.143aa

243. *Kore 684, Acropolis Museum, Athens*

1891

Graphite on off-white wove paper

9 13/16 × 6 15/16 in. (25 × 17.7 cm)

Inscribed on verso at upper left: By John S. Sargent; at center: "Archaic Koure [sic] / Athens ?"; at lower center: CD

Gift of Mrs. Francis Ormond, 1950

50.130.143bb

244. *Parthenon Athena, Acropolis Museum, Athens*

1891

Graphite on off-white wove paper

9 13/16 × 6 15/16 in. (25 × 17.7 cm)

Inscribed on verso at upper left: John S. Sargent; at center "Parthenon Athena"; at lower center: CP

Gift of Mrs. Francis Ormond, 1950

50.130.143cc

Sargent drew sculptures in the Acropolis Museum in Athens when he visited there in early spring 1891. In catalogue numbers 242 and 243, Sargent depicts two Archaic korai from the collection, including the masterful Kore 674 described by a guidebook to the museum as "*a tour de force* of the early Attic-Ionic school" (Guy Dickens, *Catalogue of the Acropolis Museum*, vol. 1, *Archaic Sculpture*, Cambridge, 1912, p. 215). A second drawing of Kore 674 is in a sketchbook in the Yale University Art Gallery, New Haven (1937.4083). Catalogue 244 represents the so-called Varvakeion Athena, a one-twelfth-scale replica of the monumental Parthenon Athena (447 B.C.E.) by the great sculptor Phidias (ca. 490–430 B.C.E.). The linear style of catalogue numbers 242–44 is similar to that of catalogue numbers 240 and 241.

EXHIBITION (cat. 244): "Treasures from The Metropolitan Museum of Art," National Pinakothiki Alexander Soutzos Museum, Athens, September–December 1979, cat. 104.

REFERENCE (cat. 244): London–Washington, D.C.–Boston 1998–99, p. 182.

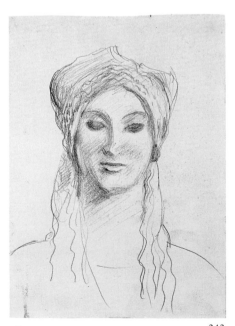

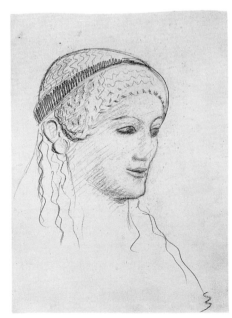

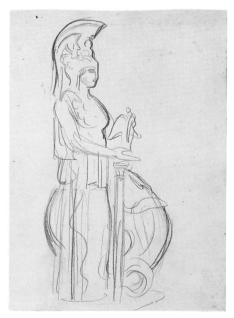

242

243

244

245 recto. *Greek Theatre, Epidaurus*

1891
Graphite on pale green wove paper
10⅛ × 13¹⁵⁄₁₆ in. (25.7 × 35.3 cm)
Inscribed at upper right: Epidaurus
Gift of Mrs. Francis Ormond, 1950
50.130.141bb recto

245 verso. *Tree*

1891
Graphite on pale green wove paper
10⅛ × 13¹⁵⁄₁₆ in. (25.7 × 35.3 cm)
Gift of Mrs. Francis Ormond, 1950
50.130.141bb verso

In late March–early April 1891, Sargent left his mother and sisters in Athens and hired a dragoman to accompany him around the Greek peninsula. He visited Olympia, Delphi, and, according to the inscription on this sheet, Epidaurus, on the coast south of Athens. Performances are still held at the theater at Epidaurus (built in the fourth century B.C.E.), which remains one of the best-preserved classical buildings in Greece. This sheet was torn from an unknown sketch-book. At the right edge of catalogue 245 verso is a sketch of a tree, probably the continuation of a drawing from the adjacent page.

EXHIBITION: "Treasures from The Metropolitan Museum of Art," National Pinakothiki Alexander Soutzos Museum, Athens, September–December 1979, cat. 103.

245 recto

245 verso

246

246. *Sculpture of a Woman*

ca. 1885–95
Graphite on off-white wove paper
6⁵⁄₁₆ × 3⅝ in. (16 × 9.2 cm)
Inscribed on verso at top: CP
Gift of Mrs. Francis Ormond, 1950
50.130.143i

The precise subject of catalogue 246 has not been identified. While the paper is similar in type and size to that in a sketchbook in the Fogg Art Museum (1937.7.15), it is not clear whether this sheet came from that book, which dates from about 1884 (see cats. 181–83). In its rapid execution and use of hatching this sketch resembles slightly later works such as catalogue 247.

247

247. *Entombment, Schreyer-Landauer Monument, Saint Sebalduskirche, Nuremberg*

1890s (after 1891)
After Adam Kraft, German, ca. 1455/60–1509
Graphite on gray-green wove paper
10⅛ × 14 in. (25.7 × 35.6 cm)
Inscribed on verso at lower right: CP
Gift of Mrs. Francis Ormond, 1950
50.130.143r

Catalogue 247 depicts the Entombment of Christ from the Schreyer-Landauer Monument, a late-fifteenth-century sandstone funerary memorial on the exterior of the apse of the church of Saint Sebaldus in Nuremberg, Germany. In a second drawing of the monument (Fogg 1931.109 verso), probably from the same sketchbook, Sargent concentrated on the figures at Christ's feet. The recto of the Fogg sheet contains studies of the *Sanchi Torso*, a tenth-century Indian sandstone sculpture

of the bodhisattva of mercy and compassion, Avalokiteśvara. The sculpture, which was discovered in excavations in 1883 in Sanchi, an important Buddhist site in central India, arrived in England in 1886 and was loaned in 1891 to the South Kensington Museum (which later became the Victoria and Albert Museum), London. The *Sanchi Torso* became part of that museum's permanent collection in 1910. The convergence of such diverse subjects—the torso and the Schreyer-Landauer Monument—on the same Fogg sketchbook page suggests that Sargent probably made catalogue 247 and Fogg 1931.109 verso after the plaster cast of the German sculpture in the museum's renowned cast court and not on site in Nuremburg.

Sargent studied artistic representations from various religious traditions for his Boston Public Library murals. Thus, a date in the 1890s, when he was working on the "Pagan" and "Christian" ends of the mural program, seems likely.

248. *Draped Woman*

after 1895
Graphite on off-white wove paper
7 × 10 1/16 in. (17.8 × 25.5 cm)
Gift of Mrs. Francis Ormond, 1950
50.130.140t

Catalogue 248, which is attached to catalogue 341, comes from a sketchbook in the Fogg Art Museum (1937.7.25) that contains drawings related to Sargent's early mural installations at the Boston Public Library (1895–1903) and the dome of the Museum of Fine Arts, Boston (1916–21). The wide range of material in the sketchbook makes it difficult to date this sheet. Although the subject of the drawing also has not been identified, a related composition is in the Fogg sketchbook (folio 7 recto).

248

249 recto

249 recto. *Man with Loincloth*

1890s
Graphite on off-white wove paper
9 15/16 × 7 in. (25.2 × 17.8 cm)
Inscribed at lower left: J.S. 358
Gift of Mrs. Francis Ormond, 1950
50.130.126 recto

249 verso. *Study for "Women Approaching"*

1890s
Graphite on off-white wove paper
7 × 9 15/16 in. (17.8 × 25.2 cm)
Inscribed on verso at upper left: 374
Gift of Mrs. Francis Ormond, 1950
50.130.126 verso

The three-quarter-length study of a man on catalogue 249 recto is related to an illustration that Sargent made for the title page of a book of music, *Five Songs from "A Book of Verses" by W. E. Henley Set to Music by Francis Korbay,* published in 1898 (figure 108). This drawing records the pose of the figure at the right with slight variations in the position of the model's legs and right arm.

A drawing in the Philadelphia Museum of Art (31-14-11 verso) records more precisely the pose of the same figure, although he appears to hold a sword rather than the long-handled mallet. The Philadelphia drawing is similar in style to catalogue 249 recto, in which dark hatching indicates strong

249 verso

283

shadow. It is inscribed with a name and North London address—most likely that of the model—which suggests that Sargent made the drawing in England. The recto of the Philadelphia sheet records two variations of this pose. A sketch related to this group but resembling the position of the figure at the left on the title page is illustrated in Charteris 1927, opposite page 116.

William E. Henley (English, 1849–1903) was a critic, editor, dramatist, and poet. In 1888, Henley published a collection of his poems, *A Book of Verses,* from which the Hungarian tenor and composer Francis Alexander Korbay (1846–1913) made a selection that he set to music. It is not known whether Sargent knew Henley personally, but they had mutual acquaintances: Robert Louis Stevenson, Edmund Gosse,

and Alice Meynell. Sargent did know Korbay, whom he mentioned in several letters to Isabella Stewart Gardner in the 1890s. Korbay may have been present when the popular Spanish dancer Carmencita performed in Beckwith's New York studio in 1890 (see Fairbrother 1982). Korbay dedicated to Sargent one of the songs in the book, "The Full Sea Rolls and Thunders."

Catalogue 249 verso records in pale graphite, with slight variations in the number of figures, the composition for catalogue 250.

EXHIBITION: (cat. 249 recto): Probably included in New York 1928 (inventory listing J.S. 358).

250. *Women Approaching*

1890s
Watercolor and graphite on white wove paper
$9\,^{15}/_{16} \times 13\,^{15}/_{16}$ *in. (25.3 × 35.4 cm)*
Inscribed on verso at top left: E.S.; at center: $^{1}/_{19}$;
at lower left: SW
Gift of Mrs. Francis Ormond, 1950
50.130.32

A date in the 1890s is suggested by the style and broad execution of this watercolor and is reinforced by its association with catalogue 249, which was executed before 1898.

Although the site has not been identified, the mysterious draped women in the foreground suggest an exotic locale. Sargent could have studied such figures in dark

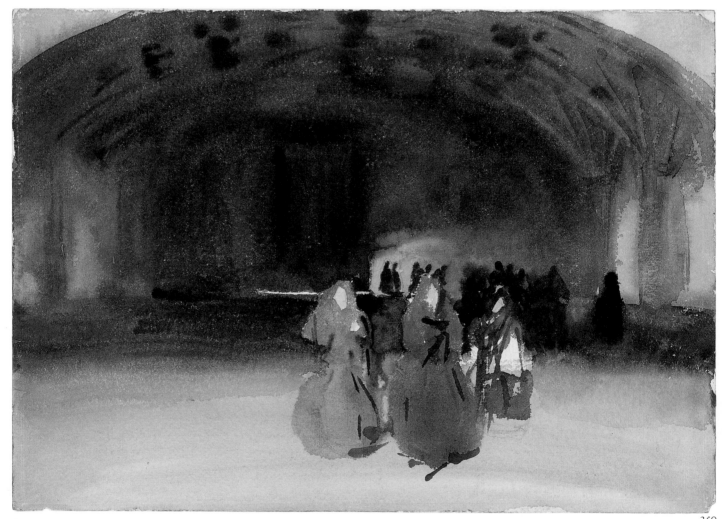

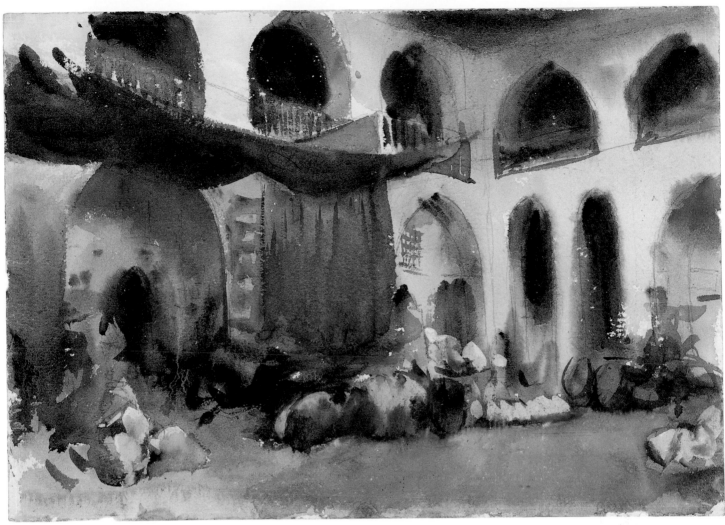

251

251. Market Place

1890s

Watercolor, gouache, and graphite on white wove paper

10 × 13 ¹⁵⁄₁₆ in. (25.4 × 35.4 cm)

Inscribed on verso at center top: ⁵⁄₁₀ [encircled]; at lower left: SW

Gift of Mrs. Francis Ormond, 1950

50.130.28

interiors while he was visiting Egypt, Greece, and Turkey in 1890–91; Tangier and Spain in 1895; or Venice in 1898. The subject and general composition of catalogue 250 echo those of the oil *Door of a Mosque* (ca. 1891, Museum of Fine Arts, Boston), which depicts a larger group of veiled women approaching the viewer as they exit a mosque.

EXHIBITIONS: New York 1966–67, cat. 104; New York–Buffalo–Albany 1971–72, cat. 31.

The earthy palette, accented by blues and purples, and the fluid technique of catalogue 251 are similar to those in catalogue 250. On both sheets, forms are characterized by indistinct edges and minimal detail. Catalogue 251 could represent a caravansary in the Middle East (which Sargent visited in 1890–91) or a market in Spain or Tangier (which Sargent visited in 1895).

The cursory graphite underdrawing is clearly visible, especially in the architecture, where it defines forms and distinguishes planes. Sargent applied broad washes to suggest the shadowed interior spaces beneath the arcades. In the courtyard, he shunned detail, leaving some forms indeterminate amidst the freely rendered clusters of urns and containers.

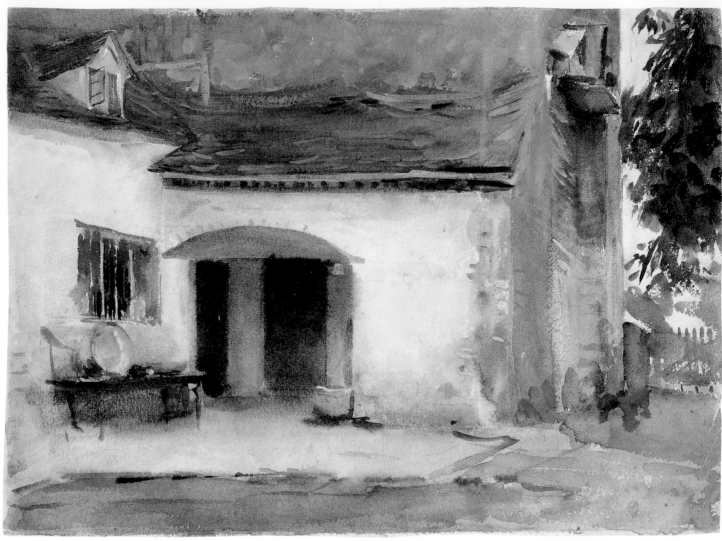

252

252. *House and Courtyard*

ca. 1895–1903?
Watercolor and gouache on white wove paper
11⅝ × 16¼ in. (29.5 × 41.3 cm)
Inscribed on verso at top center: ⁵⁄₁₀ [encircled]; at lower left: SMW
Gift of Mrs. Francis Ormond, 1950
50.130.81g

The date of catalogue 252 is based on style and on Ormond's suggestion that it may have been painted in Portugal, which Sargent visited in 1903 (oral communication, June 16, 1997).

253. *Street, Tangier*

1895
Watercolor, gouache, and graphite on off-white wove paper
13¹⁵⁄₁₆ × 9¹⁵⁄₁₆ in. (35.4 × 25.2 cm)
Inscribed on verso at upper left: 26 / Street—Tangier / 194 by J. S. Sargent / V.O (trust); at center: ⁵⁄₁₉ // 990 [encircled]; at lower left: NA; at lower right: NA
Gift of Mrs. Francis Ormond, 1950
50.130.41

254. *Tangier* (overleaf)

1895
Watercolor, gouache, and graphite on white wove paper
13¹⁵⁄₁₆ × 9¹⁵⁄₁₆ in. (35.4 × 25.2 cm)
Inscribed on verso at upper left: WA / E.S / ⁶⁄₂₈ [encircled]; at upper right: 199 Tangier / by J. S. Sargent; at center: ⁸⁄₁₉; at lower left: NA
Gift of Mrs. Francis Ormond, 1950
50.130.42

Ormond and Kilmurray have suggested that catalogue numbers 253 and 254 date from Sargent's trip to Tangier in July 1895 (oral communication, June 16, 1997). The oblique views and abrupt croppings of these architectural compositions reiterate motifs that Sargent had explored during his visit to Tangier in 1880. In several small oils, Sargent had studied Moorish buildings in sunlight and shadow (for example, *White*

286

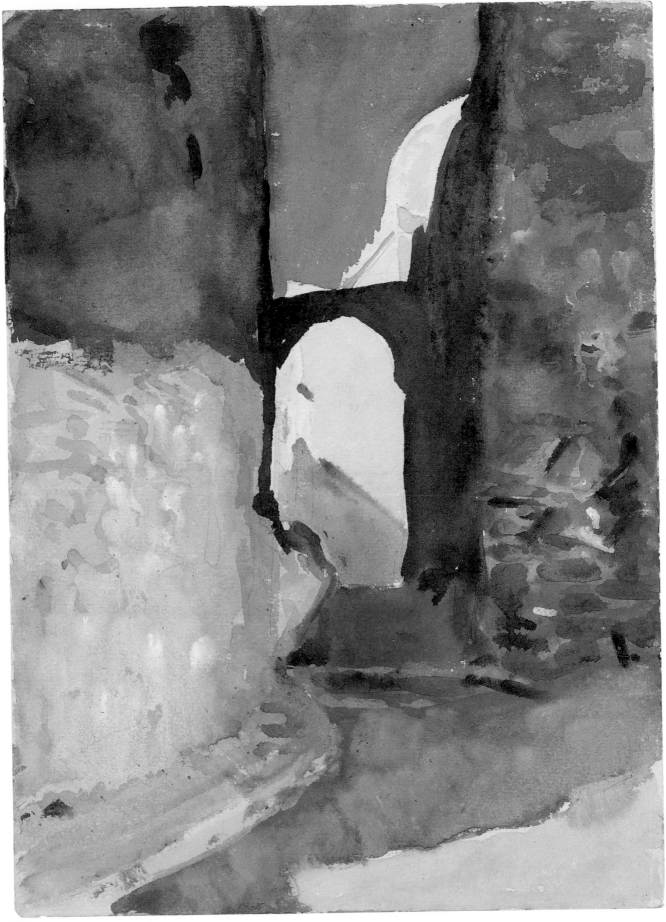

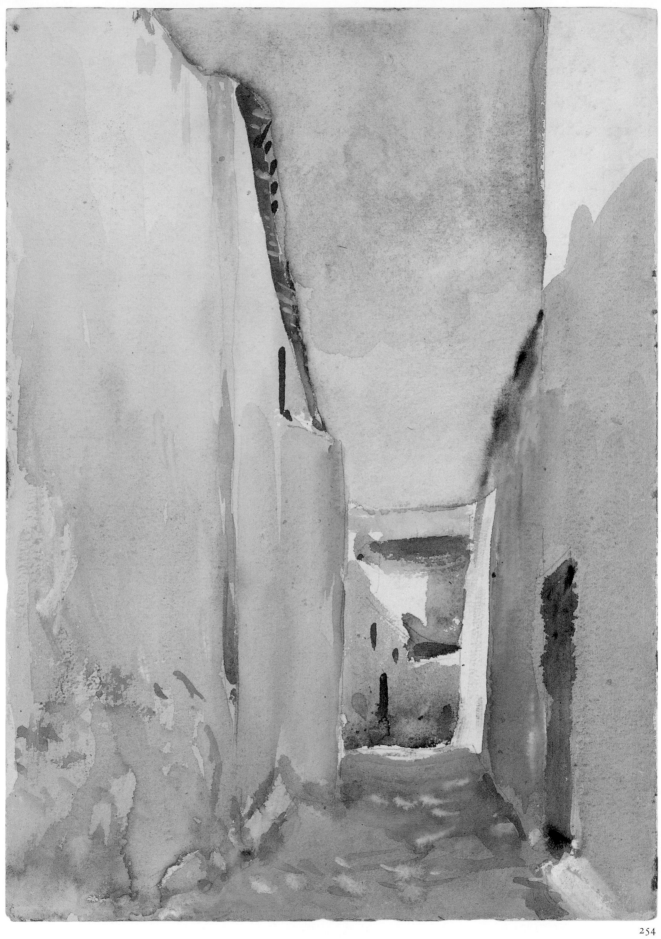

Walls in Sunlight, Morocco [1880, The Metropolitan Museum of Art] and *Moorish Buildings on a Cloudy Day* [see figure 57]). Catalogue numbers 253 and 254, executed some fifteen years later, are much more ambitious in their exploration of coloristic subtleties on the broad expanses of white walls. They may also anticipate the more complicated architectural studies that Sargent made after the turn of the century (e.g., cat. 274).

EXHIBITION: "Watercolors and Drawings by Centurion John S. Sargent," The Century Association, New York, September 21–October 23, 1982 (no catalogue).

255. *Arched Doorway*

ca. 1895–1908?
Watercolor and gouache on white wove paper
13¹⁵⁄₁₆ × 9¹⁵⁄₁₆ in. (35.4 × 25.3 cm)
Inscribed on verso at upper left: 41 *V.O / (Trust);*
at upper center: by J. S. Sargent; at center: ¹⁄₁₉; at
lower left: AW
Gift of Mrs. Francis Ormond, 1950
50.130.39

The classical architecture and warm palette in catalogue 255 suggest a Mediterranean location. Sargent's use of short, dabbing brush strokes to accent broader passages of watercolor recalls the technique seen in works such as catalogue numbers 253 and 254. For example, in both catalogue 255 and catalogue 254, Sargent used such strokes to suggest the edges of the shingled roofs. Ormond, however, has proposed that Sargent could have painted this work as late as 1908 in Majorca (oral communication, June 16, 1997).

256. *Woman with Collie*

after 1890
Watercolor, gouache, and graphite on white wove
paper
13¹⁵⁄₁₆ × 9¹⁵⁄₁₆ in. (35.4 × 25.3 cm)
Inscribed on verso at lower left: SW
Gift of Mrs. Francis Ormond, 1950
50.130.27

Unlike the watercolors that Sargent selected for sale to public collections such as the Metropolitan (e.g., cats. 313–16, 321–25, and 329), the 1950 Ormond gift includes examples of the artist's work that are less resolved,

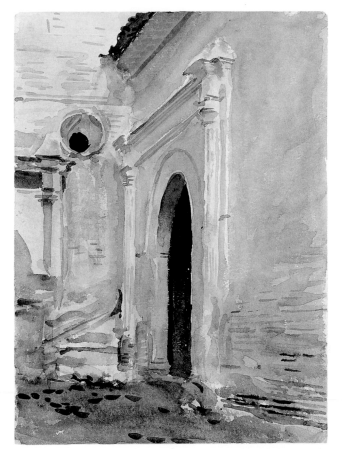

255

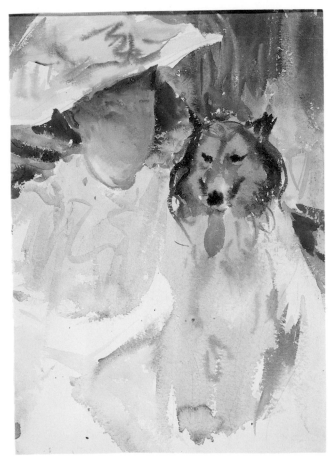

256

289

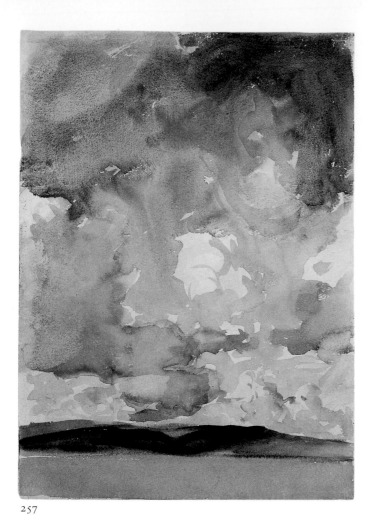

257

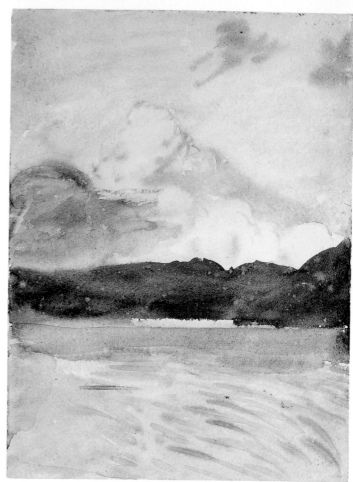

258

such as catalogue 256, a playful depiction of a woman and a dog.

The appeal of this composition lies in the witty and unusual juxtaposition of the undescribed face of the woman (purposefully unfinished or abandoned after an irreparable error?) with the freely rendered portrait of the dog. With his characteristic fluidity, Sargent suggests the dog's soft fur and big pink tongue with just a few brush strokes.

EXHIBITION: New York and other cities 1991, p. 137.

257. *Clouds*

1897
Watercolor on white wove paper
14 × 9 15⁄16 in. (35.6 × 25.3 cm)
Inscribed on verso at upper left: 156; at center top: V.O / (Trust); at center: %⁄19 [?]; at center right: 990 [encircled]; at lower left: 89 by / J.S.S.; at lower right: SW
Gift of Mrs. Francis Ormond, 1950
50.130.30

290

258. *Scotland*

1897
Watercolor on white wove paper
13 15⁄16 × 10 in. (35.5 × 25.4 cm)
Inscribed on verso at upper left: 134 // 69 Scotland / by J. S. Sargent; at upper right: V.O / (Trust); at center: E⁄19; at center right: 990 [encircled]
Gift of Mrs. Francis Ormond, 1950
50.130.81c

Ormond and Kilmurray have identified the site of catalogue numbers 257 and 258 as Loch Moidart, on the western coast of Scotland (oral communication, June 16, 1997). A related watercolor painted at this site is *Loch Moidart, Invernessshire* (1897, private collection). Sargent visited this region in 1897 with the Playfairs, a family whose acquaintance he probably first made during the mid-1880s when he painted a portrait of Edith, Lady Playfair (1884, Museum of Fine Arts, Boston).

EXHIBITION (cat. 257): New York–Albany–Buffalo 1971–72, cat. 31.

259. *Predella of Altar, Cathedral, Tarragon*

After Padre Juan, Spanish, d. 1445
1895–1908
Graphite and brown pigment (bister color) on white wove paper
14 1⁄8 × 9 15⁄16 in. (35.9 × 25.3 cm)
Inscribed along top edge: Saint Thècle dans les flammes par Pere Johan de Vallfogona / Bas-relief de prédalle—Rétable de la Cathedrale de Tarragona; at lower left corner: J.S. 130; on verso at lower left: CP
Gift of Mrs. Francis Ormond, 1950
50.130.143w

In catalogue 259 Sargent sketched a carved alabaster relief panel (ca. 1430) made by Padre Juan for the high altar of the cathedral of Tarragon, in northeastern Spain. The panel depicts a scene from the life of Saint Thecla, the patron saint of the city.

Although Sargent visited Tarragon in 1908 (and possibly in 1903), the meticulous

Sainte Thècle dans les flammes, par Père Johan de Vallfogona
Bas-relief de prédelle - Rétable de la Cathédrale de Tarragona

J.S. 130

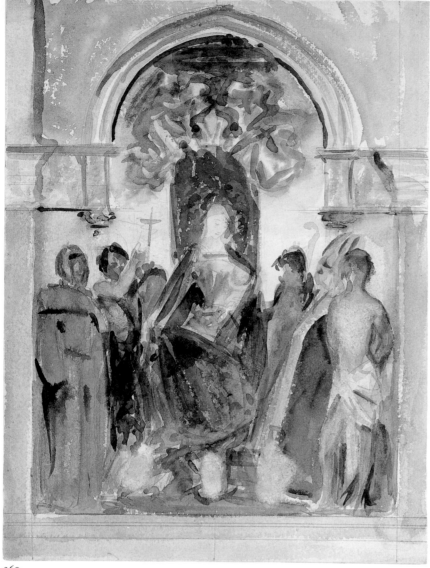

260

altarpiece has not been identified. The watercolor probably dates after 1895, when Sargent commenced serious research for the "Christian end" of the Special Collections Hall. However, the carefully ruled framework of the altarpiece, which recalls Sargent's later architectural studies (e.g., cat. 314), may suggest an even later date.

261. *Madonna, Mosaic, Saints Maria and Donato, Murano*

ca. 1898
Watercolor and gouache on white wove paper
12¾ × 9½ in. (32.4 × 24.1 cm)
Inscribed on verso at upper left: 129 ~~Ravenna~~ / by J. S. Sargent // Torcello // E.S. // ⁵⁄₂₈ [encircled]; at center: ⁹⁄₂₀ / ~~Byz Mosaic~~ "Apse, Torcello"; at lower left: C
Gift of Mrs. Francis Ormond, 1950
50.130.83e

Catalogue 261 depicts the twelfth-century mosaic that decorates the apse of the eleventh-century basilica of Saints Maria and Donato in Murano, Italy. The island of Murano, which lies north of Venice across the lagoon, is the center of the local glass-making industry.

 Although Natalie Spassky has proposed a date before 1897 for catalogue 261 (New York–Buffalo–Albany 1971–72, n.p.), Ormond and Kilmurray have suggested that it was painted during Sargent's visit to Venice

style of this watercolor may indicate an earlier date and perhaps the use of a photograph or book illustration. Ormond has suggested that Sargent may have made this copy in connection with his Boston Public Library murals (oral communication, June 16, 1997).

 Another watercolor painted at Tarragon is *Tarragona (Tarragona Cathedral)* (1908, New Britain Museum of American Art, Connecticut); two sketches are *Jamb Figures, Tarragona, Spain* (n.d., Fogg Art Museum, 1937.8.19) and *Vaulting, Tarragona, Spain* (n.d., Fogg Art Museum, 1931.99).

EXHIBITION: Probably included in New York 1928 (inventory listing J.S. 130).

260. *Madonna and Child and Saints*

After unidentified artist
1895–1915
Watercolor and graphite on off-white wove paper
13¹⁄₁₆ × 9¹¹⁄₁₆ in. (33.2 × 24.5 cm)
Inscribed on verso at upper left: 1 Spain / by J. S. Sargent / E.S. / ⁵⁄₂₈ [encircled]; at center: ½ Z / "Copy"; at lower left: C
Gift of Mrs. Francis Ormond, 1950
50.130.83c

Sargent probably made catalogue 260 after an unidentified altarpiece in connection with his Boston Public Library murals. While an inscription on the verso, not in Sargent's hand, suggests that this work was painted in Spain, the location of the

261

in 1898 (oral communication, November 9, 1997), a period during which he made a number of studies of mosaics (see cat. 262) in preparation for his Boston Public Library murals.

EXHIBITION: New York–Buffalo–Albany 1971–72, cat. 3.

262. *Angels, Mosaic, Palatine Chapel, Palermo*

1897 or 1901
Watercolor, gouache, and graphite on off-white wove paper
9 13/16 × 13 15/16 in. (25 × 35.5 cm)
Inscribed on verso at upper left: 128 Ravenna / by J. S. Sargent / E.S. / 6/28 [encircled]; at center: R/20
Gift of Mrs. Francis Ormond, 1950
50.130.83f

Catalogue 262 depicts the mid-twelfth-century mosaic decoration of the dome of the Palatine Chapel in the Royal Palace at Palermo. Sargent probably painted it on site when he traveled to Sicily early in 1897 to make studies for his murals at the Boston Public Library. The chapel was well known for its distinctive blending of Romanesque, Saracenic, and Greek influences. As the

Murray guide recorded in 1864, "Perhaps there is no remnant of antiquity which, considered with reference to the history or the state of the arts, is more curious and interesting than the Cappella Reale. . . . Nothing of the sort is to be seen anywhere else" (*A Handbook for Travellers in Sicily,* London, 1864, p. 72). The chapel's reputation endured into the twentieth century. The Blue Guide noted in 1925, "This is one of the finest works of art of its kind in Italy" (*The Blue Guides: Southern Italy,* London, 1925, p. 426).

At the center of the cupola's decoration is the image of Christ Pantocrator encircled by eight angels. Sargent studied the dome from the nave of the chapel and off to one side, so that only part of the design is visible. In the watercolor, the head of Christ is obscured, and only three of the eight angels are fully depicted. In his renderings of the ornately dressed archangels Raphael, Michael, and Gabriel, Sargent concentrated on their costumes and the inscriptions, carefully laying these out in graphite before adding color. This uncharacteristic attention to detail in a watercolor reveals Sargent working in a different mode than he used in his spontaneous "holiday watercolors." Here we see him as a researcher, attentive to specific elements and to issues of style that

he could apply to his mural program. While Sargent recorded details faithfully, he was unable to reproduce the shimmering effect of the tesserae.

The cupola's angels, with their frontal poses, ceremonial gestures, and decorative costumes, inspired Sargent's *Frieze of Angels* at the south end of the Special Collections Hall of the Boston Public Library, installed in 1903. While contemporary critics noted the generally Byzantine qualities of Sargent's angels, the artist seems to have borrowed specific components of the Palermo mosaic for his scheme. The costume and body position of the third angel from the left in the frieze relates to that of Raphael at the left in this watercolor. In both works, the angel is depicted wearing a knee-length tunic with ornamented hem and a cloak draped across the shoulders. Both figures have right arms raised and left hands reaching forward.

Proponents of Sargent's murals praised his artistic license in the *Frieze of Angels,* "a work conceived and carried out in the spirit of the past, while subtly informed with the individuality of the artist—an interpretation conveyed by a master working with modern resources and addressing himself to his own day" (Baxter 1903, p. 130).

EXHIBITION: New York–Buffalo–Albany 1971–72, cat. 1.

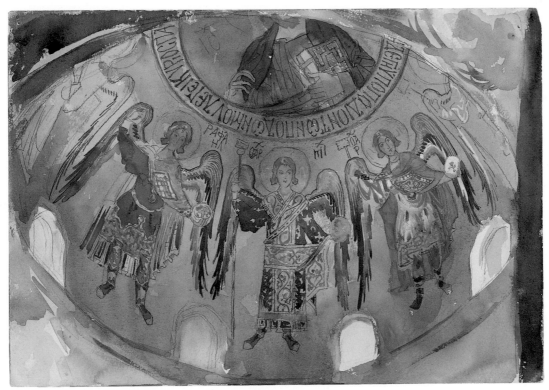

262

263. *In Sicily*

1897 or 1901
Watercolor and graphite on white wove paper
12½ × 18½ in. (31.8 × 47 cm)
Inscribed on verso at upper left: By J. S. Sargent /
In Sicily; at center: %₁₉; at lower left: V.O / (Trust)
// SMW; at lower right: 89
Gift of Mrs. Francis Ormond, 1950
50.130.81f

Catalogue 263 could have been painted
during 1897 or 1901, when Sargent visited
Sicily to conduct research for his Boston
Public Library murals (see also cat. 262).

With its minimal underdrawing and
direct layering of broad washes, this work is
typical of Sargent's watercolor technique of
about 1900, especially in the treatment of
the distant landscape. However, in the left
foreground, Sargent exhibits an uncharac-
teristic attention to detail in a landscape
study as he attempts to depict the diverse
vegetation, architecture, and roads of the
terraced hillside.

EXHIBITION: "Landscape in Art: Origin and
Development," Columbia Museum of Art, Colum-
bia, South Carolina, January 17–February 22, 1967,
cat. 55.

264. *Sky*

ca. 1900–1910
Watercolor on white wove paper, laminated on board
13⅛ × 19¹¹⁄₁₆ in. (33.3 × 50 cm)
Inscribed on verso at upper left: 143 Sky / by J.S.S.
/ E.S.; at center left: ¹⁄₁₅; at lower right: ⅞ [en-
circled]; supplier's stamp affixed at center:
EMILIO AICKELEN, Venezia, Via 22 Marzo
/ ARTICOLI PER BELLE ARTI / Via 22
Marzo 2378–2038
Gift of Mrs. Francis Ormond, 1950
50.130.68

Although the verso of catalogue 264 is
marked with a Venetian supplier's stamp,
Sargent could have painted this composition
at any number of sites that he visited after
sojourns in Venice between 1898 and 1913.

EXHIBITIONS: New York–Buffalo–Albany
1971–72, cat. 30; "Watercolors and Drawings by
Centurion John S. Sargent," The Century Associa-
tion, New York, September 21–October 23, 1982
(no catalogue).

265. *Tiepolo Ceiling, Milan*

ca. 1898–1900
Watercolor and graphite on white wove paper
14 × 9⅞ in. (35.6 × 25.1 cm)
Inscribed on verso at top: 136 Tiepolo Ceiling—
Milan / by J. S. Sargent; at upper left: E.S. ⅔
[encircled]; at center: ¹⁄₂₀; at lower left: SW
Gift of Mrs. Francis Ormond, 1950
50.130.25

When Sargent was immersed in his mural
decorations for the Boston Public Library,
he studied comprehensive decorative pro-
grams such as the frescoes by Pinturicchio
(ca. 1454–1513) in the Borgia apartments at
the Vatican (1897), as well as the grand
mosaic schemes of the churches of
Ravenna (1898). It was probably about this
time that Sargent visited the Palazzo Clerici
in Milan, whose prime attraction, accord-
ing to Baedeker, was the "admirably pre-
served ceiling fresco (Course of the Sun) by
G. B. Tiepolo (1740)" depicted in catalogue
265 (*Northern Italy*, Leipzig, 1913, p. 172).

Sargent was certainly familiar with the
celebrated paintings of Giambattista Tiepolo
(1696–1770), whose works are abundant in
his native Venice, including at the Palazzo

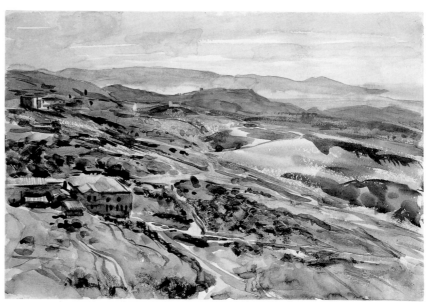

263

264

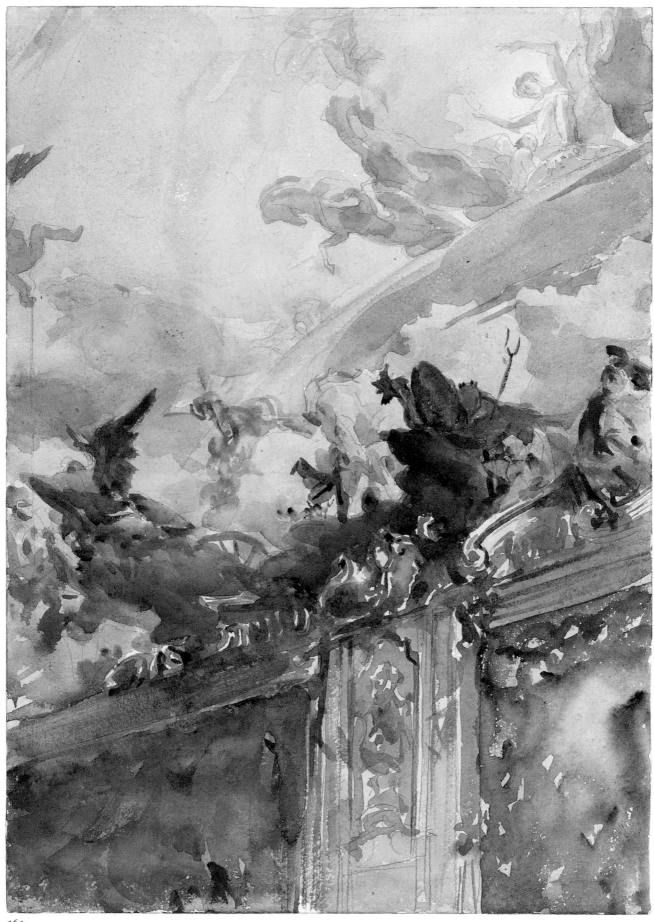

Rezzonico, where Sargent had a studio in 1880–81. The Italian artist's skills as a painter also earned him commissions in Germany and Spain.

Catalogue 265 is less a copy of Tiepolo's frescoes in the Palazzo Clerici than a composition in its own right. It is an interior counterpart to the dramatically cropped (usually exterior) architectural views that Sargent produced with increasing frequency after the turn of the century (e.g., cat. 274). The watercolor is divided along a slight diagonal by the ornate molding that separates the tapestried wall from the frescoed ceiling. At the center, above the gilt molding, Sargent copies Tiepolo's foreshortened figural groups—personifications of the continents and Olympian gods and heroes—as they appear to spill off the ceiling. At right, Europe is personified as a Roman warrior; depicted to the left is Perseus saving Andromeda, and Poseidon, whose two-pronged spear is distinctly visible.

Although Sargent studied the fresco's composition with a fairly precise, if delicate, underdrawing before building up the forms with layers of washes, details of the loosely painted figures at the center of the sheet are obscured as dark pigments blend with those of the molding below. The resulting confusion of forms effectively suggests the Baroque splendor of the hall.

According to Kilmurray, Sargent was in Milan in 1898, 1900, and 1906 (chronology in Adelson et al. 1997, pp. 239–40). Although it is not impossible that he passed through the city on other occasions during one of his many visits to Italy after the turn of the century, the style and subject of catalogue 265 suggest a date of about 1900.

A related watercolor probably made at the same time is *The Golden Room of the Palazzo Clerici* (n.d., Baltimore Museum of Art). A drawing in the Fogg Art Museum is said to be after Tiepolo as well: *Sketch of Trumpeting Angels, after a Tiepolo Ceiling Decoration* (n.d., 1937.8.56).

Sargent would later render a subject similar to that of the Clerici frescoes in his murals for the Museum of Fine Arts, Boston. There, above the staircase, he depicted the sun god Apollo with his chariot in pursuit of the moon goddess Diana (see figure 86 and cat. 208).

EXHIBITIONS: New York–Buffalo–Albany 1971–72, cat. 18; New York and other cities 1991, p. 25, cat. 93.

REFERENCES: Hoopes 1970, pp. 28–29; *Sargent at Harvard* website, July 14, 1997, reference to Harvard accession number 1937.8.56.

266. *Two Dancers*

after 1900
Pen and ink on off-white wove paper
4⁷⁄₁₆ × 6⁷⁄₈ in. (11.2 × 17.5 cm)
Engraved letterhead: 31, Tite Street, / Chelsea. S.W.; inscribed at lower left corner: J.S. 357; on verso at upper right: [partially obscured] [331?]
Gift of Mrs. Francis Ormond, 1950
50.130.96

Sargent's fascination with dance is well documented by his sketches and paintings (e.g., cats. 162 and 186). He sought to record the dancers' specific positions and their movements. In this apparently spontaneous sketch of ballet dancers, Sargent suggests the action of the figures with rapid and free ink lines.

Catalogue 266 must date after 1900, when Sargent enlarged his studio at 33 Tite Street into the adjacent building at number 31. Thereafter, he entered the studio through number 31 and used that as his address, as is indicated by the letterhead of this stationery.

EXHIBITION: Probably included in New York 1928 (inventory listing J.S. 357).

267. *Loggia, Welbeck Abbey*

ca. 1900–1902
Graphite on off-white wove paper
11¹⁄₁₆ × 7⁷⁄₈ in. (28.2 × 20 cm)
Inscribed at lower right: Welbeck
Gift of Mrs. Francis Ormond, 1950
50.130.130

On at least two occasions Sargent visited Welbeck Abbey, the family seat of the duke of Portland in Nottinghamshire, England, to fulfill portrait commissions. In 1900 he painted a full-length canvas of the duke with two dogs (private collection); in 1902 he stayed for over a month to portray the duchess (private collection). When the duke recalled in his memoirs that "Sargent was continually making rapid sketches in pen and pencil on odd pieces of paper," he may have been referring to studies such as catalogue 267 (William J. A. C. J. C. B. Portland, *Men, Women and Things: Memories of the Duke of Portland,* London, 1937, p. 220). While Sargent did not use this composition for the portraits done at Welbeck Abbey, he did pose the duchess in front of the Ionic columns of a mantel. The low vantage point and fragmented view in catalogue 267 resemble devices that Sargent often used in architectural studies after 1900 (see cat. 274).

266

267

268

268. From Ávila

ca. 1903
Watercolor and gouache on white wove paper
12½ × 18⁹⁄₁₆ in. (31.8 × 47.1 cm)
Inscribed on verso: 115. From Avila [sic] / by J. S.
Sargent / E.S.; at center top: ⅖ [encircled]; at
center: ¹⁄₁₉; at lower left: NA
Gift of Mrs. Francis Ormond, 1950
50.130.47

Sargent spent several weeks in Granada in southern Spain in 1902. In late spring 1903 he visited Madrid and several smaller cities, traveling as far north as Santiago de Compostela (see cat. 269). In mid-July 1903 he was in Portugal.

Catalogue 268, a view from Ávila, about seventy miles northwest of Madrid, was probably made in 1903. Baedeker described Ávila's "remarkable" situation "on a flat-topped ridge, three sides of which are very abrupt. This rises from a treeless upland plain, watered by the Adaja and surrounded on all sides except the N. by lofty mountains" (*Spain and Portugal,* Leipzig, 1913, p. 42).

Beyond a broad, open foreground, Sargent depicts the mountains rising toward the clouds in the distance. The generally barren landscape is punctuated with foliage, represented by small dabs of green pigment in the right foreground and the middle ground. Sargent renders his impression of the scene with pastel colors, suggesting space and atmospheric perspective with tonal gradations. The warm, soft colors of the foreground yield to a cooler palette in the distance. Broad, wavy brush strokes accent the diffuse layers of washes to suggest the gentle topography. That the overall effect recalls the works of Hercules Brabazon Brabazon (cat. 187), who stimulated Sargent's practice of watercolor during the 1890s, reinforces the date proposed for the sheet.

Several of Sargent's later watercolor landscape panoramas share similar compositions with catalogue 268. For example, *From Jerusalem* (cat. 277), *Sunset* (cat. 278), and *Sirmione* (cat. 323) exhibit broad, open foregrounds and interest in atmospheric conditions. However, they are more boldly painted and exploit a more saturated palette.

REFERENCE: New York 1993, p. 130.

269. Santiago

269

1903
Graphite on white wove paper
7³⁄₁₆ × 5¹⁄₁₆ in. (18.3 × 12.8 cm)
Inscribed at lower left: Santiago / J.S. 350; on verso
at upper right: 341
Gift of Mrs. Francis Ormond, 1950
50.130.140bb

The inscription at the lower left of this very
summary sketch depicting figures leaning
over a balustrade refers to Santiago de
Compostela, Spain, which Sargent visited
in 1903. The pages of a sketchbook in the
Fogg Art Museum (1937.7.22) have
approximately the same dimensions as cata-
logue 269, but it is unclear if this drawing
originally belonged to that sketchbook.

EXHIBITION: Probably included in New York 1928
(inventory listing J.S. 350).

270. Toledo

ca. 1903
Watercolor and graphite on white wove paper
10 × 14⅛ in. (25.4 × 37.1 cm)
Inscribed on verso at upper left: 119 Toledo / by
J. S. Sargent / E.S / ⅚ [encircled]; at center: ¹⁄₁₉;
at lower left: SMW
Gift of Mrs. Francis Ormond, 1950
50.130.81e

Sargent's solo exhibition at the Carfax
Gallery, London, in 1905 included works
he painted in Toledo, about forty miles
south of Madrid. Sargent probably visited
the ancient city during his 1903 sojourn in
Spain.

Like Ávila (cat. 268), Toledo has a
remarkable situation. Located on the slope
of a granite hill, it is surrounded on three
sides by deep gorges. Sargent presents a
fairly broad view, probably looking down
from the heights of the city into a rocky

270

valley. The contours of the landscape are indicated in graphite, but the composition is dominated by wet washes in shades of brown. In the foreground, spiky and wavy dark brush strokes suggest the rugged topography. At the center, a body of water rendered in shades of blue to yellow-green reflects on its surface the brown hillside.

EXHIBITIONS: "Watercolors and Drawings by Centurion John S. Sargent," The Century Association, New York, September 21–October 23, 1982 (no catalogue); New York 1993, cat. 43, p. 130.

271. *Cathedral Interior*

ca. 1904
Watercolor and graphite on white wove paper
13¾ × 9⅞ in. (34.9 × 25.1 cm)
Inscribed on verso at upper left: E.S.; ⅜ [encircled];
at center: ½₂; at lower center: Cathedral interior; at
lower left: SW; at lower right: 14 × 9
Gift of Mrs. Francis Ormond, 1950
50.130.35

Catalogue 271 depicts the setting for Sargent's grand portrait *Charles Stewart, Sixth Marquess of Londonderry* (figure 109), which commemorates the sitter's role in the August 1902 coronation ceremonies of Edward VII at Westminster Abbey, London.

Sargent began the sheet by carefully studying the architecture in graphite before applying fluid layers of watercolor to suggest the dark, shadowed spaces punctuated by sunlight. The graphite framework is especially visible along the left edge of the composition, where Sargent delineated the columns and their capitals and base moldings, and at the upper corner, where a sculpted figure appears. Across the top of the sheet, the graphite drawing of the ornate ceiling begins to disappear beneath the dark layers of pigment. To represent the bright daylight streaming into the church, Sargent left the white paper in reserve, creating dramatic contrast. In the oil portrait, Sargent softened this contrast and altered the background slightly—cropping it just below the ceiling and including a stained glass window in the upper right.

Richard Mortimer has suggested that Sargent based the architectural composition on the west entrance to the abbey's choir (Richard Mortimer, keeper of the muniments, Westminster Abbey, to Elaine

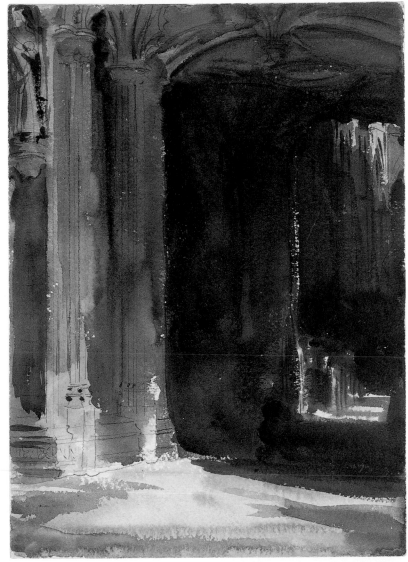

271

Kilmurray, London, December 15, 1999, copy in departmental files, American Paintings and Sculpture, kindly supplied by Elaine Kilmurray). He notes that the rendering of the space in catalogue 271 "is rather more accurate [than the oil], with a hint of choir stalls, and the arcade beginning to turn in to the apse, but both views have elements of phantasy" (ibid.).

EXHIBITIONS: Yale University Art Gallery, New Haven, October 19–November 20, 1955; The Metropolitan Museum of Art, September 1965; New York–Buffalo–Albany 1971–72, cat. 9.

Figure 109. *Charles Stewart, Sixth Marquess of Londonderry, Carrying the Great Sword of State at the Coronation of King Edward VII, August 1902, and Mr. W. C. Beaumont, His Page On That Occasion,* 1904. Oil on canvas, 113 × 77 in. (287 × 195.6 cm). Private collection

272. *Venice*

ca. 1903
Watercolor, gouache, and graphite on white wove paper
9⅞ × 13⅞ in. (25.1 × 35.2 cm)
Inscribed on verso at upper left: 31 20 / Venice / by J. S. Sargent / V. O Mrs Ormond / (Trust); at center: ³¹/₁₇; at lower left: A.W.
Gift of Mrs. Francis Ormond, 1950
50.130.37

In contrast to many of Sargent's Venetian studies, which concentrate on the effect of sunlight as it illuminates architectural details and materials, catalogue 272 evokes the city at dusk. Details are obscured and forms are softened by the fading light. Sargent suggests this effect with broadly applied, fluid pigments. In particular, he exploits the bleeding colors of a wet-on-wet technique to achieve a soft-focus quality in the windows and doors and the steps of the footbridge at right. Near the upper right corner of the sheet, he applies orange and yellow watercolor mixed with gouache in short strokes to indicate a flickering lantern. Pools of color, accented by curving brush strokes, suggest the gentle undulation of the murky water of the canal.

Lovell has suggested that "the indistinctness of forms and the ambiguity of architectural planes in *Venice* mimic the visual effect of moving through the city at twilight" (San Francisco–Cleveland 1984–85, p. 123). Numerous contemporary travel accounts described the beauty and melancholy of the city at night. One author opined, "Venice viewed by moonlight, is and will always remain, so long as one stone is left standing upon another, a fairy tale woven with glorious color" (Henry Perl, *Venezia,* London, 1894, p. 82).

EXHIBITIONS: "Sargent Watercolors," National Collection of Fine Arts, Smithsonian Institution, Washington, D.C., July 1977 (no catalogue); San Francisco–Cleveland 1984–85, cat. 77; New York–Chicago 1986–87 (Chicago only).

273. *Green Door, Santa Maria della Salute*

ca. 1904
Watercolor, gouache, graphite, and wax crayon on white wove paper
20⅞ × 14⅛ in. (53 × 35.9 cm)
Gift of Mrs. Francis Ormond, 1950
50.130.76

About 1904 Sargent painted a series of images of the grand Baroque church of Santa Maria della Salute in Venice. The best-known works in this series (for example, *Santa Maria della Salute,* 1904, Brooklyn

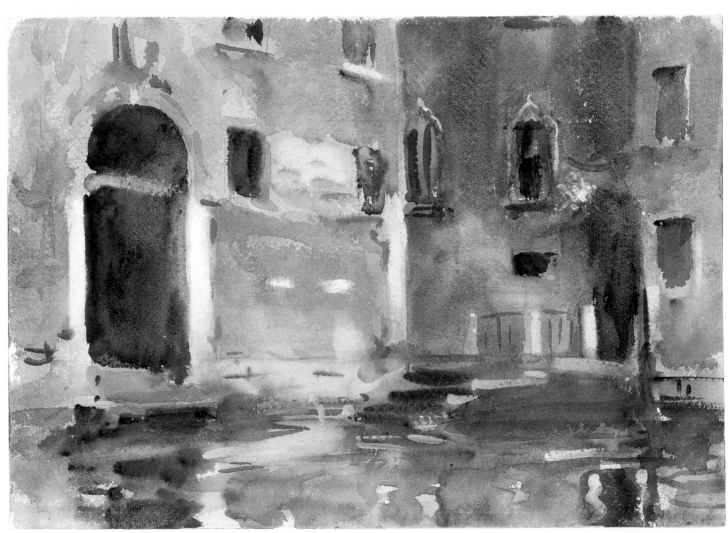

272

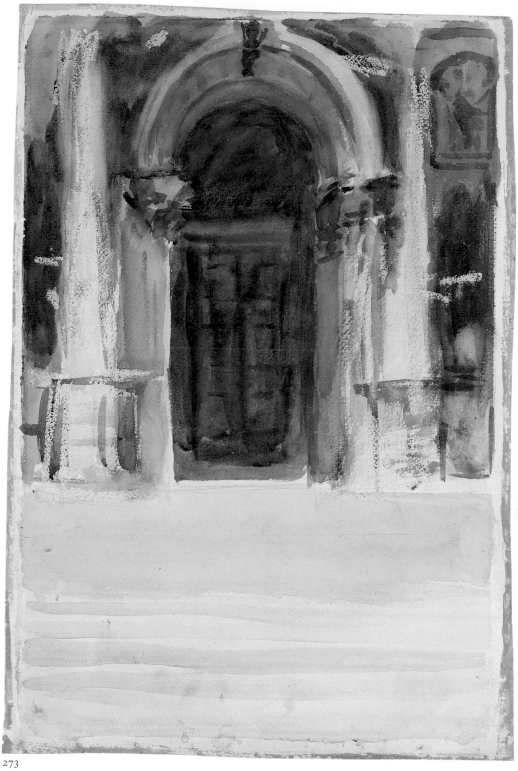

273

Museum of Art, New York, and *Santa Maria della Salute,* 1906, Joslyn Art Museum, Omaha, Nebraska) are characterized by careful, often measured, recording of architectural details from a low vantage point and dramatic croppings that emphasize the building's monumentality. In catalogue 273, however, Sargent employs a stenographic technique to depict the main portal of the church so that the site is identifiable, in spite of the fluid and broad application of paint. This apparently impromptu sketch typifies the free and experimental works left in Sargent's studio after his death, many of which were included in the Ormond gift to the Metropolitan.

Katharine Baetjer (curator, Department of European Paintings, The Metropolitan Museum of Art) identified the site.

EXHIBITION: New York–Buffalo–Albany 1971–72, cat. 25.

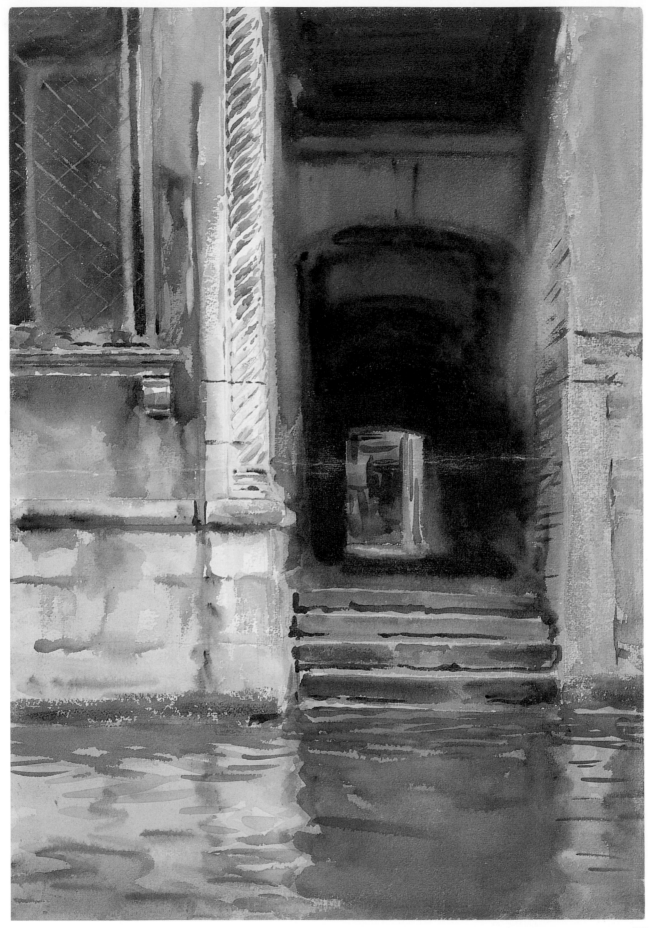

274. Venetian Passageway

ca. 1905

Watercolor, gouache, and graphite on white wove paper

21 1/16 × 14 1/2 in. (53.9 × 36.8 cm)

Gift of Mrs. Francis Ormond, 1950

50.130.77

In catalogue 274 Sargent presents a view off of a canal through a *sotto portego,* or passageway. His interest in the geometry of the scene, with its numerous horizontal and vertical divisions, is apparent in the carefully ruled underdrawing visible at the left. The proximity of the building's facade to the picture plane is underscored by the precise rendering of the bright white, carved spiral stone column at the left, in contrast to the recession of the dark *sotto portego.* Characteristically, Sargent used a wet-on-wet technique to indicate the shadowed interior of the passageway and its reflection in the murky green water.

Sargent adopted a relatively low vantage point to suggest the experience of viewing the scene from the canal, from which access to interiors is limited. By leaving ambiguous the illuminated area at the rear of the *sotto portego,* Sargent evoked the tangle of streets and passageways and the layers of space so characteristic of Venice. Lovell describes this watercolor as representing a "very personal mode, appealing more than anything else to our sense of discovery" (Lovell 1989, p. 72).

The locale of this seemingly anonymous passageway was first identified by McKibbin as the corner of Palazzo Giustiniani Faccanon on the Rio de la Fava (David McKibbin to Stuart Feld, January 11, 1967, departmental files, American Paintings and Sculpture). This *sotto portego,* which connects a major transportation axis—the canal—to the interior *calle,* lies on an important access between the *merceria,* San Marco, and the Rialto Bridge.

For the relationship of catalogue 274 to the works of Whistler, see Lovell 1989, pages 69–72.

EXHIBITIONS: New York 1966–67, cat. 117; Los Angeles–San Francisco–Seattle 1968, cat. 15; New York–Buffalo–Albany 1971–72, cat. 24; "Sargent Watercolors," National Collection of Fine Arts, Smithsonian Institution, Washington, D.C., July 1977 (no catalogue); The Metropolitan Museum of Art, September 1980; "Watercolors and Drawings by Centurion John S. Sargent," The Century Association, New York, September 21–October 23, 1982 (no catalogue); San Francisco–Cleveland 1984–85, cat. 76, p. 122; New York and other cities 1991, cat. 91.

REFERENCES: Hoopes 1970, pp. 30–31; Ratcliff 1982, p. 183; Christopher Finch, *American Watercolors,* New York, 1986, pp. 163–64; Lovell 1989, pp. 70, 72; Boston 1993, p. 153, n. 2; Adelson et al. 1997, p. 188; Weinberg and Herdrich 2000a, pp. 42–43.

275. Arab Woman

1905–6

Watercolor and gouache on off-white wove paper

18 × 12 in. (45.7 × 30.5 cm)

Inscribed on verso: 159 Arab Woman—unfinished / by J. S. Sargent / E.S. // 9/28 [encircled]; at center: 9/16; at lower left: NA

Gift of Mrs. Francis Ormond, 1950

50.130.43

Exotic figures fascinated Sargent throughout his career and were the subject of

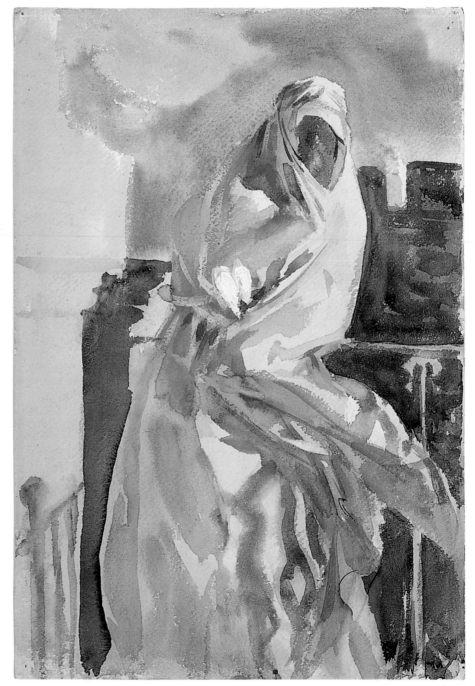

275

numerous paintings, sketches, and watercolors. Sargent probably made this image of a mysteriously draped figure posed outdoors under a bright blue sky during his trip to the Middle East in 1905–6. He had traveled to Syria and Palestine primarily to conduct research for his Boston Public Library murals, in which draped figures such as this were important components. Yet in catalogue 275, Sargent's concentration on the effect of the saturated Mediterranean sunlight on the pale drapery and his delight in a spontaneous and bravura watercolor technique create a work that appears quite independent of the library decorations.

Using no graphite underdrawing, Sargent painted directly to capture the effect of light. The folds of cascading cloth are described with loose, wavy brush strokes in tan, blues, and purples. A few thinner painted lines further define the drapery. The figure's face is shrouded in her garment and obscured by shadow. The setting appears unresolved. Parts of a railing are evident at the lower left; behind the figure at the right a crenelated rooftop or terrace is

suggested. Along the left edge, a broadly applied neutral wash indicates an ambiguous form. Sargent's palette is similar to that which he used in other works made during this trip, including catalogue numbers 277 and 278.

Sargent would continue to explore the theme of draped women in compositions other than his library murals. Most notably during the summer of 1907 in Purtud, Sargent painted his companions wearing "lovely oriental clothes" (Jane de Glehn to her mother, August 13, 1907, quoted in Adelson et al. 1997, p. 84), including a cashmere shawl that he had brought with him (see figure 104).

EXHIBITIONS: "Artistic Responses to Egypt," Newcomb College Art Gallery, Tulane University, New Orleans, October 6–November 2, 1977, p. 8; "Images of Women: Nineteenth-Century American Drawings and Watercolors," The Metropolitan Museum of Art, October 1996–February 1997 (no catalogue).

REFERENCE: Weinberg and Herdrich 2000a, pp. 34–35.

276. Bedouin Tent

1905–6
Watercolor on white wove paper
11⅞ × 17¹⁵⁄₁₆ in. (30.2 × 45.5 cm)
Inscribed on verso at upper left: 191. Bedouin Tent / by J. S. Sargent / E.S.; at center left edge: ⅙ [encircled]; at center: ⅕; at lower left: NA
Gift of Mrs. Francis Ormond, 1950
50.130.44

While traveling through the Middle East to conduct research for his library murals in 1905–6, Sargent journeyed to the desert to paint a Bedouin tribe. In addition to appealing to Sargent's interest in the exotic, the lifestyle of these nomadic people was considered to be much unchanged from biblical times and therefore pertinent to the Boston Public Library project. Sargent produced a series of watercolors of the Bedouins that feature their distinctive tents. *Bedouins* (ca. 1905–6, Portland Museum of Art, Maine) and *Arab Gypsies in a Tent* (ca. 1905–6, Brooklyn Museum of Art,

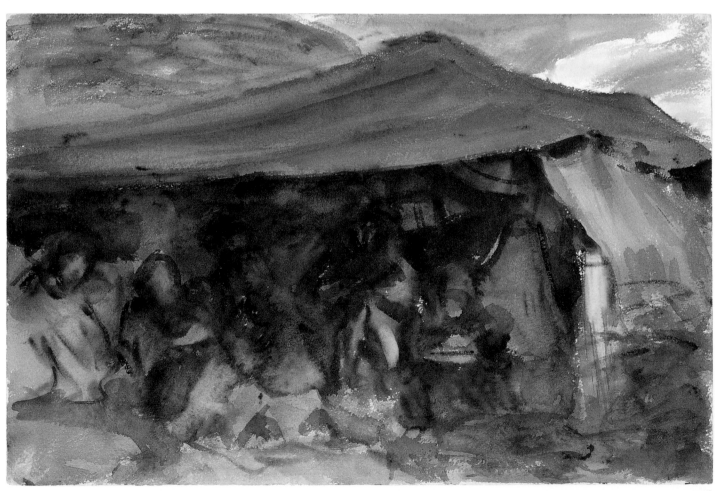

276

New York) show a group of figures in the dark, cool interior of a tent. *Bedouin Camp* (ca. 1905–6, Brooklyn Museum of Art) depicts a group of figures standing and seated in front of a tent. In these examples, Sargent often included striking portrait studies. In catalogue 276, however, the dark shadows beneath the tent are murky, and the forms that begin to emerge from the darkness remain indistinct.

277. *From Jerusalem*

1905–6
Watercolor, gouache, and graphite on off-white wove paper
12 × 17⅞ in. (30.5 × 45.4 cm)
Inscribed on verso at upper left: 139 From Jerusalem / by J. S. Sargent / E.S.; at center top: ⅐ [encircled]; at center: ¼; at lower left: NA
Gift of Mrs. Francis Ormond, 1950
50.130.45

From an elevated vantage point, Sargent recorded the gentle descent of the landscape toward the horizon, where it meets a dramatic pink, blue, and lavender sky. The vivid hues of the sky and the contrast of warm and cool colors on the ground suggest a transitional moment, probably sunset. Sargent employed multiple layers of watercolor of varying opacity and wetness to describe the scene. A cluster of whitewashed buildings surrounded by a few trees in the foreground provides a sense of scale. Two related landscapes—*El Ghor* (watercolor, 1905–6, Mead Art Museum, Amherst College, Massachusetts) and *Plains of Esdraelon* (oil, 1905–6, Tate Gallery, London)—are similarly composed, with an open vista and deep spatial recession.

EXHIBITION: "Views and Visions of the Holy Land," Bezalel National Museum (now Israel Museum), Jerusalem, June 25–September 25, 1958, cat. 47.

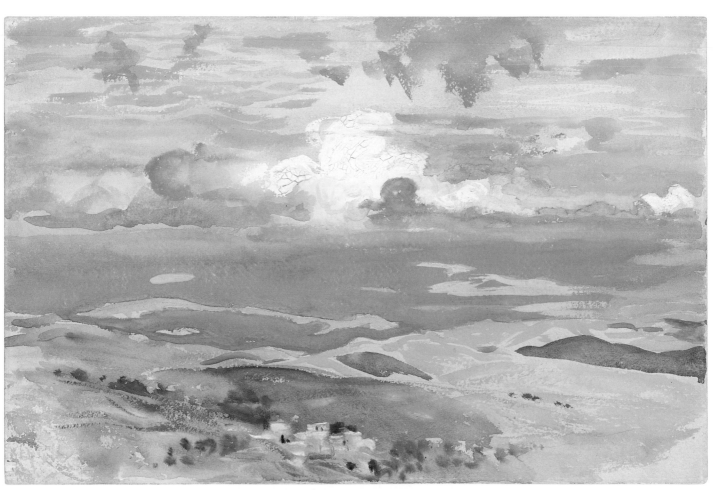

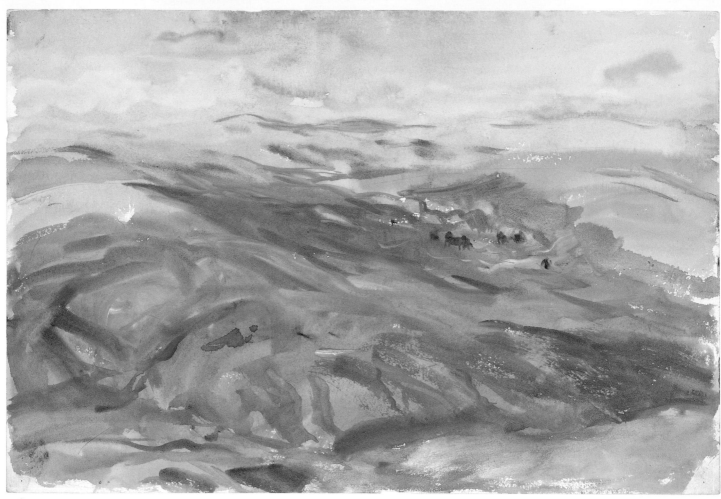

278

278. *Sunset*

1905–6

Watercolor, gouache, and graphite on white wove paper

12⁷⁄₁₆ × 18½ in. (31.7 × 47 cm)

Inscribed on verso at upper left: E.S. / ⅐ [encircled];
at center: "Sunset"; ¹⁄₁₉; at lower left: NA

Gift of Mrs. Francis Ormond, 1950

50.130.46

As in catalogue 277, Sargent used an open and deep composition to record a fleeting impression of waning daylight in catalogue 278. On this sheet, however, the landscape is steeper and more dramatic, and the technique is broader and more spontaneous. Colors and brush strokes mix to suggest the dissolution of forms in the absence of light. The purple, peach, and browns of the palette also are similar to that of catalogue 277. A related watercolor composition is *The Desert from Jerusalem* (1905–6, Nelson-Atkins Museum of Art, Kansas City, Missouri).

EXHIBITION: "Views and Visions of the Holy Land," Bezalel National Museum (now Israel Museum), Jerusalem, June 25–September 12, 1958, cat. 48.

279. *Temple of Bacchus, Baalbek*

1906

Watercolor and graphite on white wove paper

10 × 14 in. (25.4 × 35.6 cm)

Inscribed on verso at upper left: 3 / 148. Greece? /
by J. S. Sargent; at center right: ½; at lower left:
V.O (Trust); at lower center: 990 [encircled]; at
lower right: AW

Gift of Mrs. Francis Ormond, 1950

50.130.40

Because of its ancient acropolis, the city of Baalbek was "the goal of nearly all travellers to the east" during the eighteenth and nineteenth centuries (Gerald Lankester Harding, *Baalbek,* Beirut, 1963, p. 51). The sanctuary boasted the remains of two temples dating to the second century B.C.E., the Temple of Jupiter and the Corinthian Temple of Bacchus. Baedeker described the latter as "one of the best-preserved and most beautiful antique buildings in Syria" (*Palestine and Syria,* Leipzig, 1912, p. 328).

In catalogue 279 Sargent depicts the south side of the Temple of Bacchus, distinctive for its massive leaning column fragment. His pastel palette suggests saturated Mediterranean sunlight on marble. Another view is *Baalbek, Temple of Bacchus* (1906, Ormond Collection).

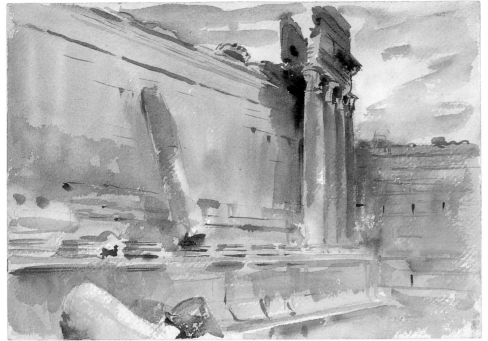

279

280. Sunset at Sea

ca. 1905–6?
Watercolor and gouache on white wove paper
10 × 14 in. (25.4 × 35.6 cm)
Inscribed on verso at center left: ⁵⁄₂₈ [encircled]; at
lower left: VMW
Gift of Mrs. Francis Ormond, 1950
50.130.80d

The site depicted in catalogue 280 is unknown. Ormond has suggested that this delicate watercolor may represent the Sea of Tiberias (Sea of Galilee), Palestine (present-day Israel; oral communication, June 16, 1997). However, this open view of distant clouds beyond an expanse of water could represent any number of coastal areas around the Mediterranean, such as Tangier, Spain, or Syria, that Sargent visited after 1890.

EXHIBITION: "Watercolors and Drawings by Centurion John S. Sargent," The Century Association, New York, September 21–October 23, 1982 (no catalogue).

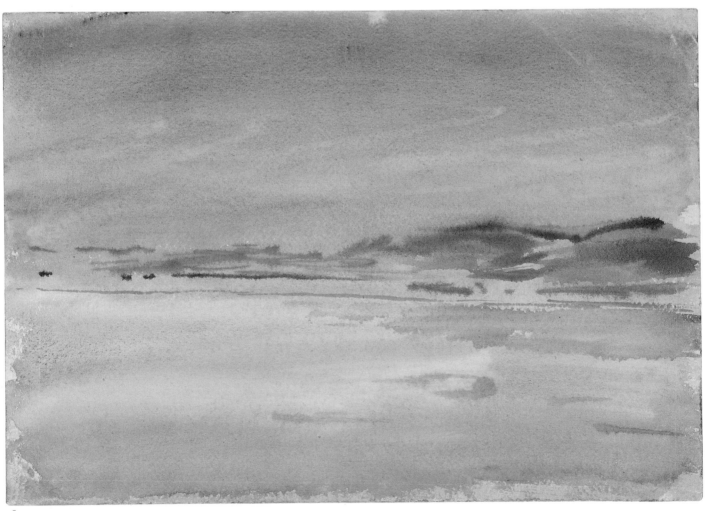

281 recto

281 recto. *Syrian Goats and Birds*

1905–6
Graphite on off-white wove paper
9 × 11⅜ in. (22.9 × 28.9 cm)
Inscribed at upper left: 361; at lower left: Syrian
Goats
Gift of Mrs. Francis Ormond, 1950
50.130.112 recto

281 verso. *Syrian Man*

1905–6
Graphite on off-white wove paper
11⅜ × 9 in. (28.9 × 22.9 cm)
Inscribed at lower left: J.S. 372
Gift of Mrs. Francis Ormond, 1950
50.130.112 verso

Although studies of goats occur frequently in Sargent's oeuvre, the inscriptions on catalogue 281 recto and on a related drawing at the Museum of Fine Arts, Boston (28.961), suggest that he drew these goats in Syria. For further discussion of this theme as well as studies of mountain goats, see catalogue 309.

Catalogue 281 verso, made probably as research for his murals, may represent Sargent's acceptance of the then-prevailing belief that "the dress, manners, customs, and language of the inhabitants of Syria and Palestine are primitive, picturesque, and interesting. As one travels amongst them or has any intercourse with them, one feels as though one were living 2,000 years ago, everything is so thoroughly un-European" (Mary Broderick, ed., *Handbook for Trav-*

281 verso

ellers in Syria and Palestine, London, 1903, p. xxxviii). Sargent suggests the model's flowing cloak and striped suit in a rapid, linear style.

EXHIBITION (cat. 281 verso): Probably included in New York 1928 (inventory listing J.S. 372).

282 recto. *Man in Robe*

1905–6
Graphite on off-white wove paper
11½ × 8⅝ in. (29.2 × 21.9 cm)
Gift of Mrs. Francis Ormond, 1950
50.130.113 recto

282 verso. *Seated Men*

1905–6
Graphite on off-white wove paper
8⅝ × 11½ in. (21.9 × 29.2 cm)
Inscribed at lower left: J.S. 375; at lower right: 358
Gift of Mrs. Francis Ormond, 1950
50.130.113 verso

Catalogue 282 recto and verso were probably made about the same time as catalogue 281.

The drawings share the same graphic style; the paper has similar dimensions and appears to be of the same type. The model depicted in catalogue 282 verso may also appear on catalogue 281 verso.

Sargent was surely interested in these figure types and their costumes in relation to his library murals. The seated-squatting pose of the figure in catalogue 282 verso may have been, in part, the inspiration for Sargent's figure of the Law in *Israel and the Law* (see figure 83), installed at the Boston Public Library in 1916. For Law, Sargent used the same basic arm positions but reversed left and right and added a scroll in the figure's right hand.

EXHIBITION (cat. 282 verso): Probably included in New York 1928 (inventory listing J.S. 375).

283. *Sleeping Man*

ca. 1905–10
Graphite on off-white wove paper
12¼ × 15¾ in. (31.1 × 40 cm)
Gift of Mrs. Francis Ormond, 1950
50.130.1400

282 recto

282 verso

During his several sojourns in the Alps (1904–11), Sargent created a series of images of his companions at rest or sleeping outdoors that Ormond has dubbed "The Siesta Pictures" (Adelson et al. 1997, p. 80). Sargent often used as a model for these figural compositions his friend and traveling companion Peter Harrison. In a group of related images dated between 1905 and 1910, Sargent depicted Harrison alone, asleep or reclining in bed. Examples are *Peter Harrison Asleep* (ca. 1905, private collection; Adelson et al. 1997, p. 83, fig. 70) and *In Switzerland* (see figure 7). As in

these depictions, known to be of Harrison, catalogue 283 shows a man in an utterly relaxed and unselfconscious pose seen from a vantage point at the level of the bed. The figure appears to have a beard like Harrison's, but the strong shadow across his face, rendered with dark hatching, precludes certain identification. A related watercolor of an unidentified figure reclining in bed is *Man Reading* (ca. 1910, Fogg Art Museum, 1943.315).

284. *Loggia dei Lanzi, Florence* (overleaf)

ca. 1902–8
Graphite on off-white wove paper
11⅜ × 9 in. (28.9 × 22.9 cm)
Gift of Mrs. Francis Ormond, 1950
50.130.131

Sargent made a number of drawings, watercolors, and an oil of the bronze by Benvenuto Cellini (1500–1571), *Perseus and Medusa* (1545–54), in the Loggia dei Lanzi, Piazza della Signoria, in Florence. The sculpture, a Mannerist masterpiece, represents Perseus holding the head of the slain Gorgon. He stands on her twisted, decapitated body as blood pours from her neck and head.

Catalogue 284 depicts the sculpture from the same vantage point as the oil *Statue of Perseus by Night* (Santa Barbara Museum of Art, California) and the watercolor *Perseus at Night* (Sotheby's, New York, April 21, 1978, sale 4112, lot 74, deaccessioned by the Brooklyn Museum of Art, New York). The rapid sketch seems to have been made under the same dramatic lighting conditions as the paintings and may even have been a preliminary study. With bold, broad hatching, Sargent indicates the planes of darkness and shadow in the right background, beneath the loggia and behind the central pilaster, as they appear in the paintings. In the oil and the watercolor, however, the pedestal of the sculpture is

283

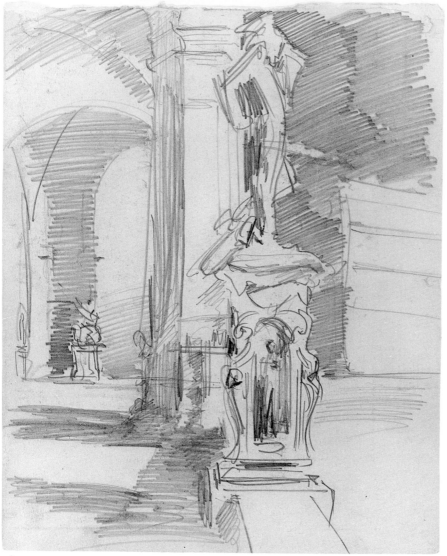

284

285. *Garden at Villa Corsini, Florence*

ca. 1906–10
Graphite on off-white wove paper
10 × 14⅛ in. (25.4 × 35.9 cm)
Inscribed at lower left: Villa Corsini – Florence
Gift of Mrs. Francis Ormond, 1950
50.130.133

The Villa Corsini (built in the fifteenth century but remodeled in the seventeenth) is actually located on the northern outskirts of Florence in Castello, a hillside region rich in villas. Sargent painted at the better-known Villa Medici at Castello in 1906. A watercolor he made at the Villa Corsini appeared in the 1908 Carfax exhibition in London (*Villa Corsini, Florence,* private collection; illustrated in Adelson et al. 1997, p. 228, where it is dated 1904–5). However, Sargent also painted and sketched at various villas around Florence in 1910 and could have returned to the Villa Corsini at that time.

Catalogue 285 probably depicts the Garden of the Four Seasons, which extends "in a semicircle in front of the villa's secondary façade, [and] is punctuated by rocaille pedestals supporting statues [personifications of the seasons] and ornamental vases" (Carlo Cresti, *Villas of Tuscany,* New York, 1992, p. 316). The composition, with the curving balustrade and regularly spaced pedestals and statues separating the empty foreground path from the vegetation beyond (indicated here by cursory squiggles), echoes the design of several garden studies Sargent made about this time. These include *Pool in the Garden of La Granja* (1912, private collection), *Boboli Gardens* (ca. 1907, Brooklyn Museum of Art, New York, 09.818), and *Florence: Fountain, Boboli Gardens* (ca. 1907, Museum of Fine Arts, Boston, 12.224).

In contemporary guidebooks, Villa Corsini is either entirely ignored or overshadowed by descriptions of its grander neighbors, the Medici villas of Careggi, Petraia, and Castello. However, Edith Wharton noted in *Italian Villas and Their Gardens* the "intimate charm" of Villa Corsini, citing it as "the finest example of a baroque country house near Florence" (1904; reprint, New York, 1988, p. 48).

cropped just below its top, and the sculpture is more prominent in the composition.

Sargent began the Perseus series as early as 1902. An unidentified work, *The Perseus of Cellini,* was exhibited at the Carfax Gallery, London, in 1903 (cited in London 1903, cat. 1, but location unknown). The terminus ad quem for the watercolor *Perseus at Night* is 1909, the year it was purchased by the Brooklyn Museum of Art from Knoedler's. Since catalogue 284 seems to relate to that sheet, a broad date has been assigned.

Various partial sketches of Perseus are in the Fogg Art Museum. Of these, *Sketch of the Base of Cellini's "Perseus," Loggia dei Lanzi, Florence* (1937.8.33) may have come from the same sketchbook as catalogue 284. Other studies of the pedestal and lower legs of Perseus are Fogg 1937.8.34, 1937.8.35, and 1937.8.36. Fogg 1937.8.112 is a study of

Perseus's head from below. Four small graphite studies are at Yale University, New Haven (1931.45). Sargent also made a study of a sculpture by Giambologna (1529–1608), *Rape of the Sabines,* which is under the Loggia dei Lanzi (Fogg 1937.8.9).

Sargent would return to the subject of Perseus in his murals for the Museum of Fine Arts, Boston (*Perseus on Pegasus Slaying Medusa,* 1921–25). His friend Paul Manship (cat. 191) created a portrait medal of Sargent (1923), the verso of which depicts Perseus liberating Pegasus, the winged horse—a symbol of poetic creation and artistic inspiration—who sprang from the bleeding neck of the beheaded Medusa.

EXHIBITIONS: "Sargent, Whistler and Cassatt," American Federation of Arts, traveling exhibition, September 1954–57 (no catalogue); The Metropolitan Museum of Art, September 1980.

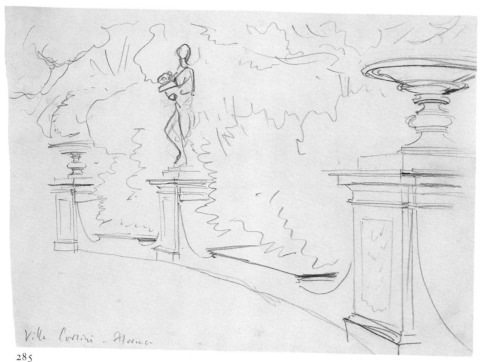

Villa Corsini - Florence

285

286. Boboli Gardens, Florence

ca. 1906–7
*Watercolor, gouache, and graphite on white wove
paper, mounted on board*
11½ × 18⅛ in. (29.2 × 46 cm)
*Inscribed on verso at upper left: 56 Italian Garden /
by J. S. Sargent; E.S; at upper center: supplier's
stamp: GIUSEPPE [obscured word] / Generi per la
pittura / FIRENZE / via Tornabuoni 12, Piaz.
Pitti 17; ⅔ [encircled]; at center: 1/16*
Gift of Mrs. Francis Ormond, 1950
50.130.74

The Boboli Gardens of the Pitti Palace
in Florence were designed in the mid-
sixteenth century for the Medici court.
Sargent painted a series of watercolors at
Boboli about 1906–7. These include two
views of the Piazzale dell'Isolotto, a foun-
tain at the northwest end of the gardens:
Boboli Gardens (ca. 1907, Brooklyn Museum
of Art, New York, 09.818) and *Florence:
Fountain, Boboli Gardens* (ca. 1907, Museum
of Fine Arts, Boston, 12.224). The sculpture

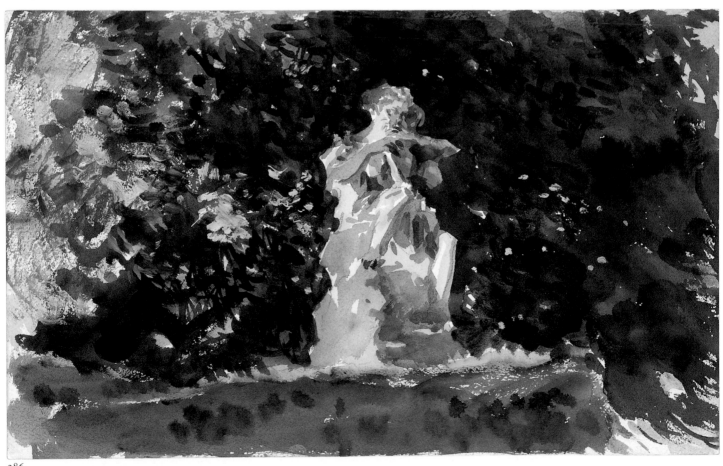

286

depicted in catalogue 286, a figure playing a pipe by Giovan Battista Caccini (1556–1612), is situated not far from the Piazzale dell'Isolotto.

In catalogue 286, a manicured hedge in the foreground provides a visual base for the statue and contrasts with the dense foliage of the trees beyond. Sargent employed dark layers of pigments of varying opacity to suggest depth and shadow in the background. He showed sunlight filtering through the branches of the trees with the application of pale-hued opaque pigments on top of the darker layers. In contrast, he depicted the *pietra serena* (a light-colored Tuscan limestone) of the statue with warm tones applied in transparent washes, left paper in reserve to create the brightest highlights, and used strokes of cool blue pigment to indicate the shadows.

A second watercolor in the Brooklyn Museum of Art, entitled simply *Boboli* (see figure 6), depicts the statue of Prudence (on a stone base) in the main avenue of the gardens, highlighted against a verdant backdrop.

EXHIBITIONS: New York–Buffalo–Albany 1971–72, cat. 26; "Watercolors and Drawings by Centurion John S. Sargent," The Century Association, New York, September 21–October 23, 1982 (no catalogue).

REFERENCE: Adelson et al. 1997, p. 135.

287. *Glacier du Brouillard from Below*

ca. 1906–7
Graphite on off-white wove paper
6⅛ × 9½ in. (15.6 × 24.1 cm)
Inscribed at lower left: Glacier du Brouillard from below; on verso along left edge: Falconieri / Sig. Ferdinando Gerald / capo l[a?] casa 18 [illegible]
Gift of Mrs. Francis Ormond, 1950
50.130.140z

The Glacier du Brouillard is located near Mont Blanc on the borders of Italy, Switzerland, and France, not far from the hamlet of Purtud, Italy, which Sargent visited several times between 1904 and 1909. During this period, Sargent explored mountain landscapes, glaciers, and moraines as subjects for oils and watercolors. He would exploit the same subjects during numerous later visits to the Simplon Pass between 1909 and 1911.

Catalogue 287 depicts from a slightly different angle the site seen in the oil painting *Val d'Aosta* (see figure 106). Sargent concentrated on the peaks of the mountain, which would become the upper part of the composition in the oil. Another drawing of this site, possibly from the same notebook, *Glacier du Brouillard from High Up,* is in the collection of the Fogg Art Museum (ca. 1906–7, 1937.8.104).

Catalogue 287 and the Fogg sheet are quite different in style and composition from the topographical alpine studies Sargent made during his childhood. His early mountain views (e.g., cats. 9, 16, and 17) were intentionally panoramic, precisely rendered studies of sites. In the two drawings of the Glacier du Brouillard made

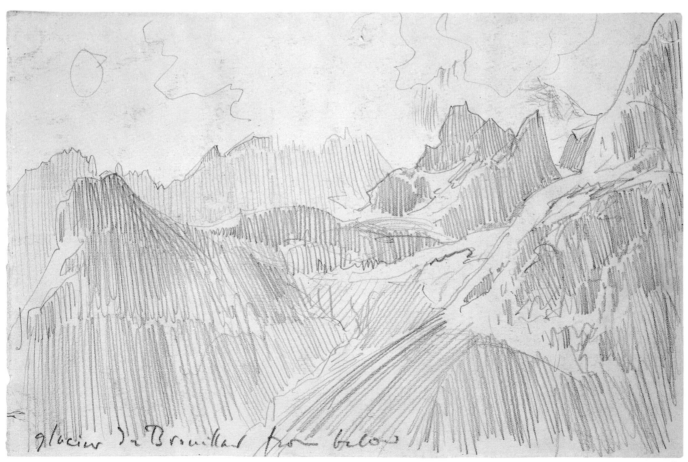

287

about 1906–7, Sargent offers more cursory images of the dramatic views by using series of quickly drawn parallel lines to differentiate surfaces.

The inscription on the verso, "Falconieri," probably refers to the villa where Sargent painted in autumn 1906 and autumn 1907.

288. *Rushing Water*

ca. 1901–8
Watercolor, gouache, and graphite on white wove paper
14 × 9¹⁵⁄₁₆ in. (35.6 × 25.3 cm)
Inscribed on verso at upper left: 37 / Purtud / by J. S. Sargent / V.O / (Trust); at center: ⁸⁄₁₈; at lower left: VMW
Gift of Mrs. Francis Ormond, 1950
50.130.80e

Sargent's depictions of flowing brooks are most often associated with his sojourns at Purtud, in the Val d'Aosta, between 1904 and 1908. Ormond has pointed out, however, that Sargent explored the same theme of vigorous mountain streams during his trip to Norway in 1901 (Adelson et al. 1997, p. 99). Sargent's best-known painting from that trip, *On His Holidays* (1901, National Museums and Galleries on

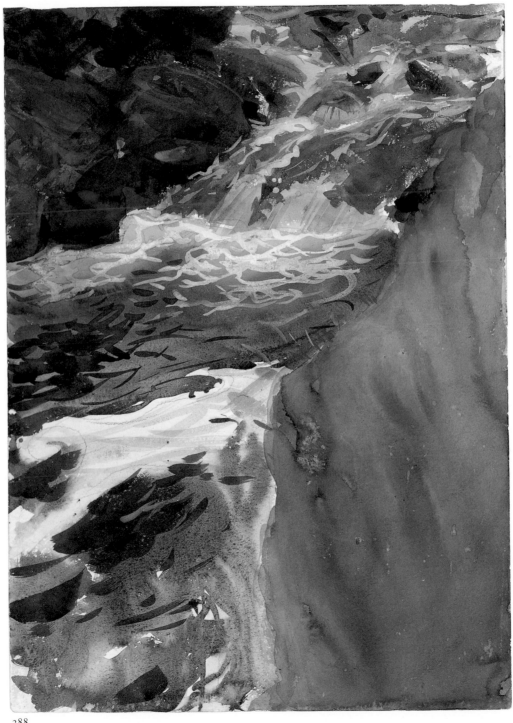

288

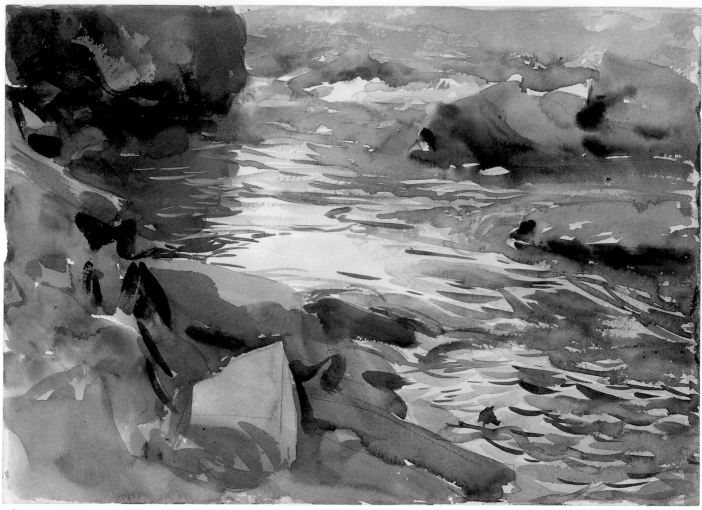

289

Merseyside, Liverpool), depicts the son of a friend reclining on the large rocks on the bank of a river. According to Ormond (ibid.), Sargent made the same Norwegian river the subject of several watercolors, including *Salmon River* (1901, Brooklyn Museum of Art, New York). Because Sargent continued to explore this theme during his travels in the Alps throughout the following decade, it is often difficult to date these works. Ormond notes, "All the brook series may not belong to Purtud" (ibid.).

In palette and technique, catalogue 288 may relate to the Brooklyn watercolor and may also have been painted in Norway. The two sheets also have the same dimensions. Here Sargent depicts a cascade in a

range of dark, rich blue tones to suggest the cool, deep water. The moving surface of the water is rendered with spiky strokes and elongated dabs of varying opacity on top of washes of color. The flowing water rushes toward the viewer from its origins in the upper right corner. Along the right edge, however, the landscape, which is rendered in flat washes of green pigment, appears unresolved and distorts the perspective of the composition.

EXHIBITION: "Watercolors and Drawings by Centurion John S. Sargent," The Century Association, New York, September 21–October 23, 1982 (no catalogue).

289. *Stream and Rocks*

ca. 1901–8

Watercolor, gouache, and graphite on white wove paper

10 × 14 in. (25.4 × 35.6 cm)

Inscribed on verso at upper left: 186 Brook / by J. S. Sargent / E.S. ; at center: ᴰ/₁₈; at lower right: 5209 [encircled]

Gift of Mrs. Francis Ormond, 1950

50.130.71

Although catalogue 289 could have been made during Sargent's visit to Norway in 1901, its origin in Purtud cannot be ruled out. The watercolor appears to be painted on the same type and size paper as both catalogue 288 and *Salmon River* (1901, Brooklyn Museum of Art, New York).

While similar to that in catalogue 288, the palette is generally lighter and contains less brown. As in catalogue 288, Sargent used

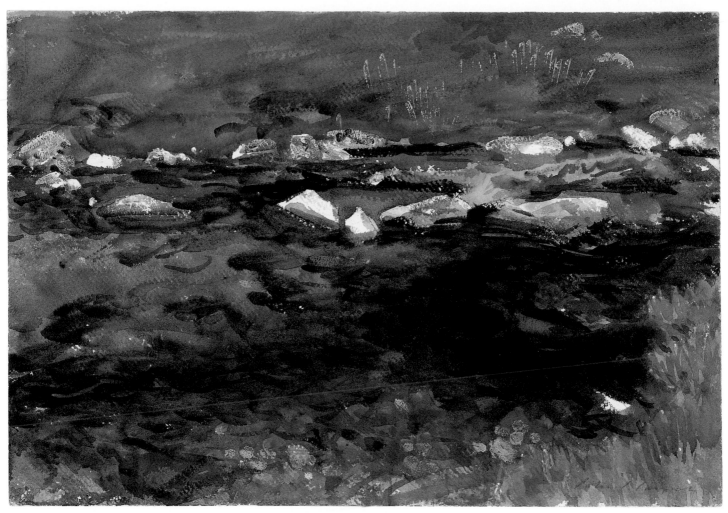

290

similar distinct brush strokes to suggest the dynamic surface of the water, but he left paper in reserve for highlights instead of covering the sheet with broad washes. The bare flat passages indicate a calm, reflective surface, suggesting slow-moving water rather than the cascade depicted in catalogue 288.

290. *Brook and Meadow*

ca. 1907

Watercolor, gouache, and graphite on white wove paper

14 × 20 in. (35.6 × 50.8 cm)

Signed at lower right: John S. Sargent; inscribed on verso at upper left: 182 Purtud / signed / by J. S. / E.S. / ³⁄₁₆ [encircled]; at center: ⁵⁄₁₅; at lower left: VMW / .28

Gift of Mrs. Francis Ormond, 1950

50.130.80j

Sargent's unflagging interest in the effect of sunlight on his subjects was particularly challenged and stimulated by the motif of flowing water. The artist was fascinated by the movement of the mutable liquid under a variety of conditions: rapidly flowing or relatively still, reflecting or absorbing sunlight.

In 1901 Sargent had experimented with this subject in oil and watercolor during a visit to Norway (see cats. 288 and 289). In 1904, Jane de Glehn recorded seeing "some lovely sketches [Sargent] had done in Switzerland of river beds etc." (Jane de Glehn to her sister, September 27, 1904, quoted in Adelson et al. 1997, p. 99), but Sargent produced his most memorable paintings of flowing water during his annual visits to Purtud, Italy, from 1904 to 1908, using the small brook there as a setting for figural compositions and as a subject in its own right.

At Purtud, where the brook flowed slowly, the visual experience of the subtle motion of the water depended on the play of light across its surface. In catalogue 290 Sargent suggests both the gentle undulation of the water and its transparency. As he often did in his images of the brook at Purtud, Sargent adopted a close vantage point, ignored the horizon, and directed his gaze downward to the shimmering water and the rocks and foliage along its banks. The results are nearly abstract arrangements of form and color.

The characteristic low, grassy, rock-strewn banks of the brook at Purtud appear in a closely related oil, *Alpine Pool* (see figure 102). A similar watercolor is *Brook among Rocks* (ca. 1907, Museum of Fine Arts, Boston). The brook also serves as the setting of the exotic figural compositions *Dolce Far Niente* (ca. 1907, Brooklyn Museum of Art, New York) and *Turkish Woman by a Stream* (ca. 1907, Victoria and Albert Museum, London).

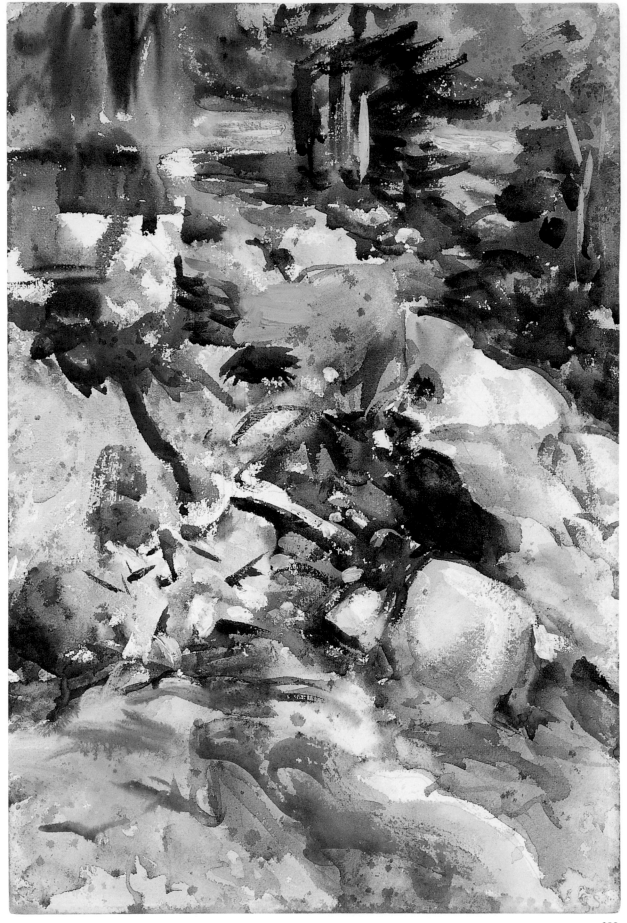

EXHIBITIONS: New York–Buffalo–Albany 1971–72, cat. 27; "Five American Masters of Watercolor," Terra Museum of American Art, Evanston, Illinois, May 5–July 12, 1981; "Watercolors and Drawings by Centurion John S. Sargent," The Century Association, New York, September 21–October 23, 1982 (no catalogue).

291. *Rushing Brook*

ca. 1904–11
Watercolor, gouache, and graphite on off–white wove paper
18 7/16 × 12 3/8 in. (46.8 × 31.4 cm)
Inscribed at lower right: J.S.S.; inscribed on verso at upper center: 3/8 [encircled]; at lower left: NMW; J.S.S. Purtud
Gift of Mrs. Francis Ormond, 1950
50.130.80i

Although the inscription on the verso, which is not in Sargent's hand, suggests that this bold watercolor was painted at Purtud, the site could well be one of the other alpine regions the artist visited after 1900. In fact, a description of Sargent painting at the Simplon Pass in 1909 and 1910 by his friend and traveling companion Adrian Stokes suggests the creation of a similar composition:

When he found something to paint, no difficulty of place or circumstance would deter him. I saw him working on a steep mountain side, the branch of a torrent rushing between his feet, one of which was set on stones piled up in the water. Several umbrellas were anchored round about him to keep off reflections. The result of that morning's work—strange though it may seem—was as consummate in technique as if it had been done in comfort. (Stokes 1926, p. 54; see figure 111)

In catalogue 291, the water cascades from the upper left corner of the vertical composition toward the right before spilling back to the left to dominate the lower edge. Various details and forms are boldly described with fluid brush strokes applied over layers of washes. Sargent applied gouache in a thick impasto in several areas amidst the rocks at the center and in a line near the upper edge of the sheet to suggest a horizon. The bright palette incorporates vivid Prussian blue, green, yellow, and crisp white gouache to create an unusually vibrant impression.

EXHIBITIONS: New York–Buffalo–Albany 1971–72, cat. 28; New York–San Francisco 1974/1977, cat. 90; "Sargent Watercolors," National Collection of Fine Arts, Smithsonian Institution, Washington, D.C., July 1977 (no catalogue); The Metropolitan Museum of Art, May 1980; New York and other cities 1991.

REFERENCE: Weinberg and Herdrich 2000a, pp. 40–41.

292. *Glacier*

ca. 1908–9
Watercolor and graphite on white wove paper
10 5/8 × 14 11/16 in. (27 × 37.4 cm)
Gift of Mrs. Francis Ormond, 1950
50.130.80h

Ormond and Kilmurray identified the site of catalogue 292 as the Brenva Glacier, which issues from Mont Blanc into the Val Veny above Purtud (oral communication, June 16, 1997). The impressive glacier figures prominently in the background of two works painted about 1908–9: the oil *Brenva Glacier* (Johannesburg Art Gallery, South Africa; illustrated in Adelson et al. 1997, p. 104) and the watercolor *A Mountain Hut, Brenva Glacier* (private collection; illustrated in Adelson et al. 1997, p. 105).

In catalogue 292 Sargent covers broad areas of pale washes with long brush strokes

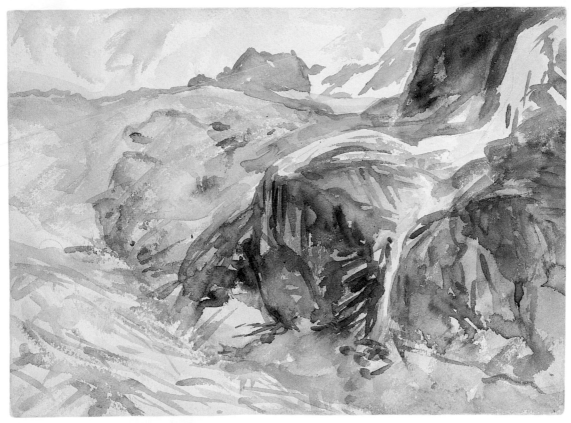

292

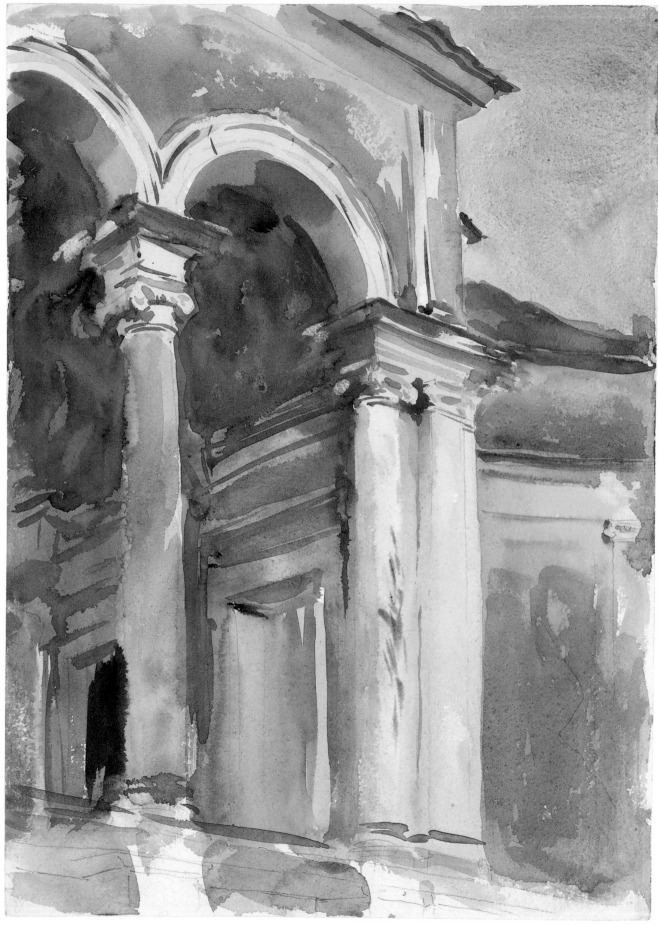

to suggest the rugged landscape and the sweeping glacier along the left of the composition. The pale blue ice at the left gently contrasts with Sargent's characteristic brown, blue, and purple palette, which he employed here in muted tones to describe the landscape at the right.

EXHIBITION: "Watercolors and Drawings by Centurion John S. Sargent," The Century Association, New York, September 21–October 23, 1982 (no catalogue).

293. *Loggia, Villa Giulia, Rome*

ca. 1907
Watercolor and graphite on white wove paper
13¹⁵/₁₆ × 9¹⁵/₁₆ in. (35.3 × 25.2 cm)
Inscribed on verso at upper left: 28 [very faint] / 43 / V.O / (Trust); at center: ½₀; at lower left: 107 Italy / by J. S. Sargent; at lower right: AW
Gift of Mrs. Francis Ormond, 1950
50.130.38

Sargent painted several architectural studies at the Villa Giulia (known informally as the Villa Papa Giulio), located on the grounds of the Borghese Gardens in northern Rome. The villa, which today houses a museum of antiquities, was built in the 1550s for Pope Julius III by several of the most eminent architects of the day: Giorgio Vasari (1511–1574), Bartolommeo Ammannati (1511–1592), and Giacomo da Vignola (1507–1573).

Ormond dates various images painted at the villa to about 1902 and 1907 (Adelson et al. 1997, pp. 132–33). Catalogue 293 relates to *Roman Architecture (Villa Papa Giulio)* (private collection; Adelson et al. 1997, p. 132), an oil that is dated about 1907.

In catalogue 293 and in *Roman Architecture (Villa Papa Giulio)*, Sargent painted opposite ends of the three-arched loggia of the nymphaeum from the courtyard below. In both works he closely cropped the compositions, omitted the balustrade between the columns, and studied the effects of light and shadow on the receding and projecting architectural elements. In the watercolor in particular, he suggested the presence or absence of light on the stone with the contrasting warm and cool tones of his palette.

EXHIBITIONS: New York–Buffalo–Albany 1971–72, cat. 16 (as *Ionic Capitals, Italy*); "Watercolors and Drawings by Centurion John S. Sargent," The Century Association, New York, September 21–October 23, 1982 (no catalogue).

294. *Terrace and Gardens, Villa Torlonia, Frascati*

1907
Watercolor, graphite, and wax crayon on white wove paper
14⅝ × 21¼ in. (37.1 × 54 cm)
Gift of Mrs. Francis Ormond, 1950
50.130.75

Sargent spent the early autumn of 1906 visiting villas in the Roman countryside. He was so entranced with their gardens as subjects for his paintings that he returned in 1907 with his sister Emily and several artist friends, including Jane and Wilfrid de

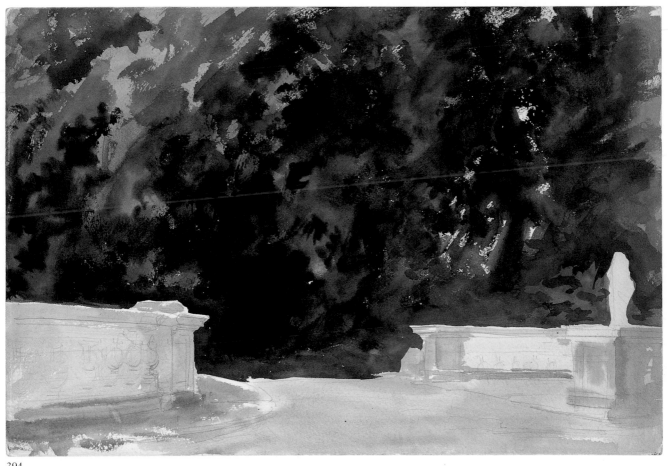

Glehn, to work at such sites around Rome and in Frascati. In 1907 he painted a series of pictures in oil and watercolor at the Villa Torlonia, about fifteen miles south of Rome. One of Sargent's traveling companions, Eliza Wedgwood, recalled the camaraderie of the holiday and the group's esteem for Torlonia: "We lived in what is called the Grand Hotel at Frascati, and the artists, the two Sargents and the two de Glehns, were busy all day painting in one lovely garden or another, the Torlonia and Falconieri being the favourites" ("Memoir," typescript, November 22, 1925, quoted in Adelson et al. 1997, p. 117). The main fountain and its ornate balustrade figure prominently in Sargent's Torlonia images, the best known of which is almost certainly *The Fountain, Villa Torlonia, Frascati, Italy* (1907, The Art Institute of Chicago), which depicts Jane de Glehn painting there as her husband watches.

Catalogue 294, made at this time, shares the composition of an oil, *A View of the Park: Villa Torlonia, Frascati* (1907, location unknown; illustrated in *Antiques* 89 [March 1966], p. 324). In the watercolor Sargent delineated the design of the balustrade in graphite and began layering in broad, pale washes, but he abandoned the work before completing it. A section of the balustrade at right remains unpainted. The verdant foliage beyond seems the raison d'être of the picture. This large expanse gave Sargent the opportunity to apply transparent and opaque washes with his characteristic virtuosity. In the oil Sargent expanded the scene to include a larger area of the greenery.

EXHIBITION: "Watercolors and Drawings by Centurion John S. Sargent," The Century Association, New York, September 21–October 23, 1982 (no catalogue).

295. *Fountain in Villa Torlonia, Frascati*

1907
Graphite on off-white wove paper
6⅛ × 9⁷⁄₁₆ in. (15.6 × 24 cm)
Inscribed at lower left: Fountain in Villa / Torlonia
Gift of Mrs. Francis Ormond, 1950
50.130.140y

Like catalogue 294, this study was made at the villa. Here Sargent carefully recorded a pedestal of one of the smaller fountains on the grounds.

296. *Casa de la Almoina, Palma*

1908
Graphite on off-white wove paper
11⅝ × 9 in. (29.5 × 22.9 cm)
Inscribed at lower right: 529; Palma
Gift of Mrs. Francis Ormond, 1950
50.130.132

Sargent visited the Mediterranean island of Majorca, Spain, in June 1908 and made a longer visit with his sister Emily and friend Eliza Wedgwood from September to October 1908. He executed several studies of buildings and architectural details in Palma, the capital. Catalogue 296 shows the facade of the Casa de la Almoina, a fifteenth-century residence adjacent to the city's cathedral. Four architectural sketches from Palma are in the collection of the Fogg Art Museum (1931.90 and 1937.8.61–.63). At least two of these studies were made at the Plaza de la Almoina. Fogg 1937.8.62 presents another view of the facade of the casa on a sheet that may have come from the same sketchbook as catalogue 296. Fogg 1937.8.63 depicts a detail of the architectural ornament over the door of the north entrance to the cathedral, which Sargent could have sketched from the same location in the plaza. The two other Fogg sheets record unidentified architectural details. These views parallel Sargent's contemporaneous fragmented architectural depictions in watercolor (see cat. 293).

297. *Renaissance Palace*

ca. 1905–10?
Graphite on off-white wove paper
10 × 7 in. (25.4 × 17.8 cm)
Gift of Mrs. Francis Ormond, 1950
50.130.140aa

In style and subject, this drawing of an unidentified building relates to catalogue 296 and may have been made about the same time.

295

296

297

298. *Pomegranates*

1908
Graphite and pen and ink on light buff wove paper
9 × 11⁹⁄₁₆ in. (22.9 × 29.4 cm)
Inscribed at lower left corner: J.S. 373; on verso at
top center: 37; at lower left: NS
Gift of Mrs. Francis Ormond, 1950
50.130.142h

Catalogue 298 belongs to a group of studies
of pomegranates that Sargent made in
Majorca in 1908. The series includes at least
three oils (private collections) and a water-
color (Brooklyn Museum of Art, New
York). A drawing in the Fogg Art Museum
entitled *Sketch of Arbutus* (1937.8.50) depicts
a cluster of pomegranates at the right of the
sheet. The local newspaper reported that
Sargent was occupied with painting olive
trees and studies of fruits "to serve as a back-
ground in a work that he is preparing in
London" (quoted in Adelson et al. 1997,
p. 174). The pomegranate, symbol of resur-
rection in Christian iconography, figures in
the composition of the lunette *The Messianic*

298

321

299

Era for the Boston Public Library (ibid.).

In catalogue 298, Sargent seems to have made a rapid sketch in graphite and then returned to the sheet with pen and ink to delineate some of the forms more specifically. This sheet does not appear to be an exact study for any of the known pomegranate paintings or the lunette.

EXHIBITION: Probably included in New York 1928 (inventory listing J.S. 373).

299. *Treetops against Sky*

ca. 1909–13
Watercolor and gouache on white wove paper
10 × 14 in. (25.4 × 35.6 cm)
Inscribed on verso at center top: ⁵⁄₂₈ [encircled];
at lower left: SW / J.S.S. [illegible] E.S.
Gift of Mrs. Francis Ormond, 1950
50.130.31

With a palette limited to blue and brown, Sargent depicted leafy treetops silhouetted against a bright sky in catalogue 299. Along the top edges of the trees, he used a dry brush to indicate the texture of the foliage. He covered areas with thick blue gouache to suggest sky and freely stroked pigment in the branches and trunks with a wetter technique.

Ormond and Kilmurray have proposed that this sheet may have been painted at either Corfu in 1909 or Lake Garda in 1913 (oral communication, June 16, 1997). Two watercolors of olive trees employ a similar dry technique to suggest the foliage against the sky. One is *Olive Trees, Corfu* (1909, location unknown; illustrated in the album donated by Mrs. Francis Ormond, The Metropolitan Museum of Art); it is signed and inscribed "Corfu." The other is known as *Olive Trees by the Lake of Garda* (1913, Ormond Collection). While these two works have similar compositions, they may derive from different locales. However, a

related oil, *Olive Trees at Corfu* (1909, Collection of Mr. and Mrs. Marshall Field), was painted at Corfu.

300. *Snow*

ca. 1909–11
Watercolor and graphite on white wove paper
11⅝ × 14 in. (29.5 × 35.6 cm)
Inscribed on verso at upper left: 180 Snow—
Unfinished / by J. S. Sargent / E.S.; at center: ½;
at center right: ¹⁄₁₀; at lower left: VMW
Gift of Mrs. Francis Ormond, 1950
50.130.80g

When Sargent visited the Simplon Pass in 1909–11, one of his favorite sketching spots "was a grassy plateau above the Simplon Hospice, from which can be seen tremendous southwest views of the Böshorn and the Fletschorn across the intervening valley" (Adelson et al. 1997, p. 199). Sargent painted

several compositions against the splendid alpine panorama, including the watercolor *Artist in the Simplon* (see figure 105) and the oil *Reconnoitering* (ca. 1911, Pitti Palace, Florence).

Catalogue 300 depicts the Fletschorn (at left) and the Böshorn (at right) under a brilliant, cloudless sky. Sargent left passages of paper in reserve to suggest the reflection of the bright sun off the snow and used a range of blues—from an icy opaque tone to a dark saturated one—to represent the shadows across the frozen peaks.

Ormond and Kilmurray identified the site (oral communication, June 16, 1997). See catalogue 301 for another view.

EXHIBITION: "Watercolors and Drawings by Centurion John S. Sargent," The Century Association, New York, September 21–October 23, 1982 (no catalogue).

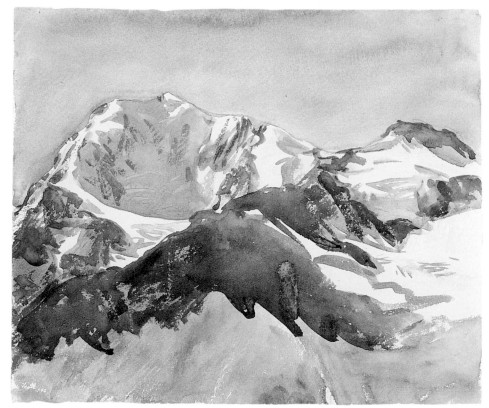

300

301. *Sky and Mountains*

ca. 1909–11
Watercolor and graphite on white wove paper
13⅞ × 20 in. (35.2 × 50.8 cm)
Inscribed on verso at upper left: ⅞ [encircled]; at lower left: SMW / .29; at lower right: by J.S.S
Gift of Mrs. Francis Ormond, 1950
50.130.81b

Catalogue 301 records the same peaks at the Simplon Pass that appear in catalogue 300 from a nearer but oblique vantage point similar to the one Sargent used in the watercolor *Artist in the Simplon* (see figure 105).

Here Sargent showed the peaks shrouded by dramatic high clouds that are rendered with a pale palette of grayish blues and soft purples.

EXHIBITION: "Watercolors and Drawings by Centurion John S. Sargent," The Century Association, New York, September 21–October 23, 1982 (no catalogue).

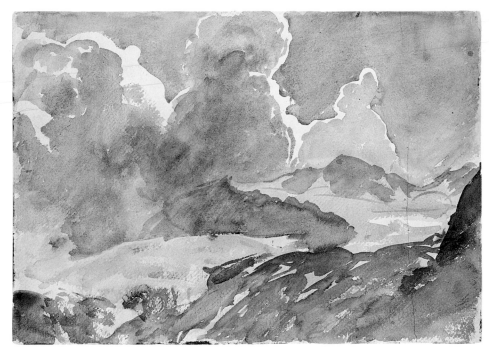

301

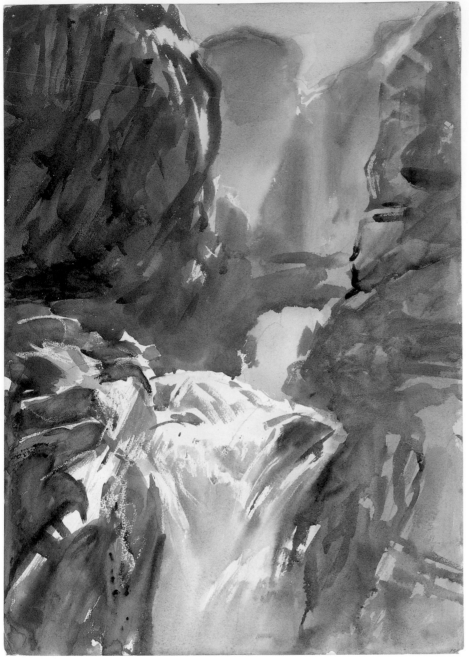

302

302. *Mountain Torrent*

ca. 1910

Watercolor, graphite, and wax crayon on white wove paper

21⅛ × 14⅞ in. (53.7 × 37.8 cm)

Inscribed at lower right: [illegible]

Gift of Mrs. Francis Ormond, 1950

50.130.80k

Catalogue 302 has the same composition as the oil *A Waterfall* (see figure 103), which was probably painted during the summer of 1910 in the Alps and shown at the Royal Academy, London, in 1911.

In the watercolor, Sargent suggested the path of the torrent with pale washes and graphite lines descending from the upper right of the composition, but he seems to have abandoned the work before rendering the flow in significant detail. He described the rugged landscape with multiple layers of diverse colors—from brown and rust to purple and deep ochre.

EXHIBITION: "Watercolors and Drawings by Centurion John S. Sargent," The Century Association, New York, September 21–October 23, 1982 (no catalogue).

303. *Garden near Lucca*

ca. 1910

Watercolor and graphite on white wove paper

13⅞ × 9¹⁵⁄₁₆ in. (35.2 × 25.2 cm)

Inscribed on verso at upper left: 42 / 53 Garden near Lucca / by J. S. Sargent; at upper right: V.O / (Trust); at center: ᴹ⁄₁₆; at lower left: SMW

Gift of Mrs. Francis Ormond, 1950

50.130.81i

The precise site of catalogue 303 is unknown, but this striking watercolor may have been painted near Lucca, as the inscription on the verso—not in Sargent's hand—suggests.

After passing part of the early autumn of 1910 in Florence, Sargent went to Varramista (near Lucca, about seventy miles west of Florence) as the guest of his friend the Marchese Farinola. Sargent was preoccupied with painting watercolors of villas and their gardens and made several well-known works at Collodi in the environs of Lucca. (Four examples are in the Museum of Fine Arts, Boston: *Villa di Marlia: The Balustrade; Villa di Marlia: A Fountain; Villa di Marlia, Lucca;* and *Daphne,* all painted at the Villa Garzoni in 1910.)

In catalogue 303 Sargent used a low vantage point to set off the sun-washed stone of the richly carved urn against a vibrant blue sky, which he created with broad, wet washes. He enlivened a static subject by placing the urn close to the top edge of the composition. Although the vine of vivid pinkish blue blossoms and greenery that he portrayed with feathery brush strokes must have grown up the pilaster to wrap around the base of the urn, it appears to cascade from it. The vine has been identified in an Ormond family inventory as convolvulus, a genus of the morning glory family (inventory courtesy of Richard Ormond).

EXHIBITIONS: New York–St. Louis–Seattle–Oakland 1977–78 (Oakland only); "Watercolors and Drawings by Centurion John S. Sargent," The Century Association, New York, September 21–October 23, 1982 (no catalogue); "Sargent Abroad: An Exhibition," Adelson Galleries, New York, November 7–December 13, 1997, cat. 18.

REFERENCE: Weinberg and Herdrich 2000b, p. 231.

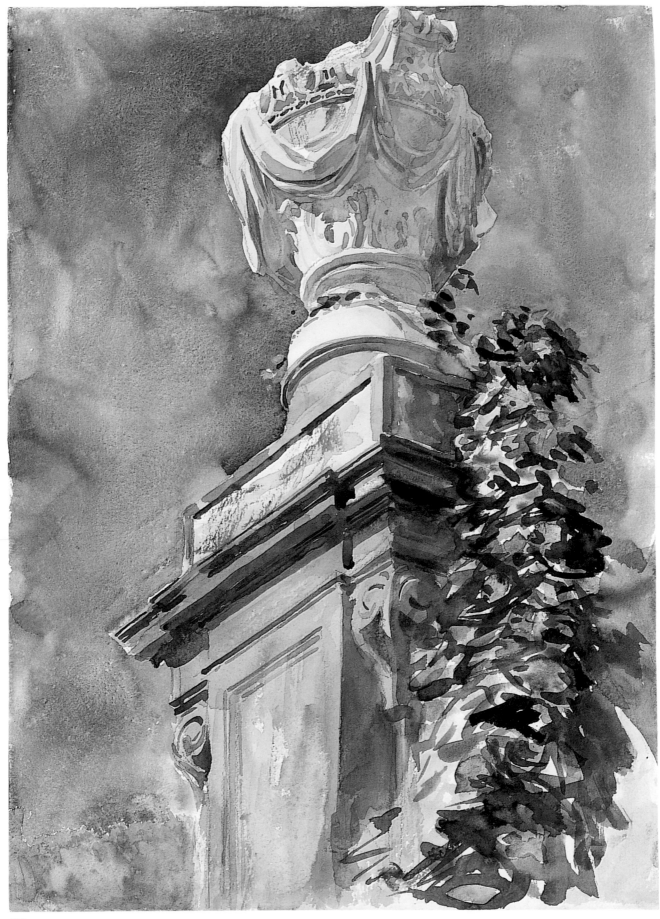

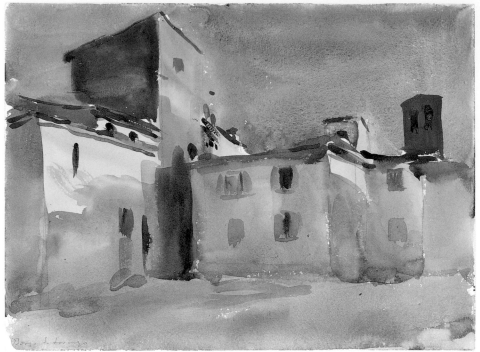

304

304. *Borgo San Lorenzo (1)*

ca. 1910
Watercolor and graphite on white wove paper
9⅝ × 13¹⁄₁₆ in. (24.4 × 33.2 cm)
Inscribed at lower left: Borgo S. Lorenzo; on
verso at upper left: 48 / 93 Venice / by J. S.
Sargent; at center: ¹⁄₂₀; at lower left: V.O /
(Trust) / SMW
Gift of Mrs. Francis Ormond, 1950
50.130.81j

305. *Borgo San Lorenzo (2)*

ca. 1910
Watercolor on white wove paper
9⅝ × 13¹⁄₁₆ in. (24.4 × 33.2 cm)
Inscribed at lower left: Borgo S. Lorenzo; on
verso at upper left: 49 / 106 Spain / by J. S.
Sargent / V.O (Trust); at center: ¹⁄₂₀; at lower
left: SMW
Gift of Mrs. Francis Ormond, 1950
50.130.81k

The agricultural town of Borgo San
Lorenzo is situated northeast of Florence
in the Mugello, the valley of the Sieve
River. (The Italian word *borgo* means
small town or suburb.) In the autumn
of 1910, Sargent painted extensively in

the region around Florence, particularly
in Lucca (to the west), but he also visited
Bologna (to the northwest). Although cata-
logue numbers 304 and 305 probably were
painted about this time, their fluid water-
color technique does not preclude an ear-
lier date.

In the nearly identical compositions,
Sargent depicted the regional architecture
under different lighting conditions, perhaps
in the moments before and after sunset. In
catalogue 304, the sky is bright blue, the
upper reaches of the buildings are illumi-
nated, and the foreground is cast in shadow
to indicate that the sun is low in the sky.
Sargent's golden-toned palette suggests the
warmth of the late afternoon. In catalogue
305, the color of the sky has mellowed
toward gray, and the fading light is ren-
dered with a cooler and paler palette.
While both sheets are broadly painted, the
edges of forms in catalogue 305 become
softer and more diffuse in the failing light.

EXHIBITION (cat. 304): "Watercolors and Drawings
by Centurion John S. Sargent," The Century Associ-
ation, New York, September 21–October 23, 1982
(no catalogue).

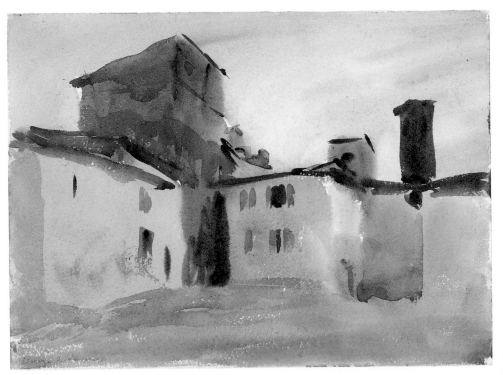

305

306. *Siena*

ca. 1910

Watercolor and graphite on white wove paper

15¾ × 20¾ in. (40 × 52.6 cm)

Inscribed on verso at upper left: 132 Siena ?
unfinished / by J. S. Sargent / E.S.; at upper cen-
ter: ⁵⁄₁₀ [encircled]; at center: ¹⁄₁₈; at bottom left: .27

Gift of Mrs. Francis Ormond, 1950

50.130.69

The silhouetted, panoramic view in cata-
logue 306 may well represent Siena, as the
inscription on the verso—not in Sargent's
hand—proposes. The city's distinctive posi-
tion on a Tuscan hilltop and the forms that
recall Siena's prominent monuments—the
cathedral, its campanile, and the soaring
tower of the Palazzo Pubblico—support the
identification.

307. *Three Oxen* (overleaf)

ca. 1910

Watercolor, graphite, and wax crayon on off-white
wove paper

12 × 18⅛ in. (30.5 × 46 cm)

Inscribed on verso: 37 Oxen / by J. S. Sargent /
E.S.; at top center ¹⁄₆ [encircled]; at center: ¹⁄₃₆

Gift of Mrs. Francis Ormond, 1950

50.130.66

308. *Oxen* (overleaf)

ca. 1910

Watercolor, graphite, and wax crayon on white
wove paper

13¹⁵⁄₁₆ × 19¹⁵⁄₁₆ in. (35.5 × 50.7 cm)

Signed at lower left: John S. Sargent; inscribed at lower
right: Siena; on verso at upper right: 40 Oxen / by
J. S. Sargent / ¹⁄₆ [encircled]; at upper right: E.S.;
at center: ⁵⁄₁₇

Gift of Mrs. Francis Ormond, 1950

50.130.67

As Sargent's inscription on catalogue 308
suggests, the artist painted this pair of
related studies in Siena. While many of the
artist's more than twenty images of oxen
are associated with Siena, he also painted
the animals outside of Naples and at Car-
rara about 1910. Sargent's friend and travel-
ing companion Eliza Wedgwood recorded
the spontaneous creation of one such com-
position that Sargent made while he and his
friends waited for a train at Narni, north
of Rome, in 1907: "We sat very cross all
round the waiting room, but John, true
philosopher that he was, sat down outside
and painted one of the loveliest of all
his great white oxen with blue shadows"
(Eliza Wedgwood, "Memoir," typescript,
November 22, 1925, quoted in Adelson et
al. 1997, p. 160). Wedgwood's testimonial
records not only Sargent's fascination with
this subject but his nearly incessant activity
and enthusiasm for portraying the world
around him.

Sargent painted the typical white oxen
of Italy both outdoors in bright sunlight
and, as in catalogue numbers 307 and 308,
in the shadowed interior of a stable. In
these fluid studies, he explored the subtle
tonalities created by the dim light on the
animals' pale, bulky bodies, set off against
the brown interior.

A related work, *Oxen in Repose* (ca. 1910,
private collection; Adelson et al. 1997,
p. 163), is signed in graphite and inscribed
"Siena," as is catalogue 308.

EXHIBITION (cat. 308): "Watercolors and Drawings
by Centurion John S. Sargent," The Century Associ-
ation, New York, September 21–October 23, 1982
(no catalogue).

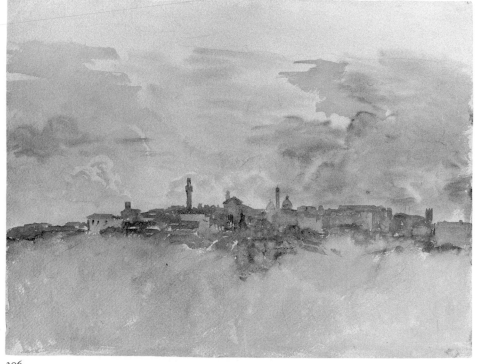

306

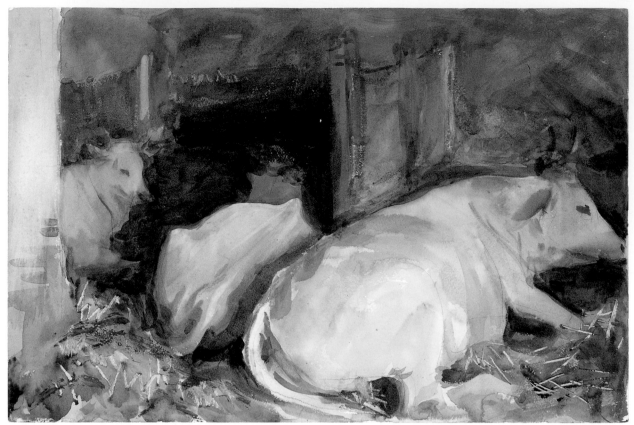

307

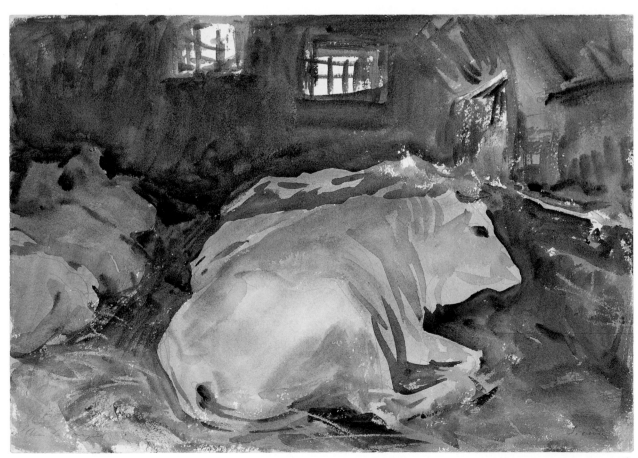

308

309. *Feeding the Goats*

1910
Graphite on off-white wove paper
5 × 7 in. (12.6 × 17.7 cm)
Gift of Mrs. Francis Ormond, 1950
50.130.140v

Catalogue numbers 309 and 310 can be dated by their relation to a sketchbook labeled "Torre Galli" at the Fogg Art Museum (1937.7.16). Both sheets are penetrated by a matching waxy stain on one long edge. This stain, the sheet size, and the paper type correspond to the Fogg sketchbook. Also in the Fogg Art Museum are several loose sheets—bearing the identical stain and apparently from the same sketchbook—that contain rapidly drawn studies of goats (1937.8.86, 1937.8.87, and 1937.8.91). The sketchbook and related sheets probably date from the summer of 1910, during which Sargent traveled in Italy before settling at Villa Torre Galli near Florence for the month of September. The Fogg sketchbook also includes architectural studies and a sketch after Michelangelo's *Deposition* (ca. 1547–55, Museo dell'Opera del Duomo, Florence).

Goats appear in several oil paintings about this time as well, including *Landscape with Goatherd* (1905, The Metropolitan Museum of Art), *Landscape with Goats* (1909, Freer Gallery of Art, Smithsonian Institution, Washington, D.C.), and *Olives*

in *Corfu* (1909, Fitzwilliam Museum, Cambridge). See also catalogue 281 recto.

310. *Allegorical Figure*

1910
Graphite on off-white wove paper
7 × 5 in. (17.8 × 12.7 cm)
Gift of Mrs. Francis Ormond, 1950
50.130.140w

Although it appears to record a sculptural group or the motif on a banner, the subject of this composition has not been identified. For a discussion of the date of this sheet, see catalogue 309.

311. *Chalet* (overleaf)

1912
Watercolor, graphite, and wax resist on white wove paper
21 × 13⅝ in. (53.3 × 34.6 cm)
Inscribed on verso at upper left: 175 Chalet / by J. S. Sargent / E.S.; at center: ⁵⁄₁₅; at lower left edge: ¼ [encircled]
Gift of Mrs. Francis Ormond, 1950
50.130.81l

312. *Abriès* (overleaf)

ca. 1912
Watercolor and graphite on white wove paper
20⅞ × 15¾ in. (53 × 40 cm)
Inscribed on verso at upper left: 68 V.O. / (Trust); by J. S. Sargent Abriez; at center: D / [illegible mark] /15; at lower left: SMW
Gift of Mrs. Francis Ormond, 1950
50.130.81m

During his alpine holidays about 1912–14, Sargent made a group of studies that, as Ormond has noted, reveal his "fascination with the construction and character of the chalet" (Adelson et al. 1997, p. 105). These two watercolors from the series were probably painted in 1912 at Abriès (Abriez), as the inscription, not by Sargent, on the verso of catalogue 312 suggests. However, little is known of Sargent's stay in the Dauphiné in southern France.

In catalogue numbers 311 and 312, Sargent exploited near and low vantage points to study the rugged materials and create a dynamic composition of steep diagonals. In choosing difficult perspectives, Sargent amplified the geometric challenge presented by depicting these structures. In catalogue 311, he rendered an oblique view of an overhang from below. Among the diverse planes—the wall of the lower story, the bottom and side of the overhang, and the eave of the roof—the rustic posts, beams, and trusses crisscross to create a web of angles. In

309

310

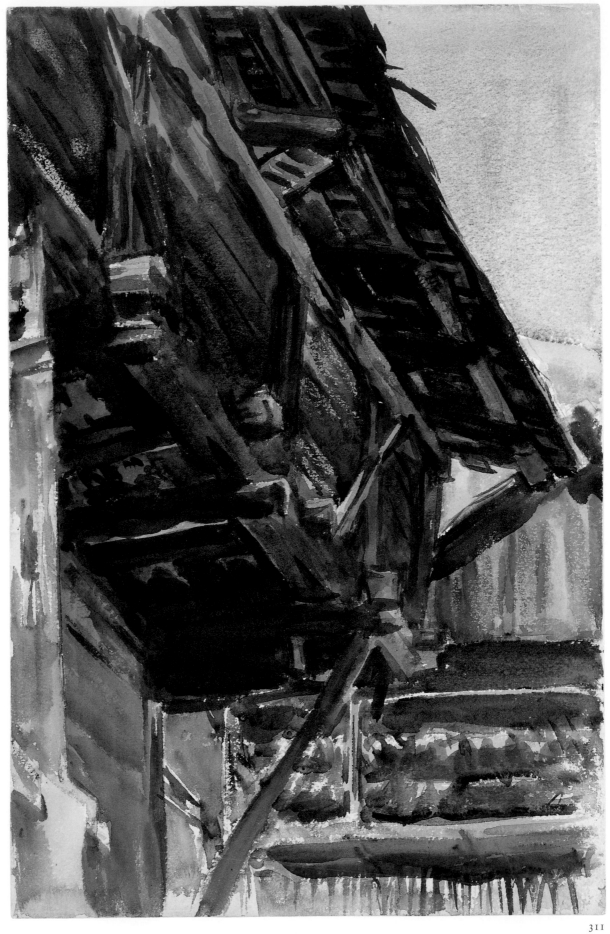

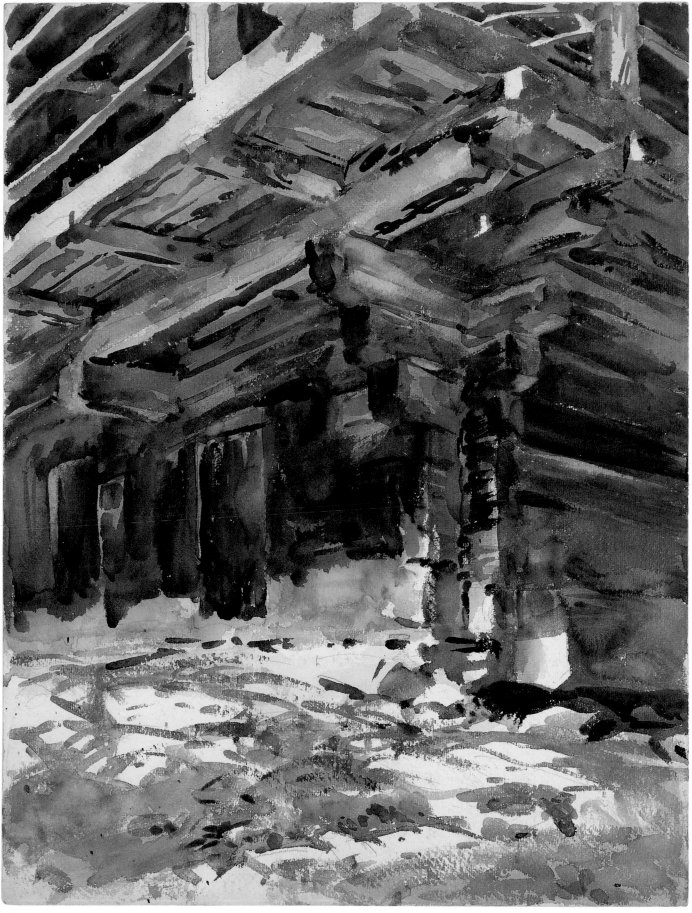

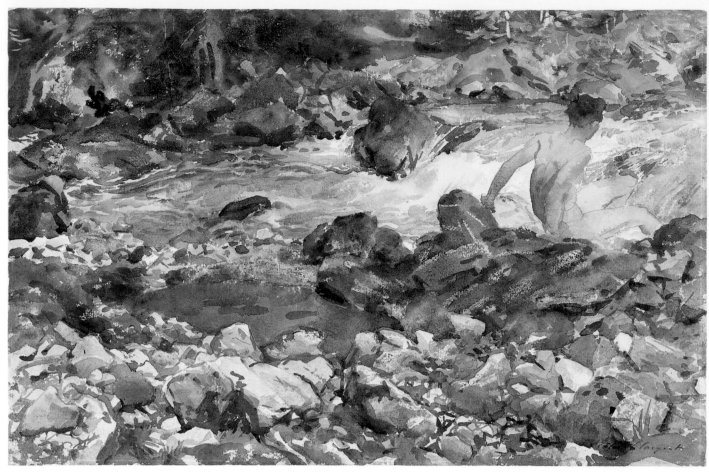

313

catalogue 312, Sargent created an even more dynamic composition by studying the intersections of the beams at the corner of the building. The image is tightly cropped to exclude the sky and appears almost abstract.

While Sargent recorded alpine structures during his childhood travels (cats. 38 and 39 recto), his later interest in them is said to have begun about 1908 with *Brenva Glacier* (ca. 1908–9, Johannesburg Art Gallery, South Africa), an image of a quintessential chalet in a dramatic landscape.

EXHIBITION (cats. 311 and 312): New York–Buffalo–Albany 1971–72, cats. 34, 35.

313. *Mountain Stream*

ca. 1912–14
Watercolor and graphite on off-white wove paper
13¾ × 21 in. (34.9 × 53.3 cm)
Signed at lower right: John S. Sargent; inscribed on verso at center right: 1004
Purchase, Joseph Pulitzer Bequest, 1915
15.142.2

Catalogue 313 is one of Sargent's most dazzling compositions based on the theme of flowing water. Beyond a carefully studied and delineated rocky foreground, a cool blue stream descends from a small cascade at the right edge of the sheet. A lone bather lowers himself into the rushing water. In the background, a lush green landscape rises from the far banks of the stream.

Although Sargent's correspondence with the Metropolitan implies that the ten watercolors he sold to the Museum in 1915, including this sheet, were created after he painted *Spanish Fountain* (cat. 315) in 1912, both Rubin and Ormond have suggested that Sargent painted catalogue 313 earlier, at Purtud (New York and other cities 1991, p. 25; Adelson et al. 1997, p. 100). In composition and subject, the watercolor is analogous to other works Sargent painted there, such as his diploma piece for the Royal Watercolour Society, *Bed of a Glacier Torrent* (1904, Diploma Collection of the Royal Watercolour Society, London), which also concentrates on form and pattern in the rocky foreground and the flowing water beyond. Erica Hirshler aptly characterizes *Bed of a Glacier Torrent* as "a distinctly anonymous view" with "no central focus, no peculiar rock formation that takes precedence over any other, no horizon line to establish a sense of scale or vantage point" (Boston 1999, p. 61). While the site depicted in catalogue 313 would be difficult to identify, Sargent's concern with foreground details, rendered with precise brush strokes within a broad, open composition that includes a figure, suggests a specificity of place and moment that is absent in works such as *Bed of a Glacier Torrent*.

Catalogue 313 also may be seen as representing a more mature approach to subjects Sargent had explored at Purtud and then at Val d'Aosta and the Simplon Pass. Oils from this period such as *Trout Stream in the Tyrol* (1915, Fine Arts Museums of San Francisco) and *The Master and His Pupils* (see figure 100), like catalogue 313, are more carefully composed than Sargent's anonymous views of the stream at Purtud and feature distinctly scrutinized rocky foregrounds and figures.

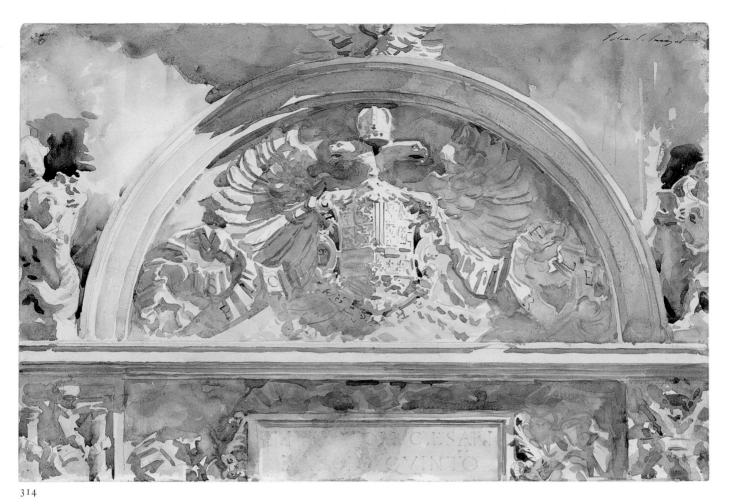

314

EX COLL.: The artist, until 1915.

EXHIBITIONS: The Metropolitan Museum of Art, January–February 1916; Boston 1921, p. 11, cat. 85; Paris 1923, cat. 44; Boston 1925, cat. 65; The Metropolitan Museum of Art, September 1965; New York 1966–67, cat. 110; New York–Buffalo–Albany 1971–72, cat. 29; "Three Centuries of the American Nude," New York Cultural Center, May 9–July 13, 1975, cat. 154; "American Drawings, Watercolors, and Prints: Part I," The Metropolitan Museum of Art, June 11–August 31, 1980; "Watercolors and Drawings by Centurion John S. Sargent," The Century Association, New York, September 21–October 23, 1982 (no catalogue); Greensburg (Penna.) 1984, cat. 96; New York and other cities 1991, p. 25, cat. 101.

REFERENCES: Ely 1923, p. 101; Downes 1925, p. 279; Ely 1925, pp. 18–19; Albert Ten Eyck Gardner, History of Water Color Painting in America, New York, 1966; Hoopes 1970, p. 68; Fairbrother 1981a, pp. 76, 79, n. 14; Ratcliff 1982, pp. 213–14; New York–Chicago 1986–87, p. 232; Christopher Finch, American Watercolors, New York, 1986, p. 169; Adelson et al. 1997, pp. 99–100; Weinberg and Herdrich 2000a, pp. 50, 52.

314. Escutcheon of Charles V of Spain

1912

Watercolor and graphite on white wove paper
12 × 18 in. (30.5 × 45.7 cm)
Signed at upper right: John S. Sargent; inscribed on
verso at center right: 1577
Purchase, Joseph Pulitzer Bequest, 1915
15.142.11

Catalogue 314 may be the most celebrated of the Metropolitan's watercolors by Sargent. In their assessments of the sheet, critics have repeatedly used the word "brilliant" to acknowledge both the artist's dazzling interpretation of sunlight and his magnificent technical ability. Cox referred to "the extraordinarily brilliant sketch" (Cox 1916, p. 36); Donelson Hoopes characterized it as "one of the most brilliant performances of [Sargent's] career" (Hoopes 1970, p. 74); and Fairbrother called it "a brilliant success" (Fairbrother [1981] 1986, p. 332).

Sargent presents a close view of a carved relief bearing the heraldic insignia of Emperor Charles V of Spain. The relief is located in the upper niche of a sixteenth-century fountain on the exterior fortification walls of the Alhambra (south of the Puerta de la Justicia), Granada. Sargent translated this monochromatic subject into a dazzling study of saturated golden light on the pale stone carving. The surface of the sheet comes alive with the myriad subtle warm and cool tones, ranging from golden tans, peach, salmon, and brown to pale blues and purples, which Sargent used to convey the optical experience.

Describing the watercolor in the Museum's *Bulletin* upon its accession, Cox marveled at Sargent's faithfully capturing the experience of light and shadow rather than slavishly rendering details of the object:

Sargent, the pure painter, has seen the sun striking across it, has noted the glitter of light on the projecting bosses, the sharp forms of blue shadows, the warm reflections; and with astonishing rapidity and simplicity of means has so set down these things as to create an absolute illusion. The

thing is there before you and you feel sure that by going a little closer you can make out the exact forms that have caused this confusion of light and shade. If you try it, you will discover that you see less than at a distance, that the forms are not there. (Cox 1916, p. 37)

The impression of rapidity and simplicity Sargent sought and Cox points out belies the artist's actual technique. Sargent began by carefully delineating the composition with pale graphite, using a compass to achieve the precise curve of the arch and a straight edge for further geometric accuracy, as he had done in other architectural studies. Yet much of this deliberation is obscured by his free and masterly application of paint.

A related watercolor shows a broader view of the entire wall fountain and the mosaic pavement in front of it (*Escutcheon of Charles V, Granada,* Sotheby's, London, December 13, 1961, lot 68). A sketchbook in the Fogg Art Museum contains a related drawing (1937.7.29). Another watercolor painted about the same time at the Alhambra is catalogue 316.

EX COLL.: The artist, until 1915.

EXHIBITIONS: "Anglo-American Exposition," London, 1914, cat. 455; The Metropolitan Museum of Art, January–February 1916; Boston 1921, p. 12, cat. 94; Paris 1923, cat. 35; Boston 1925, cat. 64; New York 1926, cat. 43; "Twentieth Century Painters," The Metropolitan Museum of Art, June 1950, p. 16; The Metropolitan Museum of Art, September 1965; New York 1966–67, cat. 108; New York–Buffalo–Albany 1971–72, cat. 20; "American Master Drawings and Watercolors: Works on Paper from Colonial Times to the Present," American Federation of Arts, traveling exhibition, 1976 (no catalogue); The Metropolitan Museum of Art, May 1980; "American Drawings, Watercolors, and Prints: Part I," The Metropolitan Museum of Art, June 11–August 31, 1980; "Watercolors and Drawings by Centurion John S. Sargent," The Century Association, New York, September 21– October 23, 1982 (no catalogue); New York and other cities 1991, p. 25, cat. 97; London–Washington, D.C.– Boston 1998–99, cat. 129 (London only).

REFERENCES: Cox 1916, pp. 36–37; Ely 1923, p. 98; Downes 1925, p. 277; Ely 1925, p. 18; Feld 1966, p. 842; Hoopes 1970, p. 74; Kathleen A. Foster et. al., "American Drawings, Watercolors, and Prints," *The Metropolitan Museum of Art Bulletin* 37, no. 4 (spring 1980), p. 49; Fairbrother (1981) 1986, pp. 332–36; New York–Chicago 1986–87, p. 232; *Sargent at Harvard* website, July 14, 1997, Harvard accession number 1937.7.29; Weinberg and Herdrich 2000a, pp. 44–45.

315. *Spanish Fountain*

1912
Watercolor and graphite on white wove paper
21 × 13¾ in. (53.3 × 34.9 cm)
Signed at upper right: John S. Sargent; inscribed on verso at lower left: 1596
Purchase, Joseph Pulitzer Bequest, 1915
15.142.6

Sargent's subject in catalogue 315 is the fountain at the center of the sixteenth-century courtyard of the Hospital de San Juan de Dios in Granada. According to Kilmurray, Sargent painted some thirty oil and watercolor studies of fountains as "an aspect of his love of the exuberance of Renaissance and mannerist garden architecture" (London–Washington, D.C.–Boston 1998–99, p. 236). In such studies, Sargent was equally fascinated with the interplay among light, water, and the fountains themselves.

In catalogue 315, Sargent's close vantage point, apparently from the very edge of the pool, excludes the top of the fountain, and hinders any view into the courtyard beyond. The varied surfaces of the three putti on the pedestal invite the artist to explore nuances of light and shadow. Water flowing from the mouth of the grotesque at the upper left accounts for the rippled surface of the pool in which are reflected the golden tones of the putti. The cool blue shadows and the tone of the water below are reflected in the underside of the upper basin.

A similar depiction of this subject is in the Fitzwilliam Museum, Cambridge. In that sheet Sargent studied the base of the fountain from a slightly greater distance under more brilliant sunlight and elaborated the arched colonnade in the background. Four photographs of the fountain, possibly taken by Sargent, are in the collection of the Ormond family. The oil *Hospital at Granada* (1912, National Gallery of Victoria, Melbourne, Australia) depicts the first-floor loggia of the surrounding building.

Catalogue 315 was the first watercolor that Sargent sold to the Metropolitan. The artist responded to director Edward Robinson's request to purchase watercolors by sending a photograph of this composition with a letter stating, "I am very flattered that the Metropolitan Museum should want a few of my watercolours and wish I had the choice to offer, but I have done very few this year, and sold two or three of them. I kept back the two best for myself, but I would sell at least one of them to the Museum for £75—it is one of a fountain in Granada" (JSS to Edward Robinson, [London?], December 31, 1912, The Metropolitan Museum of Art Archives).

EX COLL.: The artist, until 1915.

EXHIBITIONS: The Metropolitan Museum of Art, January–February 1916; Boston 1921, p. 11, cat. 89; Paris 1923, cat. 40; Boston 1925, cat. 63; New York 1926, cat. 47; The Metropolitan Museum of Art, September 1965; New York 1966–67, cat. 107; New York–Buffalo–Albany 1971–72, cat. 14; "American Drawings, Watercolors, and Prints: Part I," The Metropolitan Museum of Art, June 11–August 31, 1980; "Watercolors and Drawings by Centurion John S. Sargent," The Century Association, New York, September 21–October 23, 1982 (no catalogue); New York and other cities 1991, p. 25, cat. 96.

REFERENCES: Cox 1916, p. 37; Ely 1923, p. 98; Downes 1925, p. 278; Ely 1925, p. 18; Mount 1955a, p. 328; Feld 1966, p. 842; Hoopes 1970, p. 24; Ormond 1970a, p. 234; Ratcliff 1982, p. 177; Kathleen A. Foster et al., "American Drawings, Watercolors, and Prints," *The Metropolitan Museum of Art Bulletin* 37, no. 4 (spring 1980), p. 49; New York–Chicago 1986–87, p. 232; London–Washington, D.C.– Boston 1998–99, p. 236; Weinberg and Herdrich 2000a, pp. 50–51.

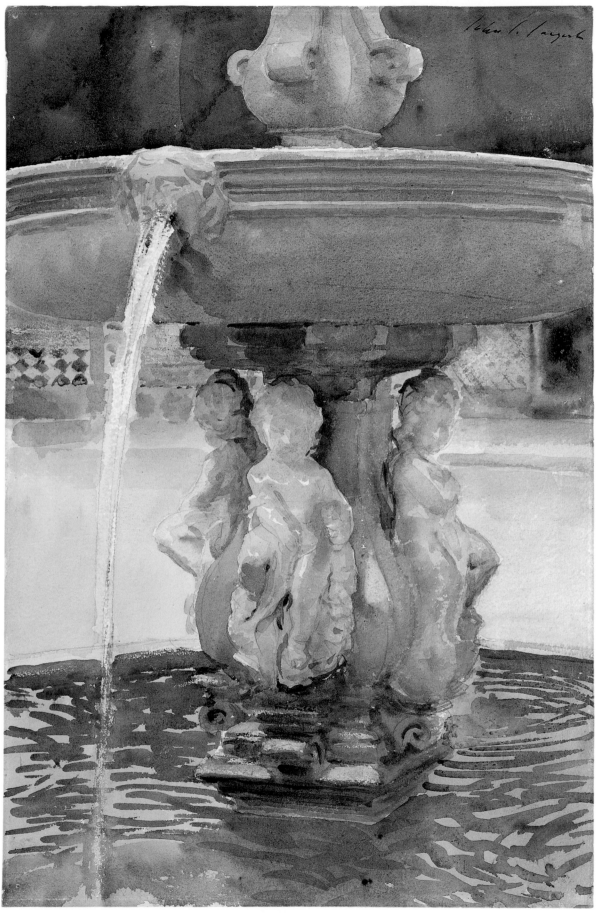

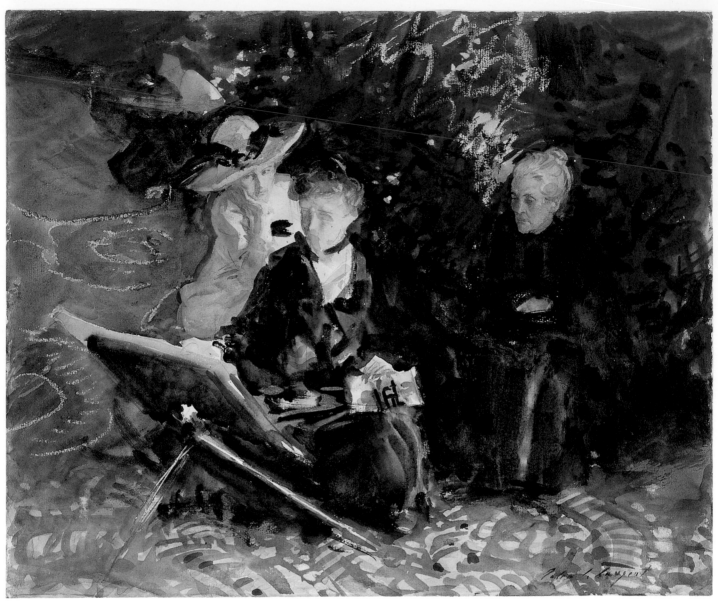

316

316. *In the Generalife*

1912

Watercolor, wax crayon, and graphite on white wove paper

14¾ × 17⅞ in. (37.5 × 45.4 cm)

Signed at lower right: John S. Sargent; inscribed on verso at center right: 5424 [encircled]

Purchase, Joseph Pulitzer Bequest, 1915

15.142.8

The Generalife (pronounced "henn-er-ah-LEE-fay"), the fourteenth-century former summer palace of the Moorish sultans, is situated on the hillside overlooking the palace of the Alhambra in Granada.

Baedeker's description of the gardens of the Generalife as "one of the most interesting survivals of the Moorish period, resembling, with its terraces, grottoes, waterworks, and clipped hedges, the park of an Italian villa of the Renaissance," suggests the inevitability of Sargent's attraction to the place (*Spain and Portugal,* Leipzig, 1913, p. 363). Sargent was again inclined to explore gardens, a subject that had captivated him throughout the previous decade, particularly in Italy (see cats. 286 and 294).

Surrounded by the lush foliage and tiled paths of the dusky garden is Sargent's sister Emily, an amateur artist, sketching at her easel. The young woman looking on at the left is Jane de Glehn (1873–1961), an artist,

frequent traveling companion, and model (see cat. 317). The figure at the right has been identified as Dolores Carmona, a Spanish friend. In the upper left corner, another barely described figure also sits before an easel.

During his annual painting holidays, Sargent often depicted his companions at work. His images of friends and family engaged in painting are among his most compelling watercolors, works in which he applied his brilliant technique to portraiture.

Although Emily occupies the center of the composition and is the object of her companions' attention, her face is rendered in a cursory fashion. In contrast, Sargent creates careful portraits of de Glehn and

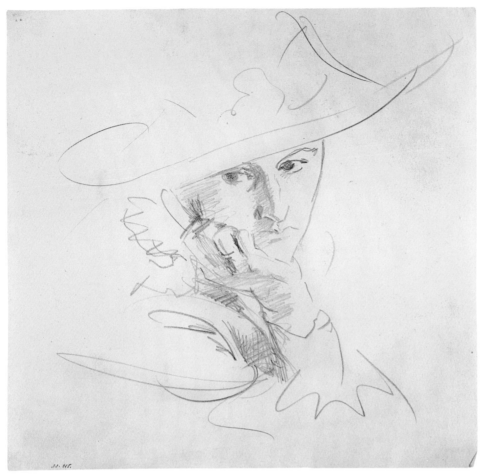

317

January 29–December 31, 1976, cat. 84; "American Drawings, Watercolors, and Prints: Part I," The Metropolitan Museum of Art, June 11–August 31, 1980; Greensburg (Penna.) 1984, p. vii, cat. 95; New York and other cities 1991, p. 25, cat. 98; "American Impressionism and Realism: Drawings, Prints, and Photographs," The Metropolitan Museum of Art, May 3–July 24, 1994 (no catalogue); "Images of Women: Nineteenth-Century American Drawings and Watercolors," The Metropolitan Museum of Art, October 1996–February 1997 (no catalogue).

REFERENCES: Tyrrell 1921, p. xxx; Ely 1923, p. 101; Downes 1925, p. 278; Feld 1966, p. 842; Kent 1970, pp. 66–72, 76; Hoopes 1970, pp. 72–73; John K. Howat and Natalie Spassky, "Exhibitions—Works by Sargent and Homer," *The Metropolitan Museum of Art Bulletin* 30, no. 4 (February–March 1972), pp. 185–86; Leeds–London–Detroit 1979, pp. 103, 108; New York 1980a, n.p.; Ratcliff 1982, pp. 213–14; New York–Chicago 1986, p. 232; Christopher Finch, *American Watercolors*, New York, 1986, pp. 161–63; Laura Wortley, *Wilfrid de Glehn: A Painter's Journey*, London, 1989, p. 43; Boston 1993, p. 161, n. 2; Adelson et al. 1997, p. 128; London–Washington, D.C.–Boston 1998–99, p. 232; Weinberg and Herdrich 2000a, pp. 44–45.

317. *Jane de Glehn, Study for "In the Generalife"*

1912
Graphite on off-white wove paper
$9^{15}/_{16} \times 9^{15}/_{16}$ *in. (25.2 × 25.2 cm)*
Inscribed at lower left: J.S. 365.; on verso at upper right: 368
Gift of Mrs. Francis Ormond, 1950
50.130.116

Parisian-trained artist Jane de Glehn and her husband, artist Wilfrid de Glehn (1870–1951) frequently traveled with Sargent. Jane de Glehn often appears in Sargent's subject pictures. In catalogue 317 made in preparation for the watercolor *In the Generalife* (cat. 316), Sargent captures light, shadow, and expression with rapid pencil strokes. Although he omits her left shoulder, making the exact position of her torso unclear, the tilt of her head resting on her right hand is nearly identical to her pose in the watercolor.

EXHIBITIONS: Probably included in New York 1928 (inventory listing J.S. 365); "Images of Women: Nineteenth-Century American Drawings and Watercolors," The Metropolitan Museum of Art, October 1996–February 1997 (no catalogue).

Carmona that reflect their absorption with Emily's task. Sargent's graphite study of de Glehn suggests that he used a calculated approach to describing her face within the context of a freely rendered plein air landscape scene.

Sargent's high vantage point yields a dynamic, tilted perspective. Although de Glehn sits behind her companions, her pale costume and the distorted space push her toward the picture plane. A strong diagonal leads from Emily to de Glehn to the obscure figure beyond. At the right, Carmona's dark clothing blends with the boldly painted greenery, but the bright highlights above her head draw attention to her and balance the composition.

Sargent showed de Glehn at work in at least two oils, *The Fountain, Villa Torlonia, Frascati* (1907, The Art Institute of Chicago) and *The Sketchers* (1913, Virginia Museum of Fine Arts, Richmond). Emily appears at her easel in a number of her brother's watercolors, including *Miss Sargent Sketching*

(ca. 1908, Ormond Collection; illustrated in Leeds–London–Detroit 1979, p. 103), *Simplon Pass, The Lesson* (1911, Museum of Fine Arts, Boston), and *Miss Eliza Wedgwood, with Miss Sargent Sketching* (1908, Tate Gallery, London). A related oil painting, *Garden at Granada* (1912, location unknown; illustrated in *Antiques* [January 1996], p. 11), also depicts sketchers in the gardens of the Generalife.

EX COLL.: The artist, until 1915.

EXHIBITIONS: Possibly included in summer exhibition, Royal Watercolour Society, London, 1913, cat. 163; possibly included in "Anglo-American Exposition," London 1914, cat. 452 or 459 (as *Grey Generalife* or *Sunny Generalife*); The Metropolitan Museum of Art, January–February 1916; Boston 1921, p. 12, cat. 91; Paris 1923, cat. 38; Boston 1925, cat. 90; New York 1926, cat. 45; "Exhibition of American Painting," M. H. De Young Memorial Museum, San Francisco, June 7–July 7, 1935, cat. 204; Chicago–New York 1954, cat. 80; The Metropolitan Museum of Art, September 1965; New York 1966–67, cat. 109; New York–Buffalo–Albany 1971–72, cat. 13; "A Bicentennial Treasury: American Masterpieces from the Metropolitan," The Metropolitan Museum of Art,

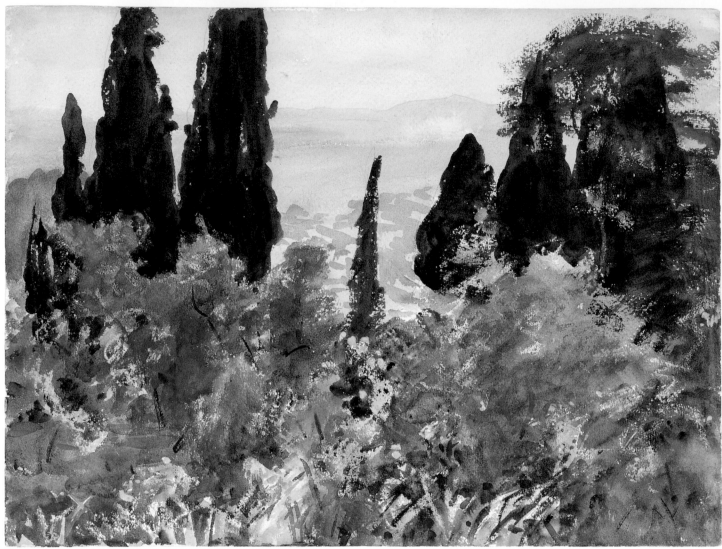

318

318. *Granada*

1912

Watercolor, graphite, and wax crayon on white wove paper

15¼ × 20⅞ in. (40 × 53 cm)

Inscribed on verso at upper left: 114 – Granada / by J. S. Sargent / E.S. / ⁸⁄₂; at center: ¹⁄₂₅; at lower left: VMW

Gift of Mrs. Francis Ormond, 1950

50.130.80m

In catalogue 318, Sargent evokes the characteristic topography of the city of Granada, which spreads across the slopes of three mountain spurs. Although the precise site of this composition is unknown, Sargent could have made it from the Alhambra or the Generalife (located on the highest of the three spurs), where he painted numerous compositions during his 1912 Spanish sojourn.

Sargent concentrated on the lush foliage in the foreground, suggesting the dense growth by applying multiple layers of diverse colors. He accented the immediate foreground with unusually high-keyed oranges and golden yellows. Tall cypress trees block the vista and separate the foreground from the barely described landscape below and beyond.

EXHIBITIONS: New York 1966–67, cat. 115; New York–Buffalo–Albany 1971–72, cat. 15; "Watercolors and Drawings by Centurion John S. Sargent," The Century Association, New York, September 21–October 23, 1982 (no catalogue); New York 1993, cat. 44.

REFERENCES: Hoopes 1970, p. 70; Mount 1955a; Duff 1993, p. 49 (mislabeled as *Camp and Waterfall*).

319. *Alhambra, Granada*

1912

Watercolor and graphite on white wove paper

19⅞ × 13⅞ in. (50.5 × 35.2 cm)

Inscribed on verso at upper left: 131; V.O / (Trust); VMW; at upper right: 62 Alhambra – Granada / by J. S. Sargent; at center: 990 [encircled]; ⅗

Gift of Mrs. Francis Ormond, 1950

50.130.80n

In catalogue 319, the fortified walls of the Alhambra serve as the backdrop for a fluid study of trees. The palette is similar to but less intense than that used for catalogue 318, and the work may have been painted about the same time.

319

320. *Spanish Midday, Aranjuez*

1912 (or 1903)
Watercolor and graphite on white wove paper
10 × 14 in. (25.4 × 35.6 cm)
Inscribed on verso at upper left: <u>11</u>; at center: ¹⁄₆₀;
at lower left: V.O / (Trust) ; By J. S. Sargent;
at lower center: 990 [encircled]; at lower right:
SMW
Gift of Mrs. Francis Ormond, 1950
50.130.81h

M. Elizabeth Boone identified the site in catalogue 320 as the park in front of the palace at Aranjuez, Spain, recognizable by the distinctive marble benches (notation, departmental files, American Paintings and Sculpture). Sargent visited Aranjuez about 1903 and again in 1912.

The prime attraction of Aranjuez, a former recreation site for the Spanish court, is its magnificent gardens. Sargent described the town in a letter to Charteris: "This place is perfectly charming, grand gardens with Cavernous avenues and fountains and statues, long neglected— good natured friendly people—lunch in the open air under arbours of roses" (Charteris 1927, p. 171).

From the right of this bold composition, the cropped bench recedes dramatically toward the center of the sheet, which is dominated by foliage, broadly painted in intense shades of green. The bench itself, though painted in a cursory manner, remains identifiable. A few strokes are applied over a pale wash to suggest the shadows of molding and ornament. Details are delineated in graphite. A related watercolor, erroneously called both *Park at Versailles* and *Garden, Villa Borghese* but depicting the park of the palace at Aranjuez, shows the same marble benches against lush foliage from a greater distance (1912, private collection).

EXHIBITIONS: "Watercolors and Drawings by Centurion John S. Sargent," The Century Association, New York, September 21–October 23, 1982 (no catalogue); New York 1993, cat. 45.

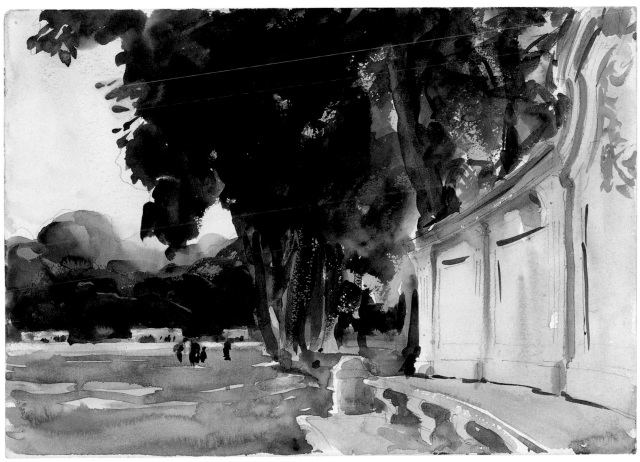

320

321. *Giudecca*

1913?
Watercolor and graphite on off-white wove paper
13¾ × 21 in. (34.9 × 53.3 cm)
Signed at upper left: John S. Sargent; inscribed on
verso at upper left: 1574; at lower right: (2)
Purchase, Joseph Pulitzer Bequest, 1915
15.142.4

To the south of Venice, a wide canal sepa-
rates the Giudecca, eight small islands, from
the rest of the city. In late-nineteenth-
century guidebooks, the Giudecca was
noted principally for its majestic Palladian
church, Il Redentore (1576). Recent
guidebooks comment on the church but
also designate the Giudecca "one of the
most characteristic parts of the city, rarely
visited by tourists" (*Blue Guide: Venice*,
London, 1994, p. 193).

In 1907 Arthur Symons described the
area: "There is, to those living on the
Giudecca, a constant sense of the sea, and
not only because there are always fishermen
lounging on the quay, and fishing boats
moored on the side canals, and nets drying
on the land, and crab-pots hanging half out
of the water. There is a quality in the air
one breathes, in the whole sensation of
existence, which is like a purification from
the soft and entangling enchantments of
Venice" (*Cities of Italy*, London, 1907, p. 99).
It is this aspect of the Giudecca, with its fish-
ing boats and distinctive yet nondescript
architecture, that Sargent focuses on in cat-
alogue 321. Although he avoids recogniz-
able Venetian monuments in recording of a
typical neighborhood, his inclusion of the
sailing vessels invokes the city's historical
importance as an Adriatic port.

Catalogue 321 is a rare example within
Sargent's Venetian oeuvre of a traditionally
constructed picturesque composition (see
also cat. 322). Perspective lines, evident in
the graphite underdrawing in the building
at left, indicate his careful articulation of
space. At the left and right edges of the
sheet, the buildings receding toward the
horizon frame the composition and focus

attention on the fishing boats and the
bridge, rendered with dynamic crisscross
strokes. The image is freely painted and
combines loose brushwork and pools of
color to create what Cox called "the per-
plexing and entertaining confusion of the
Giudecca" (Cox 1916, p. 37).

Oustinoff suggests that catalogue 321
was shown at the Carfax Gallery, London,
in 1905 (citing London 1905) and thus
dates it to about 1903 (Adelson et al. 1997,
p. 225). The authors of this catalogue,
however, have been unable to confirm that
the work exhibited in 1905 under the title
Giudecca is in fact catalogue 321. The 1913
date is based on Sargent's letter of Decem-
ber 31, 1912, which suggests that catalogue
321 was painted after 1912 (see cat. 315 for
the text of the letter).

Sargent's other watercolors of the area
include *Giudecca* (ca. 1907, Brooklyn
Museum of Art, New York), a depiction
of several large sailing vessels. In *Santa
Maria della Salute, Venice* (n.d., Victoria and
Albert Museum, London), Sargent painted

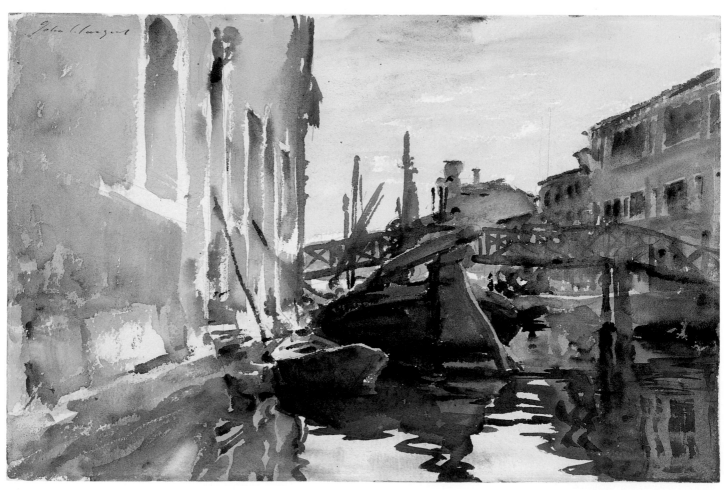

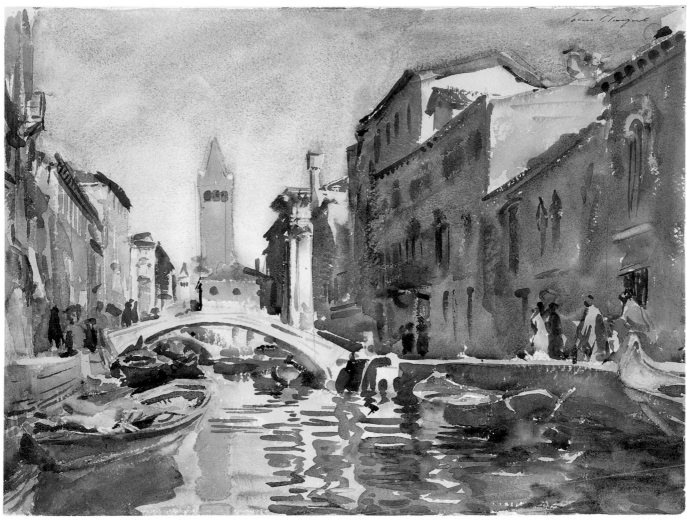

322

the church from the Giudecca Canal (see cat. 273).

A picturesque charm has long been associated with the Giudecca and has attracted artists. Both Francesco Guardi (1712–1793) and Joseph M. W. Turner (1775–1851) painted *vedute* of the Giudecca. However, their images, unlike Sargent's, almost always include recognizable landmarks such as Il Redentore or the Zitelle (1582–86), a church planned by Andrea Palladio (1508–1580) but built after his death.

EX COLL.: The artist, until 1915.

EXHIBITIONS: Possibly included in "Anglo-American Exposition," London 1914, cat. 451; The Metropolitan Museum of Art, January–February 1916; Boston 1921, cat. 87; Paris 1923, cat. 42; New York 1926, cat. 44; The Metropolitan Museum of Art, September 1965; New York–Buffalo–Albany 1971–72, cat. 23; "Watercolors and Drawings by Centurion John S. Sargent," The Century Association, New York, September 21–October 23, 1982 (no catalogue); New York and other cities 1991, p. 25, cat. 103.

REFERENCES: Cox 1916, p. 37; Ely 1923, p. 98; Downes 1925, p. 278; New York–Chicago 1986–87, p. 232; Adelson et al. 1997, p. 225.

322. *Venetian Canal*

1913
Watercolor and graphite on off-white wove paper
15¼ × 21 in. (40 × 53.3 cm)
Signed at upper right: John S. Sargent; inscribed on verso at upper left: 1373; at center: j
Purchase, Joseph Pulitzer Bequest, 1915
15.142.10

For the focal point of catalogue 322, Sargent chose the relatively obscure yet picturesque tower of the church of San Barnaba. Although the church (fourteenth century) and its tower (ca. 1000) do not merit mention in period guidebooks, one writer

described this area near the Gallerie dell' Accademia as "a delightfully airy quarter, full of light and with a good outlook, and consequently the resort of many Venetian painters, who have their studios there" (Henry Perl, *Venezia,* London, 1894, p. 176).

Sargent positioned himself close to the water, as if in a gondola, to present a view looking down the Rio di San Barnaba toward the Grand Canal. The width of the canal consumes the entire foreground, and the *fondamenta* flanking the rio recede dramatically toward the arched Ponte dei Pugni and the tower rising above it. Beyond the tower, where the canal of Rio di San Barnaba meets the Grand Canal, is situated the Ca' Rezzonico, where Sargent had a studio during the winter of 1880–81.

In 1925, Catherine Beach Ely described Sargent's powers of observation in *Venetian Canal:* "His sensitive faculties rejoice in the magic of Italian form and color. The warm

golden tones of *A Venetian Canal* are offset by a few deep green shadows, the water holds a world of reflected color, the slender tower in the center background shows orange against the sky and the little bridge which spans the canal like a golden brooch catches the direct sunlight" (Ely 1925, p. 18).

Because of Sargent's many visits to the city between 1898 and 1913, the chronology of his Venetian works is complicated. Lovell has dated this watercolor to an early moment, about 1904, because of its "adoption of a familiar pictorial arrangement" and the "non-problematical nature of the image" (San Francisco–Cleveland 1984–85, p. 125). However, in his correspondence with the Metropolitan, the artist suggested that the ten watercolors that the Museum purchased from him in 1915, including *Venetian Canal,* were created in 1912 and after (see cat. 315 for the text of the letter).

Variations of this composition, with its horizontal format, watery expanse dominating the foreground, and spatial recession toward an arched bridge at the left of center, include *Rio dei Mendicanti* (1903, Indianapolis Museum of Art) and *Ponte San Giuseppe di Castello, Venice* (ca. 1903–4, Isabella Stewart Gardner Museum, Boston). *Rio di San Barnaba* (1911), a watercolor view of the same tower by Sargent's friend Edward D. Boit (1840–1916), is in the Museum of Fine Arts, Boston (illustrated in San Francisco–Cleveland 1984–85, p. 29). In contrast to Boit's vertical composition, Sargent's horizontal format exploits an expanded pictorial space.

EX COLL.: The artist, until 1915.

EXHIBITIONS: The Metropolitan Museum of Art, January–February 1916; Boston 1921, p. 12, cat. 93; Paris 1923, cat. 36; The Metropolitan Museum of Art, September 1965; Los Angeles–San Francisco–Seattle 1968, cat. 16; New York–Buffalo–Albany 1971–72, cat. 17; "Sargent Watercolors," National Collection of Fine Arts, Smithsonian Institution, Washington, D.C., July 1977 (no catalogue); "American Drawings, Watercolors, and Prints: Part I," The Metropolitan Museum of Art, June 11–August 31, 1980; "Watercolors and Drawings by Centurion John S. Sargent," The Century Association, New York, September 21–October 23, 1982 (no catalogue); San Francisco–Cleveland 1984–85,

p. 126, cat. 80; New York and other cities 1991, p. 25, cat. 104.

REFERENCES: Ely 1923, p. 98; Downes 1925, p. 278; Ely 1925, p. 18; San Francisco–Cleveland 1984–85, pp. 59–61, 69; New York–Chicago 1986–87, p. 232; Weinberg and Herdrich 2000a, p. 42.

323. *Sirmione*

1913
Watercolor and gouache on off-white wove paper
15¾ × 21¹⁄₁₆ in. (40 × 53.6 cm)
Signed at lower right: John S. Sargent; inscribed on verso at upper left: 1373; at center: j; at lower left: xx-22
Purchase, Joseph Pulitzer Bequest, 1915
15.142.5

Sargent passed September 1913 at San Vigilio, a small town on the eastern shore of Lake Garda in northern Italy (see cats. 324 and 325). The town of Sirmione is situated on the tip of a narrow peninsula at the southern end of the lake. The rugged

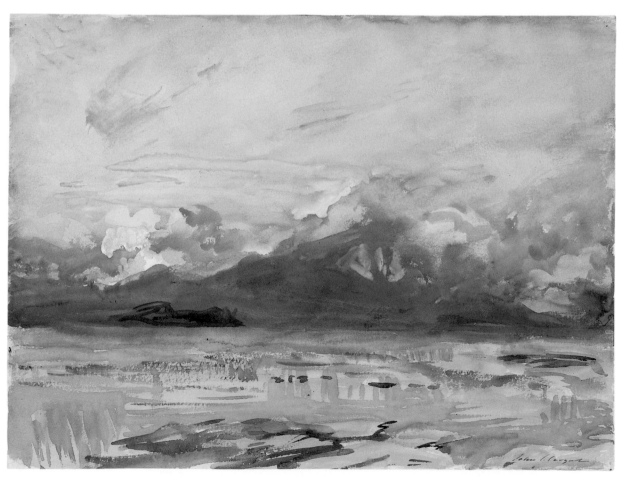

323

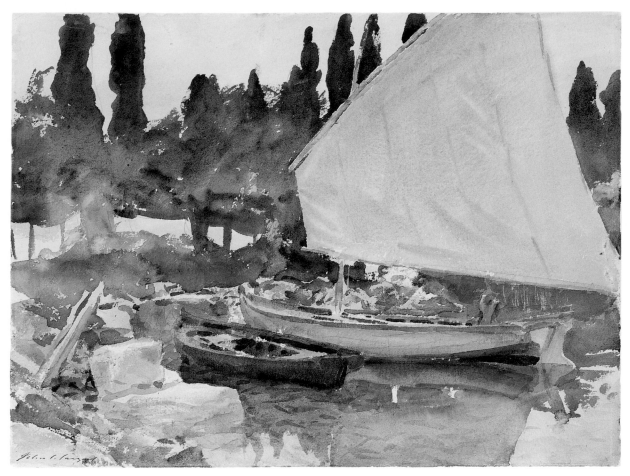

324

brown landscape at the center left edge of catalogue 323 probably represents the rocky promontory as seen from the eastern shore. While Sargent typically shunned broad, panoramic views, he did on occasion employ this sort of open and distant vista in order to record transitory atmospheric impressions such as this dramatic sky (see also cats. 277 and 278). Here Sargent layered transparent and opaque pigments to suggest the effect of clouds obscuring the peaks and the reflections on the water below. Ely described this effect as "a vision of transparent clouds and silvered mountain peaks" reflecting "itself in a pool hushed to receptive ecstasy" (Ely 1923, p. 98).

EX COLL.: The artist, until 1915.

EXHIBITIONS: "Anglo-American Exposition," London 1914, cat. 461; The Metropolitan Museum of Art, January–February 1916; Boston 1921, p. 11, cat. 88; Paris 1923, cat. 41; Boston 1925, cat. 68; New York 1926, cat. 46; New York–Buffalo–Albany 1971–72, cat. 32; "Watercolors and Drawings by Centurion John S. Sargent," The Century Association, New York, September 21–October 23, 1982 (no catalogue); New York and other cities 1991, p. 25, cat. 99.

REFERENCES: Ely 1923, p. 98; Downes 1925, p. 279; Ely 1925, p. 18; New York–Chicago 1986–87, p. 232; Weinberg and Herdrich 2000a, pp. 40–41.

324. *Boats*

1913
Watercolor and graphite on off-white wove paper
15¾ × 21 in. (40 × 53.4 cm)
Signed at lower left: John S. Sargent; inscribed on verso at upper left: 1373; at center right: h
Purchase, Joseph Pulitzer Bequest, 1915
15.142.9

From Venice and Majorca to the Middle East, Sargent often depicted the characteristic sailing boats and fishing vessels of exotic locales. In 1913 he continued his exploration of this subject around the small picturesque harbor at San Vigilio, on the shores of Lake Garda.

At San Vigilio Sargent often focused on the sails as receptors for light and shade. In catalogue 324, under a pale, perhaps somewhat overcast sky, Sargent used carefully modulated tones of white to suggest subtle shadows across the fully raised sail. Broadly painted cypress trees punctuate the background. Ever preoccupied with the interaction of light and water, Sargent captured the smooth and reflective surface in the small rocky cove. Other images painted at Lake Garda are catalogue numbers 323, 325, and 326.

EX COLL.: The artist, until 1915.

EXHIBITIONS: "Anglo-American Exposition," London 1914, cat. 457; The Metropolitan Museum of Art, January–February 1916; Boston 1921, p. 12, cat. 92; Paris 1923, cat. 37; "Exhibition of American Painting," M. H. De Young Memorial Museum, San Francisco, June 7–July 7, 1935, cat. 201; "Watercolors and Drawings by Centurion John S. Sargent," The Century Association, New York, September 21–October 23, 1982 (no catalogue); New York and other cities 1991, cat. 100.

REFERENCES: Cox 1916, p. 38; Ely 1923, p. 98; Downes 1925, p. 278; Ely 1925, p. 18; New York–Chicago 1986–87, p. 232; Adelson et al. 1997, p. 169; Weinberg and Herdrich 2000a, pp. 50, 53.

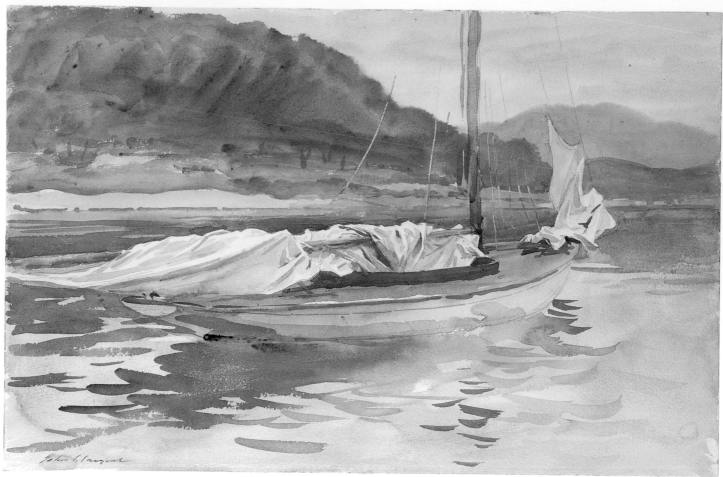

325

325. Idle Sails

1913
Watercolor and graphite on white wove paper
13⅝ × 21 in. (34.6 × 53.3 cm)
Signed at lower left: John S. Sargent; inscribed on
verso at upper left: 1374; at lower right: (5)
Purchase, Joseph Pulitzer Bequest, 1915
15.142.3

Like catalogue 324, catalogue 325 was
painted at or around San Vigilio. In this
watercolor, there is a distinct contrast
between Sargent's careful depiction of the
crumpled sail draped across the boat and his
cursory rendering of the water and the
landscape beyond. Sargent first studied the
boat and sail in graphite before adding
modulated washes and strokes in grays and
blues to suggest the shadows and reflections
off the water, leaving the paper in reserve
for the brightest highlights. Both the water
and the hilly landscape beyond are broadly
painted. While Sargent represented the

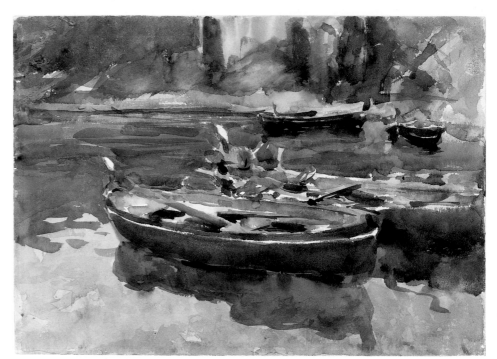

326

landscape by passages of color with little detail, he captured the gently undulating surface of the water with various bold, spiky strokes.

Ex coll.: The artist, until 1915.

Exhibitions: "Anglo-American Exposition," London 1914, cat. 458; The Metropolitan Museum of Art, January–February 1916; Boston 1921, p. 11, cat. 86; Paris 1923, cat. 43; Boston 1925, cat. 67; "Watercolors and Drawings by Centurion John S. Sargent," The Century Association, New York, September 21–October 23, 1982 (no catalogue).

References: Cox 1916, p. 37; Ely 1923, pp. 98–99; Downes 1925, p. 278; Ely 1925, p. 18; New York–Chicago 1986–87, p. 232; Adelson et al. 1997, p. 169.

326. *Small Boats*

1913
Watercolor and graphite on white wove paper
10 × 13¹⁵⁄₁₆ in. (25.4 × 35.4 cm)
Inscribed on verso at upper left: ~~131~~ Small boats / by J. S. Sargent / 36; at center: ⁵⁄₂₀; at lower left: V.O.
Gift of Mrs. Francis Ormond, 1950
50.130.70

Ormond and Kilmurray have suggested that catalogue 326 was painted at San Vigilio (oral communication, June 16, 1997). This composition is different in mood from the large-scale "exhibition" watercolors of this subject (see cats. 324 and 325). Painted on a smaller sheet, the impression is more freely rendered. Over the merest underdrawing, Sargent applied fluid passages of color using a dark palette of blues and greens that, although they resemble those used in catalogue 324, appear somewhat murkier.

Exhibitions: New York 1966–67, cat. 116; "Five American Masters of Watercolor," Terra Museum of American Art, Evanston, Illinois, May 5–July 12, 1981, no catalogue number; "Watercolors and Drawings by Centurion John S. Sargent," The Century Association, New York, September 21–October 23, 1982 (no catalogue).

Reference: Adelson et al. 1997, p. 169.

327. *Open Valley, Dolomites*

ca. 1913–14
Watercolor and gouache on white wove paper
13⅝ × 20¹⁵⁄₁₆ in. (34.6 × 53.2 cm)
Inscribed on verso at upper left: 91 / V.O (Trust); by J. S. Sargent / Open Valley, Dolomites; at center: ¹⁄₁₅; at lower left: SMW
Gift of Mrs. Francis Ormond, 1950
50.130.81a

328. *Sellar Alp, Dolomites*

ca. 1913–14
Watercolor and gouache on white wove paper
10 × 14 in. (25.4 × 35.6 cm)
Inscribed on verso at upper left: 172 Sellar Alp — Dolomites / by J. S. Sargent / E.S. / ⁵⁄₁₀ [encircled]; at center right: ¹⁄₆₈; at lower left: Sellar Alp . Dolomites / VMW
Gift of Mrs. Francis Ormond, 1950
50.130.80f

The distinctive palette shared by catalogue numbers 327 and 328 suggests that they

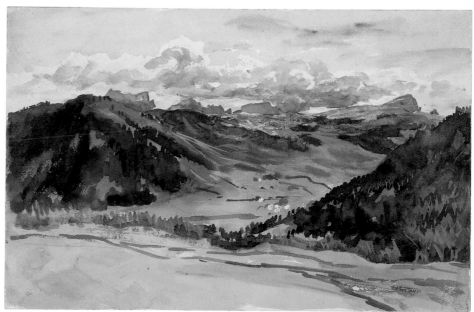

327

328

were painted at the same time. Although catalogue 327 presents a consciously picturesque composition of a verdant valley, distant peaks, and dramatic clouds, and catalogue 328 is a broadly painted, almost abstract, cropped view, both pictures include sweeping passages of bright green accented with pink (almost salmon) and purple tones.

The inscriptions on the versos of both sheets identifying the location as the Dolomites are not in Sargent's hand, but they may be correct. These watercolors may have been painted at the Seiseralp, which Sargent visited in 1914 and which was described by Stokes, Sargent's traveling companion that summer, as "an immense grassy plateau lying among the Dolomites." Stokes added, "He had been there when a boy and wished to see it again. He did not find much to paint there, but always something" (Stokes 1926, p. 57). In a letter to his sister Emily in July 1914, Sargent described his dissatisfaction with the site: "There are fine distant views, but curious dull foreground unless you go very far" (JSS to Emily Sargent, July 27, 1914, quoted in Adelson et al. 1997, p. 75). This pair of watercolors may well represent this locale and reveal a dynamic solution to rendering the "dull foreground" landscape (cat. 328) and a "fine distant" view (cat. 327).

Sargent had also visited the Dolomites in 1913.

EXHIBITION (cat. 327): "Watercolors and Drawings by Centurion John S. Sargent," The Century Association, New York, September 21–October 23, 1982 (no catalogue).

EXHIBITIONS (cat. 328): "Watercolors and Drawings by Centurion John S. Sargent," The Century Association, New York, September 21–October 23, 1982 (no catalogue); "Sargent Watercolors," National Collection of Fine Arts, Smithsonian Institution, Washington, D.C., July 1977 (no catalogue).

329. Tyrolese Crucifix

1914
Watercolor and graphite on white wove paper
21 × 15¾ in. (53.3 cm × 40 cm)
Signed at lower left: John S. Sargent; inscribed on verso at upper right: 1005
Purchase, Joseph Pulitzer Bequest, 1915
15.142.7

When England and France declared war on Austria in August 1914, Sargent was enjoying a late-summer holiday in the Austrian Tyrol. He was forced to remain there for about five months while he attempted to obtain the necessary travel documents to return to England. This period was productive for Sargent; he made a number of oils and watercolors, many of which reflect the somber mood that altered the holiday atmosphere. Ormond observes: "Many of the subjects which Sargent selected to paint at this time bear an oblique reference to the war—wooden Tyrolese crucifixes, graveyards, and a confessional. There are no obvious emotional overtones, but the recurrence of religious and death images reflects Sargent's gloomy and premonitory mood" (Ormond 1970a, p. 77).

Roofed crosses as shown in catalogue 329 were common sights in the Tyrol. Erected on roadsides or in open fields, sometimes commemorative in function, they served as places for travelers to stop and pray. This example is mounted against a gnarled tree trunk that fills the left of the composition. Sargent suggested the mottled bark with his usual technical brilliance. However, it is the figure of Christ, studied from below, that dominates. Against the bright blue sky, the leafless, angular branches of the tree echo the lifelessness of the figure.

Ely praised *Tyrolese Crucifix* as the "most striking" of the ten watercolors purchased by the Metropolitan in 1915 because of the "realism" of the figure on the cross (Ely 1923, p. 98). The image is unusual in Sargent's oeuvre as a rendering of a overtly religious symbol. Like the painting by Paul Gauguin (1848–1903) of a roadside crucifix in Brittany, *The Yellow Christ* (1889, Albright-Knox Art Gallery, Buffalo), it modernizes traditional religious imagery by depicting an actual object used for contemporary worship rather than inventing a scene of the Crucifixion.

Crucifixes and crosses appear in several oils from Sargent's 1914 Tyrol trip. *Crucifix in the Tyrol* (private collection) is a study of a similar crucifix seen against a wall. *Tyrolese Interior* (see figure 10) depicts a group of peasants pausing in benediction over a meal; above their heads hangs a large, carved crucifix with figures of saints. *Tyrolese Crucifix* (Sotheby's, New York, May 27, 1993, sale 6429, lot 54) presents a local wood-carver at work on a small crucifix; above him on the wall of the chalet hangs a wooden crucifix with saints. In *Graveyard in the Tyrol* (private collection; illustrated in Adelson et al. 1997, p. 78), the funerary monuments, including numerous crucifixes, loom over the graves against an expansive mountain landscape. A related watercolor is *Graveyard in the Tyrol* (British Museum, London). A roofed crucifix also appears in Sargent's youthful work *Tyrolean Shrine* (cat. 38).

EX COLL.: The artist, until 1915.

EXHIBITIONS: The Metropolitan Museum of Art, January–February 1916; Boston 1921, p. 11, cat. 90; Paris 1923, cat. 39; New York 1926, cat. 48; The Metropolitan Museum of Art, September 1965; New York 1966–67, cat. 111; New York–Buffalo–Albany 1971–72, cat. 33; "American Drawings, Watercolors, and Prints: Part I," The Metropolitan Museum of Art, June 11–August 31, 1980; "Watercolors and Drawings by Centurion John S. Sargent," The Century Association, New York, September 21–October 23, 1982 (no catalogue); "Sargent Watercolors," National Collection of Fine Arts, Smithsonian Institution, Washington, D.C., July 1977 (no catalogue); New York and other cities 1991, p. 26, cat. 102.

REFERENCES: Ely 1923, p. 98; Downes 1925, p. 279; Ely 1925, p. 18; Hoopes 1970, p. 76; Ratcliff 1982, p. 199; New York–Chicago 1986–87, p. 232.

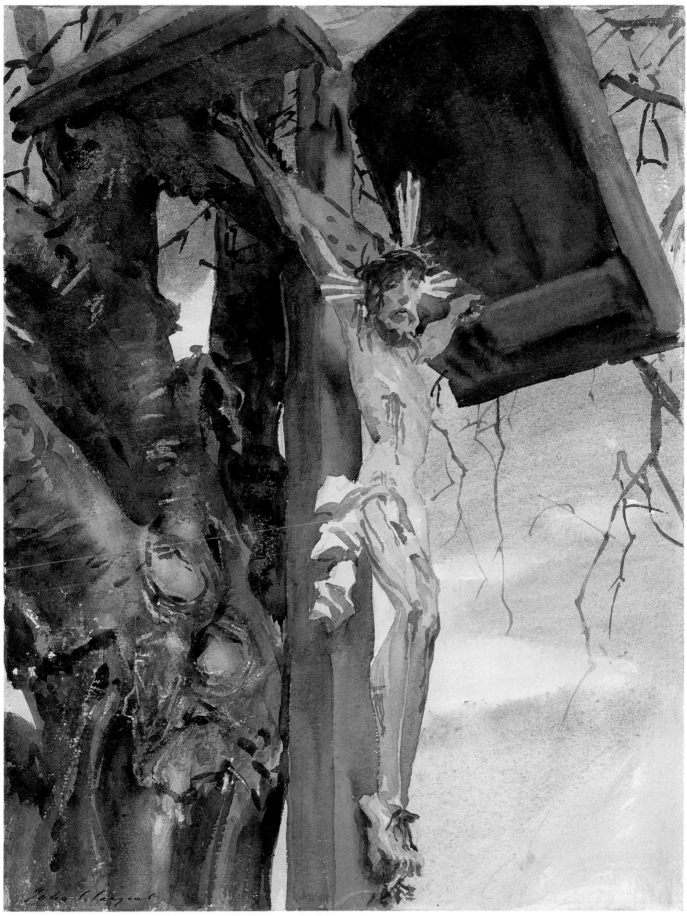

329

330. *Camp and Waterfall*

1916
Watercolor and graphite on white wove paper
19⅞ × 14 in. (50.5 × 35.6 cm)
Inscribed on verso at lower left: G. Met. 4 /
[21?].25
Gift of Mrs. Francis Ormond, 1950
50.130.80l

330

Sargent arrived in the United States in April 1916 to install the third section of his murals at the Boston Public Library. After working on the plaster reliefs during the early part of the summer, he left Boston in mid-July and traveled west "to the Rockies for mountain air and sketching" with Boston acquaintances (JSS to Evan Charteris, June 8, 1916, quoted in Charteris 1927, p. 206). After a short stay at Glacier Park, Montana, Sargent and his valet, Nicola d'Inverno, headed north to Yoho National Park in British Columbia near the border of Alberta.

Sargent spent most of August camped near Twin Falls, a picturesque and remote pair of waterfalls with a four-hundred-foot vertical drop, cited by Baedeker as one of "the most striking points in the Yoho valley" (*The Dominion of Canada,* New York, 1907, p. 271). Sargent's travels to Yoho National Park and to Twin Falls in particular seem to have been inspired at least in part by Denman Ross (1853–1935), a Harvard professor and artist who had sent Sargent a postcard of the site. Sargent described his situation in a letter to Isabella Stewart Gardner in Boston: "I am camping under that waterfall that Mr. Denman Ross gave me a postcard of. It is magnificent when the sun shines which it did for the first two days. I began a picture—that is ten days ago—and since then it has been raining and snowing steadily—provisions and temper getting low—but I shall stick it out till the sun reappears" (JSS to Isabella Stewart Gardner, Yoho Valley, British Columbia, August 20, 1916, Isabella Stewart Gardner Papers, Archives of American Art).

In his letter (and in catalogue 330), Sargent recorded the peculiar condition of the falls during his visit, writing, "now there is only one fall of the 'Twins,' thanks to some landslip above" (ibid.). In the background of the watercolor, Sargent contrasted the full cascade of the fall at right with the narrow channel at left. He effectively used a wet-watercolor technique to suggest the rising spray. His subdued palette of browns and blues conveys the murky atmosphere and dismal weather that he described to Gardner. The spots of pigment evident on the tent at the lower left may be due to a flaw in the paper or an accidental splattering of paint.

Before leaving Boston, Sargent had promised a painting from this trip to Gardner. That painting, the oil *Yoho Falls* (figure 110), also depicts Twin Falls but from a closer vantage point, from which Sargent concentrated on the spume of the cascade and recorded the path of the flow down the mountain. See catalogue 331 for a discussion of Sargent's depictions of tents in the Rockies.

EXHIBITIONS: New York–Buffalo–Albany 1971–72, cat. no. 37.

331

Figure 110. *Yoho Falls,* 1916. Oil on canvas, 37 × 44½ in. (94 × 113 cm). Isabella Stewart Gardner Museum, Boston

331. *Camp at Lake O'Hara*

1916
Watercolor and graphite on off-white wove paper
15¾ × 21 in. (40 × 53.3 cm)
Signed at lower left: John S. Sargent 1916; inscribed on verso at center left edge: # 5450–1 [encircled]
Gift of Mrs. David Hecht, in memory of her son, Victor D. Hecht, 1932
32.116

In the Rockies, Sargent painted a series of watercolors and oils depicting tents and camp life. The titles of several of these works, including catalogue 331, indicate that they were created at Lake O'Hara, south of Twin Falls in Yoho National Park, where Sargent settled in September 1916 (see *Tents at Lake O'Hara,* oil, Wadsworth

Athenaeum, Hartford; and *Camping at Lake O'Hara,* watercolor, Newark Museum, New Jersey). Two other images depicting tents in the Rockies are an oil, *Inside Tents, Canadian Rockies* (Sotheby's, New York, December 3, 1997, sale 7064, lot 16), and a watercolor, *A Tent in the Rockies* (Isabella Stewart Gardner Museum, Boston).

For Sargent, the broad, pale panels of the tents—counterparts of the sails that he frequently depicted (e.g. cat. 324)—were often vehicles for exploration of light, as in the Hartford oil and the Gardner watercolor, in which he studied the translucency of the fabric penetrated by light. In catalogue 331, in which strong sunlight is absent, Sargent modulated layers of pale washes to suggest the draping of the fabric over supports.

The lone figure at right appears in soft focus, possibly obscured by the campfire smoke. Sargent also studied this transitory effect in the Newark watercolor and the Hartford oil.

Lake O'Hara, a majestic view in oil of the lake and surrounding scenery, and a related watercolor study are in the Fogg Art Museum. Another landscape view is *Lake Louise, Canadian Rockies* (private collection), painted at the well-known lake, about sixteen miles northeast of Lake O'Hara.

EX COLL.: The artist, until before d. 1925; Victor D. Hecht, by 1925–d. ca. 1932; his mother (Mrs. David Hecht), ca. 1932.

EXHIBITIONS: New York 1926, cat. 39; The Metropolitan Museum of Art, September 1965; New York 1966–67, cat. 112; New York–Buffalo–Albany 1971–72, cat. 36; The Metropolitan Museum of Art, November 1980; "Five American Masters of Watercolor," Terra Museum of American Art, Evanston, Illinois, May 5–July 12, 1981, no catalogue number; "Watercolors and Drawings by Centurion John S. Sargent," The Century Association, New York, September 21–October 23, 1982 (no catalogue); New York and other cities 1991, p. 25, cat. 105.

REFERENCES: Hoopes 1970, p. 78; Karo 1976, p. 29; Ratcliff 1982, p. 216; Christopher Finch, *American Watercolors,* New York, 1986, p. 169; Weinberg and Herdrich 2000a, pp. 44, 46.

332. *Landscape with Palmettos*

1917
Watercolor and graphite on white wove paper
13¾ × 21 in. (34.9 × 53.3 cm)
Inscribed on verso at lower left: O. ½₂. 25 Met. [This sheet arrived at the Metropolitan with a cardboard backing that was removed in 1982. It was inscribed:] V. Ormond; By J. S. Sargent Florida / 113 (not Trust); Stamped: ESTATE OF / John S. Sargent / IN U.S.A. / B. 1956-D. 4-15-25 / NO. [inscribed] B180 R W Hale.
Gift of Mrs. Francis Ormond, 1950
50.130.64

333. *Palmettos*

1917
Watercolor, graphite, and wax crayon on white wove paper
15¼ × 20¾ in. (38.7 × 52.7 cm)
Inscribed on verso at lower left: S ½₂ 25 [illegible] / "Palmettos"
Gift of Mrs. Francis Ormond, 1950
50.130.65

In February 1917 Sargent traveled to Ormond Beach, just north of Daytona Beach on Florida's eastern coast, to paint a portrait of John D. Rockefeller (Rockefeller Collection, Kykuit, Tarrytown, New York). When not occupied with sittings, Sargent apparently passed time sketching. He wrote to Thomas Fox in March: "My Rockefeller paughtrait is almost done—but requires several more days, after which I will pay Charles Deering a visit of a week or so at Miami. I have been sketching a good deal here, but palmettos and alligators don't make interesting pictures. Surf bathing is the best of this place" (JSS to Thomas Fox, March 11, [1917], Hotel Ormond, Ormond Beach, Florida, Thomas A. Fox–John Singer Sargent Collection, Boston Athenaeum).

Although Sargent disdained palmettos in his letter to Fox, he produced at least five watercolors of the distinctive Florida plants, including catalogue numbers 332 and 333. (For alligators and futher discussion of this topic, see cat. 334.)

Sargent approached the palmettos as an occasion to study form, pattern, and light. In catalogue 333, the fronds extend across the composition against a lush tropical backdrop. The subtle depiction of the intricate design of the spiky stalks contrasts with the broadly painted background. Sargent exploited the full range of his watercolor technique to produce this effect: beginning with a slight graphite underdrawing, he applied pigment in multiple layers and used wax resist to preserve both the white of the paper and previously applied layers of colors. Sargent also scraped paint off the sheet to re-expose the white of the paper and to create additional highlights. Yet this elaborate rendering of the fan palms denies the labor involved in its creation, and the visual effect is of a near-abstract design that is enhanced by the close vantage point and cropped composition.

In contrast, catalogue 332 appears to be unfinished. There are fewer layers of color and less detail than in catalogue 333, including a large passage of undefined wash in the lower right corner. Of Sargent's depictions of palmettos, this example is unique in including a horizon and sky.

Three additional related watercolors are *The Pool* (Worcester Art Museum), *Palmettos* (private collection), and *Palmettos* (Robbie and Sam Vickers). A graphite drawing of palmettos is in the Fogg Art Museum (1937.8.101).

EXHIBITIONS (cat. 332): New York–Buffalo–Albany 1971–72, cat. 40; "Watercolors and Drawings by Centurion John S. Sargent," The Century Association, New York, September 21–October 23, 1982 (no catalogue); "John Singer Sargent: Painter of the Gilded Age," Worcester Art Museum, Massachusetts, October 1–December 31, 1995 (no catalogue).

REFERENCE (cat. 332): Strickler 1987, p. 130, n. 2.

EXHIBITIONS (cat. 333): New York 1966–67, cat. 113; Los Angeles–San Francisco–Seattle 1968, cat. 28; New York–Buffalo–Albany 1971–72, cat. 38; "Views of Florida by American Masters," The Society of the Four Arts, Palm Beach, March 8–April 13, 1975, cat. 35; "Watercolors and Drawings by Centurion John S. Sargent," The Century Association, New York, September 21–October 23, 1982 (no catalogue); "John Singer Sargent: Painter of the Gilded Age," Worcester Art Museum, Massachusetts, October 1–December 31, 1995 (no catalogue).

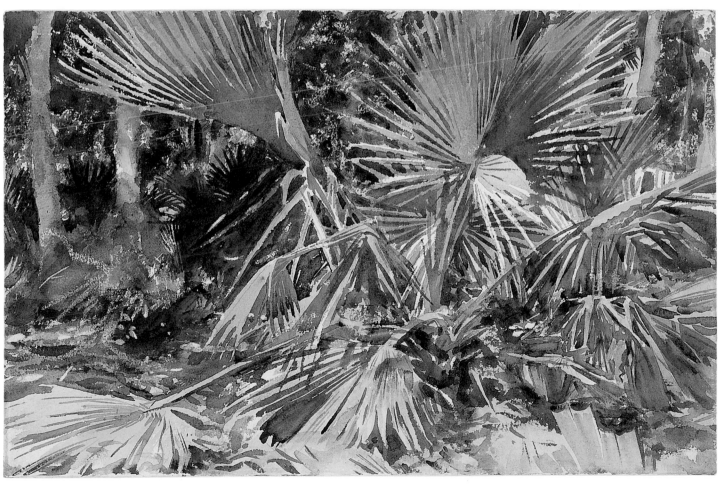

333

REFERENCES (cat. 333); Hoopes 1970, p. 80; Strickler 1987, p. 130, n. 2; London–Washington, D.C.–Boston 1998–99, p. 238; Weinberg and Herdrich 2000a, pp. 44, 46.

334. *Alligators*

1917
Watercolor, graphite, and wax crayon on white wove paper
15 13/16 × 20 15/16 in. (40.1 × 53.2 cm)
Inscribed on verso at lower left: J. [illegible] 1/22 25
Gift of Mrs. Francis Ormond, 1950
50.130.63

Sargent probably made this unfinished watercolor of alligators at Ormond Beach, Florida (see cats. 332 and 333). His assessment that "alligators don't make interesting pictures" probably reflects good-natured sarcasm rather than his true opinion of the subject (JSS to Thomas Fox, March 11, [1917], Hotel Ormond, Ormond Beach, Florida, Thomas A. Fox–John Singer Sargent Collection, Boston Athenaeum). Since Sargent included the related composition *Muddy Alligators* (and *The Pool,* which depicts palmettos) among the eleven watercolors he sold to the Worcester Art Museum in 1917, he must not have really disdained the subject at all.

In a discussion of Worcester's *Muddy Alligators,* Walsh describes catalogue 334 as a preliminary study. Sargent "developed a meticulous technique for painting alligators found in [cat. 334] and then fully developed it in the great *Muddy Alligators,*" in which, Walsh adds, "Sargent used . . . all his techniques, locally and in such subtle combinations that we must search to find them. In spite of his professed spontaneity, he constructed this picture carefully; this is no 'snapshot'" (Walsh 1987, pp. 59–60).

While the nuances of Sargent's method are obscured in the Worcester watercolor, they are revealed in the unfinished Metropolitan sheet. At the top, visible graphite underdrawing delineates the contours of the reptiles. In the right foreground the forms of several alligators are suggested only by preliminary passages of wash. For the creature at the upper left, Sargent applied delicate strokes of brown pigment to convey the details of the face, some scales, and the shadowed underbelly. At the center, Sargent indicated the reptile's scales with the incised crisscross pattern he would use in the Worcester watercolor. The striations of pale orange and blue pigment in the immediate foreground are similar to those in the Worcester sheet, where they represent the reflection of background tree trunks in the shallow water. Four graphite studies of alligators are also in the collection of the Worcester Art Museum.

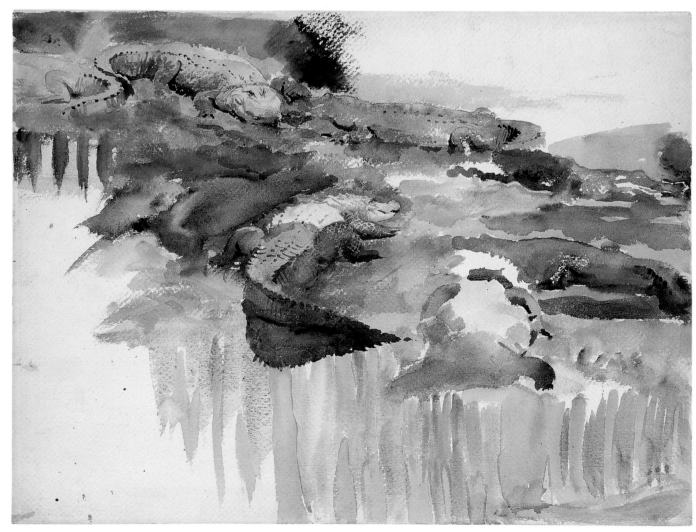

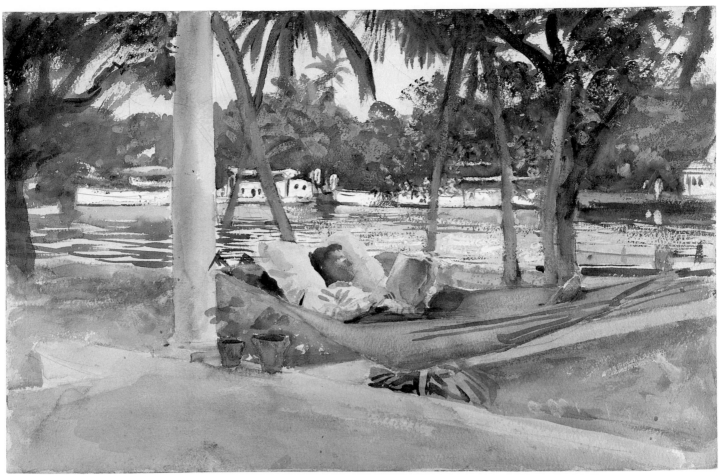

335

EXHIBITIONS: New York–Buffalo–Albany 1971–72, cat. 39; "Artist's Menagerie: Five Millennia of Animals in Art," Queens Museum, Flushing, New York, June 29–August 25, 1974, cat. 110 (as *Crocodiles*); "Watercolors and Drawings by Centurion John S. Sargent," The Century Association, New York, September 21–October 23, 1982 (no catalogue); "John Singer Sargent: Painter of the Gilded Age," Worcester Art Museum, Massachusetts, October 1– December 31, 1995 (no catalogue).

REFERENCE: Walsh 1987, pp. 59, 128, n. 5.

335. *Figure in Hammock, Florida*

1917

Watercolor, gouache, and graphite on white wove paper

13⅝ × 21 in. (34.6 × 53.3 cm)

Inscribed on verso at upper left: 95 By J. S. Sargent—Florida; V.O. / (Trust); at lower left: F; A. Met. ¹/[?] / 25; at lower right: A

Gift of Mrs. Francis Ormond, 1950

50.130.57

In March 1917, Sargent arrived in the Miami area after completing his Rockefeller portrait commission in Ormond Beach (see cats. 332 and 333). Sargent stayed with Charles Deering, a friend and important patron whom he had first met during his student days in Paris. Catalogue 335 may depict Deering at his residence at Brickell Point on the Miami River (Doris Littlefield, chief museum curator, Vizcaya Museum and Gardens, to M. Elizabeth Boone, March 28, 1994, departmental files, American Paintings and Sculpture).

EXHIBITION: "Watercolors and Drawings by Centurion John S. Sargent," The Century Association, New York, September 21–October 23, 1982 (no catalogue).

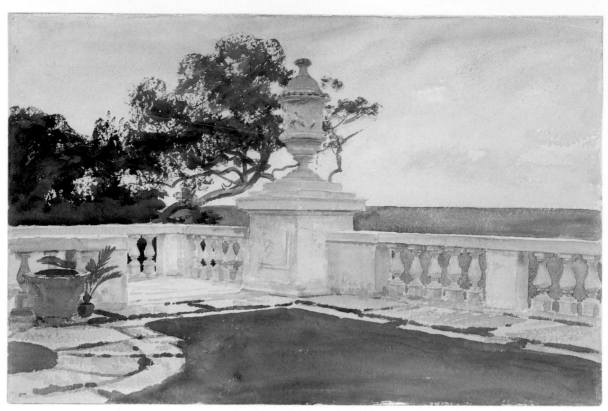

336

336. *Terrace, Vizcaya*

1917
Watercolor and graphite on white wove paper
13¾ × 21 in. (34.9 × 53.3 cm)
Gift of Mrs. Francis Ormond, 1950
50.130.81n

At the Deering estate, Vizcaya, Sargent found the American analog of the classical gardens and villas he had painted in Italy and Spain (e.g., cats. 294 and 303). James Deering recorded Sargent's passion in a letter to his villa's architect:

John Sargent is visiting my brother. They had luncheon with me yesterday and went over the house. . . . He understands and appreciates better than anyone else who has been in the house what our property is and evidently took, as he certainly expressed, much pleasure in it. . . . He stated that ever since he has been in America he has been hungering for some architectural painting and asked permission to come here and do a lot of work. This, of course, I granted. (James Deering to Paul Chalfin, Miami, March 23, 1917, Vizcaya Archives, Miami, Florida)

Sargent made a number of studies of the terraces, patios, loggias, and courtyards of the house as well as on the property (see cats. 337–40), including catalogue 336, which depicts the east terrace of the house overlooking Biscayne Bay. With his usual technical verve, Sargent suggested the bright sunlight on the carved balustrade and the antique urn surmounting the pier. By contrast, sky, water, and lawn are represented with broad, relatively flat washes.

The watercolor *The Terrace, Vizcaya* (Charles Deering McCormick) presents a view of the same terrace from a different vantage point. In 1917 Sargent sold eleven watercolors painted in Florida, including *The Terrace, Vizcaya,* to the Worcester Art Museum; when the museum deaccessioned four of them, they were purchased by a descendant of Charles Deering.

EXHIBITIONS: "Watercolors and Drawings by Centurion John S. Sargent," The Century Association, New York, September 21–October 23, 1982 (no catalogue); "John Singer Sargent: Painter of the Gilded Age," Worcester Art Museum, Massachusetts, October 1–December 31, 1995 (no catalogue).

REFERENCE: Weinberg and Herdrich 2000a, pp. 44, 46.

337. *Man on Beach, Florida*

1917
Watercolor and graphite on white wove paper
15¾ × 20⅞ in. (40 × 53 cm)
Inscribed on verso at upper left: 98 By J. S. Sargent Florida; at lower left: M. Met. ¼[?]. 25; at lower right: A
Gift of Mrs. Francis Ormond, 1950
50.130.61

338. *Bather, Florida*

1917
Watercolor on white wove paper
15¾ × 20⅞ in. (40 × 53 cm)
Inscribed on verso at lower right: X; at upper left: 97 By J. S. Sargent Florida; at lower left: F. [illegible] ¼[?] 25
Gift of Mrs. Francis Ormond, 1950
50.130.60

At Vizcaya (see cat. 336), Sargent painted a number of studies of male nudes in the preserved natural landscape on the outskirts of the property. (See also cats. 339 and 340.) These models were probably "part of the large work force developing the South Garden" (Doris Littlefield, chief museum

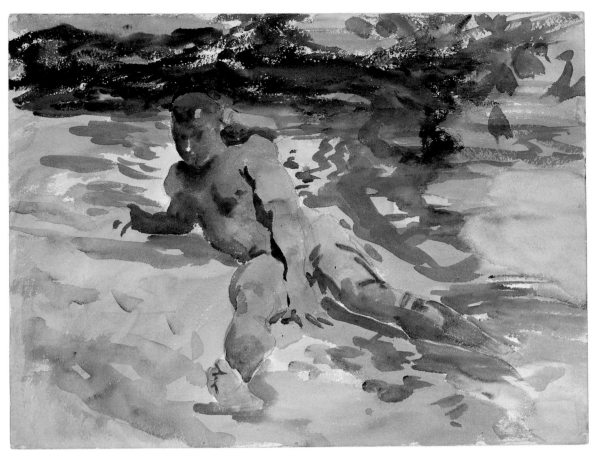

337

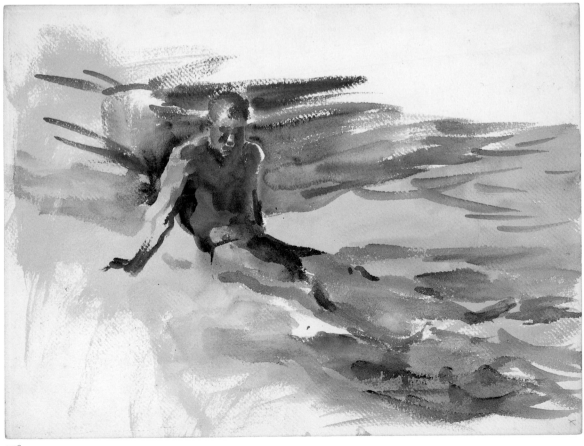

338

355

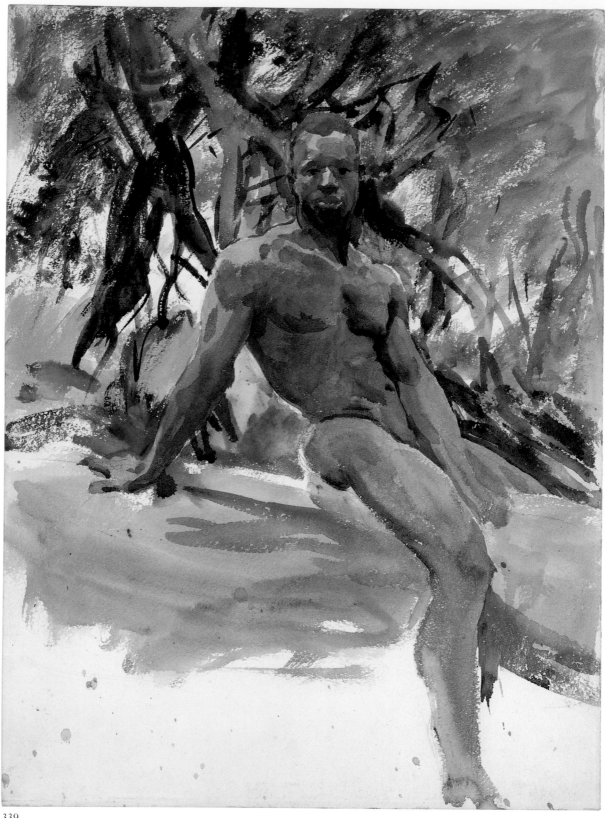

339

curator, Vizcaya Museum and Gardens, to M. Elizabeth Boone, March 28, 1994, departmental files, American Paintings and Sculpture).

Catalogue numbers 337 and 338, while not preliminary studies, are related to the watercolor *The Bathers* (see figure 107), which depicts three men in the shallow water of a tree-lined sandy beach. The subject combines Sargent's delight in rendering the human figure with one of his favorite themes: sunlight and water. Sargent concentrated on the effect of the bodies seen partially submerged.

The pose of the man in catalogue 337 is

similar to the figure in the lower right corner of *The Bathers*. Each leans back on one arm with his torso twisted; his other arm reaches across the body; his legs are partially immersed in the clear shallows; and his face is only generalized. In the Worcester composition, however, the figure is more upright and turns to the right. The settings of catalogue 337 and *The Bathers* appear to be the same, with golden sand and a broadly painted fallen log in the background.

Like catalogue 337, catalogue 338 depicts a partially submerged figure from a high vantage point but in a broad and fluid style that has the immediacy of an impromptu sketch, exploiting a limited number of brush strokes and pools of color.

EXHIBITIONS (cats. 337 and 338): "Watercolors and Drawings by Centurion John S. Sargent," The Century Association, New York, September 21–October 23, 1982 (no catalogue); "John Singer Sargent: Painter of the Gilded Age," Worcester Art Museum, Massachusetts, October 1–December 31, 1995 (no catalogue).

REFERENCE (cats. 337 and 338): Strickler 1987, p. 134, n. 3.

339. *Man and Trees, Florida*

1917
Watercolor, gouache, and graphite on white wove paper
21 × 15⅝ in. (53.3 × 39.7 cm)
Inscribed on verso at upper left: 96 By J. S. Sargent Florida / V.O / (Trust); at lower left: E. Met ½₂ 25
Gift of Mrs. Francis Ormond, 1950
50.130.59

In the other studies from this series of male nudes in Florida (cats. 337, 338, and 340), Sargent left the faces of the models obscure. Here, however, he presents a penetrating study as the man gazes directly at the viewer.

Sargent's interest in anatomy links catalogue 339 to his student works of the 1870s as well as to the many drawings of nude male models he made in connection with his murals (e.g., cats. 200 and 202). However, as in catalogue numbers 232 and 233, Sargent delights in the rendering of human form for its own sake, using fluid watercolor to depict a muscular figure in a twisted pose. Bathers gave Sargent the opportunity to record human anatomy out of doors in a

variety of natural lighting conditions. He would return to this subject in the following year with his depictions of Tommies bathing (cats. 224 and 225).

EXHIBITIONS: "Watercolors and Drawings by Centurion John S. Sargent," The Century Association, New York, September 21–October 23, 1982 (no catalogue); "John Singer Sargent: Painter of the Gilded Age," Worcester Art Museum, Massachusetts, October 1–December 31, 1995 (no catalogue).

REFERENCES: Fairbrother 1981a, pp. 75, 79, n. 12; Strickler 1987, p. 134, n. 3.

340. *Man and Pool, Florida*

1917
Watercolor, gouache, and graphite on white wove paper
13¹¹⁄₁₆ × 21 in. (34.8 × 53.3 cm)
Inscribed on verso at upper right: [T?] Met. [½₁?]; at lower left: F
Gift of Mrs. Francis Ormond, 1950
50.130.62

The site in catalogue 340, the freshwater springs in the hammock growth near the

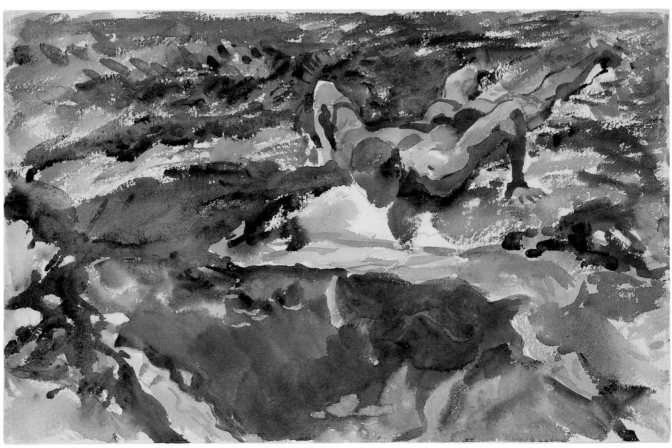

340

shoreline on the Vizcaya property, appears in a contemporary photograph (Mattie Edwards Hewitt, *Spring,* ca. 1917–19, Vizcaya Museum and Gardens). In subject and composition, this watercolor recalls traditional depictions of Narcissus, the handsome young man in Greek mythology who was made to fall in love with his own reflection as a punishment for rejecting the love of many women. The story has several variations, but the best known appears in Ovid's *Metamorphoses,* in which Narcissus sees his reflection in a stream as he bends over for a drink of water and becomes so enamored of it that he spends the rest of his life gazing at it. In the visual arts, Narcissus is commonly depicted as an idealized boyish figure poised languorously at the water's edge.

Sargent's interpretation of the subject includes an active pose for a muscular black youth who is rendered with a bold technique. As he had done in his images of the brook at Purtud, he used a high vantage point and directed his view downward, eliminating the horizon. The model lies prone, leaning on his hands as he peers over the edge of the pool. Passages of color describe the landscape with a near expressionistic intensity. The earth is rendered with a fairly dry watercolor technique with paper left in reserve between patches of browns, yellow, and ochre. A broader wet-on-wet technique of deep blues and green suggests the surface of the pool.

EXHIBITIONS: Boston 1925, cat. 104; New York 1926, cat. 52; New York–Buffalo–Albany 1971–72, cat. 41; "Sargent Watercolors," National Collection of Fine Arts, Smithsonian Institution, Washington, D.C., July–August 1977 (no catalogue); "Watercolors and Drawings by Centurion John S. Sargent," The Century Association, New York, September 21–October 23, 1982 (no catalogue); New York and other cities 1991, cat. 106; "John Singer Sargent: Painter of the Gilded Age," Worcester Art Museum, Massachusetts, October 1–December 31, 1995 (no catalogue).

REFERENCES: Hoopes 1970, p. 82; Fairbrother 1981a, pp. 75, 79, n. 12; Strickler 1987, p. 134, n. 3; Weinberg and Herdrich 2000a, pp. 44, 46.

341

341. *Landscape with Palms*

after 1895 (1917?)
Graphite on off-white wove paper
7 × 10¹⁄₁₆ in. (17.8 × 25.5 cm)
Gift of Mrs. Francis Ormond, 1950
50.130.140u

Catalogue 341 comes from a sketchbook in the Fogg Art Museum (1937.7.25), which contains drawings related to Sargent's early mural installations at the Boston Public Library (1895–1903) and for the dome of the Museum of Fine Arts, Boston (1916–21). Littlefield has proposed that the landscape depicted in catalogue 341 is at Cutler, Charles Deering's property on Biscayne Bay, Miami, which Sargent visited in 1917 (Doris Littlefield, chief museum curator, Vizcaya Museum and Gardens, to M. Elizabeth Boone, April 13, 1994, departmental files, American Paintings and Sculpture). The drawing may represent a common activity at the time—the dredging of the shallow bay so that building materials could be delivered by larger vessels. Catalogue 341 is attached to catalogue 248.

Appendix: Works of Questionable Attribution

The works below were included in the gift of Mrs. Francis Ormond to the Metropolitan in 1950 but are not easily attributed to John Singer Sargent. Where possible, other attributions have been suggested. The works are presented in accession number order.

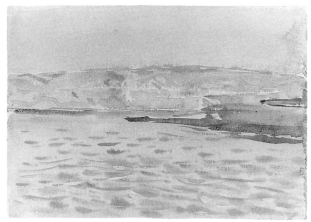

App. 1

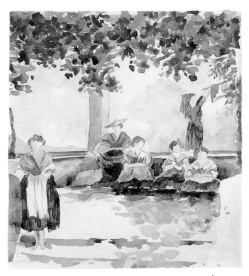

App. 2

Appendix 1. *Land and Water (No. 1)*

Watercolor and gouache on white wove paper
7 × 10 in. (17.8 × 25.4 cm)
Inscribed on verso at upper center: 6/28 [encircled];
at lower left: VMW
Gift of Mrs. Francis Ormond, 1950
50.130.80a

EXHIBITION: "Watercolors and Drawings by Centurion John S. Sargent," The Century Association, New York, September 21-October 23, 1982 (no catalogue).

Appendix 2. *Land and Water (No. 2)*

Watercolor and gouache on white wove paper
10 × 7 in. (25.4 × 17.8 cm)
Inscribed on verso at top center: 6/28 [encircled]; at
top left edge: VM[W]
Gift of Mrs. Francis Ormond, 1950
50.130.80b

EXHIBITION: "Watercolors and Drawings by Centurion John S. Sargent," The Century Association, New York, September 21-October 23, 1982 (no catalogue).

Appendix 3. *Sea, Sky, City*

Watercolor and graphite on yellow-buff wove paper
6½ × 11¹¹⁄₁₆ in. (16.5 × 29.7 cm)
Inscribed on verso at upper center: 6/28 [encircled];
at lower left: VMW
Gift of Mrs. Francis Ormond, 1950
50.130.80c

EXHIBITION: "Watercolors and Drawings by Centurion John S. Sargent," The Century Association, New York, September 21-October 23, 1982 (no catalogue).

Appendix 4. *Group of Women*

Attributed to Emily Sargent (1857–1936)
Watercolor and graphite on white wove paper
8⁵⁄₁₆ × 7⅜ in. (21.2 × 18.7 cm)
Inscribed on verso: 6/28 [encircled]
Gift of Mrs. Francis Ormond, 1950
50.130.80o

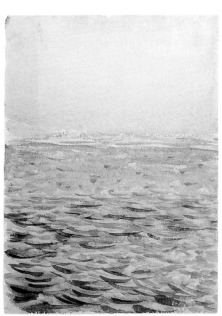

App. 3

App. 4

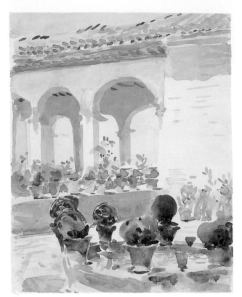

App. 5

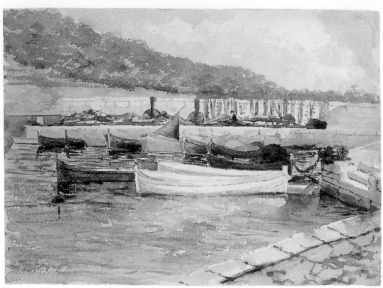

App. 6

Appendix 5. *Spain*

Attributed to Emily Sargent (1857–1936)
Watercolor and gouache on white wove paper
10⅝ × 8¼ in. (27 × 21 cm)
Inscribed on verso: by J.S.S.? / Spain
Gift of Mrs. Francis Ormond, 1950
50.130.80p

EXHIBITIONS: "Watercolors and Drawings by
Centurion John S. Sargent," The Century Associa-
tion, New York, September 21-October 23, 1982
(no catalogue); New York 1993, cat. 42, p. 129.

Appendix 6. *Boats*

Watercolor on white wove paper
10⁵⁄₁₆ × 14³⁄₁₆ in. (26.3 × 36.1 cm)
Inscribed on verso at center: "BOATS"
Gift of Mrs. Francis Ormond, 1950
50.130.80q

Appendix 7. *Landscape*

Watercolor and graphite on white wove paper
7 × 10 in. (17.8 × 25.4 cm)
Inscribed on verso at lower left: SMW
Gift of Mrs. Francis Ormond, 1950
50.130.81d

EXHIBITION: "Watercolors and Drawings by Centu-
rion John S. Sargent," The Century Association, New
York, September 21-October 23, 1982 (no catalogue).

Appendix 8. *Tomb of Francis Dineley and His Wife, Saint Michael's Church, Cropthorne*

Watercolor and graphite on white wove paper
14¾ × 22 in. (37.5 × 56 cm)
Inscribed on verso at center: English tomb; drawn on
verso: [2 perspectival sketches]
Gift of Mrs. Francis Ormond, 1950
50.130.83h

This watercolor and a related pen-and-ink
drawing (appendix 12) record a fairly
obscure seventeenth-century funerary
monument in Saint Michael's Church in
Cropthorne, England. Cropthorne is a
small town between Evesham and Pershore
in Worcestershire, about ninety miles
northwest of London. While Sargent

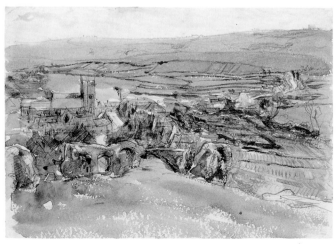

App. 7

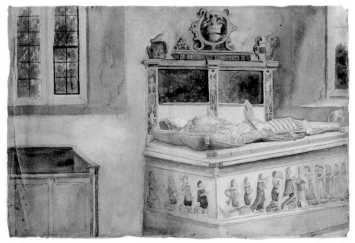

App. 8

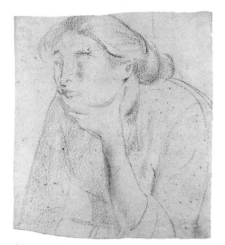

App. 9 recto

App. 9 verso

Appendix 10. *Standing Female Nude*

Charcoal on off-white wove paper
13¾ × 8¹¹⁄₁₆ in. (34.9 × 22 cm)
Inscribed at lower left: J.S. 381
Gift of Mrs. Francis Ormond, 1950
50.130.140j

EXHIBITION: Probably included in New York 1928 (inventory listing J. S. 381).

Appendix 11. *Frigate*

Graphite on pale green wove paper
11⁹⁄₁₆ × 16⁷⁄₁₆ in. (29.4 × 41.8 cm)
Inscribed on verso at lower left: EP
Gift of Mrs. Francis Ormond, 1950
50.130.141dd

This work could be a copy made by Sargent at an early age.

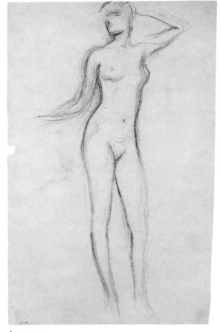

App. 10

visited this region of England in the 1880s, the style and handling of this watercolor and the graphite underdrawing are not consistent with his oeuvre.

Appendix 9 recto. *Pensive Woman*

Charcoal on white wove paper
11¾ × 9⅞ in. (29.8 × 25.1 cm) (irregular)
Inscribed at lower right: 50
Gift of Mrs. Francis Ormond, 1950
50.130.101 recto

Appendix 9 verso. *Woman*

Charcoal on white wove paper
11¾ × 9⁹⁄₁₆ (29.8 × 25.3 cm)
Gift of Mrs. Francis Ormond, 1950
50.130.101 verso

Appendix 12. *Tomb of Francis Dineley and His Wife, Saint Michael's Church, Cropthorne*

Pen and ink on white wove paper
6¹⁵⁄₁₆ × 9¹⁵⁄₁₆ in. (17.6 × 25.3 cm)
Inscribed on verso: CP
Gift of Mrs. Francis Ormond, 1950
50.130.143v

See appendix 8.

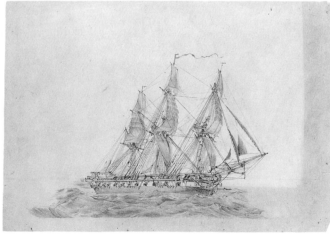

App. 11

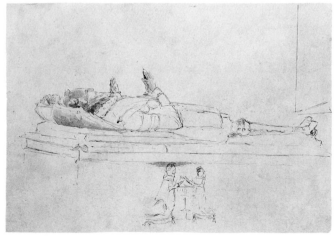

App. 12

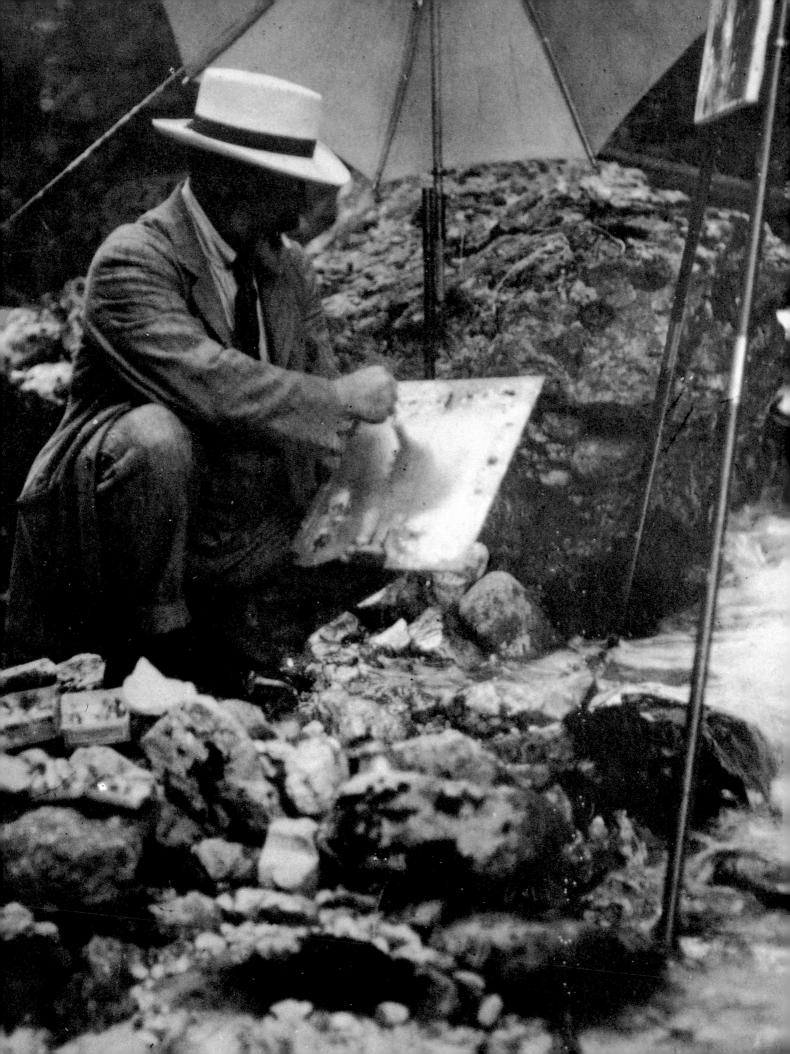

John Singer Sargent: A Chronology

READER'S GUIDE TO THE CHRONOLOGY

This chronology is based on the following sources (see bibliography for full information):

Archives

James Carroll Beckwith Papers; George Bemis Papers; Emmet Family Papers; Thomas A. Fox–John Singer Sargent Collection; Isabella Stewart Gardner Papers; Fitzwilliam Sargent Papers; and John Singer Sargent Letters to Mrs. Charles Hunter.

Text Sources

Adelson et al. 1997, Charteris 1927, Fairbrother (1981) 1986, Fairbrother 1994, Gallati 1998, Getscher and Marks 1986, Leeds–London–Detroit 1979, London–Washington, D.C.–Boston 1998–99, Mount 1955a, New York–Chicago 1986, Olson 1986, Ormond 1970a, Ormond and Kilmurray 1998, Promey 1999, Ratcliff 1982, Simpson 1993, Stokes 1926, Strickler 1982–83, Washington, D.C.–Boston 1992, and Williamstown 1997.

Where discrepancies occurred between authors, every effort was made to consult primary sources.

1850
June 27, Dr. Fitzwilliam Sargent (1820–1889) and Mary Newbold Singer (1826–1906) marry.

1851
May 3, The couple's first child, Mary Newbold Sargent (1851–1853), is born.

1853
July 2, Mary Newbold Sargent dies.

1854
September 13, Fitzwilliam Sargent, his wife, Mary, and her mother (Mary Newbold Singer) dock at Liverpool.
Winter 1854–55, Pau, in southwestern France.

1855
Summer, Fitzwilliam, Mary (who is pregnant with John), and her mother visit several spas in the Pyrenees (Luz, Bagnères-de-Bigorre, and Bagnères-de-Luchon), and then travel on to Paris.
Late October or early November, The family arrives in Florence and rents the Casa Arretini, Lung'Arno Acciaiolo, next to the Palazzo Sperini.

1856
January 12, John Singer Sargent is born in Florence at the Casa Arretini. Olson 1986 notes that this date cannot be confirmed

by any official document but that the family always celebrated his birth on this day (p. 2).
Summer, Geneva.
Winter, Rome.

1857
January 29, Emily Sargent (1857–1936) is born in Rome.
Later that year, Fitzwilliam resigns as attending surgeon, Wills Hospital, Philadelphia.
Spring–summer, Vienna.

1858
Summer, The family lives on the grounds of the Palazzo Sforza, outside Rome. Mrs. Singer is too ill to travel.

1859
Summer, Switzerland.
November 12, Mrs. Singer dies in the Sargents' apartment at 13 piazza di Spagna, Rome.

1860
Autumn, Emily, almost four years old, suffers a back injury in Rome. (Family tradition records that her nurse dropped her.) The family anticipates her death. She survives, but the injury and its initial treatment result in lifelong spinal deformity.
December, Sargent's earliest known drawing, *Portrait of Fitzwilliam Writing a Letter* (Sargent House Museum, Gloucester, Mass.).
Late in the year, The family arrives in Nice for the winter.

1861
February 1, Mary Winthrop Sargent (1861–1865) is born in Nice.
Spring–summer, Switzerland.
Late September, The family returns to Nice for the winter.

1862
Through spring, Nice.
June, London, where the family consults with surgeons about Emily's health.
July, Switzerland.
October, The family returns to Nice for the winter.
In Nice, The family lives at Maison Virello, rue Grimaldi, next door to the Rafael del Castillo family (of Spanish descent but naturalized Americans). Sargent befriends their son Ben, who is about the same age. He is friendly with the sons of Admiral Augustus Ludlow Case of the United States Navy.

1863
May, Fitzwilliam publishes a 125-page pamphlet, *England, the United States and the Southern Confederacy*.
May 12, Fitzwilliam writes his mother that the family is packing up to go to Switzerland, where they hope to be "three weeks from now." En route, they plan to stop in Lyons to consult a surgeon about one of Emily's heels, "which has become drawn up during her long confinement on her back."
June–October, Switzerland.

Figure 111 (opposite). Sargent painting by a stream, ca. 1904–11. Private collection.

363

September, The family leaves St. Gervais, Switzerland, for Clarens, Switzerland, on the shores of the Lake Geneva, where the weather is milder.

November, Nice for the winter. The family lives at the rue St. Etienne.

1864

March–September, Switzerland.

May to at least late June, Geneva, in search of healthful air for Mary Winthrop.

July 25, Fitzwilliam writes his mother from "a lowish mountain close by Geneva."

September 26, Fitzwilliam writes his mother from a boarding house above Vevey, overlooking Lake Geneva.

By November, The Sargents have returned to Nice, where they live at the Maison Virello on rue Grimaldi.

1865

April 12, The family arrives in Pau, France, having traveled from Nice through Toulouse and Bordeaux.

April 18, Mary Winthrop dies in Pau.

Late April–early May, Biarritz.

Mid-May, The family visits San Sebastian for a few days and returns to Biarritz.

June, Fitzwilliam sails to the U.S. via London. The rest of the family stays in Biarritz.

Early July, Sargent, his mother, and Emily go to Switzerland.

August 29, Fitzwilliam writes his brother Thomas from Luz in the Pyrenees, "I got back safe and sound in about 17 days from the day of our sailing from New York, i.e. back here to the Pyrenees, having spent three days in London and one day in Paris."

October 13, Sargent writes his friend Ben del Castillo from Paris, "We spent several weeks in London, and the things which interested me most there were the Zoological Gardens the Crystal Palace, the South Kensington Museum. . . . At the Zoological Gardens . . . I made several drawings of the animals there."

October–mid-November, Paris.

November, Maison Virello, Nice.

1866

In Nice, The Sargents meet the Paget family and George Bemis.

Late May, The family leaves Nice.

By June 18, Lake Como.

Summer, Lake Como and the Engadine, Switzerland.

Autumn, The family arrives at Nice (Maison Virello) for the winter.

1867

March 7, Fitzwilliam Winthrop Sargent (1867–1869) is born in Nice.

Late May–June, The family visits Paris and sees the Exposition Universelle.

Summer, The family spends a month in Hamburg, travels the Rhineland by steamer from Mayence to Cologne. They then travel back up the river, according to Fitzwilliam "retracing our steps, stopping at several of the most interesting places for a few days at a time." Nuremberg, Retisbon, ten days at Munich, Salzburg, the Tyrol, Milan, and Genoa.

October, Maison Virello, Nice, for the winter.

1868

April–May, The family visits Spain: Barcelona, Valencia, Granada (cat. 3 recto), Cordova, Seville, and Cadiz. They arrive in Gibraltar in late May.

Late May–July, Pyrenees, Biarritz.

August–September, Bagnères-de-Bigorre.

November 15, Dr. Sargent writes to his mother from Nice, "Emily is very well, and so is John,—who has begun to go to school this Winter. He goes to a small school kept by an English clergyman at Nice, who is a very nice man, and his wife a very kind, motherly and ladylike woman. The boy is very happy, and is much liked by his teachers and his companions, and he is making progress in his studies, including Latin, Euclid and Algebra."

Third week of November, The baby, Fitzwilliam, is ill, and the Sargent family moves to Rome where, as Dr. Sargent explains, "the climate is more tranquilising." They live above the piazza di Spagna at 17 Trinità dei Monti.

Winter 1868–69, The Pagets are also living in Rome. The Sargent children and Violet Paget (later Vernon Lee) accompany Mrs. Sargent sightseeing all over Rome. Sargent spends his mornings studying with German landscape painter Carl Welsch. As Sargent later recalled, he copies Welsch's watercolors and fetches beer for the studio. Fitzwilliam shelves the idea of a naval career for John, and his curriculum of Greek, Latin, and math is supplemented by music and foreign languages. Mrs. Sargent receives various members of the expatriate community, including Harriet Hosmer, Randolph Rogers, and William Wetmore Story.

1869

Mid- to late May, The family travels to southern Italy. Visits Tivoli, Frascati, Naples, and vicinity (Sorrento, Capri, Pompeii, Vesuvius, Ancona, Rimini) for about a week.

May 23, Sargent writes Ben del Castillo from Sorrento.

Ca. May 25, The family begins heading north to Switzerland.

May 29, Bozen (cat. 9h).

June 1, Innsbruck (cat. 7).

June 2, Munich. Sargent sketches *Barberini Faun* at the Glyptothek (cat. 8).

June 28, Fitzwilliam Winthrop dies at Kissingen, a spa where Dr. Sargent had been advised to take the waters. They remain there "about ten days after his death" before traveling to St. Moritz.

July–September, St. Moritz and environs (cat. 9).

By September 25, Stelvio Pass and Bormio (cats. 9aa, 9cc). From there, they pass through Tirano to Colico, where they board a steamer to Bellagio on the shore of Lake Como.

October, Fitzwilliam leaves his wife and children at Lake Como while he prepares the house in Nice to be rented. The family spends the winter in Florence living at 4 via Solferino.

Winter 1869–70, Sargent attends classes at a small day school run by a French political refugee, Joseph Domengé, in the former convent I Servi de Maria in the piazza della Santissima Annunziata and takes dancing lessons at 43 via Romana.

1870

February 9, Violet Sargent (1870–1955) is born in Florence.

May 10, The family arrives in Venice and stays in rooms rented on the riva degli Schiavone. Fitzwilliam describes the two-week sojourn: "Venice nearly killed us, it was so awfully hot."

Late May–early June, Lake Maggiore.

First week of June, The family heads north from Lake Maggiore, crossing St. Gothard Pass, arriving at Lucerne by June 6.

Mid-June, The family spends three weeks in Thun.

Late June–July, Sargent and his father take a three-week walking tour of the Alps (cats. 16, 17, 19–23). They travel south from

Thun to Kandersteg as far as Zermatt and the Matterhorn. From there, they travel northeast to Grimsel Pass.

Late July, With his father, meets Mrs. Sargent and his sisters at Interlaken, where they spend "a fortnight or more."

August, Mürren and Grindelwald.

Early September, Lucerne for a fortnight, with family friends the Bronsons. Sargent and his father climb Mount Pilatus (cats. 17ee, 17ff, 22).

Early October, The Sargents arrive in Florence for the winter. They live at 115 via de Serragli. Sargent attends the same day school as the previous winter.

Winter 1870–71, The Sargent home becomes a gathering spot for the Anglo-American colony in Florence. Charteris suggests that it is about this time that Sargent enrolls at the Accademia delle Belle Arti (not documented until 1873) (Charteris 1927, p. 15).

1871

Spring, Sketching trips in the environs of Florence, Boboli, and Poderi of Fiesole.

April, Sargent's paternal grandmother, Emily Haskell Sargent, dies; the Sargent children have never met her.

June 8, The family leaves Florence for their summer travels.

June 9, Padua. Sketches some local monuments (cats. 31–32).

June 12, The family reaches the Brenner Pass, between Verona and Innsbruck (cat. 33).

July, Six-day walking trip with father through Atzthal, Selveinerthal, to Innsbruck.

Late July or early August, Takes a sketching trip with a "German landscape painter of distinction," probably Carl Welsch.

Late summer, Fitzwilliam, worried about his son's education, decides the family should spend the winter in Dresden, which has a reputation for its excellent schools.

September, Fitzwilliam spends a month in Nice packing up and/or disposing of the contents of the family's apartment in preparation for their move to Dresden.

October, Munich.

November, Dresden for the winter. The family lives at 2 Wienerstrasse. Sargent begins preparing for the entrance exams to the Gymnasium zum Heilige Kreuz and does copy work in the Albertinum.

1872

January, In Dresden, Emily is dangerously ill with tonsillitis, fever, and peritonitis. The family prepares for her death.

Mid-February, Emily begins to recover.

Early spring, Sargent's tutorials are abandoned, and the family travels to Berlin, Leipzig, and Munich.

Late May, Carlsbad.

June 10, The family leaves Carlsbad en route for Auchensee (a small lake in the Tyrol near Innsbruck). While traveling by train to Munich, Sargent becomes ill with typhoid fever, and they remain in Munich three weeks.

Early July, The family travels to Auchensee.

Summer, The Tyrol.

August, Obladis in the upper Inn Valley.

September, The Sargents return to Florence and the apartment at 115 via de Serragli.

1873

May–July, Dr. Sargent travels to the U.S. The rest of the family visits Venice.

July, Dr. Sargent and family reunite in Pontresina, Switzerland. From there, they travel through the Alps.

September, Bologna. The Paget family is also there.

October, Florence. The family lives at 15 via Magenta.

Sometime that autumn, The family almost moves to Rome. They find an apartment there but the deal falls through, and they stay in Florence. Sargent enrolls at the Accademia delle Belle Arti.

December, Accademia delle Belle Arti closes for two months while administrators and professors discuss curriculum reform.

In Florence, Meets American artists Edwin White, Walter Launt Palmer, and Frank Fowler. White informally instructs Palmer, Fowler, and Sargent. Also meets British artists Edward Clifford and Heath Wilson. Dr. Sargent seeks the advice of artists concerning Sargent's training. Wilson (watercolorist, former headmaster of the Glasgow School of Design, and biographer of Michelangelo) urges the family to send Sargent to London. Palmer goes to Paris in late November and enters the studio of Carolus-Duran.

Winter 1873–74, The Paget family is also living in Florence. With the Accademia closed, Sargent works on his own—drawing and studying art in and around Florence—using a room in the residence at via Magenta as a studio. Once again the Sargent household becomes a center for the congregation of the expatriate community.

1874

March, Florence Accademia reopens and Sargent resumes classes.

April, Sprains his ankle on the stairs at the Accademia and cannot attend classes. Consoles himself by working at home, where he has "a very handsome Neapolitan model to draw and paint, who plays on the Zampogna and tamburino and dances tarantellas for us when he is tired of sitting."

May 16, The Sargent family arrives in Paris.

May 20, Meets with Walter Launt Palmer, who has been in Paris for five months in the studio of Carolus-Duran.

May 26, Sargent and his father visit the atelier of Carolus-Duran on the boulevard Montparnasse. Shows his portfolio and is accepted into the atelier.

June 25, Fitzwilliam writes his sister, Anna Maria Low: "We expect to leave Paris next week for a small fishing village on the coast of Normandy, four or five hours from Havre."

July 3, Carolus-Duran's studio breaks for the summer.

Early July, The family heads to Normandy for the summer. They reside in Beuzeval, near Dives, on the Calvados Coast.

August, Winthrop Sargent, John's paternal grandfather, dies; the Sargent children have never met him.

Late August–early September, The family returns to Paris.

September, Prepares for his entrance exams at the École.

September 26–October 16, Concours des places at the École des Beaux-Arts. Meets J. Alden Weir, an American student of Jean-Léon Gérôme.

October 19 or 21, The Atelier Carolus-Duran reopens.

October 26, Results of the concours are posted. Sargent places thirty-seventh out of 162 entrants. J. Alden Weir is the only other American to matriculate; he ranks thirty-first.

October 27, Matriculates at the École in the *section de peinture*.

Autumn, As a matriculant, receives daily instruction from Adolphe Yvon. May also have attended an evening class overseen by the independent portraitist Léon Bonnat. Meets James Carroll Beckwith.

1875

January, Annual studio dinner for Carolus-Duran. Sargent and two other students, Robert Hinckley and Stephen Hills Parker, accompany Carolus-Duran to Nice. Hinckley and

Parker become ill and leave Nice, and Carolus-Duran and Sargent share a room before returning to Paris together three days later.

February, Concours des places at the École des Beaux-Arts.

March 16, Matriculates at the École after placing thirty-ninth in the concours out of 197 entrants.

Late May or June, Joins his family at Maison Lefort in St. Enogat, near Dinard, on the Britanny coast (cat. 71).

Early summer, Possibly visits Barbizon with a group of students from Carolus-Duran's atelier.

Autumn, Returns to Paris while the rest of his family remains in St. Enogat.

October, Takes a room at Madame Darode's boarding house at 19 rue de l'Odéon. Shares a studio with James Carroll Beckwith at 73 rue Notre-Dame-des-Champs.

December 13, Mary Sargent writes Anna Maria Low from Maison Lefort, Dinard (near St. Malo), "We are still in our little country house, down in Brittany, where Henry [Sargent] saw us, and are going to try to remain until Spring."

Christmas, Accompanied by James Carroll Beckwith, visits his family at St. Enogat (until January).

1876

April, Possibly meets Claude Monet at the second Impressionist exhibition at Durand-Ruel.

May 15, Sails from Liverpool with his mother and Emily for the U.S. (Fitzwilliam Sargent stays in Europe with Violet, who was considered too young for the crossing.) They dock at Jersey City for the children's first visit to America.

May–late September, United States. Visits the Centennial Exhibition in Philadelphia and meets the Sargent and Newbold cousins. In Newport, visits Admiral Augustus Ludlow Case and family (whom he had met in Nice) with his mother and sister. They travel up the Hudson (visiting the Weirs at West Point) and to Montreal via Lake George and Lake Champlain. On the way back to Philadelphia they stop at Niagara Falls.

Late September, Makes a quick trip to Chicago with an unidentified artist friend from Paris.

October 4, Sargent, his mother, and sister sail for Liverpool (cat. 97).

November, Returns to the École and to the atelier of Carolus-Duran. Lives with his family.

During this period in Paris, May have met Auguste Rodin, Albert Besnard, Albert Belleroche, and Paul Helleu.

1877

March, Places second out of 179 entrants in the concours des places at the École, the highest place achieved by any American artist in the period. Completes his first portrait of a non-family member, *Fanny Watts.*

March 20, Matriculates at the École.

May, Fanny Watts, his first submission to the Salon, is accepted.

May 24, Receives a third-class medal for ornament drawing in the École des Beaux-Arts.

June, The Society of American Artists is founded. Later in the year, Sargent is one of five American artists in Paris appointed as jurors. The other four are Augustus Saint-Gaudens, Abbott H. Thayer, Frederick A. Bridgman, and Charles DuBois. Sargent probably meets Saint-Gaudens (who was in Paris after June 1877) about this time and becomes friendly with him over the course of the next year.

Summer, mid-June–end of August, Brittany and Cancale. Makes sketches that become *Oyster Gatherers of Cancale* (figure 55).

Late August–September, Visits his family in Bex, Switzerland.

October, Genoa with his family. Sketches with Heath Wilson.

Autumn, Atelier of Carolus-Duran. James Carroll Beckwith and Sargent assist Carolus-Duran with the ceiling decorations for the Palais du Luxembourg, *The Triumph of Marie de Médici.*

1878

Early 1878, Venice.

March, Fishing for Oysters at Cancale is exhibited at the first Society of American Artists exhibition at the Kurtz Gallery, New York. Artist Samuel Colman purchases it for $200.

May, Oyster Gatherers of Cancale receives an honorable mention at the Salon and is purchased by Admiral Augustus Ludlow Case.

June, Carolus-Duran sits for Sargent's portrait of him (cat. 135).

July, Stops at Aix-les-Bains en route to Naples.

August, Naples, Capri.

In Capri, Meets English artist Frank Hyde, who invites him to share his studio in the old monastery, Santa Lucia.

September, Returns to Paris.

October–November, Nice with his family.

December, Returns to Paris.

During the year, Attends the atelier of Carolus-Duran with less frequency. Meets Stanford White in Paris. Fitzwilliam's cousin Daniel Sargent Curtis takes an apartment in the Palazzo Barbaro, Venice.

1879

May, Carolus-Duran (figure 50) and *Dans les oliviers, à Capri* at the Salon. Receives an honorable mention.

Mid-summer, Finishes portrait commission of *Édouard Pailleron.*

August, Receives commission to paint Mme Édouard Pailleron. Travels to their family house in Ronjoux. Visits his mother and sisters, who are in nearby Aix-les-Bains.

Late August–early September, Travels to Spain with two French painters, Daux and Bac (of whom little is known).

October 14, Signs the Prado register. His address is listed as no. 13 [calle de la] Salud, in the center of Madrid, between the Puerta del Sol and the Gran Via. According to Volk, this was the site of a pension (Washington, D.C.–Boston 1992b, p. 95, n. 8). Copies works by Velázquez at the Prado.

After mid-October, Travels to Ronda, Granada, Seville, and Gibraltar with Daux and Bac. In Seville, begins gathering material for what becomes *El Jaleo* (figure 60).

Around the end of the year, Sargent, Daux, and Bac cross over to Tangier, Morocco.

1880

January–February, In Tangier, Sargent and his companions rent a house from the American consul. Makes a side trip to Tetuan, a small coastal town known for its tiles and decorative carving. Paints a series of architectural sketches of the houses and streets of Tangier (see, e.g., figure 57). Begins painting *Fumée d'Ambre Gris* (figure 58). Visits Tunis.

End of February, Returns to Paris. Works on *Fumée d'Ambre Gris.*

May, Fumée d'Ambre Gris is shown at the Salon and is purchased by a Frenchman for 2,000 francs.

Summer, Receives commission for portrait of Mme Ramón Subercaseaux (figure 49) and sittings begin in her apartment on the avenue du Bois-de-Boulogne.

August 15, Travels to Holland with American artists Ralph W. Curtis and Francis Brooks Chadwick to study northern masters. Studies Frans Hals, Hans Memling (cat. 149 recto), Peter Paul Rubens, and Rembrandt van Rijn.

Late summer/mid-September, Meets his family at Aix-les-Bains and together they travel to Venice. Sets up a studio in the Palazzo Rezzonico.

September–January or February 1881, Venice. His family leaves and Sargent moves to 290 piazza San Marco, all'Orologio. May have met James Abbott McNeill Whistler, who was in Venice from September 1879 to November 1880 and may also have had a studio at Palazzo Rezzonico.

1881

January–February, Venice.

March, Travels to Nice to visit his family.

Spring, London to see his mother off to America. While in London he meets Edward Burne-Jones.

May, Wins second-class medal for *Madame Ramón Subercaseaux* at the Salon and is hors-concours.

June 21, Takes Vernon Lee to see Edward Burne-Jones at his Fulham Road studio.

Late June, Paints oil portrait sketch of Vernon Lee in London.

Sometime after June 25, Returns to Paris. Visits Fontainebleau with Mrs. Edward Burckhardt and her daughter, Louise, two other ladies, and James Carroll Beckwith. Mrs. Burckhardt maneuvers to try to marry her daughter to Sargent. They travel north to Andé. Beckwith records in his diary that the pair acts like lovers, but back in Paris, Sargent seems to lose interest in Louise.

July, Travels to northern France.

August, Paris. Works on portrait of Dr. Pozzi.

October, Begins painting *El Jaleo*.

Sometime during the year, Begins painting *Lady with the Rose (Charlotte Louise Burckhardt)* (figure 51). Meets Virginie Avegno Gautreau (Mme Pierre Gautreau). Shortly thereafter he writes a letter to his friend, Ben del Castillo, "I have a great desire to paint her portrait and have reason to think she would allow it and is waiting for someone to propose this homage to her beauty. If you are 'bien avec elle' and will see her in Paris you might tell her that I am a man of prodigious talent."

1882

February, *El Jaleo* is finished.

March, Begins portrait of the daughters of Edward Boit.

By May 5, *El Jaleo* is purchased by a Bostonian, Thomas Jefferson Coolidge.

July (or July 1883), Possibly travels to Haarlem with Paul Helleu and Albert de Belleroche. Visits parents at Aix-les-Bains and Champery.

August, Travels to Venice, where he stays with the Curtis family at the Palazzo Barbaro. Paints *Mrs. Daniel Sargent Curtis* (figure 52) and genre paintings.

October, Rome, Siena, and Florence, where he visits the Pagets.

Late October–November, Paris.

1883

Late January–at least February 10, Visits his family in Nice. While there, works on his portrait of Mrs. Henry White, who had left Paris for Cannes because of the effects of typhoid. Explains to Vernon Lee in a letter dated February 10, "I have been here over two weeks paying my people the usual winter visit and going on with my Salon portrait for the original who was obliged to leave Paris before the portrait was half done fortunately went to Cannes."

February, Begins painting Virginie Avegno Gautreau. Continues working on portrait of Mrs. Henry White.

Before June 23, Moves to a new studio at 41 boulevard Berthier, Paris.

August–September, Continues work on the portrait of Virginie Avegno Gautreau at her country house, Les Chênes, Paramé, Brittany. Progress is slow, and she is an impatient sitter. In July or August, writes to Vernon Lee that he is still in Brittany, "struggling with the unpaintable beauty and hopeless laziness of Mᵉ Gautreau."

October, Visits Florence, Siena, and possibly Rome.

November or December, Returns to Paris.

1884

January, Sees the memorial exhibition of the works of Édouard Manet (January 6–28) at the École Nationale des Beaux-Arts, Paris.

January–February, Visits his family in Nice.

February 4–5, Édouard Manet's studio sale; Sargent purchases one of the large studies for *Le Balcon* and a watercolor of irises.

February, Henry James arrives in Paris and meets Sargent.

March 27, Arrives in London for his second visit. Henry James shows him around.

March 28, Attends exhibition of works of Sir Joshua Reynolds at the Royal Academy with Henry James.

March 29, Visits artists' studios with Henry James, including those of Edward Burne-Jones, Edwin Austin Abbey, Frederic Leighton, and John Everett Millais. James hosts a dinner at the Reform Club that evening.

While in London, Sees the work of Dante Gabriel Rosetti and John Everett Millais and meets up with his sister Emily, who had been visiting some Irish friends (later accompanies her back to the continent).

April 3, Henry James takes Sargent to a party in Edwin Austin Abbey's new studio at 17B Eldon Road in honor of the actor Lawrence Barrett. Sargent meets Alfred Parsons. Other guests include Sir Lawrence Alma-Tadema, John Everett Millais, Frederic Leighton, and George du Maurier.

First week in April, Returns to Paris.

May 1, Opening day of the Salon. Scandal erupts over the portrait of Mme Gautreau. Attends an opening day lunch with Ralph W. Curtis and friends at Ledoyen. Later that day, Mme Gautreau and her mother arrive at Sargent's studio "in tears" and beg for him to remove the painting immediately. Refuses. Repaints the shoulder strap shortly after the exhibition.

June 7, Hosts a lunch in Paris that is attended by Paul Bourget and Oscar Wilde and his wife, Constance.

Ca. June 10, Returns to England and lives at Bailey's Hotel.

July 22, Hosts a "farewell party" in his studio before he leaves for Sheffield to paint *The Misses Vickers*.

July 24–at least late August, Sheffield, painting members of the Albert Vickers family.

October, Petworth, Sussex, with the Albert Vickers family.

November, Travels to Bournemouth to paint first portrait of Robert Louis Stevenson.

Around New Year, Returns to Paris for the winter.

1885

January–February, The portraits of Mme Paul Poirson, Mlle Poirson, and Mrs. Alice Sumner Mason, and the double portrait of Louise and Mrs. Edward Burckhardt are finished.

March, Probably visits his family in Nice.

June–July, Paris.

Summer, probably visits Giverny, where he paints *Claude Monet Painting at the Edge of a Wood*.

Late July, Returns to England.

Early August, Bournemouth to paint portrait of Robert Louis Stevenson and his wife.

August, Takes a boating excursion on the Thames with Edwin Austin Abbey. At Pangbourne Weir, dives off the boat and hits his head on a spike. Abbey takes him to the home of Francis Davis Millet and his family at Farnham House in Broadway, Worcestershire, to recover. Paints in the garden there and conceives the idea for *Carnation, Lily, Lily, Rose* (figure 65).

September, Visitors at Broadway include Edmund Gosse, Frederick Barnard, Alfred Parsons, Sir Lawrence Alma-Tadema, and Henry James.

November, Bournemouth.

December, Tours southern England with Edwin Austin Abbey.

Christmas, Farnham House with Edwin Austin Abbey.

1886

Early in the year, Joins Edwin Austin Abbey and Francis Davis (Frank) Millet in Broadway in a temporary partnership and takes Russell House, next to Farnham House, for studio.

January, In London, works in various Kensington studios and lives at Bailey's Hotel. Elected member of the selection committee for the Society of American Artists.

April, Paris and Nice. Accepts membership in the New English Art Club. Sends fifty lily bulbs to Broadway and asks Lucia Millet, Frank's sister, to plant them for use in *Carnation, Lily, Lily, Rose.*

April–May, Visits his parents in Nice and informs them that he is planning to move to London. Packs up the Paris studio in preparation for his move.

Early May, London.

June 26, Arrives at Broadway.

Summer, Russell House, Broadway. The grounds include large gardens with animals, including two rams and a peacock, which Edmund Gosse had given to him. Edwin H. Blashfield and his wife, Evangeline, arrive in July and stay through September. Other residents include J. Comyns Carr and Dora Wheeler Keith.

July, Visits Paris and then travels to Gossenass, Switzerland, with his family.

Mid-July, Cheltenham and southern England with Edwin Austin Abbey.

Early August, To Bayreuth for the Wagner festival.

August 3, Dolly and Polly Barnard, Sargent's models for *Carnation, Lily, Lily, Rose,* arrive at Broadway with their parents for two months. They had been delayed because of their father's broken leg.

End of August, Returns to Broadway.

September, Takes Whistler's former studio at 13 (later 33) Tite Street, London.

October, Tite Street studio is ready.

By October 19, London.

October 28, Ralph W. Curtis and Henry James bring Isabella Stewart Gardner to the Tite Street studio.

November, Sargent inaugurates the new Tite Street studio with a series of receptions.

During the year (or 1887), Meets Hercules Brabazon Brabazon.

1887

February 23, After experiencing an earthquake in Nice, Sargent's family decides to move to Florence. Possibly visits them in Nice around this time.

April, Alma Strettell's *Spanish and Italian Folk Songs* is published. Sargent contributes illustrations (cat. 137 verso).

Late April, Travels to Bournemouth to paint a third portrait of Robert Louis Stevenson.

End of May/beginning of June, Paris for a short visit.

May–August, Carnation, Lily, Lily, Rose is shown at the Royal Academy to much acclaim and is purchased for the nation for £700 with funds from the Chantrey Bequest.

Late May–early June, Visits his family in Nice.

June, Returns to London, signs a three-year lease on his Tite Street studio.

July, Stays at Shiplake Court at Henley-on-Thames, the home of Robert and Helen Harrison. Visits Alfred Parsons.

August, Paints at Henley-on-Thames. Receives commission to paint a portrait of Mrs. Henry Marquand of Newport, Rhode Island.

Sometime during the summer, Visits Claude Monet at Giverny.

August, Pays 2,000 francs for Claude Monet's painting *Bennecourt,* the highest price Monet receives for a painting this year.

Before September 17, Acquires Claude Monet's *Rock at Tréport.*

September 17, Sails for America to paint Mrs. Henry Marquand's portrait at Newport.

Late September–October, Docks in Boston. Heads directly to Newport. Paints *Elizabeth Allen Marquand.* In Newport, stays with Rear Admiral Caspar Goodrich. Sees Stanford White. Intends to stay in the U.S. for two months but extends his visit, painting more than twelve formal portraits.

October, Article in *Harper's New Monthly* by Henry James heralds Sargent's arrival in America (James 1887).

Late October, Visits New York. Finds a studio on Washington Square with James Carroll Beckwith's help. Stanford White gives a dinner in his honor.

November 8, Arrives in Boston and stays with the Boit family at 65 Mount Vernon Street.

November 12, Begins portrait of Mrs. Edward Darley Boit.

November 15, Dines with Charles Follen McKim.

November 30, Finishes head of Mrs. Edward Darley Boit in the ninth sitting.

While in Boston, Takes a studio on Exeter Street. Paints portraits of the sons of Mrs. Malcolm Forbes, Isabella Stewart Gardner, Mrs. Charles Inches, General Lucius Fairchild, and Dennis Miller Bunker.

1888

January, Fitzwilliam Sargent suffers a stroke in Florence.

January 28, Is the special dinner guest at the St. Botolph Club's monthly meeting.

January 28–February 28, First solo exhibition is held at the St. Botolph Club, Boston.

January 29, Avoids the opening reception of the St. Botolph exhibition and returns to New York. Lives at the Clarendon Hotel and works in a studio on Washington Square.

January 31, Dines at the home of Stanford White with James Carroll Beckwith and others in New York.

In New York, Paints portraits of Mrs. William H. Vanderbilt, Mrs. Benjamin Kissam, Mrs. Adrian Iselin, and Mrs. Richard H. Derby.

April 2, Farewell feast in New York. More than thirty artists and friends attend.

Spring, Fitzwilliam Sargent is taken to England.

May, Portrait of Claude Monet is shown in the first exhibition of the New Gallery in London.

May 19, Sails for Liverpool with Dennis Miller Bunker.

Late May, Returns to London.

June, Spends summer with his family at Calcot Mill, outside Reading and near Pangbourne, on the Kennet, a small branch of the Thames.

Summer, Dennis Miller Bunker spends part of the summer with the Sargent family at Calcot. Other visitors include Flora Priestley, Paul Helleu and his wife, Alice, and Vernon Lee. Paints river scenes and experiments in plein-air painting.

Autumn, The ailing Fitzwilliam is moved to Bournemouth.

Mid-September, Visits Broadway for a weekend in celebration of Francis Davis Millet's wife Lily's birthday and the birth of their son, John Alfred Parsons Millet (in July).

October–November, Claude Monet visits Sargent in London.

Late December, Attends the opening night of *Macbeth*, with Ellen Terry as Lady Macbeth.

Winter, The Sargent family moves to Bournemouth.

1889

January, Begins painting *Ellen Terry as Lady Macbeth*.

March–April, Serves on the jury of the Salon. Contributes 1,000 francs towards the purchase of Édouard Manet's *Olympia* for the Louvre. Exhibits six paintings in the American section of the Exposition Universelle in Paris and receives a *grand prix*. Is made Chevalier of the Legion of Honor. Sketches and paints Javanese dancers (cats. 185 and 186) and meets with Claude Monet at the Exposition.

April 25, Fitzwilliam Sargent dies in Bournemouth and is later buried in Wimbourne Road Cemetery.

June–July, Rents Fladbury Rectory, Pershore, less than ten miles from Broadway, where his mother and sisters establish themselves. Visitors include Flora Priestley, Paul and Alice Helleu, Vernon Lee, Clementina (Kit) Anstruther-Thomson, Ben del Castillo, and Alfred Parsons.

August, Travels to Ightham Mote, Kent, to paint Elsie Palmer. Begins painting *A Game of Bowls, Ightham Mote*.

Mid-September, Visits Russell House at Broadway.

End of September, Edwin Austin Abbey visits Fladbury Rectory.

December, Sails for America with Violet (on the 4th). They dock in New York and Violet heads to Boston to stay with the Fairchilds. Sargent visits James Carroll Beckwith in New York.

1890

January, In New York, stays at the Clarendon Hotel at Fourth Avenue and Twentieth Street. James Carroll Beckwith arranges for Sargent to use Dora Wheeler Keith's studio at 115 East Twenty-third Street. The Millets are living nearby on Twenty-third Street.

Late January, Visits Boston for about ten days.

In New York, Paints *George Washington Vanderbilt* and *Beatrice Goelet*. Paints *Homer St. Gaudens (With His Mother)* in exchange for a portrait relief of Violet by Augustus Saint-Gaudens.

February, Sees the Spanish dancer La Carmencita perform at Koster, Bial and Company, a saloon on Fourteenth Street, with James Carroll Beckwith and his wife, Bertha. Invites Carmencita to his studio and engages her to perform at William Merritt Chase's studio on Tenth Street. Begins painting her portrait.

April 22, Is an usher in Edwin Austin Abbey's wedding to Mary Gertrude Mead.

May 7, Dines with Charles Follen McKim, Stanford White, Edwin Austin Abbey, and Augustus Saint-Gaudens at the Players' Club in New York and discusses a mural commission

for the new Boston Public Library designed by McKim, Mead and White.

May 14, Travels to Boston with Edwin Austin and Mary Abbey. They attend a baseball game in the afternoon, visit the Boston Public Library site in Copley Square, and dine with the trustees of the library. Sargent is assigned to decorate the Special Collections Hall; Abbey is assigned the frieze of the book-delivery room.

June 3–July, Worcester.

August, Manchester-on-Sea (Mass.), Nahant (Mass.), Narragansett (R.I.), and Cohassat (Mass.).

August 11–19, Returns to Worcester. Paints Katherine Pratt.

After August 19, Visits New York and Boston vicinity.

October, Commission to paint Boston Public Library murals is confirmed.

October 2, Attends Dennis Miller Bunker's wedding in Boston.

Early November, Sails for Liverpool.

Before the end of the year, With Violet, meets their mother and Emily at Marseilles. From there, they travel to Alexandria, Egypt.

1891

January, Takes a studio in Cairo for a few weeks.

January–February, Travels up the Nile on a steamer; visits include Luxor, Thebes, Aswān, and Philae.

March, Back in Cairo, uses the same studio. Painting *Nude Egyptian Girl*.

Late March or early April, With his mother and sisters, travels to Greece. The women remain in Athens, and Sargent hires a dragoman and travels around the Greek peninsula; stops include Olympia, Delphi, and Epidaurus. They also visit Constantinople.

Mid-May, From Bursa, writes Isabella Stewart Gardner, "The consequence of going up the Nile is, as might have been foreseen, that I must do an Old Testament thing for the Boston Library. . . . I saw things in Egypt that I hope will come in[to] play."

Early summer, The family returns to Europe.

Late June–early July, The Sargents take an apartment at 4 rue de Presbourg, Paris, and Vernon Lee stays with them.

July, Attends sister Violet's wedding to Francis Ormond in Paris.

Late summer, Travels to the Alps with Emily and his mother. Mrs. Sargent and Emily agree to "settle down" at fixed address and sign a lease for an apartment at 10 Carlyle Mansions in Cheyne Walk, London. They immediately depart for Nice, Italy, and Spain, traveling until the next spring.

September, London.

Fall–winter, Joins Edwin Austin Abbey at Morgan Hall, Fairford, where Abbey has just built a large studio, to work on his Boston murals.

During the year, Elected Associate of the National Academy of Design. Sargent writes Mrs. Hugh Hammersley, "In case your idea of my prices is based on Mrs. Playfair, Mrs. Harrison, Miss Vickers or other portraits done here two or more years ago, I must inform you that I have raised my prices since then, to: head 200 Guineas / ¼ length 400 / full length 500."

1892

January–June, London and Fairford. Working on portraits and murals.

May, Begins painting *Mrs. Hugh Hammersley* (figure 74).

August, Travels to Spain to join his mother and Emily to see his newborn niece Marguerite.

September, Visits Amsterdam.

Late autumn—winter, Morgan Hall, Fairford. Charles Follen McKim visits.

December, Paris. Introduces James Abbott McNeill Whistler to Charles Follen McKim and Edwin Austin Abbey; discussions ensue about Whistler's possible contributions to the Boston project.

Late in the year, Nicola d'Inverno comes to Fairford to model and stays on, eventually becoming Sargent's valet and studio assistant.

During the year, Writes the preface to a catalogue of works by Hercules Brabazon Brabazon. The French government purchases *La Carmencita* and hangs it in the Palais du Luxembourg.

1893

January 18, Signs the contract for the Boston Public Library murals, which gives him until December 30, 1897, to complete the work for $15,000. The contract stipulates his responsibility for the north and south ends of the Special Collections Hall.

At Morgan Hall, Models come from London to pose for Edwin Austin Abbey and then for Sargent's *Frieze of the Prophets;* they include Angelo Colarossi and Nicola d'Inverno.

Spring, Refuses, initially, to make any decorative contribution to the World's Columbian Exposition but sends several paintings anyway and receives a medal.

Late autumn—winter, Morgan Hall.

November, Completes lunette of *The Children of Israel Beneath the Yoke of Their Oppressors,* except for the bas-relief additions.

1894

January, Elected Associate of the Royal Academy. Completes vaulting section with *Pagan Deities* and begins *Frieze of the Prophets.*

April—May, Sittings for *W. Graham Robertson* and *Ada Rehan* (figure 18) in London.

May, While working on applied reliefs for the Boston decorations, seeks advice on technique from Frederick MacMonnies in Paris. First section of the Boston murals is shown at the Royal Academy. Meets his future biographer Evan Charteris at a party given by Mrs. Henry White at Losely.

Late spring, Vernon Lee writes Clementina Anstruther-Thomson: "As to Mr Sargent London is at his feet, Mrs Hammersley & Mrs Lewis are at the New Gallery, Lady Agnew at the Academy. There can be no two opinions this year. He has had a cracking success."

June, Fairford.

July, Dismantles decorations at Royal Academy; crates and ships them to America.

September, Painting the *Frieze of the Prophets* concurrently with Coventry Patmore's portrait; paints Patmore's profile into the *Frieze* as Ezekiel.

Late autumn and winter, Morgan Hall.

1895

January, Portrait commissions are put on hold while Sargent makes final corrections to the *Frieze of the Prophets.*

March, Finishes *Ada Rehan.*

April 6, Sails for Boston.

April 12, Arrives in Boston for the installation of the first section of library decorations, the "Pagan end" at the north end of the Hall *(Pagan Gods, Israelites Oppressed, Frieze of the Prophets).*

April 25, Architectural firm McKim, Mead and White hosts a reception for Edwin Austin Abbey and Sargent at the Boston Public Library for the unveiling. More than two hundred guests attend the reception, with supper following at the

Algonquin Club. Subscription ($15,000) is taken by Edward Robinson to pay for the next section of the murals, and Sargent is formally asked to continue.

May, Travels to George Vanderbilt's new mansion, Biltmore, in Asheville, North Carolina, to paint portraits of the mansion's architect, Richard Morris Hunt, and landscape designer, Frederick Law Olmsted.

June 18, Sails to Gibraltar to meet Emily and their mother, who is recovering from an attack of peritonitis.

July, Tangier. Mrs. Sargent is settled at Aix-les-Bains and Sargent returns to London via Madrid.

End of August, Back in London; portrait work.

Sometime in the autumn, Mrs. Sargent and Emily finally settle in at Carlyle Mansions. Philip Wilson Steer introduces Sargent to Henry Tonks. Sargent gives up his share in Morgan Hall, Fairford, and takes a twenty-one-year lease on two studios on Fulham Road.

October, Begins as Visitor at the Royal Academy Schools, London (one-month stint almost every year until his death).

December, Second Boston Public Library contract signed.

1896

January, Lends the Fulham Road studio to Paul Helleu and then to James Abbott McNeill Whistler.

February, Receives commission to paint Henry G. Marquand (figure 2) for The Metropolitan Museum of Art.

May, Visits Paris.

Summer, In London for portrait work.

July, Stays in London to paint Marquand, but Marquand is ill and does not show up.

October, Begins painting *Mrs. Carl Meyer and Her Children.*

December, Visitor, Royal Academy Schools, London.

1897

January, Elected to full membership at the Royal Academy.

January—February, Spends six weeks in Italy. Visits Palermo and Rome. In Rome his friend Harry Brewster helps him gain access to see the Borgia apartments decorated by Pinturrichio in the Vatican. Visits Florence.

March, London. Learns of his election to the National Academy of Design.

April, Visits William Playfair on the Isle of Schona, Loch Moidart, Scotland.

June, Sittings for *Mr. and Mrs. I. N. Phelps Stokes* (figure 77).

July, Sittings for *Henry G. Marquand* in London.

October, Visitor, Royal Academy Schools, London. Begins painting the "Christian end" of the Boston Public Library murals.

During the year, Made an Officier of the French Légion d'Honneur.

1898

January—February, Sittings for *Asher Wertheimer,* the first of a series of twelve portraits of the London art dealer and his family.

May, Spends one month away from London. Visits Venice, staying at the Palazzo Barbaro. Begins painting *An Interior in Venice.* Visits Ravenna, where he sketches the mosaics of Sant'Apollinare. Travels to Bologna, Milan, and Bergamo.

June, London, portrait sittings. Increases fee to 1,000 guineas for a full-length portrait.

Fall or winter, Teaches at the Royal Academy Schools.

October—December, Working on *The Dogma of Redemption* and crucifix for the Boston Public Library. Augustus Saint-Gaudens supervises the casting of various models.

1899

February–March, Sittings for *The Wyndham Sisters* (figure 76) at their home on Belgrave Square.

February 20–March 13, First comprehensive exhibition of his works at Copley Hall, Boston. The exhibition, "Paintings and Sketches by John Singer Sargent," includes fifty-three oils, sixteen drawings, and forty-one sketches. Does not attend but lends works from his personal collection.

During the exhibition, Sargent's death is erroneously reported in American newspapers; sends a telegram to Isabella Stewart Gardner: "Alive and Kicking, Sargent."

March, Mrs. Daniel Curtis refuses *An Interior in Venice* as a gift, saying it is an unsatisfactory portrait of her family.

April, Serves on the Hanging Committee of the Royal Academy. Visits Augustus Saint-Gaudens in Paris for consultation on the design and casting of the crucifix in *The Dogma of Redemption.*

June, Travels to Renishaw to meet George Sitwell and see the painting of his ancestors by John Singleton Copley, for which Sargent was to paint a pendant.

July, James Abbott McNeill Whistler remarks on Sargent's "dullness" after meeting on a train.

August, Mural work.

September, Meets Edith Wharton.

November, Henry James complains that Sargent is getting very fat. Sargent is on the council at the Royal Academy.

December, Visitor, Royal Academy Schools, London. Submits *An Interior in Venice* as official diploma picture in exchange for his portrait *Johannes Wolff,* which he had submitted in 1897.

1900

Early in the year, The Sitwell family moves to London for their portrait sittings in the Tite Street studio.

February, Donates *Autumn on the River* to the South African Relief Fund for sale. Claude Monet paints his Houses of Parliament series in London. Sargent and Mary Hunter play host to him.

March, Sittings for *The Sitwell Family.*

End of April, Visits Paris. Sees Claude Monet, Giovanni Boldini, and Augustus Saint-Gaudens.

May, Sends three paintings to the Exposition Universelle in Paris and receives a medal of honor. The Prince of Wales sees *The Wyndham Sisters* at the Royal Academy and dubs it "The Three Graces."

Late spring, Crucifix for Boston Public Library is finished.

August, Enlarges his studio and living accommodations on Tite Street by more than double by leasing the adjacent house (number 31) and joining the two buildings. Thereafter, enters through 31 Tite Street.

September, While the houses on Tite Street are under construction, travels to Switzerland and Italy. Visits Genoa, Milan, Bologna, and Florence. When he returns, the building is not ready and he stays at the Reform Club.

October, Visitor, Royal Academy Schools, London.

1901

January, Fairford.

January–February, Claude Monet is in London. He and Sargent visit an exhibition of Impressionist works at the Hanover Gallery (organized by Durand-Ruel).

May, Refuses commission to paint the coronation of Edward VII. Edwin Austin Abbey paints it instead.

August–September, Visits Norway with the family of George McCulloch. Paints *On His Holidays,* a portrait of his host's fourteen-year-old son, and studies of salmon and a mountain torrent.

October–November, Travels to Sicily and Rome.

November 17, Returns to London.

December, Visitor, Royal Academy Schools, London.

1902

January, Struggles with the portrait *The Duchess of Portland* at Welbeck Abbey (cat. 267).

Spring, Granada, Spain, for three weeks. (May visit some of the same cities included in his June–August 1903 trip to Spain.)

July, Paints *William Merritt Chase* (figure 3) in London.

August, Sassa Fee, Switzerland, with brothers Peter and Ginx Harrison (and probably Polly Barnard), and Italian lakes.

September–October, Venice.

November, Naples and Rome. Informs trustees of the Boston Public Library that the Christian lunette, *The Dogma of Redemption,* is nearing completion. Visitor, Royal Academy Schools, London.

During the year, Auguste Rodin calls Sargent "Le Van Dyke [*sic*] de l'époque."

1903

January 18, Arrives in New York aboard the *Lucania,* accompanied by Wilfred de Glehn. The *New York Times* reports that the purpose of his visit is to paint Theodore Roosevelt's portrait and to work on the Boston murals and that he will stay in New York two days before going to Boston.

January, Arrives in Boston for installation of decorations at the south end of the Special Collections Hall. Arranges a special viewing of the murals for Stanford White, Daniel Chester French, Augustus Saint-Gaudens, Isabella Stewart Gardner, and Mr. and Mrs. Edward Robinson.

First week of February, Second phase of mural installation is complete (*Dogma of Redemption,* including *Trinity, Crucifix,* and *Frieze of Angels*).

February, En route to Washington, stops in New York to see a Tintoretto that was offered to Isabella Stewart Gardner. He recommends the purchase, and *A Lady in Black* becomes part of Mrs. Gardner's collection. He then travels on to the White House to paint *Theodore Roosevelt.* The President invites Sargent to stay at the White House.

March, Paints *Edward Robinson* (figure 17) in New York. Back in Boston, he stays at Fenway Court, which Isabella Stewart Gardner had inaugurated with a party on the preceding New Year's Eve, and uses it as a studio. He paints Mrs. Fiske Warren and her daughter, Rachel, in the Gothic Room.

May, Philadelphia, receives Honorary Degree from the University of Pennsylvania.

May–June, "Loan Exhibition of Sketches and Studies by J. S. Sargent, R.A." at the Carfax Gallery, his first solo exhibition in London.

June, Sails for Spain.

June–August, Spain and Portugal. In Spain, visits Madrid, Santiago de Compostela, La Coruña, Toledo, Ávila, Aranjuez, and possibly León.

June 12, Signs the Libro de Copistas at the Prado to copy Velázquez.

July 18, In Alcobaça, Portugal, draws a portrait study of Rafael Bordallo-Pinheiro (inscribed "à mon excellent compagnon de voyage et ami / M. Bordallo Pinheiro / John S. Sargent / Alcobaça, 18 Juillet / 1903").

September–October, Venice, where he stays at the Hotel Luna.
November, Tite Street.

1904

Winter, Sittings for *Charles Stewart, Sixth Marquess of Londonderry* (cat. 271).

Spring, Exhibits at the New English Art Club after an absence of ten years.

June, Receives honorary degree (D.C.L.) from Oxford University.

Summer, Exhibits for the first time with the Royal Society of Painters in Water-Colours (now the Royal Watercolour Society).

July, London.

July 8, Dines at Ranelagh with Matilda and Walter Gay and Mr. and Mrs. Ralph W. Curtis.

July 15, Matilda and Walter Gay visit Sargent's studio. They see several portraits in process, including a head of Lady de Grey, the family portrait of the duke and duchess of Marlborough, Miss Wertheimer in a long cloak, Lady Warwick and her son, and Mary Garrett.

August–September, Purtud (in the Val Veny, north of Courmeyer), Val d'Aosta, Italy, with artists Alberto Falchetti, Ambrogio Raffele, and Carlo Pollonera. Switzerland.

September–October, Venice at the Hotel Luna and then at the Palazzo Barbaro. Possibly visits Milan.

November, Visitor, Royal Academy Schools, London. Roger Fry starts his campaign against Sargent with a review of his pictures at the winter New English Art Club show.

During the year, Elected to the Royal Society of Painters in Water-Colours.

1905

February, Begins to rail against the chore of painting portraits on commission.

May, Elected to the American Academy of Arts and Letters in New York. The Museum of Fine Arts, Boston, buys *An Artist in His Studio* for $1,000. It is his first non-portrait work to be purchased by an American museum.

June, London.

August–September, Val d'Aosta, Italy. Purtud with the Peter Harrison, Dorothy Palmer, Violet, Reine, and Rose-Marie Ormond. Giomein above Breuil, where he paints *Padre Sebastiano* (figure 5).

November, Travels to Syria and Palestine, Baalbek in Lebanon, Lake Tiberias and the Jordan Valley, Nazareth, Mount Tabor and the Plain of Esdraelon, Jerusalem, and Jaffa with Nicola d'Inverno and stays with a Bedouin tribe (cat. 276). The purpose of the trip is research for the murals, but he also executes more than forty watercolors (cats. 275, 277–80).

December 15, Writes Isabella Stewart Gardner from Hotel Tiberias, Tiberias, Syria.

1906

Before January 21, Travels from Syria to Palestine.

January 21, His mother, Mary Sargent, dies, in London.

January 22, Is east of Jordan when he receives a telegram with news of his mother's death. Wires his sisters to wait for his return for the funeral. Has to wait six days in Jerusalem for a steamer.

February 2, Arrives in London.

February 5, Memorial service for Mary Sargent at St. Paul's, Westminster, in London. She is buried in Bournemouth next to her husband, Fitzwilliam.

April, Serves on the Hanging Committee of the Royal Academy, London. Contributes $100 to the San Francisco Earthquake Relief organized by the National Academy of Design, New York.

August–September, Visits Purtud, Val d'Aosta, Turin, Bologna, and Venice with Emily.

October, Meets up with Mrs. Charles Hunter in Rome. During this autumn and the autumn of 1907, paints several studies of gardens in the villas around Rome, including the Villa Torlonia (cats. 294, 295). Also at the Villa Falconieri and the Villa Lante. About this time, writes to Ralph W. Curtis, "In spite of scirocco and lots of rain we have been seeing the villas within miles round thanks to Mrs. Hunter's motor. They are magnificent and I should like to spend a summer at Frascati and paint from morning till night at the Torlonia or the Falconiere, ilexes and cypresses, fountains and statues—ainsi soit il—amen." Visits Hadrian's Villa. Stanford White is fatally shot on the roof garden of Madison Square Garden.

November 16, Leaves Rome and returns to London via Milan, Lyons, and Paris.

November, Visitor, Royal Academy Schools, London.

By the end of the year, Is declining most portrait commissions.

1907

May, Vows to give up portraiture.

June, Edward VII recommends Sargent and Edwin Austin Abbey for knighthood; they both decline rather than relinquish their American citizenship.

July, London.

August, Purtud with Violet and her family, Emily, the de Glehns, and Polly Barnard.

September, Palazzo Barbaro, Venice, with Emily and Eliza Wedgwood. Together they visit Perugia and Narni.

September–October, Frascati. With Emily and Eliza Wedgwood, joins up with the de Glehns and paints at the Tivoli, Villa Falconieri, Villa d'Este, and Villa Torlonia. Takes Lady Helen Vincent around the villas.

November, Visitor, Royal Academy Schools, London.

1908

June, Watercolors at the Carfax gallery. Makes a brief visit to Majorca.

July, London.

August, Breuil in Val d'Aosta with Dorothy Palmer, Polly Barnard, and the Harrison brothers, Peter and Ginx. Paints *The Hermit* (figure 101).

September, Travels with Emily to meet Eliza Wedgwood in Avignon. Visits Tarragona. After visiting Barcelona, they cross over to Majorca and stay in Palma and Valdemosa.

October, Majorca.

November, Visitor, Royal Academy Schools, London.

During the year, Made a full member of the Royal Society of Painters in Water-Colours.

1909

February 15–27, "Water Color Drawings by John Singer Sargent and Edward Darley Boit," Knoedler, New York. Sargent shows eighty-six watercolors. Brooklyn Museum purchases eighty-three of them for $20,000.

March, Works on vaults and lunettes for the Boston Public Library.

June, London.

August, Val d'Aosta and Simplon, Switzerland, with the Stokeses and Emily.

September, With Emily, meets the de Glehns and Eliza Wedgwood

in Venice. Stays at the Hotel Luna and then at Palazzo Barbaro.

September 28, With Emily, the de Glehns, and Eliza Wedgwood, travels to Corfu.

October–November, Corfu.

November–December, Visitor, Royal Academy Schools, London.

During the year, Awarded Order of Merit from France and the Order of Leopold from Belgium.

1910

February, Travels to Holland to recover from a bout of influenza.

May 6, Edward VII dies. Sargent finally accepts a request to draw his portrait.

August, Simplon with Archbishop Randall Davidson, Adrian and Marianne Stokes, Ambrogio Raffele, and Hugo Tommasini.

September, Siena, Bologna, and Florence with Henry Tonks.

October, Is lent the Villa Torre Galli, near Florence, by his friend the marchese Farinola. With Emily, joins up there with the artist Sir William Blake Richmond and his wife. Paints a number of images of the villa, its loggia, and the gardens. Sargent's party stays at Varramista in the Val d'Arno near Lucca. Paints in the gardens of nearby villas, including Collodi and the Reale (Marlia).

November–December, Visitor, Royal Academy Schools, London. Working on east and west wall lunettes for the Boston Public Library, including *Hell* (figure 82). Finishes *Fall of Gog and Magog*.

Late December, A dispute arises between Sargent and Roger Fry when Fry includes Sargent as a supporter of Post-Impressionist art in an article in *The Nation* in conjunction with an exhibit at the Grafton Gallery of Manet and the Post-Impressionists.

About 1910, Increasingly turns to executing charcoal portraits (as a substitute for oils) to satisfy the demands of patrons.

1911

January, Row with Roger Fry in *The Nation* over the Post-Impressionists continues. Responds with an angry letter to the editor on January 7, "I am absolutely sceptical as to their having any claim whatever to being works of art."

Ca. February, The Metropolitan purchases *Padre Sebastiano* and *The Hermit* directly from Sargent.

May, Travels to Paris, sees the exhibition of works by Ingres.

June, To Munich with Adrian and Marianne Stokes.

June 28, Mrs. Edwin Austin Abbey asks Sargent to return to London to help her dying husband, who wants Sargent to attend to the necessary alterations of his murals for the state capitol rotunda of Harrisburg, Pennsylvania.

Throughout July, In London, Edwin Austin Abbey guides Sargent through the changes to the murals.

July, Heads back to the Tyrol and Simplon Pass with Charles Gere, Emily, the Barnards, and the Ormonds. Visitors include Ginx Harrison, Nelson Ward, the marchese Farinola, and Adrian and Marianne Stokes.

August 1, Edwin Austin Abbey dies.

September, Palazzo Barbaro, Venice.

October, Sketches and paints at the marble quarries of Carrara (figure 11).

End of the year, Visitor, Royal Academy Schools, London. Selects 322 works for Edwin Austin Abbey's memorial exhibition at the Royal Academy.

1912

March 16–30, "Water Colors by John S. Sargent and Edward D. Boit," Knoedler, New York. The Museum of Fine Arts, Boston, buys Sargent's forty-five works from that exhibition. Friends of Henry James arrange to have Sargent paint a portrait of the writer for his seventieth birthday.

August, To the French Alps, visits Abriès and Isère, in the Dauphiné, with the Ormonds (cats. 311–12).

September–November, Spain with Emily and the de Glehns. Visits Granada (cats. 314–19) and Seville.

1913

May–June, Nine sittings for portrait of Henry James. Friends raise money by subscription. Sargent ends up giving the £500 to the sculptor Derwent Wood to make a portrait bust of James.

August, Visits Paris for the wedding of his niece, Rose-Marie Ormond. Meets up with the de Glehns in Venice, where he briefly visits the Curtises. Makes a short trip to the Dolomites and returns to Venice.

September, Palazzo Barbaro. Travels with Emily, Eliza Wedgwood, and the de Glehns to San Vigilio, Lake Garda.

During the year, receives an honorary degree (LL.D.) from Cambridge University.

1914

March–April, Serves on Selection Committee of the Royal Academy.

May 4, Portrait *Henry James* is slashed by a suffragette at the Royal Academy.

July, Awarded gold medal by the National Institute of Arts and Letters, New York. Visits southern Tyrol and Seisser Alps with Nicola d'Inverno, Dr. Ernest A. Armstrong, and Adrian Stokes and his wife, Marianne.

August 4, Britain and France declare war on Germany.

August 10, Britain and France declare war on Austria. Sargent and his traveling companions are detained in Austria. His paintings and supplies are confiscated and sent to Innsbruck for inspection. Continues painting with other supplies. Dr. Ernest A. Armstrong is taken by the Austrians as a prisoner of war.

Late August, With Adrian and Marianne Stokes, settles at Colfuschg, Austria.

October, The detained Dr. Ernest A. Armstrong writes from Trieuil for Sargent's assistance. Helps procure his release and returns to the Tyrol to continue painting. Robert André-Michel, Rose-Marie Ormond's husband, is killed in action in France.

October–November, St. Lorenzen in the Pusterthal. With Nicola d'Inverno, Dr. Ernest A. Armstrong, and Adrian and Marianne Stokes, stays with childhood friend Carl Maldoner. They make sketching excursions into the nearby countryside (cat. 329 and figure 10).

November, Adrian and Marianne Stokes receive permission to travel to England after Sargent helps them procure a passport through the American embassy in Vienna. He writes repeatedly but does not receive one for himself. Decides to make the trip to Vienna for a passport.

November 19, Sargent's passport is issued by the American embassy in Vienna.

End of November, Returns to London, only a week later than he had originally planned, by way of Italy and France.

December, Visitor, Royal Academy Schools, London.

Christmas, At Carlyle Mansions with Henry James and "3 or 4 waifs & strays" (as described by James).

During the year, Appointed chairman of the London Committee of the Panama-Pacific International Exposition, to be held in San Francisco. Thomas Jefferson Coolidge gives *El Jaleo* to Isabella Stewart Gardner.

1915

April 16, Auction at Christie's, London, to benefit the British Red Cross. Sargent agrees to execute two charcoal portraits, which sell for 500 guineas and 650 guineas. Around this time Sir Hugh Lane agrees to donate £10,000 to the Red Cross in exchange for a portrait by Sargent. Sargent agrees. (Lane dies on the *Lusitania* on May 7; his estate gives the money to the Red Cross, and they eventually decide that Sargent should paint President Woodrow Wilson instead. See 1917.)

Spring, Sends at least thirteen works, including the portrait of Mme Pierre Gautreau, to the Panama-Pacific International Exposition in San Francisco.

October, Negotiations about architectural changes to the Special Collections Hall of the Boston Public Library.

November, Abbott H. Thayer, disturbed by the military's persistent use of white uniforms, had been researching camouflage and "protective colors found in nature." From the U.S., he enlists Sargent's help in London to present his findings to the War Offices, in the hopes that Sargent can lay the groundwork for his own planned visit to London. Sargent visits the Offices on Thayer's behalf but with few results. Thayer and Sargent correspond for several months over this matter, into the New Year.

Late in the year, Delivers *Tyrolese Interior* and ten watercolors to the Metropolitan Museum (cats. 313–16, 321–25, 326).

1916

January, Library murals are rolled and packed for shipment to America. Offers to sell *Madame Pierre Gautreau*, which was in the U.S. for the Panama-Pacific International Exposition in San Francisco, to the Metropolitan, calling it "the best thing I have done." The Museum purchases the painting for £1,000.

February, Henry James dies.

March 20, Prepares to sail for the U.S. with Nicola d'Inverno, but their departure is postponed. They wait in Falmouth for several days.

April 4, Docks in New York on the *Nieuw Amsterdam* and heads to Boston immediately, according to the *New York Times*. In Boston, stays at the Hotel Vendôme. Takes a studio on Newbury Street and then moves to the Pope Building at 221 Columbus Street.

May, Begins third Library installation. The Metropolitan Museum puts *Madame Pierre Gautreau* on display as *Madame X* in its gallery of recent acquisitions.

June, While Library ceiling is being prepared for installation, works on the bas-reliefs. Visits Worcester. Receives honorary degrees from Yale and Harvard.

July, Travels to the Rockies. Visits Glacier National Park in Montana for several weeks with friends from Boston.

August 2, Writes to Thomas A. Fox from Seattle.

August–September, With Nicola d'Inverno, heads north to British Columbia, Yoho Park. Paints watercolors and oils of Yoho Falls and Lake O'Hara (cats. 330–31).

October, Returns to Boston.

October 19, Writes Evan Charteris from Boston, "I am back from the Rocky Mountains . . . now I am winding up my Library and the scaffolding will soon come down. I have taken a studio for a month or more to do various mugs in charcoal and one paughtrait and then I will be thinking of returning."

November, Watercolors from his trip to Lake O'Hara and Yoho Falls at the Copley Society Show; many of them are sold.

Mid-November, Completes installation of third section of Boston Public Library murals (south vault: *Fifteen Mysteries of the Rosary* [figures 79 and 80], and the lunettes: *The Fall of Gog and Magog, Israel and the Law* [figure 83], *Messianic Era, Hell* [figure 82], *Judgment* [figure 81], and *Heaven*). Receives commission to decorate the rotunda of the Museum of Fine Arts, Boston.

1917

February, To Ormond Beach, Florida, to paint John D. Rockefeller Sr.

March, Stays with Charles Deering at Brickell Point, Miami. Paints watercolors at James Deering's unfinished estate, Villa Vizcaya, and its grounds (cats. 336–40).

April 6, America declares war. Is not allowed to leave America.

April 10, Writes Thomas A. Fox from Miami, "Just a line to say that the Deering brothers have seduced me into going on a week or ten days' cruise in a houseboat round to the west Coast of Florida. So I am lingering on for a bit."

May, Philadelphia, Boston, New York.

Summer, Spends most of the summer in Boston working on murals.

June, Rockefeller estate, Pocantico Hills in Tarrytown, to paint a second portrait of John D. Rockefeller Sr. Shares James Carroll Beckwith's New York studio. Beckwith is commissioned to copy the Florida version of the Rockefeller portrait in the New York studio.

October, Washington, D.C., to paint President Woodrow Wilson's portrait for Red Cross Charity. Stays at the new Willard Hotel.

November, James Carroll Beckwith dies. Sargent retouches paintings for the studio sale.

During the year, Resigns as trustee of the Tate Gallery, London, when he realizes he is the only painter on the board.

1918

March 29, Sargent's twenty-four-year-old niece, Rose-Marie, is killed in the German bombardment of the Church of St. Gervais, Paris.

April 20, Draws up his will.

May, Sails to England after discharging Nicola d'Inverno following a brawl with the bartender of the Hotel Vendôme in Boston.

By May 12, London.

June, Works on second Red Cross Charity portrait, *Mrs. Percival Duxbury and Daughter.* Negotiations with Lord Beaverbrook and the Ministry of Information about becoming a war artist.

June 10, Accepts position as war artist. His assigned program: "British and American troops working together."

July 2, Leaves for the French front with Henry Tonks.

July–October, France. Initially, he and Henry Tonks are placed under the care of Major Philip Sassoon, an old friend of Sargent's, who is secretary to the Commander-in-Chief of the British Armies in France, Douglas Haig. Sargent and Tonks then pass to the command of Major A. N. Lee and on to the Guards Division under Major General Geoffrey Fielding at Bavincourt.

July 13, Follows Fielding's headquarters to about five miles from Berles-au-Bois.

July 16, Is rejoined by Henry Tonks. They travel from Berles-au-Bois to Arras.

End of July into August, In Arras, Colonel Hastings, the town commandant, lodges Sargent and Henry Tonks in an undamaged house. They spend two or three weeks there together. According to Tonks, Sargent "did a somewhat elaborate oil painting of the ruined Cathedral and a great many water colours of surprising skill."

September, In the Somme region, at the dressing station in Doullens

Road, finds the subject for his painting when he sees a group of soldiers waiting for treatment after being blinded by mustard gas.

Before September 11, Leaves Henry Tonks at Arras and goes on to Ypres with an American division.

September 24, Arrives at a camp in the neighborhood of Peronne. Becomes a guest of Captain H. J. E. Anstruther (Twenty-sixth Royal Welsh Fusiliers).

Late September, Is stricken with influenza and taken to the Forty-first Casualty Clearing Station near Roisel.

End of October, Back at the Tite Street studio, London.

December, Categorically refuses to accept the presidency of the Royal Academy. Tells his friend Sir Arthur Cope, "I would do anything for the Royal Academy but that, and if you press me any more, I shall flee the country."

1919

January, Accepts commission for group portrait of war officers.

March, Gassed (figure 91) is completed and delivered to the Imperial War Commission. Receives £600 and does not ask for expenses.

May, Gassed is shown at the Royal Academy and voted picture of the year. Sargent returns to Boston with Emily and Reine, Violet's twenty-one-year-old daughter. They stay at the Copley Plaza Hotel and Sargent takes a studio in the Pope Building.

In Boston, Completes final installation at the Boston Public Library: *The Synagogue* and *The Church* (figure 84) are put in place over the stairway. Works on the bas-reliefs for the Museum of Fine Arts rotunda decorations.

October, Controversy arises regarding the religious symbolism of *The Synagogue* and *The Church.* The Jewish community in Boston wants them removed.

1920

April, Donates family memorabilia to the Sargent House Museum in Gloucester, Massachusetts.

May, Emily and Reine return to England.

June, Installs decorations in the Museum of Fine Arts rotunda.

July, Sails to Liverpool after spending fourteen months in Boston. Returns to Tite Street studio, London.

September, Begins painting *Some General Officers of the Great War.*

1921

January, Sails for New York.

January 29, Arrives in New York on board the *Cedric.* After registering at the Ritz-Carlton Hotel, visits Paul Manship at 42 Washington Mews and sketches his portrait (cat. 191). Visits with Paul Helleu, who is also staying at the Ritz-Carlton.

February, Heads to Boston and resumes work on the Museum of Fine Arts rotunda decorations, bas-reliefs, and oval panels.

June, Visits Montreal for work on *Some General Officers of the Great War.*

July, Visits his cousin Mary Hale at Schooner Head, Maine.

August, Violet, Emily, and Reine arrive in America.

September–October, Work on the Museum of Fine Arts rotunda murals, which are completed and installed by early October. Agrees to decorate the staircase of the museum as well.

October 15, Sails for Liverpool with his sisters and his niece a few days before the public unveiling of the rotunda decorations.

October 20, Unveiling of the Museum of Fine Arts rotunda.

November, Accepts commission to paint staircase panels for the Harry Elkins Widener Memorial Library at Harvard University, Cambridge, a memorial to alumni who died in the war (cats. 213–14).

During the year, Accepts chairmanship of the British School in Rome.

1922

Early part of the year, London, until *Some General Officers of the Great War* is finished.

March 24, The *New York Times* reports that American ambassador George Harvey hosts a dinner at the embassy in London in honor of Sargent, "who is returning to the United States."

Late March, Sails for Boston.

Summer, Working on murals for Widener Memorial Library.

August, Visits Monadnock, New Hampshire.

By the end of October, Widener Memorial Library murals are installed.

December 9, Sails for Liverpool.

Christmas, In London.

During the year, Ralph W. Curtis and his mother both die, ending Sargent's long-term connection to Venice. Boston's Jewish community petitions the state governor to remove *The Synagogue* from the library; their cause is defeated in the statehouse two years later.

1923

January, Group of nine of the Wertheimer portraits are installed in the National Gallery, London. Sargent in London working on the Museum of Fine Arts staircase panels at Fulham Road studio.

July 16, In honor of the bicentennial of Sir Joshua Reynolds's birth, delivers speech at the Royal Academy, despite his great fear of public speaking.

August, U.S. ambassador commissions charcoal portrait of the duke of York (later George VI) as a wedding present.

October 25, Sails for Boston with Emily.

November, Begins negotiations with Grand Central Art Galleries in New York for a retrospective exhibition.

1924

January, In Boston, declines to paint President Calvin Coolidge's portrait.

February 23–March 22, Retrospective at Grand Central Art Galleries in New York. The show includes sixty oils and twelve watercolors. Helps to arrange the loans, etc., but does not attend. Emily attends in his place.

July 14, Sails from Boston for Liverpool with Emily.

July 17, Death of Isabella Stewart Gardner. In her will she names Sargent as a pallbearer, but he is in London and cannot attend the funeral.

1925

March, Finishes the Museum of Fine Arts, Boston, decorations in his London studio. Tells Adrian Stokes, "Now the American things are done, and so, I suppose I may die when I like." The canvases are rolled and packed for shipping. Books passage on the *Baltic,* sailing April 18.

April 14, Emily has a farewell party at Carlyle Mansions for ten guests. In attendance are Violet Ormond, Lady Prothero, the two Misses Barnard, L. A. Harrison, Henry Tonks, and Nelson Ward. Sargent returns home to Tite Street before 11 P.M. Falls asleep reading Voltaire's *Dictionnaire Philosphique* and dies of a heart attack in his sleep.

April 18, Is buried at Brookwood Cemetery in a private ceremony.

April 24, Memorial Service at Westminster Abbey.

July 24–27, Studio sale at Christie's, London, includes 237 oils and watercolors by Sargent and nearly one hundred works by other artists. Emily and Violet purchase several lots. Sales realize £176,366.

November, The rotunda decorations are unveiled at the Museum of Fine Arts, Boston.

Exhibition History, 1877–1926

Information in brackets is supplied by the authors. All other information comes from the exhibition's catalogue, or in the case of some annual exhibitions, from an index (e.g.: Peter Hastings Falk, ed., *The Annual Exhibition Record of the Art Institute of Chicago*, Madison, Connecticut, 1990; Peter Hastings Falk, ed., *The Annual Exhibition Record of the National Academy of Design 1901–1950*, Madison, Connecticut, 1990).

1877
May 1–June 20, Paris, "Salon de 1877"
 1912. Portrait de Mlle W [*Fanny Watts*]

1878
March 6–April 5, New York, Society of American Artists, "First Exhibition"
 23. Fishing for Oysters at Cancale
May 1–October 28, Paris, "Exposition universelle"
 94. Portrait d'une dame [*Fanny Watts*]
May 25–August 19, Paris, "Salon de 1878"
 2008. En route pour la pêche

1879
March 10–29, New York, Society of American Artists, "Second Exhibition"
 37. A Capriote
April 1–May 31, New York, National Academy of Design, "Fifty-fourth Annual Exhibition"
 431. Neapolitan Children Bathing
May 12–June 30, Paris, "Salon de 1879"
 2697. Portrait de M. Carolus-Duran
 2698. Dans les oliviers, à Capri
December 17, New York, National Academy of Design, "John H. Sherwood and Benjamin Hart Sale"
 Scene in the Luxembourg

1880
March 17–April 16, New York, Society of American Artists, "Third Annual Exhibition"
 Portrait of Carolus-Duran
April–October, New York, The Metropolitan Museum of Art, "Inaugural Exhibition"
 Oyster Fishing at Cancale
May 1–June 20, Paris, "Salon de 1880"
 3428. Portrait de Mme E. P. [*Mme Édouard Pailleron*]
 3429. Fumée d'Ambre Gris
May 19–29, Boston, St. Botolph Club, "Inaugural Exhibition"
 27. Portrait of Carolus-Duran

1881
March 28–April 29, New York, Society of American Artists, "Fourth Annual Exhibition"
 73. Capri Peasant—Study [*Head of Ana Capri Girl*]
 92. Portrait of Mr. B. [*Edward Burckhardt*]
April 23–May 25, Paris, Cercle des arts libéraux
 Etude fait à Venise
 Etude fait à Venise
May 2–June 20, Paris, "Salon de 1881"
 2108. Portrait de Mme R. S. [*Madame Ramón Subercaseaux*]
 2109. Portrait de M. E. P. et de Mlle L. P. [*Édouard and Marie-Louise Pailleron*]

3413. Vue de Venise: aquarelle
3414. Vue de Venise: aquarelle
November 8–early January 1882, Philadelphia, "Works of American Artists Abroad: The Second Exhibition"
 Portrait [*Beatrix Chapman*]
 Portrait [*Eleanor Chapman*]

1882
March–April, Paris, Cercle des arts libéraux
 Portrait [*Charles Edmond*]
 Portrait [Isabel Vallé (?)]
May 1–June 20, Paris, "Salon de 1882"
 2397. El Jaleo
 2398. Portrait de M. [*Lady with the Rose (Charlotte Louise Burckhardt)*]
May 1–July 31, London, Grosvenor Gallery
 135. Venetian Interior
 140. A Study
 346. Venetian Interior [*Venetian Bead Stringers*]
May 1–August 7, London, Royal Academy, "One Hundred and Fourteenth Exhibition"
 239. A Portrait [*Dr. Pozzi at Home*]
July, London, Fine Art Society, "British and American Artists from the Paris Salon"
 8. Portrait of My Master, Carolus-Duran
 9. El Jaleo
 10. A Portrait [*Lady with the Rose (Charlotte Louise Burckhardt)*]
October 7–17, New York, Schaus Gallery
 El Jaleo
October 22–29, Boston, Williams and Everett Gallery
 El Jaleo
December 20–January 30, 1883, Paris, Société internationale de peintres et sculpteurs
 95. Portraits d'enfants [*The Daughters of Edward D. Boit*]
 96. Intérieur vénitien
 97. Autre intérieur vénitien
 98. Sortie d'église
 99. Une Rue à Venise [*Street in Venice*]
 100. Portrait de Mme A. J. [*Mme Allouard-Jouan*]
 101. Pochade. Portrait de Vernon-Lée [*sic*]

1883
February 6–March 12, Paris, Cercle de l'union artistique
 135. Conversation vénitienne
March 26–April 28, New York, Society of American Artists, American Art Gallery, "Sixth Exhibition"
 103. Portrait of a Lady [*Lady with the Rose (Charlotte Louise Burckhardt)*]
April 25–May 30, Paris, École des beaux-arts, "Portraits du siècle"
 Carolus-Duran

May 1–June 20, Paris, "Salon de 1883"
 2165. Portraits d'enfants [*The Daughters of Edward D. Boit*]
May 7–June 2, Boston, Society of American Artists
 100. Portrait of a Lady [*Lady with the Rose (Charlotte Louise Burckhardt)*]
July, London, Fine Art Society
 Édouard and Marie-Louise Pailleron
October 16–November 27, Boston, Museum of Fine Arts, "Fourth Annual Exhibition of Contemporary American Art"
 50. Portrait of a Lady [*Eleanor Jay Chapman*]
 68. Portrait of a Child [*Beatrix Chapman*]
Paris, Société internationale des peintres et sculpteurs
 A Street in Venice

1884
February–March 10, Paris, Cercle de l'union artistique
 Portrait de Mme la vicomtesse de Saint-P. [*La vicomtesse de Saint-Périer*]
February 2–March 2, Brussels, "Les XX"
 Portrait [*Dr. Pozzi at Home*]
May 1–July 31, London, Grosvenor Gallery, "Eighth Summer Exhibition"
 203. Portrait of Mrs. T. W. Legh
May 1–June 20, Paris, "Salon de 1884"
 2150. Portrait de Mme *** [*Madame X (Madame Pierre Gautreau)*]
May 5–August 4, London, Royal Academy, "One Hundred and Sixteenth Exhibition"
 788. Mrs. H. White
December 1, Dublin Sketching Club, "Annual Exhibition of Sketches, Pictures, and Photography"
 The Bead Stringers of Venice

1885
February 2–March 9, Paris, Cercle de l'union artistique
 Portrait de Mme T. L. [*Mrs. Thomas Wodehouse Legh*]
Opened April 27, London, Grosvenor Gallery, "Ninth Summer Exhibition"
 32. Portrait of Mrs. Mason
May 1–June 30, Paris, "Salon de 1885"
 2191. Portrait de Mme V. [*Mrs. Albert Vickers*]
 2192. Portraits des Misses *** [*The Misses Vickers*]
May 4–August 3, London, Royal Academy, "One Hundred and Seventeenth Exhibition"
 586. Lady Playfair
May 15–June, Paris, Galerie Georges Petit, "Exposition internationale de peinture"
 97. Portrait de Mme W. [*Mrs. Henry White*]
 98. Portrait de M. Rodin
 99. Le verre de Porto (Esquisse) [*A Dinner Table at Night (The Glass of Claret)*]
 100. Portrait de Mme W. [*Mrs. Henry White*, half length]
August 18–September 18, Geneva, Musée Rath, "Salon suisse des beaux-arts et des arts décoratifs de la vie de Genève"
 Portrait de Madame ?
 Portrait de Monsieur X

1886
April, London, New English Art Club
 17. Portrait of Mrs. Barnard
 37. A Study [*A Dinner Table at Night (The Glass of Claret)*]
May–June, London, Grosvenor Gallery, "Summer Exhibition"
 14. A Study [*Edith Lady Playfair (Edith Russell)*]

May–October, New York, Society of American Artists, "Eighth Annual Exhibition"
 95. Portrait of a Lady [*Mrs. Wilton Phipps*]
 96. Portrait [*Mr. and Mrs. John White Field*]
May 1–June 30, Paris, "Salon de 1886"
 2128. Portraits de Mme et de Mlle B. [*Mrs. Edward Burckhardt and Her Daughter Louise*]
May 3–August 2, London, Royal Academy, "One Hundred and Eighteenth Exhibition"
 78. Mrs. Harrison
 195. Mrs. Vickers
 709. The Misses Vickers

1887
April, London, New English Art Club
 55. Portrait of a Lady [*Mrs. Cecil Wade*]
 84. Portrait of Robert Louis Stevenson and Mrs. Stevenson: A Sketch
May 2–August 2, London, Royal Academy, "One Hundred and Nineteenth Exhibition"
 197. Mrs. William Playfair
 359. "Carnation, Lily, Lily, Rose"
September 5–December 3, Liverpool, Walker Art Gallery, "Seventeenth Autumn Exhibition of Pictures in Oil and Water-Colours"
 213. "Carnation, Lily, Lily, Rose"
October, Boston, St. Botolph Club, "Loan Exhibition 1887"
 21. Portrait of R. L. Stevenson
 51. Portrait

1888
January 28–February 28, Boston, St. Botolph Club, "John Singer Sargent's Paintings" (no catalogue)
 Ruth Sears Bacon
 Mrs. Wilton Phipps
 Mrs. Henry Marquand
 The Sons of Mrs. Malcolm Forbes
 Mrs. James Lawrence
 Robert Louis Stevenson
 Casper Goodrich
 El Jaleo
 Mrs. Charles Fairchild
 Lady Playfair
 Mrs. John L. Gardner
 General Lucius Fairchild
 Mrs. Edward Boit
 Dennis Miller Bunker
 Mr. James Lawrence
 Mrs. Charles Inches
 Mr. Thornton K. Lothrop
 The Daughters of Edward D. Boit
 Three Venetian genre pictures, including *Venetian Bead Stringers*
 Watercolor of ships
April 2–May 12, New York, National Academy of Design, "Sixty-third Annual Exhibition"
 213. Venetian Street
 219. Venetian Interior
 260. Portrait of Mrs. Charles Inches
April 9–May 5, New York, Society of American Artists, "Tenth Annual Exhibition"
 99. Portrait of a Lady [*Mrs. Richard H. Derby*]
May, Paris, "Salon de 1888"
 2240. Mrs. Playfair

May 7–August 6, London, Royal Academy, "One Hundred and Twenty-first Exhibition
 314. Cecil, Son of Robert Harrison, Esq.
 365. Elizabeth Allen Marquand
 432. Mrs. Edward D. Boit
May 9–August, London, New Gallery, "First Summer Exhibition"
 211. Portrait of Claude Monet

1889

April 1–May 11, New York, National Academy of Design, "Sixty-fourth Annual Exhibition"
 107. Portrait [Cara Burch]
April, London, New English Art Club, "Summer Exhibition"
 66. St. Martin's Summer
 69. A Morning Walk
May 5–November 5, Paris, "Exposition universelle"
 262. Portraits de Mlles B. [The Daughters of Edward D. Boit]
 263. Portrait de Mme W. [Mrs. Henry White]
 264. Portrait de Mlles V. [The Misses Vickers]
 265. Portrait de Mme B. [Mrs. Edward D. Boit]
 266. Portrait de Mme S. [Mrs. Elliott Shepard]
 267. Portrait de Mme K. [Mrs. Benjamin Kissam]
May 6–August 5, London, Royal Academy, "One Hundred and Twenty-first Exhibition"
 104. Sir George Henschel
 564. Mrs. George Gribble
 638. Henry Irving, Esq.
May 13–June 15, New York, Society of American Artists, "Eleventh Annual Exhibition"
 122. Portrait of Mrs. M. [Mrs. Henry Marquand]
 123. Portrait of Mrs. F. D. M. [Mrs. Frank Millet]
May, London, New Gallery, "Second Summer Exhibition"
 110. Miss Ellen Terry as Lady Macbeth

1890

January 27–February 8, Boston, St. Botolph Club, "Midwinter Exhibition"
 27. George Henschel
 61. A Summer Morning
February 13–15, New York, Union League Club, "Pictures by American Figure Painters together with an Exhibition of Persian and Indian Art"
 35. Summer Morning
 36. An Out-of-Doors Study [Paul Helleu Sketching with His Wife]
March 31–April 30, Worcester Art Society (at the Worcester Public Library), "Loan Collection of Portraits"
April 28–May 24, New York, Society of American Artists, "Twelfth Annual Exhibition"
 153. La Carmencita
 154. Portrait
 155. Portrait
 [According to Ormond and Kilmurray 1998, no. 154 or no. 155 is *Alice Vanderbilt Shepard*]
 156. Portrait of George Henschel
 157. Master Caspar Goodrich
 158. Summer Morning
 159. Study [Flora Priestley]
May 5–August 4, London, Royal Academy, "One Hundred and Twenty-second Exhibition"
 421. Portrait of a Lady; Study [Clementine Anstruther-Thomson]
 652. Mrs. K. [Mrs. Benjamin Kissam]

May, London, New Gallery, "Third Summer Exhibition"
 82. Mrs. Comyns Carr
 188. Ightham Mote
May, Paris, Société nationale des beaux-arts
 809. Portrait de Madame [possibly Princesse Louis de Scey-Montbeliard]
 810. Portrait d'Ellen Therry [sic], dans le role de Lady Macbeth
June 9–July 30, Art Institute of Chicago, "Third Annual Exhibition of American Paintings and Sculpture"
 151. La Carmencita
 152. Summer Morning
 153. Study [Flora Priestley]
November 3–December 7, Art Club of Philadelphia, "Second Special Exhibition"
 63. Plein Air Study
 65. Portrait—Son of Mr. Saint-Gaudens
 67. Plein Air Study
 [According to Ormond and Kilmurray 1998, no. 63 or no. 67 is *Paul Helleu Sketching with His Wife*]
November 24–December 20, New York, National Academy of Design, "Ninth Annual Autumn Exhibition"
 83. Portrait of Mr. Lawrence Barrett
 92. Portrait of Mr. Jos. Jefferson in the Part of Dr. Pangloss
 252. Portrait of Mrs. E. L. Davis and Her Son
December 29–January 17, 1891, Boston, St. Botolph Club, "Exhibition"
 22. Portrait

1891

January 29–March 6, Philadelphia, Pennsylvania Academy of the Fine Arts, "Sixty-first Annual Exhibition"
 257. Edward L. Davis
April 6–May 16, New York, National Academy of Design, "Sixty-sixth Annual Exhibition"
 30. Portrait
 388. Portrait [Cornelius Vanderbilt, Esq.]
April 27–May 23, New York, Society of American Artists, "Thirteenth Annual Exhibition"
 199. Portrait of Miss Beatrice Goelet
May 4–August 3, London, Royal Academy, "One Hundred and Twenty-third Exhibition"
 544. La Carmencita
 1097. Mrs. Thomas Lincoln Manson
May, London, New Gallery, "Fourth Summer Exhibition"
 56. A Portrait [Elsie Palmer]
May, Paris, Société nationale des beaux-arts
 850. Portrait de jeune garçon
June 4–July 2, Boston, Museum of Fine Arts, "Thirteenth Annual Exhibition of the Society of American Artists"
November 16–December 13, Art Club of Philadelphia, "Third Annual Exhibition of Oil Paintings and Sculpture"
 56. Portrait of a Lady
November, London, New English Art Club, "Winter Exhibition"
 64. Javanese Dancer
 67. Life Study [Nude Egyptian Girl]

1892

January 21–March 5, Philadelphia, Pennsylvania Academy of Fine Arts, "Sixty-second Annual Exhibition"
 215. Portraits of Mr. and Mrs. John W. Field
May 2–28, New York, Society of American Artists, "Fourteenth Annual Exhibition"
 191. Portrait of a Lady and Boy [Mrs. Edward L. Davis and Her Son, Livingston]

May, Paris, Société nationale des beaux-arts
 926. La Carmencita
 927. Étude de femme
November, London, New English Art Club, "Winter Exhibition"
 47. Portrait Study [Flora Priestley]
 71. M. et Mme Helleu [Paul Helleu Sketching with His Wife]
 99. Miss Duncomb [Helen Dunham]
December 5–25, New York, Society of American Artists, "Retrospective Exhibition"
 275. Portrait
 276. Venetian Scene
 277. Venetian Bead Stringers
 278. Portrait of Robert Louis Stevenson
 279. Landscape

1893

May 1–August 7, London, Royal Academy, "One Hundred and Twenty-fifth Exhibition"
 30. Lady Agnew of Lochnaw
May, London, New Gallery, "Sixth Summer Exhibition"
 128. Portrait of Mrs. Hugh Hammersley
 177. Portrait of Mrs. George Lewis
London, The New English Art Club, "Tenth Exhibition"
 49. Mr. Joseph Jefferson
November 23–December 31, Art Club of Philadelphia, "Fifth Annual Exhibition of Oil Paintings and Sculpture"
 224. Study of an Egyptian Girl
December 18–February 24, 1894, Philadelphia, Pennsylvania Academy of the Fine Arts, "Sixty-third Annual Exhibition"
 5. F. S. Pratt
Chicago, The Institute of Art, "World's Columbian Exposition"
 509. Portrait [Katherine Chase Pratt]
 513. Portrait [Helen Dunham]
 515. Portrait [Alice Shepard]
 522. Portrait of Mrs. Inches
 577. Portrait of Ellen Terry as Lady Macbeth
 680. Portrait [Alice Mason]
 686. Portrait [Homer Saint-Gaudens]
 809. Mother and Child [Mrs. Edward L. Davis and Her Son, Livingston]
 1043. Study of an Egyptian Girl

1894

May 7–August 6, London, Royal Academy, "One Hundred and Twenty-sixth Exhibition"
 61. Miss Chanler
 423. Lunette and Portion of the Ceiling (part of mural decoration of the Boston Public Library)
Paris, Société nationale des beaux-arts
 1036. Portrait de Mrs. H. H. [Mrs. Hugh Hammersley]
 1037. Étude
September 3–December 15, Liverpool, Walker Art Gallery, "Twenty-fourth Autumn Exhibition of Modern Pictures in Oil and Water-Colours"
 1206. G. Natorp, Esq.
November 1–December 1, New York, National Academy of Design, "Loan Exhibition: Portraits of Women for the Benefit of St. John's Guild and the Orthopaedic Hospital"
 256. Mrs. Henry G. Marquand
 257. Portrait of a Lady [Mrs. Richard H. Derby]
 258. Mrs. Thomas L. Manson Jr.
 259. Mrs. Adrian Iselin

 260. Mrs. Wilton Phipps
 261. Mrs. Francis D. Millet
 262. Mrs. H. Galbraith Ward
 263. Miss Elizabeth Chanler
 264. Mrs. Hamilton McK. Twombly
November–December, London, New English Art Club, "Winter Exhibition"
 28. Three Sketches
 78. A Sketch
December 17–February 23, 1895, Philadelphia, Pennsylvania Academy of the Fine Arts, "Sixty-fourth Annual Exhibition"
 1. Ellen Terry as Lady Macbeth (Temple Prize)
 270. Mrs. Henry G. Marquand
 271. Mrs. H. Galbraith Ward

1895

March 11–31, Boston, Copley Hall, "Loan Collection of Portraits of Women for the Benefit of the Boston Children's Aid Society and the Sunnyside Day Nursery"
May 6–August 5, London, Royal Academy, "One Hundred and Twenty-seventh Exhibition"
 31. Mrs. Ernest Hills
 172. Coventry Patmore, Esq.
 503. W. Graham Robertson, Esq.
 647. Mrs. Russell Cooke
 737. Coventry Patmore, Esq.
London, New Gallery, "Eighth Summer Exhibition"
 199. Miss Ada Rehan
October 30–December 7, New York, National Academy of Design, "Loan Exhibition of Portraits for the Benefit of St. John's Guild and the Orthopaedic Hospital"
 267. Beatrice (lent by Mrs. Robert Goelet)
 268. Child [Ruth Sears Bacon] (lent by Dr. Gorham Bacon)
 269. Portrait [Mrs. Jacob Wendell] (lent by Jacob Wendell, Esq.)
 270. Miss Helen Dunham (lent by James H. Dunham, Esq.)
 271. Miss Ada Rehan (lent by Mrs. G. M. Whitin)
December 23–February 22, Philadelphia, Pennsylvania Academy of the Fine Arts, "Sixty-fifth Annual Exhibition"
 298. Portrait of Miss Ada Rehan

1896

March 2–23, Boston, Copley Hall, "Loan Collection of Portraits for the Benefit of the Associated Charities and the North End Union"
 206. Miss Ada Rehan (owner: Mrs. G. M. Whitin, Whitinsville)
 207. Sketch of Edwin Booth (painted in three-quarters of an hour) (owner: Miss Fairchild)
 208. Sketch of Child (painted in one evening) (owner: Mr. C. Fairchild)
 209. Mr. James Lawrence (owner: Mr. James Lawrence)
 210. Mrs. James Lawrence (owner: Mr. James Lawrence)
 211. Mr. G. G. Hammond Jr. (owner: Mrs. G. G. Hammond Jr.)
March 28–May 2, New York, Society of American Artists, "Eighteenth Annual Exhibition"
 163. Portrait of Helen Sears
March 30–May 16, New York, National Academy of Design, "Seventy-first Annual Exhibition"
 241. Portrait of Gardiner Greene Hammond Jr.
May 4–August 3, London, Royal Academy, "One Hundred and Twenty-eighth Exhibition"
 64. The Rt. Hon. Joseph Chamberlain, M.P.
 129. Mrs. Ian Hamilton

31. *Portrait of a Young Girl* [Olivia Richardson]
32. *Portrait of the President of Bryn Mawr College*

May 7–August 6, London, Royal Academy, "One Hundred and Thirty-second Exhibition"
44. *The Earl of Dalhousie*
190. *Lord Russell of Killowen, Lord Chief Justice of England*
213. *Lady Elcho, Mrs. Adeane and Mrs. Tennant* [*The Wyndham Sisters*]
625. *Sir David Richmond, ex Lord Provost of Glasglow*
630. *Lord Russell of Killowen, Lord Chief Justice of England*
729. *An Interior in Venice*

London, New Gallery, "Thirteenth Summer Exhibition"
124. *Major-General Ian Hamilton, C.B., D.S.O.*
248. *The Hon. Victoria Stanley*

Paris, "Exposition universelle"
5. *Asher B. Wertheimer*
14. *Miss Carey Thomas*
60. *Mrs. Meyer and Children*

Paris, "Salon de 1900"
Asher Wertheimer

September 17–January 5, 1901, Liverpool, Walker Art Gallery, "Thirtieth Autumn Exhibition of Modern Pictures in Oil and Water-Colours"
68. *The Hon. Victoria Stanley*
1027. *The Late Lord Russell of Killowen*

November 1–January 1, 1901, Pittsburgh, Carnegie Institute, "Fifth Annual Exhibition"
211. *Portrait of Hon. Joseph H. Choate*
212. *Portrait of Hon. James C. Carter*

1901

January 14–February 23, Philadelphia, Pennsylvania Academy of the Fine Arts, "Seventieth Annual Exhibition"
28. *General Ian Hamilton*
636. *Portrait*

March 30–May 4, New York, Society of American Artists, "Twenty-third Annual Exhibition"
303. *Dorothy* (owner, G. M. Williamson, Esq.)

April 22–October 31, Venice, "Quarta esposizione internazionale d'arte della città di Venezia"
16. *Graham Robertson, Esq.*

May 1–November 1, Buffalo, Albright Art Gallery, "Pan-American Exposition"
26. *Portrait of a Boy* (lent by Mrs. Augustus Saint-Gaudens)
27. *Mrs. Inches*
28. *Portraits* [*Mr. and Mrs. I. N. Phelps Stokes*] (lent by I. N. Phelps Stokes, Esq.)
29. *Venetian Bead Stringers*
30. *A Street in Venice*
31. *Portrait* (lent by Thomas Lincoln Manson, Esq.)
1655. *Redemption* (first sketch for lifesize group forming central motive in a portion of the decoration in process of execution for Boston Public Library)

May 6–August 5, London, Royal Academy, "One Hundred and Thirty-third Exhibition"
103. *Mrs. Cazalet and Children*
178. *Daughters of A. Wertheimer, Esq.*
219. *The Hon. Mrs. Charles Russell*
421. *Ingram Bywater, Esq.*
576. *C. S. Loch, Esq.*
583. *Sir Charles Tennant of the Glen Bart*
811. *Sir Charles Sitwell, Lady Ida Sitwell and Family*
1792. *The Crucifix from The Dogma of Redemption*

London, New Gallery, "Fourteenth Summer Exhibition"
229. *Mrs. Garrett Anderson, M.D., Dean of the London (Royal Free Hospital) School of Medicine for Women*
259. *The Duke of Portland, K.G., G.C.V.O.*

September 16–January 4, 1902, Liverpool, Walker Art Gallery, "Thirty-first Autumn Exhibition of Modern Pictures in Oil and Water-Colours"
999. *Lieut.-Gen. Sir Ian Hamilton*

1901–2, Charleston, South Carolina, "Exhibition of Fine Arts: The South Carolina Inter-State and West Indian Exposition"
127. *Portraits* [*Mr. and Mrs. I. N. Phelps Stokes*] (lent by I. N. Phelps Stokes, Esq.)
147. *Portrait of Miss C.* (lent by Miss Chanler)

1902

January 20–March 1, Philadelphia, Pennsylvania Academy of the Fine Arts, "Seventy-first Annual Exhibition"
32. *G. M. Williamson*
40. *Dorothy*
80. *Innocence Abroad*
1059. *The Redemption: Design for Boston Public Library* (plaster sculpture)

March 28–May 4, New York, Society of American Artists, "Twenty-fourth Annual Exhibition"
26. *Portrait*

May 5–August 4, London, Royal Academy, "One Hundred and Thirty-fourth Exhibition"
89. *The Ladies Alexandra, Mary and Theo Acheson*
148. *Mrs. Endicott* [*Mrs. William C. Endicott*]
157. *Alfred Wertheimer*
175. *Lord Ribbesdale*
229. *The Misses Hunter*
323. *The Duchess of Portland*
681. *Mrs. Leopold Hirsch*
688. *Lady Meysey Thompson*

Paris, Société nationale des beaux-arts, "Salon"
1042. *Portrait de deux soeurs*
1043. *Étude*
1044. *Portrait de Léon Delafosse*

London, New Gallery, "Fifteenth Summer Exhibition"
251. *Children of A. Wertheimer, Esq.*
292. *The Late Mrs. Goetz*
297. *On His Holidays, Norway*

September 15–January 3, 1903, Liverpool, Walker Art Gallery, "Thirty-second Autumn Exhibition of Modern Pictures in Oil and Water-Colours"
870. *The Ladies Alexandra, Mary, and Theo. Acheson* (lent by the Right Hon. the Duke of Devonshire, K.G.)

Edinburgh, Royal Scottish Academy
149. *Lady Faudel Phillips*
161. *Mrs. Harold Wilson*

Boston, Copley Society, "Loan Collection of Portraits and Pictures of Fair Women"
79. *Portrait of the President of Bryn Mawr College* (lent by the trustees of the College)

1903

January 19–February 28, Philadelphia, Pennsylvania Academy of the Fine Arts, "Seventy-second Annual Exhibition" [Converse Gold Medal]
10. *The Oyster-Gatherers*
26. *P. A. B. Widener*

May 20–July 10, Cincinnati Museum, "Twelfth Annual Exhibition of American Art"
 22. *James Whitcomb Riley*

May 31–July 1, Buffalo, Fine Arts Academy, Albright Art Gallery, "Inaugural Loan Collection of Paintings"
 4. *Portrait of Mrs. Austin* (owner: Mr. George Austin, Geneseo, N.Y.)
 16. *Portrait of Mr. Edward Robinson, Director of the Boston Museum of Fine Arts* (owner: Mr. Edward Robinson, Boston)

Paris, Société nationale des beaux-arts, "Salon"
 Portrait de Mme la duchesse de S.

London, New Gallery, "Portraits: Summer Exhibition"
 216. *Mrs. Ernest G. Raphael*
 219. *Sir Frank Swettenham*
 260. *Mrs. Adolph Hirsch*

London, Royal Water-Colour Society, "One Hundred and Thirty-sixth Summer Exhibition"
 1. *Palazzo Grimani*
 2. *Bed of a Torrent*

September 18–January 6, 1906, Liverpool, Walker Art Gallery, "Thirty-fifth Autumn Exhibition of Modern Art"
 996. *Señor Manuel Garcia*
 1134. *The Duchess of Sutherland*

October–November, London, New English Art Club, "Winter Exhibition"
 82. *Lamplight Study*

November 20–December 17, Philadelphia, Art Club of Philadelphia, "Seventeenth Annual Exhibition of Oil Paintings and Sculpture"
 108. *Katherine Haven*

December 23–January 1906, New York, National Academy of Design, "Eighty-first Annual Exhibition"
 290. *Portrait of William Thorne, A.N.A.*

1906

January 22–March 3, Philadelphia, Pennsylvania Academy of the Fine Arts, "One Hundred and First Annual Exhibition"
 25. *A Vele Gonfie: Portrait of Mrs. Robert M. Mathias*
 528. *Mrs. C. B. Alexander*

March 26–April 21, Philadelphia Water Color Club, "Third Annual Philadelphia Water Color Exhibition"
 389. *Venice* (lent by Mrs. Gorham P. Sargent)

May 7–August 6, London, Royal Academy, "One Hundred and Thirty-eighth Exhibition"
 41. *F. M. Earl Roberts, K.G., V.C.—Presentation Piece*
 116. *The Hon. Mrs. Frederick Guest*
 207. *Maud, Daughter of George Coats, Esq.*
 257. *The Four Doctors*
 383. *The Mountains of Moab*

London, New Gallery, "Nineteenth Summer Exhibition"
 82. *Syrian Study*
 98. *Padre Albera [Padre Sebastiano]*
 134. *Seymour Lucas, Esq., R.A., A Sketch*
 135. *The Garden of Gethsemane*
 145. *C. Napier Hemy, Esq., A.R.A.*

London, New English Art Club, "Summer Exhibition"
 23. *Bedouins Tent*
 33. *Bedouins*
 89. *In Switzerland*
 93. *Wady-el-Nar*
 116. *Behind the Curtain (Marionettes)*

Closed June 23, London, Royal Society of Painters in Water Colours, "Summer Exhibition"
 23. *Arab Gipsy [sic] Tent*

 128. *Miss Eden*
 179. *Bedouins*

September 17–January 5, 1907, Liverpool, Walker Art Gallery, "Thirty-sixth Autumn Exhibition of Modern Art"
 153. *The Mountains of Moab*
 761. *Mrs. Archibald Williamson*
 929. *Seymour Lucas, Esq., R.A.*

November 20–December 31, Art Association of Indianapolis, John Herron Art Institute, "Inaugural Exhibition"
 Portrait of Mr. P. A. B. Widener
 Portrait of Mr. James Whitcomb Riley

Boston, Copley Hall, "Loan Exhibition of Portraits"
 206. *Miss Ada Rehan*

1907

January 21–February 24, Philadelphia, Pennsylvania Academy of the Fine Arts, "One Hundred and Second Annual Exhibition"
 140. *Reverend Endicott*

February 7–March 9, Washington, D.C., Corcoran Gallery, "First Biennial Exhibition"
 45. *Portrait of Mr. William Thorne*
 46. *Portrait of Miss Mary Elizabeth Garrett*
 47. *Portrait Group: Dr. William H. Welch, Dr. William Osler, Dr. William S. Halsted, Dr. Howard A. Kelly*
 48. *Portrait of the President of Bryn Mawr College*
 49. *Portrait of the Late John Hay*

March 16–April 20, New York, National Academy of Design, "Eighty-second Annual Exhibition"
 327. *Portrait of Reverend Endicott Peabody*

April 11–June 13, Pittsburgh, Carnegie Institute, "Eleventh Annual Exhibition"
 407. *Portrait of William Thorne*
 408. *Portrait Group: Dr. William H. Welch, Dr. William Osler, Dr. William S. Halsted, and Dr. Howard A. Kelly of the Johns Hopkins University, Baltimore*
 409. *Portrait of the Hon. Mrs. Frederick Guest*

Opened April 22, London, New Gallery, "Twentieth Summer Exhibition"
 211. *Rev. Edmond Warren, D.D., C.B., M.V.O., Late Head Master of Eton, Presentation Portrait*
 215. *Mrs. Harold Harmsworth*
 268. *Architectural Study*

April–October, Venice, "Settima esposizione internazionale d'arte della città di Venezia"
 23. *Ritratto della Signora Charles Hunter*
 24. *Ritratto del molto onorevole Lord Ribblesdale*
 25. *Ritratto di S. G. la Comtessa di Warwick*
 26. *Ritratto del Generale Sir Jan Hamilton*
 27. *Ritratto del F. C. Penrose, Presidente del Royal Institute of British Architects*
 28. *Ritratto delle Signore Acheson*

May 6–August 5, London, Royal Academy, "One Hundred and Thirty-ninth Exhibition"
 38. *Lady Eden*
 189. *Lady Speyer*
 237. *Lady Sassoon*
 331. *Mrs. Archibald Langman*
 425. *The Countess of Essex*

May–June, London, New English Art Club, "Summer Exhibition"
 20. *In a Levantine Port*
 21. *Piazza Navona*

22. *Zuleika*

26. *Hills of Galilee*

74. *A Balustrade*

78. *La Salute*

Closed June 29, London, Royal Society of Painters in Water-Colours, "Summer Exhibition"

71. *A Vagrant*

177. *Fountain at Bologna*

233. *In a Florentine Villa*

September 23–January 4, 1908, Liverpool, Walker Art Gallery, "Thirty-seventh Autumn Exhibition of Modern Art"

1036. *Lady Sasson*

1173. *The Countess of Essex*

October 22–December 1, Art Institute of Chicago, "Twentieth Annual Exhibition of American Paintings and Sculpture"

315. *Portrait of Mrs. Fiske Warren*

London, New English Art Club, "Winter Exhibition"

56. *The Moraine*

63. *The Fountain*

86. *The Brook*

Edinburgh, Royal Scottish Academy

219. *The Misses Hunter*

525. *An Egyptian Girl*

1908

January 20–February 29, Philadelphia, Pennsylvania Academy of the Fine Arts, "One Hundred and Third Annual Exhibition"

108. *Lady with a Rose* [*Charlotte Louise Burckhardt*]

623. *Portrait of A. Augustus Healy*

March 14–April 18, New York, National Academy of Design, "Eighty-third Annual Exhibition"

27. *Portrait of Miss Cram*

29. *Portrait of Mr. Henry A. Cram*

284. *Portrait of Edward Robinson, Esq.*

292. *Portrait of Miss Haven*

May 4–August 3, London, Royal Academy, "One Hundred and Fortieth Exhibition"

39. *Miss Helen Brice*

176. *F.M.H.R.H. the Duke of Connaught*

183. *H.R.H. the Duchess of Connaught*

207. *The Rt. Hon. A. J. Balfour, M.P.*

504. *Mrs. Huth Jackson*

London, New Gallery, "Twenty-first Summer Exhibition"

125. *Miss Lewis*

222. *Miss Izme Vickers*

London, New English Art Club, "Summer Exhibition"

35. *The Giudecca*

61. *Villa di Papa Guilio*

June, London, Carfax Gallery, "Water Colors by Sargent"

46 works

August(?), London, "Franco-British Exhibition" (under the auspices of the British Art Committee)

168. *Portrait of Lady Elcho, Lady Tennant, and Mrs. Adeane* [*The Wyndham Sisters*] ([lent by] The Hon. Percy Wyndham)

218. *Portrait Group of the Ladies Acheson* ([lent by] His Grace the Duke of Devonshire)

297. *Portrait of Mrs. Wertheimer* ([lent by] Asher Wertheimer, Esq.)

September 14–January 2, 1909, Liverpool, Walker Art Gallery, "Thirty-eighth Autumn Exhibition of Modern Art"

97. *Field-Marshall H.R.H. the Duke of Connaught and Stratheam*

107. *H.R.H. the Duchess of Connaught and Stratheam*

December 8–January 17, 1909, Washington, D.C., Corcoran Gallery, "Second Biennial Exhibition"

11. *Portrait of James Whitcomb Riley*

74. *Portrait of Miss Townsend*

116. *Portrait of Hon. Henry Cabot Lodge*

124. *Portrait of Mrs. William C. Endicott Jr.*

134. *Portrait of William C. Endicott Jr.*

December 12–January 9, 1909, New York, National Academy of Design, "Winter Exhibition"

46. *Portrait* ([lent by] Miss Helen Brice)

166. *Portrait of Mr. Joseph Pulitzer* ([lent by] Joseph Pulitzer)

269. *Portrait: Mrs. Joseph Pulitzer* ([lent by] Joseph Pulitzer)

Closed December 19, London, Royal Water-Colour Society, "Winter Exhibition"

80. *In Majorca*

97. *Tarragona Cathedral*

108. *Flotsam and Jetsam*

Edinburgh, Royal Scottish Academy

101. *Santa Maria della Salute*

261. *Padre Albera*

539. *"Redemption"*

1909

January 31–March 4, Philadelphia, Pennsylvania Academy of the Fine Arts, "One Hundred and Fourth Annual Exhibition"

417. *Miss Townsend*

February 2–27, Boston Art Club

13A. *Portrait of Mr. B.*

February 15–27, New York, M. Knoedler and Co., "Water Color Drawings by John Singer Sargent and Edward Darley Boit"

86 works by Sargent

March 13–April 17, New York, National Academy of Design, "Eighty-fourth Annual Exhibition"

227. *Portrait: Miss Vanderbilt: Countess Laszlo Szcshenyi* ([lent by] Mrs. Vanderbilt)

April 22–October 31, Venice, "Ottava esposizione internationale d'arte della città di Venezia

35. *Ritratto della Sig. Helen Brice*

May 3–August 2, London, Royal Academy, "One Hundred and Forty-first Exhibition"

24. *Mrs. William Waldorf Astor*

179. *The Earl of Wemyss—Presentation Portrait*

446. *Israel and the Law* (decorative design)

496. *Cashmere*

May 10–August 30, Buffalo Fine Arts Academy, Albright Art Gallery, "Fourth Annual Exhibition of Selected Paintings by American Artists"

144. *Portrait of James Whitcomb Riley* (lent by the Art Association of Indianapolis)

June, Rhode Island School of Design, "Paintings by John Singer Sargent loaned by Mr. Daniel F. Case and Reverend Endicott Peabody"

London, New English Art Club, "Summer Exhibition"

50. *The Black Brook*

54. *The Solitary* [*The Hermit (Il Solitario)*]

62. *In the South*

63. *Far Niente*

66. *Under the Olives*

Worcester Art Museum, "Summer Exhibition"

17. *Portrait* (lent by Hon. Edward L. Davis)

Opened September 12, St. Louis, Missouri, City Art Museum, "Fourth Annual Exhibition of Selected Paintings by American Artists at the Forest Park Art Building"
 144. Portrait of James Whitcomb Riley (lent by the Art Association of Indianapolis)
September 20–January 8, 1910, Liverpool, Walker Art Gallery, "Thirty-ninth Autumn Exhibition of Modern Art"
 90. The Earl of Wemyss (Presentation Portrait)
 1058. Under the Olives (lent by Harold Harmsworth, Esq.)
 1062. Cashmere (lent by R. H. Benson, Esq.)
 1063. The Solitary [The Hermit (Il Solitario)]
 1067. In the South
 1071. The Fountain
December 11–January 9, 1910, New York, National Academy of Design, "Winter Exhibition"
 109. La Gitana ([lent by] George A. Hearn)
 214. Portrait of Miss Carter ([lent by] John Ridgeley Carter)
London, New English Art Club, "Winter Exhibition"
 55. Mrs. Wedgwood
Edinburgh, Royal Scottish Academy
 219. H.R.H. the Duchess of Connaught and Strathearn
 253. Field-Marshal H.R.H. the Duke of Connaught and Strathearn

1910

January 23–March 20, Philadelphia, Pennsylvania Academy of the Fine Arts, "One Hundred and Fifth Annual Exhibition"
 421. Dr. J. William White
 423. Joseph Pulitzer
March 12–April 17, New York, National Academy of Design, "Eighty-fifth Annual Exhibition"
 303. Venetian Water Carrier ([lent by] Frederick Crane)
April 23–October 31, Venice, "Nono esposizione internazionale d'arte della città di Venezia"
 19. Il Solitario [The Hermit]
 20. La Morena
May 2–August 6, London, Royal Academy, "One Hundred and Forty-second Exhibition"
 107. Glacier Streams
 136. Albanian Olive-Gatherers
 529. Vespers
 619. A Garden at Corfu
May 2–June 30, Pittsburgh, Carnegie Institute, "Fourteenth Annual International Exhibition of Paintings"
 245. Portrait of Miss Brice
 246. Portrait of Charles J. Paine
May 11–September 1, Buffalo Fine Arts Academy, Albright Art Gallery, "Fifth Annual Exhibition of Selected Paintings by American Artists"
 189. Venetian Water Carrier
Closed June 18, London, Royal Water-Colour Society, "Summer Exhibition: One Hundred and Fifty-fourth"
 7. Under the Rialto
 99. Base of a Venetian Palace
London, New English Art Club, "Summer Exhibition"
 135. Flannels
 137. On the Giudecca
 163. The Church of Santa Maria della Salute (purchased for the Johannesburg Gallery)
 169. A Florentine Nocturne
 216. A Moraine
 285. Olive Grove

September 15–November 15, St. Louis, City Art Museum, "Fifth Annual Exhibition of Selected Paintings by American Artists"
 193. Venetian Water Carrier (lent by Frederick Crane, Esq., New York)
October 18–November 27, Art Institute of Chicago, "Twenty-third Annual Exhibition of American Paintings and Sculpture"
 209. Venetian Bead Stringers
Liverpool, Walker Art Gallery, "Autumn Exhibition of Modern Art"
 1034. Lady Ian Hamilton (lent by General Sir Ian Hamilton, K.C.B., D.S.O.)
December 13–January 22, 1911, Washington, D.C., Corcoran Gallery, "Third Biennial Exhibition"
 5. Portrait of a Girl (lent by Frederick S. Pratt)
 7. Garden of the Versailles
 24. Portrait (lent by A. Augustus Healy)
London, New English Art Club, "Winter Exhibition"
 186. The Green Parasol
 218. In the Mountains
 223. Cypresses and Vines
Edinburgh, Royal Scottish Academy
 243. The Earl of Wemyss: Presentation Portrait
Berlin, Königliche Akademie Der Künste zu Berlin, "Ausstellung Ameikanischer Kunst"
 Porträt des Herrn Graham Robertson (Im Bestiz des Herrn Grah. Robertson, London)
 Porträt des Herrn Robinson (Im Besitz des Herrn Edward Robinson, New York)

1911

April 27–June 30, Pittsburgh, Carnegie Institute, "Fifteenth Annual Exhibition"
 236. Garden of Versailles [In the Luxembourg Gardens]
Closed June 14, London, Royal Water-Colour Society Summer Exhibition, "One Hundred and Fifty-sixth"
 31. Sketching
 77. The Garden Wall
May 1–August 7, London, Royal Academy, "One Hundred and Forty-third Exhibition"
 94. A Waterfall
 206. The Archbishop of Canterbury
 482. Armageddon
 545. The Loggia
May 12–August 28, Buffalo Fine Arts Academy, Albright Art Gallery, "Sixth Annual Exhibition of Selected Paintings by American Artists"
 118. Portrait of a Lady
May 28–September 18, Worcester Art Museum, "Fourteenth Annual Exhibition of Oil Paintings by American Painters"
 48. Alpine Landscape
London, New English Art Club, "Summer Exhibition"
 29. Villa Marlia
 32. Daphne
 38. Biancheria
 146. Shoeing Oxen at Siena
 184. Nonchaloir
September 23–January 6, 1912, Liverpool, Walker Art Gallery, "Forty-first Autumn Exhibition of Modern Art"
 512. Sir Herbert Beerbohm Tree (lent by Miss Viola Tree)
 522. Miss Gertrude Kingston (lent by Miss Gertrude Kingston)
 533. Miss Viola Tree (lent by Miss Viola Tree)
 1081. Sir Henry W. Lucy (lent by Sir Henry W. Lucy)

November 14–December 27, Art Institute of Chicago, "Twenty-fourth Annual Exhibition of American Paintings and Sculpture"
 324. Study of Carmencita Dancing
November–December, London, New English Art Club, "Winter Exhibition"
 139. Summer
 170. Summer
 171. Mountain Lake
 172. A Summer Morning
 203. Summer Time
December 9–January 7, 1912, New York, National Academy of Design, "Winter Exhibition"
 291. Portrait of James Whitcomb Riley ([lent by] Art Institute of Indianapolis
Edinburgh, Royal Scottish Academy
 67. Portrait Group of Lady Elcho and Her Sisters [*The Wyndham Sisters*]
 205. The Mountains of Moloch
 376. Flannels
Rome, "Pictures and Sculpture in the Pavilion of the United States of America at the Roman Art Exposition" (Catalogue of the Collection)
 92. Portrait of General Leonard Wood, U.S.A. (lent by Mrs. Wood)
 93. Portrait of Mrs. Fiske Warren and Her Daughter (lent by Fiske Warren, Esq.)
 98. Portrait

1912

January 17–February 12, Toledo, [Ohio], Museum of Art, "The Inaugural Exhibition"
 83. Portrait of Edward Robinson, Esq. (lent by Edward Robinson, Esq., New York)
 84. Portrait of James Whitcomb Riley (lent by the Art Association of Indianapolis)
March 16–30, New York, M. Knoedler and Co., "Water Colors by John S. Sargent and Edward D. Boit"
 45 works by Sargent
April 25–June 30, Pittsburgh, Carnegie Institute, "Sixteenth Annual International Exhibition of Paintings"
 272. Venetian Water Carriers
May 6–August 5, London, Royal Academy, "One Hundred and Forty-fourth Exhibition"
 121. Bringing down the Marbles from the Quarries to Carrara
 186. Cypresses
 549. Breakfast in the Loggia
May–June, London, New English Art Club, "Spring Exhibition"
 154. Reconnoitring [*sic*]
 172. Falbalas
June 7–September 15, Worcester Art Museum, "Fifteenth Annual Exhibition of Oil Paintings"
 45. Mother and Daughter (lent by Mr. Fiske Warren)
Closed June 28, London, Royal Water-Colour Society, "Summer Exhibition"
 35. Genoa
 50. Roses
October 5–January 4, 1913, Liverpool, Walker Art Gallery, "Forty-second Autumn Exhibition of Modern Art"
 1083. Reconnoitring [*sic*]
November 5–December 8, Art Institute of Chicago, "Twenty-fifth Annual Exhibition of American Paintings and Sculpture"
 227. Venetian Water Carriers
 228. The Fountain

December 17–January 26, 1913, Washington, D.C., Corcoran Gallery, "Fourth Biennial Exhibition"
 29. Portrait of the Late Joseph Pulitzer
 30. Portrait of Mrs. Joseph Pulitzer
 31. Nonchaloir
 32. Picture of a Lady (lent by Francis H. Dewey)
 33. Mother and Daughter [*Mrs. Fiske Warren and Her Daughter Rachel*] (lent by Fiske Warren)
 34. Mrs. Arthur Hunnewell
Edinburgh, Royal Scottish Academy
 80. Cashmere

1913

April 20–June 30, Pittsburgh, Carnegie Institute, "Seventeenth Annual International Exhibition of Paintings"
 249. Mother and Daughter [*Mrs. Fiske Warren and Her Daughter Rachel*]
May 5–August 16, London, Royal Academy, "One Hundred and Forty-fifth Exhibition"
 37. Rose Marie
 135. Hospital at Granada
 229. Weavers
 271. Spanish Gipsies [*sic*]
May 10–August 31, Buffalo Fine Arts Academy, Albright Art Gallery, "Eighth Annual Exhibition of Selected Paintings by American Artists"
 102. Venetian Bead Stringers (lent by [James] Carroll Beckwith)
Closed June 7, London, Royal Water-Colour Society, "Summer Exhibition"
 23. Blind Beggars
 37. A Fountain
 163. The Generalife
October 4–January 3, 1914, Liverpool, Walker Art Gallery, "Forty-third Autumn Exhibition of Modern Art"
 974. Rose Marie
November 9–December 14, Philadelphia Water Color Club and the Pennsylvania Society of Miniature Painters, "Eleventh Annual Philadelphia Water Color Exhibition"
 882. Portrait
December 20–January 18, 1914, New York, National Academy of Design, "Winter Exhibition"
 203. A Waterfall ([lent by] Samuel T. Peters)

1914

January 8–March 29, Philadelphia, Pennsylvania Academy of the Fine Arts, "One Hundred and Ninth Annual Exhibition"
 412. A Waterfall
February 2–14, New York, M. Knoedler and Co., "Exhibition of the National Association of Portrait Painters Inc."
 26. Portrait of Mrs. John C. Tomlinson (lent by J. C. Tomlinson, Esq.)
March 14–April 12, Washington, D.C., United States National Museum, "National Association of Portrait Painters: Third Annual Circuit Exhibition"
 Portrait of Mrs. John C. Tomlinson (lent by J. C. Tomlinson, Esq.)
May 4–August 15, London, Royal Academy, "One Hundred and Forty-sixth Exhibition"
 29. Sketchers
 38. San Geremia
 220. Cypresses and Pines
 343. Henry James, Esq.
 357. Countess of Rocksavage

May 16–August 31, Buffalo Fine Arts Academy, Albright Art Gallery, "Ninth Annual Exhibition of Selected Paintings by American Artists"
 100. Portrait of A. Augustus Healy, Esq.

Closed June 6, London, Royal Water-Colour Society, "Summer Exhibition"
 5. In a Spanish Garden
 38. The Piazzetta

December 15–January 24, 1915, Washington, D.C., Corcoran Gallery, "Fifth Biennial Exhibition"
 43. Simplon Pass
 108. Portrait of Miss Ada Rehan
 156. Two Girls in White Dresses (lent by George Eastman)

Closed December 17, London, Royal Water-Colour Society, "Winter Exhibition"
 86. A Portrait

Edinburgh, Royal Scottish Academy
 224. Reconnoitering
 651. Lady Drogheda
 658. Mrs. Henschel

Worcester Art Museum, "Exhibition of Contemporary American Paintings Owned in Worcester County"
 36. Miss Ada Rehan

1915

Spring, San Francisco, "Panama-Pacific International Exposition"
 3622. Henry James
 3623. Nude Study
 3624. Hon. John Hay
 3625. Mrs. J. William White
 3626. Spanish Courtyard
 3627. Spanish Gypsy
 3628. Rose Marie
 3629. The Sketchers
 3630. Madame Gautrin [Madame X (Madame Pierre Gautreau)]
 3631. Reconnoitring [sic]
 3632. Sketch of Joseph Jefferson, Esq.
 3633. Spanish Stable
 3634. Syrian Goats

May 3–August 14, London, Royal Academy, "One Hundred and Forty-seventh Exhibition"
 28. Master and Pupils
 56. F. J. H. Jenkinson, Esq., M.A., Librarian to the University of Cambridge
 61. Mountain Graveyard
 198. Tyrolese Crucifix
 391. The Rt. Hon. Earl Curzon of Kedleston, G.C.S.I, G.C.I.E., President of the Geographical Society 1911–1914
 859. Tyrolese Interior

Closed June 5, London, Royal Water-Colour Society, "Summer Exhibition"
 17. Boats on the Lake of Garda
 92. In Tyrol

November 16–January 2, 1916, Art Institute of Chicago, "Twenty-eighth Annual Exhibition of American Paintings and Sculpture"
 291. Three Boats in Harbor at San Vigilio, Lago di Garda

Minneapolis Institute of Arts, "The Inaugural Exhibition"
 278. Venetian Water Carriers (lent by the Worcester Art Museum, Worcester, Mass.)

1916

February 6–March 26, Philadelphia, Pennsylvania Academy of the Fine Arts, "One Hundred and Eleventh Annual Exhibition"
 139. Moorish Courtyard

May 1–August 7, London, Royal Academy, "One Hundred and Forty-eighth Exhibition"
 380. Archers: Decorative Design
 383. Bacchanal: Decorative Design

May 10–November 1, Boston, Museum of Fine Arts, "Paintings by John Singer Sargent"

June 6–September 20, Cleveland Museum of Art, "Inaugural Exhibition"
 94. Three Boats in Harbor at San Vigilio, Lac da Garda (lent by M. Knoedler and Co.)

Closed June 17, London, Royal Water-Colour Society, "Summer Exhibition"
 6. Giudecca (lent by Mrs. Frederick Barnard)

Summer, London, Grafton Gallery, "Exhibition of Portrait Drawings" (no known catalogue)
 Nearly 50 works

September 30–December 30, Liverpool, Walker Art Gallery, "Forty-sixth Autumn Exhibition of Modern Art"
 475. The Late Sir Hugh Lane (lent by the Executors)
 478. The Blue Bowl
 496. Col. W. Windle Pilkington, V.D.

December 17–January 21, 1917, Washington, D.C., Corcoran Gallery, "Sixth Biennial Exhibition of Oil Paintings by Contemporary American Artists"
 206. Portrait of P. A. J. when a Child (lent by Augustus Jay)
 207. Reconnoitering
 208. Egyptian Girl
 209. Portrait of Mrs. K. [Mrs. Benjamin Kissam] (lent by Mrs. George Vanderbilt)
 210. Portrait of the Late John Hay
 211. Portrait of a Lady [Mrs. Elliott Shepard] (lent by Mrs. William Jay Schieffelin)
 212. Portrait of General Leonard Wood
 213. Portrait of a Lady (lent by J. P. Morgan)
 214. Portrait of the Late George Vanderbilt
 215. Spanish Stable
 216. Portrait of Mrs. Henry White
 217. Syrian Goats
 218. Portrait of Mrs. Valle Austen
 219. Joseph Jefferson
 220. Mountain Torrents
 221. Portrait of Miss C. (lent by Mrs. Richard Aldrich)
 222. Rose Marie
 223. Portrait of a Lady (lent by the Honorable Henry White)

Edinburgh, Royal Scottish Academy
 158. Mrs. Langham
 301. F. J. H. Jenkinson, Esq., M.A., Librarian to the University of Cambridge

1917

January 22–February 3, Boston, Copley Gallery, "Paintings and Drawings by John Singer Sargent for the Benefit of the American Ambulance Hospital in Paris"
 10 oils
 6 watercolors
 31 drawings

February 4–March 25, Philadelphia, Pennsylvania Academy of the
Fine Arts, "One Hundred and Twelfth Annual Exhibition"
 275. The Late George Vanderbilt
 287. Mrs. K. [*Mrs. Benjamin Kissam*] (collection of Mrs.
 George Vanderbilt)
 394. The Rialto
September 23–October 28, St. Louis, City Art Museum, "Twelfth
Annual Exhibition of Paintings by American Artists"
 171. The Rialto (lent by George W. Elkins, Esq.)
November 1–27, Pittsburgh, Carnegie Institute, "Winslow Homer
and John Singer Sargent, An Exhibition of Water Colours"
 25. The Bridge of Sighs
 26. Santa Maria della Salute
 27. From the Gondola
 28. Spanish Soldiers
 29. In Switzerland
 30. Zuleika
 31. Stamboul
 32. Arab Stable
 33. White Ship
 34. In the Hay-Loft (lent by the Brooklyn Museum)
 35. Camping on Lake O'Hara (lent by the Fogg Art Museum,
 Harvard University)
 36. Study of Lake O'Hara (lent by Mr. Edward W. Forbes)
 37. The Derelicts
 38. The Pool
 39. Palms
 40. The Patio, Vizcaya
 41. The Loggia, Vizcaya (lent by the Worcester Art Museum)
 42. The Mother (lent by The Bohemian Club, San Francisco)
November 8–January 2, 1918, Art Institute of Chicago, "Thirtieth
Annual Exhibition of American Paintings and Sculpture"
 170. The Rialto
November, London, Grosvenor Gallery
 Watercolors:
 99. A Study at Hill Hall (lent by Mrs. Charles Hunter)
 101. Base of a Venetian Palace (lent by Mrs. Charles Hunter)
 102. Grand Canal: Venice (lent by Mrs. Charles Hunter)
 103. Venice (lent by Mrs. Charles Hunter)
 104. Portrait (lent by Mrs. Charles Hunter)
 105. Landscape near Florence (not previously exhibited) (lent by
 Mrs. Charles Hunter)
 106. Portrait (lent by Mrs. Charles Hunter)
 143. Lady Brooke (lent by the executors of the late
 Sir Wm. Eden, Bart.)
 Oils:
 61. Statue of Perseus at Florence
 Charcoals:
 100. Dr. Ethel Smyth (lent by Mrs. Charles Hunter)
 107. Portrait (lent by Mrs. Charles Hunter)
December 2–31, Cleveland Museum of Art; see Carnegie Institute,
November 1–27, 1917
December 10–January 10, 1918, Washington, D.C., Corcoran
Gallery of Art, "Portrait of President Wilson Painted by Mr.
John Singer Sargent"
December 15–January 13, 1918, New York, National Academy of
Design, "Winter Exhibition"
 253. Portrait of John D. Rockefeller

1918

January 6–28, Toledo, [Ohio], Museum of Art; see Carnegie
Institute, November 1–27, 1917

February 2–28, Detroit Museum of Art; see Carnegie Institute,
November 1–27, 1917
February 3–March 24, Philadelphia, Pennsylvania Academy of the
Fine Arts, "One Hundred and Thirteenth Annual Exhibition"
 323. John D. Rockefeller
March 7–April 1, Minneapolis Institute of Arts; see Carnegie Insti-
tute, November 1–27, 1917
April 7–29, Milwaukee Art Institute; see Carnegie Institute,
November 1–27, 1917
May 5–28, St. Louis, City Art Museum; see Carnegie Institute,
November 1–27, 1917
May 11–September 9, Buffalo Fine Arts Academy, Albright Art
Gallery, "Twelfth Annual Exhibition of Selected Paintings by
American Artists"
 85. Portrait of John D. Rockefeller
May 25–July 31, Cincinnati Art Museum, "Twenty-fifth Annual
Exhibition of American Art"
 29. Two Girls Fishing
June 4–July 1, Rochester Memorial Art Gallery; see Carnegie
Institute, November 1–27, 1917
November 7–January 1, 1919, Chicago, Art Institute of Chicago,
"Thirty–first Annual Exhibition of American Paintings and
Sculpture"
 170. John D. Rockefeller
 171. John D. Rockefeller
November 10–December 15, Philadelphia Water Color Club and the
Pennsylvania Society of Miniature Painters, "Sixteenth
Annual Philadelphia Water Color Exhibition"
 196. Study of a Man (lithograph) (lent by Albert Eugene
 Gallatin, Esq.)
December 16–31, New York, M. Knoedler and Co., "President
Wilson's and Other Portraits by John Sargent, R.A., and
Important Works by Abbott H. Thayer"

1919

Closed January 11, 1919, London, Royal Water-Colour Society,
"Winter Exhibition"
 63. Sketchers
May 5–August 9, London, Royal Academy, "One Hundred and
Fifty-first Exhibition"
 15. San Vigilio
 46. Mrs. Percival Duxbury and Daughter
 103. Cathedral of Arras in August 1918
 120. Gassed (lent by the Imperial War Museum)
 135. The President of the United States [*Woodrow Wilson*]
May 24–September 8, Buffalo Fine Arts Academy, Albright Art
Gallery, "Thirteenth Annual Exhibition of Selected Paintings
by American Artists"
 96. Luxembourg Gardens at Twilight (lent by the Minneapolis
 Institute of Arts)
Closed June 28, London, Royal Water-Colour Society, "Summer
Exhibition"
 144. Dolomites
 176. Generalife
September 14–October 28, St. Louis, Missouri, City Art Museum,
"Fourteenth Annual Exhibition of Paintings by American Artists"
 134. Mrs. Moore (lent by Messrs. M. Knoedler and Co.,
 New York)
September 22–December 6, Liverpool, Walker Art Gallery, "Forty-
seventh Autumn Exhibition of Modern Art"
 855. The President of the United States (lent by the trustees of
 the National Gallery of Ireland—Sir Hugh Lane Bequest)

903. *Mrs. Percival Duxbury and Daughter* (lent by Percival
 Duxbury, Esq.)
983. *The Late C. Napier Hemy, R.A*

October–November, Paris, Musée national du Luxembourg,
 "Exposition d'artistes de l'école Américaine"
46. *La Carmencita*
47. *Portrait de Mme Catherine Moore*
48. *Portrait de M. de Fourcaud*

November 18–27, Dallas Art Association, "First Annual Exhibition
 Contemporary International Art"
81. *Nonchaloir* (lent by Mrs. Hugo Reisinger)

Closed December 20, London, Royal Water-Colour Society,
 "Winter Exhibition"
117. *A Larch Forest*

December 21–January 25, 1920, Washington, D.C., Corcoran
 Gallery, "Seventh Biennial Exhibition"
77. *Portrait of John D. Rockefeller, Esq.*

1920

January 10–February 15, Buffalo Fine Arts Academy, Albright Art
 Gallery, "Exhibition of Important Works by American
 Artists"
41. *Mrs. Kate Moore*

April 29–June 30, Pittsburgh, Carnegie Institute, "Nineteenth
 Annual International Exhibition of Paintings"
297. *Venetian Interior*

May 29–September 7, Buffalo Fine Arts Academy, Albright Art
 Gallery, "Fourteenth Annual Exhibition of Selected Paintings
 by American Artists"
123. *Lake O'Hara* (lent by the Fogg Art Museum)

September 25–December 11, Liverpool, Walker Art Gallery, "Forty-
 eighth Exhibition of Modern Art"
113. *On His Holidays* (lent by Mrs. Coutts Michie)

Closed December 18, London, Royal Water-Colour Society,
 "Winter Exhibition"
2. *Villa d'Este*
7. *Villa Borghese*
129. *Generalife*

1921

January 15–February 6, New York Water Color Club, "Thirty-
 first Annual Exhibition"
37. *Lake Louise*
40. *Sargent's Camp*

February 6–March 26, Philadelphia, Pennsylvania Academy of the
 Fine Arts, "One Hundred and Sixteenth Annual Exhibition"
83. *Mrs. Kate A. Moore*
285. *Carolus-Duran*

February–March, London, Grosvenor Galleries, "Re-Opening
 Exhibition"
17. *A Venetian Tavern* (lent by the artist)
19. *The Grand Canal and San Geremia, Venice* (lent by the artist)
26. *Mrs. Leopard Hirsch* (lent by Leopold Hirsch, Esq.)

March 5–22, Boston Art Club, Copley Society, "Paintings in
 Water Color by Winslow Homer, John S. Sargent, Dodge
 MacKnight"
48 works by Sargent

April 15–May 15, Art Institute of Chicago, "First Annual Interna-
 tional Watercolor Exhibition
126. *Lake O'Hara*
127. *Camping near Lake O'Hara*

April 28–June 30, Pittsburgh, Carnegie Institute, "Twentieth
 Annual International Exhibition of Paintings"
301. *The Lady in Red*
302. *Carolus-Duran*
303. *Portrait of Miss C.*
304. *Portrait of Mrs. George Swinton*

May 2–14, New York, National Association of Portrait Painters,
 "Ninth Annual Exhibition"
24. *Mrs. Moore*

May 2–August 6, London, Royal Academy, "One Hundred and
 Fifty-third Exhibition"
155. *Lieut.-Gen. Sir George H. Fowke, K.C.B., K.C.M.G.,
 Adjutant-General in France 1916–1919*

May 28–July 31, Cincinnati Museum, "Twenty-eighth Annual
 Exhibition of American Art"
1. *Portrait of Mrs. Moore*

September 24–December 10, Liverpool, Walker Art Gallery, "Forty-
 ninth Exhibition of Modern Art"
954. *The Late Mrs. Leopold Hirsch* (lent by Leopold Hirsch)

November 3–December 11, Art Institute of Chicago, "Thirty-fourth
 Annual Exhibition of American Paintings and Sculpture"
169. *The Rehearsal of the Pas de Loup Orchestra*

November 6–December 11, Philadelphia Water Color Club and the
 Pennsylvania Society of Miniature Painters, "Nineteenth
 Annual Philadelphia Water Color Exhibition"
539. *Bedowin [sic] Camp*
540. *In a Hay Loft*
541. *Pomegranates*
542. *Unloading Plaster*
543. *In a Leventine [sic] Port*
544. *Majorca*
545. *Port of Soller*
546. *La Rive*
547. *Baal Bee*
548. *Perseus: Night*
549. *Quelz [sic]: Portugal*
550. *Boboli*

November 8–December 18, Brooklyn Museum, "Group Exhibition
 of Water Color Paintings by American Artists"
268. *From the Gondola*
269. *Gourds*
270. *A Tramp*
271. *Portuguese Boats*
272. *Boats Drawn Up*
273. *Hills of Galilee*
274. *Santa Maria della Salute*
275. *A Mountain Stream*
276. *Galilee*
277. *A Falucho*
278. *Narni*
279. *Melon Boat*
280. *Black Tent*
281. *Boys Bathing*
282. *Bedouin Mother*
283. *Group of Boats*
284. *Arab Gypsies in a Tent*
285. *In Switzerland*
286. *Zuleika*
287. *Bivouac*

December 18–January 22, 1922, Washington, D.C., Corcoran
 Gallery, "Eighth Biennial Exhibition"
98. *Portrait of Charles H. Woodbury, Esq.*

London, Grosvenor Galleries, "Winter Exhibition of Paintings and Drawings by Contemporary British Artists"
9. *Lady Sassoon* (lent by Sir Philip Sassoon, Bt., C.M.G.)

1922

February 5–March 26, Philadelphia, Pennsylvania Academy of the Fine Arts, "One Hundred and Seventeenth Annual Exhibition"
253. *Helleu and Wife*
351. *Dolce Far Niente*
359. *Charles H. Woodbury*

April 15–May 21, Art Institute of Chicago, "Second Annual International Watercolor Exhibition"
130. *Lake Garda*
131. *Woodsheds, Tyrol*
132. *Olive Trees, Corfu*
133. *Workmen at Carrara*

April 27–June 15, Pittsburgh, Carnegie Institute, "Twenty-first Annual International Exhibition of Paintings"
27. *Portrait of Charles H. Woodbury*

May 1–May 13, New York, National Association of Portrait Painters, "Tenth Annual Exhibition"
25. *Mrs. Swinton*

May 1–August 7, London, Royal Academy, "One Hundred and Fifty-fourth Exhibition"
17. *The Countess of Rocksavage*
121. *Some General Officers of the Great War* (presented by Sir Abe Bailey, Bt., to the National Portrait Gallery)

London, Grosvenor Galleries, "Summer Exhibition of Paintings and Drawings by Contemporary British Artists"
8. *The Loggia* (lent by Sir James Murray)
10. *Fountain at Bologne* (lent by Sir Philip Sassoon, Bt., C.M.G.)

May 27–July 31, Cincinnati Museum, "Twenty-ninth Annual Exhibition of American Art"
38. *Portrait of Mrs. Swinton*
39. *Canal in Venice, watercolor* (lent by Knoedler)

Closed May 27, London, Royal Water-Colour Society, "Summer Exhibition"
5. *Persian Ladies*

September 15–October 15, St. Louis, City Art Museum, "Seventeenth Annual Exhibition of Paintings by American Artists"
94. *Portrait of Charles H. Woodbury* (lent by Mr. Woodbury)

September 23–December 9, Liverpool, Walker Art Gallery, "Jubilee Autumn Exhibition"
25. *The Countess Rocksavage* (lent by Sir Philip Sassoon, Bart.)
730. *The Hospital* (lent by Dr. Hugh Playfair, F.R.C.P., F.R.C.S.)
758. *A Study* (lent by Sir W. Goscombe John, R.A.)
1085. *Lady Islington*
1091. *Lady Islington*
1099. *The Hon. Joan Dickson-Poynder* (lent by Lady Islington)

November 2–December 10, Art Institute of Chicago, "Thirty-fifth Annual Exhibition of American Paintings and Sculpture"
201. *Charles H. Woodbury*
202. *Mrs. Swinton*

November 16–30, Dallas Art Association, "Third Annual Exhibition American Art From the Days of the Colonists to Now"
78. *Venetian Bead Stringers* (lent by the Albright Art Gallery)

November 20–December 2, Boston, St. Botolph Club, "Exhibition of Paintings and Drawings by John S. Sargent"
22 oils
19 charcoal sketches

Liverpool, Walker Art Gallery, "Autumn Exhibition"
750. *The Hospital* (lent by Dr. Hugh Playfair)

758. *A Study* (lent by Sir W. Goscombe John, R.A.)

London, Grosvenor Galleries, "Winter Exhibition of Paintings and Drawings by Contemporary British Artists"
58. *Troops Going Up to the Line* (lent by Sir Philip Sassoon, Bt., C.M.G.)

1923

February 4–March 25, Philadelphia, Pennsylvania Academy of the Fine Arts, "One Hundred and Eighteenth Annual Exhibition"
267. *Camps at Lake O'Hara*

February 19–March 3, Boston, Copley Gallery, "Drawings, Paintings, Water Colors by Frank Duveneck, John S. Sargent, Abbott Thayer"

February 22–April 1, Baltimore Museum of Art, "Inaugural Exhibition"
17. *At Frascati, Italy* (lent by the Brooklyn Museum)
18. *Boboli Gardens, Florence* (lent by the Brooklyn Museum)
19. *From the Gondola, Venice* (lent by the Brooklyn Museum)
20. *Spanish Soldiers* (lent by the Brooklyn Museum)
21. *The Giudeca [sic], Venice* (lent by the Brooklyn Museum)
22. *Unloading Plaster, Italy* (lent by the Brooklyn Museum)
233. *Portrait of Miss Mary Garrett* (lent by the Johns Hopkins University)

March 17–April 15, New York, National Academy of Design, "Ninety-eighth Annual Exhibition"
271. *Portrait of Charles H. Woodbury*

April 8–June 18, Buffalo Fine Arts Academy, Albright Art Gallery, "Seventeenth Annual Exhibition of Selected Paintings and Small Bronzes by American Artists"
156. *Portrait of Charles H. Woodbury*

April 26–June 17, Pittsburgh, Carnegie Institute, "Twenty-second Exhibition"
45. *Mary, Wife of Hugh Hammersley*
60. *Portrait of Mme Paul Escudier, Paris*

London, Grosvenor Galleries, "Summer Exhibition of Paintings and Drawings by Contemporary British Artists"
22. *Portrait of Mrs. Barnard* (lent by Mrs. Barnard)

May 6–June 3, Concord, Massachusetts, Concord Art Center, "Annual Exhibition of Paintings and Sculpture"
33. *Reconnoitering*

May 7–August 11, London, Royal Academy, "One Hundred and Fifty-fifth Exhibition"
147. *Sir Edward H. Busk, M.A., LL.B.* (presented to him on his retirement from the Chairmanship by Graduates of the University of London)

May 18–June 25, Paris, Association Franco-Américaine, "Exposition d'art Américain, John S. Sargent, R.A., Dodge MacKnight, Winslow Homer, Paul Manship"
75 works by Sargent

Liverpool, Walker Art Gallery, "Autumn Exhibition"
815. *Albanian Olive Gatherers* (lent by the Corporation of Manchester)
1095. *Miss. Izme Vickers* (lent by Miss Vickers)

November 4–December 23, Philadelphia Water Color Club and the Pennsylvania Society of Miniature Painters, "Twenty-first Annual Philadelphia Water Color Exhibition"
199. *On the Beach at Baja* (lent by Edmund G. Hamersly, Esq.)

December 16–January 20, 1924, Washington, D.C., Corcoran Gallery, "Ninth Biennial Exhibition of Oil Paintings by Contemporary American Artists"
216. *Girl in White Muslin Dress* (lent by Knoedler)
249. *Artist Sketching* (lent by Mr. R. T. Crane Jr.)

1924

February 23–March 22, New York, Grand Central Art Galleries, "Retrospective Exhibition of Important Works of John Singer Sargent"
60 oils
12 watercolors

March 20–April 22, Art Institute of Chicago, "Fourth Annual International Watercolor Exhibition"
 401. Palms
 402. Shady Paths, Vizcaya
 403. Boats at Anchor
 404. Derelicts
 405. The Pool
 406. Muddy Alligators
 407. The Basin, Vizcaya
 408. Loggia, Vizcaya
 409. The Bathers
 410. The Terrace, Vizcaya
 411. The Patio, Vizcaya
 412. The Mist
 413. Boboli
 414. Gourds
 415. Zuleika
 416. Galilee
 417. Bedouins
 418. Goat Herds
 419. Black Tent
 420. Bedouin Mother
 421. Hills of Galilee
 422. From the Gondola
 423. Boats Drawn Up
 424. In Switzerland
 425. A Falucho
 426. Spanish Soldiers
 427. In a Medici Villa
 428. Santa Maria Della Salute
 429. The Bridge of Sighs
 430. Mountain Fires
 431. The Tramp
 432. Al'Ave Maria
 433. The Piazzetta

April 14–June 1, Art Institute of Chicago, "Paintings by John Singer Sargent" [No catalogue. Information from Getscher and Marks 1986]
18 oils
22 watercolors

April 20–June 30, Buffalo Fine Arts Academy, Albright Art Gallery, "Eighteenth Annual Exhibition of Selected Paintings and Small Bronzes by American Artists"
 185. Portrait of a Boy (lent by Mrs. Augustus Saint-Gaudens)

April 24–June 15, Pittsburgh, Carnegie Institute, "Twenty-third Annual International Exhibition of Paintings"
 73. Portrait of Lady Agnew of Lochnaw

May 5–August 9, London, Royal Academy, "One Hundred and Fifty-sixth Exhibition"
 47. Sir Philip Sassoon, Bt., G.B.E., C.M.G., M.P.

Closed May 24, London, Royal Water-Colour Society, "Summer Exhibition"
 111. La Grañja, Madrid (lent by Mrs. Rathbone)
 116. Spanish Soldiers, Convalescence (lent by Mrs. Rathbone)

May 24–July 31, Cincinnati Museum, "Thirty-first Annual Exhibition of American Art"
 40. Portrait of Miss Anstruther Thomson

May–June, London, Grosvenor Galleries, "Modern British Painting"
 20. Portrait (lent by Mrs. Adolph Hirsch)

September 13–December 6, Liverpool, Walker Art Gallery, "Fifty-second Autumn Exhibition"
 317. Sir Philip Sassoon, Bt., G.B.E., C.M.G., M.P. (lent by Sir Philip Sassoon, Bt.)
 1283. Lady Lavery (lent by Lady Lavery)
 1285. Miss Grace Ellison (lent by Miss Grace Ellison)

October 30–December 14, Art Institute of Chicago, "Thirty-seventh Annual Exhibition of American Paintings and Sculpture"
 179. Artist Sketching

November 9–December 14, Philadelphia Water Color Club and the Pennsylvania Society of Miniature Painters, "Twenty-second Annual Philadelphia Water Color Exhibition"
 387. Rigging
 389. Aranjuez
 390. Mountain Fires
 391. Bedouin Women
 392. From the Gondola
 393. White Ships
 394. Bedouins
 395. Black Tent
 396. The Giudecca
 397. Zuleika
 398. Gourds
 399. Syrian Gypsies
 400. La Granja
 (all lent by the Brooklyn Museum)

1925

January 15–January 31, New York, National Association of Portrait Painters, "Twelfth Annual Exhibition"
 Mrs. Joseph E. Widener
 Hon. James C. Carter
 Hon. Joseph H. Choate

April 24–May 31, Boston, Museum of Fine Arts, Paintings, "Water Colors and Drawings by John Singer Sargent"

May 4–August 8, London, Royal Academy, "One Hundred and Fifty-seventh Exhibition"
 23. George A. Macmillan, Esq., Secretary of the Society of Dilletanti
 163. The Marchioness Curzon of Kedleston, G.B.E.

May 23–July 31, Cincinnati Museum, "Thirty-second Exhibition of American Art"
 49. Hon. Mrs. George Lambton
 23. George A. Macmillan
 163. The Marchioness Curzon

July, London, Claridge Gallery, "Loan Exhibition of Water Colours by the Late John S. Sargent, R.A. "
 1. Statue of Daphne in the Villa Collodi, near Lucca
 2. Siesta in a Swiss Wood
 3. Dolomites
 4. Unloading Boats
 5. A Side Canal—Venice
 6. A Square—Venice
 7. The Steps of the Salute
 8. On the Grand Canal—Venice
 9. A Side Canal—Venice

10. *I Gesuati—Venice*

11. *A Spanish Interior*

12. *The River Bank*

13. *Spanish Convalescent*

14. *In a Gondola*

15. *Palazzo Grimani*

16. *At the Hut*

17. *Portrait Sketch*

18. *The Camouflaged Gun*

19. *Gabriel Faure*

20. *Gabriel Faure*

July 21–23, London, Messrs. Christie, Manson and Woods, "Pictures and Water Colour Drawings By J. S. Sargent, R.A. and Works by Other Artists" [estate sale]

September 19–December 12, Liverpool, Walker Art Gallery, "Fifty-third Autumn Exhibition, Collective Exhibit of Works by the Late John S. Sargent, R.A."

Cat. nos. 121–67

October 15–December 6, Pittsburgh, Carnegie Institute, "Twenty-fourth Annual International Exhibition of Paintings"

275. *The Daughters of Mrs. Charles Hunter*

October 17–November 15, Washington, D.C., Corcoran Gallery, "Commemorative Exhibition by Members of the National Academy of Design 1825–1925" (Grand Central Art Galleries, December 1, 1925–January 3, 1926)

302. *A Vele Gonfie*

October 29–December 13, Art Institute of Chicago, "Thirty-eighth Annual Exhibition of American Paintings and Sculpture"

186. *Shoeing Cavalry Horses at the Front*

November 2–14, New York, M. Knoedler Gallery, "Water Colors and Oils by the Late John Singer Sargent, R.A."

November 3–December 27, Boston, Museum of Fine Arts, "Memorial Exhibition of the Works of the Late John Singer Sargent to be Opened on the Occasion of the Unveiling of Mr. Sargent's Mural Decorations over the Main Stair Case and the Library of the Museum"

143 oils

113 watercolors

November 19–December 20, Brooklyn Museum, "A Group Exhibition of Water Color Paintings, Pastels, Drawings, and Sculpture by European and American Artists"

473. *Portrait Drawings of R. F. Sargent and Frank Fowler*

474. *Saint Malo*

475. *Portrait*

Closed December 19, London, Royal Society of Painters in Water-Colours"

190. *The Rialto, Venice* (lent by Miss Emily Sargent)

191. *Jerusalem* (lent by Miss Emily Sargent)

192. *Simplon, Nicola* (lent by Miss Emily Sargent)

193. *Seville Shipping* (lent by Miss Emily Sargent)

194. *Boats on Lake Garda* (presented by the artist to the late president of the Society) (lent by Mr. Clement Parsons)

195. *Bed of a Glacier Torrent* (the artist's diploma work) (lent by the Society)

196. *Carrara* (lent by Miss Emily Sargent)

197. *Cypresses, Near Rome* (lent by Miss Emily Sargent)

198. *Val d'Aosta* (lent by Miss Emily Sargent)

1926

January 4–February 14, New York, The Metropolitan Museum of Art, "Memorial Exhibition of the Work of John Singer Sargent"

50 oils

62 watercolors

January 14–March 13, London, Royal Academy, "Exhibition of Works by the Late John S. Sargent, R.A. "

over 600 works

January 31–March 21, Philadelphia, Pennsylvania Academy of the Fine Arts, "One Hundred and Twenty-first Annual Exhibition"

213. *A Head*

217. *Portrait of a Young Lady*

March 31–May 8, York City Art Gallery, "Spring Exhibition: Loan Exhibition of Works by the Late John S. Sargent, R.A."

46 oils

29 watercolors

21 drawings

May 29–July 31, Cincinnati Museum, "Thirty-third Annual Exhibition of American Art"

26. *Miss Florence Addicks*

June–October, London, National Gallery, Millbank, "Opening Exhibition of the Sargent Gallery"

96 oils

89 watercolors and drawings

Selected Bibliography with Short Titles

ARCHIVAL MATERIAL

James Carroll Beckwith Papers. National Academy of Design, New York. Microfilmed by the Archives of American Art, Smithsonian Institution, Washington, D.C.

George Bemis Papers. Massachusetts Historical Society, Boston.

Emmet Family Papers. Archives of American Art, Smithsonian Institution, Washington, D.C.

Thomas A. Fox–John Singer Sargent Collection. Boston Athenaeum.

Isabella Stewart Gardner Papers. Isabella Stewart Gardner Museum, Boston. Microfilmed by the Archives of American Art, Smithsonian Institution, Washington, D.C.

Fitzwilliam Sargent Papers. Archives of American Art, Smithsonian Institution, Washington, D.C.

John Singer Sargent Letters to Mrs. Charles Hunter. Archives of American Art, Smithsonian Institution, Washington, D.C.

PUBLICATIONS

Adelson and Oustinoff 1992
Warren Adelson and Elizabeth Oustinoff. "Sargent's Spanish Dancer—A Discovery." *Magazine Antiques* 141 (March 1992), pp. 460–71.

Adelson et al. 1997
Warren Adelson, Donna Seldin Janis, Elaine Kilmurray, Richard Ormond, and Elizabeth Oustinoff. *Sargent Abroad: Figures and Landscapes.* New York: Abbeville Press, 1997.

Adler 1995
Kathleen Adler. "John Singer Sargent's Portraits of the Wertheimer Family." In *The Jew in the Text: Modernity and the Construction of Identity,* edited by Linda Nochlin and Tamar Garb, pp. 83–96. New York: Thames and Hudson, 1995.

"Art Museum Sifts Charge" 1926
"Art Museum Sifts Charge a 'Sargent' Is Boldini Painting." *New York Herald Tribune,* January 20, 1926, p. 9.

Auchincloss 1986
Louis Auchincloss. "A Sargent Portrait." *American Heritage* 37, no. 6 (October–November 1986), pp. 40–47.

Baldry 1900a
A. L. Baldry. "The Art of J. S. Sargent, R.A. Part I." *International Studio* 10 (March 1900), pp. 3–21.

Baldry 1900b
A. L. Baldry. "The Art of John S. Sargent, R.A. Part II." *International Studio* 10 (April 1900), pp. 107–19.

Barnes 1925
Archibald Barnes. "John Sargent." *Discovery* 6 (June 1925), pp. 209–10.

Barter et al. 1998
Judith A. Barter, Kimberly Rhodes, and Seth A. Taylor, with Andrew Walker. *American Arts at the Art Institute of Chicago: From Colonial Times to World War I.* Chicago: Art Institute of Chicago, 1998.

Baxter 1895
Sylvester Baxter. "John S. Sargent's Decorations for the Boston Public Library." *Harper's Weekly* 39 (June 1, 1895), pp. 506–7, 509.

Baxter 1903
Sylvester Baxter. "Sargent's 'Redemption' in the Boston Public Library." *Century Magazine* 66 (May 1903), pp. 129–34.

Bell 1957
Quentin Bell. "John Sargent and Roger Fry." *Burlington Magazine* 99 (November 1957), pp. 380–82.

Belleroche 1926
Albert Belleroche. "The Lithographs of Sargent." *Print Collector's Quarterly* 13 (February 1926), pp. 31–44.

Berry 1924
Rose V. S. Berry. "John Singer Sargent: Some of His American Work." *Art and Archaeology* 18 (September 1924), pp. 83–112.

Birnbaum 1941
Martin Birnbaum. *John Singer Sargent, January 12, 1856–April 15, 1925: A Conversation Piece.* New York: William E. Rudge's Sons, 1941.

Blashfield 1925
Edwin H. Blashfield. "John Singer Sargent—Recollections." *North American Review* 221 (June–August 1925), pp. 641–53.

Blaugrund 1989
Annette Blaugrund. "American Artists at the 1889 Exposition Universelle in Paris." *Magazine Antiques* 136 (November 1989), pp. 1158–69.

Boone 1996
M. Elizabeth Boone. "Vistas de España: American Views of Art and Life in Spain, 1860–1898." Ph.D. dissertation, City University of New York, 1996.

Boston 1921
Copley Society: Catalogue of Paintings in Water Color by Winslow Homer, John S. Sargent, Dodge MacKnight. Exhibition, Boston Art Club, March 5–22, 1921. Catalogue. Boston, 1921.

Boston 1925
A Catalogue of the Memorial Exhibition of the Works of the Late John Singer Sargent, to Be Opened on the Occasion of the Unveiling of Mr. Sargent's Mural Decorations over the Main Stair Case and the Library of the Museum. Exhibition, Museum of Fine Arts, Boston, November 3–December 27, 1925. Catalogue. Boston, 1925.

Boston 1993
Awash in Color: Homer, Sargent, and the Great American Watercolor. Exhibition, Museum of Fine Arts, Boston, April 28–August 15, 1993. Catalogue by Sue Welsh Reed and Carol Troyen. Boston, 1993.

Boston 1999
Sargent: The Late Landscapes. Exhibition, Isabella Stewart Gardner Museum, Boston, May 21–September 26, 1999. Catalogue by Hilliard T. Goldfarb, Erica E. Hirshler, and T. J. Jackson Lears. Boston, 1999.

Boston–Cleveland–Houston 1992–93
> *The Lure of Italy: American Artists and the Italian Experience, 1760–1914.* Exhibition, Museum of Fine Arts, Boston, September 16–December 13, 1992; Cleveland Museum of Art, February 3–April 11, 1993; Museum of Fine Arts, Houston, May 23–August 8. Catalogue by Theodore E. Stebbins Jr., with essays by William H. Gerdts, Erica E. Hirshler, Fred S. Licht, and William L. Vance. Boston, 1992.

Boston Public Library 1916
> Boston Public Library. *A New Handbook of the Boston Public Library and Its Mural Decorations.* Boston: Association Publications, 1916.

Brandt 1990–91
> Kathleen Weil-Garris Brandt. "Mrs. Gardner's Renaissance." *Fenway Court,* 1990–91, pp. 10–30.

Brinton 1906
> Christian Brinton. "Sargent and His Art." *Munsey's Magazine* 36 (December 1906), pp. 265–84.

Brock 1925
> H. I. Brock. "John Sargent, Man and Painter: Death of Modern 'Old Master' Releases Flood of Anecdote Regarding One of the Most Debated Figures in the Art World." *New York Times,* April 19, 1925, section 10, p. 5.

Burke 1976
> Doreen Bolger Burke. "*Astarte:* Sargent's Study for *The Pagan Gods* Mural in the Boston Public Library." *Fenway Court,* 1976, pp. 9–19.

Burke 1980
> Doreen Bolger Burke. *American Paintings in The Metropolitan Museum of Art.* Vol. 3, *A Catalogue of Works by Artists Born between 1846 and 1864.* New York: The Metropolitan Museum of Art, 1980.

Burns 1992
> Sarah Burns. "The 'Earnest, Untiring Worker' and the Magician of the Brush: Gender Politics in the Criticism of Cecilia Beaux and John Singer Sargent." *Oxford Art Journal* 15, no. 1 (1992), pp. 36–53.

Butler 1994
> Kathleen Lois Butler. "Tradition and Discovery: The Watercolors of John Singer Sargent." Ph.D. dissertation, University of California, Berkeley, 1994.

Caffin 1902
> Charles H. Caffin. *American Masters of Painting.* New York: Doubleday, Page and Company, 1902.

Caffin 1903
> Charles H. Caffin. "John S. Sargent: The Greatest Contemporary Portrait Painter." *World's Work* 7 (November 1903), pp. 4099–4116.

Caffin 1904
> Charles H. Caffin. "Some American Portrait Painters." *Critic* 44 (January 1904), pp. 31–47.

Caffin 1907
> Charles H. Caffin. *The Story of American Painting: The Evolution of Painting in America from Colonial Times to the Present.* New York: Frederick A. Stokes, 1907.

Caffin 1909
> Charles H. Caffin. "Drawings by John S. Sargent." *Metropolitan Magazine* 30 (July 1909), pp. 412–18.

Chapin 1932
> Adèle Le Bourgeois Chapin. *"Their Trackless Way": A Book of Memories.* Edited by Christina Chapin. New York: Henry Holt and Company, 1932.

Charteris 1927
> Evan Charteris. *John Sargent.* New York: Charles Scribner's Sons, 1927.

Chicago–New York 1954
> *Sargent, Whistler, and Mary Cassatt.* Exhibition, Art Institute of Chicago, January 14–February 25, 1954; The Metropolitan Museum of Art, New York, March 25–May 23. Catalogue by Frederick A. Sweet. Chicago, 1954. Later in 1954 a traveling exhibition was put together based on this show by the American Federation of Arts. It was titled "Sargent, Whistler and Cassatt," and included works not in the Art Institute exhibit. The AFA show had no separate catalogue.

Cleveland and other cities 1980–82
> *The Realist Tradition: French Painting and Drawing, 1830–1900.* Exhibition, Cleveland Museum of Art and other institutions, 1980–82. Catalogue by Gabriel P. Weisberg. Cleveland, 1980.

Coburn 1917a
> Frederick W. Coburn. "The Sargent Decorations in the Boston Public Library." *American Magazine of Art* 8 (February 1917), pp. 129–36.

Coburn 1917b
> Frederick W. Coburn. "Sargent's War Epic." *American Magazine of Art* 14 (January 1923), pp. 3–6.

Coburn 1923
> Frederick W. Coburn. "John Singer Sargent, Bostonian: Anecdotes of an American Portrait Painter Returned to His Ancestral New England." *New York Times Magazine,* October 28, 1923, pp. 8, 15.

Coffin 1896
> William A. Coffin. "Sargent and His Painting: With Special Reference to His Decorations in the Boston Public Library." *Century Magazine* 52 (June 1896), pp. 163–78.

Coke 1961
> Van Deren Coke. "Camera and Canvas." *Art in America* 49, no. 3 (1961), pp. 68–73.

Conrads 1990
> Margaret C. Conrads. *American Paintings and Sculpture at the Sterling and Francine Clark Art Institute.* New York: Hudson Hills Press, 1990.

Cortissoz 1903
> Royal Cortissoz. "John S. Sargent." *Scribner's Magazine* 34 (November 1903), pp. 515–32.

Cortissoz 1913
> Royal Cortissoz. *Art and Common Sense.* New York: Charles Scribner's Sons, 1913.

Cox 1905
> Kenyon Cox. *Old Masters and New: Essays in Art Criticism.* New York: Fox, Duffield and Company, 1905.

Cox 1912
> Kenyon Cox. "Two Ways of Painting." *Scribner's Magazine* 52 (October 1912), pp. 509–12.

Cox 1916
> Kenyon Cox. "The Sargent Water-Colors." *Bulletin of The Metropolitan Museum of Art* 11 (February 1916), pp. 36–38.

"Current Art" May 1887
> "Current Art.—I." *Magazine of Art* 10 (May 1887), pp. 271–77.

"Current Art" August 1887
> "Current Art.—IV." *Magazine of Art* 10 (August 1887), pp. 376–84.

"Current Art" May 1889
> "Current Art. The New Gallery." *Magazine of Art* 12 (May 1889), pp. 289–93.

Curry 1993
David Park Curry. "John Singer Sargent: *Portrait of Mrs. Albert Vickers*." *American Art Review* 5, no. 2 (winter 1993), pp. 109, 166–67.

Dini 1998
Jane Dini. "Public Bodies: Form and Identity in the Work of John Singer Sargent." Ph.D. dissertation, University of California, Santa Barbara, 1998.

Dodgson 1926
Campbell Dodgson. "Catalogue of the Lithographs of J. S. Sargent, R.A." *Print Collector's Quarterly* 13 (February 1926), pp. 44–45.

Doherty 1992
M. Stephen Doherty. "'Olimpio Fusco' by John Singer Sargent." *Drawing* 13 (March–April 1992), pp. 129–30.

Downes 1925
William Howe Downes. *John S. Sargent: His Life and His Work*. Boston: Little, Brown and Company, 1925.

Duff 1993
Odile Duff. "John Singer Sargent: American Artist Abroad." *French American Review* 64, no. 2 (winter 1993), pp. 38–50.

"Earl of Dalhousie" 1900
"The Earl of Dalhousie." *Critic* 37 (August 1900), pp. 104–5.

Easton 1971
Malcolm Easton. "Friends and Enemies: Writers and Artists in England." *Apollo* 93 (February 1971), pp. 84–89.

Ely 1923
Catherine Beach Ely. "Sargent as a Watercolorist." *Art in America* 11 (February 1923), pp. 97–102.

Ely 1925
Catherine Beach Ely. *The Modern Tendency in American Painting*. New York: Frederic Fairchild Sherman, 1925.

Erickson 1995
Kristen Erickson. "John Singer Sargent: Reassessing His Boston Murals." *American Art Review* 7, no. 2 (April–May 1995), pp. 124–27.

Fairbrother 1981a
Trevor J. Fairbrother. "A Private Album: John Singer Sargent's Drawings of Nude Male Models." *Arts Magazine* 56, no. 4 (December 1981), pp. 70–79.

Fairbrother 1981b
Trevor J. Fairbrother. "The Shock of John Singer Sargent's 'Madame Gautreau.'" *Arts Magazine* 55, no. 5 (January 1981), pp. 90–97.

Fairbrother 1982
Trevor J. Fairbrother. "Notes on John Singer Sargent in New York, 1888–1890." *Archives of American Art Journal* 22, no. 4 (1982), pp. 27–32.

Fairbrother 1983
Trevor J. Fairbrother. *Sargent Portrait Drawings: 42 Works by John Singer Sargent*. New York: Dover Publications, 1983.

Fairbrother (1981) 1986
Trevor J. Fairbrother. *John Singer Sargent and America*. New York: Garland Publishing, 1986. Originally the author's Ph.D. dissertation, Boston University, 1981.

Fairbrother 1986
Trevor J. Fairbrother. "Boston's Impressionists." *Art Today*, summer 1986, pp. 55–59.

Fairbrother 1987a
Trevor J. Fairbrother. "John Singer Sargent's 'Gift' and His Early Critics." *Arts Magazine* 61, no. 6 (February 1987), pp. 56–63.

Fairbrother 1987b
Trevor J. Fairbrother. "Warhol Meets Sargent at Whitney." *Arts Magazine* 61, no. 6 (February 1987), pp. 64–71.

Fairbrother 1990
Trevor J. Fairbrother. "Sargent's Genre Paintings and the Issues of Suppression and Privacy." In *American Art around 1900: Lectures in Memory of Daniel Fraad*, edited by Doreen Bolger and Nicolai Cikovsky Jr., pp. 29–49. Studies in the History of Art, 37. Center for Advanced Study in the Visual Arts, Symposium Papers, 21. Washington, D.C.: National Gallery of Art, 1990.

Fairbrother 1994
Trevor J. Fairbrother. *John Singer Sargent*. New York: Harry N. Abrams, 1994.

Feld 1966
Stuart P. Feld. "Two Hundred Years of Water Color Painting in America." *Magazine Antiques* 90 (December 1966), pp. 840–45.

Field 1926
Rachel Field. "John Sargent's Boyhood Sketches." *St. Nicholas* 53 (June 1926), pp. 774–77.

Flint 1926
Ralph Flint. "Sargent Memorial Exhibition in New York." *Christian Science Monitor*, January 6, 1926, p. 12.

"14 Paintings Sold" 1967
"14 Paintings Sold as Sargent's by His Biographer Called Fakes." *New York Times*, September 19, 1967, pp. 1, 52.

Freeman 1985
Julian Freeman. "Professor Tonks: War Artist." *Burlington Magazine* 127 (May 1985), pp. 285–93.

Fry 1926
Roger Fry. "J. S. Sargent as Seen at the Royal Academy Exhibition of His Works, 1926, and in the National Gallery." In his *Transformations: Critical and Speculative Essays on Art*, pp. 125–35. London: Chatto and Windus, 1926.

Gallati 1998
Barbara Dayer Gallati. "Controlling the Medium: The Marketing of John Singer Sargent's Watercolors." In *Masters of Color and Light: Homer, Sargent, and the American Watercolor Movement*, by Linda S. Ferber and Barbara Dayer Gallati, pp. 117–41. Washington, D.C.: Brooklyn Museum of Art in association with Smithsonian Institution Press, 1998.

Gallatin 1922
Albert Eugene Gallatin. *American Water-Colourists*. New York: E. P. Dutton and Company, 1922.

Gammell 1977a
R. H. Ives Gammell. "The Enigma of John Sargent's Art." *Classical America* 4 (1977), pp. 153–59.

Gammell 1977b
R. H. Ives Gammell. "A Masterpiece Dishonored." *Classical America* 4 (1977), pp. 47–53.

Getscher and Marks 1986
Robert H. Getscher and Paul G. Marks. *James McNeill Whistler and John Singer Sargent: Two Annotated Bibliographies*. New York: Garland Publishing, 1986.

Gibson 1987a
Eric Gibson. "American Round-Up." *Studio International* 200 (May 1987), pp. 32–37.

Gibson 1987b
Eric Gibson. "Homer and Sargent: Yankee Honesty vs. Cosmopolitan Flair." *New Criterion* 5, no. 6 (February 1987), pp. 58–65.

Gil Salinas 1993
Rafael Gil Salinas. "Sorolla, Sargent y la pintura americana." *Goya*, nos. 235–36 (July–October 1993), pp. 81–87.

Green 1979
Maureen Green. "A New and Admiring Look at Elegance of John Singer Sargent." *Smithsonian* 10, no. 7 (October 1979), pp. 100–109.

Greensburg (Penna.) 1984
Twenty-fifth Anniversary Exhibition: Selected American Paintings, 1750–1950. Exhibition, Westmoreland Museum of Art, Greensburg, Pennsylvania, May 20–July 22, 1984. Catalogue. Greensburg, Pennsylvania, 1984.

Gregg 1917
Frederick James Gregg. "John S. Sargent's Florida Watercolors." *Vanity Fair* 8, no. 6 (August 1917), pp. 40–41.

Gribbon 1978
Deborah Gribbon. "Mrs. Gardner's Modern Art." *Connoisseur* 198 (May 1978), pp. 10–19.

Hale 1927
Mary Newbold Patterson Hale. "The Sargent I Knew." *World Today* 50 (November 1927), pp. 565–70. Reprinted in Ratcliff 1982, pp. 235–38.

Halsby 1990
Julian Halsby. "'Fontaine de jouvence': John Singer Sargent and His Circle at the Palazzo Barbaro." In his *Venice: The Artist's Vision: A Guide to British and American Painters,* pp. 113–22. London: B. T. Batsford, 1990.

Hardie 1930
Martin Hardie. *J. S. Sargent, R.A., R.W.S.* Famous Water-Colour Painters, 7. London: The Studio; New York: William Edwin Rudge, 1930.

Harithas 1968
James Harithas. "The Sargent Drawings in the Corcoran Gallery." *Malahat Review,* no. 5 (January 1968), pp. 63–75.

Heaton 1926
Augustus G. Heaton. "John Singer Sargent." *Nutshell* 12, no. 46 (July–September 1926), pp. 1–2.

Hirshler 1995a
Erica E. Hirshler. "Dennis Miller Bunker and His Circle." *American Art Review* 7, no. 2 (April–May 1995), pp. 98–103.

Hirshler 1995b
Erica E. Hirshler. "Dennis Miller Bunker and His Circle of Friends." *Magazine Antiques* 147 (January 1995), pp. 184–93.

Honour and Fleming 1991
Hugh Honour and John Fleming. *The Venetian Hours of Henry James, Whistler and Sargent.* London: Walker Books, 1991.

Hoopes 1964
Donelson F. Hoopes. "John Singer Sargent and Decoration." *Magazine Antiques* 86 (November 1964), pp. 588–91.

Hoopes 1965–66
Donelson F. Hoopes. "John S. Sargent: The Worcestershire Interlude, 1885–89." *Brooklyn Museum Annual* 7 (1965–66), pp. 74–89.

Hoopes 1970
Donelson F. Hoopes. *Sargent Watercolors.* New York: Watson-Guptill Publications, 1970.

Howard-Johnston 1969
Paulette Howard-Johnston. "Une Visite à Giverny en 1924." *L'Oeil,* no. 171 (March 1969), pp. 28–33, 76.

James 1887
Henry James. "John S. Sargent." *Harper's New Monthly Magazine* 75 (October 1887), pp. 683–91.

James 1956
Henry James. "John S. Sargent." In *The Painter's Eye: Notes and Essays on the Pictorial Arts,* edited by John L. Sweeney, pp. 216–28. Cambridge, Massachusetts: Harvard University Press, 1956. [Reprint of James 1887.]

Jordy 1972
William H. Jordy. *American Buildings and Their Architects.* Vol. 3, *Progressive and Academic Ideals at the Turn of the Twentieth Century.* Garden City, New York: Doubleday and Company, 1972.

Judaism and Christianity
Judaism and Christianity: A Sequence of Mural Decoration Executed between 1895 and 1916. Pamphlet. Boston: Boston Public Library, n.d.

Karo 1976
Rebecca W. Karo. "Ah Wilderness! Sargent in the Rockies, 1916." *Fenway Court,* 1976, pp. 21–29.

Kenner 1986
Hugh Kenner. "A Study in Mauve: John Singer Sargent's Work of Art of a Work of Art." *Art and Antiques,* October 1986, p. 124.

Kent 1970
Norman Kent. "The Watercolors of John Singer Sargent (1856–1925): A Brief Estimate." *American Artist* 34, no. 10 (November 1970), pp. 66–72, 76.

Kilmurray and Ormond 1998
Elaine Kilmurray and Richard Ormond. "Sargent in Paris." *Apollo* 148 (September 1998), pp. 13–22.

Kingsbury 1969
Martha Kingsbury. "John Singer Sargent: Aspects of His Work." Ph.D. dissertation, Harvard University, Cambridge, Massachusetts, 1969.

Kingsbury 1976
Martha Kingsbury. "Sargent's Murals in the Boston Public Library." *Winterthur Portfolio* 11 (1976), pp. 153–72.

Kingsbury 1987
Martha Kingsbury. "Sargent." *Art Journal* 46 (winter 1987), pp. 316–19.

Kramer 1981
Hilton Kramer. "The Case of Madame's Shoulder Strap." *New York Times,* February 1, 1981, pp. D23, D27.

Lane 1941
James W. Lane. "Sargent; Brabazon." *Art News* 40, no. 3 (March 15–31, 1941), p. 46.

Lansdale 1964
Nelson Lansdale. "John Singer Sargent: His Private World." *American Artist* 28, no. 9 (November 1964), pp. 58–63, 79–83.

Layard 1907
Arthur Layard. "John Singer Sargent." *Die Kunst für Alle* 23, no. 2 (October 15, 1907), pp. 25–33. Also published in *Die Kunst* 17 (October 15, 1907), pp. 25–33.

Lee 1927
Vernon Lee. "J. S. S.: In Memoriam." In Charteris 1927, pp. 235–55.

Leeds–London–Detroit 1979
John Singer Sargent and the Edwardian Age. Exhibition, Leeds Art Galleries at Lotherton Hall, Leeds, April 5–June 10, 1979; National Portrait Gallery, London, July 6–September 9; Detroit Institute of Arts, October 17–December 9. Catalogue by James Lomax and Richard Ormond. Leeds and Detroit, 1979.

Little 1998
Carl Little. *The Watercolors of John Singer Sargent.* Berkeley and Los Angeles: University of California Press, 1998.

London 1903
 Catalogue of a Loan Exhibition of Sketches and Studies by J. S. Sargent, R.A. Exhibition, Carfax and Company, London, May–June 1903. Catalogue. London, 1903.

London 1905
 Catalogue of a Loan Exhibition of Water Colours by . . . John S. Sargent, R.A. Exhibition, Carfax and Company, London, April 1905. Catalogue. London, 1905.

London 1926a
 Exhibition of Works by the Late John S. Sargent, R.A.: Winter Exhibition. Exhibition, Royal Academy of Arts, London, January 14–March 13, 1926. Catalogue. London: William Clowes and Sons, 1926.

London 1926b
 Illustrations of the Sargent Exhibition, Royal Academy, 1926. Exhibition, Royal Academy of Arts, London, January 14–March 13, 1926. Catalogue. London: Walter Judd, 1926.

London–Washington, D.C.–Boston 1998–99
 John Singer Sargent. Exhibition, Tate Gallery, London, October 15, 1998–January 17, 1999; National Gallery of Art, Washington, D.C., February 21–May 31; Museum of Fine Arts, Boston, June 23–September 26. Catalogue edited by Elaine Kilmurray and Richard Ormond. London, 1998.

Loring 1984
 William C. Loring Jr. "An American Art Student in London." *Archives of American Art Journal* 24, no. 3 (1984), pp. 17–21.

Los Angeles–San Francisco–Seattle 1968
 Eight American Masters of Watercolor: Winslow Homer, John Singer Sargent, Maurice B. Prendergast, John Marin, Arthur G. Dove, Charles Demuth, Charles E. Burchfield, Andrew Wyeth. Exhibition, Los Angeles County Museum of Art, April 23–June 16, 1968; M. H. de Young Memorial Museum, San Francisco, June 28–August 18; Seattle Art Museum, September 5–October 13. Catalogue by Larry Curry. Los Angeles, 1968.

Lovell 1989
 Margaretta M. Lovell. *A Visitable Past: Views of Venice by American Artists, 1860–1915.* Chicago: University of Chicago Press, 1989.

Low (1910) 1977
 Will H. Low. *A Painter's Progress; Being a Partial Survey Along the Pathway of Art in America and Europe . . .* New York: Charles Scribner's Sons, 1910; reprint, New York: Garland Publishing, 1977.

Lubin 1985
 David M. Lubin. *Act of Portrayal: Eakins, Sargent, James.* New Haven: Yale University Press, 1985.

MacColl 1926
 D. S. MacColl. "Sargent." *Saturday Review* 141 (January 23, 1926), pp. 83–85.

Manson 1925
 J. B. Manson. "Notes on the Works of J. S. Sargent." *Studio* (London) 90 (August 1925), pp. 79–87.

Mather 1931
 Frank Jewett Mather Jr. "The Enigma of Sargent." In his *Estimates in Art, Series II: Sixteen Essays on American Painters of the Nineteenth Century,* pp. 235–67. New York: Henry Holt and Company, 1931.

Maynard 1989
 Margaret Maynard. "'A Dream of Fair Women': Revival Dress and the Formation of Late Victorian Images of Femininity." *Art History* 12 (September 1989), pp. 322–41.

McCabe 1923
 Lida Rose McCabe. "Carmencita and Her Painters: The Dead Spanish Dancer Who Still Lives in Her Portraits by Sargent and Chase." *New York Times Book Review and Magazine,* July 8, 1923, pp. 4, 23.

McCoy 1972
 Garnett McCoy. "Photographs and Photography in the Archives of American Art." *Archives of American Art Journal* 12, no. 3 (1972), pp. 1–18.

McKibbin 1956
 David McKibbin. *Sargent's Boston.* Boston: Museum of Fine Arts, 1956.

McKibbin 1970
 David McKibbin. "Sargent's Water-Colours of Venice at Fenway Court." *Fenway Court,* 1970, pp. 19–25.

McSpadden 1916
 J. Walker McSpadden. *Famous Painters of America.* New York: Dodd, Mead and Company, 1916.

Mechlin 1925
 Leila Mechlin. "John Singer Sargent." *American Magaine of Art* 16 (June 1925), pp. 285–87.

Meynell 1927
 Alice Christiana Thompson Meynell. *The Work of John S. Sargent, R.A.* London: William Heinemann; New York: Charles Scribner's Sons, 1927.

Miller 1979
 Donald Miller. "Inspired Friendship: Sargent and Saint-Gaudens." *Carnegie Magazine* 53, no. 4 (April 1979), pp. 4–11.

Miller 1986
 Lucia Miller. "John Singer Sargent in the Diaries of Lucia Fairchild, 1890 and 1891." *Archives of American Art Journal* 26, no. 4 (1986), pp. 2–16.

Mills 1903
 Evan Mills. "A Personal Sketch of Mr. Sargent." *World's Work* 7 (November 1903), pp. 4116–18.

Morris 1976
 Edward Morris. "Edwin Austin Abbey and His American Circle in England." *Apollo* 104 (September 1976), pp. 220–21.

Mount 1955a
 Charles Merrill Mount. *John Singer Sargent: A Biography.* New York: W. W. Norton and Company, 1955.

Mount 1955b
 Charles Merrill Mount. "John Singer Sargent and Judith Gautier." *Art Quarterly* 18 (summer 1955), pp. 136–45.

Mount 1957
 Charles Merrill Mount. "New Discoveries Illumine Sargent's Paris Career." *Art Quarterly* 20 (autumn 1957), pp. 304–16.

Mount 1963
 Charles Merrill Mount. "Carolus-Duran and the Development of Sargent." *Art Quarterly* 26 (1963), pp. 385–418.

Mount 1964
 Charles Merrill Mount. "The English Sketches of J. S. Sargent." *Country Life,* April 16, 1964, pp. 931–34.

Mount 1966
 Charles Merrill Mount. "Some Works by Sargent at Dartmouth, with Notes on the Dispersal of His Artistic Estate." *Dartmouth College, Hopkins Center Art Galleries Bulletin* 1 (January 1966), unpaged.

Mount 1978
 Charles Merrill Mount. "A Phoenix at Richmond." *Arts in Virginia* 18, no. 3 (spring 1978), pp. 2–19.

Murphy 1985
Lady Sophia Murphy. "Growing Up in a Treasure House." *Art and Antiques,* November 1985, pp. 77–81.

Museum of Fine Arts, Boston 1922
Museum of Fine Arts, Boston. *Decorations of the Dome of the Rotunda by John Singer Sargent: The Decorations in Detail.* Boston, 1922.

Museum of Fine Arts, Boston 1925
Museum of Fine Arts, Boston. *Decorations over the Main Stairway and Library: John Singer Sargent: History and Description, with Plan.* Boston, 1925.

"Music Title" 1899
"Music Title: Design by Mr. J. S. Sargent." *Critic* 34 (February 1899), p. 111.

Navascués Benlloch 1985
Pilar de Navascués Benlloch. "Sorolla y Sargent: Una relación inédita." *Goya,* no. 189 (November–December 1985), pp. 142–51.

New York 1924
Retrospective Exhibition of Important Works of John Singer Sargent. Exhibition, Grand Central Art Galleries, New York, February 23–March 22, 1924. Catalogue. New York, 1924.

New York 1925
An Exhibition of Paintings by the Late John Singer Sargent, R.A. Exhibition, M. Knoedler and Co., New York, November 2–14, 1925. Catalogue. New York, 1925.

New York 1926
Memorial Exhibition of the Work of John Singer Sargent. Exhibition, The Metropolitan Museum of Art, New York, January 4–February 14, 1926. Catalogue by Mariana Griswold Van Rensselaer. New York, 1926.

New York 1928
Exhibition of Drawings by John Singer Sargent. Exhibition, Grand Central Art Galleries, New York, February 14–March 3, 1928. Catalogue. New York, 1928. The catalogue does not contain a list of the more than five hundred drawings in the exhibition. An inventory in the Thomas A. Fox–John Singer Sargent Collection, Boston Athenaeum ("Drawings from London loaned Mr. Clark. Inventory mark J. S.") indicates works that may have been included in the exhibition.

New York 1966–67
Two Hundred Years of Watercolor Painting in America: An Exhibition Commemorating the Centennial of the American Watercolor Society. Exhibition, The Metropolitan Museum of Art, New York, December 8, 1966–January 29, 1967. Catalogue. New York, 1967.

New York 1980a
John Singer Sargent: His Own Work. Exhibition, Coe Kerr Gallery, New York, May 28–June 27, 1980. Catalogue by Warren Adelson. New York: Coe Kerr Gallery and Wittenborn Art Books, 1980.

New York 1980b
Walter Gay: A Retrospective. Exhibition, Grey Art Gallery and Study Center, New York University, September 16–November 1, 1980. Catalogue by Gary A. Reynolds. New York, 1980.

New York 1986
Sargent at Broadway: The Impressionist Years. Exhibition, Coe Kerr Gallery, New York, May 2–June 14, 1986. Catalogue by Stanley Olson, with Warren Adelson and Richard Ormond. New York, 1986.

New York 1993
Spain, Espagne, Spanien: Foreign Artists Discover Spain,
1800–1900. Exhibition, Equitable Gallery, New York, July 2–September 18, 1993. Catalogue by Alisa Luxenberg, Xanthe Brooke, Rosemary Hoffmann, and Carol M. Osborne. New York: Equitable Gallery in assocation with the Spanish Institute, 1993.

New York and other cities 1991
American Watercolors from The Metropolitan Museum of Art. Exhibition circulated in two sections by the American Federation of Arts; both sections exhibited at The Metropolitan Museum of Art, New York, October 15–December 10, 1991. Catalogue commentaries by Stephen D. Rubin. New York: American Federation of Arts in association with Harry N. Abrams, 1991.

New York–Boston 1983
Americans in Venice, 1879–1913. Exhibition, Coe Kerr Gallery, New York, October 19–November 16, 1983; Boston Athenaeum, November 23–December 18. Catalogue. New York, 1983.

New York–Buffalo–Albany 1971–72
John Singer Sargent: A Selection of Drawings and Watercolors from The Metropolitan Museum of Art. Exhibition, The Metropolitan Museum of Art, New York, December 1, 1971–February 15, 1972; Albright-Knox Art Gallery, Buffalo, March 7–April 2; Albany Institute of History and Art, April 11–May 14. Catalogue by Natalie Spassky. New York, 1971.

New York–Chicago 1986–87
John Singer Sargent. Exhibition, Whitney Museum of American Art, New York, October 7, 1986–January 4, 1987; Art Institute of Chicago, February 7–April 19. Catalogue by Patricia Hills, with essays by Linda Ayres et al.; chronology by Stanley Olson. New York: Whitney Museum of American Art in association with Harry N. Abrams, 1986.

New York–Glens Falls 1991–93
John Singer Sargent's Alpine Sketchbooks: A Young Artist's Perspective. Exhibition, The Metropolitan Museum of Art, New York, December 24, 1991–March 22, 1992; Hyde Collection, Glens Falls, New York, January 9–March 7, 1993. Catalogue by Stephen D. Rubin. New York, 1991.

New York–New Orleans–Richmond–Seattle 1999–2001
John Singer Sargent: Portraits of the Wertheimer Family. Exhibition, Jewish Museum, New York, October 17, 1999–February 6, 2000; New Orleans Museum of Art, March 4–May 21; Virginia Museum of Fine Arts, Richmond, July 11–October 29; Seattle Art Museum, December 14, 2000–March 18, 2001. Catalogue edited by Norman L. Kleeblatt. New York, 1999.

New York–San Francisco 1974/1977
Grand Reserves: An Exhibition of 235 Objects from the Reserves of Fifteen New York Museums and Public Collections. Exhibition, New York Cultural Center in association with Fairleigh Dickinson University, October 24–December 8, 1974; M. H. de Young Memorial Museum, San Francisco, June–September 1977. Catalogue. New York: Sotheby Parke Bernet, 1974.

New York–St. Louis–Seattle–Oakland 1977–78
Turn-of-the-Century America: Paintings, Graphics, Photographs, 1890–1910. Exhibition, Whitney Museum of American Art, New York, June 30–October 2, 1977; St. Louis Art Museum, December 1, 1977–January 12, 1978; Seattle Art Museum, February 2–March 12; Oakland Museum, Oakland, California, April 4–May 28. Catalogue by Patricia Hills. New York, 1977.

"No More Mugs!" 1990
"'No More Mugs!'" *Art News* 89, no. 9 (November 1990), p. 25.

Nygren 1983
 John Singer Sargent Drawings from the Corcoran Gallery of Art.
 Exhibition, Corcoran Gallery of Art, Washington, D.C.; cir-
 culated by the Smithsonian Institution Traveling Exhibition
 Service. Catalogue by Edward J. Nygren. Washington, D.C.,
 1983.

Oliver 1921
 Jean N. Oliver. "John Sargent's Decorations in the Rotunda
 of the Museum of Fine Arts, Boston." *American Magazine of
 Art* 12 (December 1921), pp. 401–7.

Olson 1986
 Stanley Olson. *John Singer Sargent: His Portrait.* New York:
 St. Martin's Press, 1986.

Ormond 1970a
 Richard Ormond. *John Singer Sargent: Paintings, Drawings,
 Watercolors.* New York: Harper and Row, 1970.

Ormond 1970b
 Richard Ormond. "John Singer Sargent and Vernon Lee."
 Colby Library Quarterly 9, no. 3 (September 1970), pp. 154–78.

Ormond 1970c
 Richard Ormond. "Sargent's 'El Jaleo.'" *Fenway Court,* 1970,
 pp. 2–18.

Ormond 1974
 Richard Ormond. "The Letters of Dr. FitzWilliam Sargent:
 The Youth of John Singer Sargent." *Archives of American Art
 Journal* 14, no. 1 (1974), pp. 16–18.

Ormond and Kilmurray 1998
 Richard Ormond and Elaine Kilmurray. *John Singer Sargent:
 Complete Paintings.* Vol. 1, *The Early Portraits.* New Haven:
 Yale University Press for the Paul Mellon Centre for Studies
 in British Art, 1998.

"Painter of Appearances" 1956
 "Painter of Appearances." *Time,* January 9, 1956, pp. 68–69.

Paris 1923
 *Exposition d'art américain: Oeuvres de John S. Sargent, R.A.,
 Dodge MacKnight, Winslow Homer, Paul Manship.* Exhibition
 organized by the Association franco-américaine d'expositions
 de peinture et de sculpture, Paris, May 18–June 25, 1923.
 Catalogue. Paris, 1923.

Patterson 1926
 A. D. Patterson. "Sargent: A Memory." *Canadian Magazine,*
 March 1926, pp. 30–31, 41.

Porter 1956
 Fairfield Porter. "Sargent: An American Problem." *Art News*
 54, no. 9 (January 1956), pp. 28–31, 64.

Pousette-Dart 1924
 Nathaniel Pousette-Dart. *John Singer Sargent.* New York:
 Frederick A. Stokes, 1924.

Promey 1993
 Sally M. Promey. "'Triumphant Religion' in Public Places:
 John Singer Sargent and the Boston Public Library Murals."
 In *New Dimensions in American Religious History: Essays in
 Honor of Martin E. Marty,* edited by Jay P. Dolan and James P.
 Wind, pp. 3–27. Grand Rapids, Michigan: W. B. Eerdmans
 Publishing Company, 1993.

Promey 1997
 Sally M. Promey. "Sargent's Truncated *Triumph:* Art and
 Religion at the Boston Public Library, 1890–1925." *Art
 Bulletin* 79 (June 1997), pp. 217–50.

Promey 1998
 Sally M. Promey. "The Afterlives of Sargent's Prophets." *Art
 Journal* 57, no. 1 (spring 1998), pp. 31–44.

Promey 1999
 Sally M. Promey. *Painting Religion in Public: John Singer Sargent's
 "Triumph of Religion" at the Boston Public Library.* Princeton:
 Princeton University Press, 1999.

"The Prophets" 1913
 "'The Prophets,' by Sargent, Added Greatly to His Fame:
 The Mural Paintings in the Boston Public Library . . . Are
 Part of a Comprehensive Religious Theme." *New York Times,*
 December 7, 1913, picture section, part 1, text, section 10, p. 4.

Punch 1923
 "The Young Master. Chorus of Old Ones (to Mr. J. S.
 Sargent, R.A., at the National Gallery). 'Well Done. You're
 the First Master to Break the Rule and Get in Here Alive'"
 [cartoon]. *Punch, or the London Charivari* 164 (January 17,
 1923), p. 51.

"Question of Roots" 1985
 "A Question of Roots" [Nineteenth-Century American
 Painters]. *Apollo* 121 (May 1985), pp. 290–93.

Ratcliff 1982
 Carter Ratcliff. *John Singer Sargent.* New York: Abbeville
 Press, 1982.

Reynolds 1986
 Gary A. Reynolds. "Sargent and the Grand Manner Portrait."
 Magazine Antiques 130 (November 1986), pp. 980–93.

Reynolds 1987
 Gary A. Reynolds. "John Singer Sargent's Portraits: Building
 a Cosmopolitan Career." *Arts Magazine* 62, no. 2 (November
 1987), pp. 42–46.

Richardson 1954
 Edgar P. Richardson. "Sophisticates and Innocents Abroad."
 Art News 53, no. 2 (April 1954), pp. 20–23, 61–62.

Ridge and Townsend 1998
 Jacqueline Ridge and Joyce Townsend. "John Singer
 Sargent's Later Portraits: The Artist's Technique and Materi-
 als." *Apollo* 148 (September 1998), pp. 23–30.

Robertson 1982
 Meg Robertson. "John Singer Sargent: His Early Success in
 America, 1878–1879." *Archives of American Art Journal* 22,
 no. 4 (1982), pp. 20–26.

Rothenstein 1931
 William Rothenstein. "When to Be Young Was Heaven."
 Atlantic Monthly 147 (March 1931), pp. 319–31.

Rowe 1937
 L. E. Rowe. "Boudin, Vinton and Sargent." *Bulletin of the
 Rhode Island School of Design* 25 (January 1937), pp. 2–5.

Saint-Gaudens 1905
 Homer Saint-Gaudens. "John Singer Sargent." *Critic* 47
 (October 1905), pp. 326–27.

San Francisco–Cleveland 1984–85
 Venice: The American View, 1860–1920. Exhibition, Fine Arts
 Museums of San Francisco, October 20, 1984–January 20,
 1985; Cleveland Museum of Art, February 17–April 21. Cata-
 logue by Margaretta M. Lovell. San Francisco, 1984.

Sargent 1916
 John Singer Sargent. "Ignacio Zuloaga." *International Studio* 60
 (December 1916), pp. xxxvii–xxxviii.

"Sargent an 'Old Master'" 1922
 "Sargent an 'Old Master.'" *Literary Digest* 73, no. 11 (June 10,
 1922), pp. 30–31.

"Sargent Masterpiece Rejected" 1916
 "Sargent Masterpiece Rejected by Subject Now Acquired by
 Museum." *New York Herald,* May 12, 1916, p. 12.

"Sargent Year" 1916
 "A Sargent Year." *Literary Digest* 53 (September 9, 1916),
 pp. 608–9.
"Sargent's Portrait of Marquand" 1897
 "Mr. Sargent's Portrait of Mr. Marquand." *Critic* 31 (November 13, 1897), p. 286.
"Sargent's Sculpture" 1916
 "Sargent's Sculpture, The Crucifixion." *Vanity Fair* 7, no. 3
 (November 1916), p. 76.
Schulze 1980
 Franz Schulze. "J. S. Sargent, Partly Great." *Art in America* 68,
 no. 2 (February 1980), pp. 90–96.
Sewell 1982
 Brian Sewell. "A Neglected Masterpiece" [Sargent's *Gassed* of
 1918]. *Art and Artists,* [no. 188] (May 1982), p. 28.
Shelley 1993
 Marjorie Shelley. "'Splendid Mountain': A Sketchbook by the
 Young John Singer Sargent." *Metropolitan Museum Journal* 28
 (1993), pp. 185–205.
Shone 1979
 Richard Shone. "John Singer Sargent and the Edwardian
 Age." *Burlington Magazine* 121 (August 1979), pp. 532–36.
Sickert 1910
 Walter Sickert. "Sargentolatry." *New Age* 7 (May 19, 1910),
 pp. 56–57. Reprinted in Ratcliff 1982, pp. 233–34.
Simpson 1980
 Marc A. Simpson. "Two Recently Discovered Paintings by
 John Singer Sargent." *Yale University Art Gallery Bulletin* 38,
 no. 1 (fall 1980), pp. 6–11.
Simpson 1990
 Marc A. Simpson. "Windows on the Past: Edwin Austin
 Abbey and Francis Davis Millet in England." *American Art
 Journal* 22, no. 3 (1990), pp. 64–89.
Simpson 1993
 Marc A. Simpson. "Reconstructing the Golden Age: American Artists in Broadway, Worcestershire, 1885 to 1889."
 Ph.D. dissertation, Yale University, New Haven, 1993.
Simpson 1997
 Marc A. Simpson. "Robert Sterling Clark as a Collector of
 Sargent." *Magazine Antiques* 152 (October 1997), pp. 554–57.
Simpson 1998
 Marc A. Simpson. "Sargent, Velázquez, and the Critics:
 'Velasquez Come to Life Again.'" *Apollo* 148 (September
 1998), pp. 3–12.
Smith 1922
 Preserved Smith. "Sargent's New Mural Decorations." *Scribner's* 71 (March 1922), pp. 379–84.
Stebbins 1976
 Theodore E. Stebbins Jr., with John Caldwell and Carol
 Troyen. *American Master Drawings and Watercolors: A History of
 Works on Paper from Colonial Times to the Present.* New York:
 Harper and Row, 1976.
Stokes 1926
 Adrian Stokes. "John Singer Sargent, R.A., R.W.S." *Old
 Water-Colour Society's Club 3,* 1925–26 (1926), pp. 51–65.
Strickler 1982–83
 Susan E. Strickler. "John Singer Sargent and Worcester."
 Worcester Art Museum Journal 6 (1982–83), pp. 19–39.
Strickler 1987
 Susan E. Strickler, ed. *American Traditions in Watercolor: The
 Worcester Art Museum Collection.* Worcester, Massachusetts:
 Worcester Art Museum; New York: Abbeville Press, 1987.

Strickler and Walsh 1987
 Susan E. Strickler and Judith C. Walsh. "Technique in American Watercolors from the Worcester Art Museum, Worcester, Massachusetts." *Magazine Antiques* 131 (February 1987),
 pp. 412–25.
Sturgis 1904
 Russell Sturgis. "Boston Public Library: The South End of
 Sargent Hall." *Architectural Record* 15 (May 1904), pp. 423–30.
Sturgis and Fowler 1903
 Russell Sturgis and Frank Fowler. "Sargent's New Wall Painting." *Scribner's Magazine* 34 (December 1903), pp. 765–68.
Sutton 1964
 Denys Sutton. "A Bouquet for Sargent." *Apollo* 79 (May
 1964), pp. 395–400.
Sutton 1979
 Denys Sutton. "The Yankee Brio of John Singer Sargent."
 Portfolio 1, no. 4 (October–November 1979), pp. 46–53.
"Talk of the Town" 1926
 "The Talk of the Town: Sargent." *New Yorker,* January 16,
 1926, p. 4.
Thompson 1989
 D. Dodge Thompson. "Frans Hals and American Art." *Magazine Antiques* 136 (November 1989), pp. 1170–83.
Thompson 1990
 D. Dodge Thompson. "John Singer Sargent's Javanese
 Dancers." *Magazine Antiques* 138 (July 1990), pp. 124–33.
"Thousands View Sargent Exhibit" 1926
 "Thousands View Sargent Exhibit at Art Museum." *New York
 Herald Tribune,* January 5, 1926, p. 22.
"Three Sisters" 1914
 "Three Sisters from Charcoal Drawings by John S. Sargent."
 Century Magazine 87 (March 1914), following p. 662.
Tintner 1975
 Adeline R. Tintner. "Sargent in the Fiction of Henry James."
 Apollo 102 (August 1975), pp. 128–32.
Troyen 1996
 Carol Troyen. "Watercolors: Sargent's Pictorial Diary." *Magazine Antiques* 150 (November 1996), pp. 668–77.
Troyen 1999
 Carol Troyen. "Sargent's Murals for the Museum of Fine
 Arts, Boston." *Magazine Antiques* 156 (July 1999), pp. 72–81.
Tupper 1919
 Tristram Tupper. "Sargent's Studio of Shellfire: Glimpses of
 the American Painter and His White Umbrella Amid the
 Dugouts of Mont Kemmel and the Ruins of Ypres." *New
 York Times,* March 23, 1919, section 4, pp. 1, 9.
Tyrrell 1921
 Henry Tyrrell. "American Aquarellists—Homer to Marin."
 International Studio 74 (September 1921), pp. xxvii–xxxvi.
Updike 1989
 John Updike. "American Children" [Homer's and Sargent's
 Declarations of Independence of Youth]. *Art and Antiques,*
 May 1989, pp. 106–7.
Van Dyke 1903
 John C. Van Dyke. "Sargent the Portrait Painter." *Outlook* 74
 (May 2, 1903), pp. 31–39.
Walsh 1987
 Judith C. Walsh. "Observations on the Watercolor Techniques
 of Homer and Sargent." In Strickler 1987, pp. 45–65.
Washington, D.C., and other cities 1964–65
 The Private World of John Singer Sargent. Exhibition, Corcoran
 Gallery of Art, Washington, D.C., April 18–June 14, 1964;

Cleveland Museum of Art, July 7–August 16; Worcester Art Museum, Worcester, Massachusetts, September 17–November 1; Munson-Williams-Proctor Institute, Utica, New York, November 15, 1964–January 3, 1965. Catalogue by Donelson F. Hoopes. Plainview, New York: Shorewood Publishers, 1964.

Washington, D.C.–Boston 1992
 John Singer Sargent's "El Jaleo." Exhibition, National Gallery of Art, Washington, D.C., March 1–August 2, 1992; Isabella Stewart Gardner Museum, Boston, September 10–November 22. Catalogue by Mary Crawford Volk, with Nicolai Cikovsky Jr., Warren Adelson, and Elizabeth Oustinoff. Washington, D.C., 1992.

"Water Colors by Sargent" 1918
 "Water Colors by John Singer Sargent." *Bulletin of the Worcester Art Museum* 8 (January 1918), pp. 72–80.

"Water-Colors of Boit and Sargent" 1912
 J. G. "The Water-Colors of Edward D. Boit and John S. Sargent." *Museum of Fine Arts Bulletin* 10 (June 1912), pp. 18–21.

Weinberg 1980
 H. Barbara Weinberg. "John Singer Sargent: Reputation Redivivus." *Arts Magazine* 54, no. 7 (March 1980), pp. 104–9.

Weinberg 1991
 H. Barbara Weinberg. *The Lure of Paris: Nineteenth-Century American Painters and Their French Teachers.* New York: Abbeville Press, 1991.

Weinberg 1994
 H. Barbara Weinberg. *John Singer Sargent.* New York: Rizzoli International, 1994.

Weinberg and Herdrich 2000a
 H. Barbara Weinberg and Stephanie L. Herdrich. "John Singer Sargent in The Metropolitan Museum of Art." *Metropolitan Museum of Art Bulletin* 57, no. 4 (spring 2000).

Weinberg and Herdrich 2000b
 H. Barbara Weinberg and Stephanie L. Herdrich. "The Ormond Gift and the Metropolitan Museum's Sargents." *Magazine Antiques* 157 (January 2000), pp. 228–33.

Whitehill 1970
 Walter Muir Whitehill. "The Making of an Architectural Masterpiece—the Boston Public Library." *American Art Journal* 2 (fall 1970), pp. 13–35.

Williamstown 1997
 Uncanny Spectacle: The Public Career of the Young John Singer Sargent. Exhibition, Sterling and Francine Clark Art Institute, Williamstown, Massachusetts, June 15–September 7, 1997. Catalogue by Marc A. Simpson, with Richard Ormond and H. Barbara Weinberg. New Haven: Yale University Press; Williamstown, Massachusetts: Sterling and Francine Clark Art Institute, 1997.

Wissman 1979
 Fronia E. Wissman. "Sargent's Watercolor Views of Santa Maria della Salute." *Yale University Art Gallery Bulletin* 37, no. 2 (summer 1979), pp. 14–19.

Young 1971
 Dorothy Weir Young. *The Life and Letters of J. Alden Weir.* New Haven: Yale University Press, 1960; reprint, New York: Kennedy Graphics and Da Capo Press, 1971.

Concordance

Acc. No.	Cat. No.	Title
15.142.2	Cat. 313	Mountain Stream
15.142.3	Cat. 325	Idle Sails
15.142.4	Cat. 321	Giudecca
15.142.5	Cat. 323	Sirmione
15.142.6	Cat. 315	Spanish Fountain
15.142.7	Cat. 329	Tyrolese Crucifix
15.142.8	Cat. 316	In the Generalife
15.142.9	Cat. 324	Boats
15.142.10	Cat. 322	Venetian Canal
15.142.11	Cat. 314	Escutcheon of Charles V of Spain
30.28.1	Cat. 201	Man Standing, Hands on Head
30.28.2	Cat. 200	Man Holding a Staff, Possible Study for Devil in "Judgment"
30.28.3	Cat. 207	Seated Figures, from Below
30.28.4	Cat. 197	Two Men, Possible Study for "Hell"
30.28.5	Cat. 199	Kneeling Figure, Possible Study for "The Crucifixion"
30.28.6	Cat. 202	Man Standing, Head Thrown Back
31.43.1	Cat. 188	Duchess of Marlborough (Consuelo Vanderbilt)
31.43.2	Cat. 167	Madame X (Madame Pierre Gautreau)
31.43.3	Cat. 166	Madame X (Madame Pierre Gautreau)
32.116	Cat. 331	Camp at Lake O'Hara
50.130.25	Cat. 265	Tiepolo Ceiling, Milan
50.130.26	Cat. 146	Cattle in Stable
50.130.27	Cat. 256	Woman with Collie
50.130.28	Cat. 251	Market Place
50.130.29	Cat. 157	Venice
50.130.30	Cat. 257	Clouds
50.130.31	Cat. 299	Treetops against Sky
50.130.32	Cat. 250	Women Approaching
50.130.33	Cat. 158	Young Woman in Black Skirt

Acc. No.	Cat. No.	Title
50.130.34	Cat. 159	Boy in Costume
50.130.35	Cat. 271	Cathedral Interior
50.130.36	Cat. 136	Patio de los Leones, Alhambra
50.130.37	Cat. 272	Venice
50.130.38	Cat. 293	Loggia, Villa Giulia, Rome
50.130.39	Cat. 255	Arched Doorway
50.130.40	Cat. 279	Temple of Bacchus, Baalbek
50.130.41	Cat. 253	Street, Tangier
50.130.42	Cat. 254	Tangier
50.130.43	Cat. 275	Arab Woman
50.130.44	Cat. 276	Bedouin Tent
50.130.45	Cat. 277	From Jerusalem
50.130.46	Cat. 278	Sunset
50.130.47	Cat. 268	From Ávila
50.130.48	Cat. 224	Tommies Bathing
50.130.49	Cat. 223	Mules
50.130.50	Cat. 226	Camp with Ambulance
50.130.51	Cat. 227	Military Camp
50.130.52	Cat. 228	Camouflaged Field in France
50.130.53	Cat. 217	Dugout
50.130.54	Cat. 218	Truck Convoy
50.130.55	Cat. 222	Mules and Ruins
50.130.56	Cat. 215	Wheels in Vault
50.130.57	Cat. 335	Figure in Hammock, Florida
50.130.58	Cat. 225	Tommies Bathing
50.130.59	Cat. 339	Figure and Trees, Florida
50.130.60	Cat. 338	Bather in Florida
50.130.61	Cat. 337	Man on Beach, Florida
50.130.62	Cat. 340	Man and Pool, Florida
50.130.63	Cat. 334	Alligators
50.130.64	Cat. 332	Landscape with Palmettos
50.130.65	Cat. 333	Palmettos
50.130.66	Cat. 307	Three Oxen
50.130.67	Cat. 308	Oxen

Acc. No.	Cat. No.	Title
50.130.68	Cat. 264	Sky
50.130.69	Cat. 306	Siena
50.130.70	Cat. 326	Small Boats
50.130.71	Cat. 289	Stream and Rocks
50.130.72	Cat. 233	Italian Model
50.130.73	Cat. 232	Man with Red Drapery
50.130.74	Cat. 286	Boboli Gardens, Florence
50.130.75	Cat. 294	Terrace and Gardens, Villa Torlonia, Frascati
50.130.76	Cat. 273	Green Door, Santa Maria della Salute
50.130.77	Cat. 274	Venetian Passageway
50.130.78	Cat. 216	Ruined Cellar, Arras
50.130.79	Cat. 213	Study for "The Coming of the Americans to Europe"
50.130.80a	App. 1	Land and Water (No. 1)
50.130.80b	App. 2	Land and Water (No. 2)
50.130.80c	App. 3	Sea, Sky, City
50.130.80d	Cat. 280	Sunset at Sea
50.130.80e	Cat. 288	Rushing Water
50.130.80f	Cat. 328	Sellar Alp, Dolomites
50.130.80g	Cat. 300	Snow
50.130.80h	Cat. 292	Glacier
50.130.80i	Cat. 291	Rushing Brook
50.130.80j	Cat. 290	Brook and Meadow
50.130.80k	Cat. 302	Mountain Torrent
50.130.80l	Cat. 330	Camp and Waterfall
50.130.80m	Cat. 318	Granada
50.130.80n	Cat. 319	Alhambra, Granada
50.130.80o	App. 4	Group of Women
50.130.80p	App. 5	Spain
50.130.80q	App. 6	Boats
50.130.81a	Cat. 327	Open Valley, Dolomites
50.130.81b	Cat. 301	Sky and Mountains
50.130.81c	Cat. 258	Scotland
50.130.81d	App. 7	Landscape
50.130.81e	Cat. 270	Toledo
50.130.81f	Cat. 263	In Sicily
50.130.81g	Cat. 252	House and Courtyard
50.130.81h	Cat. 320	Spanish Midday, Aranjuez
50.130.81i	Cat. 303	Garden near Lucca
50.130.81j	Cat. 304	Borgo San Lorenzo (1)
50.130.81k	Cat. 305	Borgo San Lorenzo (2)
50.130.81l	Cat. 311	Chalet

Acc. No.	Cat. No.	Title
50.130.81m	Cat. 312	Abriès
50.130.81n	Cat. 336	Terrace, Vizcaya
50.130.82a	Cat. 38	Tyrolean Shrine
50.130.82b recto (formerly 50.130.82b)	Cat. 19 recto	Chalets, Breithorn, Mürren
50.130.82b verso (formerly 50.130.82c)	Cat. 19 verso	Gottlieb Feutz, Mürren
50.130.82c recto (formerly 50.130.82d)	Cat. 20 recto	Mountain View, Eiger
50.130.82c verso (formerly 50.130.82e)	Cat. 20 verso	Tall Mountains and Stream, Faido
50.130.82d (formerly 50.130.82f)	Cat. 21	Mürren
50.130.82e (formerly 50.130.82g)	Cat. 22	View from Mount Pilatus
50.130.82f (formerly 50.130.82h)	Cat. 34	Innsbruck
50.130.82g (formerly 50.130.82i)	Cat. 14	Sailboats on Lake
50.130.82h (formerly 50.130.82j)	Cat. 2	View of a Southern City
50.130.82i recto (formerly 50.130.82k)	Cat. 3 recto	Torre de los Picos, Alhambra
50.130.82i recto (formerly 50.130.82l)	Cat. 3 verso	Leaves
50.130.82j (formerly 50.130.82m)	Cat. 15	Venice; Villa Nicolini, Florence; Architectural Details
50.130.83a	Cat. 4	Riders on the Heath
50.130.83b	Cat. 1	Portrait of a Man
50.130.83c	Cat. 260	Madonna and Child and Saints
50.130.83d	Cat. 6	Saint Matthew, Mosaic, Cathedral, Salerno
50.130.83e	Cat. 261	Madonna, Mosaic, Saints Maria and Donato, Murano
50.130.83f	Cat. 262	Angels, Mosaic, Palatine Chapel, Palermo
50.130.83g	Cat. 5	Apse Mosaic, San Clemente, Rome
50.130.83h	App. 8	Tomb of Francis Dineley and His Wife, Saint Michael's Church, Cropthorne
50.130.84	Cat. 214	Study for "Death and Victory"
50.130.85	Cat. 35	Mountains
50.130.86 recto	Cat. 53 recto	Seagull
50.130.86 verso	Cat. 53 verso	Seagull, Kingfisher
50.130.87	Cat. 165	Violet Sargent

Acc. No.	Cat. No.	Title	Acc. No.	Cat. No.	Title
50.130.88	Cat. 152	Man in Hat	50.130.120	Cat. 173	Conversation Piece
50.130.89	Cat. 153	Gondoliers	50.130.121	Cat. 150	Paul Helleu
50.130.90	Cat. 101	Boat Deck	50.130.122	Cat. 164	Mrs. Daniel Sargent Curtis
50.130.91	Cat. 102	Cattle in Stern of a Boat	50.130.123	Cat. 187	Hercules Brabazon Brabazon
50.130.92	Cat. 117	Woman with Basket			
50.130.93a (formerly 50.130.93 recto)	Cat. 154a	Two Seated Women	50.130.124 recto	Cat. 176 recto	Lily, Study for "Carnation, Lily, Lily, Rose"
50.130.93b (formerly 50.130.93 verso)	Cat. 154b	Venetian Ornament	50.130.124 verso	Cat. 176 verso	Japanese Lanterns and Lilies, Study for "Carnation, Lily, Lily, Rose"
50.130.94	Cat. 86	Fisherman with Nets			
50.130.95 recto	Cat. 155 recto	Figures in Gondola	50.130.125	Cat. 175	Lily, Study for "Carnation, Lily, Lily, Rose"
50.130.95 verso	Cat. 155 verso	Caricature of Man	50.130.126 recto	Cat. 249 recto	Man with Loincloth
50.130.96	Cat. 266	Two Dancers	50.130.126 verso	Cat. 249 verso	Study for "Women Approaching"
50.130.97	Cat. 121	Man			
50.130.98 recto	Cat. 122 recto	Two Men in Boats	50.130.127 recto	Cat. 198 recto	Reclining Man
50.130.98 verso	Cat. 122 verso	Oar	50.130.127 verso	Cat. 198 verso	Figure Study
50.130.99	Cat. 123	Two Men in Boat	50.130.128	Cat. 55	Life Study Class
50.130.100	Cat. 221	Road at Peronne	50.130.129	Cat. 141	Two Cats
50.130.101 recto	App. 9 recto	Pensive Woman	50.130.130	Cat. 267	Loggia, Welbeck Abbey
50.130.101 verso	App. 9 verso	Woman	50.130.131	Cat. 284	Loggia dei Lanzi, Florence
50.130.102	Cat. 236	Musicians and Listeners	50.130.132	Cat. 296	Casa de la Almoina, Palma
50.130.103	Cat. 139	Spanish Musicians with Poem			
50.130.104	Cat. 124	Oarsman	50.130.133	Cat. 285	Garden at Villa Corsini, Florence
50.130.105	Cat. 239	Draped Seated Woman	50.130.134	Cat. 142	Barber Shop
50.130.107	Cat. 49	Glacier on the Ortler	50.130.135	Cat. 171	Man Leading Horse
50.130.108	Cat. 238	Woman Walking	50.130.136 recto	Cat. 220 recto	Wasted Trees
50.130.109	Cat. 185	Javanese Dancer	50.130.136 verso	Cat. 220 verso	Walking Soldiers
50.130.110	Cat. 11	Heads	50.130.137	Cat. 138	Spanish Dancer
50.130.111 recto	Cat. 156 recto	Gondolier	50.130.138 recto	Cat. 219 recto	Poperinghe Road near Ypres
50.130.111 verso	Cat. 156 verso	Gondolier			
50.130.112 recto	Cat. 281 recto	Syrian Goats and Birds	50.130.138 verso	Cat. 219 verso	Shattered Trees
50.130.112 verso	Cat. 281 verso	Syrian Man	50.130.139	Cat. 162	After "El-Jaleo"
50.130.113 recto	Cat. 282 recto	Man in Robe	50.130.140a	Cat. 107	Sailboat Deck with Figures
50.130.113 verso	Cat. 282 verso	Seated Men			
50.130.114	Cat. 118	Child, Study for "Oyster Gatherers of Cancale"	50.130.140b	Cat. 119	Wading Children
50.130.115	Cat. 161	Marie-Louise Pailleron	50.130.140c	Cat. 99	Woman Looking Out to Sea
50.130.116	Cat. 317	Jane de Glehn, Study for "In the Generalife"	50.130.140d recto	Cat. 120 recto	Bathing Children
50.130.117	Cat. 169	Whispers	50.130.140d verso	Cat. 120 verso	Heads
50.130.118	Cat. 184	Two Women in Cafe	50.139.140e recto (formerly 50.130.140e)	Cat. 114 recto	Men
50.130.119 recto	Cat. 178 recto	Woman and Child	50.130.140e verso (formerly 50.130.140f)	Cat. 114 verso	Kneeling Woman
50.130.119 verso	Cat. 178 verso	Rose Branch, Study for "Carnation, Lily, Lily, Rose"	50.130.140f recto (formerly 50.130.140g)	Cat. 115 recto	Men

Acc. No.	Cat. No.	Title
50.130.140f verso (formerly 50.130.140h)	Cat. 115 verso	Horse and Two Men
50.140.140g recto (formerly 50.130.140i)	Cat. 88 recto	Head
50.130.140g verso (formerly 50.130.140j)	Cat. 88 verso	Three Heads
50.130. 140h (formerly 140.130.140k)	Cat. 151	Two Women
50.130.140i (formerly 50.130.140l)	Cat. 174	Parlor Concert
50.130.140j (formerly 50.130.140m)	App. 10	Standing Female Nude
50.130.140k (formerly 50.130.140n)	Cat. 170	Woman Holding Glass
50.130.140l (formerly 50.130.140o)	Cat. 172	Seated Woman with Hat
50.130.140m (formerly 50.130.140p)	Cat. 70	Firelight
50.130.140n (formerly 50.130.140q)	Cat. 69	Head of a Man
50.130.140o (formerly 50.130.140r)	Cat. 283	Sleeping Man
50.130.140p (formerly 50.130.140s)	Cat. 110	Foot
50.130.140q (formerly 50.130.140t)	Cat. 111	Nostrils and Lips
50.130.140r (formerly 50.130.140u)	Cat. 135	Hand for "Carolus-Duran"
50.130.140s recto (formerly 50.130.140v)	Cat. 137 recto	Left Hand for "Fumée d'Ambre Gris"
50.130.140s verso (formerly 50.130.140w)	Cat. 137 verso	Spanish Dancers
50.130.140t (formerly 50.130.140x)	Cat. 248	Draped Woman
50.130.140u (formerly 50.130.140y)	Cat. 341	Landscape with Palms
50.130.140v (formerly 50.130.140z)	Cat. 309	Feeding the Goats
50.130.140w (formerly 50.130.140aa)	Cat. 310	Allegorical Figure
50.130.140x recto (formerly 50.130.140bb)	Cat. 68 recto	Orlando Innamorato
50.130.140x verso (formerly 50.130.140dd)	Cat. 68 verso	Orlando Innamorato
50.130.140y (formerly 50.130.140ee)	Cat. 295	Fountain in Villa Torlonia, Frascati
50.130.140z (formerly 50.130.140ff)	Cat. 287	Glacier du Brouillard from Below
50.130.140aa (formerly 50.130.140gg)	Cat. 297	Renaissance Palace
50.130.140bb (formerly 50.130.140hh)	Cat. 269	Santiago
50.130.140cc (formerly 50.130.140ii)	Cat. 229	Military Insignias
50.130.140dd (formerly 50.130.140jj)	Cat. 234	Allegorical Subject with Winged Figures
50.130.140ee recto (formerly 50.130.140kk)	Cat. 194 recto	Arm
50.130.140ee verso (formerly 50.130.140ll)	Cat. 194 verso	Trinity Lunette, Study for South End of the Special Collections Hall
50.130.140ff (formerly 50.130.140mm)	Cat. 195	Mary, Study for "The Annunciation"
50.130.140gg (formerly 50.130.141a)	Cat. 196	Angel, Study for "The Annunciation"
50.130.141a recto	Cat. 26 recto	Seated Girl (Katy Eyre?)
50.130.141a verso	Cat. 26 verso	Tomb?
50.130.141b	Cat. 27	Portrait of a Woman
50.130.141c	Cat. 28	Helmet, Bargello, Florence
50.130.141d	Cat. 29	Lectern, Cathedral, Florence
50.130.141e	Cat. 31	Tomb of Antenore, Padua
50.130.141f	Cat. 32	Tomb of a Knight, Basilica of San Antonio, Padua
50.130.141g	Cat. 30	Door of Campanile, Florence
50.130.141h	Cat. 45	Men; Landscape with Pines, Certosa
50.130.141i	Cat. 46	Pines
50.130.141j recto (formerly 50.130.141j)	Cat. 39 recto	Chalets
50.130.141j verso (formerly 50.130.141k)	Cat. 39 verso	Zillerthal
50.130.141k (formerly 50.130.141l)	Cat. 33	On the Brenner
50.130.141l (formerly 50.130.141m)	Cat. 40	Mountains, Clouds, and Lake
50.130.141m (formerly 50.130.141n)	Cat. 93	Siesta on a Boat
50.140.141n (formerly 50.130.141o)	Cat. 94	Hugh McGehan and James Roarity
50.130.141o (formerly 50.130.141p)	Cat. 95	James Roarity and a Woman at Table, Four Profiles of James Roarity
50.130.141p recto (formerly 50.130.141q)	Cat. 44 recto	House, Hammer
50.130.141p verso (formerly 50.130.141r)	Cat. 44 verso	Woman with Basket
50.130.141q recto (formerly 50.130.141s)	Cat. 112 recto	Woman with Bow
50.130.141q verso (formerly 50.130.141t)	Cat. 112 verso	Heads
50.130.141r (formerly 50.130.141u)	Cat. 140	Queen Maria of Hungary

Acc. No.	Cat. No.	Title
50.130.141s (formerly 50.130.141v)	Cat. 113	Two Heads
50.130.141t recto (formerly 50.130.141w)	Cat. 42 recto	Girl with Parasol, Caricatures
50.130.141t verso (formerly 50.130.141x)	Cat. 42 verso	Faces
50.130.141u (formerly 50.130.141y)	Cat. 116	Dome of San Lorenzo and Campanile, Turin
50.130.141v (formerly 50.130.141z)	Cat. 23	Eiger from Mürren
50.130.141w (formerly 50.130.141aa)	Cat. 24	Thistle
50.130.141x (formerly 50.130.141bb)	Cat. 13	Heads
50.130.141y (formerly 50.130.141cc)	Cat. 47	Sleeping Child
50.130.141z recto (formerly 50.130.141dd)	Cat. 12 recto	Heads, Hands, Mother and Child, and Other Figures
50.130.141z verso (formerly 50.130.141ee)	Cat. 12 verso	Head of a Child, Mountain Scene, Objects for a Still Life, Trees, Figure in a Boat
50.130.141aa recto (formerly 50.130.141ff)	Cat. 67 recto	Entombment
50.130.141aa verso (formerly 50.130.141gg)	Cat. 67 verso	Portrait Head, Entombment, and Other Studies
50.130.141bb recto (formerly 50.130.141hh)	Cat. 245 recto	Greek Theatre, Epidaurus
50.130.141bb verso	Cat. 245 verso	Tree
50.130.141cc (formerly 50.130.141ii)	Cat. 37	Tyrolean Man
50.130.141dd (formerly 50.130.141jj)	App. 11	Frigate
50.130.142a	Cat. 143	Dog
50.130.142b recto (formerly 50.130.142b)	Cat. 181 recto	Peacocks
50.130.142b verso (formerly 50.130.142c)	Cat. 181 verso	Peacocks
50.130.142c recto (formerly 50.130.142d)	Cat. 182 recto	Peacocks
50.130.142c verso (formerly 50.130.142e)	Cat. 182 verso	Peacocks
50.130.142d (formerly 50.130.142f)	Cat. 183	Peacocks
50.130.142e (formerly 50.130.142g)	Cat. 179	Peacocks
50.130.142f recto (formerly 50.130.142h)	Cat. 180 recto	Peacocks
50.130.142f verso (formerly 50.130.142i)	Cat. 180 verso	Figures

Acc. No.	Cat. No.	Title
50.130.142g (formerly 50.130.142j)	Cat. 177	Rose Branch, Study for "Carnation, Lily, Lily, Rose"
50.130.142h (formerly 50.130.142k)	Cat. 298	Pomegranates
50.130.142i recto (formerly 50.130.142l)	Cat. 237 recto	Vulture
50.130.142i verso (formerly 50.130.142m)	Cat. 237 verso	Vultures
50.130.142j (formerly 50.130.142n)	Cat. 211	Swans
50.130.142k (formerly 50.130.142o)	Cat. 212	Swans
50.130.142l (formerly 50.130.142p)	Cat. 235	Turkeys
50.130.142m (formerly 50.130.142q)	Cat. 36	Cows and Goats; Boy Milking
50.130.143a	Cat. 63	La Faucheur (The Reaper)
50.130.143b	Cat. 64	La Tondeuse de Moutons (Woman Shearing Sheep)
50.130.143c	Cat. 65	Le Botteleur (Gathering Grain)
50.130.143d recto (formerly 50.130.143d)	Cat. 56 recto	"Paradise," Detail
50.130.143d verso (formerly 50.130.143e: now, no object)	Cat. 56 verso	"Paradise," Detail
50.130.143f	Cat. 163	Pope Paul III
50.130.143g	Cat. 57	Adoration of the Shepherds
50.130.143h	Cat. 41	Mystical Marriage of Saint Catherine Attended by Doge Franceso Donato
50.130.143i	Cat. 246	Sculpture of a Woman
50.130.143j	Cat. 230	Charity, After a Sculpture at Abbeville
50.130.143k	Cat. 231	Portal, Abbeville
50.130.143l	Cat. 60	The Triumph of Flora
50.130.143m	Cat. 72	Goethe
50.130.143n recto (formerly 50.130.143n)	Cat. 10 recto	Moderne Amoretten (detail)
50.130.143n verso (formerly 50.130.143o: now, no object))	Cat. 10 verso	Faces, Trees, Horses
50.130.143p	Cat. 48	Pieta, Detail
50.130.143q	Cat. 25	Palamedes Palamedesz
50.130.143r	Cat. 247	Entombment, Schreyer-Landauer Monument, Saint Sebalduskirche, Nuremberg
50.130.143s recto	Cat. 149 recto	The Marriage of Saint Catherine

Acc. No.	Cat. No.	Title
50.130.143s verso	Cat. 149 verso	*Hand of a Spanish Dancer*
50.130.143t	Cat. 193	*Study for South End of the Special Collections Hall*
50.130.143u	Cat. 62	*Angel with Sundial, Chartres*
50.130.143v	App. 12	*Tomb of Francis Dineley and His Wife, Saint Michael's Church, Cropthorne*
50.130.143w	Cat. 259	*Predella of an Altar, Cathedral, Tarragon*
50.130.143x	Cat. 8	*Sleeping Faun, Glyptothek, Munich*
50.130.143y	Cat. 7	*Theodoric the Goth, Tomb of Maximilian I, Innsbruck*
50.130.143z	Cat. 18	*Night*
50.130.143aa	Cat. 242	*Kore 674, Acropolis Museum, Athens*
50.130.143bb	Cat. 243	*Kore 684, Acropolis Museum, Athens*
50.130.143cc	Cat. 244	*Parthenon Athena, Acropolis Museum, Athens*
50.130.143dd	Cat. 240	*Egyptian Relief Head*
50.130.143ee	Cat. 241	*Egyptian Relief*
50.130.146	Cat. 17	*Splendid Mountain Watercolors Sketchbook*
50.130.146a	Cat. 17a	*First Page of "Splendid Mountain Watercolors" Sketchbook*
50.130.146b recto	Cat. 17b recto	*Wellhorn and Wetterhorn from Brunig*
50.130.146b verso	Cat. 17b verso	*Jungfrau*
50.130.146c recto	Cat. 17c recto	*Jungfrau from Mürren*
50.130.146c verso	Cat. 17c verso	*Frau von Allmen and an Unidentified Man in an Interior*
50.130.146d	Cat. 17d	*Kandersteg from the Klus of the Gasternthal*
50.130.146e	Cat. 17e	*View of Four Mountains from Gorner Grat, Rock*
50.130.146f recto	Cat. 17f recto	*Schreckhorn, Eismeer*
50.130.146f verso	Cat. 17f verso	*Wetterhorn, Grindelwald*
50.130.146g	Cat. 17g	*Lake of the Dead, Grimsel*
50.130.146h	Cat. 17h	*Rhône Glacier*
50.130.146i	Cat. 17i	*Monte Rosa from Hornli, Zermatt*
50.130.146j	Cat. 17j	*Village Scene, Loèche-les-Bains*
50.130.146k	Cat. 17k	*Views from Kandersteg; Entrance to Gasternthal and Kanderthal from Hotel Gemmi*

Acc. No.	Cat. No.	Title
50.130.146l	Cat. 17l	*Gemmi Pass*
50.130.146m	Cat. 17m	*Weisshorn*
50.130.146n	Cat. 17n	*Matterhorn*
50.130.146o	Cat. 17o	*Matterhorn, Zermatt*
50.130.146p	Cat. 17p	*Monte Rosa from Gorner Grat*
50.130.146q	Cat. 17q	*Riffelhorn from Zmutt Glacier, Zermatt*
50.130.146r	Cat. 17r	*Waterfall*
50.130.146s recto	Cat. 17s recto	*Waterfall*
50.130.146s verso	Cat. 17s verso	*Aletsch Glacier from Eggishorn*
50.130.146t	Cat. 17t	*Aletsch Glacier from Eggishorn*
50.130.146u	Cat. 17u	*Fiesch Glacier from Eggishorn*
50.130.146v	Cat. 17v	*Alpine View, Mürren*
50.130.146w recto	Cat. 17w recto	*Grimsel Pass*
50.130.146w verso	Cat. 17w verso	*Handek Falls*
50.130.146x	Cat. 17x	*Handek Falls*
50.130.146y	Cat. 17y	*Mountain*
50.130.146z recto	Cat. 17z recto	*Gspaltenhorn, Mürren*
50.130.146z verso	Cat. 17z verso	*Fraulein Sterchi, Mürren*
50.130.146aa recto	Cat. 17aa recto	*Chalets, Breithorn, Mürren*
50.130.146aa verso	Cat. 17aa verso	*Chalets, Mürren*
50.130.146bb recto	Cat. 17bb recto	*Jungfrau from above Mürren*
50.130.146bb verso	Cat. 17bb verso	*Two Children in Interior, Mürren*
50.130.146cc recto	Cat. 17cc recto	*Chalet, Mürren*
50.130.146cc verso	Cat. 17cc verso	*View from Schilthorn*
50.130.146dd	Cat. 17dd	*Iselle from Pilatus*
50.130.146ee	Cat. 17ee	*Mount Pilatus*
50.130.146ff	Cat. 17ff	*Hotel Bellevue and Esel Peak, Mount Pilatus*
50.130.146gg	Cat. 17gg	*Dawn*
50.130.146hh	Cat. 17hh	*Child Holding Skull*
50.130.146ii recto	cat. 17ii recto	*View from Schilthorn*
50.130.146ii verso	Cat. 17ii verso	*Mountain View, Mürren*
50.130.146jj recto	Cat. 17jj recto	*Staubbach Falls*
50.130.146jj verso	Cat. 17jj verso	*Wetterhorn, Grindelwald*
50.130.146kk	Cat. 17kk	*Matterhorn from Zmutt Glacier, Zermatt*
(50.130.146ll recto: blank)		
50.130.146ll verso	Cat. 17ll verso	*Mountain Landscape*
50.130.146mm	Cat. 17mm	*Gemmi Pass*

Acc. No.	Cat. No.	Title	Acc. No.	Cat. No.	Title
50.130.146nn	Cat. 17nn	Bies Glacier and Weisshorn, Zermatt	50.130.147o	Cat. 9o	Rocky Cliff
50.130.146oo recto	Cat. 17oo recto	Eiger from Mürren	50.130.147p	Cat. 9p	Temples at Sunset, Heads
50.130.146oo verso	Cat. 17oo verso	Frau von Allmen, Mürren	50.130.147q	Cat. 9q	Piz Julier from St. Moritz
50.130.146pp recto	Cat. 17pp recto	Chalets, Mürren	50.130.147r	Cat. 9r	St. Moritz
50.130.146pp verso	Cat. 17pp verso	Two Children in Mountain Landscape, Mürren	50.130.147s	Cat. 9s	Mountains and Sky
			50.130.147t	Cat. 9t	Mountain, Bellagio
50.130.146qq recto	Cat. 17qq recto	Eismeer, Grindelwald	50.130.147u	Cat. 9u	Bridge at Pontresina
50.130.146qq verso	Cat. 17qq verso	Grindelwald	50.130.147v	Cat. 9v	Piz Albris and Glacier du Paradis, St. Moritz
50.130.146rr recto	Cat. 17rr recto	Zur Gilgen House, Lucerne	50.130.147w	Cat. 9w	Piz Murailg from Alp Mouttas, Pontresina
50.130.146rr verso	Cat. 17rr verso	Boats on Shore, Lake of Brienz	50.130.147x	Cat. 9x	Mill at Pontresina
50.130.146ss recto	Cat. 17ss recto	View of Schreckhorn and Finsteraarhorn on the Way up to Faulhorn	50.130.147y	Cat. 9y	Mont Blanc from Brevent
			50.130.147z	Cat. 9z	Summit of Bernina Pass
			50.130.147aa recto	Cat. 9aa recto	Ortler Spitz from Stelvio Pass
50.130.146ss verso	Cat. 17ss verso	From Faulhorn	50.130.147aa verso	Cat. 9aa verso	Ortler Spitz from Summit of Stelvio Pass
50.130.146tt recto	Cat. 17tt recto	From Faulhorn			
50.130.146tt verso	Cat. 17tt verso	From Faulhorn	50.130.147bb	Cat. 9bb	Ortler Spitz from Summit of Stelvio Pass
50.130.146uu	Cat. 17uu	Mount Pilatus, Stansstadt	50.130.147cc	Cat. 9cc	Old Baths at Bormio
50.130.146vv	Cat. 17vv	Mountain Sketches (inside back cover)	50.130.147dd	Cat. 9dd	Mountain View at Bormio
50.130.147	Cat. 9	Switzerland 1869 Sketchbook	50.130.147ee	Cat. 9ee	Boat
			50.130.147ff recto	Cat. 9ff recto	Boats on Mountain Lake
50.130.147a	Cat. 9a	Fish and Fishing Motifs; Faces and Figures	50.130.147ff verso	Cat. 9ff verso	Mountain Peaks
50.130.147b	Cat. 9b	Mountain Peak	50.130.147hh	Cat. 9hh	Two Men at a Table, Man Eating
50.130.147c	Cat. 9c	Lilies	50.130.147kk	Cat. 9kk	Town at Edge of Mountain Lake
50.130.147d	Cat. 9d	Mountains			
50.130.147e recto	Cat. 9e recto	Cupid and Pysche, Faces and Heads	50.130.147ll	Cat. 9ll	Boat
			50.130.147mm	Cat. 9mm	Roseg Glacier, Pontresina
50.130.147e verso	Cat. 9e verso	Bellagio, Lake Como	50.130.147nn	Cat. 9nn	Morteratsch, Piz Bernina, Pontresina
50.130.147f recto	Cat. 9f recto	Mountain View			
50.130.147f verso	Cat. 9f verso	Knights in Armor, Warrior, Neptune Fountain	50.130.147oo	Cat. 9oo	Boats on Lake of Lecco
			50.130.147pp	Cat. 9pp	Lake of Lecco
50.130.147g	Cat. 9g	Serbelloni, Bellagio	50.130.147qq	Cat. 9qq	Town at Edge of Mountain Lake
50.130.147h	Cat. 9h	Botzen			
50.130.147i	Cat. 9i	Pediment Sculptures from Temple at Aegina, Glyptothek, Munich	50.130.147rr	Cat. 9rr	Sailboats, Geometrical Design
			50.130.147ss	Cat. 9ss	Mountain Climbers
50.130.147j	Cat. 9j	Ancient Greek Sculptures, Glyptothek, Munich	50.130.147tt	Cat. 9tt	Fish, Caricatures (inside back cover)
50.130.147k	Cat. 9k	Piz Muretto, St. Moritz	50.130.148	Cat. 16	Switzerland 1870 Sketchbook
50.130.147l	Cat. 9l	Mountain Study			
50.130.147m	Cat. 9m	Rocks and Cliffs	50.130.148a	Cat. 16a	First Page of Switzerland 1870 Sketchbook
50.130.147n	Cat. 9n	Val Bregaglia from Maloja			

Acc. No.	Cat. No.	Title
50.130.148b	Cat. 16b	*Trees and Foliage, Head of a Bull, Men*
50.130.148c	Cat. 16c	*Two Landscapes*
50.130.148d	Cat. 16d	*Landscape at Faido, Tree*
50.130.148e	Cat. 16e	*Railway Bridge at Dazio Grande, St. Gotthard*
50.130.148f	Cat. 16f	*Schöllinen Gorge, Hospenthal*
50.130.148g	Cat. 16g	*Alpine Village*
50.130.148h	Cat. 16h	*St. Gotthard and Mythen, Brunnen*
50.130.148i	Cat. 16i	*Devil's Bridge, St. Gotthard*
50.130.148j recto	Cat. 16j recto	*Urner Loch, Hospenthal*
50.130.148j verso	Cat. 16j verso	*Waterfall, Figures*
50.130.148k	Cat. 16k	*St. Gotthard*
50.130.148l	Cat. 16l	*Bay of Uri, Brunnen*
50.130.148m	Cat. 16m	*Mountain Lake*
50.130.148n	Cat. 16n	*Uri Rothstock from Brunnen*
50.130.148o	Cat. 16o	*Lion Monument, Lucerne*
50.130.148p	Cat. 16p	*Rooftops and Spire*
50.130.148q	Cat. 16q	*Three Views of Bernese Oberland from Thun*
50.130.148r	Cat. 16r	*Mountain View*
50.130.148s recto	Cat. 16s recto	*Screckhorn and Eiger from Thun*
50.130.148s verso	Cat. 16s verso	*Figure on Horseback*
50.130.148t recto	Cat. 16t recto	*Woman Sketching, Various Portraits*
50.130.148t verso	Cat. 16t verso	*Man Carrying a Sword*
50.130.148u	Cat. 16u	*Miss Mary Douglas Scott Sewing*
50.130.148v recto	Cat. 16v recto	*Mary Newbold Sargent*
50.130.148v verso	Cat. 16v verso	*Head of a Man, Hands*
50.130.148w	Cat. 16w	*Heads*
50.130.148x	Cat. 16x	*Foxes*
50.130.148y	Cat. 16y	*Eiger from Lauterbrunnen, Mürren*
50.130.148z	Cat. 16z	*Mountains*
50.130.148aa	Cat. 16aa	*Eiger, Mönch, and Jungfrau from Mürren*
50.130.148bb	Cat. 16bb	*Two Landscapes, Face*
50.130.148cc	Cat. 16cc	*Breithorn and Schmadribach Falls*
50.130.148dd	Cat. 16dd	*Breithorn and Schmadribach Falls*
50.130.148ee	Cat. 16ee	*Schmadribach Falls*

Acc. No.	Cat. No.	Title
50.130.148ff	Cat. 16ff	*Gottlieb Feutz*
50.130.148gg	Cat. 16gg	*Gottlieb Feutz, Mürren*
50.130.148hh	Cat. 16hh	*Theodore B. Bronson Jr., Lucerne*
50.130.148ii recto	Cat. 16ii recto	*Lucerne Cathedral, Farmer in Field, Foliage, Two Children*
50.130.148ii verso	Cat. 16ii verso	*Man, Horse*
50.130.148jj recto	Cat. 16jj recto	*Leg*
50.130.148jj verso	Cat. 16jj verso	*Man on Horseback, Woman Carrying a Jug, Figure with Halo Figures*
50.130.148kk	Cat. 16kk	*Figures*
50.130.148ll	Cat. 16ll	*Man in a Boat, Foliage*
50.130.148mm	Cat. 16mm	*Boat on Lake of Lecco*
50.130.148nn	Cat. 16nn	*Heads (inside back cover of Switzerland 1870 Sketchbook)*
50.130.149	Cat. 186	*Javanese Dancers Sketchbook*
50.130.149a	Cat. 186a	*Foot of a Javanese Dancer*
50.130.149b	Cat. 186b	*Head of a Javanese Dancer in Profile*
50.130.149c	Cat. 186c	*Arm of a Javanese Dancer*
50.130.149d	Cat. 186d	*Head of a Javanese Dancer*
50.130.149e	Cat. 186e	*Hand of a Javanese Dancer*
50.130.149f	Cat. 186f	*Arm of a Javanese Dancer*
50.130.149g	Cat. 186g	*Arm of a Javanese Dancer*
50.130.149h	Cat. 186h	*Arm of a Javanese Dancer*
50.130.149i recto	Cat. 186i recto	*Legs and Costume of a Javanese Dancer*
50.130.149i verso	Cat. 186i verso	*Standing Javanese Dancer from Behind*
50.130.149j	Cat. 186j	*Hand of a Javanese Dancer*
50.130.149k recto	Cat. 186k recto	*Two Seated Javanese Dancers*
50.130.149k verso	Cat. 186k verso	*Arm of a Javanese Dancer*
50.130.149l	Cat. 186l	*Seated Javanese Dancer*
50.130.149m recto	Cat. 186m recto	*Javanese Dancer in Profile Fixing Her Hair*
50.130.149m verso	Cat. 186m verso	*Hands of a Javanese Dancer*
50.130.149n recto	Cat. 186n recto	*Hands of a Javanese Dancer*
50.130.149n verso	Cat. 186n verso	*Architectural Ornament*
50.130.149o recto	Cat. 186o recto	*Hand and Body Positions of a Javanese Dancer*
50.130.149o verso	Cat. 186o verso	*Seated Javanese Dancer Fixing Her Hair*

Acc. No.	Cat. No.	Title
50.130.149p	Cat. 186p	*Javanese Dancer Applying Makeup*
50.130.149q recto	Cat. 186q recto	*Javanese Dancer Applying Makeup*
50.130.149q verso	Cat. 186q verso	*Javanese Dancer Applying Makeup*
50.130.149r	Cat. 186r	*Javanese Dancer Applying Makeup*
50.130.149s	Cat. 186s	*Heads and Faces of Javanese Dancers*
50.130.149t recto	Cat. 186t recto	*Two Javanese Dancers Applying Makeup*
50.130.149t verso	Cat. 186t verso	*Javanese Dancers Applying Makeup and Adjusting Hair*
50.130.149u recto	Cat. 186u recto	*Head and Feet of Two Javanese Dancers*
50.130.149u verso	Cat. 186u verso	*Two Standing Men*
50.130.149v recto	Cat. 186v recto	*Head with Turban*
50.130.149v verso	Cat. 186v verso	*Three Standing Javanese Dancers*
50.130.149w recto	Cat. 186w recto	*Standing Javanese Dancer*
50.130.149w verso	Cat. 186w verso	*Javanese Dancer, Arm and Hand Positions*
50.130.149x	Cat. 186x	*Javanese Dancer*
50.130.149y recto	Cat. 186y recto	*Javanese Dancer Applying Makeup*
50.130.149y verso	Cat. 186y verso	*Javanese Dancer*
50.130.149z recto	Cat. 186z recto	*Two Javanese Dancers*
50.130.149z verso	Cat. 186z verso	*Javanese Dancer with Fan, Foot, Man*
50.130.149aa recto	Cat. 186aa recto	*Javanese Dancer, Two Musicians*
50.130.149aa verso	Cat. 186aa verso	*Seated Javanese Dancer, Foot and Leg Positions*
50.130.149bb recto	Cat. 186bb recto	*Javanese Dancer Applying Makeup*
50.130.149bb verso	Cat. 186bb verso	*Javanese Dancer, Hand and Arm Positions*
50.130.149cc recto	Cat. 186cc recto	*Arms and Torso of a Javanese Dancer*
50.130.149cc verso	Cat. 186cc verso	*Two Standing Javanese Dancers*
50.130.149dd	Cat. 186dd	*Seated Javanese Dancers*
50.130.149ee	Cat. 186ee	*Javanese Dancers on Stage*
50.130.149ff	Cat. 186ff	*Arms of Javanese Dancers*
50.130.149hh	Cat. 186hh	*Figure in Architectural Setting*
50.130.149ii	Cat. 186ii	*Architectural Setting*
50.130.149rr recto	Cat. 186rr recto	*Three Standing Dancers*

Acc. No.	Cat. No.	Title
50.130.149rr verso	Cat. 186rr verso	*Standing Javanese Dancer, Face, Composition Study*
50.130.149ss	Cat. 186ss	*Javanese Dancers Performing (inside back cover of Javanese Dancers Sketchbook)*
50.130.153	Cat. 190	*Mrs. Louis Ormond*
50.130.154a	Cat. 52	*Night (from scrapbook)*
50.130.154b	Cat. 51	*Marriage at Cana (from scrapbook)*
50.130.154c	Cat. 108	*Compositional Study for "Rehearsal of Pasdeloup Orchestra at the Cirque d'hiver" (from scrapbook)*
50.130.154c2	Cat. 109	*Musicians, Related to "Rehearsal of Pasdeloup Orchestra at the Cirque d'hiver" (from scrapbook)*
50.130.154d	Cat. 66	*Noon (from scrapbook)*
50.130.154e recto	Cat. 50 recto	*The Miracle of Saint Mark, Detail (from scrapbook)*
50.130.154e verso	Cat. 50 verso	*Figures (from scrapbook)*
50.130.154e2	Cat. 130	*Classical Ornament and Greek Lekythoi (from scrapbook)*
50.130.154e3	Cat. 131	*Classical Ornament and Warrior (from scrapbook)*
50.130.154e4	Cat. 132	*Tripod (from scrapbook)*
50.130.154e5	Cat. 133	*Classical Ornament (from scrapbook)*
50.130.154e6	Cat. 134	*Chariot (from scrapbook)*
50.130.154f	Cat. 59	*The Nurture of Bacchus (from scrapbook)*
50.130.154g	Cat. 61	*The Plague of Ashdod (from scrapbook)*
50.130.154h	Cat. 160	*Seated Woman with Fan (from scrapbook)*
50.130.154i	Cat. 96	*Sailors on Sloping Deck (from scrapbook)*
50.130.154j	Cat. 97	*Lifeboats on Davits (from scrapbook)*
50.130.154k	Cat. 103	*Men Sleeping on Deck of Ship (from scrapbook)*
50.130.154l	Cat. 106	*Moonlight on Waves (from scrapbook)*
50.130.154m	Cat. 104	*Sailors on Deck of Ship (from scrapbook)*
50.130.154n recto	Cat. 89 recto	*Men Hauling Lifeboat Ashore (from scrapbook)*
50.130.154n verso	Cat. 89 verso	*Sailor (from scrapbook)*
50.130.154o	Cat. 90	*Men Hauling Boat onto Beach (from scrapbook)*

Acc. No.	Cat. No.	Title
50.130.154p	Cat. 73	Schooner and Bark in Harbor (from scrapbook)
50.130.154q	Cat. 77	Waves Breaking on Rocks (from scrapbook)
50.130.154r	Cat. 78	Rocky Coast (from scrapbook)
50.130.154s	Cat. 79	Coastal Scene (from scrapbook)
50.130.154t	Cat. 85	Sailboat Towing Dory (from scrapbook)
50.130.154u	Cat. 74	Sailors in Rigging of Ship (from scrapbook)
50.130.154v	Cat. 75	Two Sailors Furling Sail (from scrapbook)
50.130.154w	Cat. 71	St. Malo (from scrapbook)
50.130.154x	Cat. 98	Sailors Relaxing on Deck (from scrapbook)
50.130.154y	Cat. 100	Five Figures (from scrapbook)
50.130.154z	Cat. 92	Sails (from scrapbook)
50.130.154aa	Cat. 91	Men Pulling Ropes (from scrapbook)
50.130.154bb	Cat. 105	Deck of Ship in Moonlight (from scrapbook)
50.130.154cc	Cat. 144	Nubians in front of the Temple of Dendur (from scrapbook)
50.130.154dd	Cat. 145	Boy on Water Buffalo (from scrapbook)
50.130.154ee	Cat. 147	Youth (from scrapbook)
50.130.154ff	Cat. 148	Woman Seated before Piano (from scrapbook)
50.130.154gg recto	Cat. 58 recto	Man in Landscape with Temple on Hill in Background (from scrapbook)
50.130.154gg verso	Cat. 58 verso	The Nurture of Bacchus, Detail (from scrapbook)
50.130.154hh	Cat. 84	Two Small Boats Moored to Beach (from scrapbook)
50.130.154ii	Cat. 81	Two Men and a Hayrack Drawn by a Horse (from scrapbook)
50.130.154jj	Cat. 76	Two Men in Ship's Rigging, Two Scenes with Sailboats (from scrapbook)
50.130.154kk	Cat. 80	La Pierre du Champ Dolent (from scrapbook)

Acc. No.	Cat. No.	Title
50.130.154ll	Cat. 43	The Holy Family and a Monk (from scrapbook)
50.130.154mm recto	Cat. 82 recto	Boy and Girl Seated by Tree (from scrapbook)
50.130.154mm verso	Cat. 82 verso	Sailor and Reapers (from scrapbook)
50.130.154nn	Cat. 87	Water's Edge (from scrapbook)
50.130.154oo	Cat. 83	Windmill and Reapers (from scrapbook)
50.130.154pp	Cat. 54	Oscar and Bobino on the Fishing Smack (from scrapbook)
50.130.154qq	Cat. 125	Egyptian Sculpture and Motifs (from scrapbook)
50.130.154rr	Cat. 126	Egyptian Winepress and Architectural Motifs (from scrapbook)
50.130.154ss	Cat. 127	Hunting Birds, after Egyptian Relief Sculpture (from scrapbook)
50.130.154tt	Cat. 128	Egyptian Queens and Priestesses (from scrapbook)
50.130.154uu	Cat. 129	Egyptian Motifs and Musical Instruments (from scrapbook)
53.186	Cat. 192	Helen A. Clark
54.96.2	Cat. 189	Anna R. Mills
66.70	Cat. 191	Paul Manship
1970.47	Cat. 168	Madame X (Madame Pierre Gautreau)
1973.267.1	Cat. 204	Apollo, Study for "Apollo and Daphne"
1973.267.2	Cat. 206	Painting, Study for "Architecture, Painting and Sculpture Protected from the Ravages of Time by Athena"
1973.267.3	Cat. 209	Study for Danaïdes
1973.267.4	Cat. 203	Drapery Studies for "The Church"
1973.268.1	Cat. 205	Drapery Studies
1973.268.2	Cat. 208	Hands, Study for "Apollo in His Chariot with the Hours"
1980.284	Cat. 210	Wing, Study for Notus in "The Winds"

Index

Italic page references denote illustrations. Boldface page references denote principal discussions.